An Enquiring Mind

Studies in Honor of Alexander Marshack

AMERICAN SCHOOL OF PREHISTORIC RESEARCH MONOGRAPH SERIES

The American School of Prehistoric Research (ASPR) Monographs in Archaeology and Paleoanthropology present a series of documents covering a variety of subjects in the archaeology of the Old World (Eurasia, Africa, Australia, and Oceania). This series encompasses a broad range of subjects – from the early prehistory to the Neolithic Revolution in the Old World, and beyond including: hunter-gatherers to complex societies; the rise of agriculture; the emergence of urban societies; human physical morphology, evolution and adaptation, as well as; various technologies such as metallurgy, pottery production, tool making, and shelter construction. Additionally, the subjects of symbolism, religion, and art will be presented within the context of archaeological studies including mortuary practices and rock art. Volumes may be authored by one investigator, a team of investigators, or may be an edited collection of shorter articles by a number of different specialists working on related topics.

American School of Prehistoric Research, Peabody Museum, Harvard University,
11 Divinity Avenue, Cambridge, MA 02138, USA

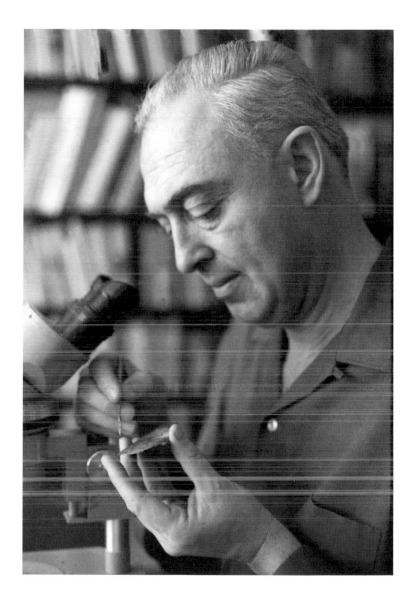

Alexander Marshack (1918-2004)

An Enquiring Mind

Studies in Honor of Alexander Marshack

Edited by Paul G. Bahn

Oxbow Books
Oxford and Oakville

Published by Oxbow Books on behalf of the American School of Prehistoric Research.

ISBN 978-1-84217-383-1

Library of Congress Cataloging-in Publication Data

An enquiring mind : studies in honor of Alexander Marshack / edited by Paul G. Bahn.
 p. cm. – (American school of prehistoric research monograph series)
ISBN 978-1-84217-383-1
 1. Art, Prehistoric. 2. Paleolithic period. 3. Cave paintings. 4. Marshack, Alexander. I. Bahn, Paul

G. N5310.E57 2009
709.01–dc22

 2009046055

TYPESET AND PRINTED IN THE UNITED STATES OF AMERICA

Contents

[†] *deceased*

Preface

Paul G. Bahn

Alexander Marshack (1918-2004)

The idea for this volume of papers written in tribute to Alex Marshack came from Michel Lorblanchet, whose immediate reaction to the news of Alex's passing was to insist that "if a book is to appear in homage to him, I want to contribute to it".

The fact that the scholar who is generally considered to be France's - and doubtless the world's - foremost specialist in paleolithic art held Alex in such high esteem (as can be seen in the article he has written) is some indication of Alex's standing in that domain, and of the immense contribution made by his unique work.

Another, very different indication of the impact of his research can be seen in the fact that, shortly after the publication in 1972 of his milestone volume, *The Roots of Civilization*, it formed the subject of a question in the undergraduate prehistory examinations at the University of Cambridge. Very few archaeology books so quickly become the focus of such questions.

And yet... despite his great prestige and his enormous contributions, Alex never received a single honorary degree or doctorate, even though most of the many people who contacted him for advice or help addressed him as "Doctor" or "Professor", assuming - perhaps from his Harvard connection - that he held such a title. It is supremely ironic that far less deserving, but academic prehistorians in the USA have received prestigious awards for "achievement", when they have, in fact, achieved nothing, or at least very little in comparison with Marshack.

For Alex Marshack single-handedly revolutionized the field of paleolithic art research. As Francesco d'Errico and Michel Lorblanchet emphasize in this volume, his astounding photographs of portable art objects caused us all to see them with fresh eyes, to ask new questions, and to understand their technology and production far more precisely; and as Yves Martin reminds us in his contribution, Alex's pioneering use of infrared and ultraviolet light in the caves revealed startling new facts about the paintings. And one can also cite his important, provocative and challenging work on archaeoastronomy, calendar sticks, female imagery, and so forth.

I first set eyes on Alex at the 1976 Nice UISPP Congress when I was a lowly graduate student, and he was already one of the "gods", sharing a podium with the likes of André Leroi-Gourhan and Paolo Graziosi in the symposium on paleolithic art. I first wrote to him in the late 1970s, and henceforth we corresponded regularly, but we really became friends at the UISPP congress in Mexico City, 1981, when he, John Clegg and I formed an inseparable threesome. He gave me tremendous help and encouragement during my doctoral and post-doctoral research.

In subsequent years we became firm friends, and I would always stay with him and Elaine during my visits to New York, where they showed me endless kindness and hospitality, and Alex even tidied the back room to enable me to sleep there. The apartment's second bedroom had gradually become a storage area for the products of Alex's research and his enormous collection of books. Having helped Elaine to clear out this chaotic and overstuffed room after his death, I was able to see what a herculean effort this tidying must have been each time, and found it a profoundly touching testimony to the extent of our friendship.

During my visits, or in the course of phone calls, Alex was always eager to hear the latest news from European prehistory, the scandals and gossip, the enmities and alliances, the new discoveries, publications and theories. His ever-enquiring mind was constantly assessing the new data and information, weighing up possibilities and implications, and raising fresh questions. Naturally, we did not agree on everything concerning Ice Age art and culture, but this never interfered with our friendship - a point also made by Francesco d'Errico in this volume.

His work, his enthusiasm and his life with Elaine all kept him astonishingly young. Before he was felled by a stroke in 2003, he could easily have passed for 60 years of age, thanks to his boundless energy. But even after the stroke and a subsequent fall, at our last meeting he still showed immense interest in all the prehistory news, and excitement at the photographs of our newly discovered cave art at Creswell Crags in England.

When I helped Elaine to sort out Alex's library, I rapidly became deeply impressed at the breadth and depth of his reading. There was a mass of annotations in so many books on so many topics. Alex had been a voracious reader, particularly in the 1960s, of archaeology, anthropology, mythology, linguistics, archaeoastronomy, psychology, the workings of the brain... and of course of prehistoric and especially paleolithic art.

He had started late but, thanks to the constant support of Hallam Movius and Harvard, he was able to do what nobody else ever had before, or perhaps ever will again - i.e., travel all over Europe, visiting not only many decorated caves but also all the portable art objects scattered throughout the continent, including Russia. This unique experience and knowledge, together with his unrivalled and amazing documentation of all this material, made him by far the United States' foremost specialist in paleolithic imagery, and the

success of his exhibition in 1978, "Ice Age Art", was largely responsible for bringing that imagery to the attention of the American public.

It was therefore only fitting and no surprise that, after the establishment of the McDonald Institute in Cambridge, dedicated to the study of cognitive archaeology, Alex was invited to give the very first of its prestigious annual lectures, in 1989.

His interminable hours of typing at the computer produced numerous invaluable papers, but never the *magnum opus* that he could and should have given us - the follow-up to *The Roots of Civilization*. Alex left so much, and so many photos, unpublished. But his archive at Harvard will preserve everything for future generations of scholars.

Like all Festschrifts, the present volume is a very mixed bag in terms of content and quality, but it gives some idea of the breadth of Alex's interests, of the geographical spread of his friends and admirers, and of the impact his work had on a variety of fields. He would probably not have agreed with everything here. Nevertheless, I hope that he would have been gratified by the volume, and that it will stand as some small, long-overdue compensation for the disgraceful lack of academic plaudits accorded him. Archaeological academia should hang its head in shame for not awarding some glittering prizes to Alexander Marshack during his lifetime.

In closing, I would like to thank all the authors for their contributions; Wren Fournier, Publications Coordinator at the American School of Prehistoric Research, for turning the material into a book; and above all Elaine for her constant help and encouragement with the task of compiling and editing the volume. It stands as a tribute to her as much as to Alex.

About the author

Paul G. Bahn, 428 Anlaby Road, Hull HU3 6QP, England; E-mail: pgbahn@anlabyrd.karoo.co.uk.

Contributor List

Anthony Aveni

E-mail: Aaronical@mail.colgate.edu; Dept. of Physics and Astronomy, Colgate University, Hamilton, NY 13346, USA.

Paul Bahn

E-mail: pgbahn@anlabyrd.karoo.co.uk; 428 Anlaby Road, Hull HU3 6QP, England.

Ofer Bar-Yosef

E-mail: obaryos@fas.harvard.edu; Harvard University, Dept. of Anthropology, Peabody Museum, 11 Divinity Avenue, Cambridge MA 02138, USA.

Anna Belfer-Cohen

E-mail: belferac@mscc.huji.ac.il; Institute of Archaeology, Mt Scopus, Hebrew University of Jerusalem, 91905, Jerusalem, Israel.

Gerhard Bosinski and Hannelore Bosinski [†]

E-mail: bosinski@orange.fr 3; Place Mazelviel, 82140 st Antonin-Noble-Val, France.

John Clegg

E-mail: jcless@mail.usyd.edu au; 24 Waterview Street, Balmain, NSW 2041, Australia.

Brigitte Delluc and Gilles Delluc

E-mail: dellucbg@wanadoo.fr; Le Bourg, 24380 Saint-Michel-de-Villadeix, France.

Francesco d'Errico

E-mail: f.derrico@ipgq.u-bordeaux1.fr; Institut de Préhistoire et de Géologie du Quaternaire, UMR 5199 of the CNRS, Université Bordeaux 1, avenue des Facultés, F-33405 Talence, France.

Roslyn Frank

E-mail: roz-frank@uiowa.edu; Dept. of Spanish and Portuguese, Schaeffer Hall, University of Iowa, Iowa City, Iowa 52242, USA.

Michael Hudson

E-mail: mh@michaelhudson.com; Distinguished Professor of Economics, University of Missouri, Kansas City, MO 64110, USA; 119-49 Union Turnpike, Forest Hills, NY 11375, USA.

Ed Krupp
E-mail: eckrupp@earthlink.net; Griffith Observatory, 2800 E. Observatory Road, Los Angeles, CA 90027, USA.

C. C. Lamberg-Karlovsky
E-mail: karlovsk@fas.harvard.edu; Peabody Museum, 11 Divinity Avenue, Harvard University, Cambridge, MA 02138, USA.

Michel Lorblanchet
E-mail: michel.lorblanchet@wanadoo.fr; Roc des Monges, 46200 St. Sozy, France.

Alexander Marshack †

Elaine Marshack
E-mail: cmarshac@hunter.cuny.edu; 4 Washington Square Village, New York, NY 10012, USA.

Yves Martin
E-mail: yves.martin.gouy@free.fr; 101 Sente aux Dames, 76520 Gouy, France.

Margherita Mussi
E-mail: margherita.mussi@uniroma1.it; Dipartimento di Scienze dell'Antichità, Università i Roma "La Sapienza", Via Palestro 63, 00185 Rome, Italy.

Elena Okladnikova
E-mail: okladnikova@pisem.net or pasternak@cycla.ioffe.rssi.ru or lena.Okladnikova@kunstkamera.ru; Museum of Anthropology and Ethnology, 3 University Embankment, 193034 St. Petersburg, Russia.

Marcel Otte
E-mail: Marcel.Otte@ulg.ac.be; Dept. of Prehistory, Université de Liège, Place du XX Août 7, B, t A1, 4000 Liège, Belgium.

Paul Pettitt
E-mail: P.Pettitt@sheffield.ac.uk; Dept. of Archaeology, University of Sheffield, Northgate House, West Street, Sheffield S1 4ET, England.

Denise Schmandt-Besserat
E-mail: dsb@mail.utexas.edu; The University of Texas at Austin, Department of Art and Art History, College of Fine Arts, 1 University Station D1300, Austin, TX 78712, USA.

Kevin Sharpe †

Olga Soffer
E-mail: o-soffer@uiuc.edu; Department of Anthropology, University of Illinois, Urbana, Illinois 61801, USA.

Ian Tattersall
E-mail: iant@amnh.org; Division of Anthropology, American Museum of Natural History, New York, NY 10024, USA.

Leslie Van Gelder
E-mail: lvangeld@waldenu.edu; Walden University, Minneapolis, Minnesota and 10 Shirelake Close, Oxford OX1 1SN, United Kingdom.

Christian Züchner
E-mail: Christian.Zuechner@ufg.phil.uni-erlangen.de; Institute of Prehistory, University of Erlangen-Nuremberg, Kochstrasse 4/18, 91054 Erlangen, Germany.

† *deceased*

List of Figures and Tables

Tables

INTRODUCTION

Elaine Marshack

Introduction

Alex would have been delighted by this tribute from colleagues he admired and, yes, often vigorously challenged. He had a goal: to understand as much as he could about evidence of symbolic thinking among early *Homo sapiens*. This quest began at age 45 and continued until shortly before his death at 86, a period that seemed much too short to him.

Alex grew up in the Bronx, a borough of New York City. His parents had each come to New York as young, single adults from Poland and Russia, leaving behind their own parents and siblings. They pioneered an early Jewish co-operative residence and fought to save it in the 1930s during the Great Depression. Alex's sister was a co-founder of a chapter of the American Civil Liberties Union in Texas in the 1960s and devoted the rest of her life to this cause.

A journalism degree from the City College of New York ended Alex's formal education. For the next 20 years he worked as a radio and television producer-director, a photojournalist, a news and science writer, and a book and drama reviewer. In writing the nation's first book about the International Geophysical Year (1957-1958), he puzzled about how and why the space age had developed. These questions led him to the archaeological record, and an article about a tiny bone that changed his career.

Alex was a risk taker. Maybe it ran in his blood. A long-standing friend said of him that, like an Ice Age artist with no precedents to guide him, he combined keen observation, careful thought and an ability to make leaps of understanding that produced daring new ideas. This little bone, found at a Mesolithic site in Africa, certainly provided an example: it gave rise to Alex's startling hypothesis that its scratch marks might represent a method for notating the passage of time.

With the support of Harvard University which made him a research associate in 1963, Alex devoted the rest of his life to examining as many mobiliary artifacts from the Ice Age as he could get his hands on. To him, the repetitive groups of short strokes and other abstract markings inscribed on bone fragments by Paleolithic artists were not accidental scratches or hunting tallies but evidence of the structured working of the early human mind.

Pursuing his research mostly in Europe Alex also spent four summers working in the Middle East. After a first bibliographic survey of marked bones and stones excavated from Ice Age sites and several short visits to France, he traveled for seven months in 1967 from Sweden to Spain, eagerly examining hundreds of objects, many in private collections. As his traveling companion and general assistant, I marveled at his ability to persuade even the most reluctant gatekeepers to allow him to examine and photograph their materials. Gustav Riek had never permitted his associates in Tübingen to view the magnificent animals from Vogelherd which he kept in a bank but finally, after hours of animated discussion, allowed Alex

to photograph them. Access to photograph the horses in Pech-Merle followed almost a day of conversation with the mayor of Cabrerets. In these exchanges, Alex amply demonstrated his infectious enthusiasm for his quest.

Neither Alex nor I was fluent in foreign languages, but along with spotty French and German, always in the present tense, he was masterful in his use of pantomime. I recall especially his long conversation with Alfred Rust in Ahrensburg, Germany; the two men discoursed comfortably in a combination of three languages, pantomime, and drawings. Conversations with colleagues were a vital component of Alex's trips, and he sought them out everywhere. He found André Leroi-Gourhan on horseback at Arcy-sur-Cure, François Bordes flint-knapping at his summer home in Carsac, Léon Pales at his laboratory in the Pyrenean foothills, Gerhard Bosinski at his research center, Schloss Monrepos in Neuwied on the Rhine, Michel Lorblanchet in the office at Pech Merle, and Marcel Otte as a student hitchhiking among the French prehistoric sites. Alex was touched when Alexey (A. P.) Okladnikov took a train from Siberia to meet him in St. Petersburg. The most frequent visits were with Hal Movius and his wife, Nancy, in their hillside farmhouse in Tursac near Hal's excavation at the Abri Pataud in Les Eyzies. In New York he welcomed visits from Jean Vertut, Paul Bahn, and Gilles and Brigitte Delluc.

The four summers in Israel (with trips to Jordan and Turkey) provided a fruitful ending to Alex's research travels. The richness of the materials and the community of scholars he encountered delighted him. He especially enjoyed working at Hebrew University's Archaeological Institute with Ofer Bar-Yosef, Anna Belfer-Cohen,

Naama Goren-Inbar, Erella Hovers, and Nigel Goring-Morris. Alex had met Francesco d'Errico in Paris some years earlier and was surprised to find him in Israel one summer. The two men took a trip to the Golan Heights together, and Alex got to see Francesco's spectroscopic microscope in action.

Alex's status as an outsider freed him from easy categorization but also set him apart from members of specific disciplines. He could be brash and self-promoting, qualities that had served him well as a freelance journalist but sometimes antagonized scientists. A tall and handsome man, he was forceful, keenly perceptive and enormously engaging, with a wry sense of humor. As I traveled with Alex, I was repeatedly struck by the wide range of knowledge he brought to each new puzzle. He drew upon astronomy, linguistics, animal studies, cognitive science, psychology, neurology, paleontology, and especially archaeology. As the London *Times* commented, Alex had "a flair for making the complex comprehensible".

Continuing archaeological research has lent support to Alex's hypothesis that early *Homo sapiens* left evidence of complex intellectual processes, a significant legacy for this highly original man.

About the author

Elaine Marshack, Alex's wife, assisted him on his research trips, which took place during summers from 1965 to 1996. Elaine Marshack was a faculty member at the Hunter College School of Social Work in New York City until her retirement in 2001. Elaine Marshack: 4 Washington Square Village, New York, NY 10012, USA; E-mail: emarshac@hunter.cuny.edu.

ALEXANDER MARSHACK AT HARVARD UNIVERSITY'S PEABODY MUSEUM

C. C. Lamberg-Karlovsky

Alex and I arrived at Harvard almost at the same time. It was the mid-1960s. I was a freshly minted Ph.D., appointed an Assistant Professor in the Department of Anthropology. Alex was in communication with Professor Hallam Movius, Jr. concerning his independent research on Paleolithic art. It was not to be predicted that Alex and Hallam would become collaborators – of sorts. Hallam was extremely demanding, precise in his scholarship, with an unparalleled command of the world's Stone Age. He was a master of the evidence; his control of facts and details was incomparable. From 1958 to 1964 his excavations in France, at the rock shelter of Abri Pataud, had set the standard for rigorous excavation techniques. Alex was a noted science writer and photographer whose specialty was covering space technology and exploration. It was far from obvious either that Hallam had an interest in space or that Alex was concerned with the art of the Stone Age. The former was true, the latter false. Alex's involvement with photographing art in the caves of France led not only to his pioneering efforts at infra-red photography but to an involvement in the 'meaning' of the art. Alex was imaginative, creative, and more than willing to speculate. Hallam resisted speculation. Even theoretical formulations, of the type that his colleague François Bordes (1961, 1979) was introducing, wedding stone tool types to specific cultures, tribes, *etc.* was to be resisted.

While Alex lacked the detailed mastery of the facts, which Hallam so thoroughly commanded, he made up for it in imaginative thought. He came to Harvard with an idea and a proposal. His idea was that certain marks, etched in patterns on bone, represented a calendrical system. From such etched patterns one could 'read' the seasons of the year in which animals migrated, gave birth, and the time of the year in which plants came to bear fruit. Perhaps such a calendar would even regulate an annual cycle of ritual behavior. Needless to say, such calendrical knowledge would have greatly advantaged the hunter and allowed for a certain seasonal predictability of animal and plant behavior. This was his idea. His proposal was that Harvard's Peabody Museum should offer him an affiliation – an appointment that would permit him to secure grants and represent the Peabody as a member of its research staff.

This required approval from the archaeologists within the Department of Anthropology, the Director of the Peabody Museum, and the appointments committee within the office of the Dean of the Faculty of Arts and Sciences. The process could be cumbersome and by no means a fluid procedure. In 1973 Alex was appointed a Research Associate of the Peabody Museum. For more than thirty years Alex held that title. Initially the appointment came without office or stipend. However, over the decades it did provide him the umbrella by which he secured research funds from the National Science Foundation, the National Endowment for the Humanities, and the National Geographic Society, to name but a few of the foundations

from which he secured major funding. Over the course of the last decade Alex was offered a modest stipend from the Peabody Museum's American School of Prehistoric Research to assist in its research interests.

To Hallam's great credit, he supported the ideas that Alex advanced. It must be clearly understood that without Hallam's support Alex would never have secured an affiliation with Harvard. However, support. in Hallam's view, did not necessarily mean agreement with Alex's ideas. On the occasions that Alex came to Harvard he often gave an update on his research results. There were times that Hallam was cautiously receptive to Alex's ideas concerning calendrical and mathematical notations; at other times he thought them too speculative, even without foundation. Nevertheless, he never withdrew his unreserved support that Alex be affiliated with Harvard. Given Hallam's predisposition to perfection, his strong and continued support of Alex attests to his belief that what counts are the standards of research design, not necessarily whether the ideas have been proven true. I remember Hal once showing me a paper that Alex published in *Current Anthropology*. Attached to the paper were at least 50 5 x 7 cards filled with Hal's writing in pen-and-ink (never ballpoint pen or pencil). I asked Hal what he thought of the paper. He reminisced. He took pleasure in the fact that it was he who brought Alex to the Peabody, encouraged him in his research, and agreed to act as co-principal investigator for Alex's grants. At Harvard only ladder Professors (from Assistant to full Professor) could serve as Principal Investigators on government grants. Hal allowed that Alex was making a very significant contribution to the field – high praise indeed from Hal. I commented on the voluminous notes that he took on Alex's paper. and

asked him if he found the thesis convincing. He answered "Perhaps. I'm sending him these", flicking the 5 x 7 cards.

Alex's relations with Harvard were at times strained. When I served as Director of the Peabody Museum I heard frequent complaints from Alex. By this time he had an international reputation, his research was much quoted and discussed. Alex would have liked a full-time paid teaching and research appointment at Harvard. That this was not to be caused tension. He rightfully believed that his research results and publications carried the name of Harvard and the Peabody Museum around the world. He believed that Harvard, in turn, was not doing enough for him. Perhaps he was right. In the final analysis, as the person at Harvard perhaps second to Hal in support of Alex, I believe both parties benefited. Without Harvard, and Hallam Movius's acting as co-principal investigator on Alex's grants, Alex would never have gained the research funding he did. Hal's collaboration offered a pledge of intellectual excellence, while Alex's Harvard affiliation opened doors for further collaboration and access to an ever increasing number of colleagues and institutions. In time Alex attained his own position of prominence. Hal's successors Glynn Isaac and Ofer Bar-Yosef welcomed Alex as a distinguished representative of the Peabody research staff. Finally, Alex's appreciation of his affiliation was affirmed in his desire to see his library and, most importantly, an archive of over 35,000 slides and images of Paleolithic sites and material remains deposited at Harvard.

About the author

C. C. Lamberg-Karlovsky, Peabody Museum (Director 1977–1990), Stephen Phillips Professor of Archaeology, Harvard University, Cambridge, MA 02138, USA.

References

Bordes, F.

1961 *Typologie du Paléolithique Ancien et Moyen.* Publications de l'Institut de Préhistoire de l'Université de Bordeaux. Mémoire 1, Bordeaux.

1979 *Typologie du Paléolithique.* Editions du Centre National de la Recherche Scientifique, Paris.

CALENDARS, COSMOLOGIES, AND THE UNWRITTEN RECORD IN ANCIENT MESOAMERICA

Anthony Aveni

I was delighted to be asked to contribute to this commemorative volume. Alex Marshack and I shared a special kinship for more than three decades. Both outsiders, we came to our respective study areas, his the European Upper Paleolithic, mine Pre-Columbian Mesoamerica, intrigued by the same sort of problem: the notational analysis of carved markings: his in bone, mine in stone and in the stuccoed floors of abandoned palaces. Also, we both experienced strong criticism for our interpretations of an unwritten record that placed our respective cultures on higher than anticipated intellectual planes concerning accepted notions of astronomical observation and calendrical record keeping.

When I pulled down my trusty first edition of *The Roots of Civilization* to review its contents, to help decide what to write about that might appeal to Alex, I happened to open to the dedication – to Elaine of course. There Alex spoke of the difficult making of that work, which reminded me of the harsh reviews he received, and the brilliant defense of both methodology and results that he and his informed colleagues (Hallam Movius comes to mind) had made concerning his dramatic findings. Tracking the course of the lunar phases 25,000 years ago makes perfect sense, and the case for it is, I believe, now well established, thanks to Alex's work on notational analysis.

When, having learned of his work, I invited Alex to present a paper at the first International Congress on Archaeoastronomy in Mexico City

in June 1973 (where I met him for the first time), I had the opportunity to share my similarly inclined pursuits with him. I trust he would find my updated version of a story I told then worthy of this tribute volume.

Introducing pecked cross petroglyphs: The alignment hypothesis

Of all the themes encapsulated in Mesoamerican cosmology none is more pronounced nor widespread than the concept of the quadripartite division of the universe. We see it reflected in pre-Conquest calendars, religious games, color coded cardinal directions, even in the morphology of certain Maya hieroglyphs. Quartered circles appear in many forms in the art and iconography of ancient Mesoamerica, where they have been variously interpreted to signify "sky", "heaven", "sun", or "time".

In 1970 I became captivated by a particular kind of quartered double concentric circle pecked with some sort of percussive device into the floors of buildings in and on rock outcrops surrounding the great site of Teotihuacán in highland Mexico. These definitive carvings comprise holes of about 1 cm dimension spaced approximately 1 or 2 cm apart. The evidence we first collected suggested that they functioned as architectural benchmarks, specifically as devices for determining astronomical alignments. One has the distinct impression that the builders of the ancient cities of Mesoamerica sought to envelop in their urban architecture a sense of harmony with the cosmos.

Figure 3.1 The pecked cross petroglyph near the northern frontier of Mexico (Chavero 1889:37).

Today we know the pecked cross petroglyphs are numerous and widely distributed across Mesoamerica. After a brief historical overview and a closer look at some examples found in both the environment of Teotihuacán and places as far flung as the Tropic of Cancer and the Petén rain forest of Guatemala, I hope to demonstrate that these quartered circles were not only ritually symbolic, but also that they took on a highly functional aspect tied to early attempts to practice astronomy and to develop a calendar.

My story begins in 1887, when Mexican historian and author Alfredo Chavero made reference in an obscure publication to a place near the northern frontier of Mexico where there can be found:

> a great slab of more than 28 square varas (about 16 square meters) on which are marked two circles and in the middle one diameter, then another at right angles to it, all indicated with groups or points giving the chronological periods (Chavero 1889:37; cf. Figure 3.1).

Whoever created it was careful enough to space the points or holes evenly and to set equal numbers of elements into each quadrant.

Students of Mesoamerican culture will immediately recognize in the arrangement a relationship with the Mesoamerican calendar: the outer circle consists of 25 holes per quadrant, totaling 100; the inner circle contains 20 holes per quadrant, totaling 80; there are 20 holes on each axis, totaling 80; and the grand total number of holes (not including the central hole) is 260.

There are at least two reasons for a logically valid association of this numerical pattern with pre-Columbian calendars: first, there is the presence of the number 20, the base of their mathematical system being vigesimal, a development likely originating from preliterate counting on the fingers and toes; second, the count total of 260 replicates the most important cyclic interval in the native ritual calendar. Formed by the successive matching of 13 numerals with 20 named days, the 260-day cycle, called tonalpohualli or "count of the days" by the Aztecs, and tzolkin or "wheel of the days" by the Maya, is the most frequently represented calendrical period in the pre-Columbian books called codices. (The system is rather like our permutation of seven named days of the week with 30 numbered days of the month.) Ethnographic studies among contemporary Maya, where this calendar still persists, reveal that only certain pairings are auspicious for particular activities such as planting, marriage, or conception. Interestingly, Alex Marshack (1974) contributed to these studies by analyzing a contemporary Maya calendar board used to tally the day count.

Six decades after Chavero's work (and apparently unaware of it), Harvard archaeologist Ledyard Smith, who was excavating the Maya ruins of Uaxactún, Guatemala, unearthed an almost identical artifact (Figure 3.2). Not a true

petroglyph or rock carving, it was pecked into the floor of Structure A-V at the Early Classic Maya site in the Petén rain forest (more than 2000 km from the "northern frontier"). Smith noted that the arms of the cross pointed to the cardinal directions (our measurements with a surveyor's transit [in the pre-GPS/total station era] indicated an orientation of 17.5° east of north, close to that of the Street of the Dead at Teotihuacán, which aligns 15°28' east of north, Aveni et al. 1978).

About fifteen years after the publication of the Uaxactún material, the first of the Teotihuacán petroglyphs was discovered by workers of the University of Rochester's Teotihuacán Mapping Project. One was carved into the floor of building 34-C, about 360 m SW of the center of the Pyramid of the Sun (Figure 3.3). Later a second circle was found in a small basaltic outcrop 3 km to the west, on the hill known as Cerro Colorado.

What surprised the project director, René Millón, was that a line connecting the two markers aligned almost exactly (the deviation is 7 m over a 3 km baseline) with the orientation of the rectangular grid system to which all Teotihuacán buildings were forced to conform. Interestingly this direction runs counter to the landscape and deviates noticeably from cardinality. Adherence to such an artificial Teotihuacán grid implied considerably more material, labor, and planning than had one simply followed the lay of the land. Millón suggested that the rulers of Teotihuacán seem to have chosen this format because of some overriding dictate. He further supposed that the direction assigned to the grid was attributable at least in part to Teotihuacán cosmology or geomancy, though he did not pursue this line of inquiry in detail.

The clarity with which one views the western horizon in the vicinity of the second marker from the vantage point of its counterpart near

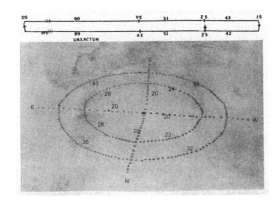

Figure 3.2 Pecked cross symbol carved in the floor of Str. A-V at Maya ruins of Uaxactún. Counts are tallied on the diagram and their possible relation to seasonal intervals is depicted at the top. (DS = December Solstice; JS = June Solstice; VE = Vernal Equinox; AE = Autumnal Equinox; ZS = Solar Zenith Passage).

the center of the ruined city led to the investigation, by a number of scholars, of various astronomical hypotheses to explain the skewed orientation from the cardinal points. In each of these schemes the observer uses one of the pecked crosses as a foresight and the other as a backsight to view a particular celestial body at the horizon. As first suggested by archaeologist James Dow (1967), the Pleiades star group, familiar to us as the Seven Sisters of Greek mythology who ride on the back of Taurus the Bull, seemed a likely candidate.

Why orient buildings to stars? Like Brasilia and Washington, D.C., Teotihuacán was a planned community. Its makers deliberately presented it as a sort of paradise on earth with a sacred geography all its own. It was the place, so said the Aztecs who postdated it by a millennium, where time began, where people first emerged from the earth at the beginning of creation, and it was the home of a powerful goddess who dwelled in natural caves. Builders enhanced the local geography

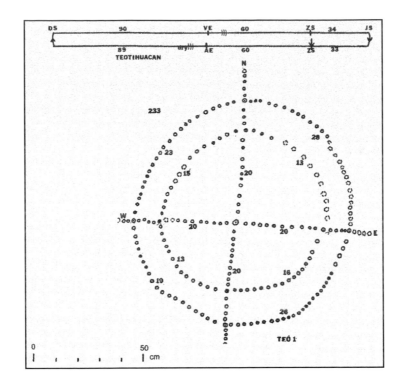

Figure 3.3 *Pecked cross petroglyph carved in the floor of a building near the Pyramid of the Sun in Teotihuacán. A line between it and a nearly identical design 3 km west points to the setting position of the Pleiades star group at the time Teotihuacán was built. The alignment also fits the east-west Teotihuacán axis perfectly. Seasonal periods for Teotihuacán are indicated at the top.*

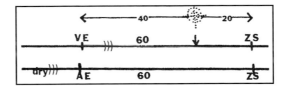

Figure 3.4 *Divisions of the Year at Teotihuacán; enlarged from Figure 3.3.*

to reflect certain aspects of the creation myth – the strict grid plan that runs against the grain of the landscape, the ancient excavation of an artificial cave beneath the Pyramid of the Sun, and the careful positioning of the urban plan respecting Cerro Gordo, the great mountain on the north. The distinctively novel axial orientation of Teotihuacán claimed for it "a new, and probably privileged, relationship to the gods", wrote art historian Esther Pasztory (1978), a reflection of the sacred cosmic blueprint handed down to them.

Where do the Pleiades fit into this scheme? Not only does the Teotihuacán E-W alignment point to the place where the Pleiades disappear in the west during the earliest building phases at Teotihuacán, but also the Teotihuacanos may have

considered the Pleiades a paramount asterism because of its association with the local zenith (the overhead point or fifth cardinal point in the Mesoamerican ideology of sacred space). Corrected for the precession of the equinoxes, we discovered that this star group passed close to the zenith when transiting the Teotihuacán meridian 2000 years ago; furthermore their heliacal rising (first annual pre-dawn appearance after blockage by the sun for several weeks) occurred on the same day as the first of two annual passages of the sun through the zenith, which was regarded throughout Mesoamerica as the start of the New Year. Thus the Pleiades epitomized both the principles of sacred geography and practical time-keeping: to indicate the position of the local zenith and to announce the day of the sun's passage through it.

Those of us who live outside the latitude of the tropics are scarcely aware of nor likely have ever experienced the phenomenon of solar zenith passage. Between the Tropics, as it moves on its northward journey in the spring time, rising ever higher in the sky at noon, the sun ultimately reaches the position where it stands straight overhead, casting no shadows and illuminating equally all sides of a vertical figure. In Mexican folklore this event is said to presage the rainy season. The sun then moves north of the zenith at noon and all objects begin to cast their shadows to the south for a short spell. On June 21, having reached its celestial elastic limit, the sun shifts direction and begins to move back toward the south, passing the zenith a second time along the way. The Spanish chronicler Bernardino de Sahagún tells us that the Aztecs timed the start of one of their principal ritual cycles by the passage of the Pleiades (known as miec, the many, or the marketplace) through the zenith. This was the permutation of the 365-day year with the 260-day cycle, a 52-year cycle they termed the "binding of the years".

A second possibility for the Teotihuacán alignment deals with the keeping of the seasonal calendar based on the division of the horizon into 20-day intervals. As Figure 3.4 illustrates, at Teotihuacán it is exactly 60 (or 3 x 20) days from the March equinox (VE) to the first solar zenith passage (ZS), as well as from the second zenith passage to the September equinox. The E-W axial alignment of Teotihuacán marked by the pair of Teotihuacán petroglyphs referred to above points to sunset 2 x 20 or 40 days after the vernal equinox and 20 days before first zenith passage (again see Figure 3.4; the intervals are reversed when the sun returns toward the south). Dividing horizon sunsets into 20-day intervals would have been a logical way for a culture with a vigesimally based arithmetic to keep an unwritten calendar. In sum, there are a host of sound cosmic reasons for deliberately skewing the grid of Mesoamerica's most famous city.

Like the tale of the forest traveler who traces his path by making marks on trees, only to be foiled by a prankster who similarly marks every tree in the forest, so too was the orientation hypothesis foiled as a result of the discovery of more pecked crosses (some examples appear in Figure 3.5). Funded by the Anthropology section of the National Science Foundation, we mapped 21 additional examples in the 1970s alone. Then in the 1980s, Swiss archaeologist Matthew Wallrath revealed the discovery of some 30 more in a 1/4 sq km region at the site of Xihuingo, located 30 km ENE of Teotihuacán. Today more than 70 pecked circles have been catalogued, the total having been elevated most recently when several more appeared among the 44 carved figures in the excavations of a 32.5 x 2.4 m section of floor on the south side of the U-shaped Platform that borders the Pyramid of the Sun by the Proyecto Especial Teotihuacán in 1992-1994 under the direction of Eduardo Matos (cf. Aveni 2005).

Figure 3.5 A sample of pecked cross petroglyphs from Teotihuacán and vicinity.

These have been securely dated to the period AD 350-450 by the archaeologists.

Given the diversity of forms and the ruined state of many of these artifacts (cf. esp. Figure 3.5, where some appear only in fragments), it becomes difficult to conceive of an explanation that embraces the origin and function of all of them. Examined from the point of view of energetics, it is clear that an enormous amount of work need not have been invested in making a pecked cross petroglyph. Most are neither very carefully laid out nor precisely oriented, though a number of them (evident among the sample in Figure 3.5) display great care in their construction. On the other hand, if the excavation of but a small fraction of the U-shaped floor that circumscribes three sides of the Pyramid of the Sun were to be extrapolated, one can only imagine how many might lie on the entire floor, not to mention vast unexcavated portions of Teotihuacán. Clearly the Teotihuacanos expended a good deal of energy making these symbols.

The calendar hypothesis

In addition to site alignment, there are several reasons for believing that the Mesoamerican pecked crosses might have functioned as counting devices, and specifically that a count of days in a calendrical scheme was intended: 1) the peck holes are large enough in most cases to have contained a moveable marker; 2) in a number of examples one finds holes in a particular quadrant so closely spaced that they appear to have been squeezed into position as if one tried to compensate for missing elements that needed to be included in a previously specified count (cf. esp. Figures 3.2–3.3) In at least one instance at Xihuingo, an auxiliary ladder or comb symbol consists of elements that point to individual holes on the inner axes (Aveni 1989).

If counting devices had been intended, it is clear that the same count was not sought in all cases, nor was the counting process universal, because: 1) the total number of elements comprising each of the extant pecked crosses exhibits a wide variation (from 7 to 792 across Mesoamerica). Note however, that there is a pronounced maximum centered on 260 (Figure 3.6). As already noted above, the axes of most of the circles contain counts of 20, the base of the Mesoamerican counting scheme. As can be seen in Figures 3.2–3.3, these are usually arranged in a 10-5-5 count (i.e., ten inside the first circle, five between the circles, five outside the outer circle).

The Uaxactún pecked cross petroglyph (Figure 3.2) offers strong evidence that both time-keeping and a relationship with Teotihuacán lay at the foundation of its design (Aveni 2000). For a long time I had wondered why the distribution of marks on various segments of this petroglyph were so peculiar, at least until I began to look further into the vagaries of the seasonal calendar.

At Uaxactún, the interval between the equinox and the first solar passage across the zenith

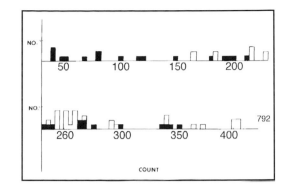

Figure 3.6 Distribution of total counts on pecked circles. Unshaded: from Xihuingo, a site near Teotihuacán. Shaded: other.

is 51 days (cf. seasonal time chart at the top of Figure 3.2). Also, the interval between solar zenith passages that includes the June solstice, which is 67 days at Teotihuacán (cf. Figure 3.3), is equal to 85 days at Uaxactún, i.e., the sun spends 298 days south of the zenith at noon and 67 days north of it at Teotihuacán, while the year is similarly divided into the intervals 280 and 85 days at Uaxactún. Finally, intervals between the dates when the sun passes the zenith can be divided into 33 + 34 = 67 days at Teotihuacán and 43 + 42 = 85 days at Uaxactún. Now, these periods and subperiods are the very numbers one might anticipate finding in artifacts hypothesized to have tallied observable solar time.

Looking closely at the tabulation of the count and arrangement of elements that make up the UAX 1 petroglyph in Figure 3.2, one notes two unusual aspects: first, the large number of elements that make up the whole design, and second, the asymmetry of their distribution, particularly on the outer circle: there are eighty-eight on the southern (top) half as opposed to sixty-eight, precisely twenty less, on the northern half. If we compare the observable solar year intervals with the breakdown of elements on various parts of

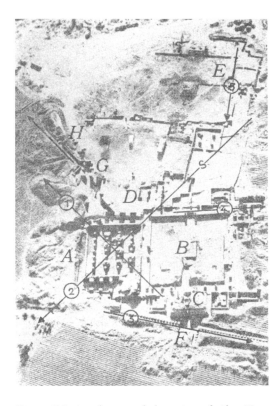

Figure 3.7 Aerial view of the ruins of Alta Vista (Chalchihuites). A number of possible alignments are indicated by key: A = Hall of Columns (Str 1); B = Southeast Patio (Str 2); C = Str 2b; D = Str 3 (west); E = Str 4; F = Serpentine Wall; G = Labyrinth; H = Equinoctial Pathway to Cerro Picacho. (Photo/diagram by J. Charles Kelley).

the design, we also discover that the way the counts are grouped supports the hypothesis that the petroglyph functioned as a seasonal calendar. First of all the number of marks on the SE plus SW quadrants (26+24), as well as that on the inner NW plus NE quadrants (23+28), is close to the observed equinox-solar zenith interval in the Petén (51 days). Second, the sum of the outer SE plus SW quadrants (43+45) equals the observed interval between the autumn equinox and December solstice, as well as that

between the December solstice and spring equinox (89-90 days). And finally, the intervals in the NW plus NE outer circle quadrants (32+36) add up to the interval between zenith passages, not at Uaxactún, but instead at Teotihuacán (60 days, cf. Figure 3.4).

In sum, if the point-by-point count on artifacts conceived as tally markers were used in practice to tabulate local solar time, that is, time as it is actually marked out by the course of the sun in the local environment, then one might expect to find slight asymmetries and inequalities due to modification by nonastronomical calendrical considerations. At two locales as widely separated as Uaxactún and Teotihuacán, discernible differences in naturally-based day count calendars ought to be apparent, indeed to a degree even predictable. But given the (now well documented) powerful influence of Teotihuacán style on pan-Mesoamerican culture, it should not be surprising to find evidence that "Teotihuacán Standard Time" was widely disseminated across far flung areas of Mesoamerica.

Alignment and the calendar hypotheses joined: The case of Alta Vista

Teotihuacán timekeeping via pecked crosses spread far north as well as south. In one dramatic case, some 650 km to the northwest of the great city, we find clear evidence that supports both the orientation and calendar hypotheses. It comes from the site of Chalchihuites, or Alta Vista, which happens to be situated close to one of the seminal geographical circles that gird the globe. Given the importance accorded the solstices, equinox and zenith passages, we might anticipate that one of the key Mesoamerican sunwatching sites would have been the place where the sun turns around on its annual journey among the stars - the Tropic of Cancer. Here, with the approach of the summer rainy season, the sun migrates ever closer to the

zenith, standing precisely overhead on the first day of summer, June 21. Now, it is only at the Tropic that the zenith passage corresponds with the longest day of the year, the day when the sun attains its greatest northerly rising and setting positions along the horizon. All separately important, these astronomical events happen at the same time in the special place that we designate as the latitude of the Tropic. Any tropical culture cognizant of the solar calendar would be expected to have recorded the confluence of these paramount natural events. The unwritten evidence in the Alta Vista ruins and environs supports this hypothesis.

Located just a few kilometers south of the Tropic, in a valley offering neither defensive nor ecological advantages, the ceremonial center of Alta Vista consists of a complex of buildings dating from AD 450-650, several centuries after the Pyramid of the Sun at Teotihuacán was built and only slightly later than the most securely dated Teotihuacán petroglyphs (AD 350-450). The main structure, called the Hall of Columns by archaeologist J Charles Kelley who excavated it, has its corners arranged to align precisely with the cardinal directions (cf. Figure 3.7, directions 1, 2). Moreover, standing in the Sun Temple and looking to the east, Kelley observed that the sun rose at the equinoxes over Cerro Picacho, the most prominent peak in an impressive mountain range to the east. Of possible terrestrial as well as celestial importance, this peak rises directly above both the principal water source, a natural spring, and the Esmeralda mine, source of the precious blue stones or turquoise after which the modern village of Chalchihuites derives its name.

To obtain an idea of the accuracy involved in this orientation, we measured the azimuth of the summit of Picacho as viewed from the Sun Temple and found it to be 91° 11'±1' from the north to the east. The azimuth of first gleam of sunrise at the equinox over the (3° 30') elevated

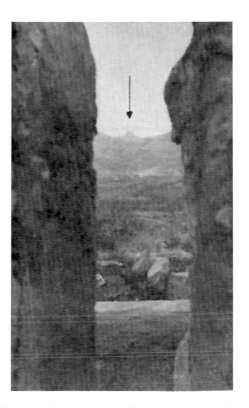

Figure 3.8 View of Cerro Picacho from the Labyrinth. The sun rises over the peak on the equinoxes (see Figure 3.7).

horizon was 91°±15'. (It could vary by as much as 15' if the time of equinox occurred at sunset instead of sunrise.) Marked out on the ground, this angular uncertainty translates to a horizontal distance of less than 50 m (Aveni *et al.* 1982).

Further excavation by Kelley disclosed an elaborate masonry-walled structure called the "labyrinth" because of its many bends and turns. It had been built along the outside of the colonnaded building on the southeast. A "pathway" about 1 m wide (Figure 3.7:H), possessing a low wall, extended about 100 m out of the labyrinth to the east. This pathway possesses an equinoctial axis (we measured an azimuth of 91°±10' - its accuracy is limited by the straightness of the wall). To a viewer situated in the adjoining labyrinth, the

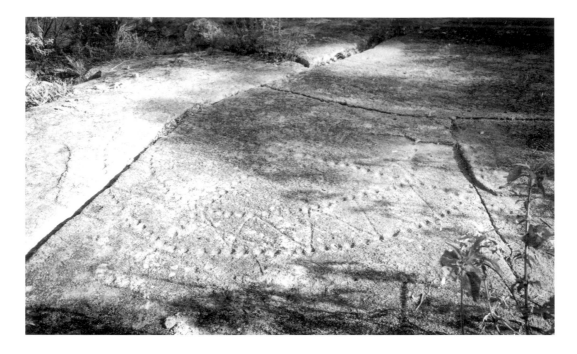

Figure 3.9 One of two pecked circles on the eastern summit of Cerro El Chapín at the Tropic of Cancer (latitude 23 1/2° North). Like the companion design 50 m to the north, it contains approximately 260 holes and its axis points to the rising sun at the summer solstice.

pathway points straight toward Cerro Picacho (cf. Figure 3.8). We regard it as a ceremonial "equinoctial pathway", an astronomical observation device designed to register the equinoctial sunrise with impressive precision.

Also figuring in the Alta Vista alignment scheme is Cerro El Chapín, a plateau of dimensions 80 x 250 m located 6.5 km SW of the ruins. On its eastern summit Kelley found a pair of pecked cross petroglyphs separated by about 50 m (Figure 3.9 shows one of them). From their vantage point, and with the ruins lying in the foreground, the viewer witnesses sunrise at the summer solstice at precisely the same point (over Cerro Picacho) where the observer in the labyrinth saw the equinox event three months earlier and where one would see

it again three months later. Furthermore, the axes of the pecked circles point in the direction of the rising sun. Figure 3.10 illustrates this unique double alignment.

Think of the skill and patience that would have been required to set up such a program in the land and skyscape. Even though the horizons as viewed from the two observation points - one to the solstice and the other to the equinox and both over the same mountain - possess different elevations, the double alignment seems to have been engineered to work perfectly. How did they do it? I speculate that the Chapín plateau site was selected first, then the astronomical and topographical considerations determined where the ceremonial center would be located.

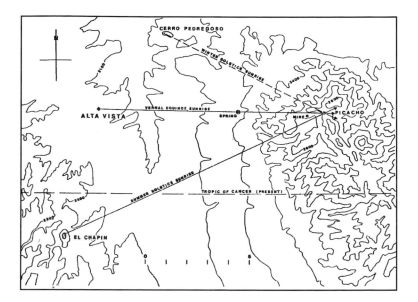

Figure 3.10 Topographic map of the region around the ruins of Alta Vista near the Tropic of Cancer, showing the equinoctial alignment from the Sun Temple, Alta Vista, which also passes through the principal water source and the turquoise mine, to Cerro Picacho. It also displays the summer solstice alignment from pecked cross petroglyphs on the summit of Cerro El Chapín to Cerro Picacho. Both lines cross at Cerro Picacho, located on the eastern side of the map. A hypothetical winter solstice alignment beginning somewhere north of the ruins and terminating on Picacho is also shown. The discovery of a marker somewhere along this line would further strengthen the suggestion that Teotihuacán calendar keepers, journeying to the northerly reaches of their empire, deliberately imposed a solar calendar on the landscape in the vicinity of the Tropic. Today the Tropic of Cancer (also indicated) is located slightly south of the ruins. At the time of the building of Alta Vista it would have been located slightly north of the ruins. Contour intervals are 100 m. CETENAL (Mexico) map sketched over by H. Hartung.

The selection of Cerro El Chapín as an observing station was surely no mean task. First the astronomers would be required to find the Tropic. This would have entailed a long-range program of repeated observation around the time of the summer solstice at many test sites. With a post set straight up in the ground, or by passing the light of the noon day zenith sun through a carefully aligned vertical tube, naked-eye observers could have pinned down the location of the Tropic to within 10 or 20 km. Next, they would have needed a prominent permanent landmark to register the solstitial sunrise, as well as an appropriate backsight from which to make the annual observations so that the attendant ritual could be performed adequately. Any alignment parallel to the line from Chapín to Picacho will work, but few would have made the event as dramatic as the one that confronts the viewer who visits Cerro El Chapín at dawn on the summer solstice.

For the next step in the program, astronomers would have been required to lay out the equinox line in order to determine the proper place to build the Sun Temple. But determining the equinox is no simple task. If the first days of autumn and spring fell midway between the beginnings of summer and winter, an observer could simply count days from the solstice and

put markers in place at the mid-points in time between the first days of summer and winter. However, as one is already aware from the diagrams in Figures 3.2–3.3, the seasons are not of equal duration, the winter-to-summer interval now being six days longer (it was not much different then). An averaging process consisting of double observations from opposite solstices minimizes the error, but our ancient astronomer would have needed to note that the position of sunrise remains nearly stationary for several days either side of the solstice. This further complicates any day counting scheme.

Sighting the Pole Star is an alternative. Indeed there is reference in the chronicles to Mesoamericans having observed it. By making nightly observations, an observer would notice that all the stars circulate around the north celestial pole, a point in the sky marked closely by Polaris (more closely now than a millennium ago). With small corrections for the movement of Polaris to either side of the pivotal point, astronomers could have marked the midpoint of the migration of the Pole Star, and extended the line from the sky vertically downward to the horizon with a plumb line. This would yield a north-south line using stakes and strings. Or, the equinox line could be determined separately: plant a stake vertically in the ground. With the stake as the center, rule a circle. Then mark the morning and afternoon crossing points of the circle by the stake's shadow. A line ruled between them yields east–west. Imagine how delighted site planners were when they discovered that the alignment passed close to the source of both blue water and blue stone.

The annual task of marking the date of arrival of the sun at its solstice by watching sunsets is also quite formidable because the sun slows drastically as it approaches and recedes from its horizon extremes. In work dating from the 1930s,

ethnologist Ruth Bunzel provides us with concrete evidence on the methodology of horizon sun-watching by contemporary native people of the US southwest. She refers specifically to the pekwin or shaman who, around the time of the solstice, observes the position of sunrise and sunset over distant landmarks. Ceremonies were held for several days around each solstice and the announcement of the actual arrival of the sun at its extreme positions was made eight days before. The planting of prayer sticks occurs precisely on the solstitial date. On another occasion the warning interval is ten days. The evidence suggests that the shaman may have struggled considerably with the problem of predicting precisely when the sun would come to a standstill.

Whether either of the aforementioned techniques or some other procedure was employed, the fact remains that the whole process of bringing time and space together by laying out the Alta Vista alignments at the Tropic of Cancer must have required great organizational capacity and a good deal of patient observing, though a technology of only modest sophistication would have been required. Architects aware of the nature of the planning and construction of the Teotihuacán grid would surely have been equal to the task of developing and producing the astronomical alignments we measured at the Tropic. Furthermore, given our knowledge of their abilities and interests, we might well expect Teotihuacán-influenced astronomers to erect solar alignments in other parts of the land.

Evidence from other media

Many Mesoamerican codices and post-conquest documents contain calendar wheels with base counts consisting of 20 and 260, the most frequent numbers that appear on the pecked crosses. For example, the basic feature of the diagram on page 1 of Codex Fejérváry Mayer (Figure 3.11),

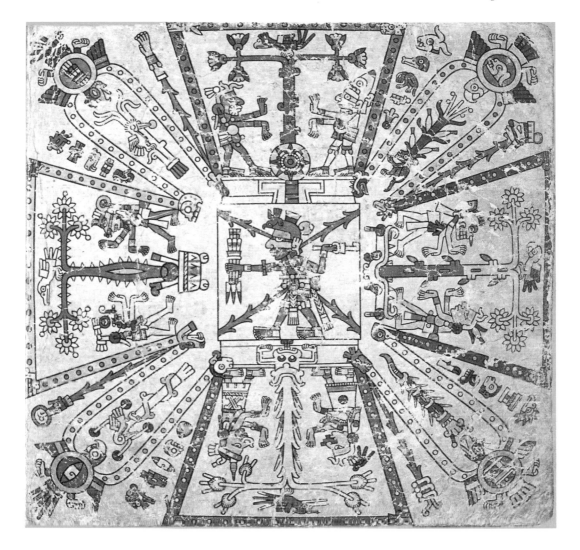

Figure 3.11 The quadripartite nature of the Mesoamerican universe is embodied in Page 1 of the Codex Fejérváry-Mayer, a Pre-Columbian space-time diagram from a 14th-15th century picture book originating in the Puebla-Tlaxcala region of Central Mexico. The diagram illustrates the fusion of time and space in ancient Mesoamerican cosmological thought. Various symbols (including regional gods, birds, colors, even parts of the body associated with the four cardinal directions) are embodied within flaps of a Maltese Cross, each flap representing one of the four sides of space. The 260-day calendar is tallied via dots on the horizon that forms the periphery of the cross, while the 20-day name symbols are divided, five to each quadrant (Codex Fejérváry-Mayer, Codices Selecti (volume 26), Akademische Druck-u Verlag, Graz, Austria, 1971).

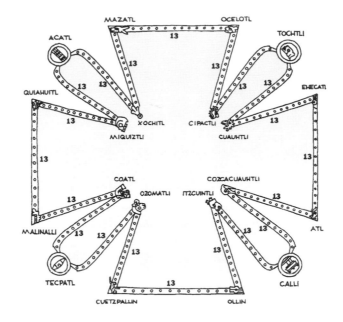

Figure 3.12 Explanatory diagram showing how the 260-day count works (H. Hartung).

a late Pre-Conquest document from highland Mexico, is a floral symbol with two sets of four petals: a) Maltese cross with large trapezoidal petals fitting a Cartesian frame; and b) St. Andrew's cross consisting of four smaller rounded petals positioned at 45-degree angles between the petals of the Maltese cross. A square design forms the center of the pattern. The border of the entire design is marked with circles whose count totals 260. The ritual count is divided into 20 named day cycles, counted in groups of 13 each. The first set of 13 commences with 1 Cipactli (alligator), which is located in the upper right-hand corner of the central quadrant (see the explanatory diagram in Figure 3.12). Moving counterclockwise, one proceeds to count 12 dots to the beginning of the next count of 13 which lands on 1 Ocelotl (jaguar). The third segment of the cycle passes across the top of the diagram ending on

1 Mazatl (deer) and one continues the pattern with Xochitl (flower), Acatl (reed), Miquiztli (death), Quiahuitl (rain), Malinalli (grass), Coatl (serpent), Tecpatl (flint knife), Ozomatli (monkey), Cuetzpallin (lizard), Ollin (movement), Itzcuintli (dog), Calli (house), Cozcacuauhtli (buzzard), Atl (water), Ehecatl (wind), Cuauhtli (eagle), and Tochtli (rabbit), finally returning to 1 Cipactli to close the ritual count. Graphically, the ritual cycle seems to enclose or enshrine all other matters, calendrical or otherwise, depicted within the count.

A variant of the pecked cross design (Figure 3.13), carved in the stucco floor of a building directly opposite that housing the first Teotihuacán petroglyph (Figure 3.3), bears a stark resemblance to the Fejérváry world diagram or cosmogram shown in Figure 3.11.

The resemblance of the quartered circle petroglyphs to pre- and post-conquest calendars,

Figure 3.13 Variant of Teotihuacán pecked cross design in the shape of a Maltese Cross. Like its counterpart in a Central Mexican codex (Figure 3.11), the count on the outer portion of the design is 260.

which were clearly meant to function as counting devices, lends strong support to the hypothesis that the petroglyphs were intended as counting devices, the holes perhaps being receptacles for tally stones to mark the passage of various calendar cycles. But how did they work in practice? We have only a partial answer to this question. If all Mexican calendars neither look alike nor function alike, should we expect all pecked circles to exhibit the same pattern of holes or, indeed, the same modus operandi?

Post-conquest writings of the Spanish chronicler of the Aztecs Diego Durán and others suggest a further link between pecked crosses and counting devices via a curious ritual game that may seem familiar even to those of us who know nothing about Mesoamerican culture. In his *Book of the Gods* (1972:302) Durán describes the Aztec game called patollioed.

Another game was played as follows. Small cavities were carved out of a stuccoed floor in the manner of a lottery board. Facing each other, one [player] took ten pebbles, and the other [also took] ten. The first placed his pebbles on his side, and the other on his. Then they cast split reeds on the ground. These jumped, and those that fell with the hollow side face upward indicated that a man could move his pebbles that many squares. Thus they played against one another, and as many as a player caught up with he won, until he left his opponent without chips. Occasionally it happened that, after five or six [pebbles] had been taken, with the four remaining ones the reeds were also bet, together with the others, and thus the game was won.

The Aztec game of patolll was known at Teotihuacán (as suggested by the appearance of several game board designs incised into the

plaster floors of buildings) long after the fall of the city. By Aztec times these devices were simple cross-shaped scratchings, and the players moved beans over their surface or over a painted mat. In at least one form of the game played in the southwest, a circle consisting of ten pits per quadrant was used. This game bears a distinct resemblance to the Indian game of pachisi (parcheesi). The principal feature of the board was an "X", or cross, undoubtedly symbolizing the four directions. Frequently the board was divided into 52 or 104 divisions and the players moved markers from point to point on the board. Dried beans were painted with numbers representing the value of the number of points to be advanced. According to Durán (1972:303):

> If the painted number was five, it meant ten [squares]; and if it was ten, it meant twenty. If it was one, it meant one; if two, two; if three, three; if four, four. But when the painted number was five, it meant ten, and ten meant twenty. Thus those small white dots were indicators and showed how many lines could be passed while moving the pebbles from one square to another.

The grouping of numbers in units of 5, 10, and 20 bears a distinct connection to the arrangement of cuplike depressions on the axes of the pecked crosses. If we include in the count the intersection of the axes with the circles, then our tally becomes 10+5+5.

Final words

Was it a tool sharpener, a tallying device, a calendar? These were the questions asked pertaining to Alex Marshack's carved Aurignacian bones. I recall an incident in one of my seminars when I raised the question that if one of the devices Marshack had analyzed were indeed a lunar calendar, then who might have employed it? "Perhaps a nocturnal hunter would have benefited from knowing the time of the month when lunar light bathed the landscape", responded one student. Or "a shaman who conducted a lunar ritual perhaps associated with acquiring good omens for the hunt", retorted another. A female student offered the opinion that a woman might have used it to time her menstrual cycle or perhaps the number of lunations between conception and birth.

The pecked crosses raise similar questions. Are they calendars or are they devices for comprehending how the world is arranged? Are they forms that describe and bring together the components of the universe, or media that tell about the origin of things? Though one tends to look for a single correct answer, I have argued that in the Mesoamerican world view this symbol possesses both temporal and spatial qualities. It is a symbol that expresses many levels of meaning.

Recognizing the multiplicity of functions and meanings inherent in so many Mesoamerican symbolic structures, I have persisted in collecting data and following their implications for a number of hypotheses regarding the use of the pecked-cross design, which continues to appear both more widespread and more abundant than hitherto believed.

Though my story is not yet at an end, to date my principal conclusion remains that no single hypothesis can account for the situation and general makeup of all the pecked cross petroglyphs; that is, they do not constitute a 'system', even if separate hypotheses adequately account for significant portions of the data. And so, I am forced to the belief that a number of different activities may have found expression in this striking design. But I am as convinced as Alex Marshack that time-factored thought pertaining to celestial phenomena played a role in the material record I continue to engage.

Although we are still a long way from understanding the grand overview of the heavens –

the so-called "cosmovision" – of the ancient Mesoamericans, the study of the pecked cross petroglyph serves as an expression of the depth and breadth of the Teotihuacán involvement in cosmology, astronomy, and timekeeping before the advent of writing. The rulers of the greatest city in the Americas created and disseminated a symbol linking architectural, astronomical, calendrical, and ritual principles. Such a development stands in contrast with astronomical pursuits in the ancient classical world which, like those in the modern branch of science derived from it, seem to be detached from social and religious matters. Thus, the study of Mesoamerican science, which flourished in splendid isolation prior to western contact, offers us a unique laboratory for comparative study.

About the author

Anthony Aveni, Russell Colgate Distinguished University Professor of Astronomy, Anthropology and Native American Studies, Colgate University, USA; E-mail: Aaronical@mail.colgate.edu.

References

Aveni A.

1989 Pecked cross petroglyphs at Xihuingo. *Journal for History of Astronomy* 14 (Supplement to Vol. 20) S73-S116.

2000 Out of Teotihuacan: Origins of the celestial canon in Mesoamerica. In *Mesoamerica's Classic Heritage: From Teotihuacan to the Aztecs*, edited by D. Carrasco, L. Jones, and S. Sessions, pp. 253-268. University Press of Colorado, Boulder.

2005 Observations of the pecked designs and other figures carved on the south platform of the Pyramid of the Sun at Teotihuacan. *Journal for the History of Astronomy* xxxvi:31-47.

Aveni, A., H. Hartung, and B. Buckingham

1978 The pecked cross symbol in ancient Mesoamerica. *Science* 202:267-279.

Aveni, A., H. Hartung, and J. C. Kelley

1982 Alta Vista (Chalchihuites): Astronomical Implications of a Mesoamerican ceremonial output at the Tropic of Cancer. *American Antiquity* 47:316-335.

Chavero, A.

1889 *En Mexico a Través de los Siglos V. Riva Palacio* (ed.). Editorial Cumbre, Vol. I., Mexico City.

Dow, J.

1967 Astronomical Orientations at Teotihuacan: A Case Study in Astroarchaeology. *American Antiquity* 32:326-334.

Duran, D.

1971 *The Book of the Gods and Rites and Ancient Calendar*, edited and translated by F. Horcasitas and D. Heyden. University of Oklahoma Press, Norman.

Marshack, A.

1974 The Chamula Calendar Board: An internal and comparative analysis. In *Mesoamerican Archaeology: New Approaches*, edited by N. Hammond, pp. 255-270. University of Texas Press, Austin.

Pasztory, E.

1978 Artistic traditions in the Middle Classic Period. In *Middle Classic Mesoamerica: AD 400-700*, edited by E. Pasztory, pp. 108-142. Columbia University Press, New York.

4

FIRST THINGS FIRST: ABSTRACT AND
FIGURATIVE ARTISTIC EXPRESSIONS IN THE LEVANT

Anna Belfer-Cohen and Ofer Bar-Yosef

Opening remarks

One of the basic questions in the study of the "artistic" expressions of human symbolic behavior which motivated many theoretical discussions pertains to whether there was an ordering of appearance, with abstract representations either preceding or following naturalistic ones. In the early days of research into Upper Paleolithic artistic expressions most scholars believed that there was some sort of logical sequence that would explain how prehistoric art came into being (from meaningless doodling to clumsy naturalistic representations to sophisticated, abstract symbolism: see history of research in Bahn 1998; Bahn and Vertut 1997; Conkey 1996; Conkey and Hastorf 1990; Conkey *et al.* 1997; Leroi-Gourhan 1965, 1981 and references therein). Undoubtedly the work of Alexander Marshack helped greatly to resolve this question, and it is now commonly accepted that both abstract and naturalistic images were created at the same time (Marshack 1991). His observations concerning European Paleolithic and Mesolithic art were complemented by his later work on some Near Eastern examples (*e.g.,* Marshack 1997, 1998).

In the following pages we would like to discuss the various symbolic manifestations available in the Near East attributed to the late Pleistocene, excluding ornaments (beads, pendants, *etc.*). We will refer only to finds from securely dated archaeological deposits and will refrain from discussing artistic phenomena outside such a

context. The chronological and geographic distribution of the various archaeological entities mentioned in the text is presented in Figure 4.1.

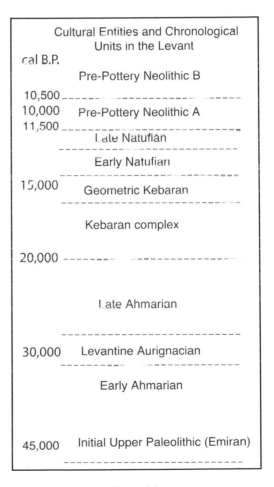

Figure 4.1
Chronological chart.

Early manifestations

There is a paucity of artistic representations in the Levantine Upper Paleolithic, especially when compared with contemporaneous Western Europe. This is true for mobiliary art as well as ornaments and body decorations (Bar-Yosef Mayer 2002, 2005; Belfer-Cohen 1988; Belfer-Cohen and Bar-Yosef 1999; Hovers 1990) Perhaps these two phenomena are unrelated, yet undoubtedly this requires further investigation. It appears that the few items dating to the Upper Paleolithic, described briefly below, are but a prelude to the relative richness of the Epi-paleolithic Natufian culture.

The engraved objects found in Levantine Upper Paleolithic contexts, including the early Epi-paleolithic entities, are rare and made on bone and small limestone slabs. It is quite possible that much more was made of perishable materials which did not "survive" in the archaeological record.

The oldest items to date are two engraved limestone plaques from the Levantine Aurignacian at Hayonim cave (Belfer-Cohen and Bar-Yosef 1981; Bar-Yosef and Belfer-Cohen 1988). One small plaque depicts a horse (and see also the detailed analysis conducted by Marshack 1997). The second portrays an anthropomorphic torso and legs, as well as a schematic four-legged animal (Bar-Yosef and Belfer-Cohen n.d.).

A bone point with a series of vertical incisions was uncovered in the Late Ahmarian assemblages in Ksar 'Akil (Tixier 1974a, b; Marshack 1997). Somewhat similar bone and wooden (!) objects were recovered at Ohalo II, dated to 23,000 cal. BP (Rabinovich and Nadel 1995; Nadel et al. 2006).

The excavations conducted by F. Hours in the Jiita II rockshelter in the Lebanese mountains produced a similarly incised bone ascribed to the Kebaran culture (Copeland and Hours 1977).

A more elaborate pattern of finely incised lines on both faces of a flat limestone pebble comes from Urkan e-Rubb, a Kebaran site in the Lower Jordan Valley (Hovers 1990), dated to ca. 16/15,500 cal. BP. One face comprises fine, semi-circular, parallel lines with short vertical ones and two sets of parallel lines with a "ladder" pattern. Five series of lines connect the previous ones to the edges of the pebble. The other side bears two clear "ladder" patterns and a fill in-between of crosshatched lines (and see Hovers 1990; Marshack 1997).

Another unique piece, an engraved flint nodule, was reported from the Geometric Kebaran site of Neve David (Kaufman 1999). All in all, it is quite apparent that the paucity of artistic representation in the Levantine Upper Paleolithic, Early and Middle Epi-paleolithic is rather outstanding (Belfer-Cohen 1988).

If we consider the above as representing the "artistic" repertoire of the Upper Paleolithic-Early Epi-paleolithic in the Levant, it appears that most of it belongs to the realm of "primitive" abstract/simple notation, yet the Kebaran object from Urkan e-Rubb is of great sophistication, thus indicating that we simply do not possess the data to understand the function and meaning of the phenomena we commonly assign to "artistic manifestations" *per se*.

The Natufian inventory

Since the original discoveries of Natufian cultural remains by Garrod in the caves of Shukbah and el-Wad, Mt. Carmel, and by Neuville in the Judean Desert (Garrod 1957; Neuville 1951), the art objects uncovered at those sites have attracted the attention of prehistoric art experts. Excavations during the 1960s through the 1990s of additional Natufian sites (especially those termed base camps or sedentary hamlets) considerably augmented the number of known objects assigned to the category of "artistic" or

"symbolic" manifestations. These sites include Nahal Oren, Eynan (Mallaha), Hayonim Cave and Terrace, Rosh Zin, Wadi Hammeh 27, and the renewed excavation at el-Wad, among others (*e.g.*, Bar-Yosef 1991, 1997; Bar-Yosef and Belfer-Cohen 1999; Belfer-Cohen 1988, 1991a, b; Edwards 1991; Noy 1991; Valla 1999; Valla *et al.* 1998, 1999, 2001, 2004; Weinstein-Evron

and Belfer-Cohen 1993; Figure 4.2). The first comprehensive interpretation of these finds was offered by Cauvin (1972, 2000 a, b) who considered the various art objects as manifestations of a prehistoric religion in the Near East.

What follows is a short description of items representing abstract and figurative artistic manifestations from a Natufian context.

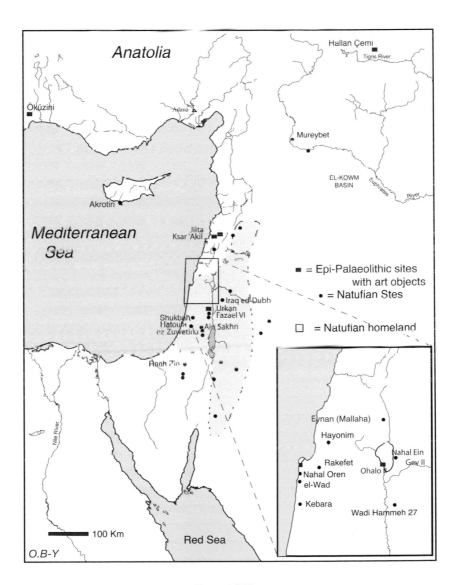

Figure 4.2 Map.

Abstract patterns

In order to simplify the description and analysis of abstract patterns, we subdivided them into several basic designs: the "ladder" pattern, the criss-cross or net pattern, and the meander pattern. Some of the incised items bear one or another pattern, while some other artifacts comprise two or more patterns, not to mention incisions that cannot be ordered into a clear pattern. The incised objects are of different sizes and were made of both stone and bone alike. Most of the items described in detail below derive from Hayonim Cave, while reference is given to objects recovered in other Natufian sites.

The largest items known to date are several big, heavy limestone slabs with incised "ladder" patterns unearthed in Hayonim Cave (Belfer-Cohen 1991a, and see a detailed description of one of them in Marshack 1977). It is worth mentioning that the "ladder" pattern was also incised on several sides of a large, squarish, elongated block referred to as the "stela", which apparently stood in one of the rounded chambers at Hayonim cave (Belfer-Cohen 1991a). A smaller flattish slab from the same site portrays an intricate web of incised patterns, barely visible to the naked eye (Bar-Yosef and Belfer-Cohen 1999). The incisions are grouped into a "ladder" pattern that separates two squarish or rectangular areas incised in clusters of lines. In one area the clusters are composed of horizontal and vertical lines, while the other contains clusters of vertical lines separated from each other by a meandering pattern. There are other incised lines nearby, but they are positioned at a distance from the tightly arranged patterns of the "areas" described above: horizontal lines above the "ladder" pattern and diagonal ones below it. The pattern is repeated on one of the narrow edges of the slab, consisting of vertical and horizontal incisions. It seems that the general surface of the slab has been divided into distinct units which

could be viewed as "territories" or "fields" of some kind. A similar interpretation, stressing the notion of "space", was put forward by Klima (1988, in Svoboda 1997) with reference to an engraved pattern on a mammoth tusk, uncovered at Pavlov I (Svoboda 1997; and see also Züchner 1996). A similar item from Hayonim Cave is still *in situ*. Natufian stone items with complex incision patterns are also reported from other sites (*e.g.*, Eynan, Wadi Hammeh 27, Fazael VI, *etc.*; Valla *et al.* 2004; Edwards 1991; Goring-Morris, personal communication) sharing to the uninitiated eye a "horror vacui" tendency.

One of the large slabs from Hayonim cave has a deep incision with numerous small incisions vertical to the main horizontal incision, reminiscent in its contour of a "fish" outline, but whether it belongs to the "abstract" or "figurative" realm is rather difficult to ascertain (Belfer-Cohen 1991a).

The distribution of these slabs is rather particular, as most of them were recovered in two discrete areas: in and around Locus 4 and in the more extended area of Loci 8–11 and the space in-between (Figure 4.3).

It is of interest to note that the most common pattern observed on the incised items from Hayonim Cave is the "ladder" pattern, while the meander design has so far been observed only on two slabs. Yet the latter does appear as a major carving on large limestone slabs uncovered at Wadi Hammeh 27 (Edwards 1991), and the same pattern is found on large curved basalt bowls from Eynan (Mallaha; Perrot 1966) and Shukbah (Noy 1991). It was also observed on a small bone object found at el-Wad (Garrod and Bate 1937). Another category of artifacts bearing carved meander patterns are basalt shaft straighteners from Nahal Oren (Stekelis and Yizraeli 1963).

The criss-cross or net pattern also appears on bone items (spatulae, sickle hafts, *etc.*) reported

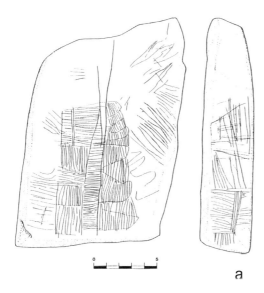

from at least three sites: Hayonim Cave (Bar Yosef and Tchernov 1970; Belfer-Cohen 1991a), Kebara Cave (Turville-Petre 1932; Bar-Yosef and Belfer-Cohen 1999) and the Iraq ed-Dubb Cave in Jordan (a small fragment, Kuijt *et al.* 1991). In each case the net pattern is encased within two parallel columns with a clear space in-between. Campana (1991) interpreted this pattern as a basketry motif, but this is only one possible interpretation.

It seems that there is more to this Natufian "decoration" than meets the eye. As mentioned above, it was proposed that the clustering of distinctive patterns found exclusively at certain sites could be interpreted as markers of specific social units - whether a group, an extended family, or a tribe. The occurrence of the same complex pattern during the Early Natufian at both Hayonim and Kebara Caves could indicate physical and/or social ties between these two sites. Undoubtedly, the presence of intricate patterns, executed by craftspersons that specialized in such endeavors, can be taken as an indication of social complexity not evidenced earlier in the local archaeological

Figure 4.3 Slabs showing drawings of: a) meander design; b) criss-cross and ladder pattern; c) fish(?).

record. These items undoubtedly represent encoded information, and the patterns, thought intricate and abstract, were understood in their context, thus their meaning and connotation were clear to their Natufian beholder.

Figurative items

No human or animal figurines dating prior to 15,000 cal. BP have been found in the Near East to date. The later Natufian culture left behind a few figurines, a trend accelerated during the Pre-Pottery Neolithic A and in particular during the ensuing Pre-Pottery Neolithic B period (Bar-Yosef 1997).

Two of the Natufian figurines, both found by Neuville in the collections of Bethlehem monasteries in the late 1920s, attracted much attention. One assumed to derive from Ain Sakhri, a small stone item assumed to represent a couple engaged in sexual intercourse, has been re-examined in detail (Boyd and Cook 1993). The general form of this figurine resembles a schematic one uncovered at Nahal Oren from a PPNA context (Hershman and Belfer-Cohen in press). The second figurine, thought to have been derived from ez-Zuwetina, is a small limestone "kneeling gazelle" with a missing head. The late R. Amiran (personal communication) considered this item to be of mid-Holocene Egyptian origin. A small figurine of a rather grotesque human head was reported from el-Wad (Garrod and Bate 1937). Even more special were the composite anthropomorphic figures, created through an arrangement of basalt pestles from Eynan (Mallaha; Perrot 1966), and a female (?) figurine made of ochre from the Hayonim Terrace (Valla 1999).

Natufian animal figurines were found at Kebara cave, el-Wad cave and terrace, Eynan (Mallaha) and Nahal Oren. Some, carved on bone, were previously interpreted as depicting young gazelles (*e.g.*, Garrod and Bate 1937; Stekelis and Yizraeli 1963; Perrot 1968; Cauvin 1972, 1994; Bar-Yosef 1983). This is probably an overstatement, since all that can be said with certainty about them is that they are generalized images of young ungulates. They appear as decorations on sickle hafts or as three-dimensional figurines. Two animal figurines carved and incised on limestone, uncovered at Nahal Oren, represent a double image of a dog and owl and a "baboon". Another double image, carved on a horn core from the same site, depicts a human face and an ungulate head (Noy 1991).

Rare anthropomorphic (?) representations from el-Wad and Eynan (Garrod and Bate 1937; Weinstein-Evron and Belfer-Cohen 1993; Perrot 1968; Marshack 1997) are often rather schematic in shape, with no specific indications of gender. They herald what later became a major subject in Neolithic iconography.

Anatolian finds

Elsewhere in the Near East contemporaneous finds are very scarce or absent. The only information available derives from Anatolia, Turkey. Due to the paucity of excavated Upper Pleistocene sites, only Öküzini and Beldibi caves, situated in the coastal plain of Mediterranean Anatolia, provide some data on artistic depictions.

Öküzini cave was found and excavated during the 1950s by K. Kökten. On the cave's wall he discovered an engraving of an aurochs after which he named the cave (Okuz is ox in Turkish). Kökten removed most of the deposits from the center of the cave, leaving only narrow portions along the walls. New, large-scale excavations were conducted by I. Yalçinkaya and M. Otte (Yalçinkaya *et al.* 2002). They revealed a detailed stratigraphy of numerous successive occupations, yielding over 60 radiocarbon dates.

The cave's stratigraphy was subdivided into three anthropogenic depositional cycles. It is the middle phase (units VI-V), dated to 16-15 cal. BP, rich in lithics, animal bones, grinding slabs and hand stones, that also provided elements of body decoration (stone and marine shell beads)

as well as mobilary art objects (Otte *et al.* 1995; Marshack 1997).

The upper phase (Units IV-I), dating to 15-12.5 cal. BP, also rich in lithics and bone tools, most probably yielded (Otte *et al.* 1995) the two incised pebbles collected by K. Kökten and described in detail by Marshack (1997).

One of the pebbles bears the incised image of an aurochs and a simplified human figure that is interpreted as thrusting a spear into the animal's chest. Aurochs bones are rare in this site but they do occur at other Late/Epi-paleolithic excavations (*e.g.*, Hallan Çemi: Rosenberg and Davis 1992). This taxon is especially common in Neolithic Çatal Hüyük, and is considered to play an important role in prehistoric Anatolian rituals (Cauvin 1994, 2000a, b).

The second pebble bears three "blocks" of parallel incised lines in a "ladder" pattern on one surface. Two groupings of "ladders" are "horizontal" and the group in between is "vertical" (in relation to the other two). The other surface of this pebble has an open circle with smaller circles in it, two branching lines forming a "corridor" with a few additional incomplete circles and yet another, branching, "ladder" pattern.

It is worth noting that the large open circle and "corridor" resemble a depiction of "desert kites" used as drives for gazelle hunting in the Levant (Meshel 1974; Betts and Helms 1987). This type of drive, with two "arms" built either as two rows of stones or as wooden pegs, is also known from various geographical regions such as Scandinavia (*e.g.*, Barth 1982) and the North American high plains (*e.g.*, Frison 1978), where they were used to hunt local big-game. In southwest Turkey, wild goats and/or wild sheep, the bones of which are common in the faunal assemblages of Öküzini (Yalçinkaya *et al.* 2002), may have been hunted by a similar technique.

Discussion

In spite of the paucity of variable iconography, whether incised, engraved or painted, in the Eastern Mediterranean, the use of symbols prior to the beginnings of agriculture documents the presence of cultures that were far more complex than had been previously assumed. That scarcity can be partially explained as due to the small number of systematic excavations of Upper and Epi-paleolithic sites when compared to the number and excavated volume of Natufian and early Neolithic sites.

The ambiguity concerning the interpretation of the Epi-paleolithic and in particular the Natufian objects is reminiscent of historical problems in decoding the patterns observed in Franco-Cantabrian Paleolithic art (Bahn and Vertut 1988). It took quite a while to consider some of the supposedly purely decorative elements as notations, etc., that they might have a coded meaning, and be instrumental, at least in part, in the delivery of coherent messages in an orderly mode (Marshack 1972). It appears that in Natufian "art" there are examples in which the engraved patterns could be interpreted as notation marks, *i.e.*, a deliberate transfer of information. A good illustration is the item, described above, of an incised limestone slab from Hayonim Cave (for detailed discussion see Bar-Yosef and Belfer-Cohen 1999). Undoubtedly, the intricate and complex patterns observed on the item support the idea that there is a message "encoded" in the incised pattern, and that it is not simply of decorative or aesthetic value. The "fields/territoriality" pattern observed on the item can perhaps be tied in with other archaeological evidence indicating territoriality among the Natufian communities, be it social or geographical or both. The idea that the Natufians were the first to cultivate fields near their sites, as suggested long ago by Garrod (1957), is popular once more (Bar-Yosef and Meadow 1995), making

the interpretation all the more enticing. There arises the question of whether the design represents an actual phenomenon, serving as a "map" of particular "fields" located in the vicinity of the site, or if it symbolizes an abstract concept of "fields". Unfortunately, 10,000 years of unremitting cultivation, erosion and alluviation have made it impossible to trace the outlines of Natufian or even PPNB fields through aerial photography. Although the Early and Late Natufian differ in burial customs, lithic production, and dwellings (Belfer-Cohen 1991b; Goring-Morris 1995; Valla 1995; Bar-Yosef 1998, 2002), notations on limestone slabs are present in Hayonim Cave throughout most of the sequence of Natufian occupations at the site.

There are many issues to be considered in deciphering the Natufian messages engraved on the limestone slabs or the bone objects. Our challenges are not so very different from those of the European researchers facing the enigmas of markings on stone and bone items from Upper Paleolithic contexts (see, for example, Bosinski 1984; Marshack 1997; d'Errico 1992; Svoboda 1997). Are these markings sequential notations recording time, events, or distances (Marshack 1997)? Do they represent sets of numbers or proto-mathematics (Frolov 1981)? Perhaps they are maps (Gladkih *et al.* 1984; Klima 1988, in Svoboda 1997; Züchner 1996), or are we looking at a mnemonic scheme (Layton 1992: Roberts and Roberts 1996)? What was the role of these notations within the social realm of past hunter-gatherers cum-early cultivators?

Current research has disclosed that the distribution of the decorative motifs among Natufian sites is not random, but that the "art" objects fall into a number of clusters characteristic of particular sites, and may therefore be considered as markers of specific groups (Henry 1989; Noy 1991; Stordeur 1992). This pattern is supported by the distribution of bead types among generally contemporary sites that form geographic clusters such as in Mt. Carmel or the Galilee (Belfer-Cohen 1988, 1991a, b).

In sum, the abstract patterns of these late foragers, whether in the Levant or Anatolia, served symbolic functions, most probably in ritual contexts rather than for public display, as the markings are too feeble to be observed unless under close inspection. The Near Eastern examples are therefore not different from some of the European Upper Paleolithic, though lacking the intricate superimpositioning observed on the engraved plaques (*e.g.,* the finds from La Marche - Pales 1969).

The figurative art objects appeared as ritual activities passed from the private to the public domain (*e.g.,* Cauvin 2000a, b), and can be connected to the increase in population resulting in larger social units. Such items should be more formal and repetitive when shaped for use in the public arena. The small figurines of the Natufian are thus seen as heralding the figurative public art of the Neolithic period in the Near East.

About the authors

Anna Belfer-Cohen, Institute of Archaeology, Mt. Scopus, Hebrew University of Jerusalem, 91905 Jerusalem, Israel; E-mail: belferac@mscc.huji.ac.il.

Ofer Bar-Yosef, Harvard University, Dept. of Anthropology, Peabody Museum, 11 Divinity Avenue, Cambridge MA 02138, USA; E-mail: obaryos@fas.harvard.edu.

References

Bahn, P.

1998 *The Cambridge Illustrated History of Prehistoric Art.* Cambridge University Press, Cambridge.

Bahn, P., and J. Vertut

1988 *Images of the Ice Age.* Facts On File, New York.

1997 *Journey Through the Ice Age.* Seven Dials, London.

Barth, E. K.

1982 Ancient methods for trapping wild reindeer in south Norway. In *The Hunters: Their Culture and Way of Life*, edited by A. Hultkrantz and Ø. Vorren, pp. 21-45. Universitetsforlaget, Tromsø.

Bar-Yosef, O.

1983 The Natufian of the Southern Levant. In *The Hilly Flanks and Beyond*, edited by P. E. L. Smith and P. Mortensen, pp. 11-42. Chicago University Press, Chicago.

1991 The archaeology of the Natufian layer in Hayonim cave. In *The Natufian culture in the Levant*, edited by O. Bar-Yosef and F. R. Valla, pp. 81-92. International Monographs in Prehistory, Ann Arbor.

1997 Symbolic expressions in later prehistory of the Levant: Why are they so few? In *Beyond Art: Pleistocene Image and Symbol*, edited by M. W. Conkey, O. Soffer, D. Stratmann and N. G. Jablonski, pp. 161-87. Memoirs of the California Academy of Science 23, San Francisco.

1998 The Natufian culture in the Levant, threshold to the origins of agriculture. *Evolutionary Anthropology* 6:159-177.

2002 Natufian: A complex society of foragers. In *Beyond Foraging and Collecting: Evolutionary Change in Hunter-Gatherer Settlement Systems*, edited by B. Fitzhugh and J. Habu, pp. 91-149. Kluwer Academic/Plenum, New York.

Bar-Yosef, O., and A. Belfer-Cohen

1988 The Early Upper Palaeolithic in Levantine Caves. In *The Early Upper Palaeolithic. Evidence from Europe and the Near East*, edited by J. F. Hoffecker and C. A. Wolf, pp. 23-41. International Series 437. B.A.R., Oxford.

1999 Encoding Information: Unique Natufian Objects from Hayonim Cave, Western Galilee, Israel. *Antiquity* 73(280):402-410.

Bar-Yosef, O., and R. H. Meadow

1995 The origins of agriculture in the Near East. In *Last Hunters, First Farmers: New Perspectives on the Transition to Agriculture*, edited by D. Price and G. Gebauer, pp. 39-94. Schools of American Research Press, Santa Fe.

Bar-Yosef, O., and E. Tchernov

1970 The Natufian bone industry of Hayonim Cave. *Israel Exploration Journal* 20:141-150.

Bar-Yosef Mayer, D. E.

2002 The use of mollusc shells by Fisher-Hunter-Gatherers at Ohalo II. In *Ohalo II: A 23,000 Year Old Fisher-Hunter-Gatherers Camp on the Shore of the Sea of Galilee*, edited by D. Nadel, pp. 39-41. Reuben and Edith Hecht Museum, University of Haifa, Haifa.

2005 *Archaeomalacology: Molluscs in former environments of human program.* Oxbow Books, Oxford.

Belfer-Cohen, A.

1988 The appearance of symbolic expression in the Upper Pleistocene of the Levant as compared to Western Europe. In *L'Homme de Neanderthal*, edited by M. Otte, pp. 25-29. La Pensée, vol. 5. ERAUL, Liège.

1991a Art items from Layer B, Hayonim Cave: A case study of art in a Natufian context. In *The Natufian Culture in the Levant*, edited by O. Bar-Yosef and F. R. Valla, pp. 569-88. International Monographs in Prehistory, Ann Arbor.

1991b The Natufian in the Levant. *Annual Review of Anthropology* 20: 167-186.

Belfer-Cohen, A., and O. Bar-Yosef

1981 The Aurignacian in Hayonim Cave. *Paléorient* 7(2):19-42.

1999 The Levantine Aurignacian: 60 years of research. In *Dorothy Garrod and the Progress of the Palaeolithic*, edited by W. Davies and R. Charles, pp. 118-34. Oxbow, Oxford.

Betts, A. V. G., and S. Helms

1987 A preliminary survey of Late Neolithic settlements at el-Ghirqa, eastern Jordan. *Proceedings of the Prehistoric Society* 53:327-336.

Bosinski, G.

1984 *Die Kunst der Eiszeit in Deutschland und in der Schweiz*. Habelt, Bonn.

Boyd, B., and J. Cook

1993 A reconsideration of the 'Ain Sakhri' figurine. *Proceedings of the Prehistoric Society* 59:399-405.

Campana, D. V.

1991 Bone implements from Hayonim Cave: Some relevant issues. In *The Natufian Culture in the Levant*, edited by O. Bar-Yosef and F. R. Valla, pp. 459-66. International Monographs in Prehistory, Ann Arbor.

Cauvin, J.

1972 *Religions Néolithiques de Syro-Palestine*. Librairie d'Amérique et d'Orient, Jean Maisonneuve, Paris.

1994 *Naissance des Divinités, Naissance de l'Agriculture*. CNRS editions, Paris.

2000a *The Beginnings of Agriculture in the Near East: A Symbolic Interpretation*. Cambridge University Press, Cambridge.

2000b The Symbolic Foundations of the Neolithic Revolution in the Near East. In *Life in Neolithic Farming Communities: Social Organization, Identity, and Differentiation*, edited by I. Kuijt, pp. 235-51. Plenum Press, New York.

Conkey, M. W.

1996 A history of the interpretation of European 'paleolithic art': Magic, mythogram, and metaphors for modernity. In *Handbook of Human Symbolic Evolution*, edited by A. Lock and C. T. Peters, pp. 288-350. Clarendon Press, Oxford.

Conkey, M. W., and C. A. Hastorf (eds.)

1990 *The Uses of Style in Archaeology*. Cambridge University Press, Cambridge.

Conkey, M. W., O. Soffer, D. Stratmann, and N. G. Jablonski (eds.)

1997 *Beyond Art: Pleistocene Image and Symbol*. Memoirs of the California Academy of Science 23, San Francisco.

Copeland, L., and F. Hours

1977 Engraved and plain bone tools from Jiita (Lebanon) and their Early Kebaran context. *Proceedings of the Prehistoric Society* 43:295-301.

d'Errico, F.

1992 Technology, Motion, and the Meaning of Epipaleolithic Art. *Current Anthropology* 33(1):94-109.

Edwards, P.

1991 Wadi Hammeh 27: An Early Natufian site at Pella, Jordan. In *The Natufian Culture in the Levant*, edited by O. Bar-Yosef and F. R. Valla, pp. 123-48. International Monographs in Prehistory, Ann Arbor.

Frison, G. C.

1978 *Prehistoric Hunters of the High Plains.* Academic Press, New York.

Frolov, B. A.

1981 *L'Art Paléolithique: Préhistoire de la Science?* Xth Congress UISPP, Mexico City.

Garrod, D. A. E.

1957 The Natufian Culture: The life and economy of a Mesolithic people in the Near East. *Proceedings of the British Academy* 43:211-227.

Garrod, D. A. E., and D. M. A. Bate

1937 *The Stone Age of Mt. Carmel. Excavations at the Wadi-Mughara.* Vol. 1. Clarendon Press, Oxford.

Gladkih, M. I., N. L. Kornietz, and O. Soffer

1984 Mammoth-bone dwellings on the Russian Plain. *Scientific American* 251:136-142.

Goring-Morris, A. N.

1995 Complex Hunter-Gatherers at the End of the Paleolithic (20,000-10,000 BP). In *The Archaeology of Society in the Holy Land*, edited by T. E. Levy, pp. 141-68. Leicester University Press, London.

Henry, D. O.

1989 *From Foraging to Agriculture: the Levant at the End of the Ice Age.* University of Pennsylvania Press, Philadelphia.

Hershman, D., and A. Belfer-Cohen

in press "It's Magic!" Artistic and Symbolic Material Manifestations from the Gilgal sites. In *Gilgal: Early Neolithic Occupations in the Jordan Valley: The excavations of Tamar Noy*, edited by O. Bar-Yosef, A. N. Goring-Morris, and A. Gopher. American School of Prehistoric Research Monograph Series, Harvard University. Brill Academic, Boston.

Hovers, E.

1990 Art in the Levantine Epi-Palaeolithic: An engraved pebble from a Kebaran site in the Lower Jordan Valley. *Current Anthropology* 31:317-322.

Kaufman, D.

1999 A unique engraved object from the Epipalaeolithic of Israel. *Rock Art Research* 16(1):109-112.

Kuijt, I., J. Mabry, and G. Palumbo

1991 Early Neolithic use of upland areas of Wadi el-Yabis: preliminary evidence from the excavations of Iraq ed-Dubb, Jordan. *Paléorient* 17(1):99-108.

Layton, R.

1992. *The Anthropology of Art.* Cambridge University Press, New York.

Leroi-Gourhan, A.

1965 *Treasures of Prehistoric Art.* Abrams, New York.

1981 *The Dawn of European Art. An Introduction to Palaeolithic Cave Painting.* Cambridge University Press, Cambridge.

Marshack, A.

1972 *The Roots of Civilization.* McGraw, New York.

1991 *The Roots of Civilization. The Cognitive Beginnings of Man's First Art, Symbol and Notation*, 2nd edition. Moyer Bell Limited, New York.

1997 Paleolithic image making and symboling in Europe and the Middle East: A comparative review. In *Beyond Art: Pleistocene Image and Symbol*, edited by M. W. Conkey, O. Soffer, D. Stratmann, and N. G. Jablonski, pp. 53-91. Memoirs of California Academy of Sciences 23, San Francisco.

1998 Space and Time in Pre-Agricultural Europe and the Near East. The Evidence for Early Structural Complexity. In *Urbanization and Land Ownership in the Ancient Near East*, edited by M. Hudson and B. A. Levine, pp. 4-48. Peabody Museum of Archaeology and Ethnology, Cambridge.

Meshel, Z.

1974 New data about the "Desert Kites". *Tel Aviv* 1:129-43.

Nadel, D., U. Grinberg, E. Boaretto, and E. Werker

2006 Wooden objects from Ohalo II (23,000 cal. BP), Jordan Valley, Israel. *Journal of Human Evolution* 50:644-662.

Neuville, R.

1951 *Le Paléolithique et le Mésolithique du Désert de Judée*. Archives de l'Institut de Paléontologie Humaine, Mémoire 24. Masson, Paris.

Noy, T.

1991 Art and decoration of the Natufian at Nahal Oren. In *The Natufian Culture in the Levant*, edited by O. Bar-Yosef and F. R. Valla, pp. 557-68. International Monographs in Prehistory, Ann Arbor.

Otte, M., I. Yalçinkaya, J. M. Léotard, M. Kartal, O. Bar-Yosef, J. Kozlowski, I. López-Bayón, and A. Marshack

1995 The Epi-Palaeolithic of Öküzini cave (SW Anatolia) and its mobiliary art. *Antiquity* 69:931-944.

Pales, L.

1969 *Les gravures de La Marche*. Delmas, Bordeaux.

Perrot, J.

1966 Le gisement natoufien de Mallaha (Eynan), Israel. *L'Anthropologie* 70:437-484.

1968 La Préhistoire Palestinienne. In *Supplément au Dictionnaire de la Bible*, vol. 8, pp. 286-446. Letougey et Ane, Paris.

Rabinovich, R., and D. Nadel

1995 Bone tools from Ohalo II - A morphological and functional study. *Journal of the Israel Prehistoric Society* 26:32-63.

Roberts, M. N., and A. F. Roberts

1996 *Memory - Luba Art and the Making of History*. The Museum for African Art, New York.

Rosenberg, M., and M. K. Davis

1992 Hallan Cemi Tepesi, An Early Aceramic Neolithic Site in Eastern Anatolia. *Anatolica* 18:1-18.

Stekelis, M., and T. Yizraely

1963 Excavations at Nahal Oren. *Israel Exploration Journal* 13(1):1-12.

Stordeur, D.

1992 Change and cultural inertia: From the analysis of data to the creation of a model. In *Representations in Archaeology*, edited by J. C. Gardin and C. S. Peebles, pp. 205-22. Indiana University Press, Indiana.

Svoboda, J.

1997 Symbolisme gravettien en Moravie. Espace, temps et formes. *Bulletin de la Société préhistorique de l'Ariège* LII: 87-103.

Tixier, J.

1974a Os incisé de Ksar 'Aqil, Liban. *Paléorient* 2(1):123-132.

1974b Poinçon décoré du Paléolithique Supérieur à Ksar 'Aqil (Liban). *Paléorient* 2(1):187-193.

Turville-Petre, F.

1932 The excavations in the Mugharet et-Kebarah. *Journal of the Royal Anthropological Institute of Great Britain and Ireland* 62:271-276.

Valla, F. R.

1995 The first settled societies - Natufian (12,500-10,200 BP). In *The Archaeology of Society in the Holy Land*, edited by T. E. Levy, pp. 170-87. Leicester University Press, London.

1999 The Natufian: A coherent thought? In *Dorothy Garrod and the Progress of the Palaeolithic*, edited by W. Davies and R. Charles, pp. 224-41. Oxbow, Oxford.

Valla, F. R., H. Khalaily, N. Samuelian, F. Bocquentin, C. Delage, B. Valentin, H. Plisson, R. Rabinovich, and A. Belfer-Cohen

1998 Le Natoufien Final et les Nouvelles Fouilles à Mallaha. *Journal of the Israel Prehistoric Society* 28:105-176.

Valla, F., F. Bocquentin, H. Plisson, H. Khalaily, C. Delage, R. Rabinovich, N. Samuelian, B. Valentin, and A. Belfer-Cohen

1999 Le Natoufien final et les nouvelles fouilles à Mallaha (Eynan), Israel 1996-1997. *Journal of the Israel Prehistoric Society* 28: 105-176.

Valla, F. R., H. Khalaily, N. Samuelian, R. March, F. Bocquentin, B. Valentin, O. Marder, R. Rabinovich, G. Le Dosseur, L. Dubreuil, and A. Belfer-Cohen

2001 Le Natoufien Final de Mallaha (Eynan), Deuxième Rapport Préliminaire: Les Fouilles de 1998 et 1999. *Journal of the Israel Prehistoric Society* 31:43-184

Valla, F. R., H. Khalaily, H. Valladas, N. Tisnerat-Laborde, N. Samuelian, F. Bocquentin, R. Rabinovich, A. Bridault, T. Simmons, G. Le Dosseur, A. M. Rosen, L. Dubreuil, D. Bar-Yosef Mayer, and A. Belfer-Cohen

2004 Les fouilles de Mallaha en 2000 et 2001: 3ème rapport préliminaire. *Journal of the Israel Prehistoric Society* 34:49-214.

Weinstein-Evron, M., and A. Belfer-Cohen

1993 Natufian figurines from the new excavations of the el-Wad cave, Mt. Carmel, Israel. *Rock Art Research* 10(2):102-106.

Yalçinkaya, I., M. Otte, J. Kozlowski, and O. Bar-Yosef (eds.)

2002 La Grotte d'Öküzini. Evolution du Paléolithique Final du sud ouest de l'Anatolie. *ERAUL* Liège.

Züchner, C.

1996 The scaliform sign of Altamira and the origin of maps in prehistoric Europe. In *"El Hombre Fósil" 80 Años Después*, edited by A. Moure-Romanillo, pp. 325-343. Universidad de Cantabria, Fundación Marcelino Botín, Institute for Prehistoric Investigations, Santander.

SEALS FROM THE MAGDALENIAN SITE
OF GÖNNERSDORF (RHINELAND, GERMANY)

Gerhard Bosinski and Hannelore Bosinski [†]

On the Gönnersdorf slate plaquettes we recognized 12 seals. Like the other animals (Bosinski and Fischer 1980; Bosinski, in press), the drawings are on plaquettes of different sizes, and are found together with many other lines, often cut-marks (Figure 5.1) and sometimes also other representations (Figure 5.2).

The Gönnersdorf seals are sometimes portrayed very exactly and with many details depicted (Figure 5.3). Nevertheless, identification of

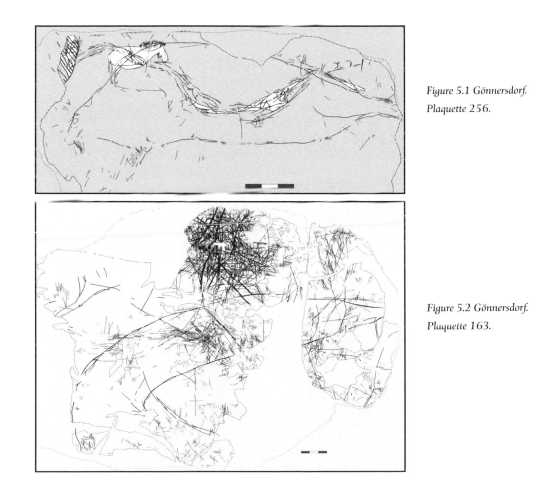

Figure 5.1 Gönnersdorf.
Plaquette 256.

Figure 5.2 Gönnersdorf.
Plaquette 163.

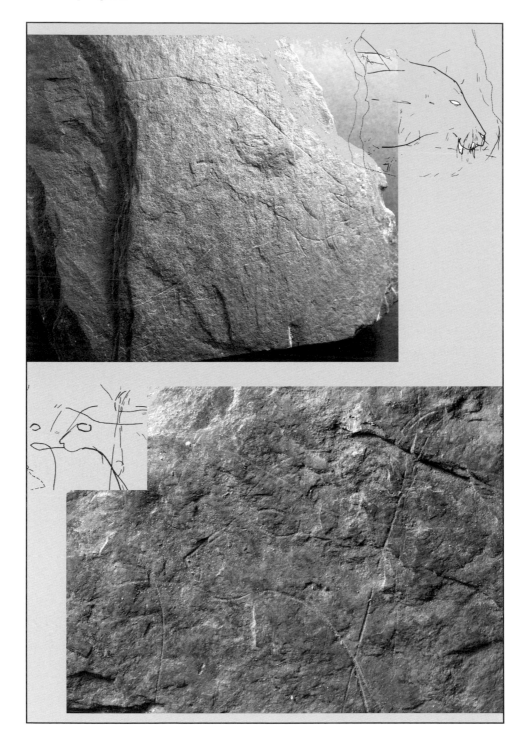

Figure 5.3 Gönnersdorf. Heads of seals 59 B and 96, 2.

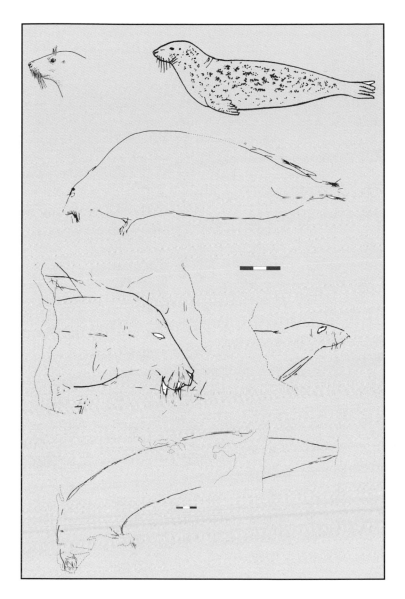

Figure 5.4 Gönnersdorf. Grey Seals (Halichoerus grypus)

the species of seal is limited in its scope, since the drawings represent the outline and some details of the animals (eye, beard), but not the color and other details on which depends the determination of different species.

The depicted animals are true seals (*Phocidae*). According to D. Robineau, Paris, some pictures represent Grey Seals (*Halichoerus grypus*). "D'après la forme de leur museau, allongé et non séparé de la boite crânienne par un resaut, plusieurs phoques de Gönnersdorf peuvent être déterminés, avec vraisemblance, comme des phoques gris (*Halichoerus grypus*)." Robineau was referring to representations 59 B,

163, 2 and 287, 2; using the same criteria we may add the big figure 256, 1 (Figure 5.4).

An animal dictionary (Görner and Hackethal 1988:307) says of Grey Seals:

> Gestreckte Schnauze und kegelförmiger Kopf. Die Tiere sind viel grösser als der Gemeine Seehund. ... Die Nasenlöcher liegen bei den Tieren weit auseinander... Vorkommen: Küsten Islands, Grossbritanniens, Irlands, der Färöer-Inseln, in der Nord- und Ostsee, Ostküste Kanadas. Bevorzugt Meeresteile mit Felsriffen und Klippen sowie Fels- und Geröllküsten.
>
> Lebensweise: Die scheuen Tiere leben meist in kleinen Gruppen oder Rudeln. Während der Paarung, zur Wurfzeit und während des Haarwechsels halten sie sich an Land auf... Die Nahrung besteht vorzugsweise aus Fischen. Weichtiere und Krebse werden auch angenommen.

Robineau recognized a second species, characterized by a step between mouth and skull:

> Une autre espèce au moins est représentée, qui se distingue du phoque gris par un museau court séparé de la boite crânienne par un resaut, mais il n'est possible de déterminer l'espèce dont il s'agit.

Robineau was referring to pictures 96, 2 and 283; we would add the big head 270 B (Figure 5.5).

Due to the form of its head, this species could be the Common Seal (*Phoca vitulina*), the Ringed Seal (*Phoca hispida*), the Harp Seal (*Phoca groenlandica*) as well as the Bearded Seal (*Erignathus barbatus*), as we determined in an earlier publication (Bosinski and Bosinski 1991). The most obvious would be the Common Seal (*Phoca vitulina*; Figure 5.5).

The animal dictionary says of this animal:

> Gedrungener Körper, grosser runder Kopf mit grossen Augen, an der Schnauze lange weisse Tastborsten. Grundfärbung graugelb bis graubraun... Die schmalen Nasenöffnungen sind v-förmig... Vorkommen: Europäische Atlantikküste (einschliesslich Nordsee) bis Spanien, Küsten Nordamerikas und des Nordpazifiks. Nachweise in der Ostsee sind selten. Einzelne Tiere wandern gelegentlich in grösseren Flüssen (z.B. Elbe) stromaufwärts. Bevorzugt werden ungestörte Küstengewässer mit flachen Sandbänken und Wattenmeere. Lebensweise: ... Ausserhalb der Paarungszeit sind es meist Einzelgänger, aber sie können auch gesellig in unterschiedlich starken Rudeln leben... Jungtiere können weite Wanderungen unternehmen. An Land sind die Tiere unbeholfen. Am häufigsten kann man sie ruhend auf Sandbänken beobachten. ... Die Nahrung besteht aus Fischen, Krabben, Krebsen und Weichtieren... (Görner and Hackethal 1988:302).

The remaining drawings are fragmentary or schematic, and cannot be determined to species (Figure 5.6).

It is primarily the completely preserved animal figures 163, 2 and 256, 1, but also the sketches 284 and 286, which display the streamlined body-shape of seals (Figures 5.4-5.6). The spread fore-fin of seals 93, 2; 96, 2; 163, 2; 256, and 286 indicate swimming animals. The head has a big eye and sometimes a bearded mouth (96, 2; 163, 2; 59 B; 256, 1; 287).

In front of seal 96, 2 there are two pointed ovals which may belong to the depiction, perhaps representing respiration bubbles (Figure 5.3).

An intended connection between seal-images and other figures may be proposed for plaquette 163 (Figure 5.2). In the upper left part of this slate, with its greenish-grey, humpbacked surface, there is the drawing of a little horse. The seal, orientated to the left, is almost complete and covers the plaquette. The very irregular surface, with

higher and lower steps, did not affect the skilful drawing at all. The head is represented with a big eye and a beard. The streamlined body-shape is well depicted, with only the fore fin projecting out of the contour. The backline is interrupted by a flaking of the slate's surface. The tail ends on the right edge of the plaquette. In addition there is a bundle of lines which runs wave-like over the upper part of the slate, crossing the small horse and the seal. In the upper left corner this bundle starts from an oval-like figure filled with oblique lines, and only partially preserved. To the right this bundle terminates in an elongated point which is subdivided by some vertical lines. The thickest part of the bundle is placed inside the seal.

This thick plaquette is almost complete, and already had its present form when the figures were drawn.

Most of the seal representations (7 images) were found in Concentration I, including the adjoining Eastern part of the excavation (Figure 5.7). This applies to the complete seal on plaquette 163 (Figure 5.2), the detailed head 59 B (Figure 5.3), seals 70 B, 4 and 93, 2 (Figure 5.6) as well as 96, 2 (Figure 5.3:9), the seal on plaquette 283 (Figure 5.5), and the big eye – perhaps belonging to a seal – on fragment 289 (Figure 5.6).

This concentration, partly destroyed by the foundation-pit of a house which led to the discovery of the site, represents the ground-plan of a habitation. Deeper parts of the cultural layer contained a hearth and more than 30 small pits, mostly cooking pits (Bosinski 1979). According to the analysis of the hunted animals, this dwelling

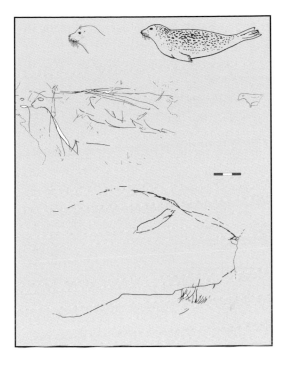

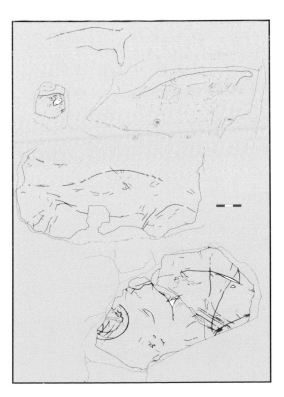

Figure 5.5 (upper right) Gönnersdorf. Seals with a step between mouth and skull, possibly Phoca vitulina. Figure 5.6 (lower right) Gönnersdorf. Seal-representations not identifiable to species.

was occupied in the winter (Poplin 1976). The flint material used for the artifacts indicates that this group came from the North (Floss 1994). The raw material includes Baltic flint which occurs in the Northern Central European lowlands, to which it was transported by glaciers.

Many drawings come from this concentration. In addition to 227 female depictions (Bosinski, d'Errico and Schiller 2001) we have recognized 149 images (mostly partial) of animals, including mammoth (66), horse (27), rhino (12), reindeer and deer (8), aurochs and bison (8), ibex (4), birds (4), bear (3), saiga (2), fish (2), wolf (1), lion (1), and turtle (1), as well as the seven seal pictures (Bosinski and Fischer 1980; Bosinski in press).

In Concentration IIa there were two plaquettes with seals (Figure 5.7): the Grey Seal 287, 2 (Figure 5.4), and the big head 270 B (Figure 5.5). The structure and subdivision of this dwelling were very similar to those of Concentration I (Sensburg 2004). The preliminary analysis of the bone-material indicates a summertime stay (Poplin 1978). The raw material used comes from the Meuse region, 100 km northwest of Gönnersdorf (Floss 1994).

From Concentration IIa we have 51 female depictions and 90 animal representations. Especially numerous are horse (35) and birds (15). In addition there are mammoths (7), reindeer and deer (6), aurochs and bison (6), ibex (4), rhino (3), saiga (2), bear (2), fish (2), turtle (1), and frog (1), as well as the two seals (Bosinski and Fischer 1980; Bosinski, in press).

From Concentration III and its southeastern spur we also have two plaquettes with seals (Figure 5.7). Plaquette 256 with an elongated, almost complete seal (Figure 5.1) was found in the central part of the concentration, and plaquette 286, with a sketch of the animal (Figure 5.6), in the southeastern part.

Concentration III is much smaller than Concentrations I and IIa, but also represents the ground-plan of a habitation with pits and fireplaces (Terberger 1997). The prey seems to indicate that this dwelling was used in the winter. The artifacts' raw material is more diversified and possibly mixed (Floss 1994; Terberger 1997). But there are components (Kieseloolith, Chalcedony) which point to the Mainz Basin, about 100 km south of Gönnersdorf.

On the slates from this concentration we have recognized 20 females and 14 animals, including horses (5), birds (2), wolves (2), and mammoth (1), as well as the two seals. Considering the small number of images, the two seals are remarkable.

Finally, plaquette 284 with a schematic seal (Figure 5.6), was discovered on the northern fringe of the excavation, between a tent-ring (Concentration IV) and an outdoor fireplace (Figure 5.7). In this northern area the drawings are very sparse, and it has been supposed that the engraved plaquettes found were taken from other concentrations and used in this zone without any notice being taken of the drawings (Bosinski, d'Errico and Schiller 2001:298).

Depictions of seals in the Magdalenian

Representations of seals from the Magdalenian are known from 14 sites (Figure 5.8). In Central Europe, besides Gönnersdorf there is only one image from Andernach representing a swimming animal with a big eye and a streamlined body-shape (Figure 5.9). The central part of the drawing has flaked off, but there would have been room in front of the damage to preserve the fore-fin. Possibly it is indicated by an oblique line inside the body. Or perhaps it is not a seal – from its head it would be the Common Seal (*Phoca vitulina*) – but an otter that is represented.

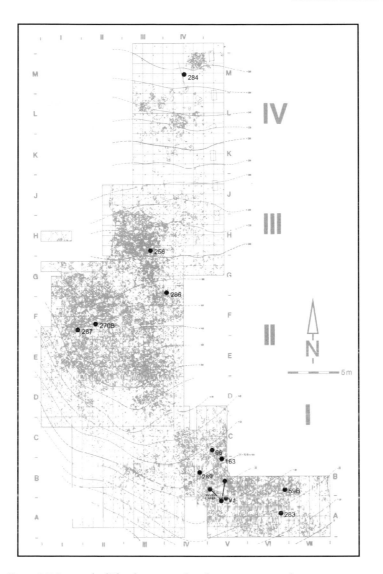

Figure 5.7 Gönnersdorf. The plaquettes with seal representations in the excavation area.

The seal-depictions of Western Europe were published by de Sonneville-Bordes and Laurent (1983) and more recently by Serangeli (2001, 2002, 2003).

The scene on the bâton de commande-ment from Montgaudier (Charente), made famous by Alex's classic study (Marshack 1970), depicts two seals (the head type corre-sponds to Grey Seals, *Halichoerus grypus*), and salmon, eels, feathered lines, and other figures that are difficult to interpret. The seals could be a male and female, both swimming as indicated by the movement of their tail-fins. Salmon and eels indicate that the scene is taking place in the water.

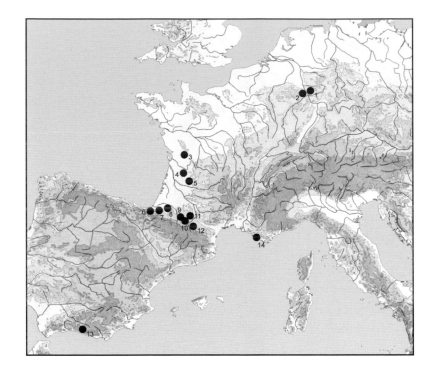

Figure 5.8 Representations of seals in the Magdalenian: 1) Gönnersdorf; 2) Andernach; 3) Montgaudier; 4) Abri Mège; 5) Abri Lachaud; 6) Duruthy; 7) Isturitz; 8) Brassempouy; 9) Gourdan; 10) Grotte Enlène; 11) Mas d'Azil; 12) La Vache; 13) Nerja; 14) Grotte Cosquer.

Two fragments of baguettes demi-rondes from the Abri Mège at Teyjat (Dordogne) also display compositions including seals. The smaller piece depicts a seal seen from above. Its bent body was described by Henri Breuil: "...au moment où il saute à l'eau, les pattes antérieures étalées, celles de derrière redressées au-dessus du bassin" (Capitan *et al.* 1906:210). Behind this animal the head of another seal is preserved.

The engravings on the bigger fragment are, according to Breuil: "...un animal fantastique qui tend la tête vers une figure plus compréhensible, un quartier de phoque; on voit sans peine les deux pieds pennés, se rattachant à l'arrière-train isolé". This image, which looks like the cut-off tail of a seal, as well as the "animal fantastique" in front of it, are seen by

de Sonneville-Bordes and Laurent (1983:71) as butchering a seal, and they suppose that some lines engraved behind the head and above the tail of the "animal sautant" also indicate how to butcher a seal.

Other representations are found in the foothills of the French Pyrenees. On a bone fragment from Le Mas d'Azil (Ariège) there are engraved seals (Serangeli 2003:72). A rib-fragment from La Vache (Ariège) preserves the front part of a seal, and another seal is depicted on a bird bone (Thiault and Roy 1996:318). From the Grotte Enlène (Ariège) comes an image of a seal carved on an antler chisel (Clottes and Courtin 1995:134) "trouvé dans les déblais des anciennes fouilles. Magdalénien moyen" (letter from R. Bégouën, 26 Sept. 2005).

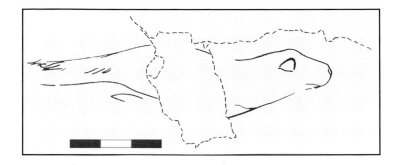

Figure 5.9 Andernach (Rhineland). Seal. After G. Bosinski 1994.

In the cave of Gourdan (Haute-Garonne) Piette found a baguette demi-ronde with the drawing of a seal with a big eye, a beard, and hatched patterns inside the body; from the position of the fore-fin this is a swimming animal. "Le Phoque présentait, quand on l'a sorti de terre, des traces très nettes d'un semis de petites mouchetures noires, faites avec de la couleur et qui se sont entièrement effacées depuis" (Piette 1907:110).

Also from Piette's excavations comes the engraving of a seal found in the Grotte du Pape at Brassempouy (Landes). This animal, too, is swimming as is the case with a seal depicted on a bear tooth from Duruthy near Sorde-l'Abbaye (Landes), already mentioned by Piette in a comparison with his finds.

The figure of a seal carved in the contour découpé technique out of a rib was found in the Magdalenian of Isturitz (Pyrénées-Atlantiques). The seal's tail is still linked to the rib. The fore-fin is engraved in a distorted way inside the body, dependent on the technique used. In addition, on a plaquette from Abri Lachaud (Dordogne) a drawing of an animal with a raised head, an eye, and an indicated fore-fin may represent a seal (Serangeli 2003:fig. 4.1:18).

The engravings from Morin (Gironde) and La Madeleine (Dordogne), also mentioned by de Sonneville-Bordes and Laurent (1983), have to be excluded. The animals on the bâton de commandement from Morin with their large mouths and square-like heads do not resemble seals. And the "seal" from La Madeleine literally dissolved after the new relevé by Tosello (2003:34 and figs. 302-303).

Further images are known from cave-art. The determination of two seals from La Peña de Candamo (Clottes and Courtin 1995:fig. 128) remains uncertain. But the painted, spindle-like animals from Nerja near Málaga are likely to represent seals (Dams 1987). The cave is near the Mediterranean coast; this led to their identification as Monk Seals (*Monachus monachus*), the only seal species of the Mediterranean.

The seals from the Grotte Cosquer near Marseilles are very different from the spindle-like type of Nerja (Clottes and Courtin 1995). Often they are merely sketches, and it happens that the hairs of the beard shift to the mouth (Figure 5.10). These figures are among the younger representations in this cave, dating to the transition from Solutrean to Magdalenian and almost contemporary with Lascaux. In view of the geographical position of the Grotte Cosquer, Monk Seals were thought of in this case too. Lines or bundles of lines associated with the seal-images are a special attribute of the Grotte Cosquer, and seem to represent weapons (spears).

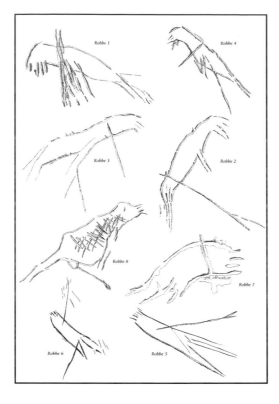

Figure 5.10 Grotte Cosquer (Bouches-du-Rhône).
Speared seals. After J. Clottes and J. Courtin 1995.

Sealing in the Magdalenian

De Sonneville-Bordes and Laurent (1983:79) assumed that the representation of seals at the end of the Upper Paleolithic could have been caused by climatic changes. But it seems more reasonable that these images of seals in Magdalenian art reflect the growing economical importance of sealing.

Upper Paleolithic sites with seal bones are mostly situated along the Spanish and Italian coasts, where the coastlines have not changed much since Magdalenian times (Serangeli 2003; Figure 5.2). But in Northern Central Europe the ocean shore was at that time more than 200 km to the north and northwest.

Even if younger seals, especially *Phoca vitulina*, migrate upstream in the bigger rivers, it can be ruled out that seals lived during the Magdalenian in the Middle Rhine Region, then about 500 km from the mouth of the Rhine and the ocean. This is supported by the absence of seal bones in the prey remains at Gönnersdorf.

Without any doubt the artists knew these animals very well. They remembered the images and were able to draw them without any hesitation or mistakes. It seems very likely that people from Gönnersdorf went to the faraway coast. In addition to the seal representations, the images of two water-turtles may be another clue to their stay at the ocean-shore (Bosinski and Bosinski 2005). Above all, the human group which used Concentration I at Gönnersdorf had relations with the North. This concerns the raw material of the stone artifacts (Baltic flint), but also the numerous representations of mammoth (66) and rhino (12; Figure 5.7), animals which are almost absent in the Gönnersdorf bone material and which lived in a northerly landscape.

Common Seals (*Phoca vitulina*) and Grey Seals (*Halichoerus grypus*), as represented at Gönnersdorf, only occasionally come ashore, and perhaps were hunted during these times. Possibly the animals were also captured near their breathing-holes in the ice.

However, sealing with boats and harpoons would have been much more successful. The use of spears seems proved by the Grotte Cosquer representations (Figure 5.10). In the later Magdalenian these spears were armed with harpoon-heads and thrown with the atlatl. In a certain way this could explain the Magdalenian harpoons whose use for fishing or horse- and reindeer-hunting appears rather questionable.

Knowledge of boats cannot be excluded when we realize that in Japan, already in the early Upper Paleolithic, a special kind of obsidian was

used which came from Kozushima, a volcanic island about 50 km offshore, that could only be reached by boat (Ono 1995). But up to the present, Magdalenian sealing sites on the shores of the Atlantic or North Sea remain unknown, because they are flooded.

About the authors

Gerhard Bosinski and Hannelore Bosinski [†], 3 Place Mazelviel, 82140 St-Antonin-Noble-Val, France; E-mail: bosinski@orange.fr.

References

Bosinski, G.

1979 *Die Ausgrabungen in Gönnersdorf 1968-1976 und die Siedlungsbefunde der Grabung 1968.* Der Magdalénien-Fundplatz Gönnersdorf 3. Wiesbaden.

1994 Die Gravierungen des Magdalénien-Fundplatzes Andernach-Martinsberg. *Jahrbuch des Römisch-Germanischen Zentralmuseum* 41:19-58.

in press *Die Tierdarstellungen von Gönnersdorf II - Nachträge Mammut und Pferd; Nashorn, Cerviden, Rinder, Steinbock, Saiga, Robben, Raubtiere, Vögel, Fische, Schildkröten, Frosch, unbestimmte Tiere und komposite Wesen.* Mit Beiträgen von A. Güth, W. Heuschen und H.-E. Joachim. Der Magdalénien-Fundplatz Gönnersdorf 9.

Bosinski G., and H. Bosinski

1991 Robbendarstellungen von Gönnersdorf. In *Festschrift für Karl Brunnacker*, edited by A. Aktes and W. Boenigk, pp. 81-87. Sonderveröffentlichungen Geol. Inst. Köln 82.

2005 Cuervo, rana y tortuga en Gönnersdorf. Animales representados raras veces, que han sido dibujados perfectamente. *Homenaje al Prof. Jesus Altuna. Munibe* 57:135-41.

Bosinski, G., and G. Fischer

1980 *Mammut- und Pferdedarstellungen von Gönnersdorf.* Der Magdalénien-Fundplatz Gönnersdorf 5. Wiesbaden.

Bosinski, G., F. d'Errico, and P. Schiler

2001 *Die gravierten Frauendarstellungen von Gönnersdorf.* Der Magdalénien-Fundplatz Gönnersdorf 8. Stuttgart.

Capitan, L., H. Breuil, P. Bourrinet, and D. Peyrony

1906 L'abri Mège à Teyjat. *Revue de l'Ecole d'Anthropologie*, pp. 196-212.

Clottes, J., and J. Courtin

1995 *Grotte Cosquer bei Marseilles. Eine im Meer versunkene Bilderhöhle.* Speläo 2. Sigmaringen, Thorbecke.

Dams, L.

1987 *L'Art paléolithique de la grotte de Nerja (Málaga, Espagne).* BAR International Series 385. Oxford.

Floss, H.

1994 *Rohmaterialversorgung im Paläolithikum des Mittelrheingebietes.* Monographien des Römisch-Germanischen Zentralmus 21. Mainz and Bonn.

Görner, M., and H. Hackethal

1988 *Säugetiere Europas.* dtv, München.

Marshack, A.

1970 Le bâton de commandement de Montgaudier (Charente). Réexamen au microscope et interprétation nouvelle. *L'Anthropologie* 74:321-352.

Ono, A.

1995 Die Altsteinzeit in Japan. Achte Rudolf Virchow-Vorlesung. *Jahrbuch des Römisch-Germanischen Zentralmus* 42:1-17.

Piette, E.

1907 *L'art pendant l'Age du Renne.* Paris.

Poplin, F.

1976 *Les grands vertébrés de Gönnersdorf. Fouilles 1968.* Der Magdalénien-Fundplatz Gönnersdorf 2. Wiesbaden.

1978 Données de la Faune sur le climat et l'environnement. *Geowissenschaftliche Untersuchungen in Gönnersdorf,* edited by K. Brunnacker, pp. 98-104. Der Magdalénien-Fundplatz Gönnersdorf 4.

Sensburg, M.

2004 Die Siedlungsstrukturen der Konzentration IIa von Gönnersdorf. Dissertation Köln.

Serangeli i Dalmau, J.

2001 La zona de costa en Europa durante la última glaciación. *Cypsela* 13:123-136.

2002 La zone côtière en Europe pendant le Paléolithique supérieur. Considérations à partir d'une base de données archéologiques. In *Equilibres et ruptures dans les écosystèmes durant les 20 derniers millénaires en Europe de l'Ouest. Actes du colloque international de Besançon 2002,* 255-264.

2003 La zone côtière et son rôle dans les comportements alimentaires des chasseurs-cueilleurs du Paléolithique supérieur. *Le rôle de l'environnement dans les comportements des chasseurs-cueilleurs préhistoriques,* edited by M. Patou-Mathis and H. Bocherens, pp. 67-82. BAR International Series 1105, Oxford.

Sonneville-Bordes, D. de, and P. Laurent

1983 Le phoque à la fin des temps glaciaires. In *La faune et l'homme préhistorique. Dix études en hommage à Jean Bouchud,* edited by F. Poplin, pp. 69-80. Mém. de la Soc. Préhist. Française, 16.

Terberger, T.

1997 *Die Siedlungsbefunde von Gönnersdorf. Konzentration III und IV.* Der Magdalénien-Fundplatz Gönnersdorf 6. Wiesbaden.

Thiault, M.-H., and J.-B. Roy

1996 *L'art préhistorique des Pyrénées.* Musée des Antiquités Nationales, Paris.

Tosello, G.

2003 *Pierres gravées du Périgord magdalénien 36.* Suppl. à Gallia Préhistoire, Paris.

SUPPORT FOR A NEW SKY HERO
FROM A CONQUERED LAND

John Clegg

Alexander Marshack's skilful and careful observations led to unexpected and powerful insights into Upper Paleolithic behavior and thought. His revolutionary discoveries did not fit comfortably into the main stream of contemporary studies, and have not had the acceptance they deserve. In this chapter I point to data that could be relevant to a recent and revolutionary Australian idea (Swain 1990, 1993) which is important, but little discussed by rock art people or archaeologists (Figure 6.1)

Tony Swain's hypothesis (Stockton 1993) is that Aborigines in the Sydney area reacted to the White invasion of 1788 and its consequences by restructuring their cosmology to include a supernatural All-Father creator, variously known as Baiami, Bunjil and Daramulan. Sometimes Daramulan is represented as the son of Baiami, mediating between him and earth. I bring to the discussion a few examples additional to those Swain mentions, and introduce three rock-art approaches, to location, landscape, and to ways of drawing, specifically "perspective" and the development of novel schemas. I conclude by suggesting a candidate for Stockton's "religious genius who brought about such a complete revolution". This whole chapter, like other work dealing with rock art, is perforce laden with assumption and speculation. Without reliable documentary accounts or witnesses, we cannot know for certain why pictures were made as they were, what any pictures meant, nor even whether they were made or intended as representations. This seldom stated qualification applies to all unwitnessed graphics.

Swain's hypothesis is summarized by Stockton (1993). He says that Swain (1990) argues persuasively that the cult of Baiami was a major religious innovation reacting to and accommodating the catastrophic coming of Europeans. The second Christian mission to Aborigines was set up at Wellington Valley some 360 km northwest of Sydney in 1831, by which time the indigenous population within a 200 km radius of Sydney had dwindled to a mere 500 individuals. Only then was made the first (written) record of the cult of Baiami, as related by Horatio Hale (Swain 1990:229–300):

> When the missionaries first came to Wellington, the natives used to assemble once a year, in the month of February, to dance and sing a song in honour of Baiami: He [Baiami] had created the entire world but long ago decided to leave this earth. From his heavenly realm he rewards and punishes people and through his mediatory son Daramulan he knows all things.

Swain's (1993:127) supporting evidence includes "The ground sculptures of Bora grounds [sites of male initiation rituals], representing Baiami's first camp. [H]is gifts of creation were later described to include domestic stock, vehicles, clothed effigies of blacks and whites, and other items of European culture." Swain (1993:117:126) adds:

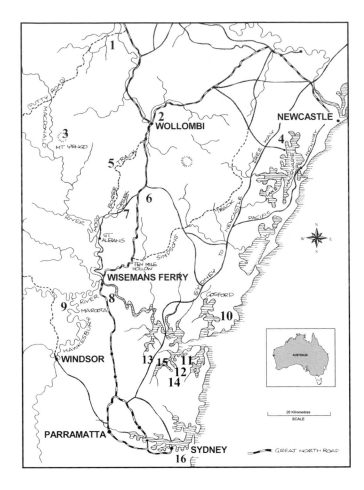

Figure 6.1 Locations of places important to this chapter. Map by Michael Barry from map by Carol Gill in Banks et al. n.d. end papers.

[S]outh-east Australian conceptions of existence could have been adapted so as to accommodate the devastating effects upon social and territorial organization. My thesis is that not only were Aboriginal worldviews restructured but that aboriginal people responded with remarkable speed to the seemingly insurmountable challenge before them I contend that the major changes had already occurred by the 1830s, when the initial reports on Aboriginal societies were being prepared. Indeed, at a prima facie level, it is virtually impossible to conceive how Aboriginal traditions in this region could have survived had it been otherwise.

The cosmological change itself could have been simple:

[T]here are well documented narratives of this region explaining how a multiplicity of Ancestral beings transformed the country. As Kolig suggests, All that was essentially required was to place this [monotheistic] figure outside and above the totemic and kinship order, thus elevating him to a status more exalted than the other beings of the theriomorphic pantheon who remained tied to the order to which the whole universe was thought to be subject.

Stockton comments:

If this hypothesis is correct, one wonders at

the religious genius who brought about such a complete revolution in cosmology and religion among a fragmented people. He had to be a karadji or 'clever man' to have gained acceptance, and a forceful individual at that.

There is one documented example of coincidence of Christian and Aboriginal beliefs. In his 6th Annual Report of the Mission to the Aborigines, at Ebenezer. Lake Macquarie (no. 4 on map) 1836, Threlkeld reported a conversation with Biraban, his Aboriginal assistant, with whom he translated the Gospels of Luke and Mark, and some of Matthew:

> Little M'Gill, whilst reading one of the lessons in the Spelling Book, in which I was explaining to him, and enforcing the truth, that 'He who made all things is God', observed, that old M'Gill knew it, for he had seen Jehovah! Enquiring further into this extraordinary assertion from a black, he said he would bring M'Gill to inform me all about the circumstances. M'Gill came, and related to me as follows: "The night before last, when coming hither, I slept on the other side of the Lake, I dreamed that I and my party of blacks were up in the Heavens; that we stood on a cloud: I looked round about in the Heavens; I said to the men that were with me, there He is; there is He who is called Jehovah; here he comes flying like fire with a great shining – this is He about whom the whites speak. He appeared to me like a man with clothing of fire, red like a flame. His arms were stretched out like the wings of a bird in the act of flying. He did not speak to us, but only looked earnestly at us as he was flying past. I said to the blacks with me, let us go down, lest he take us away; we descended on the top of a very high mountain like this pestle; (showing me one that was in the

study) we came to the bottom, and just as we reached the level ground, I awoke. We often dream of this mountain, many blacks fancy themselves on the top when asleep (Gunson 1974:134, reproducing Threlkeld's 6th annual report of the Mission to the Aborigines December 31st 1836).

Biraban's dream is clearly an expansion of Luke 21:25-28:

> There will be signs in the sun, the moon, and the stars, and on earth nations will be in dismay, perplexed by the roaring of the sea and the waves. People will die of fright in anticipation of what is coming upon the world, for the powers of the heavens will be shaken. And then they will see the Son of Man coming in a cloud with power and great glory. But when these signs begin to happen, stand erect and raise your heads because your redemption is at hand.

This passage was also popular as a hymn: Lo! He comes, with clouds descending, once for our salvation slain; Words: John Cennick 1752; as altered by Charles Wesley 1758; and then altered by Martin Madan 1760.

Penny Van Toorn (2006:Chapter 2) and I believe that the "Very high mountain" could well be Mount Yengo (no. 3 on map), which is well known as a focus of Aboriginal spirituality. It is located 65 km or so from the mission at Lake Macquarie where the dream was related (no. 4 on map), 16 km from Wollombi, (no. 2 on map) and 22 km from Milbrodale, where there is a picture that fits the vision (no. 1 on map).

When I first heard of Swain's theory, my reaction was to show him the rock-art site near Maroota called Devil's Rock (no. 8 on map) that has two large "Culture Hero" figures. One is identified with Baiame and assumed to represent an All-Father. That site also has other features equivalent to those of Mathews' Bora

Figure 6.2 Devil's Rock, from McCarthy 1959:211-213 (no. 8 on map).

Ground, including a series of engraved dots marking a path through the engravings, and engravings of a sailing boat and of a man in a top hat. The latter was discovered only long after I showed the site to Swain (Figures 6.2-6.4).

I used the then accepted archaeological argument that there are too many such figures in the Sydney area for them to have been made after the invasion with its accompanying destruction. This assertion could be checked by asking how many such figures there are in the Sydney area. McMah's (1965) is the only serious work to try to count figures and find patterns in Sydney area engravings. There are (or once were) in reality more engravings than were available to McMah, but the patterns she found are the most reliable yet discovered. Unfortunately her data base was made on edge-punched cards which are not now available for further analyses. Of the 2,890 figures McMah counted, 16 were "enlarged human males" (i.e., "Baiame" figures) and nine were "Daramulans". McDonald (1999:156, 151) counts 21 Baiame and 14 Daramulan figures in her total of 7,676. Whether this number is "too many" might be assessed by comparing it to the

number of undoubted Aboriginal engraving sites of the contact period. Griffin (2004:4-21) mentions 10 sites with clearly Aboriginal engravings of ships and other colonial items. The similar numbers of 10 contact pictures and 16 (or 21) Baiames weakens the argument that there "are too many" culture heroes for them to have been made by the tiny population of Aborigines.

Variations on my assumption that Aboriginal culture in the Sydney area became insignificant very early on under the various impacts of the white invasion are still current. The early history of the colony (see, for example, Hughes 1987, especially Chapter 4, "The Starvation Years") gives good reason. The first fleet came in 1788 with instructions to set up a colony, to be ultimately self-sufficient with appropriate agriculture. Indigenous people were to be treated with respect, and cordial relationships were desired. Unfortunately the first fleet also brought infectious diseases to which the Aborigines had no resistance, particularly smallpox. The first fleet carried enough food to keep its passengers alive for two years in Australia (Hughes 1987-96), but ambitious

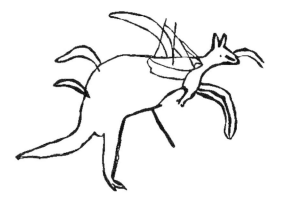

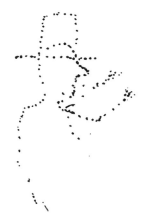

Figure 6.3 Engraving at Devil's Rock of a small sailing boat with a kangaroo (about 2 m long) speared and attacked by six boomerangs. Reversed from Clegg 1978: December 1979. Part of the boat is shown in the upper center of figure.

Figure 6.4 Man with top hat at Devil's Rock, approx. life-size. Tracing made 15.1.93 This figure is not shown on Figure 6.2. It is a few meters to the right of the large Daramulan figure.

attempts to grow crops and become self-sufficient failed. Hunger was rife and such crops as survived the alien conditions were devoured before reaching maturity. Supply ships were wrecked or otherwise failed to reach the colony, yet more people came. Disease and competition for resources had awful effects on the population. For a convincing fictional account of the relevant period in the Hawkesbury area, see Kate Grenville 2005. Nonetheless, as Nicole Steinke (2005) says and convincingly substantiates:

> For decades Sydneysiders grew up believing they'd all died or drifted away as their land was taken, leaving a smoothly white European present. But that was never the whole story... Since the early 1800s there have been reports of the 'last Sydney Aborigine'. They were conveniently thought to have all vanished – but that's been proved a trick of selective memory, collective blindness and wishful thinking.

Swain believes the cult originated in the Sydney area. He refers to three sites as physical evidence to support the case (1993:146, 151):

> one, admittedly ambiguous, piece of evidence that points in that direction. According to McCarthy, the iconography of the well known "Devil's Rock" engravings depicts the mythological motifs found in the ground sculptures of the Bora... amongst the other mythic representations, and equally weathered, is a representation of a sailing vessel which probably dates the engraving to the late eighteenth century (no. 8 on map; Figures 6.2–6.4).

I mentioned above another contact figure at the site, "man in the top hat", also made by Aboriginal engraving techniques, known as conjoint punctures. The pictures were outlined with dot-like pecked indentations or punctures, which were later joined and abraded into a continuous line. The man in the top hat has the punctures but, unlike the sailing boat, they are not conjoined by abrasion.

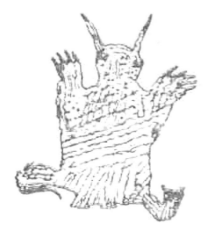

*Figure 6.5 Macintosh's tracings of
Horned Anthropomorphs (no. 6 on map).*

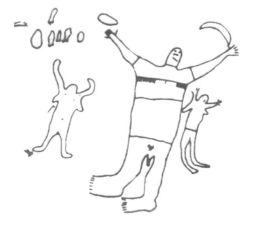

*Figure 6.7 Mount Ku-ring-gai figures. The "Baiame" is
3.4 m tall. McCarthy 1983, vol 2:86 (no. 15 on map).*

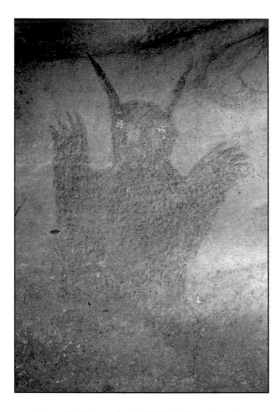

*Figure 6.6 Photo taken in 2005 of Mount Manning
"Horned Anthropomorphs" (no. 6 on map).*

Even more telling is an ochre painting which Macintosh claims to represent the same class of figures as the rock engravings of Baiami. Like the engravings, it depicts a male anthropomorph with outstretched limbs and having eyes but no nose or mouth. It differs conspicuously from the engravings, however, in one important respect. On the painted figure is a prominent pair of horns, unambiguously announcing it as a post-colonial mythic configuration (Swain 1993:146 referring to The "Horned Anthropomorphs" at Mount Manning, no. 6 on map; Figures 6.6–6.7).

Australia, unlike other continents, has no indigenous horned mammals. In the publication of this site, Macintosh reports not one, but three horned anthropomorphs, two of which seem to be a pair, the third added later. He compares the horned anthropomorphs with horned gods in the old world, and accepts a diffusionary explanation as possible. But he does not mention the connection of horns with Christian depictions of Moses. The best-known of these is Michaelangelo's statue in

the tomb of Pope Julius II in the Church of St. Peter in Chains, Rome. Two small horns nestle in Moses' hair. A large literature on this topic is available on the internet. The accepted understanding is that Michelangelo relied on Jerome's vulgate translation of the Old Testament. The "rays of light" that were seen around Moses' face after his meeting with God on Mt Sinai (Exodus 34:29-30) were expressed as horns. In the Hebrew bible it says that the skin of the face of Moses radiated (in Hebrew: karan), yet the depiction of this in sculpture would mean the defacing of Moses' face with stone rays. Michelangelo uses the other meaning of the Hebrew word karan - grew horns ('cornuto' in Italian) - and placed the rays of light on Moses' head as if they were two small horns. He may have based his action on Jerome's translation that actually used the Latin term 'cornutam' as a translation of the Hebrew word karan.

Whether the story of Moses was recounted in the early missions to Australia, I do not know.

Macintosh (1965:89) declares that the male horned anthropomorph "apart from his excessively truncated arms and the two horns on his head is fairly similar to the outline rock engraving of Baiame at Mount Kur ing gai" (no. 15 on map and Figure 6.7). Thus he made the connection between the anthropomorph and Baiame. I believe that the horned anthropomorph red ochre drawings make a better match with the female engraving at Finchley trig station, (no. 5 on map) and will discuss the implications later Figures 6.7-6.8).

Macintosh (1965:89) reports one horned anthropomorph as male, the other as "obviously female because of the well-defined vulva", a feature which was not so clear to me on examining the figures in 2005.

Another horned anthropomorph drawing is in the same general area as those at Mount

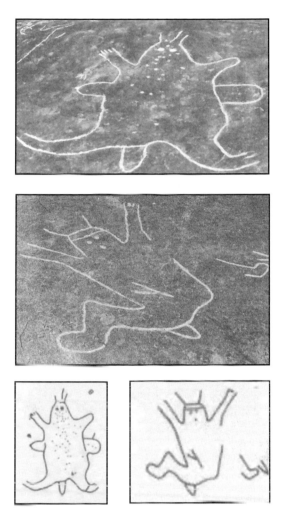

Figures 6.8-6.11 Two engravings at a site near Finchley trig. Station, (no. 5 on map) approximately 1.5 m x 2m, and 1.5 m x 1.5 m, shown as photos and drawings. Sim (1966, plan 6 and photos on p. 21 and 31).

Manning. It is in a very small shelter very close to the St. Albans detour that was trafficable shortly after 1841 (no. 7 on map). Its location is within 100 or so meters of Mogo Creek. 'Mogo' is said to be the word for 'stone axe', and the igneous rocks in the Mogo Creek a source of lithic raw material (Sim 1966:10). Stone axes were highly valued,

Figure 6.12 Mogo Creek horned anthropomorph approx 1.25 m long (no. 7 on map), photo 2006.

and had ritual significance. They were made of igneous rock, which occurs in scattered volcanic plugs intruded into the Hawkesbury sandstone of the Sydney area. One such volcanic plug (lately a basalt road-metal quarry) is within 100 m of the picture. The rock of such basalt plugs and diatremes produces rich volcanic soils that in turn have specialized flora and fauna.

These scraps of circumstantial evidence are consonant with the Mogo Creek Horned Anthropomorph's location at a special place on an Aboriginal route in an area that had a great deal of White attention in the 1820s to 1840s (Figures 6.13-6.14).

Swain quotes Burnum Burnum as expressing a recent example of acknowledged parallels between Aboriginal and White All-Fathers:

I, like every Aboriginal person, believe in and acknowledge the existence of then Great Spirit. Some of us know it as God, others by other names such as Baiami. It is believed that around Wollombi, in a cave there, is a physical manifestation of Baiami in the form

of a huge cave painting that has exaggerated arms outstretched to embrace all beings. (Swain 1993:151; Figure 6.15, no. 1 on map).

All these sites are on or close to the Great North Road (top to bottom center of map). The Milbrodale Baiame is close to the road's northwestern end, the Horned Anthropomorphs are at Mount Manning, (no. 6 on map) in the elevated country north of St. Albans, and Devil's Rock (Figures 6.2-6.4, no. 8 on map) is near Maroota, 14 km or so south of Wiseman's Ferry (no. 8 on map). According to Walton, the site was known when the Great North Road was under construction.

When, many years ago, the Great Northern Road to Newcastle via Wiseman's Ferry, was being made, a remnant of the Aborigines who lived in the Maroota district always avoided a certain part of the country, it is said they regarded it as a "Debbil Debbil Rock". It is unlikely that any of the blacks living at the time had ever seen it, because in those days the local Aborigines had been in contact with

Figures 6.13-6.14 Mogo Creek horned anthropomorph shelter photographed from St. Albans diversion, Great North Road (no. 7 on map) photo 2006 01-09. The road apparently became trafficable in 1841. Photo on right includes part of the present road; shelter shown on right.

the white race for a number of years, and with the break up of tribal life had discontinued many of their old customs, and, apart perhaps from a solitary survivor amongst the old men, had no direct instruction in their tribal lore (Walton 1932:140).

The following section relies heavily on the most recent review of the Great North Road, in Griffin (2004). The Great North Road was built using convict labor between 1826 and 1836, spanning the 250 km distance between Sydney and the Hunter Valley. It was the first in a planned network of "Great Roads", which mirrored the Great Roads of England, and aimed to facilitate colonial expansion form Sydney to the North, South and West.

In the first twelve years of settlement, between 1788 and 1800, Sydney had allocated its promising (but infertile and unreliably watered) land, and become boxed in by the Blue Mountains, the Pacific Ocean, and unpromising and inhospitable land to north and south.

The land traversed by the Great North Road is a deeply dissected plateau (see Figure 6.16). A maze of routes along the ridges make good walking for those who know where they are going. I once made a trip with two companions to a site in comparable country, when access to the vehicular track had been forbidden. The 3 km return trip took us six hours.

Beyond is the fertile Hunter valley. From 1801 it was known as a fertile area. In 1821 there were 21 free settlers, 283 by 1825. There was a great deal of chopping and changing and rethinking the route of the Great North Road, even (in 1828) superseding a section of road just after its completion. The final route of what became the present road was established unofficially when deviations from the Great North Road were adopted to provide access to settled areas such as St. Albans on the MacDonald River. The MacDonald valley had inns by 1832,

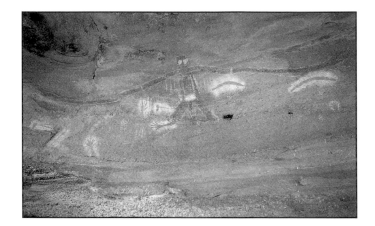

Figure 6.15 Figure "in a cave around Wollombi";the Baiame at Milbrodale. (no. 1 on map), photo 2005.

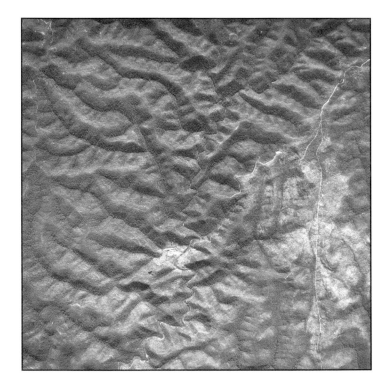

Figure 6.16 Country round the Great North Road and Mogo Creek. Approximately 10 km across. Aerial photo 1975, Copyright NSW Lands Dept. Used with permission. Mogo Creek runs overall south downwards through the center of the photo. The St. Albans diversion of the Great North Road joins Mogo Creek below center near the old basalt quarry. The Great North Road runs N-S near the right margin of the photo. Some of the Boree track may be discerned running roughly N-S at the upper left.

1837, 1842. In mid-1831, steamers (the "Sophia Jane") were introduced between Sydney and the Hunter valley. These were fast and reliable and quickly became the preferred mode of transport. Many sections of the Great North Road became disused before it was finished.

It has been suggested that the original line of the Great North Road was one of a web of Aboriginal tracks in this area (see map). In the area just north of Wiseman's Ferry the Great North Road deviates around certain sacred Aboriginal sites, suggesting that the people of the Darkinjung tribe purposefully diverted the European trail-blazers to avoid these sites. The ridgelines from the MacDonald Valley to the Hunter were in use as a route through the inland before the surveying and construction of the Great North Road. Sim (1966:10) states that there is a 'historic' track known as 'the Boree Track or Blaxlands Road' and that it 'was opened by J. M Blaxland in the 1820s for access to Wollombi Valley. It served until the 1940s as a route between the MacDonald Valley and those valleys to the north in the Hunter. The track runs from a tributary of the MacDonald River, Mogo Creek, then follows high ridges, where vegetation is light schlerophyll and movement comparatively easy. Sim (1966:10) suggests that this historically known track was 'a main line of travel' for Aboriginal people, both prior to colonial times and during the nineteenth century. Mr. A. B. Bailey of St. Albans relates his mother's accounts of the custom of the local natives, a small group of men, women and children (c. 1880), of bivouacking in Mogo Creek, camping in fire-warmed holes dug in the sand flats, and travelling in single file up the Bulga hill and along the track to Boree. Mr. C. Sternbeck of Upper MacDonald relates how his grandfather, one of the first tenants of the fertile Boree Valley, was taken there via the track by a MacDonald River native. One branch of the track leads to Mt Yengo, a sacred place, and beyond to Milbrodale, and another leads into the Wollombi valley. This general line of travel following major ridgelines was known and used by Indigenous people in pre-colonial and colonial times, as well as by convicts escaping from Newcastle before 1820 and by explorers, surveyors and settler traffic, as it afforded the best line of travel through the country. Milbrodale is where the Great North Road's north-western branch meets the Putty road (or Bulga road), which was "discovered" by Whites in 1819 (Karskens 1982:195).

Foley (2001:26) says that Baiame "is our creator and often referred to as the Supreme Being... [S]he gave birth to a son Dharamulan, whose images are permanently engraved in stone in numerous locations around our land... Dharamulan is men's business and should not be explained; rather his presence is acknowledged only." If there was a female supreme being who was a precursor to an introduced male, pictures of him could have adopted her form, changing only the sex. Early depictions of Baiame could resemble pictures of important female personages. I illustrated above engravings near Finchley trig station, close to the Boree track and not far from Mount Yengo and the Great North Road, that could serve as examples of predecessor female depictions in a squatting position with legs spread out. This simple graphic solution implies images with knees up and a penis, and thus explains the otherwise anomalous (or at least rare) red figures at Mount Manning and the red figure with white eyes at Lower Portland (no. 9 on map; Figure 6.15).

In the Sydney rock art corpus, this posture is characteristic of women, with the possible exceptions of "hocker" drawings, which are small black charcoal drawings with legs up as

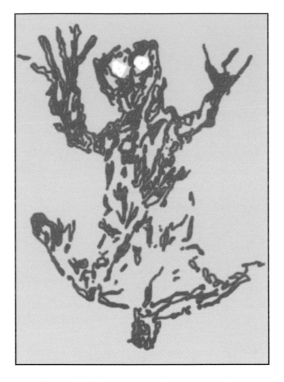

Figure 6.17 Tracing of red drawing at Lower Portland, about 0.8 m tall (no. 9 on map). See also Clegg 1974:6.12.

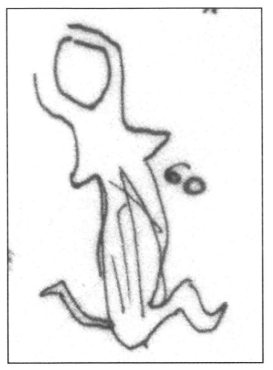

Figure 6.18 (50 cm) yellow drawing of a woman 0.8 m tall. Clegg 1974:6.4:No. 60.

though squatting. Examples have or lack marks that can be seen as breasts or penis. No particular meaning, importance or association is attached to them. The small Mogo Creek Horned Anthropomorph has legs down, but is squashed into a very small confined space. Both the Mount Manning Horned Anthropomorphs have legs in a squatting position. Other comparable figures are not far away in the Mangrove Creek catchment, and also accessible via Simpson's Track (Attenbrow, pers. comm. 2006-01-13). One of the nicest is shown in Figure 6.15 (Figures 6.16-6.18).

Foley's book primarily concerns a coastal area south of Ku-ring-gai-Chase National Park (nos. 11-12, 14 on map), which seems to be the southern end of the concentrated distribution of Daramulan engravings (McDonald 1999: 155:fig. 7). It also has several engravings which are anomalous in the Sydney corpus, in that they manifest attributes of "perspective" unique within this corpus of Aboriginal engravings, and thus may be post-contact. I am particularly well-acquainted with one large site known as Elvina Track site (no. 14 on map, Barry and Clegg 2005), which shares with Devil's Rock attributes that could represent a male initiation site (Hinkson 2001:72). Both have clear paths flanked by a variety of figures including "culture heroes".

At Elvina Track site there are several anomalous or even unique figures. The most anomalous look like two whales, one complete, the other has only the front, as though the rest is

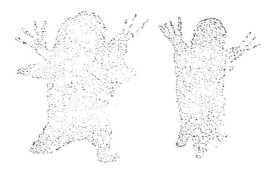

Figure 6.19 Tracings by Gunn of two figures in Black Hole cave, Mangrove Creek.
Both are 0.75 m tall. Courtesy of Val Attenbrow.

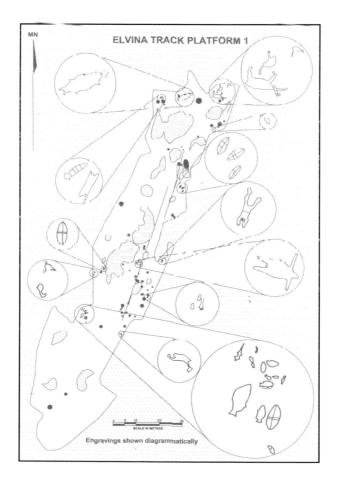

Figure 6.20 Elvina Track site (no. 14 on map) from Barry and Clegg 2005:Figure 6.
The black dots are scale representations of snames, which may be fire scars.

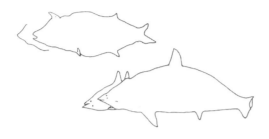

Figure 6.21 The overlapping whales at West Head (Stanbury and Clegg 1990:174). Elvina above (complete whale 7 m) Salvation loop below, nearer whale 9 m (no. 12 on map).

Figure 6.23 Waratah whale: Campbell p. 60 and plate 20; about 16 m long (no. 12 on map).

Figure 6.22 Whale at Bronte about 8 m long with a second tail (no. 16 on map); Campbell 1989:Plate 3:15.

obscured by the other (nearer) whale, which is about 7 m long (Figures 6.20-6.21).

Although in the Sydney rock art corpus there are more than the 55 whales figured in Campbell (1899), only one other pair of whales has a nearer whale obscuring a farther. It is near Salvation Track, a few km to the north of Elvina Track. The pairs of overlapping whales may be significant because the overlap is a form of perspective –

here understood as a modification of shape that takes account of distance. One more whale figure has possible perspective - or perhaps movement. The whale at Bronte (map no. 16) had a second tail when it was recorded by Campbell (1899:plate 3:15; Figure 6.22) .

The Waratah whale displays another perspective phenomenon, where one fin is shown behind and smaller than the other. This way of drawing is more common than the overlapping bodies, but is apparently confined to coastal sites (Figure 6.23).

Waratah trig whale engraving (Campbell 1899:plate 20:fig 3, and page 60) seems to have a near pectoral fin smaller than the distant one; or perhaps it is transparent. The same problem of nearer than distant fins occurs in the Daley's Point whale (Clegg 1974, Nov.; Figure 6.24).

According to one theory, the European mythical Unicorn derived from a verbal description of a rhinoceros, being the size of a horse, having a single horn (with magic properties) in the center of its forehead. If word of Daramulan reached Sydney as a verbal description (or several differing verbal versions), of a large man-like being with one leg and two heads, an artist set in the

*Figure 6.24 Daley's point whale with overlapping fins
(no. 10 on map; Clegg 1978, Nov. 1979)*

*Figure 6.25 Pink dolphin, 2005.
Early and final versions. About 1.5 m.*

normal ways of graphic expression may have been unable to visualize the whole, and made separate figures to display those two features. Such figures appear at Berowra, together with a recognizable Daramulan in profile with emu-bum, 5 m long. The Daramulan figure has a foot that is not recognizably human, but other features that occur in other examples of Daramulans, namely the penis, and a hand that seems to have two thumbs holding a stone axe (Figures 6.27-6.29).

In early 2005, I watched a group of 10-year-olds (class 4al) tackling the problem of drawing life-sized whales. They occasionally made mistakes. Only some of the whales were given perspective fins (Figure 6.24).

At the Elvina Track site (no. 14 on map) there are four unique drawings (Figures 6.30-6.31, 6.34, 6.36).

The flying bird's small wing could be an attempt at perspective (Figure 6.30). I can (almost) read the figure in correct perspective by taking it as seen from slightly below, the upper wing towards the viewer.

The leaping figure has unique and carefully observed tip-toes (Figures 6.31-6.32), unlike a

*Figure 6.26 Pink dolphin, 2005.
Early and final versions. About 1.5 m.*

Figure 6.27 (above left) Berowra engraving of a man with one leg from McCarthy 1983(2):37 (no. 13 on map).

Figure 6.28 (above right) Berowra engraving of a man with two heads from McCarthy 1983(2):37, approx. 2 m (no. 13 on map).

Figure 6.29 (above left) Berowra engraving of a Daramulan figure, approx. 5 m from McCarthy 1983(2):37 (no. 13 on map),

Figure 6.30 Flying bird" at Elvina Track, traced 2006, approx. 1.1 m long.

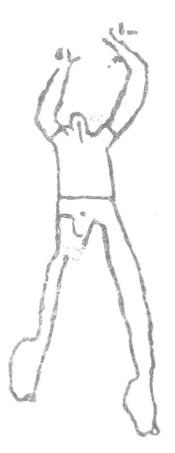

Figures 6.31-6.32 (left and above) Leaping figure at Elvina Track site, approx. 1.1 m long. Tracing 2006, photo Adam Black.

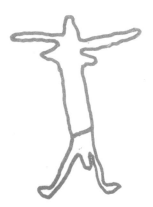

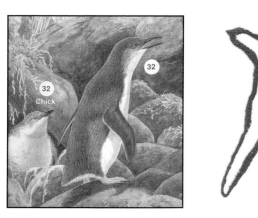

Figure 6.33 Hermaphrodite figure about 1 m at Basin Track, Clegg 1977: December 1978.

Figures 6.34-6.35 Zoologist's picture of a little penguin and chick (left; Simpson and Day 1984:20-21); Penguin engraving at Elvina Track site (right) approx. 40 cm.

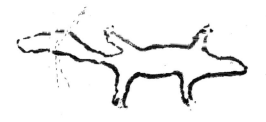

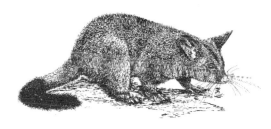

Figure 6.36 (above left) Tracing of brush-tailed possum engraving, Elvina Track site. About 1 m.

Figure 6.37 (above right) Zoologist's drawing of a brush-tailed possum Lyne (1967:43).

Figure 6.38 (right) Elvina Track possum engraving. Photo Michael Barry.

comparable figure (Figure 6.33) not far away from the Basin Track, which has breasts and a penis.

The Elvina Track penguin and brush-tailed possum are also well observed and unique (Figures 6.34, 6.36, 6.38). Such an association of unique and carefully observed figures suggests the work of an individual artist who did not mind departing from the conventional schemas (Figures 6.28-6.32).

The characteristics of foreshortening, diminution with distance, closer objects superposing and obscuring further objects, and departure from conventional forms are alien to the rock engravings of the Sydney area. But some occur in coastal sites between Gosford and Sydney, as do Daramulans. The main focus of Baiame figures is farther west (McDonald 1999:fig. 7:155) and on either side of the Hawkesbury river where the Great North Road crosses at Wiseman's Ferry. The three sites Swain mentions to support his contention are all on, or close to, the Great North Road. Other figures are on the road or Boree Track (Finchley trig, Mogo Creek Horned Anthropomorph, the "top-hatted man" (and sailing ship) at Devil's Rock, which is very like three other figures described in Griffin (2004:2-16).

We can compare the ship image to another representation associated with the OGNR, an engraving of a European person, perhaps a convict, created by drilling into a flat sandstone platform (Figure 4-39). The manner and scale of the image suggest that the artist had seen Aboriginal rock engravings and was imitating their form. The manner in which it is made, its location and the details of the picture - the long smoking pipe and high cap with brim - suggest that it is more or less contemporaneous with the road. Another engraved figure with hat and pipe is found on the Road, 7 km north of Ten Mile Hollow, while another remarkably similar profile

head, with cap and pipe, is found alongside the Windsor Road at Northmead. The similar iconography of these figures, stressing hat and pipe, suggests that they represented a 'type' of person, one that would have been readily recognized by contemporary observers.

We have two collections of recordings of Sydney area engravings; W. D. Campbell's of 1899, and F. D. McCarthy's collected and published from about 1939 to the 1960s. McCarthy synthesized both collections in 1983. These are the best approximation to a sample of what is known, and thus provide the best available estimate of the nature of the population. The Campbell and McCarthy collections were analysed by Lesley McMah in 1965. The vast majority of Sydney engravings look like life-sized depictions of animals, people, and items of material culture such as shields. But there are a few examples that, while they conform in technique and ways of drawing, do not resemble creatures known to zoological science. They are known as "culture heroes". Those relevant to this chapter are called "Baiame" and "Daramulan" figures. The Baiames are like large men, heroic in size, whose feet are drawn in plan. The Daramulans are also heroic in size, but in profile like non-human mammals, have one or two heads, a bum like an emu, and a plan human foot.

McMah (1965:36, 72-73) reports that of the 2,890 figures she analysed, 34 or 1.2 % were "anthropomorphs". These subdivide into 16 enlarged human figures, male, (also known as Baime figures); four enlarged human figures, female; nine "Daramulan" figures, and five composite human-animal figures. The striking features she found in their distribution include a preponderance of large detailed Culture Heroes of both Baiames and Daramulans in the area on either side of the Hawkesbury where the Great North road crosses the river at Wiseman's Ferry.

"These eight figures, taken as a group, are better formed, exhibit a wider variety of shape markings, more detail of body outline; in short they are more highly developed forms, and better artistic productions." Most of the Daramulans without Baiames are near the coast, especially in the Gosford and West Head areas (nos. 14-15 on map, Figure 6.1).

The penguin, brush-tailed possum, pair of whales, and tiptoes at the Elvina Track site, and the overlapping fins of some whales, are exceptions to another generalization about Sydney engravings. They conform to certain rules that seem to be common in non-western and "untrained" art: they are about life-size, and drawn showing the most necessary details to best advantage. Recent scholarship is almost silent on the question of how people "normally" (that is, untrained or free of cultural constraints) draw things. The literature focuses on why people draw as they do, emphasizing "twisted perspective", and much art history refers to departures from this normality, the gradual shift to renaissance perspective and photographic techniques. There is general agreement, but little or no scholarly investigation and substantiation of the generalities that there are commonalities between the art of children, untrained adults, and non-Western societies, once subsumed under the insulting term "Primitive Art". I believe that these commonalities are best explained by the idea that they represent a natural way to represent things graphically. This idea is often stated under some rubric such as that "XX draw what they know, rather than what they see, or what things look like". This formula fails detailed analysis and examination in the light of what is known about how we see things. (Deregowski 1980, 1984, 2005; Hochberg 1973/92).

The idea that the arts of children and untrained adults is a product of a natural way to draw things is denied implicitly by much literature; e.g. the first chapter of Gombrich's *The Story of Art* that deals with prehistoric and "primitive" art is called "Strange Beginnings"; Nicolaides (1969) is a set of recipes designed to cheat the artist away from normal perception.

The puzzle of why normal drawings are as they are was addressed by Emanuel Loewy in 1907:

Even to the layman there is noticeable in archaic Greek art a series of peculiarities which can be formulated as follows:

The conformation and movement [of] figures and their parts are limited to typical shapes. The single forms are stylised, i.e., they are schematised so as to present linear formations that are regular, or tend to regularity.

The representation of form proceeds from the outline, whether this outline is maintained independent and linear, or, being of the same color as the inner surface, combines with it to make a silhouette. When colors occur they are uniform, and are without regard for the modifications of tone caused by light and shade.

As a general rule the figures are shown to the spectator with each of their parts in its broadest aspect, as we shall express it for the present.

Apart from a few definite exceptions, the figures of a composition are spread out over the surface of the picture without allowing the main parts to cross or overlap, so that objects which in nature would be behind one another are drawn out and placed alongside of each other in the picture (pp. 5-6).

By p. 8 it is clear that this list is intended to include a refraining from reproducing the diminutions and foreshortenings as he actually saw them, and to select from amongst the real appearances those that were most definite and easily reproducible, in some cases completing

the work by adding to it parts of the object which from his point of view he could not see.

Loewy proposed an explanation, that the artist was working from a mental image or memory. "... the mental image of a quadruped, a fish, a rosebud (13), takes spontaneously a side view, and that of a fly, a lizard, a full-blown rose, takes a view as seen from above."

Loewy says (7) that the characteristics mentioned are not limited to Greek archaic art. Julius Lange (1892) shows they appear in every primitive art of the present as well as of the past.

While much of Loewy's account was revised in the last century (*e.g.*, Deregowski 2005; Schaefer-Simmern 2003), his generality will serve my present purpose.

These ways of drawing are sometimes called "conventions". I think of conventions as being limited to conformation to some sort of a cultural contract. But these behaviors are so widespread and cross-cultural that they must be more than that. I think of them as a natural way to draw things, given appropriate resources and conditions. My experience as both learner and teacher suggests that the ways artists draw things can change, through either a novel formula, or careful re-examination of how things look in nature, in some cases accessing accurate visual memory of natural appearance rather than (drawn) schemas. Results from revised formulas usually function well as symbols, because they are usually easy to recognize, but they can be subject to error (as when a head is visible as though through a transparent hat, or a closer fin drawn smaller than its more distant counterpart (see Figures 6.4, 6.20-6.21 above). In the case of finned whales, three rules of perspective are applicable: closer superposes, closer obscures and is larger, but one is not applied. Returning to the appearance of things in nature may produce original results that are puzzling because

they are unconventional. It may be necessary to have recourse to the way things look in nature if it is necessary to draw a subject for which schemas are not available – such as the tiptoes on the leaping figure at Elvina Track. In the Sydney area conventional "twisted perspective" worked very well even to the first depictions of novel, introduced items such as bulls, boats and sheep (Clegg 1984; Clegg and Ghantous 2003), but recourse to the way things look in nature is apparent in the penguin and brush-tail possum.

A few engravings in the Sydney area do not conform, being unique (so far as present knowledge shows) in subject (brush-tail, leaping figure) or perspective. And they, like the Daramulans, seem to be in coastal areas. While the perspective of the pairs of whales and their fins could be conforming to a rule (sometimes mistaken, as when the nearer fin is shown smaller than the further fin), details of tiptoe feet, and the brush-tailed possum look like careful observation. The engravings of West Head (nos. 11-12, 14 on map) are near the mouth of the Hawkesbury river. My suggestion that the distributions of Daramulans without Baiames, anomalous perspective in double whales and overlapping fins and whole whales, and unique figures at Elvina Track are linked, may fail to stand up to later scrutiny. But I suggest such scrutiny is deserved.

Stockton concluded his review of Swain's hypothesis:

> If this hypothesis is correct, one wonders at the religious genius who brought about such a complete revolution in cosmology and religion among a fragmented people. He had to be a karadji or 'clever man' to have gained acceptance, and a forceful individual at that.

There is an historical figure who could have been that person. John M'Gill or Biraban (b.c. 1800), 'a chief' of the Lake Macquarie tribe, and Threlkeld's principal assistant, spent his early

years as an officer's servant in Sydney. In 1821 he accompanied Capt. Allman to Port Macquarie as a bush constable. He had returned to Lake Macquarie when Threlkeld arrived there, and was married to a woman named Patty or Ti-pah-mah-ah, with one son Francis or Ye-row-wa, born about 1823. His own name was We-pohng, and presumably he did not assume the name Biraban until admitted into the full rites of the tribe. Although Governor Darling honored him as king of the tribe at Lake Macquarie, he does not appear to have had the same tribal status as King Ben. Thomas Chester referred to him as 'Chief of the Black tribe at Newcastle' in 1838. There are drawings of M'Gill by Browne (before 1831) and Agate (1839). He died before 1850. See *A.D.B.* (*Australian Dictionary of Biography*) Gunson (1974:317)

Two pictures of M'Gill and Biraban appear in Gunson (Figures 6.39-6.40)

The following details are from Gunson (1974) which is well indexed on p. 379. Biraban was in the right places at the right time, and had the appropriate skills. He helped Threlkeld (who never learnt Awabakal well) translate the gospel of Luke (and perhaps Mark and the first five chapters of Matthew), was an impressive graphic artist, reported his synthetic Baiame/Jehovah dream, and may have painted or modified the Milbrodale Baiame (Van Toorn 2006:Chapter 2). He surely knew the poet Mrs Dunlop, and may have featured in at least one of her poems and thus a song composed by Isaac Nathan.

Threlkeld wrote of Aboriginal graphic art and M'Gill's drawing capacity in an instalment in the *Christian Herald*, 25 November 1854: 333-334 (Gunson 1974:59):

> The stile of engraving is similar to that of the ancient Egyptians. The aborigines have a taste for the fine arts, drawing especially. M'Gill, a noble specimen of his race, my

Figure 6.39 'Magill' by convict painter R. Browne, 1831 (Gunson 1974:314)

Figure 6.34 Biraban (John McGill) 1839 by Agate. Gunson (1974:38).

companion and teacher in the language for many years, but now no more, could take a very good drawing of vessels especially. When the first steamboat arrived in the colony, the "Sophia Jane," I requested him to give me a description of it. This he did verbally, and when I required of him a representation, he drew with a pencil on a sheet of paper an excellent sketch of the vessel. The late Bishop of Sydney, the Rev. W. G. Broughton, who took a lively interest in the welfare of the aborigines, requested me to procure from M'Gill a specimen of his ability in drawing, the which I did and the Bishop forwarded it, a representation of the steamer "Sophia Jane," to one of the societies in London, as a proof of the capabilities of the aborigines of New South Wales.

Threlkeld's eighth annual report from the Mission at Ebenezer, Lake Macquarie, New South Wales, December 31st, 1838 (Gunson 1974:144) has a passage that allows a two-sided understanding of Threlkeld's and of Biraban's work.

> From conversation with the Aborigines, it appears that the Christian knowledge which has been communicated to M'gill and other Aborigines, has been the subject of discussion amongst the remnant of the tribes forty miles distant.

Measured roughly on a modern map, Threlkeld's 40 miles reaches from the mission where he was writing to most of the places mentioned in this chapter. The area includes the Great North Road from Milbrodale past Mount Finchley, Mount Moffat, Mogo Creek, and across Wiseman's Ferry to Devil's Rock, as well as Daley's Point and Ku-ring-gai chase, and almost to Bronte. Threlkeld continues:

> In two or three instances, when communicating what was supposed to be subjects

perfectly new to them, they replied with perfect coolness, "We know it, M'Gill, has told us." But whilst the mere knowledge of our Father in Heaven - his Son our Lord - future punishment, &c &c. has extended in a very small degree, no moral influence on their habits of life has been as yet discovered. The still small voice of God speaking to their consciences, must effect this desirable change, that they may be born of God (Gunson 1974:144).

When I began this chapter, I knew the anomalously drawn engravings of whales, possum and penguin at Elvina, the 'man in the top hat' at Devil's Rock, and the Milbrodale and Mogo Creek horned anthropomorph. I hoped to show how rock art might help with Swain's otherwise difficult idea, using a predictive "what if?" approach. As the work progressed, I have been sucked in to an heroic story of a renaissance in Aboriginal religion that may have ameliorated Stanner's "secret river of blood" which accompanied the first half-century of White occupation. The new religion went well enough for a substantial initiation in the 1870s as far away as the Macquarie Marshes.

Perhaps all I have done is add a little more data and new suggestions to an old dispute. Gunson writes on pp. 26-27:

> [O]ne school of nineteenth century anthropologists actually believed that mission teaching was responsible for introducing ideas concerning a creator or all-father God into the cosmology of the Aboriginal tribes of south-eastern Australia. This school was particularly anxious to believe that the Australian Aboriginal had no traditional concept of a supreme being. Their suspicions were particularly aroused by a paper presented by James Manning to the Royal Society of New South Wales in which his description of the cult of Baiame, as

described to him by an Aboriginal of Yass, read like passages from the Apocalypse. Certainly it seems that Manning used scriptural overtones in his literary account. Edward Tylor went so far as to suggest that Threlkeld's teaching was undoubtedly the source of these notions. Such sceptics were particularly influenced by the atheistic sentiments of Aboriginals on the fringe of the sky hero territories. Breton was doubtful if the Aboriginals had any religious beliefs and was certain none were held by the Moreton Bay tribes. Dawson was equally sceptical. He attempted to instruct the Aboriginals at Port Stephens that there was a supreme being.

Bungaree had been a good deal at Newcastle, and observed that Mr. Threlkeld (the missionary in that neighborhood) had told the blacks there the same thing, and that they had told him so; but it did not appear that it had made the least impression upon him, nor was it likely it should, surrounded as he was by a population whose practices every day and almost every hour were in opposition to precepts. Mr Threlkeld had the character of being a sensible, zealous and very amiable man; but he could not perform impossibilities.

We have also Threlkeld's own testimony that M'Gill and others discussed religious topics with members of other tribes and that strange tribes were often quite well informed on the subject as a result (see pp. 135, 140). But it would be idle to suppose that the sky hero cults owed anything to the infiltration of Christian teaching.

Nonetheless, a message such as the one Biraban may have spread fits well with Yorta Yorta spiritual beliefs in 2006, according to Henry Atkinson, a Yorta Yorta Aboriginal man brought up in the early 1940s in the Murray River forest near Echuca.

Atkinson still speaks of the spiritual beliefs of his Yorta Yorta culture: "Biami, the creator, sent down an old woman to look for food, and she created the landscape with her digging stick." The rainbow serpent followed and created the curves and deep holes of the Murray River. There's also "Nubanbool, a man/creature type animal", and other creatures his parents told him about (Arnold 2006:12).

About the author

John Clegg, 24 Waterview Street, Balmain, NSW 2041, Australia; E-mail: jcless@mail.usyd.edu.au.

References

Arnold, A.

2006 Backwash in the tide of history. *Sydney Morning Herald*, Monday January 9, p. 12.

Banks, L., *et al.*

n.d. *Explore the Convict Trail. Great North Road.* Tourism New South Wales.

Barry, M., and J. Clegg

2005 Snames and Science. In *Making marks: Graduate Studies in Rock Art research at the new millennium.* edited by J. K. K. Huang and E. V. Culley. American Rock Art Research Association Occasional paper No. 5, Tucson.

Burnum, Burnum (quoted in Swain 1993, p. 151)

1989 What Australians Believe About God. *Good Weekend*, March 25, p. 31.

Campbell, W. D.

1899 *Aboriginal carvings of Port Jackson and Broken Bay.* Memoirs of the Geological Survey of New South Wales, Ethnographical Series No 1, Sydney.

Clegg, J.

1974 Mathesis pictures, Mathesis words. M. A. (Hons) thesis. Dept of Anthropology, University of Sydney.

1977 Aboriginal Art Calendar 1978. Clegg Calendars, Balmain.

1978 Aboriginal Art Calendar 1979. Clegg Calendars, Balmain.

1984 Pictures of bulls and boats: some evidence of prehistoric perceptive processes, pp. 219-38 in (R. Hutch and P. Fenner, eds), *Under the Shade of a Coolibah Tree, Australian Studies in Consciousness.* Lanham, University Press of America.

Clegg, J., and S. Ghantous

2003 Rock-paintings of exotic animals in the Sydney Basin, New South Wales, Australia. *Before Farming, the archaeology and anthropology of hunter-gatherers.* Western Academic and Specialist Press: 2003/1(7).

Deregowski, J. B.

1980 *Illusions, Patterns, and Pictures: A Cross-Cultural Perspective.* Academic Press, London.

1984 *Distortion in Art: the eye and the mind.* Routledge and Kegan Paul, London.

2005 *Perception and Ways of Drawing: Why Animals are easier to draw than People.* In *Aesthetics and Rock Art,* edited by T. Heyd and J. Clegg, pp. 131-142. Ashgate, London.

Foley, D., with photographs by R. Maynard

2001 *Repossession of our Spirit: Traditional owners of northern Sydney.* Aboriginal History Monograph No. 7, Aboriginal History Inc., Canberra, Australia.

Gombrich, E. H. (many editions)

The Story of Art. Phaidon, London.

Grenville, K.

2005 *The Secret River.* Text Publishing. Griffin nrm Pty Ltd. (eds.), Melbourne.

2004 The Old Great North Road Cultural Landscapes Dharug National Park NSW NPWS Draft Conservation Management Plan www.nationalparks.nsw.gov.au/ PDFs/PoMdraft_ OldGreatNorthRoad.pdf.

Gunson, N. (ed.)

1974 *Reminiscences and Papers of L. E. Threlkeld, Missionary to the Aborigines 1824-59.* Australian Institute of Aboriginal Studies, Canberra. Australian Aboriginal Studies No. 40.

Gunn, R. (ben)

1979 (April) *Report on the Aboriginal Rock Art of the Upper Mangrove Creek Catchment Area.* (Documentation of 'Art' sites that are to be destroyed by the Mangrove Creek Dam Storage Area).

Hinkson, M., with photography by A. Harris

2001 *Aboriginal Sydney: A guide to important places of the past and present.* Aboriginal Studies Press, Canberra.

Hochberg, J.

1973/1992 The representation of things and people. In *Art Perception and Reality,* edited by E. H. Gombrich, pp. 47–94. The Johns Hopkins University Press, Baltimore.

Hughes, R.

1987 *The Fatal Shore: A History of the Transportation of Convicts to Australia 1787-1868.* Pan Books, London.

Karskens, G.

1982 The background to the Construction of the Great North Road. *Journal of the Royal Australian Historical Society* 63 (Pt 3), December, pp. 193-204.

Lange, J.

1892 "*Billedkunstens Fremstilling af Menneskeskikkelsen*". Mémoires de l'Académie Royale de Copenhague.

Loewy, E. (translated from the German by J. Fothergill),

1907 *The Rendering of Nature in Early Greek Art.* Duckworth, London.

Lyne, G.

1967 *Marsupials and Monotremes of Australia.* Angus and Robertson, Sydney.

Macintosh, N. W. G.

1965 Dingo and horned Anthropomorph in an aboriginal rock shelter". *Oceania* Volume XXXVI:2:85-101.

McCarthy, F. D.

1959 Rock engravings of the Sydney-Hawkesbury District Pt 2: Some important ritual groups in the County of Cumberland. *Records of the Australian Museum* 24:203-16.

1983 *Catalogue of rock engravings in the Sydney - Hawkesbury district N. S. W.* National Parks and Wildlife Service, Sydney.

McDonald, J.

1993 On a clear day you can see Mount Yengo - Or: Investigating the archaeological manifestations of culturally significant foci in the prehistoric landscape. In *Time and space: Dating and spatial considerations in rock art research,* edited by J. Steinbring *et al.,* pp. 84-91. Papers of Symposia F and E, Second AURA Congress, Cairns 1992. Occasional AURA Publication No 8. Australian Rock art Research Association, Melbourne.

1999 Bedrock notions and isochrestic choice: Evidence for localised stylistic patterning in the engravings of the Sydney region. *Archaeology in Oceania* 34:145-160.

McMah, L.

1965 A Quantitative Analysis of the Aboriginal Rock Carvings in the District of Sydney and the Hawkesbury River. B. A. (Hons) thesis, Anthropology Department, University of Sydney.

Nicolaides, K.

1969 *The Natural Way To Draw.* Houghton Mifflin, Boston.

Schaefer-Simmern, H.

2003 *Consciousness of Artistic Form.* The Gertrude Schaefer-Simmern Trust, Carbondale.

Sim, I. M.

1966 *Rock Engravings of the MacDonald River District, N.S.W.* Australian Institute of Aboriginal Studies, Canberra, Occasional Papers in Aboriginal Studies Number 7, Prehistory and Material Culture Series Number 1.

Simpson, K, N. Day, and P. Trusler

1984 *Field Guide to the Birds of Australia,* 5th edition. Viking Penguin, Ringwood.

Stanbury, P., and J. Clegg

1990 *A Field Guide to Aboriginal Rock Engravings with Special Reference to those around Sydney.* Oxford University Press, Melbourne.

Steinke, N.

2005 Introduction to ABC radio programme in the Radio National Hindsight series, 30 October-6 November, *Always Moving, Sometimes Staying.*

Stockton, E. D.

1993 Baiami. In *Blue Mountains Dreaming,* edited by E. Stockton, pp. 53-54. The Aboriginal Heritage. Three Sisters Productions, Winmalee.

Swain, T.

1990 A new sky hero from a conquered land. *History of Religions,* no. 29/3:195-232.

1993 *A Place for Strangers: Towards a history of Australian Aboriginal being.* Cambridge University Press, Cambridge.

Van Toorn, P.

2006 *Writing Never Arrives Naked: Early Aboriginal Cultures of Writing in Australia.* Aboriginal Studies Press, Canberra.

Walton, W. J.

1932 An Aboriginal Devil Rock. *Mankind* 1:140-141.

Eye and Vision in Paleolithic Art

Brigitte Delluc and Gilles Delluc

The study of the paleolithic art of caves and rock shelters (parietal art) and that of objects of stone and hard organic materials (mobiliary art) makes it possible to glean some observations for tackling the question of the human eye and the animal eye in prehistory.

The pages which follow make no claim to be exhaustive. In this essay, one cannot cite all the animals nor all the humans depicted with one eye, let alone two. We will content ourselves with taking some examples from the Franco-Cantabrian domain, and primarily from the animals of Lascaux: these will enable us to evoke the optical perspective and show how the artist's hand modifies what the hunter's eye sees.

Anatomical aspects

The eye and eye-socket in human evolution

In relation to the other mammals, humans have certainly lost many sensory possibilities (olfactory, auditory and visual), as the other structures of the brain developed. But even today, sight represents three quarters of an individual's sensory input.

The eye is both an expansion of the brain and a perfected camera. As we know, the wall of its eyeball is composed of three layers: external (the tough sclera, and, in front, the transparent cornea), middle (the choroid with the iris pierced by the pupil) and internal (the retina, emanation of the optic nerve). The retina contains two types of sensory cell: on the periphery, the rods, which ensure nocturnal vision; in the center, the cones, which perceive the fundamental colors (blue,

green and red, that is, a wavelength from 380 to 750 mm). This eyeball contains some transparent media: the crystalline lens just behind the iris, the aqueous humor in front of the crystalline, and the vitreous humor behind it.

The eye functions like a marvellous magic lantern. The light rays that bring images enter through the pupil and cross the eye's transparent tissues. They pass through the crystalline lens, which converges the rays emitted by the object on the retina. This is an intelligent lens which modifies its curvature and "accommodates", depending on the distance to the object, to give a clear (and inverted) image of it on the retina. The iris acts like a photographic diaphragm and controls the dilation or contraction of the pupil by modulating the luminous intensity: on closing, the iris ameliorates the quality of the image by privileging the cones.

The two images received in parallel on the two retinas are transformed, through a photochemical reaction, into a luminous signal. The optic nerves transmit them to the brain which erects them, and fuses them into a single image (in relief) which reaches consciousness. At the level of the cerebral cortex, the center of vision is the striated area, located on the two lips of the calcarine fissure, on the internal face of each occipital lobe (Brodmann area 17).

In humans, it is probable that vision has undergone few modifications for many millennia, whether in terms of the eye *sensu stricto*, the optic ducts or the cortical center of vision. It is difficult to say much more about the prehistoric

eye. Yet "see or perish", said Teilhard de Chardin, explaining that the history of the living world boiled down to the development of increasingly perfect eyes within a cosmos where one can always discern better.

The development of the skull has mostly affected the forehead, the face and the lower jaw. The appearance of the eye sockets has undergone important modifications. Originally, in *Homo habilis*, below thick brow arches which formed a ridge, and under a receding forehead, they were round and wide. In Tautavel Man, 450,000 years ago, and then in the Neandertals, the sockets were broad under strong brow ridges which were very different from our own. But they must have seen what surrounded them more or less like we do. Gradually, the sockets were to become more square, while the brow ridge decreased, the forehead rose up, and the cheekbones became marked.

The appearance of Cro-Magnon Man, who invented graphic art 35,000 years ago, was the same as ours. His eyes and his vision were similar to ours. There is no reason to suppose that, like us, he did not experience visual defects: myopia and hypermetropia (when the eye's antero-posterior axis is too long or too short), astigmatism (when the curvature of the cornea is imperfect), longsightedness (when the crystalline lens, which becomes fibrous with age, loses its faculties for accommodation), and problems with color vision (dyschromatopsias which are usually congenital).

Similarly, the eyes of prehistoric people must have perceived the same spectrum of light as ours do: ultraviolet and infrared radiation escaped them.

Depiction of the eye in prehistoric art
1. Present in all periods
In parietal figures, the drawing of the eye appears very early - from the earliest phases of the Upper Paleolithic, in the horse engraved on the gravettian pebble of Labattut, in the salmon of the abri du Poisson, and in certain figures at Gargas, Chauvet, Cosquer, Cussac, Cougnac, Pech Merle and Roucadour. In the Solutrean, 18,000 years ago, it is present in the bas-reliefs of Roc de Sers. Then it would habitually be depicted in the animal and human figures of the Magdalenian, up to the end of the last glaciation, 10,000 years ago, a period which saw the art of the great hunters become much more schematic and leave the underground domain.

The presence or absence of the eye is thus no argument for dating, but we shall see that the Magdalenians greatly applied themselves to rendering its fine anatomical details.

This subject has been of little interest to prehistorians, apart from the abbé André Glory and the authors of this paper (Delluc 1986). André Glory had begun to gather a few pieces of evidence with a view to a book on shamanism and the cult of the ongones (Glory Archives).

2. *The eyes of humans*
Like the other features of the face, the drawing of the eye is very succinct in human and humanoid figures: this discretion doubtless had a religious origin. When the eye is depicted, it is most often reduced to a pupil materialized by a simple dot (Les Trois Frères) or, more frequently, a simple little line that is circular or more almond-shaped, as at Roc de Sers, Lascaux, Gabillou (using a small natural cupule for the "woman in an anorak"), Saint-Cirq, Sous-Grand-Lac, Los Casares and Les Trois Frères, as well as on objects from Le Mas d'Azil, Isturitz and La Madeleine. The same is true of the "bestialized" humans of Comarque, Massat, Fontanet, Hornos de la Peña and Les Combarelles or for the humans of Rouffignac (one has an eye deformed into a comma, another a large triangular eye).

The Gabillou man wearing bison horns has an almond-shaped eye and a square muzzle.

The two eyes are drawn full-face on a bearded head at Rouffignac (as two circumflex accents) and Marsoulas (they are round and partly with a double outline), on a laughing face at Les Combarelles (almond-shaped with a long vertical axis), as well as on a perforated baton from Saint-Marcel. On an engraved human face at Gabillou, the two eyes are small natural cavities, hollowed out and joined by a gamma forming the nose. On the composite being (or "sorcerer") of Les Trois-Frères, the eyes with pupils and a wide peri-orbital corona, above a small beak nose, recalling those of a night bird. One can compare it with the masks with two round eyes (or slightly comma-shaped) at Altamira. At Bernifal, one mask has eyes made with a big dot surmounted by an arc, another with quarter-circle eyes, and a third with a single eye made with a short horizontal line. The "phantoms" (Les Combarelles, Marsoulas, Le Portel, Font-de-Gaume, Les Trois-Frères) usually have two eyes.[1]

The eye is rarely depicted faithfully: that on a block from La Marche is an exception, but it is extended, at the level of its inner corner, by a kind of cervid tear-duct, and the face itself is deformed, with a forward-projecting muzzle. Other engravings from this site display more realistic features: almond-shaped eyes, eyes as an horizontal 0, or seen full-face on profile faces, surrounded by the C shape of the socket. One can find this anomaly of perspective at the Ker de Massat and in Egyptian art. These eyes recall those of animals, located at the sides, and not those of humans who look straight forward: their eye should be schematized by a horizontal V open towards the front, the angle of which should be barred by a segment of curve, a bit like a horizontal A.

Human statuettes, mostly female (the famous Venuses are often gravettian) have no eyes, and even no face. The admirable little ivory head from Brassempouy looks at us with absent eyes, under harmonious brow arches, while all the facial features of the woman with a horn from Laussel are lacking.

3. The eyes of animals

In the decorated caves, next to the horses and bovids (aurochs and bison), the third animal is often the ibex or mammoth and, especially in Spain, the stag or hind. It is readily depicted on the fringes, like the stags in the painted frieze of Lascaux, the hind of Altamira, the mammoths of Font-de-Gaume and the ibex of Niaux. In certain sanctuaries, one or several animal species are dominant: the felines and rhinoceroses at Chauvet. These dangerous animals are more frequent at the beginning of the Upper Paleolithic, about thirty thousand years ago. Aurochs are numerous at Lascaux, mammoths at Rouffignac and bison at Altamira. The climate and seasons had an influence on the choice and appearance of certain animals (Delluc 1990; Dubourg 1994; Aujoulat 2004). For climatic reasons, apparently, the megaloceros (a big cervid) is only present at the start of the Upper Paleolithic, and the mammoth disappears around 12,000 years ago, shortly before the end of the Magdalenian.

Like those of humans, the eyes of animals are, most often, drawn on profile heads. They are missing in many cases, and especially in the oldest sites. They are rendered in accordance with graphic norms which generally translate a certain anatomical reality. But it is remarkable that a few artists depicted some minor but very well observed details such as the horizontal nature of the pupil in the large herbivores, the third eyelid (corps clignotant) and the lachrymal caruncle of the nasal corner of the eye, or even the swell of the orbital muscle of the eyelids.

The *equids* are, even more than the bovids, the principal characters in parietal art. The eyes of

horses are often rendered in a very simple way: a circle or half-circle in the caves (Chauvet, Cussac, Roc de Sers, Lascaux where one of the eyes is duplicated on an engraved horse in the Passage, Le Portel, Font-de-Gaume, Les Combarelles, Rouffignac, Ekain), or on objects such as the bone cutout of Arudy, the sculpted horse-head of Isturitz or the engraved stone of Limeuil.

Elsewhere it is a ring around a circle, as on the spearthrower of Bruniquel, on the horse of Labastide or at Les Combarelles. This periorbital ring corresponds to the muscles (including the orbital muscle of the eyelids) which make it possible to close the palpebral fissure.

In other cases, the appearance is even closer to anatomical reality. Sometimes it is a simple line of pigment, a line under an arc (Niaux) or a space with a pupil in a flat tint (Chauvet), two arching lines with their concavities facing each other (Cosquer) or even a triangle with blunted corners (perforated baton of La Madeleine, Les Combarelles). More often, it is an oval (on the engraved pebble of Labattut) or an almond-shape, more or less oblique and forward-pointing, as at Gargas, Lascaux (including the horse engraved full-face, or the over-engraved horses in the painting of the Nave) or Gabillou, at Font-de-Gaume, Les Combarelles, on the pebble of Villepin, and on bone cutouts (Isturitz, Le Portel, Arudy). In a few cases, this almond has a pupil (Limeuil), a double outline (Angles-sur-l'Anglin) or is perpendicular to the axis of the head (Lascaux): it is normally horizontal or elongated along the axis of the head. Certainly, in the living horse, the palpebral fissure is not round. It is a transverse buttonhole between the internal (nasal corner) and external (temporal corner) commissures of the eye. The pupil also appears as an oval with a big horizontal axis, slightly inclined downwards and forwards (Bourdelle and Bressou 1937:375, fig. 189).

But sometimes the eyes are far more detailed, in accordance with the schema which shows both the eyeball and, in the nasal corner, the cartilaginous fold of the third eyelid (corps clignotant) which hides Harder's gland and lubricates the eyeball like a third eyelid (Bourdelle *et al.* 1937, 1938). One then sees a circle behind, corresponding to the eyeball, and a triangle in front, corresponding to the third eyelid and the lachrymal caruncle and the nasal corner. This is the case for two horses sculpted at Angles-sur-l'Anglin (on one of them one can even see the pupil and the eyelids) and their equivalents on bone cutouts from Arudy and Isturitz.

On objects from Le Mas d'Azil and Isturitz, the brow arch and even the eyebrow are sometimes drawn meticulously. Le Mas d'Azil has yielded horse sculptures with oval eyes drawn with a double outline (depicting the orbital muscle of the eyelids), and two or three defleshed horse skulls with sockets lacking eyeballs.

At Cosquer, in four black horses, the eye appears as a round or almond-shaped space, as does the nostril (as in certain aurochs of Lascaux).[2] At Chauvet, it is sometimes a black spot, a circle, almond or comma with a big posterior extremity (with perhaps the indication of a pupil in a stronger black) in a space within a flat black tint. At Font-de-Gaume, two parentheses forming a V open to the front surround a comma with a posterior point: so this has a quite realistic appearance, at least in H. Breuil's recording. At Comarque, the big sculpted horse seems to show a brow arch, eyelids and eyeball.

At Lascaux, finally, André Glory in 1959 had discovered a big drawing of an isolated eye, perhaps of a horse, engraved as an almond with a pupil and sheltering beneath half a dozen lashes implanted in the upper eyelid (Glory Archives).

The eyes of *aurochs* are depicted by a circle or oval, with or without a pupil (Chauvet, Gargas,

Gabillou, Lascaux, La Loja), often surmounted by the arching curve of the super-orbital ridge (Chauvet, Lascaux).[3] Sometimes it is a white triangular or oval space in a flat black tint, with a short black horizontal line at the center (Lascaux).[4] The eye of the black bull of the Axial Gallery is a big cupule whose edge was not painted, according to Glory; its pupil is a very realistic horizontal bar, although slightly too long. The bulls of Lascaux, as Glory noted, have their eye encircled by seven black dots.

The eye of two aurochs at Teyjat deserves a mention: on these very realistic animals, from the end of the Magdalenian, the eye is depicted with an unexpected deer tearduct, made with two fine oblique lines joined together.

The eyes of *bison* are very remarkable. Sometimes they are simple circles with or without pupils (Gabillou, Lascaux, Altamira), under the brow arch (Niaux). Elsewhere they are an oval surrounded by hairs (pendant from Raymonden, Les Trois-Frères), a triangle with blunted corners (Rouffignac), a spot of pigment (dotted bison of Marsoulas) or a space in a flat tint of pigment (Chauvet, where one eye has a pupil; Lascaux). At Altamira, it is an asymmetrical oval, a comma with a big posterior extremity, circled in black, in a white space on a red background and with a black pupil.

Often they appear as a broad circle or a circular ring (two concentric circles, as at Les Trois-Frères, including on a composite being which seems to hold a bow) or an oval (two concentric ovals, as at La Mouthe, Font-de-Gaume, at Niaux or at Aguas de Novales). The peri-ocular zone even sometimes appears more or less in relief, or even surrounded by hairs (Niaux, Angles-sur-l'Anglin, the clay bison of Le Tuc d'Audoubert, perforated baton of Isturitz). This ring corresponds to the motor muscles of the eyeball (especially the orbital of the eyelids or palpebral

sphincter) and to adipose pads which allow the eye to move and pivot almost completely on itself (Montané *et al.* 1917). In the center, the actual eye is usually depicted in a very anatomical way with an acute anterior corner and a rounded posterior corner or, less often, the reverse. This aspect is particularly clear at Angles-sur-l'Anglin, at Niaux, on the spearthrower of La Madeleine or the perforated baton of Isturitz.

Between the two free edges of eyelids, sometimes, the pupil is not often drawn as at Angles-sur-l'Anglin - rounded or even triangular. But a very visible lachrymal tubercle, as well as the half-moon-shaped fold, clearly separate the ciliary portion from the lachrymal portion of the eyelids. As with equids, schematically the eye is made with a broad circle (the oculo-conjunctival cul-de-sac), with a second circle at its center (the eyeball). This double circle is joined, inside, to a little triangle with an external base (the half-moon-shaped fold, made of hyaline cartilage, or third eyelid, hiding Harder's gland and lubricating the cornea like a third eyelid, as in all large herbivores) and an external peak (with the lachrymal caruncle and the lachrymal ducts) (Montané and Bourdelle 1917:137 138).

On the famous bison from La Madeleine with its head turned back, the eye is a comma with a double outline and a big posterior extremity. The same applies to the bison of Les Trois-Frères, with its head turned back, where it has a pupil. Sometimes, moreover, the indication of the super-orbital arch, as an arc with a lower concavity, replaces the circle of the lachrymal sac (Salon Noir of Niaux): a drop-shaped image is surrounded by two arcs, above and below. Sometimes, only the brow arch appears, and the eye does not seem to have been drawn (Niaux).

Through a graphic trick, on their bison drawings certain magdalenian artists juxtaposed the base of the horn, the ear and the eye.

This ensemble gives them a kind of trifoliate appearance, as at Teyjat, Les Trois-Frères, Le Mas d'Azil, Font-de-Gaume, Altamira, Marsoulas, Bédeilhac, Le Portel, Angles-sur-l'Anglin, Hornos de la Peña, El Castillo, and on various objects including the pendant of Raymonden. The abbé Breuil had observed and drawn this. A bison at Teyjat had its head drawn with a double line, and thus displays this trifoliate layout twice.

Anatomy shows why bison - perhaps more than other animals - were the subject of such detailed research in the graphic domain. It should be noted that the bovid eyeball is smaller than that of horses by about 50%. Moreover, the socket is bigger. Hence the biggest bovid eye is smaller than the smallest horse eye, and the socket is two and a half times as big as the horse eyeball, while in bovids it is six times as big as the eyeball. In bovids the palpebral fissure is wide open, showing the sclera around the iris and giving the eye the appearance of a big round, ringed globe.

One can compare the bison with the rare figures of *musk ox*. The right eye of the sculpted musk ox of Laugerie-Haute is very globular, evoking the ocular protrusion of an exophthalmus. The same applies to a sculpted ibex from Roc de Sers, the rabbit of Gabillou and the human in the shaft at Rouffignac.

The eyes of *stags* and *hinds* are drawn with a single or double outline, round (La Pasiega, Altamira, Covalanas, perforated baton of Laugerie-Basse, hinds engraved on bone from Chaffaud) or oval, more or less comma-shaped (Altamira, El Castillo, Pergouset, Covalanas, block from La Madeleine[5]), or even a triangle with a big longitudinal axis (Pergouset). The big stag of Lascaux has an oval eye on a space in a flat black tint, and with a broad pupil at its center. Another only has the super-orbital arch. At Niaux, an oval cavity suggested a stag's head, and the antlers were added.

But the cervid eye is especially characterized by a tear-duct, an oblique slit located below and in front of the eye's inner corner: this conduit produces an unctuous, black secretion. The magdalenian artist noticed this particularity and faithfully reproduced it (cervids at Lascaux, Le Chaffaud). At Lascaux, the tear-duct also appears as a simple oblique line, below and in front of the eye, and independent of it (the eye itself consisting of a dot, a circle or a simple arch), on the stag frieze of the Nave or on the big engraved stag of the Apse.

It is doubtless a head of a young stag with a big, oval, double-outlined eye which the artist wanted to depict on a baguette from Laugerie-Basse. On a baguette demi-ronde from Isturitz, one finds a doe head that is analogous but far more stylized, displaying a circular eye with a pupil, lost in the decorative spirals. On the basis of this analogy, André Leroi-Gourhan thought he had found some even more schematic equivalents on other baguettes demi-rondes (Saint-Marcel, La Madeleine, Le Placard): a circle or an oval extended backwards by a more or less curving line (Leroi-Gourhan 1995).

In vivo, this tear-duct is less visible in the *reindeer*. It is scarcely visible, to our knowledge, on the reindeer depicted on cave walls (which are actually pretty rare). The eye is round (Arcy-sur-Cure, Font-de-Gaume, Les Combarelles, Altxerri, Tito Bustillo), oval or shuttle-shaped with a single or double outline at Les Trois-Frères or at Teyjat (but in the latter, the fawn's eye is round, as at La Bigourdane). The same applies to objects (Les Trois-Frères, Las Monedas, Le Saut-du-Perron). The tear-duct can be made out on an engraved reindeer from Pergouset, but it is marked on the reindeer engraved in clay at Isturitz or on the perforated baton from Lortet. The mobiliary reindeer head from Laugerie-Basse has a tear-duct, reduced to a little line detached from the anterior

corner of the eye, which is itself a comma with a big posterior extremity. Not only was an unexpected tear-duct drawn on the human profile from Angles-sur-l'Anglin, but it also figures on the pair of aurochs at Teyjat and even on a bone cutout horse from Arudy.

Finally, the few *megaloceros* sometimes have an eye consisting of a little dot or circle (Roucadour, Pech-Merle, Cougnac, La Grèze).

The eye of the *ibex* has no particular characteristics. In the living animal, it is oval with a lachrymal fossa in the nasal corner. In parietal works, it has the appearance of a little, more or less circular line (Rouffignac, Comarque, Niaux, Gazel), an oval with two somewhat pointed ends (Les Combarelles, Angles-sur-l'Anglin, Pergouset, El Castillo), or even a comma with an anterior point (Les Combarelles, Les Trois Frères, Angles sur-l'Anglin). Sometimes the oval is reduced to two parentheses with opposite concavities, and the dot of a pupil in the center (Les Combarelles). At Gargas, it is an oval with a double outline, as also at Roc de Sers. At Niaux, it is a broad, black orbital ring, and an eyeball at its center with an oval pupil with a horizontal axis. At Angles-sur-l'Anglin and on the bone cutouts from Labastide, it follows the circle triangle schema.

The wonderful spearthrower from Le Mas d'Azil is decorated with an ibex turning its head: its hollowed sockets once contained a small inlaid stone which formed the eyeball. The same is true of an incomplete but identical piece from Bédeilhac. Other objects from the Pyrenees were made in the same way: a little head of a young ibex from Les Trois-Frères still has an eyeball made from a fragment of burnt bone; another head, on a spearthrower from Gourdan, still has the hollowed sockets for an inlay of this type; and the same applies to the fish from Le Mas d'Azil.

The eyes of the few depictions of *chamois* or *isards* have the same appearance as those of ibex:

the eye is round or oval but with no lachrymal fossa (Ker de Massat, Las Chimeneas, El Castillo, Peña de Candamo, Fornols-Haut and a bone piece from La Vache). The same applies to the very rare *saïga antelopes*, but the engraved one from Les Combarelles II has an eye made of an almost complete circle (the orbital muscle of the eyelids is highly visible on the living animal) with a dot at its center, while the saïgas on the smoother from La Vache display an oval eye under a short arch.

The eyes of *mammoths* (like those of our elephants) were small and round, and appear to be a triangle with an upper apex because of the periorbital folds. They are usually drawn this way, often with a double outline (in particular at Rouffignac which has more than a hundred), more or less circled by a thick fleece.[6] This is also the case at Font-de-Gaume. Sometimes this triangle is even surmounted by the arc of an eyebrow or a superorbital arch (Rouffignac). In rarer cases, the eye appears broad, round or oval, made with two concentric lines as a ring (Bernifal, Grotte du Cheval of Arcy-sur-Cure),[7] or with a curved line like a parenthesis with an anterior convexity to depict the eyeball. Sometimes it is reduced to a short horizontal line (Grotte du Mammouth at Domme). Elsewhere it is often absent, but the orbital bulge usually shows its location. The mammoth on the spearthrower from Bruniquel had a light-colored inlaid eye.

In the enormous mass of the *rhinoceros* (woolly in the Paleolithic), the small, round eye was somewhat lost, surrounded by concentric curved lines. This is how it looks to us today, and it must also have appeared the same to the artist of Lascaux (a simple oval made with two unjoined curves). At Chauvet, at Rouffignac, at Les Combarelles and on the engraved pebble from La Colombière, it was schematized by means of a dot, a little arch surmounted by an arc, or just

a short line (Font-de-Gaume). On one of the rhinos at Chauvet, the posterior edge of the eyeball is depicted by a vertical curved line.

The eye of *felines* is a circle or an oval (Lascaux, Gabillou, Labastide, Font-de-Gaume, Angles-sur-l'Anglin), sometimes surrounded by a curve or a circle, as white-on-black or in black. It can have a pupil (Chauvet), sometimes with a double outline, very realistic in its hollow socket (Les Combarelles[8]). The painted feline of Les Trois-Frères has round eyes with a double outline, like spectacles, and so do its engraved counterparts in the cave. That of the spearthrower from La Madeleine is a circular relief inside a cupule.[9]

André Glory noted that, in one of the felines of Lascaux, the round eye had been replaced by another in different style, elliptical, which, he thought, indicated a different artist.

The eye of *bears* is made with two slightly curved lines with opposing concavities (Roucadour, Les Combarelles), with a circle (Les Trois-Frères, perforated baton from La Madeleine or pebble from La Colombière) or an almond-shape (Pech-Merle where it has a longitudinal slit, Rouffignac, Teyjat)[10] with a protrusion of the frontal sinuses that is weak in *Ursus arctos* and pronounced in *Ursus spelaeus* as at Chauvet.[11]

The eyes of *fishes* are usually simple circles (salmon in the Abri du Poisson, pike or sturgeon at Pech-Merle, fish in Pindal, salmon on the spatula from the Grotte Rey in Les Eyzies), ovals (trout on the floor at Niaux) or are depicted with two parentheses with opposing concavities. Sometimes there are two concentric circles which draw the socket and eye, or the eye and its iris. They sometimes make it possible to determine the species. The external corner of the commissure of the mouth reaches the level of the eye's posterior edge or goes beyond it at

the back, depending on whether it is a salmon (as in the Abri du Poisson) or a trout (as on the floor of Niaux). The heads of the fishes from Le Mas d'Azil, carved in bone or ivory, have hollow sockets that were carefully embellished with a round inlay of colored stone, like the ibex on the spearthrower from the same site.

The eye of *birds* is a dot or a circle of varying width (Lascaux, Les Escabasses, Labastide, Les Trois-Frères, Le Portel and plaquette from Le Puy de Lacan) or sometimes an oval (Gargas, Roc de Sers where it has a longitudinal slit, vulture from Fornols-Haut). The empty sockets on a spearthrower from Les Trois-Frères must have contained a colored inlay, like the fawn from Le Mas d'Azil.

The eye of the *rabbit* in Gabillou is a simple oval with two somewhat pointed ends, too big for the head of this animal; that of its counterpart at Altxerri is a simple circle.

4. *A few particular aspects of animal eyes*

A few remarks can be made here. Except for the statuettes in mobiliary art, animals - whether complete or sometimes abbreviated - are depicted in profile and each has only one eye.[12] *Parietal figures seen full-face are rare.* Their eyes are depicted by a circle or a dot (bison seen in three-quarter view at Cosquer, a "cat" at Gabillou, painted feline and family of owls in Les Trois-Frères, painted owl of Le Portel, flatfish of Le Mas d'Azil) or by an oval (bear seen in three-quarter view at Cosquer, horse at Lascaux). The animals in profile look both to the left (as a right-handed artist would draw them) and the right (as a left-handed artist could draw them). It is very difficult to draw any useful conclusions from this orientation.

Often (perhaps in one case in two), the eye of the engraved, drawn, painted or sculpted animal is missing, whether the figure is complete or abbreviated. It is often lacking in certain early

works such as Pair non-Pair[13] or La Grèze, as well as in the classic caves of the Ardèche and the Gardon. This detail is lacking on the black frieze of Pech Merle and most of the drawings in Cougnac, as well as a number of the figures in Cosquer, Chauvet and Lascaux.

In a few cases, the eye was not depicted, but the artist used *a natural feature of the rock wall.* Hence, a flint nodule forms the eye of the bear at Bara-Bahau and the saïga antelope of Rouffignac. At Le Portel, the little red horse, which seems to be climbing a hill, has a natural cupule for its eye, which thus appears white. The chamois head in clay at Le Ker de Massat seems to have an eye made by a flaked area which reveals the white rock beneath. A cupule, hollowed by a drop of water in the clay, forms that of the bison engraved in the glacial silt of the floor of Niaux (the artist completed it with the two arching lines of the eyelids, above and below, joined at an acute internal angle), whereas three other drops became wounds. In the same way, some little crevices became the eyes of the three figures in the cave of La Croix (two animals and an anthropomorph).

Paleolithic art is not a narrative art, and we do not know what the depicted animals and humans are *looking* at. At best, one can imagine that, in a few cases, they are observing their opposite number, as, for example, in the mammoths facing each other (Rouffignac), or reindeer (Les Combarelles, Font-de-Gaume) or in the confrontation of a man and a bison (Roc de Sers, Lascaux and Villars).

On the other hand, the *animals with head turned* like an Agnus Dei are looking at their hindquarters or their flank: hence, the horse of Pair-non-Pair, a big stag at Peña de Candamo, a more or less humanized bison at Les Trois-Frères, a polychrome bison at Altamira and the horse of Angles-sur-l'Anglin, where parietal art is concerned, and, for

spearthrowers, the ibex of Bédeilhac and Le Mas d'Azil, and the bison of La Madeleine.

Finally, at least two eyes have undergone *defacement* by man: that of the feline of Les Combarelles, kitted out with a pebble to mask an accident, and that of a horse at Cosquer which was replaced by a little breakage of the rock.

The physiological aspects
Eye, lamp, and colors

Certainly the engraver, who incised so finely the lines of the horse on a pebble from the Abri Labattut, was neither myopic nor hypermetropic nor long-sighted: the lines measure between 1/20th and 1/100th of a millimeter in width. The young man who crawled into the narrow passage of Fronsac and who engraved, a few centimeters from his eyes, a schematic female figure and a phallus still had a flexible crystalline lens which modified its curvature range and accommodated perfectly. Probably too, the hunter-artist who got through the tight crawl in the Grotte du Cheval at Arcy-sur-Cure or who descended the five or six meters of the Shaft in Lascaux and clambered across the top of the Pit in the same cave had not yet reached the age of long-sightedness.

Below ground, in the cave sanctuaries, lighting was also necessary: sometimes torches, perhaps fires for illumination, and in any case stone lamps, carved or not, some of which have come down to us (about a hundred were found in Lascaux).

In the experiments which we carried out on the basis of the lamps found in Lascaux, each wick of these fat-lamps would more or less provide the same light as one of our candles.[14] The power of such lamps is about ten watts, with surfaces receiving lighting of a few lux. Such a light is sufficient below ground, and the decorated caves which are today visited by tourists are not lit much more than this, for reasons of conservation.

In relation to daylight, an artificial light from the flame of a lamp, a torch or a fireplace lowers the temperature of color and provides a light rich in red. Hence one passes from 5,500 degrees Kelvin (K) in the midday sun, to values of the order of 1,800 K. This temperature of colors is a function of the temperature of the flame, expressed in degrees Celsius, and corresponds to the following formula: Tk = Tc + 273. The usual electric lights give off lights whose Tk is of the same order (2,000 K); halogen lamps allow one to exceed 3,000 K. The brain can compensate for this characteristic, as can filters. But color photographs taken in this light, without flash or floodlight, clearly show the predominance of the yellow, but especially orange and red radiations of this illumination, which our eyes, although endowed with a remarkable adaptive power, find it more difficult to detect. Flashes provide daylight.

Quite curiously, the palette of the prehistoric painters is limited to the same colors. Calcite or other minerals (kaolin, talc) could provide white (rarely used, as on a hand in Gargas), manganese dioxide (or sometimes charcoal) gave black; natural ochres gave yellows and browns (goethite) and oranges and reds (haematite) (the latter were sometimes obtained by calcination). No purple, blue or green. Not because our ancestors had a limited spectrum of visibility, but rather because natural pigments of purple, blue or green are extremely rare or - where chlorophyll and other plant pigments are concerned - fragile. We know nothing of their use in the Paleolithic.

The importance of fat lamps in parietal art appears to us to be very great. The appearance of the lamp - or at least its frequent use - at the beginning of the Upper Paleolithic marks the start of the great sanctuaries into which daylight does not penetrate. Several lamps, carved and sometimes engraved, have been reported in the Magdalenian. For the moment, none is known in earlier periods. Some torch wipes have been observed in several caves; some have been dated to the Gravettian at Chauvet.

The art of the sanctuaries, hidden below ground, would be different from that of the shelters, habitations under rock overhangs, in full daylight, seen and known by all. Doubtless its raison d'être was also different: the rarity of geometric signs in the decorated shelters leads to the same conclusion. One can compare it with the decoration of some caves which are semi-deep but lit by shafts of natural light (Pair-non-Pair and Jovelle).

The hunter's eye and the artist's genius
1. Themes

Prehistoric art comprises four essential subjects: animals, humans (much rarer), the enigmatic geometric drawings known as signs and what is absent. The animals are mostly large herbivores, since carnivores, except at sites such as Chauvet, only play a secondary role. Humans are far rarer, whether complete or not. With a few exceptions, one does not see them doing anything between themselves: the syntax which must have united these figures rested on the commentary, and is lost forever.

The animal and human figures are often depicted in profile, in a static posture. Sometimes their silhouette is animated in a coordinated way (the limbs are mobilized, as often in Les Trois Frères). An animal may trot, gallop or amble. A little horse in Lascaux's Axial Gallery seems to be walking when one passes at its level with a lamp... Often, the animation is limited to a segment or two of the silhouette: the tail whips the air, the head is lowered (as in the bison of the Lascaux shaft or the reindeer on the baton of Thayngen), turns (sometimes as an *Agnus Dei*, as

at Pair-non-Pair, in the Côa, at Peña de Candamo, at Altamira, in Les Trois-Frères, at Angles-sur-l'Anglin and Levanzo, or on objects from Lortet, Mas d'Azil, Bédeilhac, La Madeleine, Murat). Another, rare, method of animation is represented by the repetition of the same segment of the drawing: hence, the legs of an ibex from Le Colombier, the limbs of certain engraved horses at Lascaux and that on a plaquette from Limeuil, the head of a bison at Teyjat or that of a horse at Lascaux. Doubtless one can also include here the visual effect of global animation produced by the accumulation of subjects: hence the juxtaposed rhinos of Chauvet, the rolling bison of Altamira or the immense bulls in the Hall of the Bulls at Lascaux.

Some of the signs are probably schemas derived from masculine or feminine sexual images, described by the term thin signs and full signs by our teacher André Leroi-Gourhan (Leroi-Gourhan 1970-1982 and 1995). This holds good in so far as there exist all forms of transition between the realistic organ and its schematization. Certain imaginative authors have supposed that these are depictions of phosphenes or other entoptic phenomena, but nothing that is scientifically quantifiable and reproducible has confirmed this hypothesis. And similarly one does not have any evidence at all that buzzing in the ears (or acouphenes) played a role in the invention of music.

In fact, from the very birth of art, in the Aurignacian, man was able to see and depict rhythmic series (cupules, rods), next to which he represented vulvas or phalluses, selected pieces of the human silhouette, which, in the following periods, would be transformed into geometric signs of different degrees of explicitness.

The fourth subject, the absent, is abundant: one does not see any topographic details concerning the sky, the earth and its reliefs, and no (or hardly any) small fauna, objects, or human facial features. The ground is not depicted: it is virtual, imaginary, and sometimes the animals even seem to float at random in space. There is no relationship between the animal subjects, except in some rare ethological scenes; and no relations between humans and animals with the exception of half a dozen confrontations of a man versus a bovid or a bear.

2. Different styles for the eye

In the eye of the observer, style is defined as the characteristic of execution and composition, according to Emile Littré.

The first drawings, at least in the Périgord, some 30 to 35,000 years ago, are evidence for a prodigious invention: man henceforth knows how to engrave or paint in two dimensions, on the flat rock surface, what he sees in nature in three dimensions In the same period, in Germany, another artistic center appears, but the works produced there are little sculptures, reproductions in three dimensions of bison, mammoth, feline. Reduced-size models which probably demanded a less difficult process. In the same period too, in the Ardèche, there is the stroke of genius of the Grotte Chauvet.

During the Gravettian (25 to 20,000 years ago) the animal outlines display a great mastery and a constant stylistic invention, with the persistence of a few archaisms (twisted perspective of face or horns). There are numerous sanctuaries. This art is that of the great caves of the Lot (Cougnac, Pech-Merle, Roucadour) and the Ardèche, Cussac, the Grande Grotte at Arcy-sur-Cure and Gargas.

Soon afterwards, announced by the sculpted works of the Solutreans (Roc de Sers, Fourneau du Diable), is the time of the great art of Lascaux, 17,000 years ago. In the wake of its predecessors, Lascaux is the work of hunters who were accustomed to observing animals, and knew very well

their anatomical and ethological details. But it is also the work of artists who systematically deformed the optical reality that they observed, and bent it to new rules, to graphic conventions that they created. The animals of Lascaux have small heads, big bodies, short animated limbs, marks on their coats, horns seen in three-quarter view on a profile body for the bovids (the so-called twisted perspective), and hoofs seen from the front. The silhouettes seen by the hunters became the elements of an original art, far from the contingencies of copying a model, an "anti-destiny" art, to use the phrase of André Malraux.

After the period of Lascaux, in the Middle and Upper Magdalenian, the art would become much more classical and close to normal vision, to the reality seen by the hunters. Sometimes these animals are even of an almost photographic realism, at Niaux for example, or, a bit later still, at Teyjat. And it is at the end of this period, some 10,000 years ago, that art would boil down to a few geometric and succinct lines. The great animal art would be reborn elsewhere, on the rocks of all continents, in the open air.

In parietal, art and especially in the Magdalenian, a whole ensemble of graphic tricks would make it possible to render perspective, different planes, and the movement of all or part of the body. The role of perspective is to trick one's vision. A two-dimensional subject is drawn on a plane and, to our eyes, it appears to be in three dimensions. One shows the observer two animals placed one against the other, and they see them in relief on two different planes, the one partially hiding the other. Another similar process is that of resorting to anamorphosis which made it possible to restore a normal outline despite the uneven nature of the support (Lascaux).

G.-H. Luquet had wondered about the notion of realism of the image depicted in "primitive" art, especially that of the Paleolithic. He defined visual realism (the artist reproduces what his eye sees of it), which is preponderant, and intellectual realism (the author reproduces what his mind knows), which is less frequent in prehistoric art. He contrasted "the optical eye which functions as a photographic lens with a mental eye which establishes a kind of hierarchy among the elements provided by the optical eye. In the drawing, only the elements judged essential by the artist are retained and reproduced. The drawing contains elements of the model which cannot be seen, but which the artist judges to be indispensable; conversely, he neglects elements of the model which are obvious to the eye, but which for the artist are totally lacking in interest." As examples of intellectual realism, he used the pendant from Raymonden (with its people in perspective, its bison skull and its animal legs, and the depiction in non-visual perspective of animal antlers, horns, ears and legs (Luquet 1926, 1930).

3. Optical perspective at Lascaux

The example of Lascaux enables us to illustrate the many tricks of perspective used by these artists of the early Magdalenian.

The head and body of the animals are seen in profile, but the other elements of the silhouette are drawn as if they were being seen in three-quarter view (from the front or the rear), making them very conspicuous and avoiding overlaps. The abbé H. Breuil called this 45-degree turning "semi-twisted perspective" (oblique bi-angular for A. Leroi-Gourhan), reserving the term of "twisted perspective" (or right bi-angular) for cases where it reached 90 degrees (when, for example, the two horns of a bison are seen from the front, in a U-shape, whereas the head and body of the animal remain in profile).[15]

At Lascaux, in the horns of the bulls and cows, generally the one closest to the observer has an S shape, while the farther one has a C shape;

much more rarely the horns have a slightly more normal shape of two S's with parallel curves. The horns of the bison (and sometimes those of the engraved aurochs) are mostly seen from the front, like two parentheses with confronted concavities, or are limited to a single C, a bit like their counterparts in the cave of Pech-Merle (Lot).

Stag antlers are depicted in a very similar way: one antler is vertical (with tines pointing forwards), the other, behind it, is oblique (with tines pointing forwards and upwards). They are rarely seen from the front, in a V shape, with tines pointing symmetrically inward. Ibex horns are drawn one beneath the other, more or less parallel; they are never seen from the front in a V shape, except for one case. It is one of the very rare depictions of this type in the whole of paleolithic parietal art, along with the ibex of Ebbou. This view is more frequent in mobiliary art.

Seen from the front, the lanceolate ears of horses and does, the round ears of bears and those, a little more pointed, of felines appear as two identical appendices juxtaposed at the top of the skull. The far side rectangular or triangular ear of the aurochs, and the pointed ear of cervids and ibex are curiously located in the back of the neck, stuck in like a dagger, behind the horns or antlers; the other ear (the one closer to the observer) is sometimes very curiously pinned to the lateral surface of the neck, pointing towards the ground. Bison ears, when they are visible, seem to be in their natural position, a little behind and below the base of the horn.

Ungulate hoofs are mostly drawn from the front. Those of horses, as if they were being seen by a standing observer, are circles or ovals, each surmounted, on the posterior edge of the limb, by the bulge of the ergot, often with striations to depict the hairs of the fetlock. Round and oval hoofs are sometimes found on the same animal. Curiously, the hoofs of certain horses are oval,

while those of others, which follow them, are round. The hoofs of bovids and cervids, which also have an ergot, are ovals with a more or less pointed extremity, massive in bovids and more elongated in cervids (and in one of the cows), often split into two parts by the more or less broad line separating the two nails, as if they were hoofs seen in plantar position. Sometimes, the extremity even forms a veritable pincer, or even a fork, or is neglected.

Ibex limbs, when they exist, are not detailed. The felines have their claws out, like a short-toothed comb. The non-retractable and sickle-shaped claws of bears are also very visible. As for man, he depicts his upper limbs away from the body, to show them more clearly, and stretches out his fingers (four on each hand); his lower limbs are seen in three-quarter view from the front and slightly from above, thus putting one limb in front of the other, and one foot above the other. The erect appearance of the phallus is perhaps merely an explicit means of presenting the organ and clearly specifying the sex of the subject, without any other connotation.

The eye is in normal position. It is often lacking in animals depicted with flat wash. The nostril is stereotyped: a dot, a short line or a loop in the center of a C depicting the muzzle (or the end of a horse's nose), itself overhanging the short line of the lower lip.

4. Visions without words

With some exceptions (the shaft at Lascaux, the back of Villars or the block from Roc de Sers), the animals and man never form narrative scenes. The same is often true for animal interactions, despite rare scenes showing the natural behavior of species observed in nature by the hunters, especially in certain seasons: confronted ibex, herds of male ibex or stags, the bison of Lascaux with overlapping rumps, groups of felines at Lascaux and

Chauvet. But these groupings do not tell a story: they carry a mythology which escapes us.

The animals depicted are immobilized in a posture of natural repose, their limbs often vertical and extended. In many cases, the animals are in a standing posture. Hence, at Lascaux: the forelimbs are rigid, pointing obliquely forwards, the hindlimbs less perceptibly pointing backwards. Elsewhere, they were observed and captured in action by the artist. This animation puts the whole outline into movement. Their pace is sometimes indicated: a horse trots, ambles or gallops, smells the ground or grazes, another prepares to jump; a feline may leap, a bison charge and stags collapse. An ibex lowers its head and prepares to fight. This animation is sometimes very partial, involving only a very limited part of the animal, just a leg, a tail or the head. The movement is sometimes broken down into several successive images. Some horses have multiple heads, extra manes or multiple limbs. These repeated lines do not appear to be the different versions of a sketch, and this graphic depiction of movement is peculiarly modern.

In general, the animals seem very much alive. Sometimes, breath even emanates from their muzzle, rendered by a dot of a short line. A feline at Lascaux, with a spear in it, seems to be snarling, or spitting blood through its mouth; at the same time, it urinates as if to mark its territory.

A few animals are wounded. Their wounds take the form of an oblique line or a V-shape, joining the long straight line of the spear or javelin. other animals seem to be touched by several simple lines, without any obvious wound. But, normally, the animal (except for the bison in the shaft) does not seem to be explicitly affected by its wound.

Even within each panel, the animals are not always placed in disorder, at the whim of the artist's inspiration. Some arrangements are sometimes obvious, like here - because at Lascaux, one frequent theme is the association of a big bovid with a line of little horses, in a herd, mostly walking in the other direction; other groups display the natural behavior of the species observed in nature (confronted ibex, herds of male ibex or stags, bison with overlapping rumps, group of felines). In fact, apart from the confrontations and the herds, we cannot yet understand the links that unite all the elements of this bestiary: the animals are juxtaposed without any link between them.

Proportions are not always respected: there is no scale. The artist sometimes uses natural reliefs, as in the megaloceros of Cougnac, the bear of Tibiran, the head of the big sculpted horse of Comarque, for example. Sometimes, too, he is winking at us: a stalactite forms the vertical phallus of a human in Le Portel. All this testifies to the highly developed nature of this parietal art, in which the rock support is brought into play to trick the eye of the spectator.

But there are other processes used to render an impression of relief - for example, at Lascaux, the shading of the tints, the markings of hides, and the partial black infill of the legs, bellies, chests and muzzles. One very elegant process consists of interrupting the outline and the infill to mark the point of attachment of the forelimb or hindlimb that is at the far side from the observer. A white line thus appears as this "space".

In some cases an animal is drawn complete, in others one only sees one of its limbs or an abbreviated part of its body (pars pro toto, or synecdoche); elsewhere there is a symmetry between two animals or groups of animals, a careful arrangement to make them face each other. Sometimes too, everything is in disorder and it is difficult to distinguish a finely engraved outline in the midst of ten others, as in the Passage or the Apse of Lascaux. The artist must

have experienced the same optical difficulty in the face of this palimpsest, and one can sometimes wonder if the gesture of engraving was not more important than the subject depicted.

Through their size, the animals are often within the manual range and the field of vision of an average-sized man. But there are some large figures (one aurochs at Lascaux measures 5.5 m from muzzle to tail), some restricting rock supports, and galleries in which it is impossible to move back for a better view: the painter who painted the falling horse of Lascaux - like the big horse of Rouffignac on a very low ceiling - never saw the whole figure at once. Yet the outline is anatomically perfect. The same applies to the confronted mammoths of Laugerie-Haute or the *Ford crossing* of Lortet, engraved on a cylindrical reindeer antler: one has to turn the support in one's hands to understand the scene.

The indication of relief, that of successive planes, is sometimes provided by the superimposition of figures. Hence certain animals encroach on the silhouette of their neighbors; so they are in a plane that is closer to us. All these overlaps, in which one can manage to separate out the different planes, are difficult to interpret for a chronological study: is the interval between the execution of each of the figures an hour or a century? Elsewhere the superimposition of two figures does not provide any indication of depth of field, not to mention, of course, the jumble of engravings. Sometimes, on the contrary, as in certain panels at Lascaux, the superimposition of two animals was carefully avoided, in some cases at the cost of the interruption of one of the figures or a graphic anomaly.

5. At Lascaux, the hunter's eye and the artist's hand

The depicted fauna shows perfectly that the painters and engravers had often observed and had a detailed knowledge of the animals that they were representing. Lascaux is a good example of this anatomical realism being transformed by the style of the first Magdalenians: the hunter's eye and the artist's hand.

Well observed horses. Horses' coats are homogeneous (with the hair of the mane and tail of the same color) or composite (the hairs are black): the former are chestnuts (brown - more or less fair, more or less copper colored) or blacks (sometimes here with glints of red). The latter are either bays (the coat is brown or red, even cherry-colored) or light-bays. This coat is sometimes dappled. Three horses are of a kind never seen by zoologists: one is a half-bay with a brown coat and a mane of the same color, but a black tail; two others not only have their head dark head (cap de maure), but also the whole neck, as one can see in the two horses in the cave of Pech-Merle (Lot).

One sees absolutely no white marks on the head, or stockings or stripes on the limbs. The dorsal mule's stripe is not visible on animals in profile. Conversely, the shoulder-line (or cross-shaped or Jerusalem cross) is very often marked - single or multiple (up to five or six, which is exceptional today); it does not appear on engraved horses. The summer coat, with a light abdominal M-shaped mark ("doe's belly", as on the Przewalski horse and even on our modern equids), is especially seen on big horses; the winter coat is mostly found on the little horses. This dark "phase" is sometimes accompanied by more or less vertical striations on the ventral line, which mark the abundant winter hairs. Just one stallion has its sex depicted. The erect mane of these primitive horses is fuzzy in painted figures, and made with parallel hatchings in engraved figures; the same is true for the beard. The ears - folded back, as on the falling horse in the Axial Gallery, or pointing forwards - certainly depict a peculiarity of behavior (fear and vigilance).

The postures are often well studied and well captured. One horse is rearing up like in the prenuptial struggle between stallions; another is smelling the ground or grazing; another is rolling, doubtless, in the dust. A stallion is preparing to cover a mare.

Some herds, rumps to the wind, are supervised by a stallion heading the other way; it is known that each herd normally contains six to eight mares to a male. One horse seems to be ambling; others have their forelimbs animated, flexed, like in a jump or during a gallop; many seem to trot. Some may be foals: the black "ponies" (with glints of red) of the Axial Gallery. But a few aspects are quite unusual. A little engraved horse in Lascaux's Nave seems to be inside the silhouette of a bigger individual. This nested arrangement has made some people evoke an X-ray of a foal in the belly of its mother. But it is nothing of the kind: the distal ends of the forelimbs are depicted outside the big equid's abdominal line. Quite a lot of animals are represented in a conventional attitude of "flying gallop" (with all four limbs stretched out like a jumping feline), with an exaggerated secondary elongation of the trunk. These horses of Lascaux recall the ibex of Rouffignac or the bison-boar of Altamira. One engraved horse bends its leg, but at the level of the shank, which is anatomically impossible. A number of horses have a "rat's tail" or a caudal appendage like an enormous broom. The bellies (that is, the thoraco-abdominal areas) are distended, sometimes extremely so, with the belly on the floor, but this does not indicate a pregnancy, as was thought not long ago: one hemione's belly descends as far as the hoofs.

On the forehead, the tuft of hair is absent. The bulge of the withers is usually missing: the necks seem erect, but sometimes even with a cervico-dorsal break. The back-end of the horse is neglected, and we cannot count here the defects in perspective which give various horses aspects such as "oblique forelimbs extending too far back or forward" and "oblique hindlimbs extending too far back or forward" and exaggerated curvature of the back.

Impressive aurochs. The last living aurochs disappeared from our planet in 1627, but its anatomy is well known through old drawings and by the reconstitutions *in vivo* by Lutz and Heintz Heck in Germany. Those of Lascaux are typical in their clear sexual dimorphism: the male is recognizable through the massive skull, its white muzzle, its neck, chest, withers and the length of its light horns with black points. The external genital organs are represented by very drooping scrota, but the sheath is not drawn. The cows are red (sometimes with a lighter stripe on the back). They are much finer at the level of the head and the forequarters. The udders are not depicted: they quickly retract at the end of lactation. One of these cows seems to be followed by its calf, in the Hall of the Bulls. It is amusing to note that the ear is rectangular in the bulls, but triangular in the cows. Most of these bovines have an eminence at the top of the skull, a sometimes striated tuft of hairs between the horns. These figures are sometimes animated: two of them have a flexuous tail; one is rolling on the ground; a bull seems to be scratching the ground with its right foreleg, but the others are mostly planted on the ground, usually with an apparent elongation of the trunk.

A few beasts are unusual through their botched rear, their neglected extremities, their excessively long tail (according to certain authors, one tail even forms the "horns" of the "unicorn"), stump-like forequarters or horns turned downwards, but our present-day bovines sometimes display the same. One cow is two-colored, with a black head, and the bulls' coat appears not black (like that of "historic" or reconstructed aurochs) but white, with black patches.

Finally, certain signs, made of short twin lines, straight or like parentheses, nested like the elements of a telescope, are perhaps tracks of cloven-hoofed ungulates (bovines or cervids). The appearance of game tracks must have been very familiar to the artist-hunters of Lascaux.

Aggressive bison. The outline of bison is usually well observed, with the three characteristic humps (top of the skull, chignon and back), the erect mane and the dewlap, and the beard on the chin, the latter even sometimes being almost pharaonic. The tail broadens into a tuft at its end, the scrota are lacking (except for a few cases), but the sheath is often drawn, on those manifestly male bison in the Nave with their massive unnatural forequarters and their convex forehead.

All the bison of Lascaux have immense horns (in contrast with present-day bison), seen from the front, and appearing (because of the thick frontal fleece) to be connected quite low down. One beast with broad horns, which seem to be flat against the skull and then curving into fine hooks, has made people think rather of a caprid from the Far North: the ovibos or musk ox. All, or nearly all, are animated, and their gait seems to be intermediate between a fixed posture and a flying gallop. A few details are well observed: the coils of the long herbivore intestine of the eviscerated bison of the Shaft, the trot of the posterior limbs of another, the spring moult and the "rump to rump" of the overlapping bison in the Nave which, according to André Leroi-Gourhan, depict the classic intimidation of males in the rutting period.

Elegant cervids. They are red deer stags for the most part, with only three does and, very probably, a single reindeer[16], recognizable by its brow tine, the low carriage of its head, with bulging withers and antlers forming a crescent with a forward-facing concavity (but these two characteristics can be seen in old stags and in a few stags respectively).

Stags have a very elegant silhouette. The neck is fine, too fine, and the projection of the throat and the dewlap is rarely pronounced, as it must have been, especially in autumn or winter. The withers are missing. The white stomach is indicated by a double line, sometimes with curious long hairs. One painted stag seems to be bichrome. Others, engraved in the Apse, have long stripes of pigment along their backs, stomach and neck. None has its sex marked. The ear is generally planted in the nape of the neck. Sometimes the nearer ear is flat along the lateral surface of the neck. In the does and a single stag, they are seen from the front. The eye is oval or round, often with the depiction of the tear-duct.

Some stags are immobile, others are galloping or collapsing. A few seem to be groaning or belling during the rutting period, between mid-September and mid-October. The old males of the Nave form a unisex group that is quite classic during the winter (some people have seen them as crossing a river, but nothing proves this)

A few herds of ibex. The ibex are Alpine ibex (*Capra ibex*) and not the Pyrenean kind: their horns have a simple curve, not the S-shaped twist. Despite their long, heavy horns, the necks of these males are often slender. The growth nodules on the horns are never depicted, nor is the beard (except one or two). The tail, when it exists, is not recurrent. Abdomen and legs are often neglected or absent. The belly of one ibex, however, is isolated by a curved line which marks the limit between the dark coat of the stomach and that of the flank, which is lighter in the Alpine ibex. A few rare individuals have a short erect mane or two pointed ears surrounding the base of the horns.

As in nature, in summer and autumn, the old males, in an engraved and painted frieze in the Passage (blacks on the left and reds on the right) are grouped in a kind of unisex club. Two

of them are preparing to confront each other: one lowers its head, but they are not rearing and upright.

And other animals. The rhinoceros of the Shaft is certainly a woolly rhino (*R. tichorhinus*), with a thick fleece and long stiff hairs. It looks exactly like those found frozen in Siberia. It is by no means clear whether it is participating in the man-bison scene. The presence of this worrying animal is of no surprise in this gallery-end.

The same remark applies to the felines from the end of the Gallery to which they have given their name. One knows how gregarious these animals are, and here there are six of them (half of them wounded by spears). Their rounded ears and their square muzzle, their robust legs with sharp claws, their long tail (with the terminal tuft) are very typical. One of them seems to be jumping, legs outstretched, another is perhaps preparing to do so. Another one is wounded, and seems to be snarling or spitting or vomiting blood; in the whole of paleolithic parietal art, only two wounded bears from Les Trois-Frères (Ariège) can be compared with it on this point. Finally, this same feline, assuredly a male, is urinating backwards to mark its territory, as our domestic cats still do today. These felines, without manes or shaggy chest, or stripes, were doubtless very close to the present-day lion and lioness. Similarly, the heads of the two bears, with a straight and non-rounded forehead, are those of brown bears, like those of the French Pyrenees, and not those of cave bears.

6. Visual deficiencies

In the great sanctuaries, paleolithic parietal art is a very accomplished art. It is the work of professionals, early hunters who often saw the animals: they had a great knowledge of their anatomy and their ethology; they were working in the service of a great religious idea of the group.

That is why their graphisms show that choices were made: choices of themes, choices of the surfaces to decorate in the cave.[17] Lascaux and Chauvet are cathedrals of this period, and not the smoky lair of a magician, the disturbing den of the sorcerer or the domain of a shaman who had misused suspect drinks and hallucinogenic mushrooms. Despite this thoughtful professionalism, it is moving to encounter imperfections sometimes: an awkward line here, a deletion or a change of mind there, or again the clumsy trail smoothed by four fingers still impregnated with pigment.

But, alongside all these marvels, there is a place for deficiencies, failures or purposeful schematizations. Except in the Gravettian, doubtless for religious reasons. humans are most often simple, with faces that are either caricatured or absent. They stick out their limbs more to make the schema of their bodies explicit than to denote a particular gesture.

Monsters sometimes exist: the unicorn of Lascaux is perhaps a reindeer without antlers, or the figure of a feline drawn on the basis of a story, a kind of photofit picture. Other monsters sometimes cohabit with very banal animals on the cave walls, and complicate even further our reading of the Magdalenians' message.

No doubt some templates have been misunderstood. At the time of Lascaux, and during the periods before and after it, animals are often represented with a little head, a voluminous abdomen and short legs that are lopsided, the forelimbs forwards and the hindlimbs backwards. This deformation is an effect of style. And yet it was linked by François Rouzaud to the deformed barrel-shaped vision of the artist, like the distortion produced by a wide-angle photographic lens when the wide-open diaphragm is located too far forward of the optical center (Rouzaud *et al.* 1992). It is hard to understand

why paleolithic people, so similar to ourselves, should have suffered this geometric aberration.

Some details were mis-seen mistakenly. The *flying gallop*, which has horses stretching their limbs out symmetrically, is physiologically impossible. The four limbs depicted at full stretch (like a jumping feline) are the result of a visual error which could still be found in English engravings of the 19th century. It was only in 1887 that Eadweard Muybridge could show, through photos taken in a sequence, that the horse's four hoofs never all leave the ground at the same time. Similarly, certain carnivores are often depicted by the prehistoric artist with an error that we also commit: on the profile head, the lower canines are placed, when the mouth is closed, in front of the upper canines, and not behind them, as often drawn. But apart from these two examples, we do not know what to say about graphic anomalies that can also be found among our contemporaries: superfluous eyes on a profile head (as in Picasso); limbs with multiple lines (changes of mind or depictions of movement).

Present-day aspects

The observation of prehistoric parietal or mobiliary works is often difficult for the present-day researcher who wishes to analyse their various traits in all objectivity and to restore the ensemble though graphic recording.

Deciphering and translating the works

These works are often evanescent. Sometimes they are highly visible, but went unrecognized by innumerable visitors (Rouffignac). Elsewhere, the old recordings are tainted with errors. Recordings used to be done with tracing-paper (which was applied to the rock support). This technique reached its zenith in the work of André Glory at Lascaux and Roucadour (Delluc 2004). The practice of direct tracing was abandoned because of the inevitable deformations and the risk to which it subjected the walls. The same applies to the taking of casts, apart from exceptions such as at Angles-sur-l'Anglin.

Most often, the few prehistorians interested in the graphic or plastic works only recorded the best images, with no concern for exhaustivity, until the work carried out around 1970 at Sainte-Eulalie by M. Lorblanchet and at Villars by B. and G. Delluc. Dr Léon Pales brought the same care to the study of the innumerable lines on the plaquettes of La Marche, while Alexander Marshack introduced the use of the microscope to the study of mobiliary art with the ulterior motive of deducing the stages in the *chaîne opératoire*. Research into the slightest traces henceforth became the rule (Collective 1993) and some authors have also examined the more recent parietal works in other parts of the world (Vialou 1991; Lorblanchet 1995).

Photography (which restores the image on one plane, as seen by the eye of the observer, replaced tracing, and is preceded and followed by visual study, which is long and difficult. That is why various techniques are called in to see the drawings, paintings, engravings and sculptures of the prehistoric artists: oblique lighting (often coming from the upper left corner), use of appropriate photographic lenses (short focals, macrophotography), various emulsions (infrared), special light (U.V.). The taking of stereoscopic photographs for engravings, and the use of the microscope (x 30) for mobiliary art can also be useful. The parietal support can be subjected to photogrammetric recording to bring out its reliefs and their relationship to the graphisms.

Above all, the rapid vulgarization of digital photography henceforth enables everyone to use its advantages: quality of image, increased contrast, various filters, masks, equidensities. These data make it possible to restore the work in a

graphic recording. For more than thirty years we have been providing recordings that are not only synthetic, giving the tracing of the whole and of details of the work, but also analytical (Delluc 1984), in an attempt to translate the observed facts through cartographic conventions (as on a geographical map). The slowness of operations means that we have not often been followed. And yet one often encounters technological problems (reconstituting the artist's gesture) and problems of differential diagnosis (natural features in the rock).

Reproducing the works

Today, experimentation forms part of our observation of the works. It makes it possible to understand how they were executed. The innovative work of Michel Lorblanchet, based on his observations of the paintings of the Lot (Pech-Merle) and Australia, are exemplary for the reconstruction of the painters' gestures: succession of the drawings in the Black Frieze of Cabrerets and experiments at reproducing the spotted horses in the same cave.

Some works have already been partly obliterated since their discovery, almost like the Etruscan frescoes of Fellini's *Roma*. This explains the importance of current attempts to preserve these sanctuaries (at the cost of their never being opened, or being closed to the public, as was the case at Lascaux and Altamira, or the necessary limitation of access to them) and to present them in the form of less fragile and always restorable facsimiles. Good quality copies like those of Lascaux II, Altamira more recently, and perhaps Chauvet one day, enable us - by facilitating the access to these great underground sanctuaries - to remember that, in those ancient times, man was, as Vercors said, a religious animal.

About the authors

Brigitte and Gilles Delluc: Département de Préhistoire du Muséum National d'Histoire Naturelle (Paris) and Abri Pataud (Les Eyzies), USM 103 du MNHN - UMR 5198 du CNRS. Bibliographic site: http//monsite.wanadoo.fr/delluc.prehistoir; e-mail: dellucbg@wanadoo.fr.

Endnotes

1 The phantoms of Cougnac do have two eyes, but sometimes one above the other, at the level of the neck.

2 The eyes of the other animals in this cave (apart from a bovid, an ibex and three horses with complete or incomplete almond-shaped eyes and one horse with a round eye) are normally missing or, sometimes, limited to a simple dot, a recurrent curved line, or a short straight or curved line.

3 The eye of the aurochs in the famous Augsburg picture was depicted with two concentric circles surrounding the eyeball with pupil.

4 In living bovids, the pupil is a black horizontal bar, as in horses.

5 The male on this block has an almond-shaped eye, and the fawn has a round eye like the engraved fawn of Teyjat or that of La Bigourdane.

6 But one mammoth at Rouffignac has an almond-shaped eye with a pupil at its center.

7 The mammoth engraved on the ceiling of the Grotte du Cheval at Arcy has an enormous round eye.

8 It remains quite visible despite the insertion, in front of it, of a stone meant to mask a modern accident. It can be seen on old photos.

9 It should be noted that the eye of the "unicorn" of Lascaux is circular, without any other detail, a little like that of a feline or a reindeer.

10 The eyes of the few canids have fairly similar characteristics (Font-de-Gaume, Les Combarelles).

11 The red bears of Chauvet have no eyes. One of the black bears, on the other hand, has a little round eye with a pupil at its center.

12 The abbreviated animals are usually reduced to a cervico dorsal line or to a head and neck, but often it remains possible to identify the species.

13 Except in the tracings by H. Breuil.

14 Each lamp could have several wicks.

15 A. Leroi-Gourhan called normal, visual perspective uni-angular. It is normal in magdalenian art, after the time of Lascaux.

16 This single reindeer in the Apse contrasts with the remains of fauna found at Lascaux, which essentially comprise reindeer. This imbalance between depicted fauna and consumed fauna is classic in magdalenian sites.

17 The cave plans, decorated with little animal outlines, that were developed by A. Leroi-Gourhan, give a good idea of the decoration of each cave (Leroi-Gourhan 1995).

References

Archives A.

Glory. Fonds Muséum national d'histoire naturelle.

Aujoulat, N.

2004 *Lascaux. Le geste, l'espace et le temps*. Editions du Seuil, Paris.

Bourdelle, E., and C. Bressou

1937, 1938 *Anatomie régionale des animaux domestiques*. Equidés, Librairie Baillière, Paris, 4 fascicules.

Collective work

1993 *L'Art pariétal paléolithique. Techniques et méthodes d'étude*. Ministère de l'enseignement supérieur et de la recherche, Groupe de réflexion sur l'art pariétal paléolithique, directed by M. Lorblanchet.

Delluc, B., and G. Delluc

1984 Lecture analytique des supports rocheux gravés et relevé synthétique. *L'Anthropologie* 88:519-529.

1986 L'œil du chasseur et le génie de l'artiste. In *Un nouveau regard*, edited by Ruspoli, M., Lascaux, pp. 162-176. Bordas, Paris.

1990. L'oeil de l'homme et de l'animal dans notre préhistoire. *L'Ophtalmologie des origines à nos jours*. Laboratoires H. Faure, Annonay, tome 6, pp. 7-12.

2004 *Lascaux retrouvé. Les recherches de l'abbé André Glory*. Editions Pilote 24, Périgueux.

Dubourg, C.

1994 Les expressions de la saisonnalité dans les arts paléolithiques. *Préhistoire ariégeoise* XLIX:145-189.

Leroi-Gourhan, A.

1970-1982 Préhistoire. Résumés des cours, *L'Annuaire du Collège de France*, 70e à 82e années.

1995 *Préhistoire de l'art occidental*. Citadelles et Mazenod, Paris (édition revue et augmentée par B. and G. Delluc). First edition 1965.

Lorblanchet, M.

1995 *Les grottes ornées de la Préhistoire. Nouveaux regards*. Editions Errance, Paris.

Luquet, G. H.

1926 *L'Art et la religion des hommes fossiles*. Masson, Paris.

1930 *L'Art primitif*. Doin, Paris.

Montané, L., and E. Bourdelle

1917 *Anatomie régionale des animaux domestiques. Ruminants*. Librairic Baillière, Paris.

Rouzaud, F., J.-N Rouzaud, and E. Lemaire

1992 *Quelle perspective utilisèrent les hommes du paléolithique supérieur?* C. R. Académie des Sciences, Paris, tome 314, série II, p. 209-216.

Vialou, D.

1991 *La Préhistoire*. Gallimard (L'Univers des formes), Paris.

The Oldest Representation of Childbirth

Francesco d'Errico

Introduction

The history of a discipline, when reconstituted from reading the scientific literature, does not take into account the complex interactions that took place between the authors of this literature or the role that these interactions played in the evolution of each author's thoughts. A historian of science who did not take the time to seek out and read the correspondence which I maintained with Alexander Marshack and who knew nothing of the meetings and impassioned and stimulating discussions that we were able to have in Paris and Israel, might too rapidly jump to the conclusion that my relations with this colleague were always atrocious and that the only aim of a good part of the research that I carried out in my youth was to demonstrate that Alex had gone heavily astray in his theoretical and analytical approach (d'Errico 1989a, b, 1992, 1995a, b, 1996; d'Errico and Villa 1997, 1998, 2002). The reality, I think, is that we let ourselves get carried away by passion in our exchanges, and we were unable to broach, at least on paper, that dialogue which we succeeded in having *viva voce*, and perhaps that joint work which, I am convinced, could have taken us far. Too late.

What better homage could there be today to the open-mindedness and perspicacity of this renowned researcher than ideally to resume that dialogue, to try and achieve for once the same type of visionary perspicacity of which he was a master, and to present the analysis of some paleolithic depictions, my interpretation of which is broadly the same as his.

Plaquette 59 from Gönnersdorf

In his 1975 article in *National Geographic*, Alex presented the photo and tracing of an engraved plaquette (Figure 8.1) discovered by G. Bosinski's team at the Magdalenian site of Gönnersdorf in Germany, and proposed an interpretation that stupefied more than one colleague (1975:84): "One stone contains two female images, one of which is slightly more realistic than usual, since it includes a breast and two upraised arms. This image was marked twice by the kind of lines found on the La Roche stones and was then used in a most unusual way, by the addition of what appears to be a fetus. The microscope revealed what I think is an umbilical cord connecting the female image to the fetus, which is depicted with neither arms nor legs. If so, this is the only image of a human birth ever found from the Ice Age. The engraving, perhaps made by an adult woman living in the camp, may have been related to the monthly periods and eventual pregnancy. At what point in the biological sequence the fetus was engraved we cannot tell, but in the hundreds of Gönnersdorf stones found in the habitation we seem to have evidence of a female symbol system or a form of record keeping, very likely by adult women. The markings seem to indicate a knowledge and use of symbols to document human processes and activities". In the caption to the photo that accompanied the text,

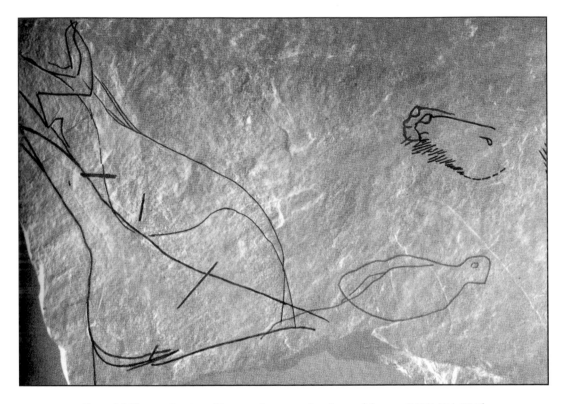

Figure 8.1 Photo and tracing of the engravings on a selected area of plaquette Gö 59 45/:c22 Pl
(modified after Marshack 1975).

Alex also called the reader's attention to the presence of "a pair of horses' heads" which he seemed to associate, even if he did not indicate how, to the depiction of the female figures and the one he interpreted as a fetus.

I had the opportunity to examine this plaquette (59 Gö 45/:c22 Pl), preserved at the Museum für die Archäologie des Eiszeitalters, Schloss Monrepos, Neuwied, Germany, in the course of my analysis of all the Gönnersdorf plaquettes bearing engraved female depictions, and to present the results of the technological analysis of the piece in the monograph devoted to these figures (Bosinki, d'Errico and Schiller 2001). Here I would like further to pursue this analysis through a detailed description of the depictions on this plaquette. This description

and the results that have already been obtained from the technological analysis will enable me to draw out some new facts that support the interpretation proposed by Alex, and to discuss how this depiction helps us to understand how the societies of the end of the Upper Paleolithic viewed childbirth.

My study reveals that three female figures were engraved on this plaquette (Figures 8.2-8.3). Two figures (8.1-8.2) are superimposed and a third (3) is engraved to the right of the first two (Figure 8.3). In comparison with the other female depictions discovered in this site, Figure 8.1 possesses an upper limb that is drawn in an exceptionally realistic fashion. The engraved female depictions of Gönnersdorf have the sketch of an arm in 16% of cases, and in 11% of

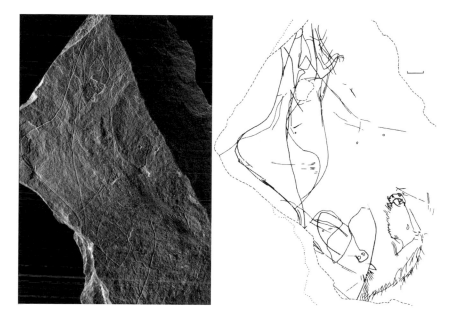

Figure 8.2 Photo and tracings of the engraving on plaquette Gö 59 45/:c22 Pl
(photo by the author, tracing by P. Schiller).

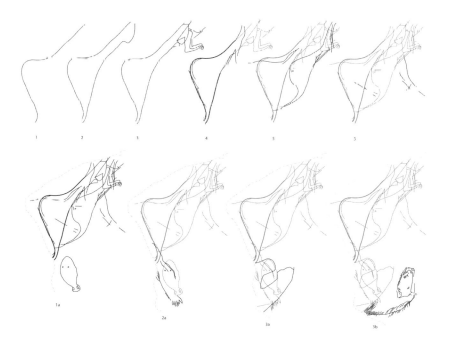

Figure 8.3 Order of execution of the different depictions engraved on plaquette Gö 59 45/:c22 Pl; 1–3:
figure 1; 4: figure 3; 5: figure 3 (drawing by the author).

Figure 8.4 Close-up view of the depiction of a possible newborn, umbilical cord, horse-head seen from the front to the right of the child's head, and meander (photo by the author).

cases the arm is accompanied by the depiction of a breast, but it is always a single arm, generally drawn with two parallel or convergent lines. In Figure 8.1 on this plaquette, the two arms and forearms are depicted and in perspective. The curve of the biceps and the deltoid is clearly marked, and the latter even seems purposely exacerbated, as if to emphasize that the arm is in abduction and the muscle contracted. This is a unique case at Gönnersdorf, as Alex pointed out, and, to my knowledge, it is unique within the whole assemblage of Magdalenian female figures of this type in Europe in that it has the hands and fingers clearly depicted. The latter are drawn with short lines, bent downwards. By this means, the artist seems to have wanted to highlight, albeit in a schematic way, the partially flexed position and the contracted position of the fingers. This figure's thorax and breast are also quite peculiar. The former is drawn with two superimposed and very different profiles, one of them straight and continuing with the pointed breast, the other excessively prominent and not forming any protuberance which could make one think of a depiction of a breast.

The breast associated with the first profile of the thorax is also unique. Out of the nine breast

morphologies recorded in the female depictions from Gönnersdorf (2001:222), the one associated with this figure is the only one that has been observed in just one example. Its peculiarity consists in the fact that the profile is inverted in relation to natural posture, and therefore the breast seems to tilt or be compressed upwards, rather than downwards, as one might expect.

The second figure uses the lines of the first for its lower limbs, but has a thorax, a stomach profile and a sketchy arm or breast, the latter partly removed by the exfoliation of the plaquette – all these features are independent of those of the first figure. The arms of the first figure cross the thorax of the third, engraved in contact with, and in front of, the first. It differs from the others in its more sinuous look and its lower limb, which is sharply bent backwards so that it crosses the extremities of the lower limbs of figures 8.1 and 8.2 perpendicularly.

Two partially superimposed lines (Figure 8.4) emerge from this crossing point, which seem to form a link between the three figures just described and the other figures present on the plaquette. It was these lines which Alex interpreted as the umbilical cord. They penetrate the interior of an elliptical shape which has a circular protuberance on the side opposite the female figures. This is the depiction which Alex interpreted as a human fetus (Figure 8.4). In the selective tracing which Alex published in *National Geographic*, he indicated a small circle in the possible fetus head, which could depict an eye. This circle is absent in the tracing of the plaquette published by Bosinski and Fischer in 1974 in the first monograph devoted to the female figures of Gönnersdorf. My analysis of this figure confirms the presence of the little engraved circle identified by Alex and even shows that a second circle, partially removed by the weathering of the surface, was engraved next

to the first. Following my examination of the pla-
quette the two circles were added to the tracing
made of this plaquette by Petra Schiller, pub-
lished in the monograph that we devoted to the
Gönnersdorf figures (2001:Tafel 56). Two small
cupules, produced by rotating the point of a tool,
are also present on the body of the fetus close to
the lines indicating the possible umbilical cord.
Their presence here very probably reflects delib-
erate behavior, if one considers the rarity of such
cupules on the rest of this face of the plaquette,
but it remains difficult to interpret.

A straight line was drawn beside the fetus
and parallel to it. At one end of it, there are
short, curved lines which, through comparison
with similar depictions, make one think of the
end of an arrow shaft. Above the head of the
newborn is an engraved motif made up of two
lateral protuberances framing a group of parallel
lines which Alex did not mention in his article
and which Bosinski and Fischer (1974) inter-
preted as a possible horse-head seen from the
front. The two protuberances, according to these
authors, supposedly represent the horse's ears,
with the lines in the middle being the tuft of
hair. But in my opinion this depiction is also very
similar to an engraved motif that one can see on
another plaquette from Gönnersdorf with
female figures (87, G ÷ 50 St. 9). Discovered in
the same concentration as the one that we are
dealing with, this plaquette (Figure 8.5) presents
four female figures that are deeply engraved and
finely cross-hatched, among which is one with a
child held on her back by means of what
appears unequivocally to be a baby-carrier. The
rigid structure which identifies the baby-carrier
has at its top a tuft of lines which recall those
that accompany the possible newborn on pla-
quette 59. But let us return to the latter.

The newborn and the other two depictions
which we have just evoked (arrow and tuft), are

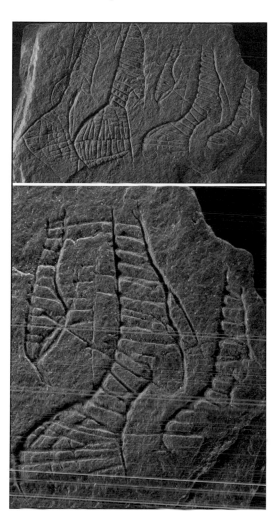

*Figure 8.5 Top: depiction of four female figures, one with a
baby-carrier, on plaquette Gö 87; bottom: close-up view of
the figure with the baby-carrier, showing the tuft of lines
recalling those close to the newborn on plaquette Gö 59
(photos by the author).*

crossed and surrounded by a deep line in the form
of a meander which is not mentioned by Alex.
Beside this assemblage one sees two superim-
posed horse-heads (Figure 8.6). Their necks have a
thick mane. In the tracing published in 1974 by
Bosinski and Fischer, the mane stops before reach-
ing the edge of the plaquette. In reality it does

Figure 8.6 Close-up view of the horse heads to the left of the possible newborn (photo by the author).

reach this edge, where it is partially superimposed on the extremities of the short lines of the "horse seen from the front". This detail suggests that the horses are indeed part of the composition.

Microscopic analysis of the lines enabled me, to some extent, to understand the order of execution of the different depictions engraved on this plaquette (Figure 8.3). The engraving began either with the "newborn" (Figure 8.3:1a) or with the female figures (Figure 8.3:1–5). The umbilical cord that crosses these two elements was engraved after the female outlines, but its relationship with the newborn could not be elucidated because of the weathering of the plaquette

at this point – hence the uncertainty about the first element to be engraved. Of the three female figures, the first to be engraved was No. 1, followed by 2 and 3 (Figure 8.3:1–5). The "horse seen from the front" and the "arrow" were engraved after the newborn (Figure 8.3:2a), and the meander afterwards (Figure 8.3:3a). The mane and the two superimposed horse-heads were the last elements to have been engraved (Figure 8.3:3b).

Discussion

My reading of plaquette 59 has highlighted several new elements which reinforce the interpretation proposed by Alex, according to which we are faced with the oldest known depiction of childbirth. The possible newborn has no traits that are unequivocally and categorically human – apart from a possible head and two eyes. The use of a circle, closed or partially open, to evoke a face, and of two smaller circles inside it to evoke eyes is a phenomenon that has been observed several times at Gönnersdorf (*e.g.* Bosinski *et al.* 2001: taf. 101), which seems to confirm the deliberate and probably human character of this depiction.

The resemblance of the tuft close to the head of the possible newborn to the one that decorates the baby-carrier depicted on plaquette 87 is another element which makes one think that we are indeed dealing with a child. This does not contradict the hypothesis proposed by Bosinski and Fischer, according to which the sign on plaquette 59 represents a horse-head seen from the front. Through the presence of this sign and of the horse-heads, the engraver may have wished to indicate that a strong symbolic link existed between this mammal and the newborn. There is nothing to prevent us thinking that this symbolic link was materialized through the presence in the space in which the childbirth took place, or in the objects surrounding the newborn during the first

years of its life, of things with an explicit reference to this animal.

The exceptional realism with which the upper limb of figure 1 is depicted also demands an explanation. One interpretation that seems reasonable to me is that the engraver wanted to depict either the effort and muscular tension of the woman giving birth, clinging or contracting her fingers during the delivery or, more probably, the help given by an assistant to the childbirth by surrounding her or supporting her with her arms, as carried out in certain natural birthing positions during which the woman giving birth is standing or sitting, and is thus supported by another woman. In that case, the woman giving birth would be figure 3, while the assistant(s) would be figures 1 and 2. The inverted profile of figure 1's breast can be explained if one accepts this latter hypothesis. The engraver was perhaps indicating by means of this device that woman 1–2 is clinging to No. 3, and consequently her breast is compressed upwards.

This position is adopted naturally by women during birth and was described as early as 1882 by Engelmann (Dundes 1987, 2003; Gupta and Nikodem 2000) who observed that in traditional societies women try to avoid lying on their backs and often change position. Upright positions during birth using posts, a slung hammock, furniture, holding on to a rope, a knotted piece of cloth, and often with the help of assistants supporting the woman giving birth (Figure 8.7), as suggested for Gönnersdorf plaquette 59. While it is common in Western societies for women to deliver in a dorsal position, this practice was adopted solely for the convenience of the obstetrician or midwife who could better monitor the birth process (Bomfim-Hyppolito 1998). The disadvantage of the supine position for the birthing mother transformed the normal birth into an unnecessarily painful, physically damaging, and often surgical event (De Jonge et al. 2004; Terry et al. 2006).

The meandering line that surrounds the newborn did not attract Alex's attention. Yet its technical analysis seems to show that it is was purposely drawn. It was engraved after the newborn, the nearby symbol and the umbilical cord. So this line cannot be interpreted as the remains of a figure that was present on the plaquette before its fracture, and which has no relationship with the scene in question. Moreover, it surrounds, and seems to want perfectly to contain, the newborn, which reinforces the idea of a link with it. This line could evoke the mouth of a big feline that is swallowing the newborn. Could we be seeing the depiction of an unfortunate childbirth during which the forces of darkness seize the newborn? Of course, this is mere speculation.

Nevertheless, it remains true that everything converges to make us consider, as Alex had proposed, that the engravings on this plaquette relate the earliest and doubtless the most convincing depiction of childbirth in paleolithic art (see Duhard 1993 and Guthrie 2005 for other possible depictions).

How does this depiction help us understand the place that this crucial moment of life held in the Magdalenian cultural system? In his transcultural analysis of practices linked to childbirth, O' Donnel (2004) identifies six aspects that, with a few exceptions, are common to all human cultures, and which seem to maximize the chances of a successful end to the childbirth: 1) thermal regulation to ensure the viability of the newborn infant; 2) a defined spatial location; 3) mobility in order for the birthing woman to negotiate the process; 4) attention to the pre- and post-natal environment; 5) support and companionship; and 6) ritual and symbolism in the psychological negotiation of the process. Plaquette 59 from Gönnersdorf offers

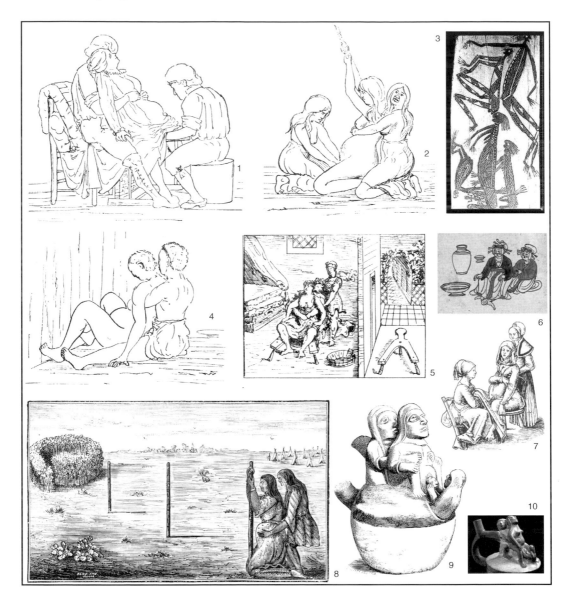

Figure 8.7 Depictions of women giving birth in an upright position with the help of an assistant supporting them with her/his arms: 1) delivery position still in use during the first half of the nineteenth century in rural areas of the southeast United States; 2) birth delivery position used by Native Americans in northern Mexico; 3) delivery among Australian Aborigines (bottom) with a woman supporting the mother from behind while another, depicted upside down, delivers the baby; 4) husband supporting his wife during the delivery in the Andaman Islands; 5) position recommended by Johannis Michaelis Savonarola in the middle of the sixteenth century; 6) delivery position in Japan; 7) delivery in Europe during the Middle Ages; 8) temporary shelter and delivery position among the Comanches; 9-10) drawing and photo of Moche pottery with depictions of deliveries. (1-2, 4-5, 8-9 after Engelmann 1886; 3 after Matthews 1899; 7 after Marie-France Vouilloz Burnier 1995).

us some direct information about these last two aspects. Although depicted schematically, the presence at the moment of birthing of at least one other woman is clear in the scene engraved on this plaquette. This woman seems to be taking an active part in the process, and physically helping the woman giving birth. Studies of the moment of childbirth and the method of organizing it within traditional cultures (Paige and Paige 1981) have clearly highlighted the fact that this help also plays a crucial role in terms of psychology. The women who offer this help have generally already given birth themselves, have been present at several births, and can impart traditional practices in real time, especially to those giving birth for the first time.

This help reduces enormously the stress of the woman giving birth, and makes a significant contribution to ensuring a favorable outcome to the birthing. The depictions on this plaquette seem to indicate that Magdalenian culture had adopted these requirements and that, in particular, relationships between women had attained a degree of complexity comparable to that of traditional societies in which these practices have been documented. The symbol soaked atmosphere in which the childbirth take place is another aspect worth underlining. The baby is literally surrounded by four symbolic depictions. The realism and the technical mastery with which one of them is executed, the two superimposed horse-heads, contrasts with the apparent schematism with which the others

avoid notice. But the overall message is clear. Among the Magdalenians, as among most human societies, it is a difficult moment of one's existence, during which the powerful forces that determine the destinies of men and women must be both appeased and feared. To guarantee the support or, at least, the non-interference of these forces, some complex rituals, particular sexual practices, appropriate food and clothing, and prohibitions of certain activities are set in place from the start of the pregnancy. Respect for these prohibitions reduces the stress of the woman about to give birth by giving her the impression that her pregnancy and birthing are part of the natural order of things, or at least have their place in a pact which humans established long ago with Nature.

Acknowledgments

I would like to thank Paul Bahn and Elaine Marshack for inviting me to take part in this volume in memory of Alex, and Paul Bahn for translating my text into English.

About the author

Francesco d'Errico, Institut de Préhistoire et de Géologie du Quaternaire, UMR 5199 of the CNRS, Université Bordeaux 1, avenue des Facultés, F-33405 Talence, France, e-mail: f.derrico@ipgq.u-bordeaux1.fr; Department of Anthropology, The George Washington University, 2110 G Street, NW, Washington, DC 20052, USA.

References

Bomfim-Hyppolito, S.

1998 Influence of the position of the mother at delivery over some maternal and neonatal outcomes. *International Journal of Gynecology and Obstetrics* 63 (Suppl. 1):67-73.

Bosinski, G., and G. Fischer

1974 *Die Menschendarstellungen von Gönnersdorf. Ausgrabung 1968.* Der Magdalenien-Fundplatz Gönnersdorf, Band 1. Franz Steiner Verlag GMBH: Wiesbaden.

Bosinki, G., F. d'Errico, and P. Schiller

2001 *Die Gravierten Frauendarstellungen von Gönnersdorf.* Der Magdalenien-Fundplatz Gönnersdorf, Band 8. Franz Steiner Verlag GMBH: Stuttgart.

De Jonge, A., T. A. Teunissen, and A. L. Lagro-Jans

2004 Supine position compared to other positions during the second stage of labor: A meta-analytic review. *Journal Psychosom. Obstet. Gynaecol.* 25(1):35-45.

d'Errico, F.

1989a Palaeolithic lunar calendars - a case of wishful thinking? *Current Anthropology* 30(1):117-118.

1989b Reply to Alexander Marshack (1989). Wishful Thinking and Lunar "Calendars". *Current Anthropology* 30(4):494-500.

1992 Reply to A. Marshack. *Rock Art Research* 8(3):122-130.

1995a New model and its implications for the origin of writing: the La Marche antler revisited. *Cambridge Archaeological Journal* 5(1):3-46.

1995b *L'Art Gravé Azilien. De la technique à la signification.* XXXIe Suppl. à Gallia Préhistoire. CNRS Editions, Paris.

1996 Marshack's approach: poor technology, biased science. *Cambridge Archaeological Journal* 6(2):39-45.

1998 Palaeolithic origins of artificial memory systems: an evolutionary perspective. In *Cognition and Material Culture: the Archaeology of Symbolic Storage,* edited by C. Renfrew and C. Scarre, pp. 19-50. McDonald Institute Monographs, Cambridge.

2002 Memories out of mind: The archaeology of the oldest artificial memory systems. In *The Mind's Eye,* edited by A. Nowell, pp. 33-49. International Monographs in Prehistory, Archaeological Series 13, Ann Arbor.

d'Errico, F., and P. Villa

1997 Holes and grooves. The contribution of microscopy and taphonomy to the problem of art origins. *Journal of Human Evolution* 33:1-31.

Duhard, J.-P.

1993 *Réalisme de l'image féminine paléolithique.* Editions CNRS, Paris.

Dundes, L.

1987 The evolution of maternal birth position. *American Journal of Public Health* 77(5):636-641.

2003 *The Manner Born: Birth Rites in Cross-cultural Perspective.* AltaMira Press, Walnut Creek, CA.

Engelmann, G. J.

1882 *Labor Among Primitive Peoples: Showing the Development of the Obstetric Science of Today, from the Natural and Instinctive Customs of All Races, Civilized and Savage, Past and Present.* Verlag J. H. Chambers and Co.

Gupta, J. K., and Nikodem, C.

2000 Maternal posture in labour. *Eur. J. Obstet. Gynecol. Reprod. Biol.* 92(2):273-277.

Guthrie, R. D.

2005 *The Nature of Paleolithic Art*. University of Chicago Press, Chicago.

Marshack, A.

1975 Exploring the mind of Ice Age Man. *National Geographic* 147:65-89.

Matthews, R. H.

1899 *Folklore of the Aborigines*.

O'Donnel, E.

2004 Birthing in prehistory. *Journal of Anthropological Archaeology* 23:163-171.

Paige, K. E., and Paige, J. M.

1981 *The Politics of Reproductive Ritual*. University of California Press, Berkeley.

Terry, R., J. Westcott, L. O'Shea, and F. Kelly

2006 Postpartum outcomes in supine delivery by physicians vs nonsupine delivery by midwives. *J. Am. Osteopath Assoc.* 106:199-202.

Vouilloz Burnier, M. F.

1995 *L'Accouchement entre Tradition et Modernité*. Editions Monographic, Sierre.

Hunting the European Sky Bears: A Diachronic Analysis of Santa Claus and His Helpers

Roslyn M. Frank

Everybody says, "After you take a bear's coat off, it looks just like a human".

> *- Maria Johns (cited in Snyder 1990:164)*

Lehenagoko eüskaldünek gizona hartzetik jiten zela sin-hesten zizien. ("Basques used to believe that humans descended from bears").

> *- Petiri Prébende (cited in Peillen 1986:173)*

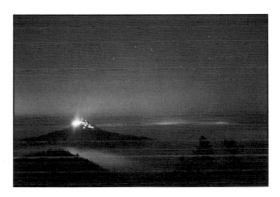

Hohenzollern Castle and the big dipper above clouds. © T. Credner and S. Kohle, AlltheSky.com.

Abstract

Using a diachronic approach to the data, the so-called "good luck visits" involving masked figures that in Europe have typified the period from the beginning of November to early January will be analyzed. It will be argued that these visits, con ducted in the United States by Santa Claus and his helpers, can be traced back to an earlier pan-European cosmology based on Bear Ceremonialism and the belief that humans descended from bears. Apparently, these bear ancestors were given a prominent place at the pinnacle of heaven, near the North Pole, where they were projected onto the circumpolar stars of Ursa Major (Frank 1996, 1996b, 1997, 2001). Although somewhat reshaped under the influence of Christianity, the actions of the Bear Shaman and his Spirit Animal Helpers still retain many aspects related to the spatial coordinates intrinsic to the earlier ritual landscape such as entering and exiting through a smoke hole.

Introduction

The Great Bear (Ursa major) has been classified as belonging to the most archaic strata of the star figures.[2] It has been assumed that scenes portrayed by certain other constellations were associated with some half-forgotten sky text handed down to us, albeit incompletely, through Greek mythology (Gingerich 1984). Although previously in the case of Europe no archaic set of stories connected to the Sky Bears (Ursa major and Ursa minor) had been clearly identified,[3] extensive fieldwork over the past thirty years (Figure 9.1) in the Basque region of the Pyrenees has allowed me to discover the existence of an archetypal

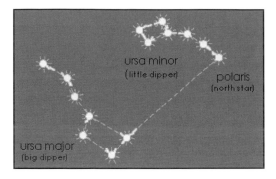

Figure 9.1 Location of pointer stars of Ursa Major with respect to Polaris in Ursa Minor in early September. After Susan Palmer. Source: Bullock 1981:6. www.artnut.com.

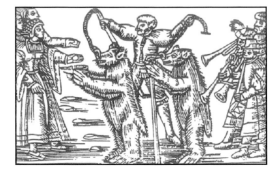

Figure 9.2 Bear leader and musicians. Source: engraving from Olaüs Magnus, Historia de gentibus septentrialibus. Rome 1555. Reproduced in Michel and Clébert (1968:329).

hero called *Hartz-Kume* in Basque whose name means "Little Bear".[4] The figure of the Bear Son, born of a Great Bear and human female, far from being exclusive to the Pyrenean zone, is identified with a cycle of stories and related ritual performances found throughout Europe. The latter include what are called "good-luck visits" (Figure 9.2). Variants of these visits and related ritual practices have survived surprisingly intact into the twenty-first century (Alford 1930, 1931, 1937; Fabre 1986; Frank 1996a; Molina

González and Vélez Pérez 1986). Indeed, they form part of rich legacy of popular performance art whose cognitive roots and unique image schemata reach back to a much earlier pan-European ecocentric worldview (Frank 2005a; Frank and Susperregi 2000). As we shall see, the "good luck visits" themselves have acted as a vehicle for the cultural storage and preservation as well as oral transmission of the tenets of the earlier European belief system, through reiterative mechanisms typical of oral cultures.[5]

The Bear Son tales represent one of the most common motifs found in European folklore (cf. Frank 1996a).[6] The widespread distribution of the motif is best understood once we recognize that we are dealing with relatively archaic materials emanating from an earlier European cosmology. The latter continue to project the tenets and ceremonial practices related to this earlier European story of origins, namely, one that held human beings descended from bears (Peillen 1986:71-173).[7] In fact, for Europe there is reason to believe that the Bear Ancestor progenitor of humans is linked symbolically with the Great Bear constellation and probably with the constellation of Little Bear, although, admittedly, evidence for archaic conceptual linkages to Ursa Major is more readily accessible than for Ursa Minor (Frank 1996a, 2001; Shepard and Sanders 1992; Schaefer 2006). Moreover, it would seem that these two star figures represent the exteriorization of the earlier belief system itself. These tracings in the sky appear to have acted as visual supports, illustrations that aided the tellers in narrating the tales (Frank 1999a, b; Frank and Arregi Bengoa 2001).

Evidence for the residual practice of Bear Ceremonialism in Europe is demonstrated in many forms (cf. Frank 1996a), including ritual reenactments of the bear hunt and folkloric performances portraying other scenes from the

Bear Son saga itself. These social practices are particularly abundant not only in the Atlantic Façade but also in many parts of Central and Eastern Europe (Fabre 1968, 1986; Praneuf 1989; Rockwell 1991; Vukanović 1959).[8] In summary, there is reason to believe that the eco-centric discourse intrinsic to the Bear Son saga antedates the anthropocentric discourse of the celestially encoded Greek materials, the latter often being fragmented versions of the much earlier pan-European text, the celestially encoded narrative that encapsulated the worldview of hunters and gatherers (Frank 1997, 2000, 2005a; Frank and Arregi Bengoa 2001). The latter has survived on the margins of elite discourse, in folkloric practices transmitted orally and quite unobtrusively from one generation to the next in villages across Europe.

Morphology of the "Good Luck Visits" from a diachronic perspective

The "good luck visits" in question and associated ritual repertoire derive their vitality specifically from their intimate connection to the cycle of pan-European tales centered on the exploits of the Bear Son who acts as the intermediary, the mediator between the world of humans and bears. Based on the results of research carried out to this point, in addition to Great Bear and Little Bear, other scenes from the life and times of the Bear Son appear to have been projected onto the sky screen. These star paintings functioned in the sky above as a means of illustrating and exteriorizing the meaning of the action sequence found in the tales, while on earth the same scenes were reenacted in song, dance, and mime by masked figures performing the roles of the hero and the Spirit Animal Helpers that accompanied him (Frank 2001).

The Bear Son's adventures portray the protagonist first as a young shaman apprentice, as a medicine man initiate who sets out on a vision quest to acquire his Spirit Animal Helpers and his Medicine Bundle. Indeed, the scenario is quite similar to the age-old vision quest known as *hambleceya* encountered among the Plains Indians of North America, a ritual that is a focal point in the religious life of most Native Americans (Time–Life Editors 1992:125). Later, as an adult, the Bear Son engages in a series of ritual battles with another shape-changing shaman. Significantly, for the most part the shape-shifting abilities of the two characters serve to set up narrative confrontations in which the Bear Son transforms himself into one "predator" animal after another, while his shaman adversary shape-shifts so that he plays the role of the corresponding "prey". The latter character has his own set of Spirit Animal Helpers. The "battles" between the two shamans take place on a ritual landscape typical of shamanism where the hero is seen climbing or flying up and down along a vertical axis. In some cases the movement is from Middle Earth to the Under World. In others, the shamanic figure's journey takes him from the Upper World back down to Middle Earth.[9]

According to the spatial coordinates intrinsic to such a shamanistically-coded landscape, the vertical axis is often portrayed as a smoke-hole, a shaft, and it is through this aperture that the healer descends and ascends on his journeys, *e.g.*, when seeking information about his patients, hunting and retrieving their "lost souls" (cf. Brunton 1993; Frank 1996a; Hoppál 1992, 1993a, b). Furthermore, linked to the ritual journeys of the shaman healer are the actions carried out by the spirit of the earthly bear representative itself. A fundamental component of European Bear Ceremonialism has been a bear hunt in which the ancestral animal was sacrificed and its blood and flesh eaten at a banquet (cf. Frank 2001; Milkovsky 1993; Shepard and

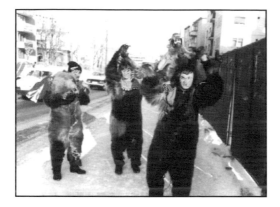

Figure 9.3 Romanians dressed as bears at the Winter Carnival in Sibiu, performing traditional dances said to bring good luck. Troupe members come from Comanesti, Romania (December 1998). Source: Florin Stanescu.

Sanders 1992). Today such hunts are encountered as performances in which a human actor mimes the role of the earthly bear. Subsequently there is an interlude intended as a sending home ceremony in which the earthly bear's soul is sent back up the Sky Pole to heaven so that it can give a report to the Great Sky Bear concerning the overall comportment of its human descendants, for instance, whether they treated the animal properly prior to killing it, whether they expressed their humility and gratitude for the sacrifice made by the animal when it gave up its life (Frank 1996a, 2001; Hollingsworth 1891).[10]

In short, the earthly bear's report served to inform the Celestial Bear of the details of the behavior of its human offspring. A positive report card guaranteed the health and well being of the Celestial Bear's human descendants. If the ceremonies were properly performed, in the spring the bones of the earthly bear would take on flesh anew in the form of bear cubs, while the souls of all the other beings were thought to be released by the bear in the spring when it awoke from hibernation (Chiclo 1981; Elgström and Manker 1984; Fabre 1986; Lebeuf 1987; Praneuf 1989; Tiberio 1993).

In the tales and related folk performances found across much of Europe, the Bear Son intermediary often appears dressed as a bear. This character, in turn, is regularly accompanied by a number of musicians and false faces, masked figures that portray his Spirit Animal Helpers. Ritual bear hunts are still performed in the Franco-Cantabrian region and the Pyrenees (Alford 1928, 1930, 1931; Frank 1996a, 2001), where today they are acted out publicly during the period of Winter Carnival (Figure 9.3).[11] For example, in Andorra the *Festa de l'Ossa* is celebrated both on December 26 and during Spring Carnival (Praneuf 1989:62). Other data strongly suggest the ritual importance of these "good luck visits" or house calls to the community as a whole (cf. Giroux 1984).

Previously, the "good luck visits" were clearly understood to have specific purposes.[12] For instance, they were perceived as having a cleansing or prophylactic healing function and, therefore, were considered fundamental in order to guarantee the health and well being of the household visited and all its inhabitants. On the other hand, the "good luck visits" appear to have acted as a complex mechanism for inculcating and reinforcing the belief in the importance of proper behavior, i.e., in behaving according to the tenets of Bear Ceremonialism itself. Thus, there was an educational component involved in such visits.[13]

In many parts of Europe once at their destination the Bear Shaman and his/her bear(s), along with the other guisers, perform an abbreviated play in which the bear's hunt, death and resurrection are reenacted. In some cases a rather ribald report critiquing the householders' behavior is read or sung by a member of the troupe of actors and musicians.[14] Afterwards, the actors

are treated to food and drink by their hosts.[15] Traditionally, the latter "passion play" was reenacted before each farmstead as an integral part of a cleansing ritual intended to protect the family, animals and crops from harm throughout the rest of the year. One of the reasons behind the performances is the fact that the motley crew of masked actors along with their earthly bear or a man dressed as a bear was (is) believed fully capable of carrying away with them the maladies and misfortunes of their patients (Frank 1996a; Vukanović 1959).[16]

Timing of the performances

Originally it would seem that these visits and attendant performances took place throughout the year, motivated by the specific needs of the patient, household or community in question. In this sense, the Bear Shaman and his bear along with the other Spirit Animals functioned much in the same way as the members of the Society of False Faces of the Iroquois and the *heyoka* of the Sioux. These Native American medicine men and women were the contraries or sacred clowns who performed when need be, in the homes of the afflicted (Speck 1945; Time-Life Editors 1992:142-143).[17]

Although previously in Europe such performances probably took place throughout the year, our ethnosemiotic analysis focuses on the morphology of the traditional performances that take place during the period from the beginning of November to early January. In the United States the period in question contains only three days in which masquerading is commonplace, *i.e.*, when disguised characters regularly walk about the streets, namely, All Hallow's Eve, Christmas Eve and New Year's Eve. Moreover, in most parts of the United States, the customary "good-luck visits" associated with Halloween are no longer carried out by adults wearing masks

(cf. Halpert and Story 1969). The same is not true, however, in the case of the Advent period when homes are regularly visited by an adult disguised as St. Nicholas or Santa Claus. Moreover, in the case of the extant traditions found in the United States we will discover that several members of the original cast of characters have been lost, specifically, the figures of the earthly bear and the White Mare. Yet when examined from a diachronic perspective, it would appear that the motivations behind the actions of these New World mummers, although not fully understood at a conscious level by the practitioners themselves, are, nonetheless, the result of the resilience and strength of traditional practices associated with the earlier European ursine cosmology.

The White Mare Hobby-Horse and the *Schimmel*

Several additional comments should be made concerning the prototypical morphology of the European "good-luck visits". Frequently the Bear Leader (trainer) is followed by a number of villagers dressed up as bears with their faces blackened, wearing bells about their waists and small jingles attached to their calves. In their manner of walking they often imitate the rocking gait of a bear (cf. Urbeltz 1994). They are accompanied by a group of musicians and other guisers dressed as ancestral Spirit Animal Helpers. Perhaps the most popular and widespread of these creatures is one referred to in the Bear Son tales as a White or Grey Mare, an astrally-coded character with possible linkages to the pre-Greek constellation Centaurus, who in the stories helps the hero kill his adversary, the Black Wolf Trickster (cf. Frank 2005b).[18]

In Germany this Hobby Horse character is called *der Schimmel*, a term used to refer to a white (or grey) horse. In some parts the two

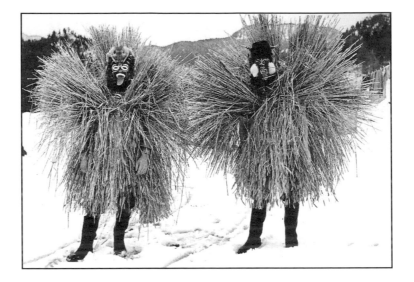

Figure 9.4 Examples of der Erbsenbär *("Pea Haulm Bear"),*
Berchtesgadener, Germany, 1958. Photo Wolf Lücking.
Reproduced in Weber-Kellermann (1978:30).

characters are fused in the figure of the
Schimmelreiter ("the White-horse rider").[19]
Nonetheless, even when "emphasis is laid upon
the rider, and the name *Schimmelreiter* is given ...
[it] is accompanied by a 'bear', a youth dressed in
straw who plays the part of a bear tied to a pole"
(Miles 1912:200).[20] According to Germanic tra-
ditions, the *Schimmel* is regularly accompanied
by a bear guiser (Figure 9.4) called *der Erbsenbär*
("Pea Haulm-Bear")[21] or *der Strohbär* ("the Straw-
Bear"), actors covered with stalks of pea haulm
or straw rather than fur.[22]

The Strohbär appears in the eastern part of
Germany, Pomerania, Bavaria and Switzerland
while a similarly dressed personage is found
across the channel in England as well as further
west in the Pyrenees. In short, representatives
of these Strawbears can be found today in much
of the rest of Western Europe, often accompa-
nied by the White Mare (Praneuf 1989:63;
Alford 1969, 1978:116).[23] Indeed, far from

disappearing, the Strawbears appear to be gain-
ing in popularity (cf. Figures 9.5-9.6).[24]

Since the White Mare has been a regular
member of the cast of characters taking part in
the European "good luck visits," it is not surpris-
ing that St. Nicholas was thought to arrive on a
white horse or when he did appear in person, he
carried a replica of the animal in his hand. In
addition, children often left their shoes, stuffed
full of carrots and hay, just outside the doors of
their houses (Nast 1971:44). As we shall see,
once transported to the United States, the shoes
would turn into stockings and the astrally-coded
White Mare into reindeer.

The Dancing Bear Martin:
"He who walks barefoot"

The "good luck visits" can be divided into two gen-
eral categories. The first type is best understood
as a form of preventative medicine, periodic
cleansing rituals carried out with the intention of

warding off future physical and spiritual disease. Initially, as has been noted, these prophylactic rituals appear to have taken place on a regular basis throughout the year. In contrast, the second type of "good-luck visit" was triggered when a family member or animal fell ill. In such cases the Bear Leader was contacted to make a house call—along with his earthly bear—and to perform a ceremony for an individual member of the community. In the Balkans such house calls were regularly conducted with a live bear into the 1930s (Vukanović 1959; cf. also Seshamani and Satyanarayan 1997).[25]

Under the influence of Christianity the central role of the bear was slightly modified, his functions being reassigned by the Church to a specific saint even though it appears that both the clergy and the general populace were well aware of the substitutions that were taking place. In order to illustrate this process of ritual substitution, we shall turn to a concrete example: that of the transference of the functions of the bear to St. Martin, while the role of his trainer was taken over by the figure of a bishop.[26] In such cases the bishop chosen was usually one whose historical origins were remote, shrouded in the mists of time. For instance, St. Martin, Bishop of Tours, was finally consecrated by the Church in the fifth century, and turned into the central character of

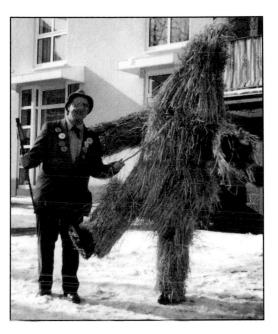

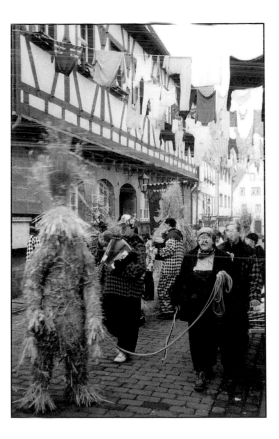

Figure 9.5 (upper right) The Strohbär of the village of Waldurn, near Frankfurt, Germany. Photo taken in 2001. Source: Source: http://www.strawbear.org.uk/ Bear in Waldurn.htm. (Right) Strawbear of Whittlesea, England 2001. Source: http://www. strawbear.org.uk/Bear in Waldurn.htm.

Figure 9.6 (lower right) Strawbears in Waldürn, Germany, 2001. Source: http://www.strawbear.org.uk/ Bear in Waldurn.htm.

a great Church festival, Martinmas.[27] A curious story was propagated about this Martin. Indeed, there is reason to believe that the legend itself was a conscious attempt to link the saint's name and related performances conducted in his honor, directly to those of the dancing bear. In order to understand this process we need to recognize that in the Middle Ages across much of Europe a common nickname for any bear brought in to conduct a cleansing ceremony was Martin. In fact, this name was frequently modified by adding the phrase "he who walks barefoot," *e.g.*, as in the expression *Mestre Martí au pès descaus*, literally, "Bare-Foot Martin" or "Martin, he who walks barefoot," while the phrase "he who walks barefoot" was used to refer to bears in general.[28] In Romania the animal is known both as Old Martin and Brother Nicholas (Praneuf 1989:66). Indeed, Vukanović (1959:118) speaking of the Gypsy Bear Leaders of the Balkans, states that among them "it was a traditional custom from olden times to give a Christian name to each male or female bear and always use that when talking or singing to it. So almost invariably, as if by a fixed rule, bears are still given a human proper name: Bozana generally for a female and Martin or Marco for a male".

The Church spin-doctors concocted a series of pious legends that would seek to stitch the two belief systems together. Apparently the stories were an attempt, although quite an unsuccessful one, to counter the wide-spread belief in the efficacy of the Bear Shaman trainers and their dancing bears or at least to give them an air of legitimacy within the framework of Christian belief. The legend propagated by the Church with respect to St. Martin shows the ingeniousness of its authors, particularly with respect to the way in which they managed to elaborate such a convoluted plot for the story itself. It was one that told of the generosity of the Bishop of Tours, a man named Martin. When visited by his disciple and friend Valerius, who was said to be a fifth-century bishop of Austria, Martin gave him an ass so that Valerius would no longer have to laboriously traverse the rugged mountainous terrain on foot and, consequently, would be better equipped to spread the good word. And Valerius, in turn, named his ass Martin. However, just when Valerius reached the path that would lead him to the Pyrenean town of Ustou, darkness overtook him. The next morning much to his chagrin Valerius discovered an enormous bear standing next to the tree where he had left his ass tied the night before. Realizing the beast was devouring the last remains of his pack animal, Valerius calls out to him, "The Devil take you! No one will ever say that you have kept me from spreading the good word across these mountains. Since you have eaten my friend Martin, you will take his place and carry me about." The bear approaches Valerius and sweetly agrees to do what he has been asked. When they arrive in the village of Ustou, the inhabitants crowd around Valerius and his bear. And at this point after being given a bit of honey, in a sign of his appreciation, the bear Martin takes the bishop's walking staff in his hand, raises himself up on two feet and begins to dance, according to the text, "the most graceful of dances ever executed by a bear" (Bégouën 1966:138-139). But there is more. Because the villagers are so impressed by Valerius and his dancing bear Martin, they decide to set up their own school where little bears can be taught to dance. Moreover, the pious story could be understood equally to be one utilized to explain and legitimize the prestige, indeed, the European-wide reputation of the Bear Academy that had been established in the Pyrenean village of Ustou (Praneuf 1989:66-70).[29]

Such pious legends need to be examined more closely in terms of their psycho-social

intentions as well as their actual consequences. For instance, the above legend, in all likelihood promoted by the Church and locals alike, also gave the clergy a Christian-coded explanation for why bears were called Martin.[30] In addition, it sought to identify the bishop in question, Valerius, with the person of the Bear Shaman trainer. Even the dancing bear's long pole, the standard prop of all bear trainers, was attended to narratively and reinterpreted as the bishop's walking stick, his staff of office. As a result of these symbolic reinterpretations, the legend ended up providing the populace with an ingenious justification for conducting "good luck visits"; the narrative became a means of justifying deeply ingrained patterns of belief while slightly modifying them. At the same time by associating the dancing bear with a given saint's day, those wishing to carry out "good luck visits" were given a green light. Indeed, in many locations the performances continued to be conducted with relatively little interference from the Church authorities.

For example, today in many parts of Europe on the saint's day in question, November 11, an actor appears in the guise of the bishop, St. Martin. But, more importantly, when the individual dressed as a bishop does appear, he continues, as before, to be accompanied on his rounds by a bear-like creature, his pagan double. In short, these ursine administrants, in recent times merely ordinary human actors, perform their duties authorized by a kind of Christian dispensation that permits them to continue to preside, quite discreetly, over the festivities (Miles 1912:208). In turn the bishop in question takes over the role and attributes of the Bear Shaman healer. Thus, the meaning of the bishop's companion, the masked figure representing the bear, is transparently obvious once one understands the mechanisms involved in

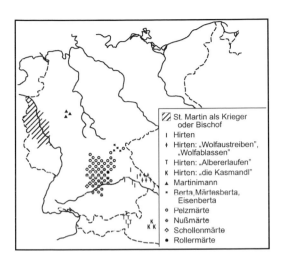

Figure 9.7 Names of the gift-bringers on St. Martin's Day (November 11). Adapted from Erich and Beitl (1955:509).

the renaming processes themselves.[31] In short, any attempt to discover the identity of the furry, often frightening, masked figures associated with St. Martin's day must take these facts into account (cf. Figure 9.7).

Moreover, in case there were doubts on anyone's part concerning the real identity of the bishop's companion, in Germanic speaking zones his side-kick was referred to not merely as Martin, but rather as *Pelzmärte*, a term that would be interpreted today as "Furry Martin" or perhaps "Martin with a Fur Coat". In fact, the *Pelzmärte* frequently appears alone, without his bishop, on St. Martin's day as well as on Christmas Eve. With respect to the *Pelzmärte*, we should recall that in much of Europe the "good luck visits" conducted on St. Martin's day (November 11) only later came to be transferred to the winter solstice (Miles 1912:161–247; Rodríguez 1997:97–105).

As has been noted previously, "Martin" was a common name for a "dancing bear" in France and Germany. However, the etymology given for

the German expression *Pelzmärte*, one that interprets the second element of the compound *märte* as a proper name, i.e., "Martin," could be nothing more than a folk-etymology, as I will demonstrate shortly. At the same time, the folk explanation for the meaning of *märte* as a proper name would have been reinforced, also, by the celebration of the "good-luck visits" on St. Martin's Day. As was shown in the narrative relating to how St. Martin acquired his bear and began to travel about with it, the introduction of a Christian saint served as a pretext for continuing with the highly entrenched practice of "good-luck visits".

Given that the belief in the supernatural healing powers of the bear and its retinue harkens back to a pre-Christian cosmology, to expect a conscious or inadvertent reanalysis of preexisting terminology would not be unusual. For example, there are two terms in German for the furry visitor that include the same prefixing element: *pelz-* "fur, furry". We have the expression *Pelznickel* where the second element - *nickel* is equated with a kind of "demon"; then, if we continue with the same semantic logic, we have *Pelzmärte* where the second element would also refer to a "demon" or some other sort of "supernatural being". Recalling that in addition to the term *Pelznickel*, in Germany we also find similar compounds for the "gift-bringers": *Nufssmärte*, *Rollermärte*, *Schellenmärte* as well as *Märteberta* (Erich and Beitl 1955:509), where in the latter case, the second element *Berta* refers to an ominous pre-Christian female figure, also referred to as *Pertcha* (cf. Weber-Kellermann 1978:19-23).

Although outside the scope of this study, there is reason to believe that these compounds containing *märte* are related to the terms *mârt*, *mârte*, *mârten*, as well as to the compound *Nachtmârt* (the Night-Mare) discussed at length in Thorpe (1851-1852:Vol. 3:154-155): "Under

all these denominations is designated that spectral being which places itself on the breast of the sleeping, depriving them of the powers of motion and utterance" (Thorpe 1851-1852:Vol. 3:154). These terms are linked etymologically to the English "nightmare" in which the second element - *mare* - is the modern English equivalent of the German *mârt*, *mârte*, *mârten*. These phonological variants, as well as other etymologically linked terms, refer to a supernatural being, a disturbing night visitor, often described as an ominous "presence" or "other" (Cheyne *et al.* 1999; Cheyne 2001, 2003; Hufford 2005). Curiously, the intruder is frequently attributed threatening, animal-like features that resonate with the description of a powerful supernatural being: "Qualitative descriptions of the sensed presence during sleep paralysis are consistent with the experience of a monitoring, stalking predator (Cheyne 2001:133). In short, with respect to its etymology the second element in German compounds such as *Pelzmärte* would appear to be related directly to the second element in the compound term "night-mare". However, in the latter expression, the adjective "night-" appears to focus attention more specifically on the ominous being's "nocturnal" manifestation and activities.

For those not familiar with the etymology of the English expression, the following summary puts things into perspective and demonstrates that previously the second component was a free-standing element:

"Nightmare" is built on Old English *mare* "female goblin", the feminine form of *mar* "goblin". This word is recorded from at least AD 700 in English, and it has established cognates in other Germanic languages. In English, it was applied from the beginning to an imaginary monster which perched on people's chests while they slept and caused them to feel suffocation or

other distress. From the late thirteenth century, the word often came to be reinforced by 'night', in the same sense. The original form *mare* endured until the seventeenth century, at least, after which it died out, though Dr. Johnson listed it in his 1755 dictionary.

For a long time, 'nightmare' continued to denote the monster, in which sense it competed with the alternative 'night-hag'. Until well into the nineteenth century, the usual locution was still 'to have the nightmare'. Only in the nineteenth century does the *Oxford English Dictionary* record any citations in which the newer sense of 'bad dream' seems to be intended. Since then, this has become the only sense, and the locution has become 'to have a nightmare'. With the disappearance of the original 'mare' from the language, an obvious folk-etymology has led to the reinterpretation of the second part of 'nightmare' as the unrelated word 'mare' (female horse; Trask 2000).[32]

As is apparent, the English term can be traced directly back to its Germanic origins: MDu *nacht-mare*, *-maere*, *-mier(i)e*, (Du. *-merrie*); MLG *nachtmar*, *-maer* (LG *moor*); MHG *nachtmare* (G. *nachtmahr*, *-mähr*) (cf. OED 1971:1926). Further research into this semantic field is merited and could reveal valuable additional insights into the cognitive origins of these terms.[33]

St. Nicholas and Black Peter

In the case of St. Nicholas, said to be a fourth century bishop from Myra in Turkey, his saint's day was celebrated in the spring until the thirteenth century. From the thirteenth century to the time of the Protestant Reformation in the sixteenth century, the individuals who dressed up as this bishop made their house calls on the sixth of December (cf. Figure 9.8).

It wasn't until after the Council of Trent (1545-1563) that the figure of Christkind or, in

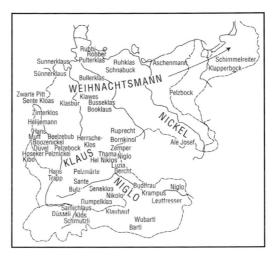

Figure 9.8 Names of the gift-bringers on St. Nikolaus's Day (December 6). Adapted from Erich and Beitl 1955:564.

its diminutive form, *das Christkindel*, the Christ child, was introduced.[34] He, too, was supposed to distribute gifts, but on Christmas Day.[35] That practice eventually forced St. Nicholas to change the date of his "good luck visits" to December 25, while, somewhat ironically, the expression *das Christkindel*, originally intended to designate little Jesus, evolved into Kris Kringle, one of the Germanic terms for Father Christmas (Rodríguez 1997:99-103). In the Netherlands, the bishop in question is accompanied, nonetheless, by Black Peter (*Zwarte Piet*), his faithful servant, whose role included carrying off misbehaving children in his giant sack.[36] And, on that note, we should recall that among Germanic speakers, one of the common nicknames of the dancing bear was Peter (Praneuf 1989:71).[37]

In addition, St. Nicholas himself has his semantic counterpart in *der Pelznickel*, an expression that could be translated either as "Furry Nicholas" or "Nicholas with a Fur Coat".[38] The fierce *Pelznickels* go by many other names, for example, Hans Trapp and Knecht

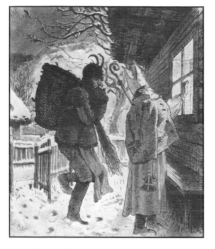

Figure 9.9 St. Nikolaus Eve. Source:
Weber-Kellermann 1978:27.

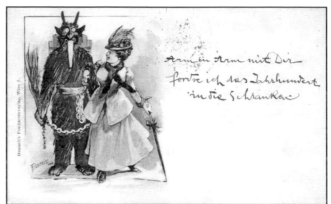

Figure 9.11 Krampus. Austrian postcard
from ca. 1900, provenance unknown.

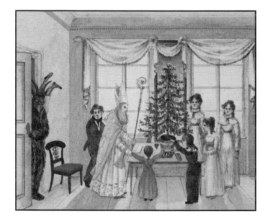

Figure 9.10 Painting by Franz Xaver von Paumgartten: Christmas Eve and St. Nicholas with the Krampus. Vienna 1820. (Museen de der Stadt Wein). Reproduced in Weber-Kellermann 1978:26.

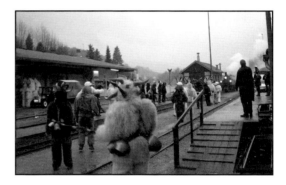

Figure 9.12 Waidhofen Station: Krampus performers preparing to catch a special steam locomotive that will take them to Ybbsitz, Austria, December 2, 2006. Source: http://www.ybbstalbahn.at/nostalgie_alt.htm#0212.

Ruprecht in Germany as well as Krampus in Austria (cf. Rodríguez 1997:103-104; Miles 1912:218-221, 231-232; Müller and Müller 1999; cf. Figure 9.9).[39]

The latter are rather scary creatures who appear either alone or in the company of an individual dressed as a bishop. The latter wears a long flowing robe or coat trimmed with fur and carries a staff.[40] In zones where the two characters appear together, the pair plays the role of "white and black inquisitors" (Halpert 1969:43; cf. Figures 9.10-9.11).[41]

Far from being a tradition lost in the mists of time, the customary visits by the Krampus and his Bishop are alive and well, indeed, thriving in modern-day Austria, where Krampus troupes have sprung up across the land. For instance, in places like Salzburg, Krampus performers number, quite literally, in the hundreds (cf. Figures 9.11–9.13).

In other contemporary European versions of this performance piece, for example, in Amsterdam, the Christian bishop Nicholas called *Sinterklaas*, dressed in white or red, enters first, followed by *Zwarte Piet* (Black Peter), his dark-faced companion (Chris 1992). The former interrogates the children and in the case of a good report, distributes gifts. Meanwhile his black-faced counterpart stands at the door, poised, if need be, to administer punishment, lashes, leaving whips, rods or chunks of coal behind for the misbehaving children.

It should be noted that, in contrast, when only one figure appears, *e.g.*, *der Pelzmärte*, *der Pelznickel*, *Hans Trapp* or *Knecht Ruprecht*,[42] although he often frightens the children he is in charge of distributing both punishments and rewards (cf. Figures 9.14–9.16).

For example, in the Mittelmark the name of *de hêle Christ* ("the Holy Christ") is given strangely to a skin- or straw-clad man, elsewhere called Knecht Ruprecht, Klas, or Joseph (cf. Figure 9.16). In the Ruppin district the man dresses up in white, with ribbons, carries a large pouch, and is called *Christmann* or *Christpuppe*. He is accompanied by a *Schimmelreiter* and a troupe of *Feien* with blackened faces. As the procession goes round from house to house, the *Schimmelreiter* enters first, followed by *Christpuppe* who makes the children repeat some verse of Scripture or a hymn; if they know it well, he rewards them with gingerbreads from his wallet; if not, he beats them with a bundle filled with ashes.[43] Then both he and the *Schimmelreiter* dance and pass

Figure 9.13 Entrance of Nikolaus and the Krampus in Dorplatz, Austria. December 2, 2006. Source http://www.ybbstalbahn.at/nostalgie_alt.htm#0212.

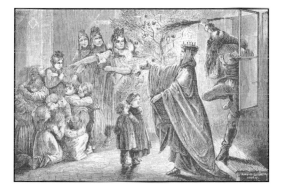

Figure 9.14 Christkind and Hans Trapp in Elsace 1850. Reproduced in Weber-Kellermann (1978:35).

on. Only then are the *Feien* allowed to enter; they jump about and frighten the children (Miles 1912:230–231) (cf. Figures 9.17–9.20).

While at first glance a gift of black charcoal appears to carry a purely negative connotation, Miles (1912:251–260) has demonstrated that charcoal was originally viewed in a positive light. Specifically, pieces of charcoal from the Yule Log were highly valued for their prophylactic characteristics as were the log's ashes which were carefully collected and utilized for a

Figure 9.15 Franz von Pocci (1807-1876): Der Pelzmärtel, 1846. Reproduced in Weber-Kellermann 1978:32.

Figure 9.16 Franz Regi Göz. Knecht Ruprecht 1784. Reproduced in Weber-Kellermann 1978:32.

Figure 9.17 Father Christmas (Weihnachtsmann) with a White-Horse (Schimmel) and two companions carrying grease (Schmalzbäckerpaar), Demmin, Pommern, Germany. c. 1930. Photo Wolf Lüking. Source: Museum Stralsund. Reproduced in Weber-Kellermann 1978:29.

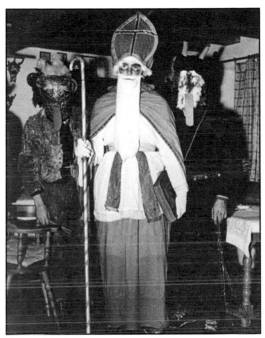

Figure 9.18 St. Nikolaus with his companions in
Berchtesgaden, Bavaria 1958. Photo Wolf Lüking.
Reproduced in Weber-Kellermann 1978:33.

Figure 9.19 St. Nikolaus with his companions in
Bavaria 1958. Photo Wolf Lüking. Reproduced
in Weber-Kellermann 1978:29.

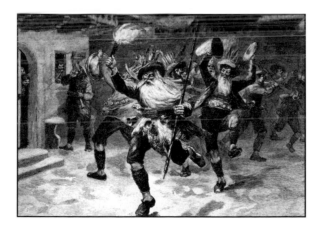

Figure 9.20 Oscar Gräf (1861-1902). Perchtenlaufen Festival in
Salzburg 1892. Reproduced in Weber-Kellermann 1978:21.[44]

variety of healing purposes.[45] Moreover, it has been argued that the ethical distinction between good children and bad children along with the consequent distribution of gifts or blows, "is of comparatively recent origin, an invention perhaps for children when the customs came to be performed solely for their benefit, and that the beatings and gifts were originally shared by all alike and were of a sacramental character" (Miles 1912:207). Further evidence for structural inversions in gift-giving comes from the fact that in other parts of Europe it is a troupe of young adults along with their bear (or bears) who visits the households and expects, in return for their services, to receive, not give, "treats" of food and drink (Alford 1928, 1930, 1931, 1937; Praneuf 1989).

In Europe, the ritual cleansings that formed part of the "good luck visits" included fumigations, incensing by smoke, and flailing the person with aromatic branches. Such ceremonies recall similar healing techniques involving smudging with the sacred smoke of juniper branches, still performed today by Native American medicine men and women (Brunton 1993:138). Hence, from a diachronic point of view the European whipping customs are perhaps better understood not as "punishments, but kindly services; their purpose is to drive away evil influences, and to bring to the flogged one the life-giving virtues of the tree from which the twigs or boughs are taken" (Miles 1912:207). Indeed, wands were often constructed for this purpose from a birch-bough with all the leaves and twigs stripped off, except at the top, to which oak-leaves and twigs of juniper pine were attached along with their bright red berries. Devoid of decoration, these rods or switches became broom-like devices that were used to sweep away unhealthy influences.[46] Pig bladders attached to poles were also used in such prophylactic flagellations. In short, blows delivered by the switches and bladders were believed to insure good health, promote fertility in animals and humans alike as well as the fruitfulness of crops: they were intended to bring about prosperity in general.

The Demise of Furry Nicholas and the White Mare

At this point we can finally turn our attention to the transformations that took place once these European traditions reached the United States, particularly under the influence of the Dutch colonists who in the sixteenth century brought over their *Sinterklaas* and associated customs. In fact, upon their arrival, in 1621, to New Amsterdam (the island of Manhattan), they erected a statue to St. Nicholas in gratitude for his protection on their transatlantic voyage. Naturally, the colonists continued to celebrate their saint's day on the sixth of December. However, it would appear that while *Sinterklaas* arrived safe and sound, Black Peter would meet a different fate. Indeed, there is not hide, nor hair of him in the engraving commissioned in 1810 by the New York Historical Society. There we see St. Nick standing tall, if not somewhat arrogantly, all decked out in his bishop's regalia, holding a sack in one hand and his staff in the other. He has two children beside him, one, cherubic and happy, holding his stocking jammed full of gifts, and another, sad and frowning, with a pathetic handful of sticks. But Black Peter is nowhere to be found (Chris 1992:34–37; Rodríguez 1997:107).

How conflicting forces can reshape even deep-seated customs can be seen in the following example: that the universal practice of guisers blackening their faces was banned in the Philadelphia Mummers Parade in 1963 by the city fathers "out of fears concerning the sensitive color issues of the time", *i.e.*, at the height of the Civil Rights Movement and, specifically, the year of major demonstrations, the National March on

Washington, sit-ins and freedom riders moving across the southern states (cf. Halpert 1969:55; Welch 1966:533-535). Furthermore, I would argue that in the United States the eventual disappearance of Black Peter from public consciousness is directly linked to other even earlier events, the Civil War and Reconstruction. This is because in the performance pieces brought by the sixteenth-century Dutch colonists, the European bear figure with its blackened face had already been reinterpreted as a "negro man-servant" who regularly accompanied *Sinterklaas* on foot, while the latter appeared riding on his elegant white horse.

While Black Peter disappeared from the cast of characters in the USA, he still accompanies *Sinterklaas* in Holland even though his presence has given rise to discussions concerning the political correctness of this practice (cf. Figure 9.21).

On the one hand, there are those who have argued that the figure of Black Peter is tainted with colonialism and racism; others maintain that tradition is tradition and this character should be retained (cf. Blakely 1993, 2003; Helder 2005; Helder and Gravenberch 1998) (cf. Figures 9.21-9.22).[47]

In the United States other transformations would take place, not the least of which being the metamorphosis of the traditional White Mare into reindeer. Upon closer examination we discover that many familiar aspects of the American Santa Claus can be viewed as products of the fertile imaginations of four remarkable individuals. First, we have Washington Irving (1783-1859) who in his *Knickerbocker's History of New York* (1809) divested St. Nicholas of his bishop's garb and severe inquisitorial demeanor, took away his white horse and bear companion, leaving behind a quintessentially good-natured bourgeois Dutchman contentedly smoking his long clay pipe. Indeed, in a very short time Washington

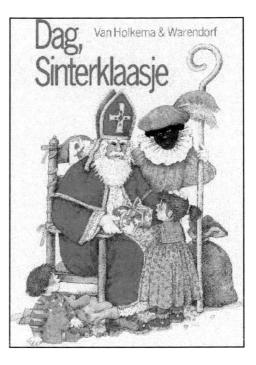

Figure 9.21 Dag, Sinterklaasje (Hello, Sinterklaas). Source: Vrions 1983. Illustration by Dagmar Stam.

Irving's writings managed to turn the popular *Sinterklaas* or *Sinter Klaas* of Holland into the tutelary guardian of New York (cf. Chris 1992:37-41; Rodriguez 1997; Webster [1869] 1950 rpt; cf. Figure 9.23).

The next step in the metamorphosis of the European character was undertaken by Clement C. Moore, the biblical scholar who, in 1822, wrote his now famous poem "An Account of a Visit from St. Nicholas" in which Santa acquires his sled and reindeer.[48] This poem, in turn, was illustrated by the political cartoonist Thomas Nast in a series of vignettes published in *Harper's Weekly* between 1863 and 1886 (cf. Nast 1971).[49]

However, the artist, born in Bavaria, brought with him to New York fond memories of the *Pelznickel* whose furry brown body and paws

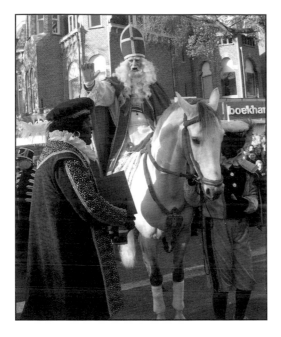

Figure 9.22 Official arrival of Sinterklaas *on his White Horse with two companions* (Zwarte Pieten) *in the Scheveningen Harbour, The Hague (November 13, 2004). Photo: ShanT Frigge from the website "ShanT's World" at* http://www.shant.eu.

Figure 9.23 Brown furry-suited Santa.
Source: Webster ([1869] 1950) version of book cover.

reappear quite clearly in his early drawings (cf. Nast [1890] 1971:53), although the creature is also often shown smoking a long-stemmed Dutch pipe (cf. Nast [1890] 1971:56).[50] Nast's Santa has been categorized as "a direct descendent of *Pelz-Nicol* [sic], the counterpart of St. Nicholas ... [and] the beaming, wholesome Santa Claus of today with his baggy costume gradually evolved from the more sinister appearing Santa with his furry skin tight costume" (Webster [1869] 1950 rpt.).[51]

Finally, in 1931, we find Haddon Sundblom, a publicist for Coca-Cola® from Chicago. It is Sundblom who should be given credit for giving the American Santa his final form, for crafting that jovial consumer Santa so familiar to children and adults alike the world over.[52] And in a stroke of genius, from 1931 forward the official colors of *Coca-Cola*®, red and white, would be identified year after year with the bright colors found in Santa's suit (cf. Chris 1992; Rodríguez 1997:107-132). The Chicago artist reworked Nast's chubby bear-like Santa into a taller, ever smiling and more humanized version, the ideal grandfather, basing his paintings initially on the face of his friend Lou Prince and upon the death of the latter, on his own.

Almost every year from 1931 to 1964 Sundblom painted new illustrations for Coca Cola and their annual Christmas advertising campaign. These advertisements appeared in *Saturday Evening Post*, *Ladies' Home Journal*, *National Geographic*, *Life*, *etc.*, as well as on billboards and point-of-purchase store displays. As Berryman (1995) has noted: "The Coca-Cola Company's large advertising budget ensured that Sundblom's distinctive vision of Santa

received massive exposure across the country and around the world." Unquestionably the jolly, fully human Santa figure popularized by Coca-Cola was a successful ambassador of feel-good consumerism and optimism and, like Moore's Santa, he was plump and grandfatherly with twinkling eyes and a hearty laugh.[53]

In short, the massively successful publicity campaigns surrounding these illustrations, still used by Coca-Cola today, are undoubtedly one of the major reasons for the rapid diffusion of the image of the American Santa Claus throughout the world (cf. Rodríguez 1997:108-132; Chris 1992) and the consequent loss from our collective consciousness of the astrally-coded figures of the European Bear Ancestor and his Spirit Animal Helpers.[54] In the United States the sack is stuffed not with terrified children, but with candies and toys. By this point, we might argue that the conversion of the animal-like creature into an inoffensive, child-friendly bearer of consumer goods is nearly complete,[55] while the "good-luck visits" have ended up having primarily children as their beneficiaries, rather than adults. Yet this fact should not lead us to the naïve conclusion that the transformation has been uniform or that the only image left is that of the rosy-cheeked American Santa. Rather, for example, in Austria still today we discover the older horrific image of the Krampus, the creature who goes after innocent passersby, often striking fear in the hearts of misbehaving children, another sign of the continuing strength of this ancient and quite indigenous ursine tradition of Europe (cf. Figures 9.24-9.25).

Epilogue

My relationship with Alexander Marshack dates back some thirty years. It started in October of 1975, when I first contacted him concerning his research, not long after the publication of his book, *The Roots of Civilization* (1972). At the time I was preparing a syllabus for a course on Basque language and culture at the University of Iowa. By then I had already initiated fieldwork in the Basque Country and was exploring various aspects of traditional Basque culture, including Basque metrological practices. That line of ethnomathematical research had led me to discover that certain Basque numbers had connotations that struck me as, frankly, rather bizarre, especially the expression *hamalau* which means "fourteen". It would not be until nearly two decades later that I would finally discover, with Alex's help and encouragement, that this number was also the name of the Bear Son ancestor in Euskara.

Indeed, I can say that the present chapter owes a great deal to a casual conversation that I had with Alex in April of 1990 when I was visiting him and his wife, Elaine, at their home in New York City. In the course of our discussions he brought out an old clipping he had saved from a French newspaper. The clipping included a quote from the work of Bernard Duhourcau. He asked me whether I knew anything about the folktale cited by Duhourcau (1985:45), which includes a main character called *Hamalau* "Fourteen". At the time I had never heard anything concerning the Bear Son tales, let alone any mention of the numerically-coded name of the Bear Son, but I promised him that I would look into the matter further.[56]

Over fifteen years have passed since that initial query on Alex's part - years spent interviewing elderly Basque speakers, examining aspects of European performance art that previously had gone relatively unnoticed and finally reaching a point at which the cognitive networks connecting the various datasets began to merge and coalesce.

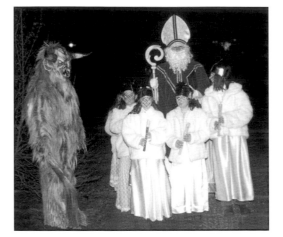

Figure 9.24 Nikolaus und Krampus. Pettneu am Arlberg,
December 2003. © Karl C. Berger.

In short, I should say that the present study is the fruit of that initial conversation with Alex as well as the result of many subsequent long distance telephone calls, exchanges of emails and letters over many years in which Alex continued to patiently question me on each stage of my research, while at the same time encouraging me to continue to pursue further this line of investigation into European bear ritualism and the hunt for the origins of the European sky bears.

About the author
Roslyn Frank, Dept. of Spanish and Portuguese, Schaeffer Hall, University of Iowa, Iowa City, Iowa 52242, USA; E-mail: roz-frank@uiowa.edu.

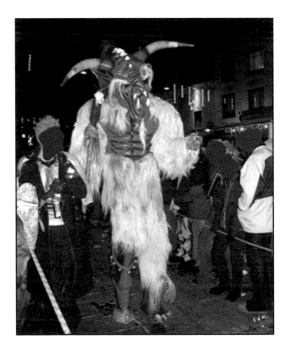

Figure 9.25 A very large Krampus. December 2002.
Source: http://www.luehrmann.at/ BildderWoche/ 2002/02-12-04-krampus.jpg.

Endnotes

1 The quote is from an interview conducted in the fall of 1983 with the last Basque-speaking bear hunter in the Pyrenees, Petitiri Prébende who among other things said the following with the tape-recorder running: "Lehenagoko euskaldunek gizona hartzetik jiten zela sinhesten zizien" ["Basques used to believe that humans descended from bears"] (Peillen 1986:173).

2 The photo, taken by Till Credner of www.AlltheSky.com, is a view of the constellation Ursa Major shining over Castle Hohenzollern in the Swabian Alb range of southern Germany.

3 While there are extant Greek tales, *e.g.*, Callisto, these are clearly modern in their conceptualization, rather than reflecting a cosmology congruent with a hunter-gatherer mentality.

4 The expression derives from *hartz* "bear" and *(k)ume* "infant, baby, little one", literally translated, "bear-baby".

5 In certain zones of the Pyrenees the popular performances acted out each year by the villagers include vignettes that reproduce scenes from the Bear Son saga (cf. Alford 1930, 1937).

6 Although initially, some thirty years ago, my field work and archival research focused almost exclusively on the Basque region of the Pyrenees, eventually I discovered that the same cycle of Bear Son stories is found throughout Europe (Barakat 1965; Claudel 1952; Cosquin 1887; Espinosa 1911, 1951). Even though initially folklorists did not recognize the significance of the European stories, the surprisingly widespread distribution of the Bear Son tales caught the attention of researchers and was already an object of serious investigation by ethnographers in the 1880s (Cosquin 1887). By 1910 Panzer had documented 221 European variants of the 301 story type, the descent of the Bear Son hero to the Under World (Panzer 1910). In a study published in 1959, 57 Hungarian versions of the tale are mentioned (Kiss 1959) and in 1992, Stitt, in his study *Beowulf and the Bear's Son; Epic Saga, and Fairytale in Northern Germanic Tradition*, recorded 120 variants of the Bear Son story for Scandinavia alone. The cycle of oral tales is present in all the Indo-European language groups of Europe and, more significantly, in European languages classified as being far older, such as Basque and Finno-Ugric, Finnish, Saami (Lapp) and Magyar (Hungarian), languages that antedate structurally those of the Indo-European group. However, in the latter languages and cultures the tales retain more clearly the earlier shamanic cosmology which served cognitively to transmit the traditional tales and to communicate their celestially encoded message concerning the Celestial Bear to the teller of the tales and his/her audience (Arratibel 1980; Cushing 1977; Dégh [1965] 1969; Erdész 1961, 1963; Shepard and Sanders 1992). Nonetheless, throughout Europe still today we encounter abundant examples of the cultural practices that implicate the previous veneration of bears and the bear ancestor.

7 Paul Shepard has referred to this earlier ecocentric worldview as a kind of "trophic metaphysics" where the complex network of food chain relations is understood and articulated in narrative and social practice. Furthermore he has suggested that initially the image of Ursa Major, the "sidereal bear" was projected on the upper world as "the mythic celestial equivalent" of these relations in the earthly world (Shepard 1995:6, 1999:92, 97). Gary Snyder, on the other hand, speaks of the process of "re-inhabitation" where the separation and alienation between human and animal – the boundaries between culture and nature – become diffused (Snyder 1990:155–174, 1995). Assuming that we descend from bears ruptures more familiar hierarchical anthropocentric modes of thought (Frank and Susperregi 2000; Frank 2003, 2005a; Hartsuaga 1987).

8 Over the past decade a remarkable number of studies have been published dealing with the Bear Son tales and their ritual re-enactments. They reflect the increased interest on the part of scholars in deciphering the deeper and often enigmatic ecocentric narrative coding of the European materials (Frank 1996a:131).

9 Although it would be tempting to see in these spatial coordinates a seeking of transcendence, as Brunton in his study of Kootenai shamanism has astutely pointed out, all three "worlds" are altered time-sync extensions of this one: "The visionary has not transcended one world to another; he or she has shifted consciousness so as to notice the approach of a spirit who has come to meet him or her. In Harner's (1980) terms, the person has left the 'ordinary state of consciousness' (the OSC) and has entered the 'shamanic state of consciousness' (the SSC)... Ceremonies involve the same basic approach. In each the spirits are 'called' to join the Kootenai in the Middleworld to help resolve some problem or provide some information... When Kootenai shamans do 'journey', they do so in the Middleworld in a clairvoyant journey" (Brunton 1993:142–143). Hence, the Upper World, as such, is merely the space where birds fly, while the Under World is where roots grow and rabbits hide.

10 There is a suggestion that previously in the European ritual performances the Sky Pole was symbolized by a long staff or sapling decorated with leaves and ribbons. Moreover this *axis mundi* appears to have been perceived as incarnate in the long heavy stick held by the dancing bear himself. In fact, at one point in the performance the bear's trainer makes him climb back up the pole (cf. Alford 1930:270).

11 For a discussion of similar public re-enactments and "good luck visits" conducted on Candlemas Bear Day (February 2) and understood to form part of the World Renewal Ceremonies associated with the Spring Carnival period, cf. Frank 2001.

12 For a detailed discussion of the typology of the "good luck visits", cf. Halpert 1969.

13 As is well known, violence and veiled, even overt forms of social protest were frequently associated with the "tricks" carried out on All Hallow's and during the Christmas mumming season when the performances were utilized as a mechanism for enforcing community norms of behavior and an opportunity to punish those who digressed with relative impunity. Certainly, the butt of these satires was often the Church and civil authorities, a fact that brought about repeated ecclesiastical and civil condemnations of the mummers and their plays (cf. Alford 1930; Caro Baroja 1965; Halpert 1969; Le Roy Ladurie 1979; Miles 1912; Szwed 1966).

14 For a discussion of contemporary samples of such reports, cf. Fabre 1986; Fernández de Larrinoa 1997.

15 For additional bibliography and a discussion of modern versions of the performance, cf. the collection of essays in Halpert and Story 1969.

16 Some of the most archaic versions of these performances have survived in the Pyrenean region. Among them the Basque *Maskaradak* is undoubtedly the most complete performance piece in terms of its robust repertoire of dances, songs and associated characters. Yet the prototypical performance piece appears to have a somewhat more learned counterpart in the English Mummers' Play and Morris Dances, in the "St. George" dramas and "Soulers' Play", performed on or near All Souls' Day, as well as in the continental "St. Nicholas" plays. The German "St. Nicholas" plays appear to be more Christianized and sophisticated forms of the prototypical folk-drama in question (cf. Miles 1912:298–301; Alford 1978; Halpert 1969; Sieker 1997).

17 In the case of the Basque *Maskaradak* performances the cast of characters appears to include the counterpart of the female Black Wolf, the Trickster character from the Bear Son story, who is the hero's nemesis (cf. Frank 1997, 2005b). In the Basque performances we find a character called Pitxou who is equipped with a bushy tail and furry animal mask. The character dances about, repeatedly squatting on all fours and miming the movements of a wolf or fox-like animal (cf. Fernández de Larrinoa 1997; Frank 2005b; Urbeltz 1994:371). In addition, the actor's role is clearly that of a contrary, a sacred clown, a jester, and for that reason he sometimes appears equipped with a stick with a bladder attached to it.

Indeed, Pitxou might be considered a proto-clown, *i.e.*, kind of prototype of the early European ritual clown. In the English "St. George" dramas and Mummer's Plays, Pitxou's counterpart seems to be "the 'fool' (Tommy) who wears the skin and tail of a fox or other animal" (Miles 1912:301). Although in some regions the fool's props and costume took a decided turn toward the decorative, even the pretty, the foxtail continued to be fairly common "in later fool iconography in German Carnival plays and satirical broadsheets of the sixteenth and seventeenth centuries, *e.g.*, in Hans Sachs' *Fuchsschwanz-kram* (Foxtail Market), Arlecchino of the *Commedia dell'Arte* would also occasionally sport one. The dwarf-fool Godfrey Gobelyve in Stephen Hawes' *Passetyme of Pleasure* (1505) is outfitted 'with a hood, a bell, a foxtayle and a bagge'. The foxtail as hand prop appears to be an alternative to the bladder for flogging purposes" (Walsh 1996:136–137).

18 Among the cast of characters participating in the "good luck visits" we repeatedly find the astrally coded figure of the White Mare. She is called *Làir Bhan* ("White Mare") in County Cork; the midwinter *Mari Lwyd* in Wales; the *Zaldiko* and *Zamalzain* in Euskal Herria (the Basque Country); *Caballito* in Majorca; *Chivalet* in Languedoc; *Bidoche* in Normandy and Brittany; *Chivau Frusc* in Provence; "Hobby-Horse" in Cornwall and Ireland; "Old Tup" in Yorkshire; the midwinter Abbots Bromley "Horn Dance Hobby"; the midwinter daemon "Hooden Horse" of Kent; the Flemish *Huppelpaardje* and in Brussels *Bierzepaardje*; in Holland the *Chins-Chins* of Mons; the *Klibnas* of the midwinter carnival in the Czech Republic and Slovakia and *Caluts* in Romania (cf. Alford 1978; Praneuf 1989:139; Miles 1912:199–202 and also http://www.hoodening.org.uk). In some locations the White Mare Spirit Animal Helper has been replaced by a goat or buck, *e.g.*, in the island of Usedom she appears as the *Klapperbock*, a youth who carries a pole with the hide of buck thrown over it and a wooden head at the end. The lower jaw moves up

and down and clatters, and she charges at children who do not know their prayers by heart. In Upper Styria there is a similar figure, the *Habergaiss*, a wooden goat with a jaw that rattles and at Ilsenburg in the Harz we find the *Habersack*, formed by a person taking a pole ending in a fork, and putting a broom between the prongs so that the appearance of a head with horns is obtained (Miles 1912:201).

19 As has been mentioned, the horse in question could be linked symbolically to two constellations hanging low in the southern sky where Centaurus is shown slaying Lupus (the Wolf). The scene depicted is highly suggestive of the encounter between the White Mare Animal Helper aiding the Bear Son slay the female Black Wolf. Thus, taken together, the celestial duo would illustrate a culminating moment in the Bear Son saga. In that story the White Mare is a Spirit Animal Helper and, consequently, the hero takes on her identity by shape-shifting. That fact leads to the fused nature of horse and man (cf. Frank 2005b). In folk performances the anthropomorphic element sometimes becomes the focus of attention, converting the hero into the rider of the horse, rather than portraying him as partially shape-shifted and, hence, as a more centaur-like being. Furthermore, as Alford (1978) has suggested, in some locations ritual behaviors originally related to the death and resurrection of the bear were transferred to the Hobby-Horse, in all likelihood a strategy of popular resistance that came into play after the Church's repeated attempts to marginalize the bear's central role in the public performances.

20 In Denmark, Sweden and Norway creatures resembling both the *Schimmelreiter* and the *Klapperbock* are or were to be met at Christmas. "The name Julebuk (yule buck) is used for various objects: sometimes a person dressed up in hide and horns, or with a buck's head, who 'goes for' little boys and girls; sometimes a straw puppet set up or tossed about from hand to hand; sometimes for a cake in the form of a buck" (Miles 1912:202).

21 The characters shown in Figure 9.4 also go by the name of *Buttenmänner*, a term apparently deriving from the type of basket traditionally used to collect grapes in this zone that the masked creatures would carry on their backs while they made their rounds with St. Nikolaus.

22 Other materials used for the bear's costume include moss and/or leaves. These actors, sometimes called "men of the forest" – as were bears themselves – are identified also as "wild-men" (cf. Bartra 1994; Giroux 1984; Truffaut 1988; Urbeltz 1994).

23 The dates for the public performances vary. For instance, in Romania, *e.g.*, in Moldavia, the performance of the Bear Fest and related "good-luck visits" occur between December 25 and January 1, while in Greece they take place at the end of spring, in May, for example, in Makrynitsa, a locality in Thessaly at the foot of Mt. Pelion, where the other actors are also accompanied by a group of Hobby-Horse Centaurs (Praneuf 1989:66).

24 For additional information and valuable documentation concerning the Whittlesea Straw Bear festival, cf. http://www.strawbear.org.uk/. The festival is celebrated each year in the month of January in Whittlesea, England. The Whittlesea Straw Bear is supported by the Fenland District Council and Whittlesea Charities.

25 For an intriguing discussion of contemporary belief in the healing powers of "dancing bears" in India and the efforts to protect these so-often abused bears, cf. Seshamani and Satyanarayan (1997:Chap 5).

26 In many versions of the Bear Son saga this Spirit Animal Helper appears as a grey mare rather than a white one (cf. Frank 2005b).

27 At this stage I should express the following caveat. Although in this paper I refer to Bear Shaman healers in the masculine, there is evidence that in Europe the ritual healers themselves were often women. Indeed, terms such as *belharegile* and *belharegin* "plant worker, healer, shaman" (Iribarren 1984:83) as well as Hartz Kume "Little Bear" in and of themselves have no overt gender identity in Euskera (Basque). Moreover, in the cycle of tales all the Spirit Animal Helpers appear to be female, just like the White Mare. There is additional evidence for a female-oriented interpretation of the European materials, but given the complexity of the arguments required to explain that interpretation of the data, I have chosen to refer to the figure of the Bear Shaman in the masculine. Moreover, I would note that when contemplated from within the cognitive framework of shamanism, gender identities are constructed in a radically different fashion (cf. Balzer 1996; Shepard 1992; Sokolova 2000).

28 Because of his mode of walking the bear's footprints are remarkably similar to those left by human beings. For this reason in the Pyrenees, the bear is often referred to as *pedescauous* (*pieds nus*), i.e., "he who walks barefoot" (Calés 1990:7; Dendaletche 1982:92-93).

29 In Ustou and Ercé, we discover two of the most well known of those institutions of higher learning where little bears were sent to be educated and trained, often at public expense. The schools continued to function into the

twentieth century. Indeed, earlier the teachers and future bear trainers constituted a highly structured fraternity based in the Pyrenean zone of Ariège, while their pupils ended up performing throughout Europe (Bégouën 1966:138-139; Praneuf 1989:67). Upon graduation the ursine pupils were brought to the town square for a remarkable public ceremony (Praneuf 1989:68-69). While our previous example is based on data drawn from the Pyrenean region, in the northeast of France, in the Bas-Rhine at Andlau, there is documentary evidence concerning a Christian site inaugurated in the ninth century, the Abbey of Andlau. Although nominally Christian, the legends connected to the location strongly suggest a deeply rooted belief in the sacredness of bears. The site in question is linked to a miracle about a bear. Supposedly, as a result of the miraculous event, those inhabiting the abbey began to house bears inside their quarters. The villagers of the area brought a loaf of bread each week to offset the costs of feeding the ursine lodgers. Up until the French Revolution, bear-trainers of this zone of Alsace also had the privilege of free lodging and a stipend of three florins and a loaf of bread. Even today, next to the crypt of the tomb of the officially recognized saint of the Abbey, Saint Odile, one can see the figure of a bear, carved in stone, resting on one of the pillars (cf. Clébert 1968:325-328). Yet one suspects that in earlier times the Christian saint's silent companion may have played a more active role. In fact, one suspects that the location in question may have served as a breeding ground for tame bears and bear trainers, as a place were the members of the guild met and exchanged information (cf. Gastou 1987). Perhaps further research would reveal the existence of other religious sites, inhabited by bears and their keepers, scattered across Europe. It should be remembered that in Medieval Europe the bear-keepers often performed in the company of a troupe of masked actors, musicians and jesters. However, until now little attention has been paid to the role of the bear-keepers' and jesters' guilds.

30 For additional discussion of this legend and similar ones, cf. Lebeuf 1987.

31 In addition to the Pyrenean zone, across much of France and the rest of Western Europe the dancing bear is called Martin; in the Carpathian region of Romania among its nicknames are *Mos Martin* (Old Martin), *Mos Gavrila* (Old Gabriel), as well as *Frate Nicolae* (Brother Nicholas). In Russia, the bear is referred to as *Mikhail* (Michael) or, more familiarly, by the diminutive *Michtka*, an expression whose popularity is perhaps connected to the phonological convergence of this term of endearment with *Mechka* ("Little Bear"). The latter comes from *medvedica*, a diminutive form of *medved* "honey-eater". In other parts of Europe the bear is also called *Blaise*. The name is linked to the date of February 3 and the figure of St. Blaise, the patron saint of bears. In addition, this saint's day coincides neatly with the day after Candlemas Bear Day, the latter being celebrated on February 2. In the Balkans, it is St. Andrew who is presented as the patron of bears (cf. Lebeuf 1987; Praneuf 1989:32, 61-71).

32 Trask (2000), drawing on the resources of the OED (1971:290), continues discussing a related spectral being, the *bugbear*:

> As for 'bugbear', this appears to be built on the obsolete word 'bug', meaning 'an object of terror, especially an imaginary one', 'bogey man'. This is suspected of deriving from an early Welsh word *bwg* 'ghost', 'hobgoblin'. This 'bug' is recorded from the late 14th century to the early 18th century, since then it has died out. The compound 'bugbear' is recorded from the late 16th century, and its second element is apparently the ordinary word 'bear', the animal name. It originally denoted an imaginary monster, presumably in the shape of a bear, which supposedly ate naughty children, and which was used by nurses to threaten children. This sense eventually died out in favor of the more general sense of 'an object of needless dread', 'imaginary terror'. It is possible, though far from certain, that the original 'bug' is continued in 'bogey man'. The problem is that 'bogey man' is not recorded until long after the original 'bug' had apparently disappeared from the language.

An animistic worldview can be discerned in the fact that the Welsh meaning of *bwg* "ghost, hobgoblin" is also the etymology of the English term bug "insect" (OED 1971:290).

33 I explore the etymological origins of the terms used to refer to the concept "night-mare" in more detail in the second half of this study, namely, in an essay entitled "The Darker Side of Santa". In addition to the Germanic reflexes of the nocturnal mare, that essay addresses Slavic reflexes of the term and, more concretely, Sorbian/Wendish terms, as well as the Sorbian/Wendish "good-luck visits", their structure and cast of characters. Finally, in that essay Sardinian data are analyzed which demonstrate remarkable similarities with the Basque materials. In this regard, it should be noted that the other name for the Bear Ancestor is Hamalau, a word composed of *hama(r)-lau* "ten-four" which means "fourteen" in Basque. Stated differently, the being's name is the number "Fourteen". Perurena (1993:265-280; 2000) has suggested that Hamalau is the name that was given to the main pre-Christian (ursine)

divinity of the Basques. Curiously, variants of the Basque name of this supernatural being are also employed to refer to the ominous night-visitor while the Basque phonological variants are themselves remarkably similar to the Germanic and Slavic terms discussed above (Satrústegi 1975, 1981, 1987; Frank in prep. a, b). The similarities between the lexical items bring into view the thorny question of the nature of the linguistic landscape during the Mesolithic (and earlier), a topic broached by investigators working within the framework of the "Paleolithic Continuity Theory" (cf. http://www.continuitas.com/ ; cf. esp. Alinei 2004; Costa 2001; 2004; Otte 1995). as well as by Theo Vennemann (Vennemann 2002; Lekuona 2002) who alleges that languages from the Vasconic family of which modern Basque is a descendent, were spoken earlier across much of Europe. Thus, according to Vennemann, Basque should be considered a descendant of the Old European language family, which he refers to as Vasconic. It is proposed that after the last glaciation, peoples from southern Europe who spoke Vasconic languages populated western, northern, and large parts of central Europe before the advent of the Indo-Europeans, naming important features of their environment in a uniform way with appellative expressions that were later taken over by successive non-Vasconic intruding populations. For another perspective, cf. d'Errico *et al.* 2003:49-50.

34 For a detailed and eminently erudite discussion of the various and sundry efforts, often frustrated, on the part of the Church to establish the date for celebrations associated with the birth of Christ, cf. Tille 1899:119-137. Based on Tille's discussions, it should be noted that in Britain even into the sixth century there was significant confusion concerning whether the third of the three great Christian festivals, the first two being Easter and Pentecost, was Epiphany or Christmas. Indeed, for many centuries competing dates for Christ's birth were November 17 and March 28 (Tille 1899:119).

35 Nonetheless, in the United States, as in many other European countries, even into the early nineteenth century, if presents were exchanged at this season it was usually done on New Year's Eve and they were exchanged between adults rather being given to children. "In the 1840s there was an increasing emphasis on Christmas Day. This seems to have happened for several reasons. The press – which now reached a far wider audience with its cheaper production costs and consequently wider circulation – stressed the fact that Christmas Day was the celebration of the birth of Jesus. Birthdays had always been a day for giving presents and it was a natural step to celebrate Jesus's birth by giving gifts on that day. ... By the end of the century Christmas Day was firmly fixed – in England at least – as a children's festival and the day on which presents were given" (Chris 1992:87-88). Similarly, in the United States, the gift bringing aspect of the celebration of St. Nicholas' day (December 6) was eventually reassigned to Christmas Eve.

36 For a particularly cogent analysis of the "bellsnickles" and Christmas mumming as well as the connections between the "bellsnickles", Zwarte Piet and the Caribbean counterparts of this furry figure, cf. Siefker 1997, especially pp. 7-15 and Chapter 3, "His Clothes Were All Tarnished With Ashes and Soot", pp. 17-39. Cf. p. 11 for the reproduction of a curious painting with the heading: "The Black Pete figure that accompanied Saint Nicholas on his Christmas expeditions also accompanied women saints on their gift-giving rounds, as shown above. Black Pete's role was to threaten misbehaving children and rattle his chain." Unfortunately, no source is provided for the painting.

37 Concretely, in Germanic zones, he is called Per, Pater, Petz and Batz as well as Meister Braun (Mister Brown/Bruin), while in Switzerland the bear's common nickname is Mutz (cf. Lebeuf 1987; Praneuf 1989:71). Moreover, according to a popular belief still alive at the end of the nineteenth century in the Pyrenees, there was a great bear who sat beside St. Peter and when a person's soul arrived at the Gate of Heaven, the saint began his interrogation by asking the individual whether she had treated bears properly and with respect in this life (cf. Hollingsworth 1891).

38 Examples of this visitation by disguised inquisitors are found in North American German traditions from Nova Scotia, Virginia and particularly the nineteenth-century Pennsylvania Dutch where it is called "belsnickling" (Halpert 1969:43), obviously a verb derived from a phonological reinterpretation of the German expression Pelznickel (cf. Bauman 1972; Cline 1958; Creighton 1950). Indeed, there is evidence of further attempts to make sense of the name given to these actors who were referred to as "belsnickles" and "bellschniggles", by reinterpreting the term as two separate words: Bell Snickles (Siefker 1997, esp. pp. 17-26). Here the folk reinterpretation appears to have been motivated by the ox bells and other noise-makers employed by the mummers (Creighton 1950:58-59): "It was the custom of young people ... to organize Bell Schnickling parties in October and November of each year..." (cited in Halpert 1969:40-41). By 1827, as Nissenbaum (1997:100) points out, in the *Philadelphia Gazette* "the Belsnickle was being compared to Santa Claus" and we see that the Belsnickle described

in this newspaper article was made up in blackface: "Mr. Bellschniggle is a visible personage. ... He is the precursor of the jolly old elf 'Christkindle,' or 'St. Nicholas,' and makes his personal appearance, dressed in skins or old clothes, his face black, a bell, a whip, and a pocket full of cakes or nuts; and either the cakes or the whip are bestowed upon those around, as may seem meet to his sable majesty (cited in Shoemaker 1959:74). Cf. also Nissenbaum:99-107.

39 For further discussion of these characters as well as excellent illustrations of them, cf. Weber-Kellermann 1978:24-42.

40 From a comparative standpoint, the bishop's staff corresponds morphologically to the pole carried by bear trainers by means of which the dancing bear is able to support himself in an upright position while he executes his dance steps (cf. Dendaletche 1982:89-91).

41 For additional commentary on the color-coding involved, cf. Faris 1969:126-144; Frank 2001.

42 For an interesting discussion of Knecht Ruprecht and his European counterparts, cf. http://en.wikipedia.org/wiki/Companions_of_Saint_Nicholas.

43 I should point out that the standard cast of characters in these "good-luck visits" was more complex, a topic which will be taken up in the second part of this study (cf. Frank in prep.-a). For example, as Weber-Kellermann (1978:29) has documented in her interview with Lina Kellermann (born 1890) relating to customs from the period around 1900, the performances involved six distinct characters. The informant, Lina Kellermann, was from Maleiken/Masuren, Ostpreußen (East Prussia) which is currently part of Poland.

Kann Dir heute einen Tatsachenbericht über die Weihnachtsbräche schreiben und zwar von einem älteren Mann erzählt, der selbst dabei gewesen. Hat nicht weit ab von uns im Kreise Gerdauen gewohnt. ["Today I can write you a report about the beginning of Christmas, and more particularly as told by an old man [Lina Kellermann] who was [present] there. He used to live not far from us in the district of Gerdauen."]

6 Männer gehörten dazu, natürlich alle verkleidet. Als erster ein Gendarm, dann kam der Schimmelreiter, ritt auf einem Stock mit einem Pferdekopt vorne, 2 Beine mit weißem Laken behängt, 3. der Storch mit einem langen Schnabel, in den eine Nadel eingeklemmt war. Nro. 4 ein Schornsteinfeger, 5 ein Barbier und 6 eine Zigeunerin. ["Six men took part, of course, all disguised. The first was a guardsman (Gendarm), then came the White-horse-rider (Schimmelreiter), who rode on a stick with a horse's head [attached] at the front end of it, with a white sheet hanging over his two legs; third, the Stork (Storch) with a long nose, into which a needle was jammed; fourth, a Chimmey Sweep (Schornsteinfiger); fifth, a Barber (Barbier); and sixth, a Gypsy woman (Zigeunerin)."]

Der Gendarm fragte beim Betreten des Hauses, ob es gestattet sei einzutreten. Der Schimmelreiter– es mußte ein besonders flinker und geschickter Mann sein–hüpfte mit seinem provisorischen Reittier auf Tische und Bänke. Wenn der Tisch mit Tassen, Tellern und Gläsern besitzt war, gab es natürlich Scherbe n. Der Storch zwackte und stach mit seinem Schnabel, wen er zu fassen kriegte. Der Shornsteinfeger umfaßte und küßte mit seiner schwarzen Kluft, wer nicht flüchten konnete. Der Barbier schlug den Seifenschaum und seifte seine Opfer, daß die nur immer so nach Luft prusteten. Die Zigeunerin hatte in ihrem vollen weiten Busen eine, gewichtige Kanne. Darcin goß sie die Schnäpse unk Liköre, die den Spaßmachen überall spendiert wurden, denn dieselben mußten ja alle im Dorfe beglücken. Sie zogen auch in die Nachbardörfer und wehe, wenn sie sich außer ihrer Ortsgrenzen mit einem anderen solchen Zug begegneten, dann gab's eine groß Keilerei. Dabei ist wohl irgendwie einmal ein Beteiligter zu Tode gekommen. Daher die Sage, wenn sich zwei Schimmelreiter außerhalf des Ortes begegnen, daß einer davon im Laufe des nächsten Jahres sterben muß. Wenn die Umzüge beendet waren, dan leerten die Beteilgten natürlich nicht mit einem Male die Kannen. Und wurde dann das ganze lustige Spiel noch einmal richtig durchgesprochen. ["When entering the house the guardsman would ask whether they were allowed to enter. The White-horse rider - who always had to be an especially nimble and skillful man - hopped with his improvized riding animal onto the tables and benches. When the table was set with cups, plates and glasses, there were of course potsherds. The Stork pinched and pecked everyone he could catch, with his beak. The Chimney Sweep with his black costume hugged and kissed everyone who wasn't able to flee. The Barber so thoroughly smeared his victims with lather, whipped up from his shaving soap, that they were left gasping for air. The Gypsy had a heavy jug in her full wide bosom. Into it she would pour all the brandy and liquors the merry-makers received everywhere [they

went], since they had to be wished well by everyone in the village. They also went to the neighboring villages and, oh, when they ran into another such troop outside the local village's boundaries, there would be a big fight. In such encounters sometimes somehow one of the participants may have lost his life. Whence [comes] the saying that if two White-horse riders run into each other outside the village [beyond the limits of the local village], one of them must die within the course of the next year. When the rounds [visitations to the houses] ended, of course, the participants emptied the jug at once. And then the entire merry play was discussed over and over again in detail."] (Translation by Roslyn M. Frank & Eduard Selleslagh)

44 For more on the Krampus and Perchten runs, cf. http://www.serve.com/shea/germusa/nikohelp.htm and for a recent video clip from Pongau, Saltzburg, showing the variety of masks employed, cf. http://www.aeiou.at/aeiou.film.o/o189a and also http://krampusverein-anras.com. The regional variation of the costumes and masks is noteworthy, while performers dressed in straw with blackened faces also are commonplace, e. g., the St. Nikolaus day characters called Perschtln in the Austrian Tirol.

45 In zones where only one character clad in skins or straw examines children, distributing blows and gifts alike, *e.g.*, in the case of the Christpuppe or Knecht Ruprecht, ashes play a major role. For example, in Mechlenburg where he is called *rû Klas* ("rough Nicholas"), he sometimes wears bells and carries a staff with a bag of ashes at the end. Hence the name *Aschenklas* is occasionally given to him. One theory connects this aspect of him with the Polaznik "first footer" visitor of the Slavs. On Christmas Day in Crivoscian farms he goes to the hearth, takes up the ashes of the Yule log and dashes them against the cauldron-hook above so that sparks fly (Miles 1912:231, 252). For other cases of the European belief in the "good luck" conferred by ashes, blackening one's face with them and black creatures in general, cf. Alford 1930:277 ff.; Barandiaran 1974:II:375; Creighton 1950:20-21; Frank 2005a; Frank and Susperregi 2000.

46 Miles suggests a connection between the different parts of the healing wand: "Or possibly the rod and the fruit may once have been conjoined, the beating being performed with fruit-laden boughs in order to produce prosperity. It is noteworthy that at Etzendorf so many head of cattle and loads of hay are augured for the farmer as there are juniper-berries and twigs on St. Martin's *gerte*" (Miles 1912:207). Praneuf (1989:63-64) provides additional information on St. Martin's gerte: "Presque partout en Europe, il y a un rituel de la dernière gerbe, laissée sur pied ou soigneusement conservée dans la grange, car, dans le champ fauché, elle est le dernier refuge de l'esprit de la végétation. En Allemagne, le moissonneur à qui il échoit de faucher les derniers épis (ou de terminer le battage) s'habille de paille et prend place sur la dernière charrette de blé, parfois avec une 'compagne-ourse' ou un couple de 'fiancés des blés'; (un équivalent 'du rosier et de la rosière'); il est à la fête de clôture des moissons. Parfois, les filles dansaient avec la dernière gerbe, appelée 'l'ours', qu'elles enlaçaient comme un cavalier" ["Almost throughout Europe, there is a ritual of the last sheaf, left standing or carefully preserved in the barn, for, in the mowed field this [sheaf] is the last refuge of the spirit of vegetation. In Germany, the reaper to whom falls the harvesting of the last sprigs (or finishing the threshing) dresses up in straw and places himself in the last wagon of wheat, sometimes with a 'bear mate' [female] or a couple of 'betrothed of wheat' (the equivalent of 'the rose tree [male] and rose tree [female]'); this is the festival of the closure of the harvests. Often the young women dance with the last sheaf, called 'the bear', who they embrace as if he were a man."] (Translation Roslyn M. Frank)

47 In the rest of Europe the costume types associated with the individual playing the role of the "bear" can be divided into roughly three categories: 1) a bear mask from a real bear (Romania) or a replica of such a head; 2) a furry mask, often with a long red tongue and nose (snout), *e.g.*, Bavaria, Austria; 3) a mask created only by the application of charcoal and grease, today grease paint, often with red around the eyes and/or mouth, *e.g.*, the *zomorro* in Euskal Herria (the Basque Country) and Zwarte Piet in the Netherlands.

That type of "masking" often led to an association between the "bear" and the Christian "demonic". On the other hand, the fact that the "bear" character often carries a bag with ashes in it which he smeared on the faces of his victims often allowed him to morph into a chimney-sweep (*e.g.* the Dutch Zwarte Piet) and/or a charcoal-maker (*e.g.*, the Basque Olentzaro). In Spain he sometimes became a "Moor" who was led through the streets on a rope or chain; or even "Judas" who suffered a similar plight, being paraded through the streets, although both of these transformations are associated with the Carnival period. Similarly, the ritual conflict that often concludes the "good-luck visit" performance piece would pit the "reds" against the "blacks" (the "rich" against the "poor", the monologic "reds" against the dialogic "blacks" (Frank and Susperregi 2000; Frank 2001, 2005a). In much of

Europe the contingent of "blacks" came to be reanalyzed as the "other", as the enemy, "Turks" or "Moors", depending on the geographical location and nature of the process of identity construction of the community in question. In this way, the performances could continue, now assimilated into a Christian narrative of good versus evil.

In the case of the Netherlands, one suspects that the portrayal of Sinterklaas and Zwarte Piet as coming from Spain is also linked to earlier attempts at constructing (and contesting) Dutch identity. For instance, there is little doubt that the Spanish presence was viewed in a negative light, as that of an oppressive colonial power. Moreover, attempts by members of an oppressed people to manipulate traditional symbols as a means of (subtly) contesting the authority of a colonial power are commonplace: the rituals become sites of contestation and (re-)negotiation of (community) identity. Moreover, it could well be that earlier representations of Zwarte Piet were far more animal-like, as continues to be the case in Germany and Austria, and that the Spanish Inquisition might have played a role in his conversion into a fully-human figure. At the same time, the reanalysis of the figure of the "bear " into a pantalooned "Moor" smacks of Spanish influence since the same reanalysis can be documented in Spain and Portugal. Hence, one might argue that the Spanish Inquisition played some role here, perhaps prohibiting animal masks, again as appears to have happened in other locations.

In the case of Zwarte Piet the debate over his colonial and racist connotations has become a major issue in the Netherlands with people, including politicians, lining up on both sides of the debate (Bal 2004; Brown and Tavares 2004; Clifford 2004; Helder 2005). At the same time, it is clear that Americans and Canadians, alike, are particularly incensed by what they view as blatant racism in the portrayals of this figure (cf. Doze 2002, for examples of the Zwarte Piet paraphernalia that abounds in shops at Christmas time), perhaps because they are only familiar with the jolly Coca-Cola Santa. To discover that he has a "black-faced" side-kick strikes them as totally inappropriate (Armstrong-De Vreeze 1997; Doze 2003; Lowe 2002). Launched in 1995, when the debate first began to heat up, the so-called "Zwarte Piet Revolution" has captured the imagination of non-white minorities. Indeed, it has even resulted in a satiric, rap video produced by Boom Chicago of Amsterdam (2004). For information on the video, cf. Hotep 2003, co-director of PanAfricans, a collective of creative artists based in Rotterdam (http://www.myspace.com/panafricans). Considering the message of this rap video, it would appear that Zwarte Piet is about to undergo another transformation, although this time he may exchange his submissive secondary role for a more dynamic and central one, as was the case of the "dancing bear" whose sexual innuendo and deliberately anti-social antics were part and parcel of the "good-luck" performances in other parts of Europe, and probably in the Netherlands also, in times past, behaviors well documented by Alford (1930, 1931) as well as others (cf. Pranuef 1989).

One of the complicating factors for altering Dutch tradition, as, say, the video by Boom Chicago suggests, is the fact that the anti-authoritarian antics of the dialogic "blacks" are not tolerated during the Advent period in the way that they are in the case of festivities surrounding the European Candlemas Bear Day, as well as Winter and Spring Carnival periods in other parts of Europe. In other words, whereas the counterparts of the unruly "dancing bears" described by Alford are tolerated and their activities "licensed" ritually during periods designated as "carnival", for the most part, Christmas mumming and related ribald behavior, including the "good-luck visits", have fallen into disrepute (cf. Nissenbaum 1997), even though the practice of New Year "masking" continues in some locations. And, in contrast to Europe, in the case of Newfoundland, it would seem that Christmas mumming survived well into the latter half of the twentieth century (Halpert and Story 1969). For Europe, the custom was still found in England at the end of the nineteenth century, but was dying out. In Figure 9.26 (right), Father Christmas, wearing a mask with a pronounced snout, introduces the rest of the cast, including the "Turkish Knight" who will battle "St. George", to the householders before the performance begins..

48 Composed for his own six children's diversion, Moore's poem first appeared in *The Troy Sentinel* of New York on December 23, 1823.

49 The following is a good example of how entrenched traditional customs can be modified, if not erased, by the way that (unconscious) beliefs and as well as other circumstances come into play, specifically in order to make the past conform more closely with the present. In this case, we have the original cover page where Nast's childhood memories of the furry Pelznickels are clearly evident in the brown tones of the creature's fuzzy costume and paws (cf. Figure 9.23). When this book was reprinted, in 1950 (Webster [1869] 1950 rpt.), a decision was taken with respect to the cover of the new edition to alter the colors of this earlier illustration. That choice brought the color-coding of

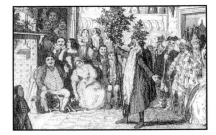

Figure 9.26 Father Christmas and a group of English mummers.
From a work published in 1888. Source: Hervey (1888).
Reproduced in Rodríguez 1997:120.

the book's cover into greater conformance with the then current view of the colors associated with the Coca-Cola Santa, namely, red and white. Quite possibly those in charge of deciding on the packaging of the book were doing nothing more sinister than attempting to make it as visually marketable as possible. Luckily, those in charge of the reprint also decided to include a color reproduction of the original cover, that is, from the 1869 edition, in the 1950 edition of the book.

50 In Nast's drawings frequently the creature is shown as elf-like, far smaller than a human being.

51 First published about 1870, Webster's poem "Santa Claus and his Works", loosely based on Moore's poem, was also illustrated by Nast, while somewhat earlier, in 1863, in the Christmas edition of *Harper's Weekly* it was Nast's drawings that illustrated Moore's poem and showed Santa with his sleigh and reindeer much as Moore had described him (Nast 1971:6-7).

52 According to Chris (1992:57), although "most of the United States did not legally recognize Christmas until the latter half of the nineteenth century, by the 1840s it was already being seen very much as a children's festival...". For a more finely grained analysis of the socio-cultural and economic factors affecting the transformation of these European traditions into the American version of Christmas, cf. Nissenbaum 1997.

53 For a large sampling of representations of Sundblom's Coca-Cola Santa as well as an analysis of the publicity campaign associated with them, cf. http://www.angelfire.com/trek/hillmans/xmascoke.html.

54 Whereas there are over 8,000 hits when googling for sites with reproductions of Sundblom's Coca-Cola Santa (http://www.google.com/search?hl=en&lr=&q=santa+sundblom), there is no single web site that brings together visual representations of his European predecessors and contemporaries. Cf. the following for an example of one such collection: http://www.thecoca-colacompany.com/heritage/pdf/cokelore/Heritage_CokeLore_santa.pdf. However, across Europe individual local initiatives have given rise to a wealth of online materials, *e.g.* fascinating cyber-museum presentations, such as the Krampus Museum http://krampusmuseum.suetschach.com/ and http://www.serve.com/shea/germusa/nikohelp.htm and the one dedicated to the Sardinian Mamutzones: http://www.museodellemaschere.it/index.html. Most particularly, over the past five years the number of web sites with digital images documenting contemporary manifestations of the Krampus as well as Zwarte Piet has skyrocketed. One simple example of the popularity of the Austrian Krampus is the fact that using "Krampus" as the search word at a popular photo archiving web site (http://www.flickr.com), we discover nothing less than 1,019 different photos), some of which are photos of old postcards, but the vast majority are of contemporary Austrians dressed as the Krampus, cf. http://www.flickr.com/search/?q=krampus.

55 Lest the impression be left that the reshaping of this personage has only taken place in the United States, it should be noted that in recent years significant progress has been made in stripping the Basque "charcoal-maker" Olentzaro of his threatening demeanor and other perceived anti-social characteristics, and turning him into a polite, well-groomed, child-friendly equivalent of the American Santa or, as others have noted, converting him into the Basque counterpart of the fully domesticated Spanish Papá Noel. This newer image contrasts starkly with Kurlansky's description of him (Kurlansky 1999:43): "Olentzaro [is] a pre-Christian evil sort of Santa Claus who slides down chimneys on Christmas Eve to harm people in their sleep. Fireplaces are lit for the holiday to keep him away." The reference to harming people in their sleep forms part of the same network of belief surrounding the Basque "night visitor" discussed previously in this study. For an outstanding example of the efforts underway to turn Olentzaro into a kind, sweet-natured Santa Claus and to encourage children to write letters to him, cf. www.olentzaro.net/ and http://www.getxo.net/eus/cult/gabonak/olentzero1.htm as well as http://es.wikipedia.org/wiki/Olentzaro.

References

Alford, Violet

1928 The Basque Masquerade. *Folklore* XXXIX:(March):67-90.

1930 The Springtime Bear in the Pyrenees. *Folklore* XLI (Sept.):266-279.

1931 The Candlemas Bear. *National and English Review* (Feb.):235-244.

1937 *Pyrenean Festivals: Calendar Customs, Music and Magic, Drama and Dance*. Chatto and Windus, London.

1969 The Hobby Horse and Other Animal Masques. *Folklore* LXXIX:122-134.

1978 *The Hobby Horse and Other Animal Masks*. The Merlin Press, London.

Alinei, Mario

2004 The Paleolithic Continuity Theory on Indo-European Origins: An Introduction. Available online at: http://www.continuitas.com/intro.html.

Armstrong-De Vreeze, Pamela

1997 Surviving Zwarte Piet: A Black Mother in the Netherlands Copes with a Racist Institution in Dutch Culture, *Essence* (Dec.). Available online at: http://www.findarticles.com/p/articles/mi_m1264/is_n8_v28/ai_20039487.

Arratibel, José

1980 *Kontu zaarrak*. Editorial La Gran Enciclopedia Vasca, London.

Bal, Mieke

2004 Zwarte Piet's Bal Masqué. In *Questions of Tradition*, edited by Mark Phillips and Gordon Schochet, pp. 110-151. University of Toronto, Toronto; Buffalo, NY.

Balzer, Marjorie Mandelstam

1996 Sacred Genders in Siberia: Shamans, Bear Festivals and Androgyny. In *Gender Reversals and Gender Cultures*, edited by Sabrina Petra Ramet, pp. 164-182. Routledge, London and New York.

Barakat, Robert A.

1965 Bear's Son Tale in New Mexico. *Journal of American Folklore* 78:330-336.

Barandiaran, Jose Miguel

1974 *Obras completas*. La Gran Enciclopedia Vasca, Bilbao.

Bartra, Roger

1994 *Wild Men in the Looking Glass: The Mythic Origins of European Otherness*, Translated by Carl T. Berrisford. The University of Michigan Press, Ann Arbor.

Bauman, Richard

1972 Belsnickling in a Nova Scotia Island Community. *Western Folklore* 31(4):229-243.

Bégouën, Jacques

1966 L'Ours Martin d'Ariège Pyrenées," In *Société Ariégeoise [des] Sciences, Lettres et Arts. Bulletin Annuel* XXII:111-175.

Berryman, Val R.

1995 Michigan's Coca-Cola Santa Claus: Haddon Hubbard Sundblom. *Michigan History* (November/ December). Available online at: http://www.michiganhistorymagazine.com/extra/christmas/ coca_cola.html.

Blakely, Allisson

1993 *Blacks in the Dutch World*. Indiana University Press, Indianapolis.

2001 Black 'Reconstruction' in Europe in African Diaspora Perspective, presented at the Internationale Conference "Oral History," Detraumatisering en Reconstructie, sponsored by the Dutch National Slavery Atonement Monument Foundation, in the Hague, July 7, 2001.

Boom Chicago of Amsterdam

2004 "Zwarte Piet Revolution." Available online at: http://www.boomchicago/Videos/ZwartePiet?page=2.

Brown, Julie, and Izalina Tavares

2004 Black Pete: Analyzing a Racialized Dutch Tradition Through the History of Western Creations of Stereotypes of Black Peoples. In *Humanity in Action Reports of 2004 Fellows in Denmark, Germany and the Netherlands* (Vol. 6, December), edited by Katherine Grecevich, pp. 94-99. Humanity in Action, New York. Available online at: http://www.humanityinaction.org/docs/Brown__Tavares.pdf.

Brunton, Bill B.

1993 Kootenai Shamanism. In *Shamans and Cultures*, edited by Mihály Hoppál and Keith D. Howard, pp. 136-146. Akademiai Kiado; International Society for Trans-Oceanic Research, Los Angeles, Budapest.

Bullock, James Benbow

1981 *Stars for Lincoln, Doctors, and Dogs*. Gourmet Guides, San Francisco, CA.

Calés, Michel, ed.

1990 *L'Ours des Pyrénées: les Carnets de Terrain*. Parc National des Pyrénées.

Caro Baroja, Julio

1965 *El carnaval (análisis histórico-cultural)*. Madrid: Taurus, Madrid.

Cheyne, J. Allan

2001 The Ominous Numinous. Sensed Presence and 'Other' Hallucinations. *Journal of Consciousness Studies* (8):5 7:133-150.

2003 Sleep Paralysis and the Structure of Waking Nightmare Hallucinations. *Dreaming* 13:163 180.

Cheyne, J. Allan, Ian R. Newby-Clark, and Steve D. Rueffer

1999 Hypnagogic and Hypnopompic Hallucinations during Sleep Paralysis: Neurological and Cultural Construction of the Night-mare. *Consciousness and Cognition* 8:319-337.

Chiclo, Boris

1981 L'Ours Chaman. *Études mongoles* 12:35-111.

Chris, Teresa

1992 *The Story of Santa Claus*. New Burlington Books, London.

Claudel, Calvin

1952 Some Comments on the Bear's Son Tale. *Southern Folklore Quarterly* 16:186-191.

Clébert, Jean-Paul

1968 Le Guide du Fantastique et du Merveilleux: une Géographie du Sacré. In *Histoire et Guide de la France secrète*, edited by Michel Aimé and Jean-Paul Clébert, pp. 257-439. Editions Planète, Paris.

Clifford, James

2004 Traditional Futures. In *Questions of Tradition*, edited by Mark Phillips and Gordon Schoche, pp. 152-168. University of Toronto Press, Toronto; Buffalo, NY.

Cline, Ruth H.

1958 Belsnickles and Shanghais. *Journal of American Folklore* 71:164-165.

Cosquin, Emmanuel

1887 Jean l'Ours. In *Les Contes populaires de Lorraine*, pp. 1-27. F. Vieweg, Libraire-Editeur, Paris.

Costa, Gabriele

2001 Continuitá e identitá nella prehistoria indeuropea: Verso un nuovo paradigma. *Quaderni di Semantica* 22(2):215-260. Available online at: www.continuitas.com/continuita_identita.pdf.

2004 Linguistica e preistoria. I: evoluzione delle lingue e delle culture. *Quaderni di Semantica* 25(2):255-271. Available online at: www.continuitas.com/linguistica_preistoria.pdf.

Creighton, Helen

1950 Folklore of Luneburg County, Nova Scotia. *National Museum of Canada Bulletin*, No. 117. Ottawa.

Cushing, George F.

1977 Bears in Ob-Ugrian Folklore. *Folklore* 88:146-159.

d'Errico, Francesco, Christopher Henshilwood, Graeme Lawson, Marian Vanhaeren, Anne-Marie Tillier, Marie Soressi, Fréderique Bresson, Bruno Maureille, April Nowell, Joseba Lakarra, Lucinda Backwell, and Michèle Julien

2003 Archaeological Evidence for the Emergence of Language, Symbolism, and Music: An Alternative Multidisciplinary Perspective. *Journal of World Prehistory* (March) 17(1):1-70. Available online at: www.cognisud.org/documents/030919/derrico2.pdf.

Dégh, Linda, (ed.)

[1965] 1969 *Folktales of Hungary*, Second Edition. The University of Chicago, Chicago.

Dendaletche, Claude

1982 *L'Homme et la Nature dans les Pyrénées*. Berger Levrault, Paris.

Dose, Eric V.

2003 Downwind of Amsterdam [Blog]: Man, I Don't *Get* Zwarte Piet. (7 Dec. 2003). Available online at: http://www.awfulgood.com/doa-archives/000212.php.

Duhourcau, Bernard

1985 *Guide des Pyrénées mystérieuses*. Éditions Tchous Princesse, Paris.

Elgström, Ossian, and Ernst Manker

1984 *Björnfesten*. Norrbottems Museum.

Erdész, Sandor

1961 The World Conception of Lajos Ami, Storyteller. *Acta Ethnographica* X:327-344.

1963 The Cosmological Conception of Lajos Ami, Storyteller. *Acta Ethnographica* XII:57-64.

Erich, Oswald, and Richard Beitl

1955 *Wörterbuch der Deutschen Volkskunde*. Alfred Kröner Verlag, Stuttgart.

Espinosa, Aurelio M.

1911 New-Mexican Spanish Folk-Lore. *Journal of American Folklore* 24:397-444.

1951 Spanish and Spanish-American Folk Tales. *Journal of American Folklore* 64(252):151-162.

Fabre, Daniel

1968 *Jean l'Ours: Analyse formelle et thématique d'un Conte populaire*. Editions de la Revue 'Folklore', Carcassonne.

1986 Le Carnaval de l'Ours Saint-Laurent de Cerdans. In *L'Ours brun: Pyrénées, Abruzzes, Mts. Cantabriques, Alpes du Trentin*, edited by Claude Dendaletche, pp. 135-148. Acta Biologica Montana, Pau.

Faris, James C.

1969 Mumming in an Outport Fishing Settlement: A Description and Suggestions on the Cognitive Complex. In *Christmas Mumming in Newfoundland: Essays in Anthropology and History*, edited by Herbert Halpert and G. M. Story, pp. 126-144. University of Toronto Press, Toronto, Canada.

Fernández de Larrinoa, Kepa

1997 *Mujer, ritual y fiesta: género, antropología y teatro de carnaval en el valle de Soule*. Pamiela, Pamplona-Iruña.

Frank, Roslyn M.

1996a Hunting the European Sky Bears: When Bears Ruled the Earth and Guarded the Gate of Heaven. In *Astronomical Traditions in Past Cultures*, edited by Vesselina Koleva and Dimitir Kolev, pp. 116-142. Institute of Astronomy, Bulgarian Academy of Sciences, National Astronomical Observatory Rozhen), Sofia. Available online at: http://www.uiowa.edu/~spanport/personal/Frank/FrankHm.htm.

1996b An Essay in European Ethnomathematics and Orality: Celestial Traditions of John Little Bear in Europe and Euskal Herria (the Basque Country). Presentation in the Session Working Group 21: Mathematics and Culture, ICME-8, Seville, Spain, July 14-21.

1997 Hunting the European Sky Bears: The Grateful Eagle, Little Bear, Amirani and Prometheus. *Actas del IV Congreso de la SEAC Astronomía en la Cultura/Proceedings of the IV SEAC Meeting Astronomy and Culture*, edited by Carlos Jaschek and Fernando Atrio Barandela, pp. 55-68. University of Salamanca, Salamanca, Spain.

1999a An Essay in European Ethnomathematics: The Basque Septuagesimal System. Part I, *Actes de la Vème Conférence Annuelle de la SEAC. Gdansk 1997*, edited by A. Le Beuf and M. S. Ziólkowski, pp. 119-142. Warszawa-Gdansk: Département d'Anthropologie Historique, Institut d'Archéologie de l'Université de Varsovie - Musée Maritime Central). Available online at: http://www.uiowa.edu/~spanport/personal/Frank/FrankHm.htm.

1999b An Essay in European Ethnomathematics: The Social and Cultural Bases of the *vara de Burgos* and Its Relationship to the Basque Septuagesimal System, ZDM. *Zentralblatt für Didaktik der Mathematik* 31(2 April):59-65. Available online at: http://www.fiz-karlsruhe.de/fiz/publications/zdm/zd-m992a3.pdf.

2000 Hunting the European Sky Bears. Hercules meets Hartzkume, Archaeoastronomy and Astronomy in Culture. In *Exploring Diversity*, edited by Juan Antonio Belmonte and Cesar Esteban, pp. 295-302. OAMC, Santa Cruz de Tenerife.

2001 Hunting the European Sky Bears: Candlemas Bear Day and World Renewal Ceremonies. In *Astronomy, Cosmology and Landscape. Proceedings of the Seventh Annual Conference of the European Society of Astronomy in Culture*, edited by C. R. N. Ruggles, Frank Prendergast, and Tom Ray, pp. 15-45. Ocarina Press, Dublin, Ireland, Bognor Regis, England.

2003 Shifting Identities: The Metaphorics of Nature-Culture Dualism in Western and Basque Models of Self. *metaphorik.de* (electronic journal) 04/2003. Available online at: http://www.metaphorik.de/04/frank.pdf.

2005a Shifting Identities: A Comparative Study of Basque and Western Cultural Conceptualizations. *Cahiers of the Association for French Language Studies* 11(2):1-54. Available online at: http://www.afls.net/cahiers/11.2/Frank.pdf.

2005b Hunting the European Sky Bears: A Proto-European Vision Quest to the End of the Earth. In *Current Studies in Archaeoastronomy: Conversations Across Time and Space*, edited by John W. Fountain and Rolf M. Sinclair, pp. 455-474. Carolina Academic Press, Durham, North Carolina.

in prep.-a The Darker Side of Santa, Ms. Available online at: http://www.uiowa.edu/~spanport/personal/
Frank/FrankHm.htm.

in prep.-b Metrological Traditions of the Atlantic Façade: The Geometry and Cognitive Architecture of Basque
Stone Octagons.

Frank, Roslyn M., and Jesus Arregi Bengoa

2001 Hunting the European Sky Bears: The Origins of the Non-Zodiacal Constellations. In *Astronomy, Cosmology
and Landscape. Proceedings of the Seventh Annual Conference of the European Society of Astronomy in Culture*, edited by
C. R. N. Ruggles, Frank Prendergast, and Tom Ray, pp. 133-157. Ocarina Press, Dublin, Ireland, Bognor Regis,
England.

Frank, Roslyn M., and Mikel Susperregi

2000 Conflicting Identities: A Comparative Study of Non-commensurate Root Metaphors in Basque and
European Image Schemata. In *Language and Ideology: Cognitive Descriptive Approaches*, edited by René Dirven,
Roslyn M. Frank and Cornelia Ilie, pp. 135-160. John Benjamins, Amsterdam and Philadelphia.

Gastou, François-Régis

1987 *Sur les Traces des Montreurs d'Ours des Pyrénées et d'Ailleurs*. Loubatières, Toulouse.

Gingerich, Owen

1984 Astronomical Scrapbook: The Origin of the Zodiac," *Sky and Telescope* 67(March):218-220.

Giroux, Françoise

1984 *Carnavals et Fêtes d'Hiver*. Centre Georges Pompidou, e.d.l.e.c., Paris.

Halpert, Herbert

1969 A Typology of Mumming. In *Christmas Mumming in Newfoundland: Essays in Anthropology and History*, edited by
Herbert Halpert and George M. Story, pp. 34-6. University of Toronto Press, Toronto, Canada.

Halpert, Herbert, and George M. Story, eds.

1969 *Christmas Mumming in Newfoundland: Essays in Anthropology and History*. University of Toronto Press, Toronto.

Harner, Michael

1980 *The Way of the Shaman*. Harper and Row, San Francisco.

Hartsuaga, Juan I.

1987 *Euskal Mitologia Konparatua*. Kriselu, S. A., Donostia.

Helder, Lulu Njemileh

2005 Question of the Month: Who is Black Peter? Ferris State University: Jim Crow. Museum of Racist
Memorabilia. Available online at: http://www.ferris.edu/news/jimcrow/question/jan05/.

Helder, Lulu, and Scotty Gravenberch, eds.

1998 *Sinterklaasje, kom maar binnen zonder knecht*. EPO, Berchem, Belgium.

Hervey, Thomas K.

1888 *The Book of Christmas*. Warne, London.

Hollingsworth, Thomas

1891 A Basque Superstition, *Folklore* II:132-133.

Hoppál, Mihály, ed.

1992 *Northern Religions and Shamanism: Selected Papers from the Regional Conference of the International Association of the
History of Religions*. Akademiai Kiado, Budapest; Finnish Literature Society, Helsinki.

1993a Shamanism: Universal Structures and Regional Symbols. In *Shamans and Cultures*, edited by Mihály Hoppál and Keith D. Howard, with the assistance of Otto von Sadovszky and Taegon Kim, pp. 181-192. Akademiai Kiado, Budapest; International Society for Trans-Oceanic Research, Los Angeles.

1993b Studies on Eurasian Shamanism. In *Shamans and Cultures* dited by Mihály Hoppál and Keith D. Howard, with the assistance of Otto von Sadovszky and Taegon Kim, pp. 258-292. kademiai Kiado, Budapest; International Society for Trans-Oceanic Research, Los Angeles.

Hotep, Iyahmin

2003 'Zwarte Piet': An Impression on a Dutch Tradition. Video.

Hufford, David J.

2005 Sleep Paralysis as Spiritual Experience. *Transcultural Psychiatry* 42(1):11-45.

Iribarren, José María

1984 *Vocabulario navarro*, Nueva edición preparada y ampliada por Ricardo Ollaquindia. Institución Príncipe de Viana, Pamplona.

Kiss, G.

1959 *A 301-es mesetípus magyar redakciói* (The Hungarian Redactions of the 301 Story Type). *Ethnographia* (Budapest) LXX:253-268.

Kurlansky, Mark

1999 *The Basque History of the World*. Walker & Company, New York.

Lebeuf, Arnold

1987 Des Évêques et des Ourses. Études de Quelques Chapiteaux du Cloître de Saint Lizier en Couserans. *Ethnologia Polona* 13:257-280.

Lekuona, Iñaki

2002 L'euskara, la première langue d'Europe: Une recherche linguistique ressuscite l'hypothèse d'un peuple apparenté aux Basques qui aurait vécu sur le continent européen bien avant les indo-européens. *Le Journal du Pays Basque*. Available online at: http://www.lejournaldupaysbasque.fr/article.php3?id_article=364.

Le Roy Ladurie, Emmanuel

1979 *Carnival in Romans*. George Braziller, Inc., New York.

Lowe, Kevin

2002 Zwarte Piet: A Sinister Symbol in a 'Tolerant' Country. *Expatica*. Available online at: http://www.expatica.com/source/site_article.asp?subchannel_id=1&story_id=1658.

Marshack, Alexander

1972 *The Roots of Civilization: The Cognitive Beginnings of Man's First Art, Symbol and Notation* McGraw Hill, New York.

Michel, Aimé, and Jean-Paul Clébert

1968 *Histoire et Guide de la France Secrète*. Editions Planète, Paris.

Miles, Clement A.

1912 *Christmas in Ritual Tradition: Christian and Pagan*. T. Fisher Unwin, London.

Milkovsky, Alexander

1993 Hail to Thee, Papa Bear, *Natural History* 12 (December):34-40.

Molina González, Avelino, and Angel Vélez Pérez

1986 L'Ours dans les Fêtes et Carnavals d'Hiver: La Vijanera en Vallée d'Iguna. In *L'Ours brun: Pyrénées, Abruzzes, Mts. Cantabriques, Alpes du Trentin*, edited by Claude Dendaletche, pp. 135-146. Acta Biologica Montana, Pau.

Müller, Felix, and Ulrich Müller

1999 Percht und Krampus, Kramperl und Schiach-Perchten. In *Mittelalter-Mythen 2. Dämonen-Monster-Fabelwesen*, edited by Ulrich Müller and Werner Wunderlich, pp. 449-460. St. Gallen. Available online at: http://www.fmueller.net/krampus_de.html.

Nast, Thomas

[1890] 1971 *Thomas Nast's Christmas Drawings for the Human Race*, with an Introduction and Epilogue by Thomas Nast St. Hill. Harper & Brothers, New York.

Nissenbaum, Stephen.

1997 *The Battle for Christmas*. Vintage, New York.

Oxford English Dictionary

1971 *The Compact Edition of the Oxford English Dictionary*. Oxford University Press, New York.

Otte, Marcel

1995 Diffusion des langues modernes en Eurasie préhistorique. *C.R. de l'Académie des Sciences, Paris*, t. 321, série IIa:1219-1226.

Panzer, Friedrich

1910 *Studien zur germanischen Sagengeschichte, I, Beowulf.* Munich.

Peillen, Txomin

1986 Le Culte de l'Ours chez les Anciens Basques. In *L'Ours brun: Pyréenées, Abruzzes, Mts. Cantabriques, Alpes du Trentin*, edited by Claude Dendaletche, pp. 171-173. Acta Biologica Montana, Pau.

Perurena, Patziku

1993 *Euskarak Sorgindutako Numeroak*. Kutxa Fundaxioa, Donostia.

2000 Patziku Perurenarekin egindako elkarrizketa. *Euskadi Irratia* (Aug. 8, 2000).

Praneuf, Michel

1989 *L'Ours et les Hommes dans les Traditions européennes*. Editions Imago, Paris.

Rockwell, David

1991 *Giving Voice to Bear: North American Indian Myths, Rituals and Images of the Bear*. Roberts Rinehart Publishers, Niwot, CO.

Rodríguez, Pepe

1997 *Mitos y ritos de la navidad: origen y significado de las celebraciones navideñas*. Ediciones B, S.A., Barcelona.

Satrústegi, José María

1975 *Euskaldunen seksu bideak*. Aranzazu, Donostia.

1981 Sueños y pesadillas en el foklore tradicional vasco. *Boletin de la Real Sociedad Bascongada de los Amigos del País* 37(3-4):359-375.

1987 Sueños y pesadillas en el devocionario popular vasco. *Cuadernos de etografia y etnografia de Navarra* 47:5-33.

Schaefer, Bradley

2006 Origin of the Greek constellations. *Scientific American* 295(5):70-75.

Seshamani, Geeta, and Kartick Satyanarayan

1997 The Dancing Bears of India. Available online at: http://www.apasfa.org/peti/dancing_bears.pdf.

Shepard, Paul

1992 Post-Historic Primitivism. In *The Wilderness Condition: Essays on Environment and Civilization*, edited by Max Oelshlaeger, pp. 40-89. Sierra Club Books, San Francisco.

1995 Bear Essay (unpublished ms.).

1999 *Encounters with Nature: Essays by Paul Shepard*, edited by Florence R. Shepard. Island Press/Shearwater Books, Washington, D.C.; Covelo, CA.

Shoemaker, Alfred

1959 *Christmas in Pennsylvania: A Folk-Cultural Study*. Pennsylvania Folklore Society, Kutztown.

Siefker, Phyllis

1997 *Santa Claus, Last of the Wild Men*. McFarland & Company, Inc., Publishers, Jefferson, NC.

Snyder, Gary

1990 *The Practice of the Wild*. North Point, San Francisco.

1995 Re-inhabitation. In *The Deep Ecology Movement: An Introductory Anthology*, edited by Alan Drengson and Yuichi Inoue, pp. 67-73. North Atlantic Books, Berkeley, CA.

Sokolova, Zoya P.

2000 The Bear Cult. *Archaeology, Ethnology & Anthropology of Eurasia* 2(2):121-130.

Speck, Frank C.

1945 *The Celestial Bear Comes Down to Earth: The Bear Ceremony of the Munsee-Mahican in Canada as Related by Nekatcit.* in collaboration with Jesse Moses, Delaware Nation, Ohsweken, Ontario, Canada. Reading Public Museum and Art Gallery, Reading, PA.

Stitt, J. Michael

1992 *Beowulf and the Bear's Son: Epic, Saga, and Fairytale in Northern Germanic Tradition*. Garland Publishing, Inc., New York and London.

Szwed, John F.

1969 The Mask of Friendship: Mumming as a Ritual of Social Relations. In *Christmas Mumming in Newfoundland: Essays in Anthropology and History*, edited by Herbert Halpert and G. M. Story, pp. 104-117. University of Toronto Press, Toronto.

Thorpe, Benjamin

1851-52 *Northern Mythology: Popular Traditions and Superstitions of Scandinavia, North Germany and the Netherlands*. Edward Lumley, London.

Tiberio, Francisco Javier

1993 *Carnavales de Navarra*. Colección Temas de Navarra, No 6, Fondo de Publicaciones del Gobierno de Navarra.

Tille, Alexander

1899 *Yule and Christmas: Their Place in the Germanic Year*. David Nutt, London.

Time-Life Books, eds.

1992 *The American Indians: The Spirit Life*. Time-Life Books, Alexandria, VA.

Trask, R. Larry

2000 Re: 'nightmare' and 'bugbear'. Indo-European mailing list <Indo-European@xkl.com (18 Oct. 2000). Available online at: http://listserv.linguistlist.org/cgi-bin/wa?A2=ind0010&L=indo-european&P=R4789.

Truffaut, Thierry

1988 Apports des Carnavals ruraux en Pays Basque pour l'Étude de la Mythologie: Le Cas du 'Basa-Jaun'. *Eusko-Ikaskuntza: Sociedad de Estudios Vascos. Cuadernos de Sección. Antropología-Etnografía* 6:71-81.

Urbeltz, Juan A.

1994 Bailar el caos: la danza de la osa y el soldado cojo. Pamiela, Iruña-Pamplona.

Vennemann, Theo

2002 *Europa Vasconica–Europa Semitica*. Mouton de Gruyter, Berlin/New York.

Vriens, Jacques

1983 *Dag, Sinterklaasje*. Illustrations by Dagmar Stam. Van Holkema & Warendorf, Amsterdam.

Vukanović, T. P.

1959 Gypsy Bear-leaders in the Balkan Peninsula. *Journal of the Gypsy Lore Society* 3(XXXVII):106-125.

Walsh, Martin W.

1996 The King and his Own Fool. In *Fools and Folly*, edited by Clifford Davidson, pp. 34-46. Medieval Institute Publications, Western Michigan University, Kalamazoo, Michigan.

Weber-Kellermann, Ingeborg

1978 *Das Weihnachtsfest*. Verlag C. J. Bucher, Luzern und Frankfurt.

Webster, G. P.

1869 *Santa Claus and his Works*. 1950 Report with an epilogue "The History of this Book". McLoughlin Brothers, New York; The Evergreen Press, Nevada City, CA.

Welch, Charles E., Jr.

1966 Oh, Dem Golden Slippers': The Philadelphia Mummers' Parade. *Journal of American Folklore* LXXIX:533-535.

Wikipedia

2005 Olentzaro. Available online at: http://es.wikipedia.org/wiki/Olentzaro.

2007 Companions of St. Nicholas. Available online at: http://en.wikipedia.org/wiki/ Companions_of_Saint_Nicholas.

After the Ice Age: How Calendar-Keeping Shaped Early Social Structuring

Michael Hudson

I first met Alex Marshack in 1982 at a lecture he gave in New York City, where we both lived. That evening he described the Paleolithic "time-factored" notational systems that traced the rhythms of the moon and sun, and how Neolithic calendars governed the rhythms of planting and harvesting, as well as the rites of passage and social integration via festivals that were occasions for gift exchange and intermarriage. After the talk I introduced myself to him, and more than twenty years of friendship followed.

I was writing a history of interest-bearing debt and debt-annulment practices ("clean slates"), and was just beginning to trace the genesis of interest-bearing debt and how early societies dealt with the problems it caused. This led me to note the calendrical timing of early debt payments, along with the standardization of money and interest rates as a byproduct of weights and measures calendrically based for periodic distribution by Mesopotamia's temples and palaces. Alex saw immediately the convergence between my research, working backward from classical antiquity to the Early Bronze Age, with his own studies going forward from the Paleolithic. He introduced me to the Peabody Museum's director, Karl Lamberg-Karlovsky, who later helped me organize a group of assyriologists and archaeologists to publish what are now five colloquia on the genesis of money, account-keeping, debt, urbanization, land tenure and public employment.

At our second colloquium, held at New York University in 1996 on urban development in the ancient Near East, Alex summarized his views on how the time-keeping practices that began in the Paleolithic laid the foundations for civilization in the Near East and Europe. Using many of the slides from the lecture I had heard him give fourteen years earlier, he described the calendrical orientation of early ceremonial sites, reflecting their role as seasonal gathering places. The literal meaning of orientation, after all, refers to the east where the sun rises, as if to sanctify temples and other monuments of rulership by grounding them in the heavenly cosmos, "on earth, as it is in heaven." The videotape operator became so fascinated as soon as Alex took the podium that she forgot to press the "on" button on her machine.

The fact that Neolithic agriculture was dependent on the seasons, Alex explained, made the calendar the key to post-Paleolithic social organization, shaping "the way in which archaic communities structured their modes of cultural complexity" inasmuch as agriculture "increasingly requires 'time-factored' divisions of labor and skill, allotted times and places for specialized activities, and calendrically precise times for ritual, aggregation, and exchange."[1] The same may be said of trade. Sea commerce depended on the annual winds, and even war-making traditionally was waged after the harvest was in.

Calendrical rhythms determined the times when sparse populations came together in the seasonal gatherings that were the occasions for exchange – of family members as well as gifts. These ritual sites typically were on rivers, often

near distinguishing natural features such as caves. The most famous sites were orientated to the rising or setting of the sun at the four major points of the year, the solstices and equinoxes. Their calendrical character was further reflected in the art whose calendrical reference Alex showed to reflect the seasonality of fish mating, deer molting and vegetation sprouting.

Based on the spread of artifacts reflecting a diversity of notational systems – signs that had been viewed simply as decorative markings prior to his 1972 article on the Blanchard bone's lunar notations c. 28,000 BC – he postulated a worldview extending from the Atlantic to the Russian plain. "Long-distance movements and a dispersal of cultural influences were clearly present during this [Magdalenian] period." "On the Russian plain ... there were summer and winter sites along [the network of rivers that flow toward the Black Sea], including riverside sites that were specialized for seasonal resource exploitation and for seasonal symbolic performance and production."[2]

Alex concluded that rather than trying to explain "the rise of agriculture in the essentially material and materialistic terms of regional resources, changes in climate and demography, technology, and modes of harvesting and storage, or in terms of the self-domestication of plants and cereals through periodic harvesting," archaeologists and prehistorians "may now also have to consider the long and incremental cognitive and conceptual preparation that made these other processes viable."[3] He traced this cognitive development largely to the development of calendrical observation and its associated social structuring. "The well-known urban tapestries of temples, records, astronomies, and regional calendars, day-and-night hours, scheduled debts, and debt amnesties, and the increasing specialization of skills and the times and places for their use, all

required a developing, increasingly precise, and carefully monitored calendar."[4]

This paper was the closest he came to publishing his *longue durée* synthesis. Alex often spoke of writing a sequel to *The Roots of Civilization* describing how classical social structuring, myth and ritual preserved traces of Paleolithic cosmology. And what makes the Ice Age so relevant, after all, is how its time-structuring led to subsequent social practice – the civilization dimension of his book. Archaic calendrical regularities led to practices that survived even into the Bronze Age and classical antiquity. But he concentrated so much effort on defending his interpretation of Ice Age notational systems that he never got around to further elaborating his view of the Paleolithic as the matrix out of which subsequent thought evolved.

What he did elaborate was how time-factored notation evolved into arithmetic. Alex emphasized that tracing lunar patterns did not have to involve mathematical calculation. Paleolithic calendar keeping was pre-mathematical, predating actual arithmetic in the sense of counting in the abstract. It represented sequence (as do the alphabet and the musical scale) but not numbering as such. But it was the matrix out of which counting systems developed, inasmuch as the first phenomena to be counted seem to have been the rhythms of the moon and sun, not one's fingers. The key number 28, for instance, evidently was derived from the days of visibility in the lunar month, to which Alex attributed the prominent role of the number 7 as its divisor. This suggested that the first phenomena being counted were calendrical, and special significance came to be given to number in an increasingly abstract sense. Some New Guinea and Indonesian counting systems started from the fingers and went up across the arm and neck and down the opposing arm, up to 28 points.[5]

It was in the Neolithic, he believed, when some individuals began to count everything and developed more abstract mathematics, searching for a clue to the order of nature, as expressed first in its calendrical rhythms and then in natural musical and more abstract cosmological proportions. This search for order was the inspiration for science, as well as for myth and ritual.

Some people seem to have found remarkable parallels between calendrical fractions and those of tuning the musical scale. The 12 months of the year found their counterpart in the 12 tones of the musical scale, and the "Pythagorean comma" found its analogue in the gap between the solar and lunar years. These parallels fascinated Alex, and he arranged for us to meet with music historians. But he realized how speculative it was to infer how far archaic individuals had gone along these lines. How could we know whether we were being anachronistic? We had found these parallels, but the dangerously speculative waters of reconstructing archaic awareness dissuaded us from publishing until we could make a more thorough case.

Nonetheless one can deem the pattern-seeking individuals who embedded these proportions in ancient mythology to have been protoscientific, given their power of abstraction and ability to find connections. Myth and ritual, religion and social structuring sought ordering in nature, and also social equity. In a sense Alex himself was like a shaman in seeking to re-create the cosmological template that led chieftains to organize social rhythms to coincide with calendrical cycles.

The problem in trying to re-create the archaic mental template, of course, is that surviving tools, inscribed bones, art and burials, monuments and buildings were only a shadow. There are suggestive inferential phenomena, but the only conclusive facts that could prove Alex's

reconstructions would be written narratives. Recognizing that artifacts have little conclusive to say about the social structures that produced them, he scoured the anthropological literature for studies about what chieftains did, and also shamans, to whom he looked as kindred spirits. To suggest the ways of thought that inspired Paleolithic calendar-keepers and civilization's cognitive takeoff, he compiled a library ranging from archaeoastronomy to classical myth and ritual, seeking clues in the practices of chieftains among the Native Americans and other surviving tribal enclaves. But only in classical antiquity did writers begin to explain the logic behind their policies. All that one finds earlier are records of what was done, not why, so there is no way in which the grand schema that Alex postulated can be more than inferential.

The line of analysis that he initiated did not fit into any academic box in the sense of a discipline and departmental definition. That was his strong point. But it also made it hard to fit his discoveries into the curriculum, even that of anthropology or archaeology, quite apart from the fact that his background as a science writer did not include the Ph.D. that has become the union card for modern professorship.

I have been no bolder in publishing my own ideas along the lines we discussed over the years. As a coda to my reminiscences of our discussions, I may briefly sketch the train of effects on which we agreed on how the calendar shaped the development of urban centers, weights and measures, and political divisions into calendrical tribes (thirds, fourths and twelfths). Of particular importance was the shift from lunar to solar calendars, and how early societies handled the disparity between the 356-day lunar year and the 365?-day solar year, with a New Year interregnum of chaos, after which order was restored to start the new year in balance.

Early weights and measures were divided into calendrical fractions for distribution on a monthly basis. This required the standardization of months, and hence the creation of a solar year with artificially standardized 30-day months. The mina's fractional division into 60 shekels in turn determined the rate of interest – 1/60th per month, doubling the principal in five years.[6] Rome adopted a 12-fold division, and its rate of interest was 1/12th.

Serving as a cosmological model for social organization, the calendar found its spatial analogue as the template for early walled cities, which typically had four gates (sometimes as many as twelve) reflecting the cardinal points of the year (or months). Major streets often were aligned to the rising or setting sun, except where adjusted for wind factors.[7]

Greek city-states divided society into calendrical tribal fractions (halves, thirds, fourths or twelfths) as a means of rotating administration of their ceremonial and increasingly political center. It seems that each city-state sought to do so in its own way as a sign of distinction, but shared a common denominator in changing the calendar and tribal divisions[8] together as new tribes were added. Each tribe was assigned its proportional period of rotating control of the center on a seasonal basis (for "four-square" tribal divisions) or monthly basis for twelve-tribe nations. When the calendar was changed, so were the tribal divisions.

Alex and I often spoke of how such social structures imitated astronomical rhythms to create what must have been perceived as early social science, aiming to establish regularities in earthly structures to reflect those of the heavens in a kind of "sympathetic logic." This ran the danger of becoming magical, *e.g.*, in astrology, much medical philosophy and other associative logic associated with early societies. But the attempt to create an ancient "general field theory" of society and nature also provided the intellectual impetus for what has become civilization.

About the author

Michael Hudson, Distinguished Prof. of Economics, University of Missouri (Kansas City) 119-49 Union Turnpike, Forest Hills, NY 11375, USA; E-mail: mh@michael-hudson.com.

Endnotes

1 Alexander Marshack, "Space and Time in Pre-agricultural Europe and the Near East: The Evidence for Early Structural Complexity," in Michael Hudson and Baruch A. Levine, eds., *Urbanization and Land Ownership in the Ancient Near East* (Peabody Museum of Archaeology and Ethnology, Harvard University, 1999:19-63), pp. 19, 53.

2 *Ibid.*, pp. 40 and 32.

3 *Ibid.*, p. 57.

4 *Ibid.*, p. 53.

5 See for instance Aletta Biersack, The Logic of Misplaced Concreteness: Paiela Body Counting and the Nature of the Primitive Mind, *American Anthropologist*, 1982, 84(4):811-29..

6 I have traced the calendrical basis for the payment of debts, weights and measures in "How Interest Rates Were Set, 2500 BC - 1000 AD. Má?, tokos and fænus as metaphors for interest accruals," *Journal of the Economic and Social History of the Orient* 43 (Spring 2000):132-161; "Reconstructing the Origins of Interest-Bearing Debt and the Logic of Clean Slates," in Michael Hudson and Marc Van De Mieroop, eds., *Debt and Economic Renewal in the Ancient Near East* (CDL Press, Bethesda, 2002):7-58; and "The Development of Money-of-Account in Sumer's Temples," in Michael Hudson and Cornelia Wunsch, ed., *Creating Economic Order: Record-Keeping, Standardization and the Development of Accounting in the Ancient Near East* (CDL Press, Bethesda, 2004):303-329.

7 I elaborated this idea in my own contribution to *Urbanization and Land Use in the Ancient Near East*, "From Sacred Enclave to Temple to City."

8 When the Athenian Cleisthenes changed the number of tribes from 12 to 10 late in the 6th century BC, for example, he adjusted the public prytany calendar accordingly, from a 12 month to a 10 month basis.

References

Biersack, A.

1982 *The Logic of Misplaced Concreteness: Paiela Body Counting and the Nature of the Primitive Mind*. American Anthropological Association, January 1982.

Hudson, M.

1999 From sacred enclave to temple to city. In *Urbanization and Land Ownership in the Ancient Near East*, edited by Michael Hudson and Baruch A. Levine. Peabody Museum of Archaeology and Ethnology, Harvard University, Cambridge, MA.

2000 How Interest rates were set, 2500 BC-1000 AD: Má?, tokos and fænus as metaphors for interest accruals. *Journal of the Economic and Social History of the Orient* 43 (Spring 2000):132-161.

2004 The development of money-of-account in Sumer's Temples. In *Creating Economic Order: Record-Keeping, Standardization and the Development of Accounting in the Ancient Near East*, edited by Michael Hudson and Cornelia Wunsch, pp. 303-329. CDL Press, Bethesda.

2007 Reconstructing the origins of interest-bearing debt and the logic of clean slates. In *Debt and Economic Renewal in the Ancient Near East*, edited by Michael Hudson and Marc Van De Mieroop, pp. 7-58. CDL Press, Bethesda.

Marshack, A.

1999 Space and time in pre-agricultural Europe and the Near East: The evidence for early structural complexity. In *Urbanization and Land Ownership in the Ancient Near East*, edited by Michael Hudson and Baruch A. Levine, pp. 19-63. Peabody Museum of Archaeology and Ethnology, Harvard University, Cambridge, MA.

THE CROW, THE CUP, AND THE WATER SNAKE: CELESTIAL SEASONALITY OF FIGS AND RAIN

E. C. Krupp

Interpreting some paleolithic notations as sequential signs of the changing phases of the moon, Alexander Marshack argued that the roots of astronomy penetrate more deeply into the prehistory than anyone imagined in 1972, when his unusual and impressively detailed book, *The Roots of Civilization*, was published. Studies of prehistoric astronomy then emphasized Stonehenge and other neolithic and bronze age monuments in northwest Europe. However, the range of archaeoastronomy was expanding and when astronomer Gerald S. Hawkins surveyed those studies in 1973 in *Beyond Stonehenge*, he included a brief account of Marshack's ideas (Hawkins 1973:228-229, 232, 306).

Although Marshack's lunar sequences look like calendrical tallies, Marshack instead regarded them as symbols and favored linking them with time-factored narrative (Marshack 1972:135). For Marshack, astronomically significant notations meant storytelling, and because storytelling can provide an accurate description of nature, it is a tool for survival.

Marshack never isolated his paleolithic moonwatching from the rest of the paleolithic environment, but instead emphasized its seasonal meaning. The Blanchard bone sequence documented "the changing moon that marked the passing seasons" (Marshack 1975:66).

The seasonality of lunar cycles is well documented ethnographically in traditional cultures. Systems of seasonally-named moons are encountered, for example, in dozens of groups of North American Indians (Cope 1919).

Marshack also detailed explicit seasonal symbolism in paleolithic icongraphy. Seasonal references in the imagery of animals and plants on the Montgaudier antler baton (Marshack 1972: 170-174, 1975:62-63) and on the La Vache bone knife (Marshack 1972:174-175, 1975:63) transform these images into visual seasonal narratives.

Alexander Marshack's compelling demonstrations of celestial and seasonal symbolism in prehistoric iconography and notation and his attribution of its function to storytelling have kept me alert to astronomically delineated seasonality in mythic narrative. Taking a cue from Marshack's attention to symbolic detail, I examined the astronomical and seasonal dimensions of an ancient Greek constellation myth involving Crater the Cup, Corvus the Crow, and Hydra the Water Snake. The story appears in several sources, and the earliest of them, the *Catasterismi* of the Pseudo-Eratosthenes, calls it a "famous episode" (Condos 1997:119). It has been described as a "moral tale" (Ridpath 1988:57).

The *Catasterismi*, the oldest known collection of ancient Greek star myths, is believed to have been based on a longer work authored by Eratosthenes, the head of the Alexandrian Library, in the third century BC. The digest that survives as the *Catasterismi* was probably prepared in the first or second century AD. It combines the three constellations into a single chapter, which explains how the Olympian gods,

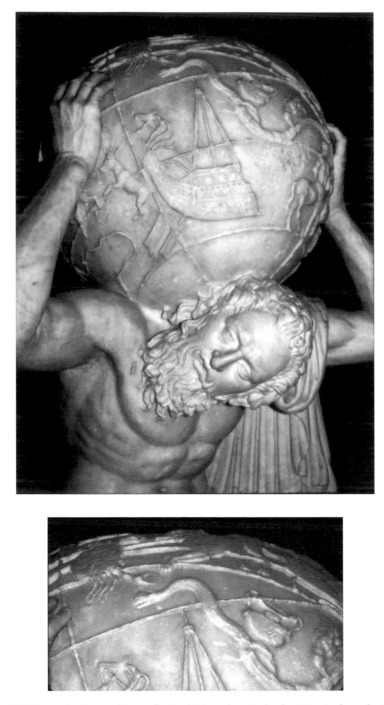

Figure 11.1 *Corvus the Crow and Crater the Cup hitch a ride on Hydra the Water Snake on the Farnese Atlas celestial globe, which probably represents the Greek constellations in the time of Hipparchus, in the second century BC (Naples Archaeological Museum; photograph E. C. Krupp).*

preparing a sacrifice, dispatched the crow, the bird of Apollo, with a cup to fetch water from a sacred spring. At the spring, however, the crow noticed a fig tree with unripe fruit. His taste for figs prompted him to delay his return with the water until the figs matured. Days elapsed, the figs ripened, and the crow consumed them.

Worried about his truancy, the crow needed an excuse to explain his delay. He caught a water snake that inhabited the spring and returned with a tale that blamed the serpent for drinking up the water. Apollo, however, knew the crow was lying and condemned him to a period of thirst. Then, "in order to provide a clear warning about sinning against the gods, Apollo placed among the stars the image of the Water-snake, the Water-cup, and the Crow and depicted the latter as if prevented from drinking..." (Condos 1997:119).

Without additional detail included by the Roman mythographer Hyginus (Grant 1960: 225-227), the story would be an entertaining but innocuous admonition. Hyginus authored the *Poeticon Astronomicon* in the first century A.D., and his account of this myth reports the crow's late arrival after a hasty flight with a full cup. The delay prompted Apollo to inhibit crows' ability to drink during the period when figs are ripening:

> As long as the figs are ripening, the crow cannot drink, because on those days he has a sore [?] throat. So when the god wished to illustrate the thirst of the crow, he put the bowl among the constellations, and placed the water-snake underneath to delay the thirsty crow. For the crow seems to peck at the end of its tail to be allowed to go over to the bowl. (Grant 1960:225).

Closing his astronomical description of the trio of constellations, Hyginus added several other legends associated with the Crow or the Cup, but none links the two. They ignore Hydra altogether.

Crater the Cup and Corvus the Crow are both located upon the back of Hydra the Water Snake. The Cup is a little beyond the midpoint of the serpent's coils and beyond the reach of the Crow, which is farther to the east, closer to the snake's tail.

In the third century BC, Aratus of Cnidus, in Asia Minor, included the three constellations in the *Phaenomena*, the oldest surviving ancient Greek sky guide. His description of them confirms that he saw them in the same disposition:

> But yet another constellation sweeps across the horizon; they call it the Hydra. Like a living thing it winds at great length, its head comes below the middle of the Crab, its coil under the Lion's body, and its tail hangs over the Centaur himself. On its middle coil like the Bowl, and on the last one the figure of a Raven that looks like one pecking the coil. (Kidd 1997:105.)

The Raven and the Crow are interchangeable here.

The *Phaenomena* is thought to be based on a book composed by Eudoxus, an astronomer and mathematician, in the fourth century BC. The three constellations are probably, then, at least that old.

Despite the *Catasterismi*'s claim that the story of the Crow, the Cup, and the Water Snake is "famous," Theony Condos, a Classicist, indicates the fable is not found in any other early sources and is repeated by just a handful of later writers (Condos 1997:122), including Ovid (*Fasti* 2.243). The three constellations appear, however, on the celestial globe held aloft by the Farnese Atlas, a sculpture now in the Naples Archaeological Museum. Believed to be a Roman copy, from the second century AD, of an earlier Greek sculpture, its depiction of constellations on the celestial sphere is, according to astronomer Brad Schaefer, based on the lost star catalog compiled by Hipparchus in the second

century BC (Schaefer 2005). Corvus, Crater, and Hydra are also inscribed on the Mainz Himmelsglobus (Figure 11.2), a small copper-and-zinc constellation globe crafted perhaps between 150 and 220 A.D. (Künzl 2000:523-524; Künzl 2005:67)

Hydra slithers just below Leo the Lion upon the circular Dendera "zodiac" ceiling relief from the rooftop Osiris chapel on the Temple of Hathor at Dendera, Egypt. A mixture of Graeco-Roman and Egyptian constellations, it was installed in the Late Ptolemaic era, before 30 B.C. (Neugebauer and Parker 1969:72) but is now on display in the Louvre, in Paris. Although the Cup is absent in this portrayal of the sky, there is a bird perched on the snake where Corvus usually stands.

An illustrated stone fragment bearing cuneiform text from Mesopotamia's Seleucid

Figure 11.3 The Circular Dendera Zodiac puts Leo the Lion upon a celestial serpent that must be Hydra the Water Snake. This Egyptian astronomical monument includes Egyptianized constellations from Greece and Rome but omits Crater the Cup. A bird that is probably equivalent to Corvus the Crow has alighted on the snake's tail. (Louvre. Photograph E. C. Krupp.)

Figure 11.2 The Mainz Himmelsglobus, a Roman era celestial globe. Corvus the Crow and Crater the Cup perch in their traditional locations on Hydra the Water Snake's undulations. (Mainz Römisch-Germanisches Zentralmuseum. Photograph E. C. Krupp.)

period (312-280 BC) includes images of Virgo the Maiden, the planet Mercury, and a portion of a serpent's tail, on which a bird is pecking (van der Waerden 1974:81). The era of the inscriptions on this object, which is now in the Vatican Museum, is consistent with the time of Eudoxus.

Although the myth of Corvus, Crater, and Hydra can only be documented with confidence to the first century AD, and perhaps extrapolated to the third century BC, the graphic celestial

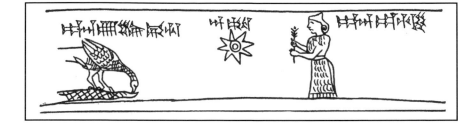

Figure 11.4 Seleucid celestial imagery includes a bird on the tale of a snake. Inclusion of a Virgo the Maiden, a constellation near the tail of Hydra the Water Snake and Corvus the Crow, verifies those constellations are portrayed. The large starlike object is identified in the accompanying text as the planet Mercury. (Langdon, Stephen Herbert. The Mythology of All Races, Volume V, Semitic. Boston: The Marshall Jones Company, 1931, collection Griffith Observatory).

iconography of the myth seems to be as old as the Hellenistic era and perhaps the late fourth century BC. Textual references to the constellations are reasonably rooted in the fourth century BC. This evidence suggests these three constellations comprised a set, and the tale that connects them is specific about their relationship, which is odd.

It is difficult to understand why the Crow's irresponsible but relatively inconsequential behavior deserved such a high-profile commemoration in the sky. It must be more important than it seems, and the seasonality embedded in the myth suggests an analysis of the seasonal behavior of these constellations might disclose its meaning (Krupp 2006).

Fundamentally, the story of the Crow, the Cup, and the Water Snake is about water and figs. Consecrated water is needed by the gods and must be obtained. Eventually it is brought to them, but only after the designated transport agent was tempted by unripe figs. Delivery of the water had to wait until the figs ripened. The delivery agent is punished and denied water during the time figs are ripening.

Because the story involves a seasonal agricultural cycle - fig cultivation - the water in play is

likely rain. The seasonality of rain and figs, in that case, would be signaled by Crater the Cup, a beverage container, and Corvus the Crow, whose behavior is leveraged by figs.

Crater the Cup is not a conspicuous constellation. Most of its stars are fourth and fifth magnitude, and in the time of Aratus they were intersected by the celestial equator. There is no reference to them earlier than the *Phaenomena*. If the constellation were contrived in the third or fourth century BC, its inventors may have designed it as an equatorial reference with seasonal value.

In Mediterranean Asia Minor, for example, where Aratus lived, the peak rain arrives in December/January. It is greatly diminished by April/May, and in summer July/August the rain is gone. It returns again in September/October.

Looking for connections between the seasonality of the rain, the seasonality of figs, and the seasonality of Crater the Cup, I examined celestial maps generated by Voyager II astronomical software. With the latitude (36° 40' north) and longitude (27° 45' east) for Cnidus, on southwest Turkey's Resadiye peninsula, near Datça, and with enough precessional displacement for 400 BC, the maps showed Crater the Cup setting with the sun, and disappearing from the night sky, in

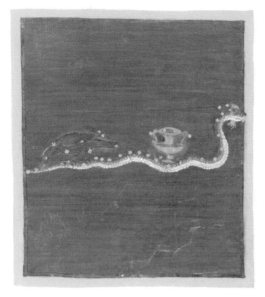

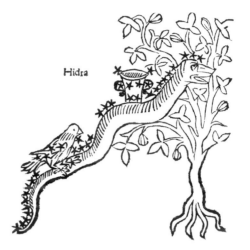

Figure 11.6 A 1488 edition, published in Venice, of the Poeticon Astronomicon by Hyginus completes the illustration for the story about Hydra, Corvus, and Crater with a fig tree. (Collection Griffith Observatory.)

Figure 11.5 Although Aratus did not consolidate Hydra, Crater, and Corvus with a mythic narrative, the Leiden Aratea, an illustrated Carolingian manuscript of the Phaenomena, combines the three into a single picture. (Reproduced by permission of the University Library, Leiden, The Netherlands (ms. Voss.Lat.Q.79, f.50b) collection Griffith Observatory.)

August. It remained hidden in the sun's glare until between late-September and mid-October, when it rose before dawn. Its heliacal rising and return to the night sky therefore accompanied the start of the rains.

As a receptacle for water, Crater the Cup is an apt symbol for the delivery of rain. Rising earlier each night, Crater the Cup remained visible in the night sky through the rainy period of winter and spring. Its absence from the night sky in August and September coincided reasonably with the absence of rain.

By December, the time of greatest rain, Crater was on the meridian, its highest elevation, at dawn. By the beginning of March, it rose when the sky had grown dark after sunset, and it remained above the horizon all night. By the following August, Crater was again setting at sunset and abandoning the Crow, which for a little while longer remained above the western horizon.

Figs are believed to have originated in southern Arabia, and they have been cultivated for thousands of years in Mediterranean semi-desert territory, including Asia Minor. Figs ripen, usually in two crops, from July until October, when there is little or no rain and when Crater the Cup is not around to carry water. They must ripen on the tree and be collected before the rains arrive in fall (University of California, Davis, Fruit and Nut Research Information Center 2005).

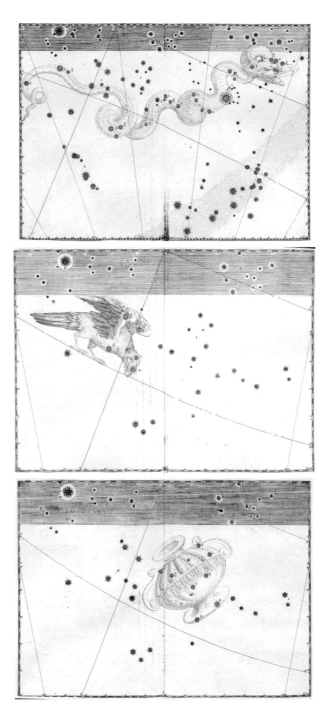

*Figures 11.7-11.9 Johann Bayer dedicated an individual chart to each of the three constellations -
Corvus the Crow, Crater the Cup, and Hydra the Water Snake - in Uranometria, the innovative
celestial atlas he published in Germany in 1603. (Collection Griffith Observatory.)*

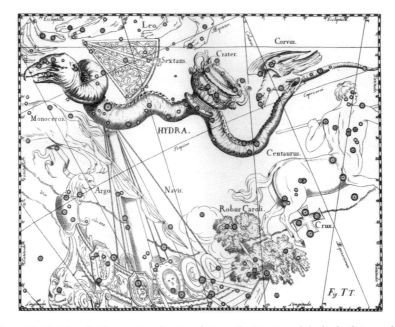

Figure 11.10 Although Johannes Hevelius tipped Crater the Cup toward the beak of Corvus the Crow in a star atlas, Firmamentum Sobiescianum, published in 1690, after his death, the water remains out of the bird's reach. (Collection E. C. Krupp.)

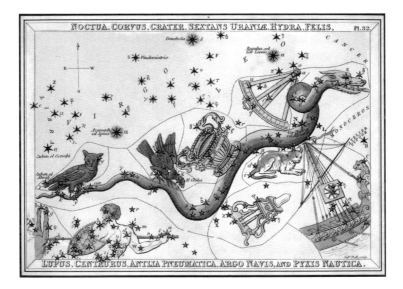

Figure 11.11 Corvus the Crow competes in a celestial bowl game but can't seem to win the Cup on one of Samuel Leigh's cards for Urania's Mirror (c. 1820). Hydra the Water Snake, playing fullback, hosts not only the celestial Sextant but also Noctua the Night Owl, a constellation introduced first in 1776 as Turdus Solitarius the Solitaire bird by Pierre-Charles Le Monnier. Noctua, which never became an official constellation, didn't give a hoot about figs and rain. (Collection E. C. Krupp.)

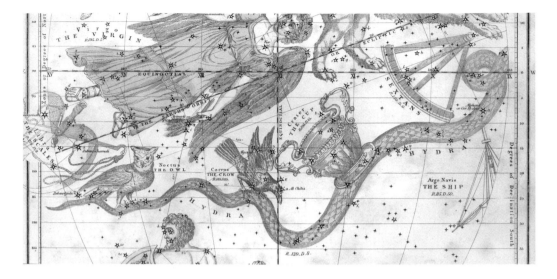

Figure 11.12 Hydra the Water Snake is too long to fit on only one of the constellation maps in Elijah H. Burritt's Atlas Designed to Illustrate the Geography of the Heavens (1893). Burritt perpetuated the presence of a second bird, the obsolete constellation Noctua, on the snake's tail. (Collection E. C. Krupp.)

According to the myth, the Crow is delayed while the figs are still maturing and fails to bring back the needed water at that time, which is the summer dry season. Taking a cue from the Cup, the Crow also disappears from the sky during the dry season and later returns after the Cup has come back with the autumn rain. The Crow cannot drink in the dry season, when the figs are ripening. There is no rain, no Cup to carry it, and no Crow.

The evidence implies that Crater, a celestial cup for celestial water, was contrived in the fourth century BC. On the celestial equator, in the company of Crow and the Water Snake, it helped announce the onset and departure of rain. This function lodged it in a myth incorporating Corvus the Crow and Hydra the Water Snake, both of which may have greater antiquity. In the earliest Greek constellation myths, however, they are bonded with Crater. Together, the three constellations represent elements of a mythic iconography that confederates the rains, the figs, and the stars that announce their seasonal changes.

Understanding the meaning of the myth requires recognition of the time-factored symbolism of the constellations and their relationship to important seasonal dimensions of the environment – fig cultivation and rain. In this case, ancient Greek star lore gave a fig about the rain.

About the author

Edwin C. Krupp, Director, Griffith Observatory, 2800 East Observatory Road, Los Angeles, CA 90027 USA. E-mail: eckrupp@earthlink.net.

References

Condos, T.

1997 *Star Myths of the Greeks and Romans: A Sourcebook*. Phanes Press, Grand Rapids, Michigan.

Cope, L .

1919 Calendars of the Indians North of Mexico. *University of California Publications in American Archaeology and Ethnology*, XVI, No. 4 (1919-1920):119-176.

Grant, M.

1960 *The Myths of Hyginus*. University of Kansas Press, Lawrence, Kansas.

Hawkins, G. S.

1973 *Beyond Stonehenge*. Harper and Row, Publishers, Inc, New York.

Kidd, D. (Editor and Translator)

1997 *Aratus Phaenomena*. Cambridge University Press, Cambridge, U. K.

Krupp, E. C.

2006 The Bowl of Night. *Sky and Telescope* 111, No. 3 (March):43-44.

Künzl, E.

2000 Ein Römischer Himmelsglobus der Mittleren Kaiserzeit. *Jahrbuch des Römisch-Germanischen Zentralmuseums Mainz*, 47:495-594 + plates 33-94.

2005 *Himmelsgloben un Sternkarten*. Stuttgart, Germany, Konrad Theiss Verlag GmbH.

Marshack, A.

1972 *The Roots of Civilization*. McGraw-Hill Book Company, New York.

1975 Exploring the mind of ice age man. *National Geographic*, 147, No. 1 (January):62-89.

Neugebauer, O., and R. A. Parker

1969 *Egyptian Astronomical Texts III. Decans, Planets, Constellations and Zodiacs*, 2 vols. Brown University Press, Providence, Rhode Island.

Ridpath, I.

1988 *Star Tales*. Universe Books, New York.

Schaefer, B. E.

2005 The epoch of the constellations on the Farnese Atlas and their origin in Hipparchus's Lost Catalogue. *Journal for the History of Astronomy* 36, Part 2, No. 123 (May):167-196.

University of California, Davis, Fruit and Nut Research Information Center

2005 "Fig Fact Sheet." <http://fruitsandnuts.ucdavis.edu/crops/fig_factsheet.shtml>.

van der Waerden, B. L.

1974 *Science Awakening II (the Birth of Astronomy)*. Noordhoff International Publishing, Leiden, The Netherlands.

CLAW MARKS AND RITUAL TRACES IN THE
PALEOLITHIC SANCTUARIES OF THE QUERCY

Michel Lorblanchet

Introduction

I often met Alexander Marshack in the cave of Pech Merle (Lot, France). We used to swap our impressions and our opinions in front of the panel of the spotted horses which we both loved. Our relationship developed at congresses, and we established a friendly and authentically scientific communication. Even if I did not always share his interpretations, I personally admired his work which still serves as a model.

I would like to recall that, in a recent book, while he was still alive, I emphasized:

> "...the immense contribution of this researcher to the study of paleolithic art, at the very time when the structuralist theories illustrated by the research of Max Raphael, Laming-Emperaire and Leroi-Gourhan were enveloping the art in a perfectly closed system. Whereas in that interpretative system, each decorated cave, each engraved object tended to seem like an instantaneous and rigid composition, produced in a single event, once and for all, and whereas only the themes – and not the detail of the figures – were henceforth attracting the attention of prehistorians, the splendid macro- and micro-photographs of A. Marshack opened up new horizons; they revealed the hidden and mysterious beauty of the artworks, the importance of the detail in the figures and the artists' gestures. In undertaking the exploration of a hitherto neglected domain, they completely changed the way prehistorians looked at paleolithic art, brought them back to the documents themselves by restoring to them the dynamism and the meaning of life and of the humanity in them. They showed that many artworks had been produced progressively, sometimes by different hands, and that they had been used for ritual activities and bore the marks of re-uses. The time factor had played an essential role in their fabrication and their utilization" (Lorblanchet 1999:174).

My long familiarity with the paleolithic decorated caves of the Quercy led me – in the same spirit as Alexander Marshack – to discover and analyse human traces which often resemble animal claw marks; today I consider them to be "ritual traces", that is, as traces of actions carried out close to figures or in a close relationship with them, but which were not necessarily meant to produce a parietal image. They are evidence for ritual activity in the heart of the paleolithic sanctuaries.

Traces and human parietal markings in the Paleolithic art of the Quercy

Animal claw marks are traces, that is to say, often unintentional marks left by some action by animals on the floor and walls of caves, whether it be slides (Pech Merle has a magnificent example in the "Galerie des Pas" where a bear fell from a ledge and left a claw mark some 2 m long) or supporting themselves on a ledge; however, some animals like bears and felines "sharpen

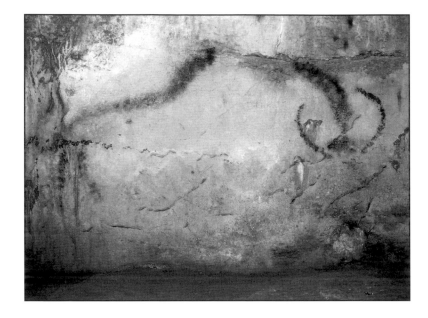

Figure 12.1 Marcenac Cave (Cabrerets, Lot). Bison painted by spitting technique, 1.6 m long. (Photo M. Lorblanchet.)

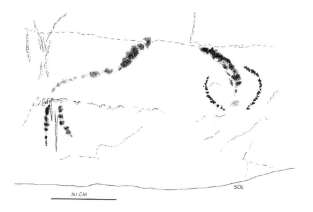

Figure 12.2 Marcenac Cave (Lot). Tracing of bison by M. Lorblanchet.

their claws" on a variety of supports, and it is by no means certain that their tactile sense is in those cases the only motivation for their claw marks. Their visual perception of the marks that they produced in the caves, a wish to "mark territory", perhaps also motivated the act of making

a claw mark and the production of visible marks.

So it is sometimes difficult, even where animals are concerned, to distinguish between involuntary traces and markings which are intentional.

Where human marks in decorated caves are concerned, the distinction between traces and

Figure 12.3 Marcenac Cave (Cabrerets, Lot). Back and horns of the bison. The photographic analysis brings out vertical digital marks, which are almost invisible, over the whole painted surface. These fingermarks, a ritual "combing" of the wall, are covered by the paint. (Negative photo, M. Lorblanchet.)

markings is also sometimes tricky: the intentional nature of many parietal anthropic marks is clear, especially when they are organized in a complex motif; these are obviously markings. Conversely, human footprints on the floor of certain decorated caves (Pech Merle, Pyrenean caves, etc.), often considered as the involuntary traces of someone passing through a gallery, may be intentional prints, a ritual marking attesting a presence in a particular part of the cave, and even implying a search for clayey areas where footprints can easily be made. The direct, physical contact with the cave and the print that it produces could have had a meaning. The same applies to the "disorganized finger marks", Breuil's famous "macaroni", which may be a ritual marking expressing a human ascendancy, a dialogue with the cave, with absolutely no figurative intention on the part of the authors.

The "hand rubbings"

Twenty years ago (1984:95) I published some peculiar parietal motifs, which had been neglected by prehistorians. in the decorated caves of the Quercy and in a few other sites (notably Gargas), and which I baptized "hand rubbings". These are "traces" or "markings" created by the rapid gesture of a hand, coated with color, being rubbed on the wall to produce 3 to 5 long and parallel digital lines: the gesture implies that the palm was not in contact with the wall, so that all the fingers produce a dynamic image formed of a cluster of lines which is very different from a simple digital mark. So far I have recorded about twenty of these motifs in the Quercy (especially at Pech Merle, and Cougnac, Les Fieux, Cantal – 1984; Figure 12.11), generally associated with dots and often in immediate proximity to bear claw marks. Their positioning in the decorated space and in time, and their constant association with other paintings, show that they cannot represent the gesture of the painters wiping their hands on the wall (and on their "apron", perhaps?). The gesture and its result, in their aspect and in their dimensions, are in reality the exact equivalent of a bear claw mark.

Moreover, in Le Combel (Pech Merle) I have recorded and published a panel in a niche showing five sets of bear claw marks associated with five red "hand rubbings" (Lorblanchet 1999:15); here the paleolithic people were probably imitating the

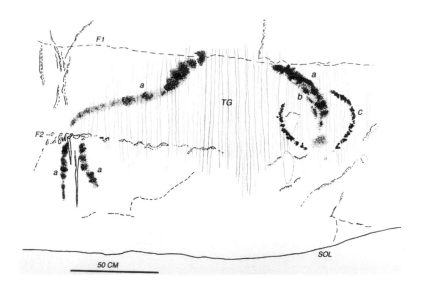

Figure 12.4 Marcenac Cave (Lot). Bison, tracing by M. Lorblanchet: F1-F2) fissures; TG) fingermarks; a-b) spat paint; c) horns drawn by finger; SOL) cave floor; NB: The entire bison profile is painted by spitting. Hence the drawing comprises lines of large dots. This technique was fully mastered, as the drawing is well-shaped: it is more accentuated behind and in front of the hump, and lighter in the animal's rear. The animal's chignon is made up of two series of parallel dots. One should note the gap at the top of the hump: the paint stops and gives way to the natural fissure. So it was important to integrate the fissure (F1) in the drawing. The contrast with the horns is striking: they are very black and were drawn by rubbing a finger coated with pigment (manganese oxide) onto the wall.

claw marks which are covered here and there by the red ochre (1984; Figure 12.11). This interesting example is to be added to the difficult file of relations between bears and people in the decorated caves , and the thorny question of a possible origin of a certain type of parietal art in imitations of claw marks.

Ritual traces in Roucadour (Thémines, Lot)

In the course of five years of collective and multidisciplinary research in the decorated cave of Roucadour, several types of ritual marks have been identified and recorded:

1) Striated areas

These are dense and confused networks of fine striations made up of subvertical incisions which cross each other and generally cover a surface of about twenty centimeters high and the same in width. These striated surfaces are sometimes isolated between engraved figures (horses, megaloceros, mammoths, felines, *etc.*) but are themselves often also underlying hand stencils which are not "striated" or "scraped hands", but hands painted onto a previously striated area.

In other cases, these striated areas are integrated into panels that are very rich in figurative engravings and geometric signs; the study of the superimposition of motifs indicates that these striated surfaces are among the very earliest marks made on the rock, often just before or just after the mammoths which, themselves, also belong to the first phases of activity on the panels.

Figure 12.5 Marcenac Cave (Cabrerets, Lot). Photographic research brings out the fingermarks underneath the bison. Here one can see a detail of these fingermarks, between the chignon and the bison's left horn (photo M. Lorblanchet).

Finally, in other cases, some more extensive striated areas (60 x 50 cm), which are isolated and not associated with other motifs, cover the edges of deep concavities in the wall, and draw attention to and underline their natural, probably female symbolism. The topography of the cave and the morphology of the walls had meaning, of course.

2) Hammering impacts

In two places we have noted the presence of hammering marks made with a pebble or pointed tool: tiny cavities in groups, or superficial star-shaped marks on the calcite film covering the limestone. These hammered areas are located in a cavity with the shape of a "natural vulva", as well as around a sign made up of an indented circle, at the back of the decorated passage (panel IV). These traces suggest a rhythmic hammering of the decorated wall, doubtless associated with songs, which must have taken place during visits

to the site, as I observed in rock shelters decorated with paintings in Queensland (Australia). In that region, the "site owner", who is an old initiate, enters into communication with the spirits through his song for which he marks rhythm by beating the painted wall with a pebble.

"Phantom finger markings"

In the course of my last work in Le Combel (Pech Merle) in 2000, I discovered and recorded some extremely unobtrusive new marks which I had not detected previously. They are a few traces of the spraying of ceilings with pigment and especially of finger tracings that can be called "invisible" – that is to say, the marks of a ritual touching of the wall, the aim of which was not to produce a drawing nor to leave any kind of visible mark. The concavities of the small chamber of the "Lion Cage" were systematically "combed" with fingers which scarcely altered the white surface of the compact limestone. This "combing" covered the whole concavity and was carried out with a gesture which imitated that of bears clawing the wall, but in this case the gesture was devoid of aggression and full of gentleness, perhaps even of veneration? It was a simple "parietal caress" orientated from top to bottom in successive and roughly parallel "coups de main": the fingertips brushing against the stone left no trace; it simply, very lightly disturbed the superficial state of the wall, the organization of the rock's grains, and thus provoked phenomena of differential condensation which, at certain times and with certain kinds of lighting, today make these delicate traces visible. It is clear that, in this case, only the gesture was important, not its result.

My new recording of the "Lion Cage" detected the same invisible finger traces in the center of the panel which features 23 big red dots, a lion and three horses, all in red, and a brown-black hook-like sign; the previous motifs were retouched with

the same color. The stratigraphy of this assemblage was worked out: after the production of the dots, the surface was "ritually prepared" by the kind of systematic "combing" described above, which scarcely affected some red dots. The bottom of the wall was sprayed with a diluted red clay; then the lion and then the horses were drawn, a different pigment was used to make the hook-shaped sign and, finally, to retouch the outline of the three animals.

So here the "phantom finger markings" exist between two pictorial strata, which shows that they are well integrated with the activity in the sanctuary, an activity that comprised not only the creation of paintings but also other rites that left barely perceptible traces which the prehistorian has to make an effort to rediscover.

It should be recalled that in the same cave, the Megaloceros of the Ossuary was drawn with a finger in a concavity that is entirely covered with vertical digital marks, identical to the superficial combings of Le Combel. But here, any brushing of the clayey surface inevitably left a visible trace. It follows that certain non-figurative finger markings are only traces of touching the wall, of ritual gestures, and not, perhaps, of markings that were meant to be seen.

In the same hill as the cave of Pech Merle, and close to it, the cave of Marcenac displays the same hitherto unnoticed phenomenon. At the end of this cave, a spectacular big black bison was drawn with a series of big dots made by spitting, while its horns - which are presented from the front, as if the animal was turning its head towards the spectator - were made with a line scraped with a finger. The whole animal occupies a broad concavity whose light surface was previously lightly rubbed, vertically "combed" with the hands, as in the "Lion Cage" of Le Combel; here again this act has left an almost invisible trace which only a particular lighting and photographic research make it possible to reveal today (see figures).

Conclusions

The transition from animal claw marks to human traces and markings is imperceptible; numerous confusions are possible, if the prehistorian's perceptions are too rapid and are not based on authentic recordings. It seems that a number of human markings are in fact only traces, where only the gesture seems to have counted.

Moreover, certain human traces seem to imitate bear claw marks, which perhaps reveals that bears played a particular role in mythology, the organization of the parietal sanctuaries and the artistic creation of paleolithic people.

Acknowledgments

I am most grateful to Paul Bahn for translating this article.

About the author

Michel Lorblanchct, Roc des Monges, 46200 St. Sozy, France. E-mail: michel.lorblanchet@wanadoo.fr.

References

Lorblanchet, M.

1984 Nouvelles découvertes d'art pariétal en Quercy. In *L'Art Pariétal Paléolithique*, Colloque Périgueux-Le Thot, pp. 79-105. Ministère de la Culture, Paris.

1999 *La Naissance de l'Art, Genèse de l'Art Préhistorique*. Paris, Errance.

2003 Des griffades aux tracés digitaux. *Préhistoire du Sud-Ouest* 10:157-76.

2006 *Etude de la grotte ornée de Roucadour (Thémines-Lot), état d'avancement des recherches* Préhistoire du Sud-Ouest.

ALEXANDER MARSHACK: HIS ORIGINAL VIEWS AND THOUGHTS. A REMARKABLE CONTRIBUTION TO THE EVOLUTION OF RESEARCH: THE CONTRIBUTION OF A FASCINATING SESSION OF WORK AT GOUY

Yves Martin

Introduction

Alexander Marshack's encounter with Gouy, a small decorated Paleolithic cave in Normandy (Seine-Maritime, France) is presented here. This memorable visit was a key moment in the history of this cave's study, because it is absolutely certain that Alexander Marshack's visit was extremely beneficial to research on Gouy. The considerable contribution that resulted from it, in just one, excessively short day, bears witness to this: 1) revelation of a "patina" on Gouy's walls; 2) revelation, under UV light, of a painting (far more extensive than hitherto supposed), 3) revelation of a period of much greater internal hydrous activity (solution of an enigma); 4) confirmation of the presence of an exceptional depiction on a limestone block.

But Alexander Marshack's contribution did not end on the day of his encounter with Gouy – it had a far greater effect, since most of the discoveries made in this cave since his visit are the prolongation of that day.

Most of the photographs illustrating this article are unpublished photos by Alexander Marshack, and were taken on the day of our meeting at Gouy.

Meeting Alexander Marshack

By giving himself the means to verify his famous intuition, Alexander Marshack undertook some unquestionably innovative research. When he began his investigations in 1962, posing new questions, his subject had barely been touched by prehistorians.

Before his analyses, the notations that were to make him famous had generally been called "hunting tallies" and no detailed work had really been done on them. It was difficult for most researchers to have access to the heavy equipment that was indispensable for the extremely detailed kind of study that he undertook.

Today it is hard to imagine the resultant huge contrast, in publications concerning that infinitely visual subject "the study of the images created in the Ice Age" – the yawning gap between the studied image and the printed version.

Yet is was obvious that the technical means needed for the transmission of far more reliable reproductions already existed (Bataille 1955; Zervos 1959), but generally without a notable contribution by the specialists who studied these Paleolithic images.

The lack of precision had become normal, and even seemed to suit a few people – to the point where errors were spread around, and interpretations became increasingly fantastic. Today, alas, certain scholars – albeit highly critical of others – still sometimes proceed in this way, and even steal other people's work, distorting it and publishing it under their own name.[1]

Be that as it may, what seems to have been most lacking was not only the necessary financial means, but also the determination to achieve – as Marshack did – the possibility of acquiring these means. Hence the reproductions that were indispensable to published work and which should, in principle, be usable by the reader, could not be used in any serious way within the framework of scientific studies, because the quality of reproduction of these documents was astonishingly mediocre. In such conditions, without the possibility of referring to the original objects, it is impossible to work with any rigor – that is to say, without danger of committing numerous errors of interpretation.

Alexander Marshack notes in the magnificent and exemplary book, *The Roots of Civilization* (Marshack 1972), that followed his first publication in France (Marshack 1970), "...[Hallam Movius] agreed that one could not trust the traditional scientific renderings of the archaeological material..."

It was thus with several hundred kilos of material, including a binocular microscope with variable focus, as well as photographic equipment (macro and micro-optic), in part loaned by Nikon Camera (Ehrenreich Industries), that he carried out this work. With the encouragement of Professor Hallam Movius, who supported his methodology, he thus criss-crossed France and the whole of Europe, as a researcher from the Peabody Museum of Archaeology and Ethnology at Harvard University.

As he developed techniques of analysis and comparison, in a constantly evolving process, his research and deductions advanced as he examined the facts and revealed his interpretations and the possibilities for interpretation. Hence, studies of several other kinds of graphic evidence were added to his research, such as: ritual and symbolic marking; additions, overmarkings, reactivated images and re-use of depictions; indications of seasons or seasonal migrations; patina and polish; meanders (Marshack 1977); symbolic depictions; images of females and animals (Marshack 1990).

Basing himself on his remarkable photographic documents, he provided us with irrefutable elements of extreme precision. As he penetrated to the very depths of the images, he showed us the obvious path to follow.

It was only some years after the publication of his first work that various specialists were inspired by him. In the same way, some of his most virulent disparagers also adopted his working methods and, without admitting it, plunged in their turn into the road that he had so brilliantly opened up.

He therefore made an important contribution to the evolution of research. And so it was with great impatience that I awaited his visit to Gouy, in July 1973, after I had learned of it from Maurice-Jacques Graindor, former regional director of Prehistoric Antiquities, and (at that time) director of the study of Gouy.

Revelation: "Patina" on the walls of Gouy

As soon as he entered the little cave of Gouy, Marshack, assisted by his wife Elaine, seemed to be surprised by the aspect of the incisions. It is true that the apparent freshness of these engravings is very deceptive. At first sight they may appear recent, an effect reinforced by the whiteness of the chalk walls.

Any doubts felt at first glance about the real antiquity of Gouy disappeared completely when Marshack returned with a powerful battery-powered Wood lamp, which he had gone to fetch from his car. Because for the first time, thanks to this ultraviolet light, we all had the amazing good fortune to visualize the great age of this cave.

The walls, like the engravings, suddenly appeared to be covered with a (very dense) dark

gray coating that contrasted with one's normal view of them. A patina, or rather a venerable deposit of compact dust, hitherto undetected, was thus revealed: the "dirt of the centuries" as Henri Breuil called it.

Only two or three (historical) scratches displayed the rock beneath, in dazzling white. These traces of blows, contrasting with the rest of the wall, reinforced the impression of the sites general antiquity.

The subsequent phase of this captivating analysis of the decorated surfaces was no less interesting, since the UV light brought other revelations.

Revelation: Fluorescent red painting

The UV lamp was suddenly turned towards the left-hand wall, and revealed in a striking way that it had been painted far more than had been supposed (and likewise the right-hand wall). None of the few vestiges of red ochre coloring known until then had suggested such a great expanse of this red (Martin 1984).

In UV light, this paint in Gouy produces a strong luminescence – a highly saturated, fluorescent pinkish-red (Figure 13.1:b). This spectacular phenomenon was intensified by the revelation of surfaces bearing weathered paint (invisible in normal light – Figure 13.1:a). These metamorphosed surfaces react to UV as violently as those already known, with intact pigments. The display is caused by the ultraviolet luminous excitation of the pigments which, in their turn, emit pinkish-red light (in the visible range). This is unusual in parietal art.

The luminescent materials that are normally encountered below ground and described so far are generally limited to calcite and aragonite (Aujoulat 1987). They display a dazzling white which cannot be confused with the (pink magenta) color emitted by this red. However, "red and orangey-red" are mentioned as the fluorescent color of certain forms of calcite in Arizona, California and New Jersey (Eastman Kodak 1972), when short-wavelength UV is used, in contrast to Gouy, where the luminescence is only generated with a long-wavelength UV light. No publication mentions a phenomenon resembling what is observed in Gouy. Painted motifs usually appear black (or gray) in UV, with no emission of light (Collison and Hooper 1976a, b).

Following Marshack's visit, we sought to acquire the same material in order to pursue the research, but it was only much later that it was possible to procure it.

At Gouy, the pinkish-red photoluminescence was recorded on color photographic film of "daylight" type (Figure 13.1:b).

There may be many reasons for the emission of this light. It could be the incorporation of particular substances in the paint, whether purposely or not, or the presence of micro-organisms (certain lichens?). But in the latter case, if this is what had happened at Gouy, it would have to mean that the micro-organisms were exclusively preserved on the painted surfaces, without ever prospering beyond them (Figure 13.1:b, c).

Pigment analyses are indispensable here (Martin 2004), and a request for authorization to carry out a program of research has been made with that intent. A project for study of the Gouy pigments has been submitted. A preliminary series of exchanges with Bernard Guineau, ingénieur de recherche at the CNRS "Study of pigments, history and archaeology" (Center Ernest Babelon, Orleans) has been going on since 1996 with that aim in mind.

It was also thanks to long-wavelength UV light that two different red paints could be distinguished from the initial red, which was thought to be the only one present. One of these reds is fluorescent, while the other remains neutral (it does not react to UV).

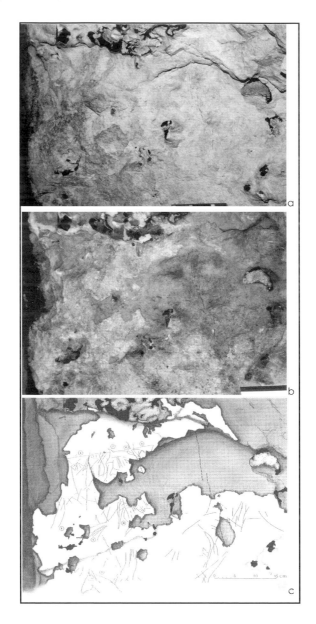

Figure 13.1 Upper register of the left wall (first chamber, close to ceiling). State of the painted wall (detail: 65 x 45 cm): a) using the light of an electronic flash (red painting n°4, damaged today); b) using ultraviolet light (Wood lamp). The luminescence (pinkish-red: saturated) emitted by the painted wall (in reaction to the UV) helps one precisely to delimit the surfaces with discolored paint, or those which are flaked; c) tracing. The painted surface also comprises some fine engravings, including a horse-head (bottom) and a sign resembling female silhouettes in profile (top, and Figure 13.13:d). The surfaces with flaked paint have removed a large part of the imperceptibly engraved decoration. The dark part along the left edge of three illustrations marks the limit of the cave's destruction: it was cut through during construction of a road. Tracing: Y. Martin. Photographs by OMG/Y. Martin.

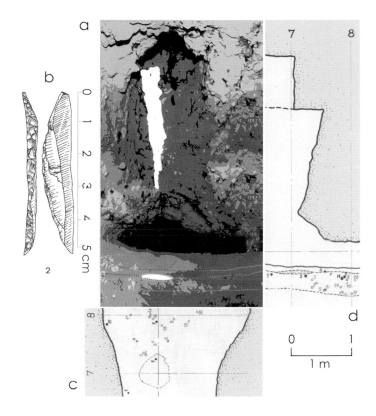

Figure 13.2 a) veil of calcite ("cascade") revealed by UV light, with indication on the ground of a heap of lime-stone sands and calcite (photo-montage); b) curved-back point n° 2. Drawing: Y. Martin; c-d) section and plan with the heap (on the ground: green dots) having "sealed" the flint point (n° 2) into place. Black numbers: lithic industry. Red numbers: other archaeological material. Section and plan (1964) by P. Martin.

Red paint (neutral red)

Under UV light this paint appears black or grey, depending on its concentration in the pigments, but never emits the slightest luminescence. It is therefore extremely difficult to localize with the Wood lamp, on these walls where all kinds of grey are mixed together.

Its use appears very scarce in contrast with the fluorescent red: 1) dots and red touches seem to be limited to this neutral red paint; 2) it has never flaked off, unlike the fluorescent red.

The difference between the two paints seems to have been confirmed. This is certainly what is suggested by preliminary tests carried out by scanning electron microscope (Eric Beucher, "Analyses and Surface", Louviers, Eure).

Revelation: Greater period of hydrous activity

When UV light was directed toward the back of the cave, another vision was seen, no less spectacular than the first: that of a hitherto unknown "stream" of calcite (Figure 13.2).

Figure 13.3 Sketch by A. Marshack (rapidly drawn to explain his viewpoint: July 1973); a) female outlines with the specimen from Gouy (confirms a joint analysis: Figure 13.4); b) vulva in bas-relief (Gouy) and notch (Figure 13.11). To facilitate notably comments on the notch; c) horses. To support a discussion about graphic conventions.

From the ceiling where it formed, it appeared like a frozen cascade springing out, intensely white and luminescent, from the shadows (over a surface of *ca.* 2 m x 1 m).

It was surprising to find that this "calcite veil" suddenly stopped above the ground (at an overhanging ledge).

Until that day, the traces had been too sparse to enable us to detect (precisely) at this spot the exact extent of this major concretion (which is now dry). Especially as Gouy was not known to contain any concretions. This calcite: 1) bears witness to a period of far greater internal humidity (a period probably datable by means of the calcite); 2) covers some engravings; 3) finally, it sealed a curved-back point to the floor.

Hence the formation of an (enigmatic) heap of agglomerated limestone, which had no definitive explanation, has today had light shed on it.

It is an aggregate of limestone sand, forming a "lens", 50 cm in diameter and 7 cm thick, on the ground; it is very friable (Figure 13.2).

It now seems that this aggregate was constituted from the calcite "veil" revealed by the UV light. As it developed, this "veil" drained a seepage of percolating water up to the overhanging ledge, from which it flowed, drop by drop, into the void, down to the ground.

Hence the "lens" was gradually formed by capillary action, inside a layer of consolidated limestone sand, but was never transformed into a true stalagmite. The curved-back point, No. 2 (Figure 13.2), was thus more or less sealed (in place) a few cm below the "lens" (Azilian point "No. 3" in François Bordes' study, 1974).

Of course, as soon as the opportunity presents itself, it will be extremely interesting to ask for some direct (U/Th) dating to be done on this

calcite (Li *et al.* 1989; Genty *et al.* 2005; Ambert and Guendon 2005) if radiometric methods through mass spectrometry and isotopes prove to be possible.

Confirmation of an exceptional figure

Before we entered the cave, and because Alexander Marshack was wondering about the appearance of the walls he was about to see, I showed him a decorated block from the cave so that he could judge for himself. This block was absolutely captivating, and its study was already underway. Hence, at this time, the block's decorated face was presented to him, although nothing was said to him about the unpublished image, so as to arouse his appreciation without influencing him.

Almost immediately, he enthusiastically confirmed our reading (for the most part), but because of the language barrier our exchanges were based on a few rapidly drawn sketches (which still survive). This is why he drew on paper what he saw on the stone (Figure 13.3.a). In that way, his drawing provides a permanent record of his spontaneous reading (as do his excellent photographs).

It should be noted that, when Elaine and Alexander Marshack came, the album of plates of Gouy had just been published, an album that essentially consisted of photos, tracings and sketches (Martin 1973).

The purpose of that publication was to provide through images a first glimpse of Gouy's parietal art, with reproductions of the best possible quality. It also presented a selection of the different types of decorated limestone blocks, purposely submitting them to the reader, with no analysis and without imposing any kind of reading of the "objects". For that reason, block C had intentionally been published upside down, so as not to influence anyone; we refused to present interpretations which were not based on the complete study of the "objects" (Martin 1973:141:c).

Hence, the option that was adopted: that of at first only publishing a collection of unbound plates, the aim being to offer the reader the greatest number of possibilities for comparing documents (which could thus be turned in any direction). Nevertheless, it should be noted that from this other viewpoint (the stone seen upside down) the motif is equally visible.

Naturally, with such possibilities for juxtapositions, even as we continued work, the reactions and observations of readers were eagerly awaited, especially with regard to the block (C).

However, with the exception of Marshack, no reader has so far communicated any observations. It is true that Marshack was one of the few people who was able to see the block itself. Nevertheless, the image can be seen quite well (Figure 13.4:a) on the black and white photo already presented in the album of plates (C).

Because I was intending to publish a detailed study of all the decorated blocks, including this stone, in a more complete monograph, I asked Marshack not to publish his photos before the publication of the study that was underway.

Marshack kept his promise, and I am extremely grateful to him for this – especially as it was very tempting to make such an exceptional "object" known rapidly. That is why his attitude was truly exemplary.

But since 1996 I have no longer had official authorization to enter Gouy, despite the opinion of the interregional commission on archaeological research in the Grand Ouest. The local authorities decided to defer (in the middle of this period of discoveries) all requests to continue the research: requests which were presented officially on 10 December 1996, and renewed on the 27 August 1998 (Martin 2001, 2004, 2006).

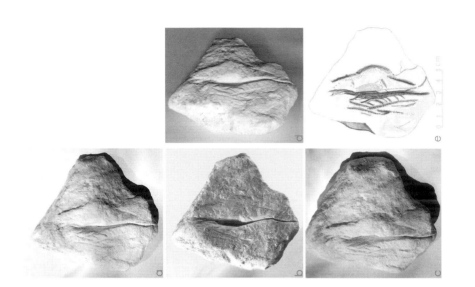

Figure 13.5 Because of the diversity of its volumes and the angle from which it is observed, the bas-relief's appearance varies enormously: a–d) four of these different aspects; e) 12 superimposed tracings. b) photo: A. Marshack; a, c–d) photos: Y. Martin.

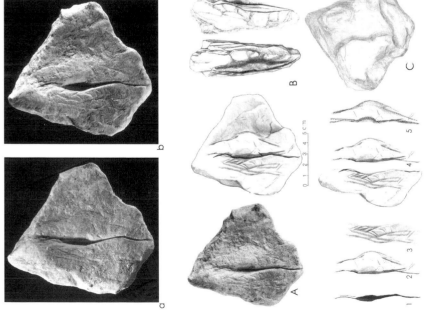

Figure 13.4 a, b) female outline depicted in profile (bas-relief). Photograph by A. Marshack: a) photograph published in 1973 (Martin 1973:141); b) face and profiles of the bas-relief; c) reverse side of the limestone block: 1) cleft; 2) silhouette; 3) chevrons; 4) probable female bodies (and face to face); 5) one of the aspects of the sculpted profile (indirect lighting at left). Tracing: Y. Martin.

Hence many years of possible work have already been lost. With no access to the site itself, the cave of Gouy which I discovered with my brother, Pierre Martin, it is impossible to carry out the work necessary to finish the monograph (which, however, has been officially asked for!).

Certainly, one can see how desirable it would be to include unpublished material in a book of that type. However, since I do not know when it will be possible to resume the research (with a view to publication), and because of the above-mentioned regrettable circumstances, I have decided to modify my initial project. Hence I can pay homage to Alexander Marshack by waiting no longer, and dedicating to him the first study of the decorated block which thrilled him so intensely.

Engraved and carved limestone block (No. 99 C, regional archaeological depository): 12 cm x 11 cm, and 2-4 cm thick

Several different readings are possible of this wall-fragment, or "mobiliary object" from the "first chamber" of Gouy (Figure 13.4:a, b).

The vertical groove is the first intentional element that one notices (Figure 13.4:1). It looks like a simple incision, (9 cm long and 12 mm deep), vigorously made in the middle of the block. In fact, the few people who have seen the block itself only noticed this cleft.

However, as can be seen clearly in the two photographs by Marshack (Figure 13.4:a, b), it would not be unreasonable to interpret it as a credible depiction of an "isolated" vulvar cleft, made long before the famous painting by Gustave Courbet, "*L'Origine du Monde*".

The interpretation may seem frivolous and shocking (especially when put forward by a Frenchman!), but the motif has been analysed for a very long time and the elements present are rather in favor of this possibility (Bahn 1986).

Moreover, when one takes a closer look, one is surprised to see a definite and authentic sculpting (Figures 13.5-13.6). The inner edge of one of the labia has been meticulously chiselled, until the artist obtained an extraordinary female body in bas-relief (left profile, in the middle of the stone).

The vertical groove, the medial axis of the composition, was obtained by repeatedly passing the tool over it. The precise disengagement of the body, from the cleft, was done next (bust, belly, pubis, groin crease, and top of the thigh) in accordance with a technically mastered protocol, albeit of great sensitivity.

The placing of the breasts is also very clearly marked, although they are not really detailed. The belly is flat, at the bottom of the cleft, and is even slightly hollowed towards the interior of the body. Higher up in the relief, the limestone is even more carved. The removals of rock at this spot (by "chips") give some curvature to the torso, thus highlighting the position of the breasts (above) and the Mons Veneris (below).

The general, somewhat hieratic conformation of the Gouy figure includes the graphic conventions that are most often used for female outlines presented in profile - headless and often without limbs (of the La Roche Lalinde/ Gönnersdorf type) with which it could be compared.

Despite these analogies, this specimen is currently the only one made in relief (Cartailhac 1903; Peyrony 1930; Darasse 1956; Breuil 1957; Bordes *et al.* 1963; Feustel 1970; Alaux 1972; Bosinski and Fischer 1974; Rosenfeld 1977; Marshack 1976; Delporte 1979; Carcauzon 1984; Lorblanchet 1986; Lorblanchet and Welté 1987; Martin 1988; Archambeau 1991; Bosinski and Schiller 1998; Welté and Cook 1992; Fritz *et al.* 1993; Delporte 1993; Delluc 1995; Sentis 1999; Martin 2001).

The statuettes in mammoth ivory from Andernach, Gönnersdorf, Oelknitz and Nebra

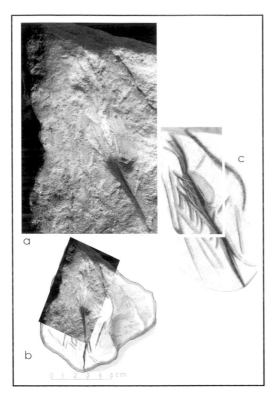

Figure 13.6 a) detail of the bas-relief (marks of the sculptor's actions on the rock); b) position of the macrophotograph on the stone. Photos by A. Marshack; c) diagram highlighting the marks left by the tool, and with indication of the photographed area.

(Germany), like those from Mezin (Ukraine), are also constructed with the same principles of depiction of the female body, but, unlike the Gouy bas-relief, these little figures are sculpted in the round. Moreover, the same convergences and divergences can be seen in the tiny jet pendants of Neuchâtel-Monruz (Switzerland) and Petersfels (Germany).

Because of the subtle diversity of its volumes, the sculpted profile from Gouy displays several different aspects depending on the lighting and the direction of view (Figure 13.5). It is therefore impossible to present the object in its full reality through fixed images. For example, with an indirect light-source on the left, the silhouette appears far more geometric and refined (Figure 13.4:a:5).

The original concept of an apparently cumulative assemblage is very inventive. It underlines the theme by uniting, it seems, female body and "sex" ("the cleft of a vulva") made at the same size.

This hitherto unknown "probable construction" of associated images and volume on a single theme gives food for thought concerning a fairly typical magdalenian way of thinking (Olins Alpert 1992; Martin 2001:210, 215), even if it can already be observed in an even more remote past (Coppens 1989; Lorblanchet 1995, 1999).

To express an idea by means of plastic methods of expression that amplify it is truly special. Obviously, this subtlety has no link with the graphic conventions and the state of mind that motivated the production of very fine (barely visible) engravings like those of the upper register in the "first chamber" of Gouy (Martin in press).

A plaquette from the cave of La Marche (No. 77.684, Musée d'Archéologie Nationale), which is slightly smaller than the block from Gouy (Figure 13.7a), is the only specimen (Pales and de St. Péreuse) which could be compared with it in terms of conception (although there is no use of the bas-relief technique).

This plaquette has the superimposition of a woman's body in profile (Figure 13.7:b) and a portrait, also in profile (Figure 13.7:c), both of them of identical dimensions (as on the sculpted block from Gouy). The outline of the body and that of the head are (more or less) formed by the same lines. The eye and the breast, the pupil and the aureola, coincide perfectly. Such a precise and unusual concordance of details seems difficult to achieve without the engraver being determined to do it. The same incisions constitute both the point of the breast and the eye (not without humor, it

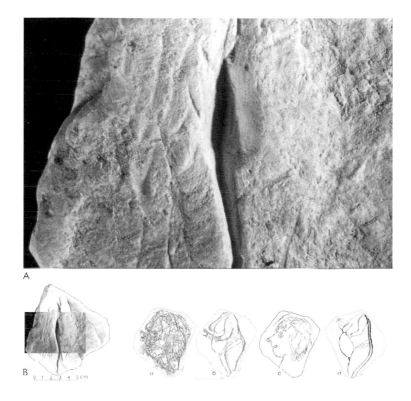

Figure 13.7 *a) Central detail of the bas-relief Macrophoto by A. Marshack; b) position of Marshack's macrophoto on the stone* a) *Grotte de la Marche (engraved plaquette: also b, c, d); b) woman's body in profile, figure extracted from superimpositions; c) portrait, also in profile: figure extracted from superimpositions; d) (other side) second woman's body. Tracings: Léon Pales 1976.*

seems) Moreover, a second woman's body is also depicted in profile on the other side of this plaquette (Figure 13.7:d).

Body and head are fully integrated in the cave of La Marche, whereas in the cave of Gouy it seems to be body and "sex" which are united, following the same procedure. At Gouy, the relief of the body, masterfully disengaged from the cleft, gives the impression that it becomes more slender to the right, as far as the outline of the back (which today is imperfectly defined). The edges of the relief and the engraving are indeed rather difficult to make out, due to the lack of deep incisions. However, multiple lights clearly show the

relief. Hence, the volume of the buttocks changes in size depending on the direction of the lighting. This part of the figure has been the most exposed to rubbing and wear. Consequently, it is not possible to specify what is depicted by the exact shape that can be seen, with a variety of lighting, just above and below the buttocks (from which a sinuous line leaves). Only a few hypotheses can be presented, since the sinuous line divides lower down, and forms a kind of porkcet or envelope (which cannot be identified with any certainty).

Conversely, the marks produced by the action of the tool on the stone have been protected in the hollow of the inner edges of the vertical cleft, and

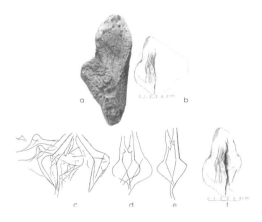

Figure 13.8 Comparison. a) sculpture of a female outline in mammoth ivory, with chevrons on it (Andernach, Germany). Photo: Alexander Marshack; b) left part of the Gouy bas-relief and its chevrons (a and b: proportions are respected). Female silhouettes face to face (reduced to the same size); c) La Roche Lalinde (Peyrony 1930; Breuil 1957; Marshack 1976); d-e) Gönnersdorf (Bosinski and Fischer 1974); f) bas-relief of Gouy (layout perhaps intentionally similar to c, d, e).

are thus perfectly preserved. Numerous striations, as well as accumulations of limestone pushed into the place where the sculptor's flint stopped, are still present. Probably the cutting edge of a blade was used, after scraping. Deep and strong incisions were also made, together with the highlighting of the relief, as well as other, lighter incisions.

The publication of the results of an experimental study of sculpture of this rock will follow the one already devoted to the engraving techniques imposed by the walls of Gouy (Martin 1988:529-544).

Along the left edge of the cleft, some lines in the form of chevrons are set out vertically, above each other. Some continue, in a wavy line, inside the cleft, where they intersect. Here again, there are several possible interpretations: a simple grouping of signs; folds of the labia and nymphae

(Figure 13.4:3); or even all of the above (that is, several things at once).

This assemblage of lines could also complete the natural shape of the left part of the block (a process that was used frequently). In that case, the engraver's action may have been limited to outlining the subject he saw in the stone with a few lines, without seeking to modify the contour, and without interfering too much on this side, since it was already sufficiently evocative Figure 13.4:4; Figures 13.7-13.8). Indeed, it is possible that the engraver wanted to suggest one or several female bodies.

In an effect of perspective, the chevrons could evoke several busts, shoulders, breasts or portions of arms, and, following the same principle, the upper part of the thighs below? Hence a confrontation of female bodies would have been purposely created in relation to the bas-relief (a layout also encountered in engravings of La Roche Lalinde and in some at Gönnersdorf, Figure 13.8).

Unfortunately, as on the right side, the surface in question has been exposed to wear, and the engraver's actions are no longer as clearly readable as those sheltered inside the cleft. This drawback is accentuated by the cross-section of the lines which is not sharp but U-shaped, and rather broad (as in the posterior line of the thighs and buttocks) or shaped like an asymmetrical V, with one edge sloping sharply.

Object, or detached wall fragment?

The walls of Gouy have suffered enormously (mostly in the first chamber). Explosives were used to make the Paris-to-Rouen road in the hillside. When this work was being carried out, the porch, as well as part of the narrow gallery, were destroyed; the base of the walls was spared but collapsed in plaques. Some decorated blocks came from these collapsed rock surfaces. Indeed, a few have been restored to their original

position after explorations in the cave (Martin 1974, 1993). On the other hand, the question of whether several others are mobiliary objects or elements detached from the walls is not yet completely resolved.

Block C, bearing the bas-relief, is one of these. However, some elements argue in favor of a block that was already engraved and sculpted before it fell, such as the appearance of its posterior surface (Figure 13.4:C). Moreover, it is perfectly possible that the block's outline, from its very conception, had the same shape (or delimitation) on the wall in this period as it has today, away from the wall. This is what the outline of the sculpted vulva (No. 55), still *in situ*, may lead one to suppose (Figure 13.12).

The vulva walls

At Gouy, depictions of vulvas are distributed, facing each other, on two opposing walls, and starting at the present entrance. Today these same walls (with their anterior parts amputated) are arbitrarily defined (for convenience) as being those of a "first chamber", whereas in reality we do not know what the configuration of the disappeared part of the cave was like.

Among all the walls of Gouy that Alexander Marshack wanted to photograph, it was these which particularly caught his attention.

Vulvas and bird

The first two vulvas are very clearly visible on the left wall, at eye-level. Both are depicted by a line corresponding to the triangular part of the pubis (Figures 13.9-13.11). The curve of the upper line of these two (more or less triangular) figures gives them a "badge" or "shield" shape (15 and 20 cm high). Intentional cupmarks mark their lower portions strongly and deeply.

To the left of the two vulvas, a line (the remnant of an engraving) seems to correspond to a segment of the outline of a pubis (that of a third vulva). This deduction was made by comparing the upper-right angles of the vulvas with this vestige.

The smaller of the two vulvas is engraved near the depiction of a bird, with two arched wings.

This assemblage (vulvas and bird) is complex, and comprises a very great number of superimpositions (Martin 1988). Traces of red-ochre paint, intentionally applied to the wall, accompany this engraved assemblage.

With regard to this panel, Marshack wrote: "The overmarking of a vulva (...) represents the re-use or the participation in the symbolism of the female image. A similar overmarking of engraved vulvas and the surface of the wall nearby can be found in the cave of Gouy (Seine-Maritime)..." (Marshack 1976:751).

The chronological order of the superimpositions has made it possible to deduce five phases in the production and overmarking of this assemblage: 1) fine engraving; 2) red ochre paint; 3) more or less fine engraving; 4) engraving of the "bird"; 5) violent blows to the engraved wall, marked by six very visible impacts (some of them destroyed several square cm of engraving).

Probably purposeful destructions have often been noted elsewhere, but on mobiliary artworks (Capitan and Bouyssonie 1924; Peyrony 1934:90; Laming-Emperaire 1962: 203-206; Pales and de St. Péreuse 1969:26; 1976:17-18, 137, pl. 29; 1981: 22, 67, 69-70; Bégouën *et al.* 1982: 106; 1984/5: 72-73, 78; Mons 1986; Bégouën *et al.* 1987:23). In parietal art, cases of purposeful destruction seem to be far less common (Montespan: Bégouën and Casteret 1923; Breuil 1952; Leroi-Gourhan 1965; Rivenq 1984; Angles-sur-l'Anglin: Laming-Emperaire 1962: 204-205; Iakovleva and Pinçon 1997; Grotte Cosquer: Clottes and Courtin 1992; Grotte Chauvet: Chauvet *et al.* 1995).

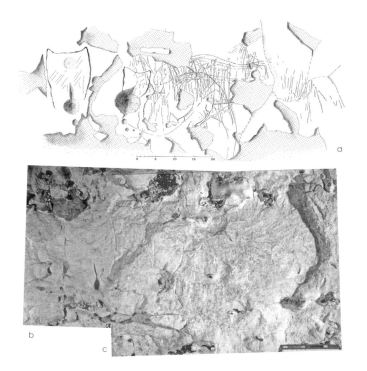

Figure 13.9 Tracing. a) two vulvas next to a depiction of a bird (red-ochre painting and engraving), tracing: Yves Martin; photo-montage; b) vulvas (photograph by Alexander Marshack); c) bird (photograph by Olivier Martin Gambier).

Bas-relief vulva

On the opposite wall (right side), a very realistic vulva (a bas-relief, 20 cm high) was directly carved into the rock. The sculptor perhaps took advantage of a natural triangular protuberance, whose curves were efficiently reworked in order to highlight the pubis (Figure 13.12).

A V- or Y-shaped notch was applied (on the left) to the upper part of the bas-relief. Marshack (1976, 1984, 1986, 1991, 1992) saw this mark as a "reactivation" of the subject depicted (Figure 13.12b).

The (damaged) wall around it was unquestionably sculpted too. So far it has not yet been possible to specify what these nearby volumes could have depicted, but they probably form part of the same bas-relief. Naturally, at Le Roc-sux-Sorciers at Angles-sur-l'Anglin (Vienne), as well as in the cave of La Magdeleine des Albis (at Penne, Tarn), entire female bodies have survived. However, Gouy is one of those very rare sites to have on its walls a bas-relief vulva whose volumes fully correspond to the realities of the human body.

Whereas it has been possible to compare the engravings of the upper register (near the ceiling) of this "chamber" (Martin 1988) to the mobiliary engravings of La Borie del Rey (Lot-et-Garonne), and of the Abri du Pont d'Ambon (Dordogne) as well as three others from the Abri Morin (Gironde), the lower register (sculpted) cannot be compared with them in any way. For the moment,

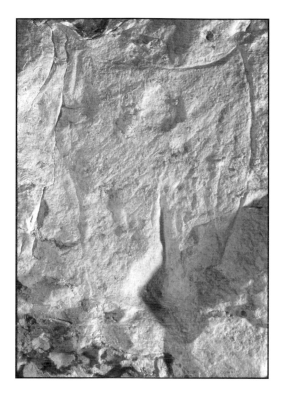

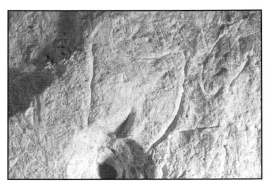

Figure 13.11
Vulva (15 cm high). Photo by A. Marshack.

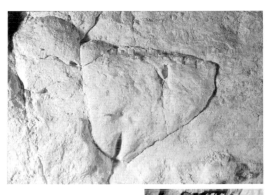

Figure 13.10 Vulva (20 cm high). Photo by A. Marshack.

Figure 13.12 (right) a) Vulva (bas-relief, 20 cm high, photo by
A. Marshack, b) profile of the bas-relief, photo by Y. Martin.

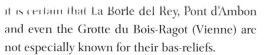

it is certain that La Borie del Rey, Pont d'Ambon and even the Grotte du Bois-Ragot (Vienne) are not especially known for their bas-reliefs.

Today, the presence of the block (No. 99 C), like that of the sculpted vulva (on the wall) suggests that the use of sculpture at Gouy was not due to chance (Figure 13.13). Moreover, other clues to the utilization of this technique exist, despite the disastrous destruction suffered by the site. It is therefore essential to bear in mind that, if the destruction had been just 1.5 m more invasive, we would not have known of any sculpted element on the walls of Gouy.

Triangular vulvas

On the same side as the bas-relief, but about 2 m higher and on the left, Marshack took a last photo (Figure 13.14:a): the detail of an assemblage of triangular vulvas with cupules (vulvas reduced to the state of signs).

This assemblage too comprises a succession of phases of activity on the wall, to which have been added some exfoliations of the limestone support, causing the disappearance of some decorated surfaces.

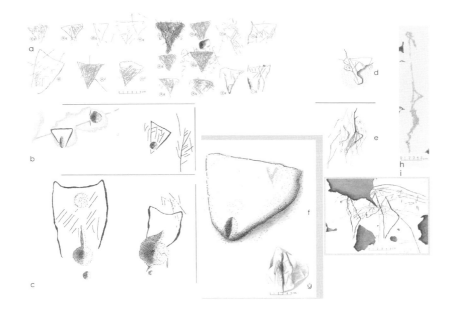

Figure 13.13 Utilization of engraving at Gouy: a, d) The 18 triangular signs in the upper register (feebly engraved); d-e) signs derived from depictions of female outlines in profile (type: La Roche Lalinde / Gönnersdorf); b) vulvas and cupules (triangular signs and cupules); c) vulvas and cupules with outline of the pubis. Utilization of sculpture at Gouy. Preserved vestiges (bas-reliefs); f) vulva and Mons Veneris; g) cleft and female silhouette. Tracings: Y. Martin.

These gaps in the decoration liberated some little spaces for new engravings. Two triangles, as well as three cupmarks, may perhaps have been intentionally placed there. It is also possible that it was the actual engraving of these cupmarks and triangles, with strong, deep and energetic incisions (in fragile locations) which caused the two exfoliations. In any case, that is the impression given by the part photographed by Marshack, but we shall see below - in the section on the application of color, discovered long afterwards - that this is not what happened. Be that as it may, one of the vulvas (an equilateral triangle, 5 cm x 5 cm) has an oval-shaped cupmark deeply hollowed into its lower point.

The asymmetrical vulva (triangular sign) on the right is leaning (Figure 13.14:b). Several lines on the outline of the pubis were made before the definitive shape was adopted and accentuated. It occupies the back of the second exfoliation with a "branched" sign to its right. In this case, it was no longer possible to be sure of the chronological order of all these graphic activities and events on the wall.

The repercussions of Marshack's visit

After the acquisition of UV lamps, a series of discoveries were added to those already made during the meeting with Alexander Marshack, but only after a pretty long period of tests and using other methods. Thus, we finally resorted to the use of a fluorescent tube of a kind used for plants (in addition to UV and Infrared photography).

Used for the first time in the study of parietal art, the fluorescent tube immediately revealed a line painted in red (Martin 2004), a line joined to one of the engraved triangular vulvas (Figure 13.14b).

Today, practically invisible and with its lower part destroyed,, it nevertheless extends for 1.30 m (passing by the triangular sign, the exfoliation and the cupmark). However, the upper-right corner of Marshack's excellent photograph reveals a small section of this line, with no particular lighting (Figure 13.14a).

In the absence of the red line, it was logical to conclude that the intervention of the engraver could have caused the exfoliation (cf. above). But since this line was detected, it has become possible to establish a chronological sequence of events, contrary to that which previously seemed to fit the facts (among the hypotheses that could be envisaged): 1) fine engravings; 2) exfoliations; 3) application of paint; 4) engraving of the triangular sign and the cupmark – with elimination in places of the red line by the engraving.

Hence it is clear that the red line was applied to the wall after the exfoliation took place. The triangular sign and the cupmark were incised on the painted line, in the final phase.

Discoveries of paint followed in succession, overturning the data, until the deplorable suspension of authorized access to the cave. Nevertheless, the following paintings have already been recorded: 1) painted line: red No. 1 (dark brick red); 2) deposit: red No. 2 (projected red ochre); 3) big painted sign: No. 3 (orangey yellow ochre); 4) painted sign: No. 3 (orangey yellow ochre); 5) outlines of shapes, lines and flatwash applications: No. 4 (fluorescent red ochre); 5) dots and fingermarks (with no flaking): red No. 5 (neutral red ochre).

Some evidence makes it possible to assert that other paintings will be revealed when the

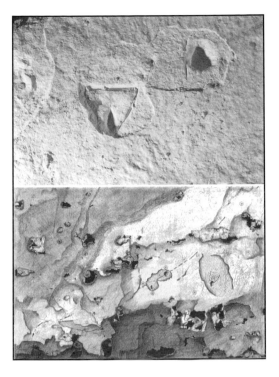

Figure 13.14 a) vulva and cupules (triangular sign and cupules), photo by A. Marshack; b) location of A. Marshack's photo on the wall. Drawing and tracing: Y. Martin.

study is resumed. But already, thanks to the potential revealed by the intervention of Alexander Marshack, a totally different view of the whole cave has been made possible. This is an extremely noteworthy event for a cave that was previously known exclusively as an "engravings cave".

Consequently, it is a matter of enormous regret that I only saw Alexander Marshack once more, briefly, in France in 1987, on the occasion of the International Conference on Paleolithic Mobiliary Art (Foix/Le Mas d'Azil). Later, I received news of him directly via my nephew, Olivier Martin Gambier, an author/ photographer, with a new diploma from the Ecole Nationale Supérieure de la Photographie (Arles),

who went off to practise his art for nine months in New York in 1990-1991.

Having participated fully in the research campaign in Gouy (1990-1992-1993), which was filled with discoveries, Olivier had also taken almost all of the photographs needed during the campaign. Hence, with a full mastery of his subject, he was obviously able to give Marshack the latest news from Gouy. I felt it extremely useful that they were able to meet during his stay, and this is how Elaine and Alexander had the extreme kindness to receive him at their home in New York, and to give him a series of documents for me. Those were, alas, our final exchanges.

Acknowledgments

I would like to offer my warmest thanks to Paul Bahn for translating this article.

About the author

Yves Martin, 101 Sente aux Dames, 76520 Gouy, France; E-mail: yves.martin.gouy@free.fr.

Endnote

1 After having added a non-existent line, without ever having seen the original. Hence the impostor's erroneous presentation becomes included in the corpus and is propagated in the place of the true study, to the detriment of all.

References

Alaux, J-F.

1972 Gravure féminine sur plaquette calcaire, du Magdalénien supérieur de la grotte du Courbet (commune de Penne, Tarn). *Bulletin de la Société Préhistorique Française* 69(4):109-112.

Ambert, P., and J.-L. Guendon

2005 Estimation AMS des ages de l'art pariétal et des empreintes de pas humains de la grotte d'Aldène (Sud de la France). *INORA* 43:6-7.

Archambeau, M., and C. Archambeau

1991 Les figurations humaines pariétales de la grotte des Combarelles. *Gallia Préhistoire* 33:53-81.

Aujoulat, N.

1987 Le relevé des œuvres pariétales paléolithiques. Enregistrement et traitement des données. *Documents d'Archéologie Française*, n°9. Maison des Sciences de l'Homme, Paris.

Bahn, P. G.

1986 No sex please, we're Aurignacians. *Rock Art Research* 3(2):99-04, and comments, pp. 105-119.

Bataille, G.

1955 *Lascaux ou la naissance de l'art*. Skira, Paris.

Bégouën, H., and N. Casteret

1923 La caverne de Montespan (Haute-Garonne). *Revue Anthropologique* XXXII (No. 11-12):533-45.

Bégouën, R., F. Briois, J. Clottes, and C. Servelle

1984/85 Art mobilier sur support lithique d'Enlène (Montesquieu-Avantès, Ariège) collection Bégouën du Musée de l'Homme. *Ars Praehistorica* III/IV:25-80.

Bégouën, R., J. Clottes, J.-P Giraud, and F. Rouzaud

1982 Plaquette gravée d'Enlène, Montesquieu-Avantès (Ariège). *Bulletin de la Société Préhistorique Française* 79(4):103-109.

1987 Un bison sculpté en grès à Enlène, *Bulletin de la Société Méridionale de Spéléologie et de Préhistoire* 27:23-27.

Bordes, F., P. Fitte, and P. Laurent

1963 Gravure féminine du Magdalénien VI de la Gare de Couze (Dordogne). *L'Anthropologie* 67:269-282.

Bordes, F., M.-J. Graindor, Y. Martin, and P. Martin

1974 L'industrie de la grotte ornée de Gouy (Seine Maritime). *Bulletin de la Société Préhistorique Française* 71(4):115-118.

Bosinski, G., and Fischer, G.

1974 *Die Menschendarstellungen von Gönnersdorf der Ausgrabung von 1968*. Steiner, Wiesbaden.

Bosinski, G., and P. Sschiller

1998 Représentations féminines dans la Grotte du Planchard (Vallon Pont d'Arc, Ardèche) et les figures féminines du type Gönnersdorf dans l'art pariétal. *Bulletin de la Société Préhistorique de l'Ariège* 53:99-140.

Breuil, H.

1952 Quatre Cents Siècles d'Art Pariétal. *Centre d'Etude et de Documentation Préhistorique*, Montignac.

1957 Une deuxième pierre gravée de figures féminines stylisées de la grotte de la Roche (Dordogne). *L'Anthropologie* 61:574-575.

Capitan, L., and J. Bouyssonie

1924 Un atelier d'art préhistorique: Limeuil. Son gisement à gravures sur pierre de l'Age du Renne. *Institut International d'Anthropologie*, Paris, n°1.

Carcauzon, C.

1984 Une nouvelle découverte en Dordogne: la grotte préhistorique de Fronsac. *Revue Archéologique Sites* 22:7-15.

Cartailhac, E.

1903 Les stations de Bruniquel sur les bords de l'Aveyron. *L'Anthropologie* 129-150 and 295-315.

Chauvet, J.-M., E. Brunel Deschamps, and C. Hillaire

1995 La grotte Chauvet à Vallon Pont d'Arc. Le Seuil, Paris.

Clottes, J., and J. Courtin

1992 La grotte Cosquer. Le Seuil, Paris.

Collison, D., and A. Hooper

1976a L'art paléolithique de la grotte des Eglises à Ussat (Ariège). *Gallia Préhistoire* 19(1):221-238.

1976b Nouvelles information sur la grotte des Eglises à Ussat (Ariège). *Bulletin de la Société Préhistorique de l'Ariège* 31:13-20.

Coppens, Y.

1989 L'ambiguïté des doubles Vénus du Gravettien en France. *Comptes Rendus Acad. Inscriptions and Belles-Lettres* (Juillet-Décembre), pp. 566-571.

Darasse, P.

1956 Dessins paléolithiques de la vallée de l'Aveyron identiques à ceux de l'Hohlestein en Bavière. *Quartär* 7/8:171-176.

Delluc, B., and G. Delluc

1995 Les figures féminines schématiques du Périgord. *L'Anthropologie* 99(2/3):236-257.

Delporte, H.

1993 *L'Image de La Femme dans l'Art Préhistorique*. Picard, Paris.

Eastman Kodak Company

1972 *Ultraviolet and Fluorescence Photography*. Kodak Publication N° M 27.

Feustel, R.

1970. Statuettes féminines paléolithiques de la République Démocratique Allemande. *Bulletin de la Société Préhistorique Française* 67(1):12-16.

Fritz, C., G. Tosello, and G. Pinçon

1993 *Les gravures pariétales de la grotte de Gourdan (Gourdan-Polignan, Haute-Garonne)*. 118e Congrès National des sociétés historiques et scientifiques, Pau, pp. 381-402.

Genty, D., D. Blamart, and B. Ghaleb

2005 Apport des stalagmites pour l'étude de la grotte Chauvet: datation absolues U/Th (TIMS) et reconstitution paléoclimatique par les isotopes stables de la calcite. *Bulletin de la Société Préhistorique Française* 102(1):45-62.

Iakovleva, L., and G. Pinçon

1997 La Frise Sculptée du Roc-aux-Sorciers. Angles-sur-l'Anglin (Vienne). *Documents préhistoriques* 9. CTHS, Paris.

Laming-Emperaire, A.

1962 *La Signification de l'Art Rupestre Paléolithique. Méthode et application*. Picard, Paris.

Leroi-Gourhan, A.

1965 *Préhistoire de l'Art Occidental.* Mazenod, Paris.

Li, W. X., J. Lundberg, A. P. Dickin, D. C. Ford, H. .Schwarcz, R. McNutt, and D. Williams

1989 High-precision mass-spectrometric uranium-series dating of cave deposits and implications for palaeoclimate studies. *Nature* 339:534-536.

Lorblanchet, M.

1986 Premier bilan de nouvelles recherches à l'abri Murat (Rocamadour, Lot). *Préhistoire Quercynoise* 2:57-70.

1995 *Les Grottes Ornées de la Préhistoire. Nouveaux Regards.* Errance, Paris.

199. *La Naissance de l'Art. Genèse de l'art préhistorique dans le monde.* Errance, Paris.

Lorblanchet, M., and A.-C. Welté

1987 Les figurations féminines stylisées du Magdalénien supérieur du Quercy. *Bulletin de la Société des Etudes du Lot* 3:3-57, 29.

Marshack, A.

1970 *Notation dans les Gravures du Paléolithique Supérieur.* Institut de Préhistoire de l'Université de Bordeaux. Mémoire n°8.

1972 *Les Racines de la Civilisation.* Plon, Paris.

1976 Complexité des traditions symboliques du Paléolithique supérieur. In *La Préhistoire française. Les civilisations paléolithiques et mésolithiques de la France*, vol. 1., Edited by H. de Lumley, pp. 749-754. CNRS, Paris.

1977 The meander as a system: the analysis and recognition of iconographic units in Upper Palaeolithic compositions. In *Form in Indigenous Art*, edited by P. J. Ucko, pp. 286-317. Duckworth, London.

1984 Concepts théoriques conduisant à de nouvelles méthodes analytiques, de nouveaux procédés de recherche et catégorie de données. *L'Anthropologie* 88:573-586.

1986 The eye is not as clever as it thinks it is. *Rock Art Research* 3(2):111-116.

1990 L'évolution et la transformation du décor du début de l'Aurignacien au Magdalénien final. In *L'Art des Objets au Paléolithique. Les voies de la recherche*, pp 139-162. Colloque international d'art mobilier paléolithique, Foix-Le Mas d'Azil, 1987, t. 2.

1991 The female image: a "time-factored" symbol: a study in style and aspects of image use in the Upper Palaeolithic. *Proceedings of the Prehistoric Society* 57(1):17-31.

1992 The analytical problem of subjectivity in the maker and use. In *The Limitations of Archaeological Knowledge*, edited by T. Shay and J. Clottes, pp. 181-210. Liège, Université de Liège, ERAUL 49.

Martin, Y.

1973 *L'Art Paléolithique de Gouy.* Editions Yves Martin, Gouy.

1974 Technique de moulage de gravures rupestres. *Bulletin de la Société Préhistorique Française* 71(5):146-148.

1988 Nouvelles découvertes de gravures à Gouy. *L'Anthropologie* 93(2):513-546.

1993 Méthode de moulage employée à Gouy. In *L'Art Pariétal Paléolithique. Techniques et Méthodes d'Etude*, pp. 365-368. GRAP. CTHS, Ministères de l'Éducation Nationale et de la Culture, de l'Enseignement Supérieur et de la Recherche: Paris.

2001 Authentification d'une composition graphique paléolithique sur la voûte de la grotte d'Orival (Seine-Maritime). *Comptes Rendus de l'Académie des Sciences de Paris*, 332:209-216.

2004 Découvertes de peintures dans la grotte paléolithique de Gouy (Seine-Maritime): apport d'un éclairage inhabituel dans l'étude de l'art pariétal. *C. R. Acad. Sci. Paris. Palevol* 3:143-156.

2006 *La grotte paléolithique de Gouy: Conservation et protection*. Communication présentée le vendredi 28 février 1997, au Musée de l'Homme (in press).

(in press) The engravings of Gouy, France's northernmost decorated cave. In Creswell Art in its European Context, edited by P. Pettitt *et al.* Oxford University Press, Oxford.

Martin, Y., and P. Martin

1984 Grotte de Gouy (Seine-Maritime). In *L'Art des Cavernes. Atlas des grottes ornées paléolithiques françaises*. pp. 556-560. Ministère de la Culture et Imprimerie Nationale, Paris.

Mons, L.

1986 Les statuettes animalières en grès de la grotte d'Isturitz (Pyrénées-Atlantiques): Observations et hypothèses de fragmentation volontaire. *L'Anthropologie* 90(4):701-711.

Olins Alpert, B.

1992 Des preuves de sens ludique dans l'art au Pléistocène supérieur. *L'Anthropologie* 96(2-3):219-244.

Pales, L., and M. Saint-Péreuse, de

1969 *Les Gravures de La Marche*. I, Félin et Ours. Institut de Préhistoire de l'Université de Bordeaux, Delmas, Bordeaux.

1976 *Les Gravures de La Marche. II, Les Humains*. Ophrys, Paris.

1981 *Les Gravures de La Marche. III, Equidés et Bovidés*. Ophrys, Paris.

Peyrony, D.

1930 Sur quelques pièces intéressantes de la grotte de la Roche près de Lalinde (Dordogne). *L'Anthropologie* 40:19-29.

1934 La Ferrassie. *Préhistoire* 3:1-92.

Rivenq, C.

1984 Grotte de Ganties-Montespan (Haute-Garonne). In *L'Art des Cavernes. Atlas des Grottes Ornées paléolithiques françaises*, pp. 438-445. Min. de la Culture, Paris.

Rosenfeld, A.

1977 Profile figures: schematisation of the human figure in the Magdalenian Culture of Europe. In *Form in Indigenous Art*, edited by P. J. Ucko, pp. 90-109. Duckworth, London.

Sentis, J.

1999 La grotte de Pestillac: découverte d'une grotte ornée à Montcabrier (Lot), en octobre 1998. *Bulletin de la Société Préhistorique Française* 96(3):441.

Welté, A-C., and Cook, J.

1992 Un décor exceptionnel (silhouette féminine stylisée) sur godet de pierre de la grotte du Courbet (France). *Comptes-rendus de l'Académie des Sciences* 315(II):1133-1138.

Zervos, C.

1959 *L'Art de l'Epoque du Renne en France*. Cahier d'Art, Paris.

The Venus of Macomer: A Little-Known Prehistoric Figurine from Sardinia

Margherita Mussi

In 1949, Francesco Marras, a carpenter of Macomer, in western Sardinia, started digging out with a friend the deposit of a small cave in his orchard, discovering prehistoric implements. He eventually assembled a large archaeological collection, without any recorded stratigraphic provenience, from the cave itself and from the area at the entrance. Most of it comprised lithic implements and potsherds, but a female figurine was also unearthed. The digging of an archaeological deposit without proper permits was - and is - illegal under Italian laws. The material was confiscated and ended up in the collections of the *Museo Archeologico Nazionale in Cagliari*. Gennaro Pesce (1949), then *Soprintendente alle Antichità della Sardegna*, published a preliminary inventory of the finds, and a description of the statuette. He insisted upon the novelty of the figurine, when compared to others from Sardinia, and called it *Venere di Macomer*, i.e. "Venus of Macomer". He doubtfully labelled it as "pre-Neolithic", making cautious comparisons with Upper Paleolithic statuettes known at the time, but insisting on the lack of any stratigraphic evidence or firm association.

More than half a century later, precious little complementary information has turned up. The prehistoric record of Sardinia, however, is presently known in detail, and no figurine approaching the stylistic attributes of the *Venere di Macomer* has been found since. The "pre-Neolithic" is also better documented, even if the age of the earliest peopling of the large island is still an open and

hotly debated question (Cherry 1990; Martini 1999; Melis and Mussi 2002; Mussi 2001; Mussi and Melis 2002; Mussi *et al.* 2005; Vigne 1996). I have been able to visit the site, study the original statuette, and examine the collection from the cave as well as the museum archives. A detailed description of the figurine, hardly mentioned in the international literature, is given below, together with an overall reassessment of the find.

Setting and general background

Macomer stands in a commanding position at 550 m asl, on the edge of a dissected basalt plateau. North of the town, the elevation rises rapidly to over 800 m, while south of it the escarpment plunges by some 100 m towards a wide tectonic depression, the graben of Ottana (Figure 14.1). Macomer itself is further delimited, to the North and East, by the deeply encased valley of Rio s'Adde (Figure 14.2). The cave of the figurine reportedly way at the eastern edge of the town, where the Via Aspromonte ends, facing the incision of Rio s'Adde - hence the name of Riparo s'Adde (Figure 14.3). The cave - actually, a rockshelter with a low ceiling - opens in an orchard, and much of the original entrance appears to have been artificially modified. It is now encased within a dry stone wall, made with huge rocks, apparently built to consolidate the collapsing roof, as the basalt is heavily fissured (Figure 14.4). Stone walls also partition the rockshelter itself into smaller rooms, each with a distinct opening. The cave continues outside the property which once belonged

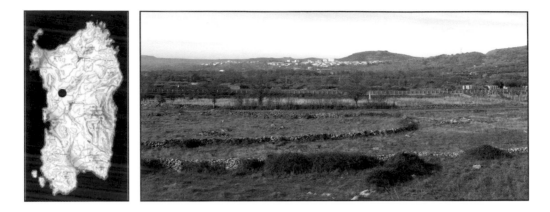

Figure 14.1 Macomer seen from the south, on the basalt plateau at the edge of the graben of Ottana. (Photo by M. Mussi.)

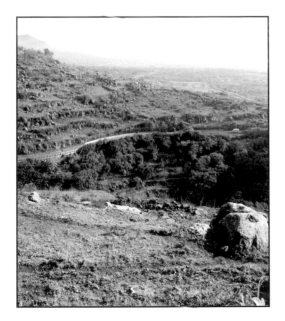

Figure 14.2 The deeply encased valley of Rio s'Adde seen from Riparo s'Adde, with the graben of Ottana in the background. (Photo by M. Mussi.)

to F. Marras. The original depth could well have been in the range of 2 m, while the width of the entrance, which can only be guessed, might have been 5 m or more. Only a fraction of the surface was actually excavated at the time of the discovery.

Lilliu (1950) reports that *ca.* 1.6m of deposit was dug. According to Pesce (1949:124), the statuette *"fu trovata non nell'ammasso degli altri manufatti, ma imprigionata in una masso di breccia ossifera, formatosi per deposito all'interno della grotta"*. That is, "it was discovered not in the same accumulation as the remaining implements, but within an ossiferous breccia, which had formed and deposited inside the cave". Remnants of the hypothetical breccia are not currently to be seen anywhere on the figurine.

Figure 14.3 A topographic map of Macomer, with the location of Riparo s'Adde at the eastern edge of the town. The grid is 1 km wide.

Figure 14.4 Front view of Riparo s'Adde, with modern dry-stone walls and multiple entrances to the rockshelter. (Photo by M. Mussi.)

Except for a small number of Roman items, Pesce recognized as prehistoric the thousands of archaeological remains from the cave and adjacent area. The extant collection includes polished stone implements, pounding and grinding stones, basalt implements, obsidian tools, bone tools, terracotta spindle whorls, animal bones, and a large quantity of potsherds. There is also a great number of unmodified limestone and basalt fragments, suggesting little selection, either by Francesco Marras and his friend Felice Cherchi Paba, who dug the cave, or later by Gennaro Pesce, who took legal charge of the collection. I suspect that some of them are the three "rough casts" mentioned by Pesce (1949:123) that I was unable to identify. Two of them were published by Lilliu (1950:Tav. I) and definitely look like natural shapes.

Lilliu suggested, in 1966, that everything in the cave belonged to an early phase of the *cultura di San Michele* (Chalcolithic). Thirty years later, however, he accepted and sketchily reported the conclusions of a revision made in 1972-1973 by L. Mulas, in her unpublished *Tesi di Laurea* (Lilliu 1999). Accordingly, a more complex sequence was hypothesized, from the early Neolithic (lithic implements exclusively), to the late Neolithic (*cultura di Ozieri*), the Chalcolithic (*cultura di Monte Claro*), and the middle and late Bronze Age. As far as the female figurine is concerned, Lilliu first dated it to the Chalcolithic, like everything else in the collection (Lilliu 1966). Then, Mulas having suggested that there was evidence of earlier prehistoric phases at Riparo s'Adde, he moved it to the Neolithic, and eventually to the early Neolithic (Lilliu 1999).

Lilliu's hypotheses are based on typology, and on comparisons with properly investigated sites. After a recent synthesis, the calibrated dates of the early Neolithic of Sardinia are in the range of 5900-4900 cal. BC, while the middle Neolithic is bracketed between 4900 and 4300

cal. BC (Luglié 2005). I will not go into further detail as far as the post-Neolithic phases are concerned. However, I will underline some aspects of the lithic collection.

Obsidian exploitation in Sardinia is well documented from the Neolithic onwards, with both local use and exportation to mainland Italy and southern France (Tykot 1996). The availability of this choice raw material at Riparo s'Adde is evidenced by more than 4000 pieces of knapping debris, large flakes, and formal tools, including bifacially retouched points. I was also able to observe two obsidian cobbles, of *ca.* 2 kg each, which had been collected and slightly worked, while a third one had been left intact. Monte Arci, and the alluvia of rivers flooding from the mountain, are the main sources of obsidian in Sardinia, at a minimum of 40 km south of Macomer.

Much more than obsidian, however, was used at Riparo s'Adde: chalcedony, quartz crystal, and some flint were all knapped, even if fracture cracks and inclusions make them scarcely suitable for percussion flaking. Small-sized débitage and many pieces of debris were produced. There are a few bladelet cores, and some bladelets as well, but most cores are exhausted and rather shapeless. Large flakes were also produced using basalt, but this, apparently, was not in the cave, as there is no evidence of basalt cores. Overall, formal tools, including some endscrapers, are rare. Except for basalt, which can be found nearby (but not on the spot, as it is much fractured and not suitable for knapping), the source of such raw materials lies within metamorphic rocks. Primary or secondary sources are to be found west of Macomer, around Bosa; and east of the town, in the middle Tirso valley. Both areas are at a distance of some 20 km, as the crow flies (M. Marchi, pers. comm. 2006).

Accordingly, different provisioning strategies are evidenced by obsidian, and by other raw

materials. Within a radius of 20 km, the raw material collected by Late Paleolithic hunter-gatherers is better understood as local, while at more than 40 km the source is usually said to be exotic (Féblot-Augustins 1997:236). Prehistoric hunter-gatherers tend to make more thorough use of rocks obtained at a distance, and transported throughout their journey. When reaching a new area, local stone, if any, quickly replaces the exotic one, unless of poor quality. Oddly, at Riparo s'Adde, the local raw material, of metamorphic type and of poor quality, is rather exhausted; while the excellent obsidian, only available over 40 km away, is abandoned partially knapped or not even tested. If all the lithics are contemporary, this can be explained by a model of human groups using local basalt, but also getting a limited supply of miscellaneous metamorphic rocks, eventually knapped to exhaustion. Later they move away, towards the south, reaching the area of Monte Arci. On the journey back to the north, they carry abundant supplies of obsidian. Not everything is knapped, and heavy obsidian cobbles are actually abandoned on leaving the site again.

According to an alternative and more parsimonious hypothesis, the exhausted lithics of miscellaneous raw materials are not of the same age as the obsidian ones, which reach the site following different lines of provisioning. Lilliu (1950:409) actually reports that obsidian implements were collected from the surface, outside the cave. It can be guessed - but definitely not proved - that the débitage and formal tools made with poor-quality local rocks are earlier. Following this line of reasoning, a layer once existed, with remains pre-dating the time at which obsidian was commonly exploited and traded, i.e. the early Neolithic according to Lilliu (1988), or the middle Neolithic according to Luglié (2005). I was actually unable to

spot the four microliths, mentioned by Lilliu (1999) as evidence of early Neolithic at the cave but never properly published. So far, the early Neolithic of Sardinia is known only at a handful of stratified sites - even fewer at the time of L. Mulas' thesis - with much interest focusing on ceramics and ceramic shapes. I doubt that a few poorly documented microliths are, and were, enough to claim that a distinct prehistoric phase once existed. According to my own analysis, some of the extant evidence from Riparo s'Adde is consistent with a limited part of the deposit pre-dating not just the well-documented late Neolithic, but the Neolithic altogether.

Description

The figurine (Figures 14.5-14.6) is carved in stone, but so heavily patinated into a rich brown color that, in an early description kept in the files of the *Museo Archeologico Nazionale*, it was entered as "*terracotta*". Because of the patina, the composition of the rock cannot be determined by visual inspection in any detail. Sampling the item for petrographic determination was not considered a feasible option. Observations were made using a low-magnification binocular microscope (x20 to x100).

The Venus is currently fractured. Most or all of the damage was apparently caused after the item entered the museum collections, and possibly while pictures were being taken. The distal end, which looks pointed in some of the black and white archive pictures, is now broken off and missing. According to Pesce's documentation, (1949:124), the figurine was originally 140 mm long.

In my description, the head is the proximal end; the opposite part of the statuette is the distal end; the right and the left are in accordance with anatomical right and left; the same holds true for the ventral and the dorsal face.

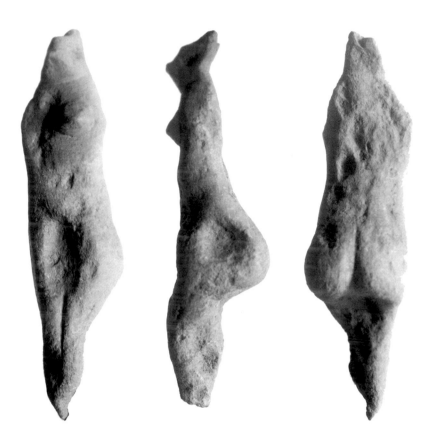

Figure 14.5 The Venus of Macomer, after pictures in the archives of Museo Archeologico Nazionale in Cagliari. Note that the figurine is nearly complete in frontal and dorsal view, but that the distal end is broken off in the left lateral view. (Copyright Ministero per i Beni e le Attività Culturali, Italia.)

Raw material
Volcanic rock (basalt or andesite) (M. Marchi pers. comm. 1998).

Current length: 134 mm.
Maximum width (buttocks): 35 mm.
Maximum thickness (left buttock): 31 mm.

Current weight: 95.09 gm.

Color (Munsell Charts): 7.5 YR 4/3 - 7.5 YR 5/3 (brown to dark brown).

Preservation: overall preservation is good. Both the proximal and the distal end, however, are affected by recent multiple fractures, which are fixed. Some fragments are missing, mostly at the distal end, which is shorter by some 6 mm than documented in the earliest record. A second fracture has occurred at this end. On the left distal end a fresh scar can be observed, left by a missing flake of *ca.* 15 x 9 x 2 mm. There is an additional double fracture running from the neck to the right shoulder. The right appendix on the top of the head (see below) is broken off.

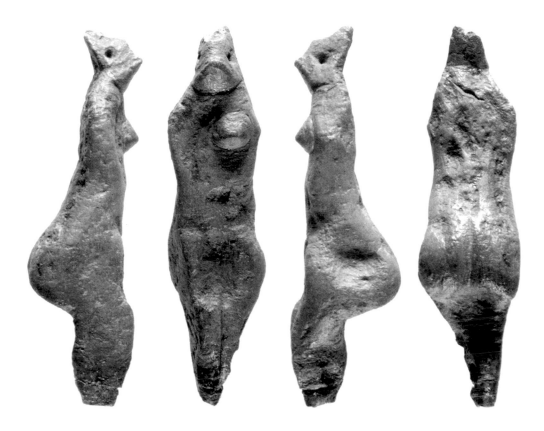

Figure 14.6 The Venus of Macomer, after recent pictures of the Museo Archeologico Nazionale in Cagliari. Note the diagonal fracture across the upper back, and the fixed fracture at the distal end. (Copyright Ministero per i Beni e le Attività Culturali, Italia.)

Surfaces: the statuette is heavily patinated, as one can see where recent fractures have occurred. The patina does not allow one to determine the nature of the included crystals. Here and there the surface is much polished, and even glossy (parts of the trunk and trunk sides; legs; back; buttocks). There are remnants of a reddish film, possibly ochre, better preserved in hollows, as in the back. The hypothetical ochre is, in turn, coated by a gray- to-beige fine-grained deposit, which could well be the remains of the original cave sediment. This is better seen in the hollows in the left back. Undetermined tiny yellow spots are observed on the ventral face, at the distal end. There is no record of casts having been made, and I have never seen casts of the figurine in museums.

Morphology: The head, which is distinct, is partially divided from the trunk by a groove, which fades away on the dorsal face and on the left side, and is altogether lacking on the right side (Figure 14.7). The overall shape of the head is pyramidal, with the triangular base of the pyramid making

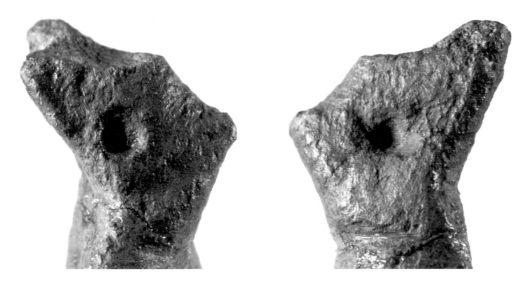

Figure 14.7 Venus of Macomer: a detailed view of the head, after recent pictures of the Museo Archeologico Nazionale in Cagliari. (Copyright Ministero per i Beni e le Attività Culturali, Italia.)

the nape of the neck. The apex points ahead, as the three sides converge into a pointed, chinless feature, suggestive of a muzzle with a flat throat. The forehead is ridge-like, as the uppermost part of the head is slightly concave, ending at the rear with two vertical appendices in the continuum of the nape plane. The right appendix is fractured after a recent impact. The left one is complete, with a quadrangular base.

The only details of the face are the eyes, in a lateral position. To produce them, a hole was drilled. The section is conical, with an annular, ring-like step, most visible in the right eye. A red deposit, which could well be ochre, can be seen inside the two holes and at the very bottom of the eyes.

The neck, incompletely separated from the throat by a groove, rests on the right shoulder, which is carefully shaped, while the left shoulder is non-existent.

Arms and hands are altogether lacking. The thorax and abdomen are flat, except for a single,

left breast (Figure 14.8). This breast has a neat conical shape. The nipple is not in evidence. It is surrounded, at the base, by an incision, which turns as a double line below and on each side.

The waist, navel, hips and pubic triangle are not marked. In this part of the figurine there are shallow hollows of different size, of natural origin and most probably already found on the original surface of the volcanic rock.

The two thighs are distinct, and parted by a well defined rectilinear groove. The latter starts in a natural depression corresponding to the pubis, and ends before the distal end of the statuette. Accordingly, the thighs continue with two distinct, straight legs, without knees. Pictures in the archives suggest that the distal end, which is now broken off, tapered into a flattish point, slightly arched backwards (Figure 14.5).

On the back, the nape is inclined and suggests that the head is slightly bent backwards. There is no narrowing indicative of the neck, nor is the spine in evidence. The hollows on the

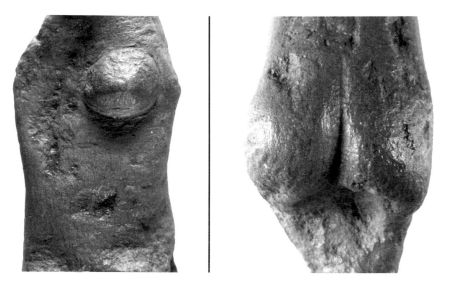

Figure 14.8 Venus of Macomer: A detailed view of the thorax and buttocks, after recent pictures of the Museo Archeologico Nazionale in Cagliari, (Copyright Ministero per i Beni e le Attività Culturali, Italia.)

back, more or less in a longitudinal row, are of natural origin.

The buttocks are protruding. The longitudinal groove in the middle starts where the coccyx would have been (but is not in evidence) and ends in a natural hollow below the buttocks (Figure 14.8)

Seen from the back, the thighs and the legs make a single, unarticulated volume. The volume of the right thigh is more complete than the left one, which tapers towards the distal end.

There is no evidence of any dress or ornament.

Working scars: The developed patina and polished surfaces do not allow much observation, except in depressed parts. The groove between the buttocks was made by first cutting off the volcanic rock, then by a number of thin, longitudinal striae, and eventually with a single, deep incision. Some twenty short, transversal incisions, each approximately 1 mm long, are

superimposed on the longitudinal one, producing an unusual, zip-like appearance (Figure 14.8). The eyes were made by a complete rotating perforation. The single breast was similarly shaped by a tool which rotated around a central axis, producing a very regular conical shape.

Preferential resting surfaces: the figurine can be placed laying either on the anterior face (muzzle, breast, legs), or on the posterior face (proximal end and buttocks), as well as on each side. However, it rests more easily on the right, flattish side.

Iconographic interpretation

The statuette is realistic enough, even if there are neither arms nor hands. The body can be recognized as anthropomorphous at first glance, while the breast and protruding buttocks allow one to sex it as female. The head, however, is not plainly human. It was first described by Pesce as "*un prisma regolare*", *i.e.* "a regular prismatic shape",

Figure 14.9 Stag and hind busts, after an early XIXth-century engraving.

with a pointed end on the top, that he interpreted as a possible hairdo. Lilliu (1966) mentions a pointed hood, opposite to the conical lower end, and a profile in the shape of a muzzle or beak. Graziosi (1973), in his monograph on Italian prehistoric art, underlines that both the proximal and the distal ends taper and are pointed. Oddly, the former end is never accounted for as double. One of the uppermost appendices, admittedly, is partially broken off, but the two of them do not converge at all into a cone (Figures 14.6–14.7). Vertical as they are, and rising laterally above the head, they are not a human feature: human ears are rather flattish, positioned on the sides of the face, more or less level with the eyes. Either horns or animal ears are depicted here. In cervids as in caprids, however, horns are positioned more or less centrally on the head, while the two appendices are on

the side, directly in the continuation of the cheeks (compare Figure 14.9). As such, they look like upright animal ears – not a human trait, in any instance.

The eyes' lateral position is another distinctive feature. In primates, including humans, the eyes are positioned frontally, just as in predators: this allows a stereoscopic vision, and an accurate evaluation of distance. In herbivores, lagomorphs, rodents and, overall, among prey species, a lateral position of the orbits is adaptive, as a wider area is under visual control. Even if perceived in a rather flattish way, threats can be spotted from a wider stretch of the landscape.

The figurine also lacks a proper, vertical face. It is rather characterized by some kind of pointed muzzle which, together with the lateral orbits, and pointed rising ears, allow one to define the head as belonging to an animal.

Accordingly, the Venus of Macomer is a combination of both animal and human traits or features, *i.e.* it is a therianthrope. Actually, it is more accurately defined as a theriogynous being or entity, as the human component of the figurine is that of a woman.

The identification of the animal component is made relatively easy by the limited number of mammal species living in Sardinia during the final Pleistocene and early Holocene. Sardinia merged with Corsica during times of low sea-level, making it the largest island in the Mediterranean, but even then it was always at a fair distance from the mainland. After the Miocene, when the geography was quite different from that of today, only a very few terrestrial species were able to cross the arm of the sea and to settle, and highly endemic, unbalanced faunas developed (Mussi *et al.* 2005). Not taking into account micromammals, seals and marine otters, in the final Pleistocene the only extant terrestrial species were *Cynotherium sardous*, a small canid; *Megaceros cazioti*, a cervid; and *Prolagus sardus*, a short eared lagomorph. *Prolagus* was the only one to survive into the Holocene and to the Iron Age (Wilkens and Delussu 2002). New species were then introduced, mostly domesticated ones, as can be seen at Neolithic and later sites: *Vulpes vulpes*, *Ovis aries*, *Sus scrofa*, *Cervus elaphus*, while the horse is first found in the Iron Age (Wilkens and Delussu 2002).

The two carnivores, *i.e.* the endemic canid and the fox, can be easily ruled out, because of the frontal position of the orbits. The pig is similarly out of the question, as the pointed muzzle of the figurine cannot be a snout. The horse will not be further considered, because of its elongated mandible and late appearance. The only candidates left are the goat, the endemic cervid, the red deer, and *Prolagus*. Because a theriogynous

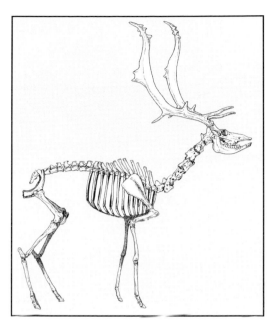

Figure 14.10 The skeleton of a Megaceros cazioti *stag, after Caloi and Malatesta (1974).*

adult is represented, as suggested by the fully-developed breast, if a she-goat head were intended, it should have been characterized by both ears and horns. The latter are nowhere to be seen, and furthermore goat ears do not stand upright. Turning to deer, both in *Cervus elaphus* and in the extinct *Megaceros cazioti*, females are not antlered (Klein Hofmeijer 1997), which is compatible with the characteristics of the Venus head. Hinds, however, just like stags, have a rather elongated muzzle, hardly compatible with the figurine (Figures 14.9-14.10).

The only candidate left, therefore, is *Prolagus sardus*. Indeed, the lateral orbits, short raised ears, lack of neck and a short muzzle are all consistent with the known characteristics of this species (Figure 14.11). Accordingly, I interpret the figurine as a theriogynous being with a *Prolagus sardus* head.

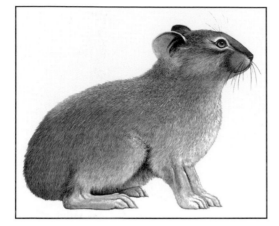

Figure 14.11 Prolagus sardus, *after a reconstruction in Puddu and Viarengo (1993), with modifications.*

Comparisons

Therianthropes, either of undetermined sex, or specifically female, but rarely male, are known all over the Upper Paleolithic, starting with the Aurignacian and with both figurines (Hohlenstein-Stadel – Hahn 1986) and paintings (Grotte Chauvet – Clottes 2001). Early representations focus on lion and bison features, in good accordance with a general prevalence of mighty species (Clottes 1995). Later, in the final phases of the Upper Paleolithic, therianthropes include features of less impressive animals (Figure 14.12): elk at Tolentino (Massi *et al.* 1997); canid at La Madcleine (Delporte 1993); mountain goat at Las Caldas (Corchón Rodriguez 1990).

A lagomorph head fits better into the second group. More features of the Macomer figurine find suitable comparisons in the late Upper Paleolithic record, most notably the S-shaped profile of the body. Female representations found in association with the final Magdalenian are well-known all over Europe, and led to the description of the distinctive Gönnersdorf type by Bosinski (1991). Gönnersdorf shapes are found both as carvings, including pendants, and as engravings – the latter always from a lateral viewpoint. They are rather stylized, generally lack arms and often even breasts. The thighs are flexed or semi-flexed in the continuation of the protruding buttocks, producing the S-shaped profile mentioned above (Figure 14.13). This is also the posture and profile of the Venus of Macomer, as seen best when it rests on its side – and, as stated above, it actually lies quite easily on the right, flattish side (Figure 14.6).

Turning to comparisons with figurines of Holocene age, none is known to occur at early Neolithic sites of Sardinia, while they are a distinctive feature of the Bonu Ighinu Culture of the middle Neolithic. Bonu Ighinu statuettes, mostly in stone, are beautifully carved, with much care for the rendering of details of the face, dress and ornaments, and with perfectly symmetrical and rather rounded volumes (Figure 14.14b). Later figurines, of so-called "Cycladic" type, are much more stylized and often rather flat (Figure 14.14c). In later prehistoric periods, statue menhirs with female attributes also exist (Lilliu 1997). They have little in common with the Macomer figurine, except for the simple fact of being stone carvings, and female representations. The well-known Nuragic bronzes are not only stylistically and technologically quite distinct, but also mostly refer to males (cf. Lilliu 1966). None of the Bonu Ighinu or later representations, furthermore, depicts a therianthrope. The same is true for the record of peninsular Italy, with a fair number of terracotta female representations from Neolithic sites, which have little in common with the statuette under study (cf. Fugazzola and Tiné 2002-2003).

Concluding remarks

The Venus of Macomer fully exemplifies the difficulties experienced when studying prehistoric collections made without proper scientific

Figure 14.12 Theriogynous engravings and carvings of late Pleistocene age, at different scales: a) Venus of Tolentino, Italy, engraved pebble, height 127 mm, 12,000-10,000 bp (after Massi et al, 1997); b) La Madeleine, France, engraved pebble, height 98 mm, c. 13,000 bp (after Delporte 1993); c) Venus of Las Caldas, Spain, deeply incised bone, height 198 mm, c. 13,000 bp (after Corchón Rodríguez 1990).

control. The accompanying evidence is lost, even if a handful of rather informal flaked tools in the archaeological collection possibly suggests that a pre-Neolithic deposit once existed in Riparo s'Adde.

Only the item itself, if carefully analysed, can give some clues to its age and meaning. The typo-technological study points to the carving of a suitably shaped volcanic rock fragment, making use of lithic implements. In Paleolithic art, the clever use and accurate modification of natural features is well exemplified (Bahn 1997:105-106), just like the depiction of therianthropes, while this is not documented in the remaining, supposedly later prehistoric record of Sardinia. More stylistic comparisons can be made with the Gönnersdorf representations of late Pleistocene age – even if the head, being that of an animal, is definitely unlike any such carving or engraving. The figurine looks rather like the combination of the Gönnersdorf typology with a theriogynous model. This double affinity, in style and content, is just compatible with a Late Pleistocene age. My interpretation of the head as belonging to the extinct, endemic *Prolagus sardus* is consistent with this hypothesis.

Figure 14.13 Female figurines of late Pleistocene age, at different scales: a) Vénus du Courbet, France, height 25 mm (after Ladier 1992); b) pendant from Neuchâtel-Monruz, Switzerland, height 16 mm (cliché Musée Cantonal d'Archéologie); c) Vénus d'Enval, France, height 31 mm (after Bourdelle et al. 1971).

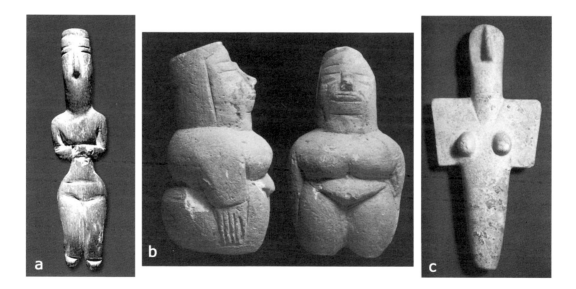

Figure 14.14 Examples of prehistoric female figurines from Sardinia, 4th-3rd millennium BC, at different scales (after Atzeni et al. 1985): a) Monte Meana (Santandi), carved bone, height 73.5 mm; b) Polu (Meana Sardo), carved stone, height 83 mm; c) Turriga (Senorbi), carved stone, height 422 mm.

I have been unable to find any suitable comparisons with the Neolithic and later record not only of Sardinia, but also of the mainland. Accordingly, my educated guess is that this figurine was produced in Sardinia before the Holocene, when all or part of the endemic fauna was not yet extinct. It is a local adaptation, possibly of Late Pleistocene age, of a model and of a set of beliefs developed far away, elsewhere in continental Europe (Mussi 2007). As such, it should be seen in the perspective of the elusive Upper Paleolithic colonization of Sardinia, for which some new evidence has turned up in the last few years (Mussi and Melis 2002).

Acknowledgments

Thanks are due to all those who made possible the study of the statuette at the *Museo Archeologico Nazionale in Cagliari*. At the *Soprintendenza archeologica per le provincie di Cagliari e Oristano*, these were Dr. Carlo Tronchetti and Dr Luisanna Usai in 1998; Dr. Vincenzo Santoni, Soprintendente, Dr. Alessandro Usai, and again Dr. Tronchetti in 2006. The local personnel helped with materials, pictures and archives. Prof. Marco Marchi (Dipartimento di Scienze della Terra, Università di Cagliari) introduced me to the problems related to petrography. Dr. Fulvia Lo Schiavo, former Soprintendente, *Soprintendenza archeologica per le provincie di Sassari e Nuoro*, encouraged me in many ways, while Mr Giancarmelo Melis kindly accompanied me to visit Riparo s'Adde. I also wish to remember Dr. Maria Grazia Melis (Università di Sassari) for many fruitful discussions on Sardinian prehistory. Prof. Rita Melis (Dipartimento di Scienze della Terra, Università di Cagliari), offered help in countless ways, including understanding the local geology, and kindly assisted me throughout my stays in Sardinia.

Mr. Filiberto Scarpelli (Laboratorio di Paletnologia, Dipartimento di Scienze dell'Antichità, Università di Roma "La Sapienza") elaborated the illustrations. The research was supported by a grant of the University of Roma "La Sapienza" (Ricerca di Ateneo 2004), funded by MIUR.

I am grateful to Paul Bahn for inviting me to contribute to this volume in memory of Alexander Marshack. Alex will be remembered in many ways for his contribution to the study of prehistoric art. My own special recollection is about the rediscovery of the lost Balzi Rossi figurines. It was Alex who pointed out in 1986, after 60 years of dormancy of the problem, that, against all odds, the statuette at the Peabody Museum, nicknamed "the Janus", was part of this fabulous collection. His insight paved the road to the proper attribution of seven more Balzi Rossi statuettes, which surfaced again in Canada ten years later, under different circumstances. I am pretty sure that he would have appreciated the Venere di Macomer, another semi-forgotten, delicate female carving.

About the author
Margherita Mussi, Dipartimento di Scienze dell'Antichità, Università i Roma "La Sapienza" Via Palestro 63 00185 Roma, Italia; E-mail: margherita.mussi@uniroma1.it.

References

Atzeni, E. M., F. Barreca, M. L. Ferrarese Ceruti, E. Contu, G. Lilliu, F. Lo Schiavo, F. Nicosia, and E. Equini Schneider

1985 *Ichnussa*. Garzanti-Scheiwiller, Milano.

Bahn, P. G.

1997 *Journey through the Ice Age*. Weidenfeld and Nicolson, London.

Bosinski, G.

1991 The representation of female figures in the Rhineland Magdalenian. *Proceedings of the Prehistoric Society* 57:51-64.

Bourdelle, Y., H. Delporte, and J. Virmont

1971 Le gisement magdalénien et la Vénus d'Enval, Comune de Vic-le-Comte (Puy-de-Dôme). *L'Anthropologie* 75:119-128.

Caloi, L., and A. Malatesta

1974 Il cervo pleistocenico di Sardegna. *Mem. Istituto Italiano di Paleontologia Umana* II:163-240.

Cherry, J.

1990 The first colonisation of the Mediterranean Islands. *J. Mediterranean Archaeology* 3:145-221.

Clottes, J.

1995 Changements thématiques dans l'art du Paléolithique supérieur. *Bull. Soc. Préhistorique de l'Ariège* 50:13-34.

Clottes, J. (ed.)

2001 *La Grotte Chauvet - L'Art des Origines*. Seuil, Paris.

Corchón Rodriguez, M. S.

1990 Iconografía de las representaciones antropomorfas paleolíticas: a propósito de la "Venus" magdaleniense de Las Caldas (Asturias). *Zephyrus* XXXXIII:17-37.

Delporte, H.

1993 *L'image de la femme dans l'art préhistorique*. Picard, Paris.

Féblot-Augustins, J.

1997 La circulation des matières premières au Paléolithique. *E.R.A.U.L.* 75, 2 vols. Liège.

Fugazzola Delpino, M. A., and V. Tiné

2002-2003 Le statuine fittili femminili del Neolitico italiano. Iconografia e contesto culturale. *Bullettino di Paletnologia Italiana* 93-94:19-51.

Graziosi, P.

1973 *L'arte preistorica in Italia*. Sansoni, Firenze.

Hahn, J.

1986 Kraft und Aggression. *Archaeologica Venatoria* 7, Tübingen.

Klein Hofmeijer, G.

1997 *Late Pleistocene Deer Fossils from Corbeddu Cave*. BAR Int. Series 663, Oxford.

Ladier, E.

1992 La Vénus du Courbet. *L'Anthropologie* 96:349-356.

Lilliu, G.

1950 Scoperte e scavi di antichità fattisi in Sardegna durante gli anni 1948 e 1949. *Antichità Sarde* IX: 394-561.

1966 *Sculture della Sardegna Nuragica*. La Zattera, Verona.

1986 Le miniere dalla preistoria all'età tardo-romana. In *Le miniere e i minatori della Sardegna*, edited by F. Mannoni, pp. 7-18. Consiglio Regionale della Sardegna, Cagliari.

1997 La grande statuaria nella Sardegna Nuragica. *Atti dell'Accademia Nazionale dei Lincei, Memorie*, ser. IX, IX:283-385.

1999 *Arte e religione della Sardegna prenuragica*. C. Delfino, Sassari.

Luglié, C.

2005 *Risorse litiche e tecnologia nel Neolitico antico della Sardegna*. Tesi di Dottorato di Ricerca, Università degli Studi di Roma La Sapienza. Unpublished.

Martini, F. (ed.)

1999 *Sardegna paleolitica*. Museo Fiorentino di Preistoria "Paolo Graziosi", Firenze.

Massi, A., M. Coltorti, F. d'Errico, M. Mussi, and D. Zampetti

1997 La Venere di Tolentino e i pionieri della ricerca preistorica. *Origini* XXI: 23-65.

Melis, R. T., and M. Mussi

2002 S. Maria Is Acquas, a new pre-Neolithic site, South-Western Sardinia. In *World Islands in Prehistory, International Insular Investigations*, edited by W. H. Waldren and J. A. Ensenyat, pp. 454-461. BAR Int. Series 1095, Oxford.

Mussi, M.

2001 *Earliest Italy. An overview of the Italian Paleolithic and Mesolithic*. Kluwer Academic/Plenum Publishers, New York.

2007 Palaeolithic art in isolation: the case of Sicily and Sardinia. In *Palaeolithic Cave Art at Creswell Crags in European Context*, edited by P. Pettitt, P. Bahn, and S. Ripoll, pp. 194-206. Oxford University Press, Oxford.

Mussi, M., and R. T. Melis

2002 Santa Maria Is Acquas e le problematiche del Paleolitico superiore in Sardegna. *Origini* XXIV:67-90.

Mussi, M., M. R. Palombo, and R. T. Melis

2005 Il più antico popolamento della penisola italiana, della Sicilia e della Sardegna. In *Geoarqueología y Patrimonio en la Península Ibérica y el Entorno Mediterráneo*, edited by M. Santonja, A. Pérez-González and M. J. Machado, pp. 17-27. Adema, Soria.

Pesce, G.

1949 La "Venere" di Macomer. *Rivista di Scienze Preistoriche* IV:123-137.

Puddu, E., and M. Viarengo

1993 *Animali di Sardegna, i mammiferi*. Delfino, Sassari.

Tykot, R. H.

1996 Obsidian procurement and distribution in the central and western Mediterranean. *Journal of Mediterranean Archaeology* 9:39-82.

Vigne, J-D.

1996 Did man provoke extinctions of endemic large mammals on the Mediterranean islands? The view from Corsica. *Journal of Mediterranean Archaeology* 9:117-126.

Wilkens, B., and F. Delussu

2002 Les mammifères sauvages de la Sardaigne: extinctions et nouvelles arrivées au cours de l'Holocène In *Mouvements ou déplacements de populations animales en Méditerranée au cours de l'Holocène*, edited by A. Gardeisen, pp. 23-31. BAR Int. Series 1017, Oxford.

CHASING THOUGHTS LOST THIRTY MILLENNIA AGO

Elena A. Okladnikova, translated by Danil Frolov

Morphogenesis and human consciousness are problems that remain the most current for contemporary science. Thousands of publications by the world's scientists are devoted to these problems, yet an exhaustive answer still eludes us. The subjects of study – techniques, logic, methods and algorithms for scientific research into a phenomenon as unique as human consciousness - are enormously diverse. But whatever diversity they show, each researcher is in any case preoccupied with the problem once formulated by A. Marshack in a discussion with journalists. Answering their question "What new information do you want to see in Paleolithic stone tools?" Alexander Marshack said "I'm seeking thoughts lost thirty millennia ago". Chasing these very thoughts he came to Leningrad in the winter of 1977. That winter happened to be very cold with lots of blizzards. My father, the archeologist A. P. Okladnikov, came from the Akademgorodok (scientific complex) of Novosibirsk to meet him. On a cold January evening he and I came to meet Alexander Marshack and his wife Elaine in the "Astoria" hotel. Passing through the hotel's hallway and up its wide marble staircase, we came to the second floor and entered the room where Elaine and Alexander were staying. It was an expensive, spacious suite, appointed with elegant aureate empire furniture; the snow-covered dome of St. Isaac's Cathedral could be seen from its windows. The lights were muted, the thick twilight inside the room matching the dusk of the winter evening outside. Together with the extremely refined, almost vanishing, figure of Elaine Marshack and the soft, slightly tired voice of Alexander Marshack, it had an almost mystical mood. After my father returned to Novosibirsk, I continued to visit Elaine and Alexander at the hotel, trying to figure out what created that mood, trying to understand more clearly what the scientific connection was between Alexander Marshack and my father, along with the archeologists O. N. Bader, E. E. Fradkin, B. A. Frolov, and the Moscow neuropsychologist A. R. Louria, all the colleagues that he met during his visits to Moscow in 1976 and Leningrad in 1977.

From the talks I had with my father while going to the hotel to visit Alexander Marshack, I gathered that he was a world-class scientist. But there was something more in my father's voice as he gave me a short overview of Marshack's scientific achievements and his contribution to our knowledge of the Paleolithic. That "something" only appeared in my father's voice when he talked about his scientific associates, about those people whose scientific views he not only shared, but also had a deep interest in, whose thoughts inspired him to press on with his own research. During the different periods of my life I've turned my thoughts to this "something", and if you were to ask why I tried to figure it out, I would say that I was seeking the answer to many questions, all of them leading up to an ultimate one: "what was it that made all the above-mentioned scientists

forget themselves as they worked, neglecting sleep, food and health?" Why did Alexander Marshack, who began as a journalist, press photographer, scenario writer, famous theatre critic, and reporter specializing in newspaper reviews in the field of European and Asian art, turn into the author of a world-famous book about the aims and results of the International Year of Geophysics, and then become absorbed in the study of the Stone Age? His enthusiasm for archeology, which he found when he was already not so young, led him to become a research associate of Harvard University and its renowned Peabody Museum of Archeology and Ethnography.

As a rule, working on a scientific project leads to new questions, even upon the project's completion, and these questions often become those that give rise to the researcher's passion. For Alexander Marshack it was his work on the *International Year of Geophysics* book that became such a project. The idea arose that researching the path of humanity's intellectual development might be far more interesting than learning the structure of spacecraft. His work on this project posed many important questions in the fields of archeology and paleoanthropology. For example, what observations, experience, knowledge and abilities of our ancient ancestors were the cause of their first observations of the night sky? Or, doesn't the time gap between contemporary scientific and technical omnipotence and the complete intellectual helplessness of our ancestors only 30-40,000 years ago seem too short?

The observations made by Alexander Marshack drew a picture of the intellectual world of humans separated from us by 30,000 years, which was completely different from the one proposed by official science:

> I used A. R. Louria's lessons and came to the conclusion that Stone Age man had a brain that structurally was almost the same

as the one we have today – or else he would not have been able to create such a developed culture. It would not have been possible if Paleolithic man had lacked the areas providing the 'work' of language, capability for symbolic thinking, fine and precise hand movements. In those distant times the intellectual world was not a simple one. It is clear that while economically Cro-Magnon man languished in poverty, in a biological sense, as a conscious being, he wasn't inferior to us... (stated Alexander Marshack, following his visit to the Moscow Institute of Neuropsychology).

"Officially, the Space Age was announced on 4 October 1957, with the launch of the first Soviet satellite, but in fact it began far earlier" (Marshack 1972). These words, first presented in his book, *The Roots of Civilisation* (Marshack 1972), are, as a matter of fact, the tuning fork by which Marshack collated all his hypotheses and assumptions. As the book's cover said, "What he has discovered shows that, evidently, people were capable of complex thinking processes many millennia earlier than had hitherto been considered".

This brilliant and spectacular research has added unexpectedly fresh and fundamentally important traits to the portrait of ancient man" – this is how the renowned American archeologist, Hallam Movius, whom Marshack considered his teacher, concludes the book. The lunar calendar, created by Stone Age man, the transition from realistic signs to increasingly abstract ones, and the developed thought that backed it all up – that's what Alexander Marshack saw while examining under the microscope the fragments of ancient tools or objects that for decades had gathered dust on museum shelves. "I searched for the thoughts lost thirty millennia ago". This search for the thoughts, just thoughts, lost long ago – that's what made Alexander Marshack come to

Russia. In the winter of 1977, he came to Leningrad - not only to see the paleolithic collections of the Museum of Anthropology and Ethnology named by Peter the Great (the Kunstkamera) - but also to meet the curator of these collections, E. E. Fradkin, as an unexpected consequence of Fradkin's interest in the search for the origins of art. In the mid-1970s the journal, *Current Anthropology*, sent articles out to a number of specialists, seeking their opinions on possible publication (Marshack 1972), and E. E. Fradkin received Alexander Marshack's article in which he discussed late Paleolithic art from the perspective of contemporary man's cognitive activities. Soon this work was published along with Fradkin's comments. That's why Marshack found Fradkin as soon as he arrived in Leningrad.

Fradkin was a real enthusiast for his work. Short and lean, stooping a bit, he rushed around the museum halls of the Kunstkamera, often with one hand in the pocket of his dark brown suit.

From the beginning of the 1960s, when he became curator of the paleolithic collections, he was responsible for more than half a million archeological items, a collection that was started in the time of Peter I. By the 1970s a good few of these collections consisted of paleolithic items. As a curator, he examined one drawer after another, taking out the stones and trying to look at them through the eyes of the person who turned them into stone tools. His teacher, the archeologist S. N. Zamyatnin, was the first to draw attention to an amazing feature of some stones which comprised two, three, and even five different forms at a time. If you look at the stone from above, it's a stone knife, a chopping or scraping tool. But if you turn the stone, you can see the portrait of an animal. Zamyatnin succeeded in recognizing and publishing these zoomorphic sculptures (Zamiatnin 1973).

Fradkin continued Zamyatnin's research using material from the Yahshtuh site near Sokhumi. He wasn't embarrassed by the fact that items from the Mousterian and Acheulian periods were mixed in the dozens of boxes that constituted the Yahshtuh collection. As he said to journalist K. Levitin:

If were to take that into consideration, I would never have re-examined these stones. But here they are before us. There's no doubt that there are some big beasts, and there's no doubt that these figures were consciously made of flint by human hands, and the reason behind this is far from practical expediency. Before us is a tool: it can be seen how this piece was broken off a large stone. The struck surface is present, and the bulb of percussion and ripples that appear in such cases are evident. And at the same time these sparing lines delineate the figure of an animal. Then there was nothing that could stop me directing my magic carpet to other sites, since they were all closely located: Staroselye, Kiik-Koba, Teshik-Tash, Ilyinskaya site, Bougoutlyu, Ashhtyr cave, Kostenki, the Gagarinskaya site... Everywhere I found the same tendency. For comparison I took a pebble from the renowned Tripolye culture that is a relatively recent one. Look: one is five and other is fifty, or even one or two hundred thousand years old. Certainly, there is difference. But also, there is likeness! (Levitin 1979).

Many thoughtful researchers, including A. Leroi-Gourhan and H. Breuil, who tried to reconstruct the intellectual world of primeval people, assumed for a long time that ancient people's thoughts were constantly stimulated by a storm of emotions, unconscious yearnings, unsatisfied desires that raged in the soul (Breuil and Lantier 1959).

The ability to see not only the utilitarian basis, but also the fundamental problems concerned with the formation of art, scientific knowledge and the birth of human civilization itself in paleolithic objects, was what united Fradkin, Marshack and Okladnikov as associates.

Okladnikov's conversations with Marshack and those of Marshack with Fradkin revealed the analogous viewpoints of these researchers which can be applied to the following ideas: 1) As early as in Mousterian times, several symbolic systems existed - cuts, ornaments, and zigzags; 2) the people who developed these symbol systems must have had advanced brain areas responsible for directional attention, activity planning, and the ability to correlate various signals - in short, they must have had linguistic abilities, i.e., they must have been able to talk, to communicate with each other; 3) Acheulian man, judging by his tools, was able to neatly coordinate his left and right hands, when he had to produce, for example, a chopping tool. He understood how to systematize the objects of the surrounding world; 4) Acheulian man, our distant ancestor, was a thinker.

Fradkin was inspired by Zamyatnin's ideas to such an extent that, from then on, the notion that the origins of art must be sought in increasingly early eras of human culture never left him. His interest in paleolithics never hindered his interest in ethnographic collections. Fradkin con¬tinued his research in this area, considerably widening the array of items he studied. Once, while we were passing by the hall of the Kunstkamera where the collections from the Indian cultures of the northwest coast of North America were exhibited, he led me to the showcase containing rattles. "Look, this shaman rattle has pictures of a raven, a Mother Earth face, and a shaman frog-ancestor, it's a true polyicony " (Author's archive, St. Petersburg 1977). That term - polyicony, meaning multiformity - was

proposed a lot later by S. V. Ivanov, a researcher in the ethnography of Siberian peoples, as a definition of primeval and traditional art's syncretic features, when it is viewed as a form of artistic vision. But Fradkin liked this term so much that he accepted it in his ongoing work. He was so engrossed by thoughts about "polyicony" - the ability of ancient craftsmen to create multifunctional and multiform products not only during ethnographic periods, but also in the Paleolithic epoch - that he frequently carried paleolithic stones in his pockets (Author's archive, St. Petersburg 1977; the main ideas about polyiconia were published by Emil Fradkin 1961). Once, he took one of these museum exhibits out of his pocket during an academic council meeting, trying to illustrate his ideas with it. Since carrying museum items out of the depository was a gross violation, this resulted in a reprimand from the authorities!

Yet many specialists regarded Emile Evseevich Fradkin's ideas critically. They believed that seeing a beast in the lines of utilitarian flakings is a figment of the imagination. Undoubtedly, ideas like this could only be accepted by scientific society after passing through the stage of scientific filtration, i.e., after becoming shared by most scientists worldwide. The process of scientific filtration consists of several stages, figuratively described by A. Gumboldt: First stage - "what rubbish!", second - "it makes sense...", and third - "it's common knowledge!"

Nowadays, almost forty years after the publication of A. P. Okladnikov's book, *The Morning of Art*, and a series of great discoveries about the Paleolithic era, the scientific community considers it tactless to speak about the intellectual helplessness of Cro-Magnons (Okladnikov 1967).

The abundance of geometric signs and symbols in the monuments of the Stone Age always

suggested that their proximity to the realistic images of humans and animals was not accidental. In the 1970s, B. A. Frolov, at that time a post-graduate student in the History, Philosophy and Philology Institute of the USSR Academy of Sciences' Siberian department, with A. P. Okladnikov as his scientific advisor, began to do research into the rhythms of Paleolithic ornaments. Frolov developed a special method of analysis, which verified and expressed statistically all the ways of producing ornamental elements in the USSR's collections of paleolithic graphic arts (Frolov 1973). The results were unexpected in many respects and confirmed the following suppositions: 1) The presence of a developed practice of systematic calculation among paleolithic hunters; 2) the use of calculation by paleolithic people for the primary observation of cyclic processes in Nature, primarily the lunar cycle.

While the first articles by post-graduate student B. A. Frolov containing these conclusions were already on his scientific adviser's table in the Akademgorodok of Novosibirsk, the latter received a letter from his colleague, Professor Hallam Movius, the renowned American archeologist, and member of the USA National Academy of Sciences. Movius wrote that his student Alexander Marshack was studying the cutmarks on paleolithic objects in the Harvard University Museum. He also communicated that Marshack had discovered several series of cuts that could be compared with a record of lunar cycle stages.

In January 1977, a collection of articles was published in Novosibirsk under the title, *At the Sources of Art* (Chernish 1976). This publication featured among others an article by the Ukrainian archeologist A. P. Chernysh on his discovery of systematic cuts on a mammoth scapula from a site on the banks of the Dnestr. "A. P. Chernysh's discovery can realistically be said to be of epochal, fundamental importance",

A. P. Okladnikov wrote in his afterword to Chernysh's short communication:

> As a result of methodically impeccable research into reliably dated layers from Mousterian times... he discovered an example of true, albeit still primitive, graphic work, a specimen of Mousterian man's art. It is important that the Mousterian settlement researched by A. P. Chernysh has also presented us with the remains of ancient dwellings that are typologically the same as the subsequent dwellings of the Upper Paleolithic. It means that Mousterian men had indeed reached the level of *Homo sapiens* in their art and in mastering the opportunities that Nature provided them with (Chernish 1976).

The marks on the mammoth scapula – engraved lines, zigzags, squares, animal figures, traces of paint – all belong not to the early, but to the late paleolithic, Mousterian epoch. Mousterian means the period before the Aurignacian and, therefore, it is not even the time of Cro-Magnon man – who was *sapiens* for sure – but that of his predecessor, Neanderthal, who was nevertheless able to create works of art. That's the idea that was almost universally called into question until the end of the 1970s.

B. A. Frolov, A. Marshack and A. P. Chernysh were unaware of each other's existence during the mid-1970s. The historical monuments they worked on were different. They followed different paths to lead them to their conclusions, and used different research methods. Nevertheless, the results of their research were congruent. "Parallel" or "simultaneous" discoveries like these show that the development of scientific knowledge has a logic and rules of its own, with problems ripe and waiting to be solved. The basis of this is time itself – the time of an epoch that has yielded so many data and hypotheses

Figure 15.1 Petroglyphic drawings. E. A. Okladnikova and her son Alexey Okladnikov (to the right) on the left bank of the Elangash River (1979).

about our ancient ancestors' life that the very logic of scientific development required scientists to take increasingly decisive steps.

The parietal works of art from the renowned paleolithic caves in France, Spain, and also Kapovaya cave in the Urals, which had already been recognized by the scientific establishment for a long time, were more attractive to researchers in paleolithic culture than the examination of geometric signs – the symbols that covered portable works of art found at the same caves, near the paintings of animals. But after the appearance of a series of publications that attracted scientists' attention to these very objects, whole new areas of archeology and paleoethnography such as astroarcheology and astroethnology were discovered. Expeditionary research data, particularly, data in the field of the petroglyphic art of the Altai Mountains, also continued to accumulate (Figure 15.1).

In the 1980s in the Altai Mountains I discovered one of the most renowned petroglyphic art monuments of the area - Kalbak-Tash. The Kalbak-Tash Mountain is situated at kilometer 726 on the Chuyskiy Highway, and borders on the Chuya River. Numerous zoomorphic and anthropomorphic compositions were discovered on its rock surfaces. Many of these zoomorphic and anthropomorphic petroglyphs were surrounded by dots that could be interpreted as astral symbols. In undertaking a hermeneutic analysis of the Kalbak-Tash petroglyphs, I always considered the ideas formulated earlier by V. I. Ravdonikas, A. P. Okladnikov, A. Marshack, A. P. Chernysh and B. A. Frolov. These were ideas about the human ability to count time, of man's interest in observations of the night sky, and of his inclination for associative thinking and astral symbolization, manifesting itself particularly clearly in the monuments of petroglyphic art. This striving for astral symbolization was particularly graphic in the petroglyphs of Kalbak-Tash.

Silence reigned in the long, wide glade on the top of Kalbak-Tash. A sticky, thick aroma of wormwood hardened in the still, sun-heated air. We followed our guide, shielding our eyes from the blinding sun with our hands. Suddenly, he stopped before the tall, violet rock that jutted towards us like an ocean wave. Patches of drawings, hardly distinguishable in the direct rays of the sun, covered in the whitish sweat of dew, could barely be seen on it. As if erasing the wet breath of night, our guide ran his fingers over the stones, and tears of dew ran down, towards the bottom of the rock, in long rivulets. His hand gradually brought out a long round dance of shadows for us to meet: a line of six broad-shouldered men, closely resembling the Great Archer - Koguldey. Under the men's feet lay a whole crowd of animals: bulls, horses, goats, rams, deer, and also human figures and a chariot.

High above them, on the edge of the stone, there soared an obscure outline picture, light and airy. After long efforts we could at last take a better look at it, and it

turned out to be the figure of a leopard. His huge sharp-toothed jaws faced the biggest human figure on the frieze. The beast hung vertically over the men who walked to the right, towards the source of the Chuya River. The whole world opened itself before us: a universe filled to the highest degree with animals and humans equipped with various things – staffs, weapons, bags.

All of this moved, shifted in the space of the figurative plane, running one over another, crowding and swiftly stretching over the rock's edge. Some of the pictures perished under the deep vertical and horizontal cracks.

Despite its apparently chaotic nature, the composition of the central panel as a whole had an inner life of its own. Its division into three horizontal tiers promoted this impression, reflecting the notion of three realms. The upper tier – the picture of a beast of prey; the middle – a procession of six male figures; the lower – and the one most full of figures – could be most closely compared to the earthly, or real, world but for several details. In its lower part there were figures of sacrificial horses with their legs pulled up to their bellies (hobbled animals), their swan-necks bent helplessly, and their upright stick-like tails ending in stars which reminded one of the lower, underground world, where the souls of sacrificed animals find refuge (Figure 15.2)

In addition, a vertical line was present, stretching from the lightweight lone beast-of-prey figure to the heavy, picture-rich lower portion, accentuating the pyramidal shape of the composition. Before us was a pyramidal composition similar to that seen on a boulder in the Elangash valley.

The peculiarity of the picture was emphasized by the abundance of differently sized dots, made either by careful and accurate or by negligent hammering. Some ethnographers have

Figure 15.2 Kalbak-Tash, central panel, picture
of the main hero.

proposed an interpretation of the the dots in south Siberian petroglyphs as astral signs or images of stars. After all, the shaman's tambourine depicts the world, the universe, as old shamans usually told researchers.

The multi-figure, sometimes multicolored Similar dots covered the area between the composition was divided by horizontal lines into figures at the renowned Boyarskaya Pisanitsa in three tiers: the celestial, earthly, and under-Khakasia. The horizontal frieze of that petro-ground. The space between the figures was filled glyph retained the picture of a settlement with by dots – symbols of constellations (Figure 15.3), framework buildings, scenes of grazing cattle, and a figure of a deer-rider. Archaeologists assumed that it is not a scene of the life of stock-breeders of the

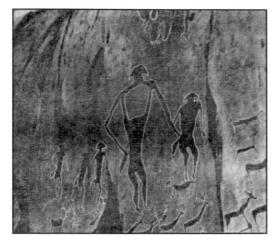

Figure 15.3 Kalbak-Tash,central panel,
main characters.

Tagar epoch (second-first millennium BC), but the portrayal of an ancestral land, Elysium, where the souls went after death to continue their cycle of life. This land was lost among the constellations of the Milky Way, over which the souls of the ancestors ascended to the upper world, to heaven. In other words, the composition preserved on the top of Kalbak-Tash was similar, extending the model of the world to the borders of space, taking in both hierarchical levels of the universe: celestial with its symbols - leopard and a row of celestials - and earthly, with humans, animals and scenes of sacrifices to the spirits (Master of Animals).

The distribution of human and animal figures, signs and symbols, including dots representing stars, in the space of a figurative plane is a peculiar artistic technique, characteristic of Eurasian Neolithic-period petroglyphic art. Compositions are constructed in two-dimensional space, lacking the third dimension that would provide the figures with volume. They lack perspective as we understand it, considering our

experience of perception through easel painting. Differently scaled pictures of humans and animals resemble bigger or smaller stars shining in the two-dimensional sky. They hang in space without correlation to a horizon line, even if it is present as in the composition in question. The hanging of figures, as an artistic technique of depicting them in space, and surrounding them with astral signs and symbols, emphasized the cosmogonic nature of the compositions. The division into tiers with horizontal lines turned them into peculiar models of the universe. Tiers can also be divided from one another by deep long natural cracks. The dividing line was a symbol of the horizon line - the real edge between earth and sky. But it was never regarded as a thin line, as a streak between night and day. It was a whole world, a separate land, an area that was the location of births and deaths. There, on the horizon line, a new day was born, that's where the sun rose from, and that's where it declined after its long path across the sky. As the ancestors' land - a land of the dead - was placed in the sky by the notions of south Siberia's third to second millennia BC population, a horizon line, this dividing line between worlds, was a threshold of the celestial world, an exit, a door to the cosmos.

Later, when artistic imagination began to connect the land of the dead with the earthly and underground worlds, the symbolism of the horizon line lost its significance. The idea of a birthplace, expressed by the dividing line, was also embodied in other monuments of petroglyphic art of the Altai Mountains. For example, a big zoomorphic panel, divided into horizontal tiers by deeply incised, accurate, straight lines, was found on the glittering, oily, sunburned surfaces of rocky outcrops in the Ak-Kewl valley, near the Kara-Oyuk road. Above them rows of wild and domestic animals were arranged in long lines. Another composition embodied the procession

of several Sayan Mountain deer with magnificent branching horns. All these compositions can be ascribed to the Bronze Age, in accordance with all of these identical characteristic features. Only on the Bira stone image, a second millennium BC monument amid the stone stelae of the Minusinsk Basin on the left bank of the central part of the Elangash river, did we find similar pictures. The Bira stone image is a monument of the Yenisei region's Bronze Age, the time when one of the most powerful South Siberian centers of metallurgy and cattle-breeding existed here.

The animals there had long, thin cords going from their snouts to columns - tethers, depicted with long vertical lines. The animals were distributed across the plane in tiers, divided by horizontal lines analogous to those we observed on the Ak-Kewl Mountains and Kalbak-Tash rock, deeply incised into the stone. These pictures are set apart by their pronounced linearity and accentuated hierarchy of subjects: the upper tier was occupied by domestic animals - bulls - and wild deer and elks were situated below them.

A hierarchy of subjects, bas-relief technique, tiers, and dividing borders are all peculiar features that link the slab from the Tengin lake with, on the one hand, the Yenisei River monuments of the Okunev epoch, including the slab found by archeologist A. N. Lipskiy and kept in the Abakan regional museum, and, on the other hand, with ancient Egyptian reliefs. But even locally in the Altai, the Tengin slab had analogues in tiers, numbers, the hierarchy of dual subjects (*e.g.* male and female), and the assortment and combinations of wild and domestic animals. One of them is a composition found on the rock out-crops of Tengin, facing the village and the sacred Shibelek peak. It has deer, bulls, wolves and horses following one another pictured on it.

On first sight, the Tengin slab makes an amazing impression. In the sun-burned grass,

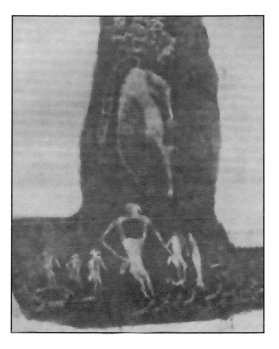

Figure 15.4 Kalbak-Tash, central panel, heroes and mythical creature descending from above

near a cow-shed, it looks alien, like a meteorite. It is a messenger from other worlds, a splinter from a different culture. And at the same time its appearance there, in the Altai region, resulted from the course of native cultural development itself. The central panel of the Kalbak-Tash mountain-top, a rock with animal pictures facing Shibelek, and the Abakan slab express ancient artists' ideas about the world, being peculiar models of the universe. The finesse of the artistic technique suggests the possibility of strong external influence. The susceptibility to such an influence was made possible by the course of the social and cultural development of the native Neolithic and early Bronze Age people of Sayan-Altai as well as the Minusinsk Basin and the Baikal region. It is convenient to cite linguist and historian A. Fergusson's opinion about continuity in

national cultures: "When nations truly borrow from their neighbors, they probably borrow only those things that they were almost capable of inventing themselves" (Figure 15.4).

Compositions in tiers with a dividing line as a component extend over a long period. The ideas behind them were adopted by the Scythian culture of Central Asian and Kazakhstan peoples, finding their reflection in monuments of petroglyphic and decorative art, for example in the Ilian Golden Man. Later, the dividing line manifests itself in ancient Turkic art - pictures of deer galloping, flying over the zigzag peaks of mountain ridges (for example, on the front part of a saddle from an excavated burial at Kopenskii Chaatas).

In the Kalbak-Tash panel's central area's upper tier we can see six male figures. Despite the difference in proportions, they look as if they are copying each other: the poses, figure outlines, clothing details and attributes are all the same. Men are shown moving in a row while performing a slow ritual dance - a round dance. Round dances like this, consisting of dozens of anthropomorphic figures, were depicted by artists on the Tamgaly rocks (Kazakhstan), Sagan-Zaba (White rock) on the shore of Lake Baikal, and the Bratskaya Kada cliffs on the Angara River. The ritual dance figures move in a grave and monotonous motion. The dance pattern reproduced the daily path of the Sun across the sky, and by night under the earth or under the ocean, as if showing the continuous round of natural events. That's where the round motion, depicted by rows of humans and animals in petroglyphic art, comes from. Kinematic rites, communicated by the language of dance, conveyed the idea of a fertility cult - of death containing new birth and the renewal of nature - no less clearly than the verbal form of the myth. The fluent, smooth round dance symbolized the

dying of Nature. It was similar to the sacred dance of King David before the Ark of the Covenant. In ritual mysteries this type of dance was contrasted with the fast round dance, fre¬quently accompanied with orgiastic rites and the presence of phallic characters. In the Altai Mountain petroglyphs, attributed to the Bronze Age, we can see both forms of cult dance: slow (six male figures of the Kalbak-Tash upper tier central panel are involved in it), and fast, more resembling a run. Four youths, whose half-erased outlines we could hardly see on a glacier- and weather-eroded horizontal slab in one of the Ak-Kewl rock outcrops, in the slanting beams of the setting sun, were pictured precisely in this impetuous dance. Near the dancers is a depiction of a chariot on two high wheels, with numerous spokes, and with a disproportionately long load-board, planked with short straight sticks. To the right of it there are two bulls similar to those that decorate the Okunev-period stelae of the Minusinsk Basin.

The Ak-Kewl pictures are not incised, but cut with a metallic tool. The cutting tool left an even, deep and confident contour. The groove of the carved line looks much darker than the rocks - a feature that is characteristic exclusively of ancient inscriptions. The considerable age of the dancers is made evident by the deer pictures overlapping them, left by a late medieval artist. But the deer pictures had time to acquire a patina too - they have a dark yellow tint.

The round dances of the Kalbak-Tash Mountain and Ak-Kewl rock differed not only in dance tempo and the artistic performance of the dancing figures, but also in the dancers' appearance. The artists of Ak-Kewl, depicting the elegant bare male figures, strove for the accentuation of light, abrupt, weightless, oblong proportions - the youths stride on tiptoe, their shoulder-length wavy hair flying. On the chest of one of the figures

there are small circles. It is tempting to guess that there are young girls, youthful priestesses of the Spring, among the sacred dance performers. But a decoration with round plates like that is also known from the costume of an archer pictured on the same rock, but at a different time. The pronouncedly muscular bodies of the Ak-Kewl rock dancers indicate that they are male.

The spring round dances in honor of recovering nature persisted in some Kazakhstan (Tagmaly) and Kirghizia (SaymolyTash) petroglyphs of the Bronze Age. The impetuosity of the dancers' movements, and of their gestural expressions, is accentuated by the slightly bent, spread and springy legs, as well as by their hands, thrown wide and raised to the sky. The same movements can be perceived in the round dances conveyed with cross-shaped anthropomorphic figures in the Transbaikal Selengin group, which follow the pictures of yard-walls and bird-ancestors. They fit into the conception system of fertility, the cult of nature's renewal, indicating the existence of seasonal rites among the South Siberian and Transbaikal Bronze Age people.

At the dawn of the Bronze Age, the inhabitants of Siberia, Kazakhstan and South Siberia, including Sayan-Altai, sang and danced in a ring on warm spring nights under the decorated rocks, just as Buryats and Yakuts do during the spring festival of Ysyach.

Ysyach was a bright spring festival of Nature's regeneration. B. E. Petri, an ethnographer from St. Petersburg who worked in Irkutsk, was one of those who witnessed such a festival, and wrote: "The night is falling. The audience lines thin out. The fires are built here and there. The young people start round dances and begin songs. The last rays of the fading sunset burn down; the loud and confident singing resounds. Lads and girls move in tightly closed rounds in time with the dance. The merriment, long pent-up during the whole

day, breaks loose. Everyone wants to dance, everyone has to dance! Many deities have invisibly gathered for today's initiation festival. They have tethered their invisible horses and make merry here, among the youths. If the latter were to dance poorly the deities would be bored and return home mirthless, which is bad. 'Don't you see? - Shaman Varnak Turlakov told me - All three are dancing there. Look! Don't you see? No, you can't!' - he spoke with such conviction that I could have no doubt that he saw something."

The little dancing men of Siberian petroglyphs were not always performing ritual dances. For example, those on the rocks of the Tuba river (tributary of the Yenisei) were participants in hunting scenes, and those at Bratskaya Kada, Sagan Zaba or Upper Bureti are solely shaman pictures. But the characteristic poses of the characters - their torsos turned full-face and legs half-face, with bent legs - led to these figures being named "S-shape". The ancient artists strove to convey male force, the inner elastic dynamic of the male image.

The nakedness, proportions, subtlety, and potential force of youthful energy concealed in the dancing-men figures of the Siberian Bronze Age are also characteristic of northeast Uzbekistan's Mesolithic images (the Sarmysh Sai row of three female figures), those of Kobystan' of the same epoch, and some Near Eastern sanctuary paintings, for example, those of Northern Anatolia of the seventh-sixth centuries BC. Moreover, at Çatal-Hüyük, naked dynamic male figures are depicted with the same mushroom-like head-dresses as those of Siberia and Central Asia. If one looks carefully, the threads connecting Siberia, the Baikal region, Sayan–Altai, Mongolia, Kazakhstan and Central Asia's Bronze Age petroglyphic images of dancing figures with analogous Near Eastern and even Ancient Egyptian

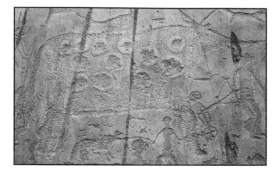

*Figure 15.5 Kalbak-Tash, central panel,
sacred animals.*

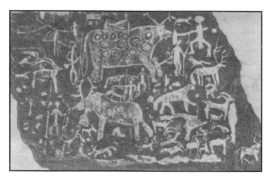

*Figure 15.6 Kalbak-Tash, central panel,
sacred animals.*

Eneolithic images are much more numerous than they seem at first glance.

Besides their pose, the male figures of the Kalbak-Tash frieze have some other peculiar inherent details that can be called semantic indicators. Among these are paraphernalia, costume details that reveal who is depicted on the rock. These features, insignificant at first sight, can confirm or disprove assumptions based on the style or subject of the pictures. These very features, when compared to the material culture items unearthed during archeological digs, can provide us with the keys to the chronological classification of petroglyphs. A striking example of this is the Valcamonica petroglyphs containing pictures of bronze daggers, which are exact copies of excavated ones.

Among the paraphernalia with which the men on the Kalbak-Tash frieze are equipped are staffs, depicted by straight vertical lines, which stand out, as well as oval pouches at their waists. Among the intriguing details are the moon-like, or mushroom-like, headdresses and breastplates.

Breastplates The central, biggest figure is depicted with a rectangular outline on his chest. Apparently this breastplate is part of the male costume peculiar to the Andronov and Karasuk peoples of the Altai Mountains. It was made of leather and decorated with metallic plates. Breastplates like this became an essential part of the clothing ensemble of the Siberian taiga and steppe peoples. In Scythian times a cattle-breeder's costume consisted of a fur coat like the one found at the Katandinsk barrow archeological excavation in Altai - a long, buttonless garment with a breast-plate in the form of an apron that covered the chest and stomach. Archeologist S. V. Rudenko suggested that the Scythian-period breastplate and a fur coat that survived beneath the barrow were copied from Achaemenid Iranian clothing.

At the same time the breastplates and buttonless fur coats were the most ancient clothes of the Stone Age taiga hunters. Fur breastplates, with elegant embroidery and fur application, were worn by the Tungus of the Baikal region.

The essential decor of the breastplate was metallic staple-like plates. They symbolized the teeth of totemic animals - Siberian deer, wild boars, wolves and bears - and denoted the object of worship. A breastplate decorated like this counted as an amulet to drive away misfortune, just like a necklace of animal teeth. Each of the above-mentioned animals was connected with

the light (Siberian deer, wild boars) or dark (wolves, bears) spheres of the mythical universe. These animals conveyed the idea of the continuous round of natural events, and expressed the ancient artists' views on life and death (Figures 15.5-15.6).

Headdresses

The hundreds of dancing figures in the petroglyphs of the Siberian Bronze Age show three different types of headdress: horned, mushroom- or moon-like, and radial. Examples with one, two or three horns exist in the taiga petroglyphs; mushroom-like ones occur in the steppe petroglyphs from Mongolia to the Caucasus and the Mediterranean. In South Siberia and Central Asia, mushroom-like headdresses could have had real prototypes in everyday hats such as malakhai. It has been suggested that dancing men in headdresses resembling hallucinogenic mushrooms are depictions of spirits. As shown in Indo-European mythological tradition, such mushrooms were used to prepare ritual narcotic drinks that brought shamans into a trance state. Images found on the cold, stern rocks of Pegtymel (Chukchi peninsula) were thought by archeologist N. N. Dikov to depict female shamanic spirits - "fly-agars" - coming to shamans and leading them to the other world, but we believe that they merely represent Chukchi women with their hair tied in a typical bun at the back of the head.

The form of the headdresses on the dancing figures of the Sayan-Altai, Mongolia, Kazakhstan and Kirghizia Bronze Age also resembles one of the astral symbols: the moon on the wane, or crescent. We can surmise that lunar deities participated no less actively than solar ones in the scenes connected with fertility, nature's death and the revival cult. We have already mentioned the presence of solar anthropomorphic characters in the compositions of Sayan-Altai, Kazakhstan and Mongolian Bronze Age petroglyphic art. But lunar characters have so far not been found. Perhaps they are concealed within the mushroom- or moon-like headdresses of the dancers - performers of magic round-dances. It is no accident that Great Archers - archers, warriors, heroes - have precisely such hair dresses, which emphasize their hostility towards deities of the light. It should be recalled that the archer Koguldey had a similar headdress, as did the Altai epic hero Djel-begen - a malicious cannibal-crescent. In his mushroom-like headdress, he hunts people or chases an innocent orphan, who is saved from certain death only by the intervention of a solar deity.

There are few images of people with radial headdresses in the petroglyphic art of the Altai Mountains. The most outstanding are: a man in the top central frieze of Kalbak-Tash, under a bull figure, with a chariot in his right hand and a wand in the left; and shamanic pictures on the Oroktoi rock at the Katun River. They are especially interesting because they have astonishingly ancient prototypes in local South Siberia, which deserve a particular mention. The first group of these prototypes are the numerous and well-studied Okunev stelae from the Minusinsk Basin with pictures of people in radial headdresses. They have elegant figures, depicted in dynamic poses. Bulls and horses surround them. Who are they? Most probably these are magi, ritualists, shamans, performers of mysterious ancient fertility rites related to cults, the intermediaries between the world of the living and the ancestor-spirits. Analogous radial headdresses adorn the heads of ancient anthropomorphic masked stone statues in the Yenisei region.

The second group of prototypes was found in the early 1980s in the Karakola valley in the village of the same name, almost on the Chuyskiy

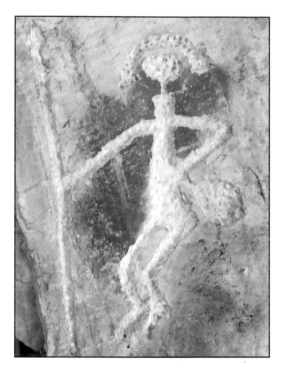

Figure 15.7 Kalbak-Tash, warrior.

Highway. During construction of a school building, the workers came upon ancient sarcophagi slabs - stone boxes in which Bronze Age people buried their dead. When archeologists removed the upper slabs, they saw rows of human figures drawn with red, white and black paint on the inner walls of the sarcophagus. The heads of those drawn with white and black paint were crowned with multiradiate headdresses resembling the feather headdresses of prairie Indians. On the faces of the figures painted in red and black there were masks resembling the mask-disguises of the Tuva petroglyphs, found on stones near the renowned Chinginskaya crater: one can see the same vertical and horizontal dividing lines, round dispassionate eye sockets, and straight crossbar lines conveying nose and mouth. Incised pictures of humans and animals

served as the background for colorful pictures. But who did these incised figures resemble? They were almost identical to the magi from the Okunev stelae of the Yenisei River, and the animals were similar to the bulls of the Afanasiev period in the same region. They were done with the same accurate and thorough technique of stone carving followed by the polishing and smoothing down of the cut-out images.

The sarcophagus slabs were re-used: first, they stood in the steppes of the Karakola valley as stelae, perhaps in special sanctuaries. Then they were dug out, carried to where the barrow was being constructed, and put into the grave. The barrow-builders took little interest in pictures on the stelae slabs, so they placed them horizontally although the pictorial composition extended vertically. They painted a long horizontal red stripe over the carved pictures first, and then placed a row of colorful human images on top. As in Egyptian tombs, the guardian spirits of the Karakola sarcophagi in radial head-dresses are facing the deceased. They are framed to accompany him in the afterlife and share the burden of his difficult journey to the other world. These spirits are similar to the colorful figure of a female anthropomorphic guardian spirit, depicted on the side of a Bronze Age sarcophagus found near Ozernoe village, on the Tengin lake shore. The Tengin slab with Egyptian bulls and horizontal dividing lines, the colorful guardian spirit figures of the Altai and Yenisei petroglyphs in radial, perhaps feathered, headdresses - these constitute the range of monuments dated by to this same period: the late third and early second millennia BC. At this time the flourishing of an Indo¬European type culture is characteristic of South Siberia and the Altai, and these regions had strong connections with South Eurasian civilizations including Egypt, perhaps to an even greater extent than we realize (Figure 15.7).

Oval items

Oval items, attached to the waists of dancing figures in the petroglyphs of the Altai Mountains, are mostly interpreted as images of hunting pouches - an essential part of hunting equipment.

If we assume that the men depicted in the central frieze of Kalbak-Tash are facing us, the viewers, then the oval shapes would be under their left arm, just where the dagger - an important attribute of a man, hunter and warrior, and a symbol of formidable male power - must be located. The bronze dagger was so important and indispensable in everyday life that people departing to the other world were equipped with miniature copies of these daggers, which are known from the archaeological excavations of Southern Siberia's Andron burials (second millennium BC). The daggers were carried in special, usually wooden, sheaths. These sheaths were unearthed during the excavation of Scythian period burials in the Altai Mountains. They were painted bright red and had an elongated shape. This may explain the oval shape of the items depicted at the waists of the anthropomorphic dancing figures of Kalbak-Tash and on their analogues from Central Asia and South Siberia.

When studying the petroglyphic pictures on rocks in the Elangash river valley, we examined dozens of these oval items, attached to the waists of the dancers or hunters. Comparing their forms and measurements with those of the same oval items found on the other monuments of Siberia and surrounding regions, it is easy to notice that they nevertheless differ from each other. The absolutely round ones with long straight handles, like the one at the waist of the man in a moon-like headdress, drawn near the bull in the central part of the frieze of Kalbak-Tash, stand out among them. There are oval items in the shape of a long rod with a tear-shaped extension on the end, with radial rays emerging

from it - a kind of mace. An oval item of this kind was depicted by an artist at the waist of one of the fighting archers of the Elangash valley.

An oval item on a long handle is of particular interest because it is does not resemble a hunter's pouch at all, but rather an image of a metallic mirror in a special leather bag that was attached to the belt with a rope. Beliefs related to mirrors, including bronze ones, are so diverse that they deserve special study. Suffice it to mention that a mirror was considered to be a double, reflecting the second, essential nature of a man, highlighting his soul, by the people of Bronze Age Southern Eurasia, the Caucasus, the Near East (even earlier, IVth millennium BC), Middle and Central Asia and China. It was also part of the important priestly equipment. Shamans and priests used mirrors for divination. Fortune-telling by means of mirrors was usually taken as a relationship with the other world and cosmic forces; moreover, the round form of a metallic mirror was associated with the sun because the mirror was able to reflect light, to shine like the sun.

Staffs

The leftmost participant in the procession/round dance in the central frieze of Kalbak-Tash is holding a short straight rod or staff in his outstretched hand, while the other five lack this attribute. If one looks closely at the rock, a figure of man in a multiradiate headdress, a true solar deity, can be seen under the large bull figure with twelve rings or circles on its body. In one hand this man holds a small unharnessed chariot, and in the other a long straight staff like a goad. Staffs with which other people are equipped - for example, a man in a mushroom-like headdress from a small tablet at the rock base, depicted in the typical pose of dancing people - have a pointed end like a spearhead, and a pear-shaped extension on the shaft.

The staff as a male attribute was associated with the male role in reproduction. Vertical lines, particularly the groups of geometric subjects in Western European petroglyphic art, are an essential motif of Stone Age petroglyphs, traditionally interpreted as phalluses in the belief system of productive hunting magic. They were in opposition to triangles, the female origin symbol. Later they became increasingly associated with astral-solar symbolism. There is a wide range of meanings concealed behind this attribute - so simple in form, but deep in meaning - of the male anthropomorphic images of the monuments of the Altai, Central Asia and surrounding regions. The stick, staff or wand is also an attribute of a chariot rider, warrior, priest, king, hunter or shaman. The presence of a staff, and its configuration, gave importance to the characters, and defined their function, social status and occupation. The dancing humans of the frieze on the central panel at Kalbak-Tash can be considered to be the performers of ritual round dances related to a fertility cult. They are dressed in outfits that symbolize their solar-lunar nature. But the male origin, an energetic, militant, heroic essence, can be seen in them as well. They are archer-warriors like Koguldey; they are close to the war deity of the Indo-European tradition, like Mars, the Roman god of war, whose image is related to the element of thunder and to the revival of nature. It should be remembered that Mars was also a patron of people settling in a new place, and developing new lands. And this is important because the dancing men appeared on Southern Siberian rocks as a result of cultural influences from the south.

The composition at the top of Kalbak-Tash rock differs sharply from the zoomorphic cycle of previous epochs, and the artists chose a separate place for it. The large male figures of the central part are surrounded by multiple zoomorphic images, among which the most striking, and unusual in terms of previous Neolithic petroglyphs, are a bull and a panther. The bull, panther, and dancing man in a mushroom-like headdress - this is the main triad of subjects in the Bronze Age petroglyphs of Southern Eurasia. The fourth subject, inevitably added to the first three, was a chariot (Okladnikova 1990).

In the late 1990s the ideas of A. Marshack, E. E. Fradkin and B. A. Frolov underwent a new development. The case in point was France's prehistoric art, particularly the Lascaux (Dordogne) cave paintings. In the course of research by Chantal Gege-Vakivi who examined the orientation of prehistoric images towards sunrise and sunset, it was found that:

> The ancient artists chose a workplace opposite the cave's entrance, so that they were able to draw what they saw in the opening: the Sun illuminating the grotto by day, the stars during evenings and nights.

> An animal on the cave wall is nothing else than the Capricorn constellation, created in prehistoric times in the form of a pictograph, and it means that this constellation could be visible through the cave entrance at that time. The mighty bull, its chest spattered with dots, drawn a bit farther away on the wall, corresponds to the modern Scorpio constellation, crossed with the Milky Way. The other zoomorphic figures mark the Taurus constellation, and the Heiades and Pleiades constellations.

Be that as it may, the hypothesis that paleolithic people needed the stars to count time and foresee seasonal changes is very real. In the 1970s, Alexander Marshack, through his research on items from paleolithic life with images on them, had proposed that they depicted the lunar cycle (Ostiakova and Orlov 2002).

This line of investigation, begun in the 1970s through the work of Americans (A. Marshack and others) and Russians (A. P. Chernysh, A. P. Okladnikov, B. A. Frolov, E. E. Fradkin and others) was building on the ideas of French archeologists (H. Breuil, A. Leroi-Gourhan and others). This work has been continued in Russia on paleolithic material (V. E. Larichev and others) and petro-glyphic art (Y. A. Sher, E. A. Okladnikova, V. D. Kubarev, L. N. Marsadolov and others). The chase after thoughts lost thirty millennia ago is far from its end, and looks very promising.

About the authors

Elena Okladnikova, Museum of Anthropology and Ethnology, 3 University Embankment, 193034 St. Petersburg, Russia; E-mail: okladnikova@pisem.net; or pasternak@ cycla.ioffe.rssi.ru; or lena.Okladnikova@kunstkamera.ru.

Daniil Frolov, Research Fellow, I. P. Pavlov Physiology Institute RAS, Post-Graduate student of St. Petersburg State University Chair of General Physiology.

References

Author's archive

1977 St. Petersburg.

Breuil, H., and R. Lantier

1959 *Les Hommes de la Pierre ancienne.* Leroi-Gourhan, A. 1964/5. Le Geste et la Parole. Paris.

Chernish, A. P.

1976 O vremeni visniknovenia palcoloticheskogo iskusstva v svaizi s issledovania-mi goda. Stoianka Moldova-1. U Istokov tvorchestva. Red. R. V. Vasilievski, Nauka 1978, Novosibirsk.

Fradkin, E. E.

1961 Polieconicheskay skulptura iz verchnepalciliticheskol stoyanki Kostionki-1. Sovetskaia etnografia, N 1.

1969 Osobii vid iskustva pervobitnogo cheliveka. *Vestnik drevney istorii* ANSSSR. N 10.

Frolov, B. A.

1973 Pervie issledovateli sibiorskogo paleolita. *Voprosi istorii.* Moskva N 51.

1981 *Chisla v grephike paleolita.* Novosibirsk, Nauka.

2002 Dar znania I motivazia tvorchestv. Shananskii dar. M., Nauka.

Levitin, K.

1979 *Iskopaemie conseptii.* Znanie-Sila.

Marshack, A.

1972 *The Roots of Civilization: The cognitive beginnings of man's first art, symbol and notations.* New York.

1972 Cognitive aspects of Upper Paleolithic notation and symbol. *Current Anthropology* 13:455-77

Okladnikov, A. P.

1967 Utro iskusstva. L.: Isskustvo.

Okladnikova, E. A.

1990 *Tropou Koguldea.* L: Lenisdat, pp. 93-107.

Ostiakova, G. and V. Orlov

2002 *Lascaux.* NLO.M. N

Zamiatnin, S. N.

1973 Peshernie navesi Mgivemi bliz Chiaruri (Gruisia). *Sovietskaia archeologia* Vol. 3.

16

PALEOLITHIC MOSAICS

Marcel Otte

Morphemes

The profound depths of caves sometimes contain strange plastic messages, expressed for tens of thousands of years, whose arrangements reveal imprecise but logical articulations. In reality, this concerns a dialogue between rock and thought, through which wild nature seems to be itself articulated by the contact of lines added to the rocky relief. The spirit of the Paleolithic message is here: natural and mute, it forms a group of signs disposed in harmony with the surroundings in which they are presented.

Formal categories respond to several codifying registers, including the "morphemes" of drawings, outlines, colors and textures. In the absence of accessible meanings, at minimum the rhythms of these schemes are immediately felt: they evidence the presence of a clearly mastered "semiotic." Faced with such schemes, the operation of our spirit is based first on the reference between these outlines and our own memorized record: certain animal figures are easily identified, while other schemes, progressively more abstract, show that it is the meaning and not the form that guided Paleolithic artists (Figure 16.1).

These simple units are found organized according to different repeating schemes, in symmetry or superimposed. Linearity, proper to writing, is irrelevant: the design primarily exploits the available surface according to laws of association. Each theme is integrated with the others, using all of the spatial dimensions that unite them (Figure 16.2).

Figure 16.1 *What would someone from the Paleolithic think in front of our warning signs, without being aware of cars, houses, children's ball games and the risks associated with recklessness, proximity of the road (curved line) and the assumed speed of the car? We react similarly to the same strangeness faced with a bison raised on his hind legs, associated with mysterious signs and rectilinear outlines evoking small human figures. The intensity of the code, like the diversity of the status of the images (figurative, schematic, abstract) attest to the same flexibility in thought and richness of content. (Niaux, Ariège, drawing after photo by L. Remacle; road sign in Liège.)*

Figure 16.2 A subtle "signature" associates two signs: the minimum of a dorsal line designating a horse, for which the contingent significance is immediately integrated in the message, while a barbed line creates the connotation between the two terms, analogous to the hint of a syntax. (Niaux, Clastres network, Ariège: drawing after photo: L. Remacle.)

Figure 16.3 The descriptive value of certain animals is quite clear when they are reduced to the minimum necessary for their identification (horns, antlers, chest). The message is already "complete", intelligible, no longer a copy of the entire animal, but a word, bent by the imperatives of a spiritual expression. The intimacy of the rocky supports is manifested by the clear association of a ridge at the start of an alcove, in front of the nose of the ibex: the image is thus placed in a situation on the neutral base of the cave, as if it did not have an isolated existence. The series of black dots emphasizes the rocky contour, to confirm the relationship between the place and the game, together constituting the value of the sign. (Travers de Janoye, Tarn; drawing after photo: L. Remacle.)

Natural relief, textures of the rock and the colors selected for the features make up the plastic components on which these messages were constructed. But this game "in mosaic" is more specifically a carrier of an instructive mythic discourse that preceded the execution of the art. The animal or the sign constitute substitutes for sacred abstractions by which savage thought is expressed and materialized (Figure 16.2). One of the strongest forms of evidence unique to Paleolithic art resides in the total absence of randomness, fantasy or games of chance. Formal, stylistic and geometric regularities endow the seriousness of the action with mystical significance. At the same time, the image captures a part of nature, and then adapts it by metamorphoses imposed by a spiritual codification. Parietal art never refers directly to real life, but always to a profoundly cultural world, imbued with mythical thought.

Seduction is not foreign to the plastic supports of these mysteries. We find ourselves faced with various superimposed "codes" (form, meaning and emotion), without being able to disentangle the interweaving (Figure 16.3). It is thus that over the millennia, and following a development inaccessible even to the artists themselves, the notion of "beauty" is inflected. "Bodies of rules" for distortion succeed one another, imposing particular styles on each contour. The message thus combines inflections, like signatures of a time or a style that, for us, reveal a history of aesthetic tastes which were each rigorously respected in their own frameworks.

The spiritual coherence that emerges is composed of infinite variations that were apparently

Figure 16.4 This bust of a red deer is found "embellished" by the impact of the style to which it conforms: large neck, straight and elongated head, antlers multiplied and fingered at the extremes. There is no doubt that nature cedes in front of the convention that imposes its own vision of the world, and chooses the elements worthy of its vocabulary and eliminates the "superfluous" from its own language. Our regard captures, in the same association, the icon of a deer and two graphic signs, constituting a single phrase (dots and rectangle). Repeated several times, these figures have a coded meaning, external to all formal similarities. Their repeated presence and systematic structuring demonstrate that the Paleolithic narration is based on a coded meaning, in which animal representations no longer refer to reality, comparable to our games of cards. Everything here is a game of symbols and metaphors, just as human redemption is contained in the innocuous images of the Stations of the Cross. (Lascaux, Dordogne; drawing after photo: L. Remacle.)

Figure 16.5 Example of associated signs: contour of an ibex and "open-grid" schema. The spirit of the ibex adapts willingly to such combinations, as if to offer a trap to attempts by the non initiated to a first degree reading: if we recognize the animal, the setting immediately indicates that the meaning of the message does not refer to the reality of the subject, taken here as a symbol and not as a direct reflection of nature. The ibex is no longer figurative, and the opacity of the meaning remains total. Only the finesse of the articulations lifts the veil on the elaboration of the mythic thought by comparison of one work to another. (Lascaux, Dordogne; drawing after photo: L. Remacle.)

guided by the topography and use of different places. A broad range suggests a highly subtle system of thought and a variety of functions, brought together by these illustrations. It is as if a mystical veil, vast and supple, could have attached itself to the rocky contours wherever it found a formal resonance and a plastic harmony. This extraordinary semantic richness thus melds with a great flexibility of adaptation, both apparently placed in the service of a fine delicateness in the expressive sensibility.

The dominant impression is that of an effervescence of mysticism founded on the mastery of natural forces, creating encoded scenarios that are displayed materially, by the image, as if to assure their effectiveness.

Figure 16.6 The elaboration of a sort of "symphony" of signs can be today decoded according to the order of their superimposition. This language begins by the disposition of this rock face on a bay in a vast chamber, massive and inevitable, like the stage of a theatre, and cut naturally like the contour of a horse, turned to the right; the paintings are also natural. The impact of the code is immediately clear: the two monumental figures are inversed and bent according to the rules of the style (large bellies and reduced heads) (I). Everything is fantastic, foreign to the world outside the cave. Hands are superimposed (II), like a human anatomical trace of a photographic reality, the sign of presence and control over the place, images and their power. Dots were then added (III), giving consistency to the outlines by giving them texture, but they also establish a common network uniting rock, signs and horses. It is the same message for which the meaning would be revived once again by the red signs of the final phase (IV). (Pech Merle, Lot; after M. Lorblanchet.)

Paleolithic mosaics form the echo of this battle between natural chaos and the order which the spirit wishes to impose upon it (Figure 16.4). Yet, structuring this chaos passes by a process of symbolization that establishes an "operational distance" by which human will constructs its self-expression: more than the reflections of a system of thought, these structured images help to conceptualize the world. They are themselves practical and effective; they evidence the hazards of conquest, by their own variability, much as repeated attempts over the millennia.

Construction

With the establishment of virtual units, the eye captures the relationships of spatial associations, developed according to different schemas that one can then extract and consider separately, by way of logical structure: it is a means by which the spirit seizes the world in order to understand it. But for us, it serves rather as a key that is able to reveal Paleolithic thought.

Schemas of double meaning are common in the language of forms. Constructed in inverse symmetric opposition, analogous to "butterfly wings", such figures can be neither random nor confused with a real representation, not least because they concern different species whose plastic conjunction can only be symbolic.

Moreover, such compositions can be "translated" when the opposed animals "slide", one behind the other, on two parallel planes of the supporting panel, or when the graphic construction is reduced to a head to tail, as on medieval crests (Figure 16.6).

Figure 16.7 *The compression of signs in a global message functions equally through time as it has the force of law comparable today to the "rules of the road", in our most mundane daily life, the most directly accessible and the most explicit. The meaning of the sign would be absurd if not for its topographic placement: consider, for example, the stacking of old road signs in a warehouse! Such signs combine evocative signs (directions of arrows), conventional signs (warning triangle, the color red) and iconic signs (It is the "cow" to which we must pay attention here, not deer.) Similarly, arrows, geometric signs and referential animal outlines reproduce the structure of the Paleolithic message (although its meaning was probably more elaborate). The topographic position of the panel places a role in its formulation, as do signs at intersections and rotaries. (Cave of the Tête du Lion at Bidon, Ardèche, after J. Combier; road signs in the province of Liège.)*

Figure 16.8 *The contours of a horse and bison are engraved on the rocky support, at the viewer's eye-level, following the curve of the straight gallery where the signs are succeeded and complemented in the meaning given by the regard of the two animals, which in this way impose on us our own physical approach. With the same view, our spirit acquires and blends the opposing proportions of the two figures identified, their relationship to the rocky texture and their association with a geometric sign, often found in these contexts. The long rectilinear line, feathered at the extremities, is imbued with a meaning that we consider to be masculine in comparison with other, more explicit, examples. The Paleolithic plastic discourse presents a rigorous construction, as if it would reflect the seriousness of an act of mythic power. (Le Gabillou, Dordogne, after J. Gaussen.)*

Triangular structures were built on this fundamental duality, where a third sign is introduced to close the intermediate space. Added to opposing colors, their respective proportions complete the discourse (Figure 16.7).

Modes of association are also based on a central empty space around which different signs are placed. This "absence" creates a link between complementary figures (*e.g.*, at Santimamiñe cave). This aspect seems even more crucial as certain animals positioned on their hind legs encircle the space, taking the human form as a supplementary mark of nature placed in the service of the spirit.

Nevertheless, integrated figures are sometimes juxtaposed at different scales, in such a manner that they are not contrasted and maintain a plastic link, transmitted by the gesture and guided by the meaning (Figure 16.8).

Such realities are most often combined, from the image to schemas; they are elaborated and extended in triangular structures (Figure 16.7) or,

Figure 16.9 *Nature sometimes serves as an absolute reference for an image while it loses its sacredness: it evidences an idea largely dependent on the mind. These "mosaics" were thus created with natural and wild elements, entirely removed from their original context, deformed by the ruling and articulated thought for a message that imposes its rule on the world order. Like the lamb of the Redemption, animal images were filled with a symbolic meaning, produced and used by their own context. Lucidity and intelligence take the form of an owl with penetrating eyes. Greek thought gives to this capability the power of the goddess Athena, but she was, in fact, the reflection of a challenging will by the human spirit to forge his destiny despite natural laws. Later, this audacity was recovered by Christian theology that gave responsibility for one's destiny to each individual. The humble bird, perched on its branch, remains ignorant of our torments and only the conventional value that we confer to it gives it the authority, like a Paleolithic animal, to enter into the discourse enveloped in the meanings, forms and values. Once these change, after spiritual experiences, their active supports are modified by us: from the Paleolithic aurochs to the redeeming lamb. (Athena, symbolized by the owl; painting on a Greek vase.)*

Figure 16.10 *Open signs, bell-shaped or oval, evoke femininity on this well-exposed surface of a rocky panel. The formal opposition, with a central barbed line, is complemented by the chromatic duality of red and black. While the assimilation of the two genres can be followed, the message clearly evokes the graffiti filled with hope scribbled in our streets or carved in trees today. This fundamental complementarity, like yin and yang, seems to deeply affect the spirit of prehistoric representations, at different levels of abstraction and symbolism permitted by the graphic formulas for identifiable outlines in the simplest schemas. (Monte Castillo, Cantabria, drawing after photo: L. Remacle; graffiti in the streets of Liège.)*

Figure 16.11 At the end of the prehistoric period, conventional tendencies focus on the use of natural images. Filled with coded meanings, the signs are split up to be reduced to points, line and traits. Contemporaneous with human mastery of food production (perhaps even earlier), humans eliminate natural and wild elements: the spirit invests all forms of communication reduced to finely elaborated situations. (Remouchamps, bone blade, Final Paleolithic; after M. Dewez.)

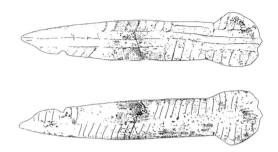

more profoundly still, by integrating details of the rock support as elements of the discourse. Alcoves, fissures, calcitic lines, among others, invite a dialogue with the signs (Figure 16.2).

If not the reality itself of these constructions, the grouping of images, clear and articulate, has a great variability and evidences the richness of the messages; they are also supple and fluid, defying attempts at decoding the meaning.

In fact, one often passes from a representative mode (lines of animals) to a hermetic code where one finds groups of split schemas and animal elements at the limits of perception (antlers, horns, the forepart of horse heads, dorsal contour of mammoths). A simple graphic allusion seems to have sufficed both to define the species and to invest the sign with its equivalent symbolic value Figure 16.9)

Details

The uniqueness of such formal manoeuvres resides in the coherence of the network finally constituted with the aid of numerous details resulting from distinct categories. This apparent heterogeneity thus affects only the families of signals, joining their distinct repertoires in the selection of an unknown formula.

At each step, this contradiction disorients: the animal register rejoins the inventory of memorized forms, but their symbolic use escapes our understanding. Natural forms are grouped following entirely cultural rules for which a new meaning emerges precisely from this unknown formula.

When one considers abstract signs, the disorientation becomes more striking, because their form cannot be associated with known forms in the real world. It is a sort of insult to thinking, because nothing can directly substantiate the original iconic relationship, apart from courageous attempts to give them a value in the masculine/feminine dichotomy.

As for the "neutral" basis of the cave, one confronts a veritable impasse because nothing appears more natural than these contours, and the profound intimacy of their participation leaps to the eye (Figure 16.5).

The deconstruction of Paleolithic art is thus accomplished by the recording of formal catalogues, autonomous and deprived of meaning. By contrast, such elements judiciously assembled (stone included) create a complex weaving of a new and coherent message, like the most beautiful phrases of our language.

The power of the Paleolithic message can be decoded at different levels for which certain components are formal: the nature of the rock, the qualities of the lines, the stylistic transformation undergone by the natural referent, the spatial organization, catching of the light, the dominant colors and opposing categories (icons or

abstractions). The range of possibilities is, in theory, large, but limited in implementation, and thus significant. The diversity of groupings is infinite, but is even more limited in the options selected. Evidence of codes is imposed and, even more so, of harmony and complementarity. It is as if, by these groups, a significant threshold was crossed, that a crystallization of disparate elements occurred to accede to a supplementary global level. This ambiguous impression is present throughout all Quaternary art, based, like sweet-and-sour sauce, on familiar ingredients (animals) for which the association itself dissipates the particular meaning to retain only the force resulting from the interrelations (Dellenbach 2001:76-79).

Symbolism

Such a call to homogeneity once again troubles the spirit as soon as one attains this integrated vision because the gravity of the message is immediately imposed: no anecdote requires such care in the elaboration of the formal code, less still of such balance between such disparate abstract elements.

The first issue is based on emotion: the harmony of the textures and the contours is mixed with the mysteries of place, strangeness, unfamiliarity, and the hostility of damp, cold and dark depths. The mixture of sentiments disrupts the aesthetic sense well before a logical structure is imposed after analysis! The intuition itself of a value of intelligence, of structuring, participates in the emotional jubilation, because this "mosaic" resonates with creative thinking, as if it directly emanated from the walls themselves.

The first global impression thus evokes the fascination of the original founding spirit, powerful, in which our own system of thought finds its source. A fall in the abyss toward this primitiveness prolongs that suffered physically during the

progression into the profound, rocky galleries. Roots of the soul and light of the spirit rise from the combined harmonies of place and signs. This impression is also reinforced by the existence of acoustic sound boxes in certain painted caves: traces of percussion on calcite sheets regularly attest to this. A physiological dimension is added to the formal messages of the place, where musicality complemented the harmony and opened the way to another semiotic infinity.

All of these "deliberate concurrences" are articulated in addition by the physical walking from one gallery to another. Panels accessible by a single view are integrated into our thinking as a global unit, but the memory captures them long enough for the impression formed to combine each panel with those successively discovered. Another level of harmony and globality is thus imposed, that of sanctuary whose sacred function requires a macro-spatial delimitation, extending - at least - throughout a gallery, or even an entire cave, and constituting a microcosm of the mythic world. The orchestration is then total, because it implies a physical progression regulated by the viewing of enlightening panels at each step.

The histrionic use of space in caves was aimed at the required participation of the spectator himself (including us) to put the scenes in motion: to the revitalization of the myth and the reproduction of the ritual.

Time, space and movements are found through the millennia to condition our progressive meeting with codified space. Such imagery and deployment of the means available assure the symbolic actions used; all of these messages are based on a double game, between appearance and meaning. Such evidence shows through the refinement accorded to formal edifications. The opacity of the reading, slowly laid down through time, tends to confine us to the role played by these symbols in a forgotten world.

About the author

Marcel Otte, Université de Liège, Préhistoire, Place du XX Août 7, B,t A1, 4000 Liège, Belgium; E-mail: Marcel.Otte@ulg.ac.be.

References

Dellenbach, L.

2001 *Mosaïques, Un objet esthétique à rebondissements*. Seuil, Paris.

Edeline, F., J.-M Klinkenberg, and P. Minguet

1992 *Traité du signe visuel*. Seuil, Paris.

Leroi-Gourhan, A.

1971 *Préhistoire de l'Art occidental*. Mazenod, Paris.

Lorblanchet, M.

1999 *La naissance de l'Art*. Errance, Paris.

Otte, M.

1997 Constitution d'une grammaire plastique préhistorique. *L'Anthropologie* 101(1):5-23.

Raphael, M.

1986 *L'art pariétal paléolithique*. Kronos, Limoges.

Sauvet, G., and A. Wlodarczyk

1977 Essai de sémiologie préhistorique. *Bulletin de la Société Préhistorique Française* 74:545-558.

THE CHAUVET CONUNDRUM: ARE CLAIMS FOR THE 'BIRTHPLACE OF ART' PREMATURE?

Paul Pettitt, Paul Bahn, and Christian Züchner

Introduction

The spectacular Upper Paleolithic art of the Grotte Chauvet (Ardèche, France) includes over 420 images in two broad series, black and red. Given the sophistication of the techniques and artistic skill displayed in many of the cave's images, it plays an important role in our understanding of the origins of art, Upper Paleolithic behavior, and wider issues such as the emergence of 'modern' cognition. On the basis of a few radiocarbon dates directly on black (charcoal) images and a number of dates on charcoal from the cave floor, the Chauvet team ascribe the art to the European Early and Mid Upper Paleolithic, specifically the Aurignacian and Gravettian. Such an early date (*ca.* 32–26 kyr BP) is remarkable given that the style of the art, techniques of surface preparation, execution, perspective and the subjects depicted are found elsewhere only from the Solutrean and Magdalenian, i.e., half the suggested age of Chauvet. Previously, we have raised the possibility that the Chauvet art is much later than the team suggest, on the basis of style and content (Züchner), and we have questioned the robustness of the direct dating program (Pettitt and Bahn). As the team have yet to respond satisfactorily to the issues we raised, we repeat and develop our themes here. In addition, we raise objections to the Chauvet team's archaeological reasoning. We divide our comments and concerns into the areas of style and the paradox of "Chauvet evolution"; tautologies and anachronisms in the Chauvet team's case; the dating

program; available access to the cave in Antiquity; the archaeology of Chauvet cave and the surrounding region; analogies of the Chauvet art with Aurignacian art; and technical problems with the dating program. We put forward what we hope is a falsifiable hypothesis, i.e., that most of the art is of Solutreo-Magdalenian age, half that of what the Chauvet team suggest.

We are happy to dedicate this paper to Alex Marshack, a man who was constantly questioning the orthodox view of the Paleolithic. Like ourselves, he was profoundly troubled by the inherent contradictions in the data emerging from Chauvet cave, and one of us (PB) had numerous discussions with him about this problem.

Background

In 1994, France's Grotte Chauvet yielded some of the most spectacular examples of Upper Paleolithic cave paintings as yet known. Today, over 420 depictions have been identified in several chambers of the cave, among which 14 faunal taxa can be identified and of which carnivores – particularly lions – represent over 50%. The complexity of techniques used to create the stunning images is surprising, and includes preparation of the cave surfaces by scraping, use of topographic features to bring out dynamism, complex 'stump' shading and attention to detail, group composition and perspective. In the decade subsequent to the discovery several popular books have appeared on the cave (*e.g.*, Chauvet *et al.* 1996; Clottes 2001, 2003a), in addition to a collection

of short scientific papers (see especially *Bulletin de la Société Préhistorique Française* 102, 2005), with a proliferation of secondary publications that tend to stress the technical sophistication of the art and its importance for our understanding of the behavior and cognition of early members of *Homo sapiens* in Europe. The titles of the popular monographs clearly indicate the Chauvet team's belief that the cave is, as yet, at least one of the oldest examples of art in Europe, *e.g., Chauvet Cave: the Discovery of the World's Oldest Paintings* (Chauvet *et al.* 1995), and especially *Chauvet Cave: Excavating the Birthplace of Art* (Clottes 2003a; our emphases).

While this impressive canon of art is obviously important in its own right, the importance of the perceived antiquity of the Chauvet art has played a significant role in its assimilation and interpretation by the archaeological community. Although it was initially attributed to the Late Upper Paleolithic (Solutrean and Magdalenian) (see Chauvet *et al.* 1995) the specialist team of researchers assigned to study the site soon came to the conclusion that much (or all) of the art was considerably older, *i.e.,* of European Gravettian and Aurignacian age. Since the first publications of this view appeared, the Aurignacian antiquity of the art has come to be accepted almost unquestioningly. But is it correct? Surprisingly, few other scholars have dared to query this (but see Alcolea and Balbín 2007). For example, one recent examination of doubts about Chauvet takes as its starting point that "both the AMS radiocarbon dates and the archaeological analyses of Chauvet confirm the Aurignacian antiquity of the paintings" (Moro and González 2007:112), in our opinion a somewhat over-confident statement that obscures the need for objective enquiry. Here, in the spirit of scientific debate, we recap and elaborate on concerns raised over the last decade which remain issues critical to Chauvet, and by

extension to our understanding of the cognition of Upper Paleolithic *Homo sapiens.*

In earlier papers we drew attention to arguments from style and content that at face value would indicate that the art is much younger than the Chauvet team have suggested (*e.g.,* Züchner 1995, 1996, 1999, 2001, 2003, 2007; Pettitt and Bahn 2003; Pettitt and Pike 2007). We also drew attention to the many uncertainties concerning the true age(s) of the Chauvet art, the relevance of the radiocarbon measurements to the actual age of the art, and used as a reference major problems which have affected the chronometric accuracy of the Upper Paleolithic art in Spain's Candamo Cave as a model of caution for Chauvet (Pettitt and Bahn 2003). We requested that samples of Chauvet Cave's art be subjected to age-verification by other laboratories, and indeed that those samples should be divided between laboratories where possible, and that ambiguities in the dating program be addressed and explained. We argued that these very simple recommendations would place the study of the cave on a firmer scientific footing. As yet our critiques have been largely ignored – Pettitt and Bahn 2003, for example, is specifically mentioned only once by the team (Bocherens *et al.* 2005:78) in the special issue of the *Bulletin de la Société Préhistorique Française* devoted to the cave, despite the existence of a paper in that journal concerning the cave's radiocarbon dating (Valladas *et al.* 2005). We believe that the main points we raised still stand. Here, we elaborate on our arguments over several areas: 1) Heterogeneity, homogeneity and the paradox of "Chauvet evolution"; 2) Style and content, tautologies and anachronisms in the Chauvet team's case; 3) the Chauvet team's dating program and response to our criticisms; 4) available access to the cave in Antiquity; 5) the archaeology of Chauvet cave and surrounding region;

6) analogies of the Chauvet art with Aurignacian art; 7) problems with the dating program.

Heterogeneity, homogeneity and the "Chauvet Evolution" paradox

In the first monograph (Chauvet *et al.* 1995) Jean Clottes proposed, on the grounds of stylistic comparison, that the paintings and engravings of the Grotte Chauvet were created mainly in the Solutrean period and more broadly over the period 17,000 to 21,000 BP. Subsequent to this, however, the radiocarbon dating of charcoal from the cave floor and from some of the black drawings, published in 1995, seemed to demonstrate that these animals were drawn about or over 10,000 years earlier, during the Aurignacian. Because of this, Grotte Chauvet is now considered nearly unanimously to be the oldest known painted cave in the world. Some 48 published radiocarbon dates have been interpreted to reflect two main periods of occupation or use of the cave, one in the Aurignacian and one in the Gravettian. As on stratigraphic grounds the 'directly dated' black paintings are seen to belong to the youngest artistic horizon of the cave, one has to conclude that all chronologically anterior pictures and engravings are also of Aurignacian (or older) context, and that the younger radiocarbon measurements testify only to the presence of some visitors during the Gravettian.

If the Grotte Chauvet is really a sanctuary of one single period, the Aurignacian, we would expect that its art should look stylistically and technically homogeneous to some degree. But in fact it does not. The cave is divided into two main parts. In the part near the ancient entrance red paintings dominate, while black figures dominate in the deeper part. Engravings are mainly situated in the middle section. The red drawings of animals, signs and dots are relatively homogeneous;

they are mostly linear drawings in absolute profile, and static, with no attempt at a third dimension and no feet (Alcolea and Balbín 2007:446). Without the radiocarbon dates, most scholars would agree that the handprints and certain signs are type-fossils of the Gravettian and Solutrean (cf. Gargas, Cosquer, Le Placard, El Castillo *etc.*). Unequivocal elements of the Aurignacian like circular 'vulvas' or animals comparable to the engravings of La Ferrassie, Abri Belcayre, etc, are totally absent. Only two engraved horses near the ancient entrance of the cave (Clottes 2001:fig. 143) can be compared with the famous ivory horse of Vogelherd (SW Germany: Aurignacian) and the rock engravings of La Croze à Gontran (Dordogne) and Pair-non-Pair (Charente), which are very old, *maybe* even Aurignacian (Delluc and Delluc 1991).

By contrast, the black series of drawings is remarkably heterogeneous. They show greater modeling, display movement, and show far more interest in anatomical details such as hoofs and in effects of perspective (Alcolea and Balbín 2007:446). There are also great differences in the style of rendering the animals, movement, anatomical details, perspective, and the species depicted, to name but a few. To illustrate these differences it is sufficient simply to compare the representations of lions (Clottes and Azéma 2005, 2005a) and mammoths (Gély and Azéma 2005, 2005a). Many of the details observed among depictions of these species at Chauvet occur in other decorated caves and in portable art which no one would accept as Aurignacian. The internal structure of some of the panels, and the differences in the rendering of certain animals, strongly suggest that the black series spans a long period of time. The animals and signs of the black series bear clear resemblances with those of other caves and archaeological periods. Without the radiocarbon dates most scholars

would agree that the evolution of Chauvet covered several thousand years between the Gravettian and the (middle) Magdalenian.

Moreover, as Alcolea and Balbín have pointed out (2007:446–447), where there is superimposition, the red figures are always under the black (*e.g.*, on the lion panel); and since the red series, including the hands, resembles figures which are the earliest in caves such as Tito Bustillo, La Garma or El Castillo, and since hands generally seem to date to the Gravettian, this makes it somewhat difficult to place Chauvet's black figures in the Aurignacian.

But if one accepts that the directly dated, latest black animals are Aurignacian, all other drawings and engravings in the series must be of the same age or even older. If this were the case then one would have to conclude that the complete evolution of Paleolithic art was anticipated in this one single cave ("Chauvet Evolution"). Here, it would have to have come to an end without any influence on the following epochs and cultures, even in the Ardèche valley. Following this, even more remarkably, the evolution would need to have started again with the same sequence of styles, signs and animals in the early Gravettian, not only at this one site, but in the whole Franco-Cantabrian and Andalusian world ("Post-Chauvet Evolution"). This process would effectively be unique in the human past.

Despite the overwhelming number of consistent radiocarbon dates for Chauvet charcoal, we are inclined at present not to accept this version for two reasons. First, we raise considerable issues with the radiocarbon dating program below. Secondly, the existing evolution of Chauvet would suggest that technically there is some break between the Aurignacian and Gravettian. Such a break, however, does not exist in art and symbolism elsewhere. Groups of

dots and/or cupules, and the typical circular 'vulvae' of the Aurignacian survive until the Gravettian; and the animal figures of eastern Central Europe (Pavlov, Dolní Vêstonice) may derive from the ivory statuettes of the Swabian Jura, SW Germany (Vogelherd, Geissenklösterle, *etc.*). It would be no problem to accept that negative handprints start in the Aurignacian, but wherever we have information on their chronological context (*e.g.*, at Cosquer) they are clearly dated to the Gravettian. The consequence would be that they are restricted in Chauvet to the first period, followed by the long-lasting black series, but that they survived in other caves into later periods, followed by the same evolutionary sequence which is well dated from the Gravettian to the Magdalenian.

If the apparent radiocarbon chronology were not so surprisingly old, the Grotte Chauvet would be a "normal" but technically outstanding sanctuary like Lascaux, Altamira and some other caves. Its internal evolution would be seen to follow that of Paleolithic art in general; nevertheless it seems in some details not so much linked to the Dordogne, the Pyrenees or Cantabria, but to belong to an artistic province of eastern France which has become better understood only during the last few decades.

The consequences of these contradictory issues that arise from the Chauvet team's insistence on the antiquity of the art should be discussed without prejudice. Why does the art, if it is Aurignacian, contradict so starkly our existing understanding of the development of Upper Paleolithic art in Europe? How does one explain how the entire evolutionary cycle of cave art observed elsewhere over the best part of 20,000 years might be found *earliest* and *within the space of a few millennia* in *one* cave, only to be forgotten until played out again over a dramatically long timescale?

Style and content, tautology, and anachronism

We are concerned that, when we read in depth the arguments of the Chauvet team for the antiquity of the art, a number of contradictions and confusions arise that weaken their case considerably. There is also the question of anachronism; we realize that one cannot rule out the possibility that the Chauvet art is Aurignacian simply on the grounds of its technical sophistication, but this question remains and in archaeological terms is similar to ascribing a Renaissance painting to the Roman period: not impossible, but unlikely. To take simplistic and problematic analogies and dates at face value and promulgate such a view leaves us in danger, to paraphrase François Bordes, of putting Charlemagne on a motorbike. The team's questionable references to the art of other caves have led directly to a basic tautology, in which Chauvet's art is 'proved' to be Aurignacian by being compared to the art of some undated caves, whose figures are thus confirmed as Aurignacian because of supposed similarities with those of Chauvet! Some dots and lines in the Grotte aux Points could be attributable to this period (Gély 2005:21) - but of course 'could' does not necessarily mean 'are' and they could also be of a completely different age. As Gély (2005:21) has admitted, "L'art pariétal Aurignacien était mal connu jusqu'à la découverte de Chauvet". Indeed the aesthetic quality of certain works in the cave are 'sans équivalent à ce jour en Préhistoire' (Gély 2005:19). As Drouot (1984:325) pointed out ten years before the discovery of Chauvet, 'Très rares, en effet, sont en Languedoc les figures riches en détails naturalistes ainsi que les figures exprimant le mouvement à l'aide de différents procédés, ou représentées en perspective.' Yet in a surprising twist of logic, this lack of similarities with other caves in the region is now taken as proof of the later date of the other Ardèche sites

(Gély and Azéma 2005:187). Azéma's study (2004) of movement in Paleolithic parietal art features Chauvet as his only Aurignacian example - all the others are later, mostly Magdalenian. The same applies to his other study (Clottes and Azéma 2005, 2005a), in which the red felines in the cave are recognized as static, whereas some of the black examples are leaping, and some form at least three scenes including a hunt. Even one of the cave's mammoth depictions displays movement (Gély and Azéma 2005:184). The authors admit, somewhat disingenuously, that in Azéma's thesis on movement in Paleolithic parietal art, the examples of animation are 'surtout au Magdalénien il est vrai' (Clottes and Azéma 2005:181). None of these arguments is clear or convincing, and, viewed against Geneste's tautological use of archaeological parallels (see below), they severely erode our confidence in the Chauvet team's overall dating of the cave.

In earlier papers, one of us (CZ) listed a number of artistic features in Chauvet which are generally associated with later phases of the Upper Paleolithic, such as the red claviform sign (La Baume Latrone also has one - Gély 2005:23), the engraved tectiform, the depiction of animals from the front, the animated scenes, the Magdalenian-style vulva, the scraping of wall surfaces, and others. Since then, more such anachronisms have come to light: for example, depictions of reindeer are not known in any other Paleolithic art, whether parietal or portable, before the Magdalenian (note, for example, the complete absence elsewhere of reindeer figures before the Magdalenian in the tables drawn up by Djindjian [2004:147]). Chauvet, however, contains no less than 12. The depiction of animals with details suggestive of three dimensions as found at Chauvet is found elsewhere no earlier than the late Solutrean. Clottes (2003b:51-52) has revealed that at

Chauvet, several animal figures have the far limbs indicated by not being connected to the body, as at Lascaux , but 'ces cas sont trop isolés et peu systématiques pour en tirer des conclusions'! He also admits (Clottes 2003b:58) that "Les pattes en Y [which are known at Cosquer, Gabillou, and in the Solutrean of Parpalló] sont également présentes sur un bison de Chauvet, grotte où les fréquentations humaines ne sont pas postérieures au Gravettien".

As Tosello and Fritz (2005:160-161) have shown, some Chauvet panels display a highly sophisticated four-phase process in their production, from preparatory scraping of the surface to final engraved touches around the animals' anatomy. They see the accumulation of animals on the horse panel as a premeditated and meticulous composition, with dynamic movement. There are very few or no features unique to the Aurignacian - *e.g.*, legs ending in a point are found throughout the Upper Paleolithic (Tosello and Fritz 2005:163). The same authors show (2004) that the earliest figures on the horse panel are engravings including a very archaic-looking rhino; and there is also a highly stylized red rhino on the panel - all extremely different from the horses. In a comparative table (2004:79), only the early rhino engraving looks like a rhino figure from Aldène - but in the opinion of Vialou (1979:71-74), author of the only detailed tracings of that cave's art, the Aldène pseudo-rhino never existed! Even if one were to accept that Aldène were Aurignacian in date (which is very open to question, as discussed below), then only the earliest figures from Chauvet would be comparable to it.

If Chauvet were Aurignacian in age, some of these problems might be expected to arise. But the overall stylistic case for the antiquity of Chauvet has been put forward in a mess of contradictory statements. Either the cave is unique and thus without comparison, in which case it is stylistically undatable, or it bears stylistic similarities with the art of other caves. If one accepts examples of the latter, making the simple assumption that the art of similar caves elsewhere is an indication of the age of the Chauvet art, then one would, in almost all cases, have to conclude that Chauvet is Solutreo-Magdalenian. We return to specific comparisons between the Chauvet art and presumed Aurignacian art below. First, we examine the Chauvet ^{14}C dating program, which constitutes the sole grounds on which the art (or some of it) is thought to be of Aurignacian age.

The Chauvet dating program

The great number of apparently consistent radiocarbon dates on charcoal samples from Chauvet appears at face value to prove beyond any reasonable doubt that the Grotte Chauvet is the earliest known Paleolithic cave sanctuary. This is certainly what the Chauvet team believe. It must understandably appear rash and adventurous to question the antiquity suggested by *ca.* 48 radiocarbon dates. But there are strong reasons for assuming that things are in fact much more complicated than they seem. Here we raise some potentially severe problems with the radiocarbon measurements from Chauvet.

As far as we are aware, the Chauvet radiocarbon dating program has still only been reported in a popular book (Valladas *et al.* 2001, 2003) and in brief journal articles (Valladas *et al.* 2005; Fosse and Philippe 2005), and thus the crucial details of the samples and processes involved remain as yet unknown and unavailable to scientists. As a result, no detailed discussion of the sampling, pretreatment and measurement methods employed by the team has been presented for independent scrutiny, nor has any information been provided as to what dates have not

been published because they are assumed to have 'failed'. In the best of circumstances radiocarbon samples fail for a number of reasons, and in large-scale, multi-sample projects a number of measurement outliers and failed samples are routine. Presumably similar problems and failures have been encountered in the Chauvet dating program, but we have not been told about them. Why is this? As part of any dating program the means and reasons by which samples have been failed should be made clear and discussed; only in this way can one ascribe validity to the measurements that are accepted as bearing a true relation to the real ages of the selected samples. We have no way to evaluate the relative successes and failures of the Chauvet dating program. Of more concern, given that the measurement of ^{14}C in very small samples of cave art pigments is non-routine, we find the publication of apparent results in such a cursory fashion very surprising. It has often been boasted that Chauvet is the world's best-dated decorated cave, and it is certainly true that some of the many samples of charcoal from the floor have indeed been sent to several laboratories; however, the same is not true of samples from its art (the black drawings), which, despite requests from outside, remain the sole preserve of the Gif-sur-Yvette laboratory.

We are not convinced that the AMS radiocarbon dating program has been sufficiently rigorous to demonstrate the antiquity of the art in Chauvet cave. Given this, and our reservations in several other areas expressed above and below, we regard the question of the age of the Chauvet art as entirely open. In an earlier (and generally ignored) paper on the matter (Pettitt and Bahn 2003) we drew attention to the fact that the direct dating of cave art by AMS radiocarbon should be regarded as developmental, given the serious potential for error such as minute sample sizes (of charcoal and resulting carbon for measurement),

the active chemical environment of cave walls, and the need to establish sources and levels of potential carbon contamination of the pigments and limestone 'canvas'; and of course the archaeological issue as to what dates actually mean. Given these potential pitfalls, the dating of cave art pigments is not at all simple and one should not, we suggested, simply 'date' samples and publish the results. We suggested that, as with all cutting-edge science, independent verification of the measurements obtained on the art should be sought (e.g., Rowe 2004), and we expressed serious concerns about conflicting data, in which case the Gif-sur-Yvette laboratory always produced surprisingly old dates. We wondered if there might be a systematic over-estimation of age at the Gif laboratory. Although we acknowledge that this would require significant contamination, this is not inconceivable, and at present one still cannot rule this out. We drew attention to two measurements from a horse depiction that were separated by 1.5 half lives of radiocarbon which to us would suggest that the sample was contaminated and therefore the 'dates' are meaningless, but the older date (of ~29,000 BP) was taken by the Chauvet team to be correct, even though it was measured on a humic fraction, a notoriously misleading carbon fraction (see below).

More worryingly, we expressed concern that samples removed from the same art panels (in fact, the same dots on one panel) from the Spanish cave of Candamo produced ages of >31,000 BP at Gif, but of ca. 15,000 at the Geochron laboratory in the USA, a surprising discrepancy of approaching three half-lives of radiocarbon. In response to our initial concerns, Valladas and Clottes (2003:142) were not surprised to hear that the labs produced separate ages on samples that 'were obtained from the same (mixed) sample' and stressed their belief that there is 'absolutely no evidence that the samples

analysed... or dated... come from pigment of the same age and type'. This statement seemed to imply that each dot at Candamo actually comprises a mix of charcoal of radically different ages, and would, if this is correct, support our suggestion that Magdalenians around 15,000 BP used their own charcoal as well as that produced over 15,000 years earlier! Either that, or Valladas and Clottes mean that these samples were mixed in the sense of not originating from the same dots, which would also support our concern that isolated dates are not reliable estimates of the age of decorated cave systems (see below). Their concomitant view, that 'this cave may have been visited at different periods by prehistoric people' and 'the decoration of this cave is rather complex' (Valladas and Clottes 2003:142) is exactly the opposite of what they are arguing for Chauvet - one cannot run with the hare and hunt with the hounds! In any case Valladas and Clottes are incorrect, as the original report made it very clear that samples measured at Gif and in the USA were removed from the same dots, and subsequently Fortea (2002:28) confirmed quite emphatically that the samples had indeed been taken from the very same dots: 'Ce sont toujours les mêmes ponctuations des taureaux 15 et 16 qui ont fait l'objet des prélèvements.'

We are surprised that such confusion is evident among the Chauvet team. One would hope that such circumstances might lead to a systematic examination of the problem, but this still remains to be seen. Instead, without showing any inclination to resolve the issue, Valladas and Clottes (2003:142) raised the possibility that the discrepancy between the French and American dates on the dots from Candamo could have resulted from the fact that '...pollution might have affected certain samples but not others'. If this is so, why are they so confident about the dates they publish, when by their argument 2/4

samples measured (50%) may contain contamination which has been undetected? Obviously the demonstration that the samples dated in the USA originated from the same dots as the samples dated by Gif eliminates this possibility: how could contamination within the same small dots of a composition be so discrete that it produces results in one laboratory that are internally consistent, and results in another that are equally internally consistent, while the two labs are nearly three half-lives of radiocarbon in disagreement? The arguments are inconsistent here, and the very real possibility therefore remains that a mistake has been made. Surely this should be investigated? We obviously do not seek to denigrate the excellent track record of the Gif laboratory for routine dating but, as any radiocarbon laboratory will admit, when it comes to cutting-edge, non-routine projects such as the dating of cave art pigments, considerably more experimentation, analysis, and inter-laboratory comparisons are necessary. For now, we repeat our concern, but also our interest that the dates produced in the USA for Candamo fall into a respectable range for the Magdalenian, the period into which scholars sceptical of early dates for Chauvet would place some of its art.

There are other mysteries above and beyond Candamo. We note that there are only three existing dates for the End Chamber at Chauvet: one of these, an AMS measurement at Gif, is ~30,000 BP while the other two, conventional measurements from Lyon, date to ~22-25,000 BP (Valladas et al. 2003:33). The samples from the floor (the Lyon measurements) only indicate Gravettian age activity in the End Chamber; thus, if we accept the AMS determination on the art as indicating an Aurignacian age, why did the Aurignacians apparently leave no traces of lighting or the charcoal production that forms the team's interpretation of the charcoal in the rest of

the cave? By the Chauvet team's argument it would seem that in this part of the cave the Aurignacians were as elusive as they seem to have been in the Ardèche as a whole (see below)!

It can never be assumed that a direct radiocarbon date on cave art pigment (at least charcoal) reflects the age of the art itself. There is no *a priori* reason why there should be a correspondence between the age of occupational traces in a cave and the art on its walls, and in one of our earlier papers we raised the issue that the correlation between early dates measured on samples of charcoal from a few depictions and a number of hearths and charcoal around the cave is problematic and needs resolution (Pettitt and Bahn 2003). The scenario that requires elimination is that humans lit one or a few fires in the cave around 33,000 BP (indulging in little or no art) and then, 15-20,000 years later, Magdalenians entered the cave and used its charcoal to produce the art. Thus, the radiocarbon determinations on the art would erroneously suggest that it was actually 33,000 years old. The repeat measurement of the same age on a number of charcoal fragments dispersed by natural action (see below) would appear to reinforce the importance of the cave around 33,000 BP to fire-using hominins, but this could be illusory. Clottes (2003b:214) regards this 'fossil wood hypothesis' as 'bizarre' as he finds it remarkable that all of the art should be produced using fossil wood (which, judging by the team's frequent insistence, is abundant within the cave and of such fresh condition today that it could still be used) and presented the amusingly illogical argument that, if fossil charcoal were used to create the art, then it also should have been used for the torches! We know of no successful torch that was created using charcoal as opposed to fresh wood, and in any case deal with the dated charcoal below. We therefore disagree with his premature

rejection of the hypothesis, and argue that his opinion cannot be taken seriously.

There are further problems in the dating of Chauvet itself. For example, the cave's youngest date is claimed to be 22,800±400 BP (Gély 2005:28; Valladas *et al.* 2005:111) - yet in a paper in the same journal, a radiocarbon date of 19,105±150 BP is reported for a cave bear bone (Fosse and Philippe 2005:94-95). Moreover, as we pointed out (Pettitt and Bahn 2003), there is a radiocarbon date on charcoal from a horse depiction which is also relatively young (20,790±340 BP). This result was from the charcoal fraction, but the dating team declared for no explicable reason that the (usually highly unreliable) humic fraction result of 29,670±950 BP was preferable! Whether humic fractions are always unreliable or not is irrelevant: they often are, and no one should accept them as 'real' measurements of the age of a charcoal sample. Now, in the light of our reasonable questioning of this situation, they have stated that this result needs future verification (Valladas *et al.* 2005: 111), and we were surprised to see the omission of the problematic dates in their 2005 publication in which they are not discussed. Have they been withdrawn? We agree that verification is necessary, and furthermore suggest that such verification should be extended to their entire dating program. This one weakness throws significant doubt on the team's dating program so far.

Access to the cave

We should remember that the existing *ca.* 48 AMS and conventional radiocarbon dates, assuming they are correct, are presumably sampling only a few of an unknown and unknowable number of human visits, and therefore that the two groups of dates represented thus far do not reflect simply two single human incursions into the cave. As Geneste (2003:50) has noted, bears

alone 'have considerably diminished our sense of human visits'; thus in this case, as with much of archaeology, absence of evidence is not evidence of absence. Similarly (Philippe and Fosse 2003:54) we learn that 'cave bears visited the cave for millennia, before, during and after the visit(s) by humans' but on the same page that 'the cave was visited by bears and prehistoric people at the same time'. Is not the logical correlate of these two statements the hypothesis that humans also visited the cave for millennia? That a number of large animals such as roe deer were able to enter the cave apparently in the Holocene (Philippe and Fosse 2003:53) indicates that it probably remained accessible to humans for a long period of time. Indeed, Garcia (2001:43) has pointed out the possible existence of more than one entrance. And it is important to note, as Alcolea and Balbín (2007:450) have emphasized, that there are almost no bear clawmarks on top of the black figures in the cave (Fosse and Philippe 2005:Table 3). Did the bears lose interest in the cave's walls over time?

Similarly, where the cave's accessibility is concerned, there have been highly inconsistent claims by the researchers: *e.g.*, the collapse of its entrance occurred 'il y a plus de 20,000 ans' (Baffier 2005:12); the collapse occurred 'il y a environ 20,000 ans' (Bocherens *et al.* 2005:78); Valladas *et al.* (2005:111) admit that the cave was blocked 'à la fin du Pléistocène', yet claim that there is no pertinent evidence of any human occupation after 23,000; while Le Guillou (2005:134) claims that the cave was blocked 'vers la fin du Gravettien'. However, Genty *et al.* (2004, 2005:49) dated stalagmites on the rubble at the ancient entrance, and found that its summit is older than 5800±90 BP and its base is older than 11,500±170 BP - hence the evidence is that the entrance collapsed sometime before *ca.* 11,500,

as with so many other decorated caves. If this dating is accurate, what is one to make of the above-mentioned claims? It is true, as pointed out by Genty *et al.* (2005:50), that the stalagmitic growth may have begun some millennia after the collapse, but how can one know? It is simply nonsensical to use as support for an early collapse the limited sample of ^{14}C dates obtained for charcoal and bones from the cave which suggest no human activity involving the creation of charcoal after 23,000 BP and no 'large' animal entering after 22,000 BP (Genty *et al.* 2005:51) - especially as Bocherens *et al.* (2005:86; 2006) report that about 70% of the animal bones in the cave have lost more than 90% of their collagen and thus cannot be radiocarbon dated. And, as mentioned above, there is a radiocarbon date of *ca.* 19,105 BP on a bear bone in the cave. Once again, there seems to be no consistency to these claims and results. One might object that, if people entered the cave after 23,000 BP, where are their traces? But many caves, even pristine ones, lack traces of human footprints, which are very rare; and in Chauvet there are the tracks of a large ibex in the deepest part of the cave, yet it left absolutely no traces in the passage leading there (Garcia 2005:108). Clearly this ibex was guilty of leaving an absence of evidence of its presence in parts of the cave!

Is there any Aurignacian archaeology at Chauvet?

The poor archaeology of the cave is no help. Of the 'small number of flints' recovered from the cave (Geneste 2003:47) none is diagnostic, and they would certainly not be out of place in the Magdalenian. There are about 20 flints in total, and no retouched tools with clear cultural attributes (Geneste 2005:141), and they have been described as 'souvent bruts et peu caractéristiques' (Gély 2005:19). Geneste (2005:48) makes use of a large biconical point of mammoth ivory

embedded in the cave floor to support the Aurignacian attribution of much of the art. It is more slender than the Mladec points of the Aurignacian of Central Europe, but thicker than those of the Solutrean or Magdalenian (Geneste 2005:48). The fact that it was found 'in the sector close to the hearths' is irrelevant and, in fact, it is stated to have been found 'under a thin film of sediment that had accumulated since the prehistoric occupation' (Geneste 2005:48). Geneste notes that objects of this type are 'known *throughout* the Upper Paleolithic' (our emphasis) but that points of this large size (the Chauvet example probably measured close to 30 cm in length) 'are well known at the start of the Aurignacian in Germany and Central Europe'. Geneste cites the work of Albrecht *et al.* (1972) to justify his somewhat tautological argument that this must therefore mean that the Chauvet point is of Aurignacian age. There are a number of problems with Geneste's use of the Central European data. The latter are of either split or massive based forms, not biconical, which may invalidate any comparison purely on typological grounds. Neither are the few poorly-dated Aurignacian bone points from the region noted by Gély (2005) at all typologically similar to the Chauvet example. In terms of absolute dimensions it is true that a small number of Central European forms approach 30 cm in maximum length, but a glance at Albrecht *et al.*'s Figure 17 reveals that these are exceptionally rare, with by far the greater majority around 20 cm in length and shorter (only eight artifacts used in their analysis were >30 cm, whereas 79 were <30 cm and the majority <20 cm). In fact, the differences in morphometrics between the split and massive based forms lead Albrecht *et al.* to believe that these represented 'distinct *local* projectile point populations' (Albrecht *et al.* 1972:82; our emphasis); there are therefore no grounds for

believing that they have any currency for understanding the Chauvet point. We rather prefer a typologically close, French parallel, a biconical point of large dimensions (>30 cm), also recovered from the floor of a painted cave. This is the sagaie géante à base conique recovered from the Solutreo-Magdalenian occupation of Lascaux, which is seen by specialists as proto-Magdalenian and where the archaeological assemblage overall is seen to be homogeneous and representative of no earlier or later periods than the Solutreo-Magdalenian (Allain 1979). We are therefore unconvinced by Geneste's arguments and, given that they rely on the presumed Aurignacian age of the art to suggest that the most plausible age for the point is also Aurignacian, they can be eliminated on the grounds that they are tautological. Unfortunately, direct radiocarbon measurement cannot solve this issue, because the sagaie contains no collagen (Bocherens *et al.* 2006:372). But we call upon the Chauvet team to refute the hypothesis that the lithics and ivory sagaie are of Solutreo-Magdalenian age.

We find Gély's pro-Aurignacian arguments from the regional archaeological context equally dubious. By his own admission (Gély 2003:28) there is 'little evidence' of the Aurignacian in the region, so the fact that there is evidence 'further south in the Languedoc' is taken as an appropriate cultural context. As Floss (2003:277) pointed out, 'In a vast area from the Lyonnais in the north to the Gard and the Vaucluse in the south, we note only two or three localities where Aurignacian occupations can be demonstrated. In the context of such a sparse Aurignacian record it was so much more surprising that some of the Grotte Chauvet paintings were dated to >30,000 years ago. If we assume these dates to be correct, the only possible cultural assignment of the paintings would be to the Aurignacian.

Nevertheless, considering that outstanding examples of Paleolithic cave art are generally located in areas with a well-documented habitation settlement of the period, we are beginning to regard the early dates from Grotte Chauvet with some skepticism' (see also Alcolea and Balbín [2007:448] for similar doubts).

Why is the regional archaeological record not unambiguous in demonstrating Aurignacian settlement? Saint Marcel dates to younger than 30,000 BP and the dufour bladelet-yielding site of Mandrin is on the opposite side of the Rhône to Chauvet (Gély 2005:18), and the river appears to have acted as a cultural barrier in the Upper Paleolithic. The one example Gély cites as 'convincing evidence' is a split-based bone point from the Abri des Pêcheurs some distance to the west. This was found in a layer with dates of 26,760±1000 BP (which to Gély, inexplicably, is 'très aléatoire'), 29,400±900 (which he believes to be 'compatible avec l'ancienneté de cet objet *très rare dans notre région*' - Gély 2005:24, our emphasis), and 23,880±750 BP - Gély 2005:32)! This is hardly a convincingly dated context. In fact, in this region only Chauvet has dates in the earlier Gravettian (~28-25,000 BP - Gély 2005:24). Gély stresses the 'indigence des documents typiquement aurignaciens, et jusqu'au Gravettien moyen' and contrasts this with the 'relative densité en sanctuaires profonds datés ou attribués à cette période' - *i.e.,* Chauvet, Latrone, Les Points, Ebbou (Gély 2005:31, but see below).

The available chronology for the region is clearly so poor that one has no confidence in it. By his own admission, Gély employs only selected dates (2005: 19), so it is impossible to evaluate his conclusions. On what grounds has he 'selected' them? He also admits that it is difficult to 'dater précisément cette longue période' due to various distortions (Gély 2005:19), and, as

one warning, we cite the one date from a Gravettian industry at the Aven de l'Arquet, of 35,400±1900 BP! Similarly, we are unconvinced by the conclusions of Théry-Parisot and Thiébault (2005) that the absolute dominance of *Pinus sylvestris* in the Chauvet charcoal indicates a deliberate selection of this taxon for charcoal production and therefore art, as the pollen diagrams indicate it was by far the dominant taxon in the region (Girard 2005). It was also the dominant taxon in the nearby Magdalenian site of Fontgrasse, the lithic assemblage from which bears a number of similarities with the retouched tools from Chauvet (Bazile *et al.* 1989). Either the palynology is of no significance to the dating of Chauvet, or it is not incompatible with Magdalenian use of the cave.

In a surprisingly naïve attempt to link Chauvet with the Aurignacian, Bednarik (2005:89) claimed that 'arrangements of deposited cave bear skulls have been found in numerous sites, mostly in Central Europe. All of them date from the earliest Aurignacian, and from similar industries of the interface between the Middle and Upper Paleolithic. Therefore, if the same kind of program were demonstrated in Chauvet, it would secure solid dating to a period close to the Campanian ignimbrite eruption. In view of the distortion that presumably affects all radiocarbon dates of that period from southern Europe, it is perfectly possible that the charcoal dates for the older art phase in Chauvet are too low rather than too high, as some have suggested. Nevertheless, evidence of cultural program involving the placement of cave bear remains would securely place any related rock art into the early part of the Aurignacian'! This argument assumes a genuine connection between bears and humans at all sites (something long since dismissed); it suggests that only Aurignacians handled cave bear bones (this would be news to the Magdalenians of Le Tuc

d'Audoubert!); it suggests that the movement of bones can somehow be linked to the date of art on the walls, and apart from the fact that it does not begin 'once upon a time' is no more credible than a fairy story.

Robert-Lamblin (2005:201) has sensibly pointed out that the famous cave-bear skull placed on a rock in Chauvet's Salle du Crâne need not be attributable to the Aurignacian at all; fragments of charcoal on the rock's surface have been dated to 31–32,000, but this in no way tells us when the skull was placed there – her careful examination revealed that the skull is on top of some of the charcoal, which may therefore predate it by some considerable margin. In fact, given that geological phenomena may have been responsible for wedging a bear rib into a crack in the wall it is not inconceivable that natural processes were responsible for the deposition of the charcoal before a human placed the bear skull atop the limestone block. If that is indeed the case, then, in her opinion, this calls into question the hypothesis of Aurignacian (or earlier) ritual practices involving the use of bear remains and fire.

Clearly, one obvious way ahead would be a substantial AMS dating of bone objects and items of fauna. We find Bocherens et al.'s (2005) observations that bones from Chauvet are 'useless' for dating as 90% of collagen seems to have been destroyed in 70% of samples surprising. It takes no mathematician to work out that this implies that enough collagen survives in up to 30%, which, given the abundance of bones throughout the cave, would provide a large dating sample! In view of the very small sizes of samples required for AMS radiocarbon dating, which indeed have permitted the dating of bone points (*e.g.,* Bolus and Conard 2006; Higham *et al.* 2006), we do not accept the argument that 'preservation is the highest priority' as sampling would be effectively invisible. We see no reason why a major AMS

radiocarbon dating program involving several laboratories should not be possible on bone from the cave floor.

Analogies with other Aurignacian art?

In their reply to our earlier criticisms, Valladas and Clottes (2003) emphasized, as usual, the possible thematic parallels between the Chauvet art and the sophisticated art mobilier of the German southwest which, unlike Chauvet, has been unambiguously dated to the Aurignacian period. Clottes and Azéma (2005:181) also tried to link the felines of Chauvet with the carved specimens from the SW German Aurignacian sites, but made scant mention of the equally good or better examples in the Pavlovian (Gravettian) portable art of Moravia. Such comparisons are tautologous. In any case, this material really has very little in common with the images of Chauvet, except that some of the same species are represented. In fact, of the German sculptures that are emphasized by Valladas and Clottes, there are only three felids, one bear and an indeterminate carnivore from Vogelherd (where there are at least five herbivores), and one bear from Geissenklösterle where there are three herbivores (Verlaine 1990). Even if one includes the Löwenmenschen from Hohlenstein-Stadel and Hohle Fels caves which are of dubious relevance, Serangeli (2004) agrees the supposed links between the two arts are largely non-existent. Serangeli has also shown that Hahn's old theory of 'Kraft und Aggression' being predominant in early art is illusory, since there is no general emphasis on dangerous animals, and the carnivores and other animals usually display no aggression at all. In fact, the recent recovery of a water bird sculpture (Conard 2003) suggests that carnivores simply played a role in a far wider symbolic system. Where then, are the carnivores on other Aurignacian sites outside of this small

area of Germany? If one were to use simple numbers of carnivores as a direct analogy, the Central European Pavlovian materials would be far more appropriate than the German. But in any case the matter is academic as no dates exist for any of the Chauvet carnivores!

Tosello and Fritz (2005:168-169) attempted to link Chauvet's art with that of known Aurignacian sites - the art on blocks from the Dordogne, and the crudely painted blocks from Fumane, Italy; they admit that this art on blocks has very few points in common with the Aurignacian carvings of SW Germany, used so often, as we have already seen, as the main (indeed the only) supporting evidence for the age of the Chauvet images, despite the problems inherent in this exercise. The researchers of the Grotte Chauvet have been striving for some time to find Aurignacian analogies for the cave's parietal art; but the major problem is that very little parietal art can be dated to the Aurignacian with any confidence. For example, the caves of Chauvet and Ebbou are very close geographically - Ebbou can be seen from Chauvet's cliff - and have astonishing stylistic similarities but clear thematic and technical differences (Gély 2005:31). Ebbou contains a bison attributable to the Magdalenian and an occupation of that period, but the rest of its decoration may be earlier (Combier 1984). It has a very original style; some estimates place all of its art in the Solutrean and Magdalenian; Combier himself attributes some of its figures to the Magdalenian, but for the rest he finds strong analogies with some plaquettes from Parpalló that are dated to the upper and final Solutrean (Combier 1984:615).

Drouot (1984) attributed the figures of the Grotte Bayol (Gard) to the Solutrean through comparison with better dated sites as it contained no industry. The art of La Baume Latrone (Gard) is unlike anything else, and certainly bears no

resemblance to Chauvet - they are both unique. This cave too has no industry, and Drouot (1984a) attributed its art to the Gravettian and Solutrean. The drawings have been attributed by others to the Aurignacian, Gravettian and Solutrean (Gély 2005:23); but overall this cave's art has long been termed 'inclassable' (Gély 2005:23) and some of it 'n'a pas d'égal dans l'art paléolithique' (Clottes and Azéma 2005:181). The Grotte du Déroc merely contains red-brown dots and some ibex horns; its age is unsurprisingly difficult to estimate, and has even been placed in the Holocene, but the horns, in 'Cougnac style', suggest an Upper Paleolithic date - Combier (1984) goes no further than this judicious estimation, but certainly makes no suggestion of an Aurignacian date. As for the Grotte des Bernous, farther afield in Dordogne, Delluc and Delluc (1984) argued for an attribution to Leroi-Gourhan's Style II rather than to the Aurignacian.

Tosello and Fritz (2005) have drawn particular attention to the art in Aldène (Hérault) and La Baume Latrone. As we have already seen, La Baume Latrone's art is undated, and looks very different from that of Chauvet. The analogies between Chauvet and Aldène were first pointed out by Sacchi (2001), but the felines, bear and other enigmatic motifs of Aldène (Vialou 1979), in the careful and objective view of Pales and Vialou (1984:342), are highly problematic, and they state that 'Seule l'appartenance au Paléolithique supérieur est indéniable'. But they add that 'L'apparence d'un archaïsme stylistique a trompé les visiteurs pressés. Il suffit d'observer avec soin la composition spatiale, l'expression de certains détails morphologiques tels les mufles et les oreilles des carnassiers pour se convaincre qu'il ne s'agit pas d'un art très ancien, antérieur aux cultures magdaléniennes par exemple. Comme la Baume-Latrone, et de nombreux sites pariétaux, l'Aldène ne peut actuellement être

rapportée valablement à une des cultures classiques du Paléolithique supérieur aquitanien, pyrénéen ou même rhodanien.'

Recently, Ambert *et al.* (2005) have suggested that engravings from Aldène have stylistic and content similarities with the Chauvet art, and claim that geological and chronometric data place them in the Aurignacian. On this basis they view the Aldène art as being 'synchrone de la première phase de l'art de Chauvet.' Clottes and Azéma have also tried to link Chauvet's art with that of Aldène and Bayol, but admit that the 'exact chronological attribution of these sites is problematic' (2005:181). We regard the attribution of the Aldène art to the Aurignacian by Ambert *et al.* as highly problematic on several counts. Their case rests on the *supposition* that a flowstone (termed c5) sealed the entrance to the decorated chamber, thus the age of its formation provides a *terminus ante quem* for the art. Given that much of the c5 flowstone has now been removed they cannot demonstrate that the decorated chamber was completely blocked and that at least a crawl space did not exist. Thus their general argument is undemonstrable and untestable. In any case, they note that their U Series dates on a lower flowstone are 'not reliable', and this produced four dates which (at 2σ) range from 45-31,000 BP! More worryingly, they note that the dating of the relevant c5 stalactite is 'even more complicated', and yet nevertheless place considerable faith in one U-Series date of 24,400±900 as estimating the age of the formation of the flowstone and thus the blocking of the gallery. Even if one were to assume that the date is at all reliable, at 2σ the flowstone could have formed as late as *ca.* 22,000 BP, which would indicate that the decorated gallery was accessible through the entirety of the Gravettian! One ^{14}C date on a charcoal twig from a lower flowstone of 30,260±220 is seen to corroborate these data

and provide an age for the human incursion, but of course this is one date and need bear no meaningful relationship to the age of the art. One simply cannot take the suggestions of Ambert *et al.* seriously. Overall, Tosello and Fritz (2005) were unable to find any examples of Aurignacian art that can be compared in *any* way with the images of Chauvet. If it is Aurignacian, it is so far unique, and undated.

Specific issues with the dating evidence

We do not have a completely clear picture of the overall Chauvet dating program for two reasons. First, the team have never published their full methodologies and experimental work so as to enable independent valuation of their results in this cutting-edge and non-routine endeavor. In such a full treatment one would also expect details of samples that have 'failed', and detailed discussion of how and why 'failures' occurred. Given the large number of dates the team have produced, we would be very surprised if there were not several 'failures'. If samples deemed to have 'failed' were measured (*i.e.*, dated), what 'dates' were obtained and on what grounds were they 'failed'? Secondly, the details of some samples have changed from publication to publication. Thus, a comparison of the dates presented in the Chauvet popular volume (Valladas *et al.* 2003, 33) with those published later in a more academic treatment (Valladas *et al.* 2005:110) reveals that certain AMS radiocarbon dates that were originally published (the two we criticized from a horse) are absent in the later publication. Given the authors' confidence in these results (Valladas and Clottes 2003:144) we are surprised at this omission. In addition, one dated torch wipe (VPA-1) that was listed as belonging to the Hillaire Chamber in the 2003 book is listed as belonging to the Galerie du Cierge in the 2005 paper, and a corresponding set of samples have moved in the

Table 17.1 Charcoal radiocarbon dates

Site	Torche	Sample Number	Dating
Galerie du Cierge	torche VPA-1	GifA 95129	26,980±410
	Same *mouchage de torche*	GifA 95130	26,980±420
Salle Hillaire	torche VPA-4	GifA 95127	26,120±400
Galerie des Croisillons	torche GC-00-23	GifA 101453	26,160±260

opposite direction: clearly the two samples have been swapped around. We are greatly concerned at this, as it hardly improves our confidence in the Chauvet dating program.

As things stand, 48 AMS radiocarbon dates have been published from various contexts in the cave (excluding those for some reason published in previous popular works but omitted from the academic publication: Valladas *et al.* 2005). In the absence of any other guiding principles we therefore assume that the academic publication should take precedence. A number of these measurements are on samples taken from the same context: thus, for example two dates are from the same torch wipe, three are from the 'confronted rhinos' (we assume this is one depiction) and a further measurement comes from the same panel (Panel of Horses); three measurements were obtained from charcoal found on the limestone block with a bear skull placed on top of it; two on charcoal from the cave earth in the gallery of crosses, three from charcoal in the cave earth at the entrance to the Megaloceros Gallery and eight from 'charcoal zones' in the Megaloceros Gallery. One would obviously expect measurements from the same chronometric contexts to have identical ages, so correcting for this there are actually no more than 26 independent dated contexts, possibly considerably less.

Four Gif AMS radiocarbon dates come from charcoal that derived from torches that were snubbed against the cave's walls, *i.e.*, *mouchages de torche* or torch wipes. The existing Gif dates derive from three separate torch wipes. The results for these samples are in Table 17.1.

Clearly, all three torch wipes date to an uncalibrated age range of 27,820 to 25,320 BP (2σ) and therefore presumably relate to the Gravettian. The torch wipes do not, therefore, indicate an Aurignacian age for the Chauvet art.

Only 17 AMS radiocarbon measurements come from identifiable chronometric contexts, *i.e.*, the parietal art, torch wipes (*mouchages de torche*) and charcoal deposits referred to as 'hearths'. It is unclear whether most separately classified examples of the latter are discrete hearths or represent a more continuous and potentially contemporary burning event – it is simply impossible to evaluate this independently from the published data available. In fact, there is considerable evidence for postdepositional movement within several galleries of the cave system, and presumably therefore one cannot rule out that the actual separate chronometric contexts of human activity in the cave were originally remarkably small, perhaps as few as two or three burning events that have subsequently been dispersed by water action and bioturbation. The Chauvet team certainly need to deal with these issues in detail. Footprints avoid the depression formed by the Skull Chamber, which is interpreted as having formed a small lake (Garcia 2003:40); and mixing can be observed in the silty clay of the Hillaire Chamber (Garcia 2003:42). Temporary waterflows are inferred in areas close to the entrance, as well as disturbance by bears before, between and after the supposed human

Table 17.2 Distribution of AMS radiocarbon dated charcoal samples from Grotte Chauvet

Charcoal context/ Age range	> 30 ka BP	30-25 ka BP	<25 ka BP
Isolated charcoal	111111112233 = **12**	1111111 = **7**	11 – **2**
Hearths	0	1	1
Combustion zone	11111111 = **1?**	0	0
Torch wipes	0	112 = **3**	0
Parietal art	1113 = **3/4***	1	0

Dates are presented by context, i.e., 1 = 1 date from 1 context, 2 = 2 dates from 1 context, thus 112 equates to one date from one context, one date from one context, 2 dates from 1 context. Numbers in bold = total number of dated contexts.

*Either 3 or 4 separate art panels have yielded measurements > 30 ka BP: 3 if one includes the aurochs and rhinos together from the panel of the horses, or 4 if these are separated. We took the large number when calculating percentages (Table 17.3).

incursion, which led the team to the conclusion that the galleries contain "palimpsests of floors which are very complicated to interpret" (Geneste 2003:44). In addition, a fragment of bear rib found 'at a person's height' in a fissure in the wall of the Chamber of the Bear Hollows is seen by Geneste (2003:48-49) as possibly a 'natural geological deposit', which, if true, would imply considerable water activity. If, on the other hand this is interpreted as deliberate placement of the bone by humans, it represents a phenomenon hitherto known only from the Gravettian to Magdalenian, as Clottes (2003b:212) notes.

Water activity seems clearest in the galleries closest to the entrance, leading Geneste (2003:45) actually to note that 'water action probably dispersed the wood charcoal' of the small hearth in the Candle Gallery. As the age of the charcoal sample from this hearth is Gravettian it indicates that such dispersal certainly occurred after the combustion event(s) of 33–32,000 BP and could therefore be responsible for the degree of charcoal dispersal elsewhere in the cave, i.e., in the Megaloceros Gallery, from which most of the early dates come and which is not much further in the system than the Candle Gallery, and which is near the inferred lake of the Skull Chamber. It is apparently the

Megaloceros Gallery where the team believe that the more numerous hearths were found, and which contained an abundance of charcoal. Although distribution plans of the charcoal have yet to be published and it is currently impossible to evaluate these claims, a parsimonious interpretation of the difference between the Megaloceros Gallery and Candle Gallery is simply different levels of water dispersal. The fact that an almost complete fox skeleton was found in close proximity to the hearths in the Megaloceros Gallery in a completely different state of patination to the bear remains from the same area (Philippe and Fosse 2003:53) indicates that complex phenomena were at work this deep into the cave. The Chauvet team clearly need to eliminate this possibility for the perhaps illusory 'abundance' of charcoal in the former, and at present it should certainly not be taken as an indication of the deliberate production of charcoal for the purposes of art. If this is the case, simply obtaining more dating samples from the charcoal on the cave floor will inevitably produce more dates of the same age. Thus, the team's arguments that the majority of dates belong to the Aurignacian period are illusory. Moreover, the simple fact that the hearth charcoal dates range from 32,900 to 31,250 whereas the "reliable" dates from drawings lie between

Table 17.3 Percentage of Chauvet dates by period and context

Charcoal context/age range	>30 Ka BP	30-25 Ka BP	<25 Ka BP
Isolated charcoal	37.5% (37.5%)	14.5% (22%)	4% (6%)
Hearths	0%	2% (3%)	2% (3%)
Combustion zone	17% (3%)	0%	0%
Torch wipes	0%	8% (9%)	0%
Parietal art	12.5% (12.5%)	2% (3%)	0%
Total	67% (53%)	26.5 (37%)	6% (9%)

First percentage is in terms of the number of measurements, the second (in parenthesis) is the percentage obtained when one converts the data to dated contexts. Note that 43% of existing radiocarbon dates for Chauvet belong to the 30-20,000 BP period.

30,940 and 26,670 demolishes the theory that the charcoal was made for art – why produce it for a use several millennia later (Alcolea and Balbín 2007:449)?

One can explore the sampling issue further. It is important to note that the only AMS radiocarbon measurements that *may* demonstrably relate to artistic activity in the cave are those on the art itself. Table 17.2 presents the chronological distribution of AMS radiocarbon measurements on three classes of charcoal sample. It can be seen that the existing chronometry for the site dates 30 or 31 separate contexts (depending upon whether one counts all dates for images on the panel of the horse as one (= 30) or if one separates the one measurement on an aurochs from this panel from the three on rhinos (= 31)). Table 17.3 expresses this distribution of dates as a percentage of the total number of dates and (in parenthesis) as a percentage of the total number of dated chronometric contexts.

It can be seen that only six measurements (out of a total of 48: 12.5%) derive from samples taken from the 'Aurignacian age' art, but which actually only relate to four separate depictions out of a total of well over four hundred for the cave as a whole. In order for the four measurements on torch wipes to relate to this it must be demonstrated that they are either examples of

art themselves or were left by the artists. As they all date to the Gravettian the most plausible argument is that they were left by the Gravettian explorers/artists. They do not indicate human activity in the cave before *ca.* 28,700 BP. Of the charcoal samples from floor deposits seven are younger than 30 ka BP and two even younger than 25 ka BP. Together, 28% of the isolated floor charcoal and 6% of the hearth charcoal belongs to the broad Gravettian period – over a third of the dated floor charcoal.

Calculating the relative percentages of the dated samples and reducing these to the relative importance of dated contexts weakens the dating argument even further (Table 17.3). While it appears at first glance that 67% of the measurements are older than 30 ka BP, when this is converted to a figure for the number of separately dated contexts (i.e., to control for multiple dating) the number of dated contexts >30 ka BP reduces to *ca.* 53%, with *ca.* 46% dating to the period between 30 and 20 ka BP. This is hardly convincing evidence of a dominance of Aurignacian art. When one actually removes the number of measurements that *do not obviously relate to the artistic activity*, i.e., the isolated charcoal, hearths, combustion zones and torch wipes, one is left only with 12% of the relevant dated contexts that are 30 ka BP or older. How, then,

can one conclude that the Gravettian use of the cave was 'more transient' than the Aurignacian (Geneste 2003:50)?

We are not claiming that the dating evidence is incorrect, but we are stating that when it is viewed critically the 'evidence' for an Aurignacian antiquity for the Chauvet art dissipates. The more robust evidence for human incursions in the cave - torchwipes and hearths as opposed to dispersed charcoal - comes from the Gravettian, so how can one infer that the Gravettian use of the cave did not concern the paintings, as Baffier (2005:11) has suggested? Clearly, the existing dating project for Chauvet cave leaves a lot to be desired.

Conclusions

Chauvet's art remains undated to any satisfactory degree. Attempts to prove its Aurignacian age by comparison with other caves have so far failed, and there is as yet no archaeological material from the cave which can be attributed to the period and which cannot be attributed to later periods. There is an ever-growing list of features, motifs and techniques in the cave's art which are normally - and securely - ascribable to later phases of the Upper Paleolithic. The official researchers' view is that Chauvet was only frequented and decorated in the Aurignacian and Gravettian (though one should recall that Clottes has admitted a possible Magdalenian visit - see Pettitt and Bahn 2003:139).

Two of us initially expressed no firm belief about the age of the art, merely a concern that its age had not been at all demonstrated. In the sad absence of any attempt to address our concerns by the Chauvet team, and with the accumulation of additional problems, inconsistencies and contradictions, we now suggest that the 'younger chronology' suggested by one of us is at present far more sensible, and at present fits the available data far better. Thus, while one cannot rule out the possibility of a limited amount of Aurignacian art in Chauvet, by far the greater amount of its parietal figures should be attributed to the Gravettian, Solutrean and Magdalenian. Hence, even if the radiocarbon dates obtained on charcoal from the floor are accurate, it is perfectly possible that later visitors to the cave used the abundance of charcoal with which to make drawings, as one could do today. Thus, radiocarbon is dating the death of the trees in question, not the use of the charcoal to make art. This is a difficult proposition to prove or disprove, but in our opinion this is the best-fit hypothesis - otherwise, one would need to assume that the Aurignacian and Gravettian decoration of Chauvet was a unique episode in the history of art, which left no subsequent trace, and which had no effects at all even on the many other decorated caves of the region. In effect, Paleolithic art would have to be divided into two phases; Chauvet, and Post-Chauvet, with no link between them. We find this extremely hard to believe.

About the authors
Paul Pettitt, Dept. of Archaeology, University of Sheffield, England; E-mail: P.Pettitt@sheffield.ac.uk.

Paul Bahn, 428 Anlaby Road, Hull HU3 6QP, England; E-mail: pgbahn@anlabyrd.karoo.co.uk.

Christian Züchner, Institut für Ur und Frühgeschichte, Universität Erlangen-Nürnberg, Erlangen, Germany; E-mail: ch-zuechner-prae-hist@t-online.de.

References

Albrecht, G., J. Hahn, and W. G. Torke

1972 *Merkmalanalyse von Geschossspitzen des Mittleren Jungpleistozän in Mittel- und Osteuropa.* Verlag W. Kohlhammer, Stuttgart.

Alcolea González, J. J., and R. de Balbín Behrmann

2007 ^{14}C et style. La chronologie de l'art pariétal à l'heure actuelle. *L'Anthropologie* 111:435-466.

Allain, J.

1979 L'industrie lithique et osseuse de Lascaux. In *Lascaux Inconnu*, edited by A. Leroi-Gourhan and J. Allain, pp. 87-120. XII Supplément Gallia Préhistoire, Paris.

Ambert, P., J-L. Guendon, P. Galant, Y. Quinif, A. Gruneisen, A. Colomer, D. Dainat, B. Beaumes, and C. Requirand

2005 Attribution des gravures paléolithiques de la Grotte d'Aldène (Cesseras, Hérault) à l'Aurignacien par la datation des remplissages géologiques. *Comptes Rendus Palevol* 4(3):275-84.

Azéma, M.

2004 La décomposition du mouvement dans l'art pariétal: et si....les hommes préhistoriques avaient inventé le dessin animé et la bande dessinée? *Bulletin de la Société Préhistorique Ariège-Pyrénées* 59:55-69.

Baffier, D.

2005 La grotte Chauvet: Conservation d'un patrimoine. *Bulletin de la Société Préhistorique Française* 102:11-16.

Bazile, F., P. Guillerault, and C. Monnet

1989 L'habitat Paléolithique Supérieur de plein air de Fontgrasse (vers Pont-du-Gard, Gard). *Gallia Préhistoire* 31:65-92.

Bednarik, R. G.

2005 Study of a Palaeolithic time capsule: the Chauvet Cave project. *Rock Art Research* 22(1):87-89.

Bocherens, H., D. Drucker, and D. Billiou

2005 État de conservation des ossements dans la grotte Chauvet (Vallon-Pont-d'Arc, Ardèche, France). *Bulletin de la Société Préhistorique Française* 102:77-87.

Bocherens, H., D. G. Drucker, D. Billiou, J.-M. Geneste, and J. van der Plicht

2006 Bears and humans in Chauvet Cave (Vallon-Pont-d'Arc, Ardèche, France); insights from stable isotopes and radiocarbon dating of bone collagen. *Journal of Human Evolution* 50:370-76.

Bolus, M., and N. Conard

2006 Zur Seitstellung von Geschossspitzen aus organischen materialien im späten Mittelpaläolithikum und Aurignacien. *Archäologisches Korrespondenzblatt* 36:1-15.

Chauvet J. M., E. Brunel Deschamps, and C. Hillaire

1995 *Grotte Chauvet. Altsteinzeitliche Höhlenkunst im Tal der Ardèche.* Thorbecke Speläo 1, Jan Thorbecke Verlag, Sigmaringen.

1996 *Chauvet Cave: The Discovery of the World's Oldest Paintings.* Thames and Hudson, London.

Clottes, J. (ed.)

2001 *La Grotte Chauvet. L'Art des Origines.* Le Seuil, Paris.

2003a *Return to Chauvet Cave: Excavating the Birthplace of Art.* Thames and Hudson, London. (In the USA: *Chauvet Cave; the Art of Earliest Times.* University of Utah Press, Salt Lake City.

Clottes, J.

2003b Un problème de parenté: Gabillou et Lascaux. *Bulletin de la Société Préhistorique Ariège-Pyrénées* 58:47-61.

Clottes, J., and M. Azéma

2005 Les images de félins de la grotte Chauvet. *Bulletin de la Société Préhistorique Française* 102:173-82.

2005a *Les Félins de la grotte Chauvet. Les Cahiers de la Grotte Chauvet.* Éditions du Seuil, Paris.

Combier, J.

1984 Grotte d'Ebbou. In *L'Art des Cavernes. Atlas des Grottes Ornées Paléolithiques Françaises*, pp. 609-616. Min. de Culture, Paris.

Combier, J., and G. Taupenas

1984 Grotte du Déroc. In *L'Art des Cavernes. Atlas des Grottes Ornées Paléolithiques Françaises*, pp. 628-629. Min. de Culture, Paris.

Conard, N. J.

2003 Palaeolithic ivory sculptures from southwestern Germany and the origins of figurative art. *Nature* 426:830-832.

Delluc, B., and G. Delluc

1984 Grotte des Bernous. In *L'Art des Cavernes. Atlas des Grottes Ornées Paléolithiques Françaises*, pp. 86-88. Min. de Culture, Paris.

1991 *L'art Pariétal Archaïque en Aquitaine.* XXVIIIe supplément à Gallia Préhistoire. Éditions CNRS, Paris.

Djindjian, F.

2004 L'art paléolithique dans son système culturel, II. De la variabilité des bestiaires représentés dans l'art parietal et mobilier paléolithique. In *La Spiritualité*, edited by M. Otte. ERAUL 106, Liège, pp. 127-152.

Drouot, E.

1984 Grotte Bayol. In *L'Art des Cavernes. Atlas des Grottes Ornées Paléolithiques Françaises*, pp. 323-326. Min. de Culture, Paris.

1984a Grotte de La Baume-Latrone. In *L'Art des Cavernes. Atlas des Grottes Ornées Paléolithiques Françaises* pp. 333-339. Min. de Culture, Paris.

Floss, H.

2003 Did they meet or not? Observations on Châtelperronian and Aurignacian settlement patterns in eastern France. In *The Chronology of the Aurignacian and of the Transitional Technocomplexes. Dating, Stratigraphies, Cultural Implications*, edited by J. Zilhão, and F. d'Errico, pp. 273-287. Trabalhos de Arqueologia 33, Lisbon.

Fortea Pérez, J.

2002 Trente-neuf dates de C14-AMS pour l'art pariétal des Asturies. *Bulletin de la Société Préhistorique Ariège-Pyrénées* 57:7-28.

Fosse, P., and M. Philippe

2005 La faune de la grotte Chauvet: Paléobiologie et anthropozoologie. *Bulletin de la Société Préhistorique Française* 102:89-102.

Garcia, M.

2001 Les empreintes et les traces humaines et animales, pp. 34-43. In *La Grotte Chauvet: L'Art des Origines*, edited by J. Clottes. Le Seuil, Paris.

Garcia, M.-A.

2005 Ichnologie générale de la grotte Chauvet. *Bulletin de la Société Préhistorique Française* 102:103-108.

Gély, B.

2005 La grotte Chauvet à Vallon-Pont-d'Arc (Ardèche). Le contexte régional paléolithique. *Bulletin de la Société Préhistorique Française* 102:17-33.

Gély, B., and M. Azéma

2005 Approche des représentations de mammouths de la Grotte Chauvet. *Bulletin de la Société Préhistorique Française* 102:183-188.

2005a *Les Mammouths de la grotte Chauvet. Les Cahiers de la Grotte Chauvet.* Éditions du Seuil, Paris.

Geneste, J.-M.

2003 Visiting the cave and human activities. In *Return to Chauvet Cave. Excavating the Birthplace of Art: the First Full Report,* edited by J. Clottes, pp. 44-50. Thames and Hudson, London.

2005 L'archéologie des vestiges matériels dans la grotte Chauvet-Pont-d'Arc. *Bulletin de la Société Préhistorique Française* 102:135-144.

Genty, D., D. Blamart, and B. Ghaleb

2005 Apport des stalagmites pour l'étude de la grotte Chauvet: Datations absolues U/Th (TIMS) et reconstitution paléoclimatique par les isotopes stables de la calcite. *Bulletin de la Société Préhistorique Française* 102:45-62.

Genty, D., B. Ghaleb, V. Plagnes, C. Causse, H. Valladas, D. Blamart, M. Massault, J.-M. Geneste, and J. Clottes

2004 Datations U/Th (TIMS) et ^{14}C (AMS) des stalagmites de la grotte Chauvet (Ardèche, France): Intérêt pour la chronologie des événements naturels et anthropiques de la grotte. *Comptes. Rendus Palevol* 3:629-642.

Higham, T., R. Jacobi, and C. Bronk Ramsey

2006 AMS Radiocarbon dating of ancient bone using ultrafiltration. *Radiocarbon* 48(2):179-195.

Le Guillou, Y.

2005 Circulations humaines et occupation de l'espace souterrain à la grotte Chauvet-Pont-d'Arc. *Bulletin de la Société Préhistorique Française* 102:117-134.

Moro Abadía, O., and M. R. González Morales

2007 Thinking about 'style' in the 'post-stylistic era': reconstructing the stylistic context of Chauvet. *Oxford Journal of Archaeology* 26(2):109-125.

Pales, L., and D. Vialou

1984 Grotte de l'Aldène. In *L'Art des Cavernes. Atlas des Grottes Ornées Paléolithiques Françaises,* pp. 340-342. Min. de Culture, Paris.

Pettitt, P., and P. G. Bahn

2003 Current problems in dating palaeolithic cave art: Candamo and Chauvet. *Antiquity* 77:134-41.

Pettitt, P. B., and A. W. G. Pike

2007 Dating European Palaeolithic cave art: progress, prospects, problems. *Journal of Archaeological Method and Theory* (14/1):27-47.

Philippe, M., and P. Fosse

2003 The animal bones on the cave floor. In *Return to Chauvet Cave. Excavating the Birthplace of Art: the First Full Report,* edited by J. Clottes, pp. 51-56. Thames and Hudson, London.

Robert-Lamblin, J.

2005 La symbolique de la grotte Chauvet-Pont-d'Arc sous le regard de l'anthropologie. *Bulletin de la Société Préhistorique Française* 102:199-208.

Rowe, M. W.

2004 Radiocarbon dating of ancient pictograms with accelerator mass spectrometry. *Rock Art Research* 21(2):145-53.

Sacchi, D.

2001 Données récentes sur le Paléolithique supérieur du midi de la France, des Pyrénées au Rhône. In *Le Paléolithique Supérieur Européen, Bilan Quinquennal 1996/2001*. ERAUL 97:127-134, Liège.

Serangeli, J.

2004 Kraft und Aggression, existe-t-il un message de 'force' et d''agressivité' dans l'art paléolithique? In *L'Art du Paléolithique Supérieur, Congrès de l'UISPP, Liège, 2-8 septembre 2001*, edited by M. Lejeune and A-C. Welté. ERAUL 107:115-125, Liège.

Théry-Parisot, I., and S. Thiébault

2005 Le pin (*Pinus sylvestris*): Préférence d'un taxon ou contrainte de l'environnnment? Étude des charbons de bois de la Grotte Chauvet. *Bulletin de la Société Préhistorique Française* 102:69-76.

Tosello, G., and C. Fritz

2004 Grotte Chauvet Pont d'Arc: Approche structurelle et comparative du panneau des chevaux. In *L'Art du Paléolithique Supérieur, Congrès de l'UISPP, Liège, 2-8 septembre 2001*, edited by M. Lejeune, and A.-C. Welté, 107:69-86. ERAUL, Liège.

2005 Les dessins noirs de la grotte Chauvet-Pont-d'Arc: Essai sur leur originalité dans le site et leur place dans l'art aurignacien. *Bulletin de la Société Préhistorique Française* 102:159-71.

Valladas, H., and J. Clottes

2003 Style, Chauvet and radiocarbon. *Antiquity* 77:142-45.

Valladas, H., N. Tisnérat, M. Arnold, J. Evin, and C. Oberlin

2001 Les Dates des Fréquentations. In *La grotte Chauvet, les origines de l'art*, edited by J. Clottes, pp. 32-34. Le Seuil, Paris.

2005 Bilan des datations carbone 14 effectuées sur des charbons de bois de la grotte Chauvet. *Bulletin de la Société Préhistorique Française* 102:109-113.

Verlaine, J.

1990 *Les Statuettes Zoomorphes Aurignaciennes et Gravettiennes d'Europe Centrale et Orientale*. Mémoires de Préhistoire Liègeoise, Liège.

Vialou, D.

1979 Grotte de l'Aldène à Cesseras (Hérault). *Gallia Préhistoire* 22:1-85.

Züchner, C.

1995 Grotte Chauvet (Ardèche, Frankreich) - oder - Muss die Kunstgeschichte wirklich neu geschrieben werden? *Quartär* 45/46, 1995(1996):221-226.

1996 La Grotte Chauvet: radiocarbone contre archéologie - The Chauvet cave: radiocarbon versus archaeology. *INORA* 13:25-27.

1999a Grotte Chauvet Archaeologically Dated. http://www.uf.uni-erlangen.de/chauvet/chauvet.html.

1999b La cueva Chauvet, datada arqueológicamente. *Edades, Revista de Historia 6, Edición Jovenes Historiadores de Cantabria*, pp. 167-185. Universidad de Cantabria.

2001a The Pont-d'Arc Venus: Aurignacian, Gravettian or Magdalenian? Additional observations on the age of Chauvet Cave. http://www.uf.uni-erlangen.de/chauvet/chauvetvenus.htm.

2001b Archäologische Datierung - Eine antiquierte Methode zur Altersbestimmung von Felsbildern? *Quartär* 51/52:107-114.

2003a La cueva Chauvet y el problema del arte auriñaciense y gravetiense. In *Primer Symposium Internacional de Arte Prehistórico de Ribadesella. El arte prehistórico desde los inicios del siglo XXI*, edited by R. de Balbín Behrmann and P. Bueno Ramírez, pp. 41-51. Edición Asociación Amigos de Ribadesella, Ribadesella.

2003b Datations archéologiques de l'art rupestre, rien qu'une méthode subjective? - Archaeological dating of rock art, nothing but a subjective method? *INORA* 35:18-24.

2003c Zu den Anfängen der Höhlenkunst in Westeuropa. *Erkenntnisjäger - Kultur und Umwelt des frühen Menschen. Festschrift für Dietrich Mania*, pp. 689-695. Veröffentlichungen des Landesmuseums für Archäologie Sachsen-Anhalt - Landesmuscum für Vorgeschichte Band 57/II, Halle.

2007 La grotte Chauvet - Un sanctuaire aurignacien? Les conséquences pour l'art paléolithique. Die Grotte Chauvet - Ein Kultplatz des Aurignacien? Die Konsequenzen für die paläolithische Kunst. In *Les Chemins de l'Art Aurignacien en Europe. Das Aurignacien und die Anfänge der Kunst in Europa*, edited by H. Floss and N. Rouquerol, pp. 409-420. Colloque international - Internationale Fachtagung Aurignac 2005. Editions Musée - forum Aurignac Cahier 4.

18

COMMUNICATION WITH SYMBOLS: ART AND WRITING

Denise Schmandt-Besserat

Introduction

Humans created two major systems of visual symbols to express themselves and to communicate with others: art and writing. These two unique human achievements are often mistakenly viewed as being related. Namely, it is a common assumption that writing had its origin in pictures. In this paper I will demonstrate that, from their origins, art and writing were fundamentally different and fully independent from each other, and that they played different roles in society. I dedicate this paper to Alexander Marshack, who shook the world of Paleolithic scholarship.

The context

The first sustained evidence of art comes from Western Europe, at such sites as La Ferrassie, Abri Cellier and Abri Castanet in the south west of France. The first images were created by the hunters and gatherers of the Aurignacian culture, in the early Upper Paleolithic period, *ca.* 30,000 BC. (Leroi Gourhan 1971; Bahn and Vertut 1988, 1997). Startlingly, the first picture making does not coincide with any major physiological, technological, or economic innovation in human development. The appearance of art is still, therefore, a complete mystery and scholars keep wondering why art occurred so late in human cultural development - 20 000 years after *Homo sapiens sapiens* had settled in Europe and 4,000,000 years after the anthropoid era.

Writing followed art by as much as 25,000 years. The first written texts, dating to about 3200 BC, were recovered on the Asian continent, in

particular in Mesopotamia, present-day Iraq, but also in various contemporaneous sites in Elam, present-day Iran and Syria (Schmandt-Besserat 1992:129-154). They were part of the administrative apparatus that was developed with the rise of urban civilization and state formation. Namely, the first script was used by temple accountants to administer goods delivered by worshippers for the upkeep of the gods. The origins of art and writing were therefore vastly dissimilar. Art is yet an unexplained phenomenon, but writing was created to fulfil specific accounting needs of the budding Mesopotamian temple institution.

The evidence

The first art creations consisted of motifs drawn from nature with various degrees of stylization such as incomplete sketches of horses, rhinoceroses or other animals, and a motif interpreted as a female vulva. They also included sets of parallel lines and circular depressions called 'cup marks'. The geometric motifs and stylized animal or female representations were either depicted alone or, more frequently, were associated with one another in various enigmatic combinations. All the figures were drawn on the same type of background, that is to say, large and small stone boulders usually found upside down around rock shelters. All the motifs were also engraved using the same technique characterized by broad, shallow lines or outlines pecked with a flint tool. It is not until the Gravettian period, several millennia later, about 23,000 BC, that small three-dimensional sculptures became familiar. These often

represented an obese woman standing up with her head slightly bent forward. Some of the incised bones definitively treated by Alexander Marshack (1991) also belong to this period. They are beyond the scope of this paper which focuses on image making.

The format of writing was, of course, completely different. It was couched on small, rectangular tablets fashioned in a cushion shape by the scribes. These archaic tablets belong to two types: some bear impressed signs and others have both impressed and incised signs. An assemblage of three hundred tablets, bearing signs imprinted by pressure, is the most archaic. Such impressed tablets, dating to about 3200 BC, were recovered in Uruk, Mesopotamia, Susa and Chogha Mish in Iran, and Habuba Kabira and Jebel Aruda in Syria. To these three hundred earliest specimens must be added a collection of four thousand tablets excavated at Uruk. These texts, characterized by more elaborate incised signs traced with a stylus, date to *ca.* 3100 BC.

The subject matter

What did the Aurignacian cup marks mean? And why were they associated with lines or unfinished animal designs? We will never know. However, most scholars consider Paleolithic art to symbolize elements of a cosmology. If this is correct, the images stood for ideas of utmost significance to the society, such as the creation of the world, the meaning of death and the principle of reproduction. According to this hypothesis, Paleolithic visual art dealt with the supernatural, the unknown, the feared or the desired. Therefore, from its origin, art was a powerful instrument of thought for people to conceive ideas and create a community united by a common understanding of the mysteries of life.

The data recorded by writing were utterly different. The signs of the script stood for mundane goods – namely, each represented a precise unit of a specific daily-life commodity, such as 'a basket of grain' or 'a jar of oil.' The tablets recorded the quantities of goods received or disbursed by the temple administration. They featured small lists of staples, mostly quantities of measures of grain or numbers of domestic animals. The tablets featuring incised signs also noted the name of the individual who gave or received the goods. Thus, symbols of art expressed what words cannot; but signs listed on the tablets corresponded to staple goods commonly referred to in the Sumerian daily vocabulary.

A system

Because the same repertory of Aurignacian wall art motifs was repeated and similarly combined in several rock shelters of southwestern France, and because the Gravettian figurines have been found in a wide geographical extension stretching from France to Siberia, there can be little doubt that, from its origin, art was a complex system of visual symbols. In other words, the Paleolithic images were expressly created for the purpose of communication. Each picture had a meaning that was shared by a community – in the same way as the picture of a dove evokes 'peace' in a Western society.

Written signs and art symbols shared something in common: they both belonged to a system, that is to say they were part of a repertory of signs meant to be combined together to communicate meaning. It is quite remarkable that, with exceedingly rare exceptions, the earliest 300 Mesopotamian, Iranian, and Syrian impressed texts shared exactly the same format. They were written on similar clay tablets, in the same rectangular form and in the same small size. Moreover, the lay-out of the signs that will be discussed below was uniform. This demonstrates that, from its very beginning, writing observed a precise

canon. This means in particular that, about 3200 BC, the scribes of the Uruk metropolis established rules concerning the direction of the script and where and how the signs were to be organized on a tablet. And these rules were imposed on the scribes of distant subject states in Elam and Syria.

The antecedents of art and writing

Art appears without precedent. In contrast the signs of writing derived their shape, meaning, and economic function from a 4,000 year old system of counters called 'tokens.' The long evolution from tokens to writing can be summarized as follows (Schmandt-Besserat 1996).

Starting about 7500 BC, from the Eastern Mediterranean coast to the confines of present-day Iran, tokens served as counters to keep track of agricultural products. The small objects were modeled in clay in multiple striking shapes, each standing for a specific unit of a commodity. The tokens reflected the archaic counting system of the time, called concrete counting, which was characterized by the use of special numerations, or sequences of number words, to count different commodities. For example sheep or goats were counted with tokens in the shape of cylinders that symbolized specifically the animal numeration, and small and large baskets of grain were counted with cones and spheres that stood for the grain numeration.

About 3500 BC, the temple administration created round clay envelopes in order to store together the tokens representing outstanding debts. This innovation prompted a series of remarkable technical changes, as explained below.

Tokens were impressed on the surface of the envelopes to show how many of what shape were included inside. The token impressions reduced the three-dimensional counters to two-dimensional signs. Wedges and circular signs replaced the cones and sphere tokens to symbolize numbers of baskets of grain.

The token impressions were laid out on the surface of the envelopes according to the following precise rules: 1) signs of the same kind were entered on a line; 2) the number of units of merchandise were shown in one-to-one correspondence. For example, three small baskets of grain were shown by three wedges

The lines of signs representing greater units were placed above those of lesser units. For example, a line of circular signs representing large baskets of grain was inscribed above a line of wedges representing small baskets.

About 3200 BC tablets – shaped as solid clay balls – replaced the hollow clay envelopes. The signs impressed on tablets were the same as those impressed on envelopes. They also followed the same rules of one-to-one correspondence; the arrangement of signs in lines; and the hierarchical order of the lines.

About 3100 BC, a stylus was used to inscribe signs in the shape of tokens, instead of impressing them.

Whereas art seems to appear suddenly, it took writing 4000 years to achieve its format. The earliest signs of the impressed and incised script derived their form from tokens. They were inscribed on clay tablets that derived from envelopes. This format, with only minor changes, continued as long as the cuneiform script was used in the Near East, until *ca.* AD 30.

The evolution of art and writing

During the millennia following its appearance, iconic art proliferated according to the improvements of lithic technology. The development of fine blades, burins and drills resulted in a more precise execution. The outlines of designs and carvings became sure and crisp compared to the Aurignacian lines. More importantly, the new tool

kit gave access to more materials. Consequently, the scope of art was enlarged to mobiliary art, or art on portable objects made of bone or antler, such as spears, spear throwers and harpoons.

During the two centuries after its invention the changes in writing came from within and not without. The system strived to communicate data more and more efficiently and, in order to do so, made two great strides. First, about 3100 BC, the notations in one-to-correspondence were superseded by the appearance of abstract numerals - signs that represented abstract numbers used indiscriminately to count various commodities. The impressed signs for measures of grain, the wedge and circular signs became the first numerals, standing for 1 and 10. Thirty-three jars of oil were shown by three circular signs and three wedges.

Second, about 3000 BC, phonograms - signs standing for sounds - were used to record personal names. These signs are dubbed 'pictographs' because they consisted of small sketches of things easy to draw. But the signs did not refer to the object they represented, but to the sound of the word they suggested. The drawing of an arrowhead was read 'ti' which was the sound of the word for 'arrowhead' in Sumerian (Gelb 1952:67). It is particularly important to note that the stage of 'pictographs' never meant writing with small pictures. Instead, the 'pictographs' heralded phonetic writing - a script in which signs represented sounds.

By developing abstract numerals and by creating signs that emulated the invisible and intangible sounds of spoken language, writing further distanced itself from art. Art is fettered in the concrete universe of volume, shape and light because images - even stylized to the utmost - evoke the object or idea they stand for. Furthermore, pictures always remain anchored in one-to-one correspondence: in art three

sheep could only be pictured by the representation of three sheep.

The spread of art and writing

Because images are accessible to anyone and are effortlessly understood, art became a world-wide phenomenon as early as the Upper Paleolithic period, and remained so ever since: no culture is known that does not foster art.

On the contrary, because writing and reading a text required knowledge of the system and learning the correct value of signs - misreading a sign severely alters the intended meaning - literacy was adopted by few select cultures. Compared to the simplicity of art, the complex analytical processes involved in writing and reading must have felt threatening to many.

Conclusion

From its beginning writing was fundamentally different from art. The two communication systems had a different origin, history and evolution. Their invention was separated by twenty millennia. Whereas art came without precedent, writing evolved over four thousand years from a counting system using clay counters. While art seems unrelated to any particular landmark of human evolution, the development of writing coincided with state formation. Whereas art was subordinated to technological advances, writing was driven by the administration of an economy of redistribution. In art two-dimensional images preceded three-dimensional sculptures. In contrast, it took four millennia to reduce three-dimensional tokens into two dimensional signs. Finally, whereas art became a universal phenomenon, writing remained the privilege of a few societies.

About the author

Denise Schmandt-Besserat, The University of Texas at Austin; E-mail: dsb@mail.utexas.edu.

References

Bahn, P., and J. Vertut

1988 *Images of the Ice Age.* Facts on File, New York.

1997 *Journey through the Ice Age.* University of California Press, Berkeley.

Gelb, I. J.

1952 *A Study of Writing.* The University of Chicago Press, Chicago.

Marshack, A.

1991 *The Roots of Civilization.* Moyer Bell Ltd., Mont Kisko.

Schmandt-Besserat, D.

1996 *How Writing Came About.* The University of Texas Press, Austin.

1992 *Before Writing.* The University of Texas Press, Austin.

Four Forms of Finger Flutings as Seen in Rouffignac Cave, France

Kevin Sharpe [†] and Leslie Van Gelder

Introduction

Building from Marshack's method of internal analysis, four forms of finger flutings are isolated and illustrated from Rouffignac Cave, France: Mirian, Evelynian, Rugolean, and Kirian. They are respectively characterized by lower-body movement by the fluter while fluting with more than one finger, lower-body movement and fluting with one finger, standing still and fluting with more than one finger, and standing still and fluting with one finger. Initial thoughts are provided as to where this analysis might lead.

Prehistoric finger flutings (the lines that human fingers leave when drawn over a soft surface) occur in caves through southern Australia, New Guinea, and southwestern Europe, and were presumably made over a considerable time span including some or all of the Upper Paleolithic. Most are not obvious figures or symbols; flutings of this type, along with similar engravings, are termed "severines."

Lorblanchet (1992:451) writes about the 120 m² of flutings that occur in Pech Merle Cave in the Lot Department of France: "Almost all the clay walls that are accessible without too much difficulty bare these markings." Plassard (1999:62) mentions 500 m² of flutings ("meanders" as he calls them; they are also known as "macaroni" and "serpentines" (Marshack 1977:286)) in Rouffignac Cave in the Dordogne, France, whereas he isolates 254 figures (animal, human, and other motifs) in the cave; these cover far less surface area. Leroi-Gourhan

(1958:314) reports that "incomplete outlines and bundles of lines...with very few exceptions...exist in every cave". Severine flutings form a major component of Paleolithic "art."

Little is written and known about them, however; Clottes and Courtin (1996:59) write, "Barely a quarter of the finger tracings in some seventy European Paleolithic painted caves has been the subject of surveys and precise analyses". Almost all writings on them either barely describe them, say that they exist in profusion or are enigmatic, or mention them only in-so-far as they occur in conjunction with or are used to create figures such as mammoths (Barrière 1982:150) and motifs such as Tectiforms (Barrière 1982:156; Plassard 1999:61; for examples of other motifs, see Barrière 1982:158). "Archaeologists have not known what to do with this class of marking or image" Marshack (1977:286, 300) says, though examples have "been seen, copied, and published" for a century.

The reason for this, Marshack continues, 'is that there has been no theoretical basis for internal analysis or interpretation of form, no technology for its study, and no means for relating these forms to the recognizable animal images with which they are often associated.' Or, as Clottes and Courtin (1996:59) write: 'This clearly has to do with the indifferent aesthetic appeal of these depictions, with the technical difficulty their study presents, and with the uncertain and often insufficiently gratifying results that the researcher can expect at the conclusion of the task.'

Speculation as to their meaning, therefore, can run unchecked; they are seen, for example, as representing such things as water (Marshack 1977:314), entoptic shapes or phosphenes (Bednarik 1984), huts, comets, or rivers (Leroi-Gourhan 1958:314), snakes (and thereby associated with death) (Barrière 1982:88, 195), psycho-neurological archetypes (Gallus 1977), and hunting marks (Barrière 1982:184). Four of the most well-known experts on prehistoric art fall to over-reaching speculation.

Breuil (1952) describes severines carefully, seeing them in part as the first scribbles by humans, though intuitive and random. The fluters probably recognized images in the severines and thus, from them, developed the tradition of simple and crude outline figures. Breuil's interest lies in the development of a comparative typology and chronology of the styles of the "art." He speaks of severines as serpentine-meanders and thinks of them as snakes.

Using statistics, Leroi-Gourhan (1958) studies the placement and spread of signs and images within a cave and their association with each other. He calls these relationships polar, oppositional, "sexual," or female-male. He speaks of severines as linear-phallic and thinks of them as male symbols or as unfinished outlines.

Marshack (1977:301) not only suggests that the meaning of severines lies in an association with water, but he also offers an evolutionary sequence of severine forms "in which a more formal [form] begins to give a geometric appearance to the linear, carefully drawn [severine] structure."

Bednarik (1986a:35–36) distinguishes three styles of European flutings: the oldest, what he calls "digital fluting," comprises "complete finger sets (*i.e.*, usually of four digits) running a predominantly rectilinear course" and which are short (less than half-a-meter long). More recent is the style he calls "conventional macaroni."

Here, "serpentine, curvilinear, and conjunctive elements are a characteristic, as is the frequent use of less than four fingers." Sets tend to be longer than those of digital flutings, reaching several meters. Sometimes "iconic representations are incorporated into the arrangements of macaronis, or are obviously intentionally associated with them." The third style in Europe that Bednarik isolates, but which does not occur in Rouffignac, comprises "finger paintings produced by the application of a pigment onto a hard surface with fingers of one hand." With this three-fold style analysis, Bednarik takes the study of finger flutings a little further, though his parallel investigations into such things as the geomorphology of the media fluted (*e.g.*, Bednarik 1999) has added much more.

Lewis-Williams (2002:215) begins to approach flutings more openly when he writes that they "appear without representational images often enough to suggest that they had their own significance." However, he holds firm ideas as to this significance; he and Clottes write:

> In some instances, it seems as if people were trying to penetrate the surfaces, to reach through the walls; in other instances, people were simply touching – and leaving evidence for their actions on – the walls. Why did they do this? [For Upper Paleolithic people,] the walls, ceilings, and floors of the caves were....little more than a thin membrane between themselves and the creatures and happenings of the underworld. The caves were awesome, liminal places in which to be: Literally, they took one into the underworld..... Perhaps one could say that the caves were the entrails of the underworld.... What people believe[d] about the walls influence[d] those who made the images [on the walls] (Clottes and Lewis-Williams 1998:85–86).

All such speculations need putting aside until proof for any of them can be found; nothing as yet can reasonably arbitrate between them. The chief problem is that investigators bring to their study preconceived, modern western notions as to what is meaningful or ought to be meaningful in this context, and what constitutes a pattern. They impose what they consider is the meaning of the severines and how the various forms of prehistoric "art" relate to each other. As Marshack writes,

> [previous investigations try] to recognize or interpret images or signs on the basis of what the modern eye sees or on what historic cultures might offer for analogic comparison.... to seek for the origins of "art" in the recognizable image, recognizable to us. Because recognizable images such as animals are occasionally found among the [severines], it was assumed that it was out of random marking that representational art was eventually born (Marshack 1977:287, 300).

Should or can nothing therefore be said about severines? Ucko (1992:158) states: "It is.... inconceivable to us today to understand the nature of [severines]." Often thought of as meaningless, they are now usually considered beyond interpretation. This is too extreme a conclusion.

Rather, it is instructive to say with Lewis-Williams (2002:215) that severines "had their own significance." They need to be taken seriously and not dismissed or subordinated to some other form of "art." In other words, it makes sense at this stage of the study of severines to leave aside the question of meaning; better would be to see what can be said about the marks themselves as they were made. Such investigations, anyway, come logically before subjective-interpretative and meaning-seeking approaches to severines and may help sort out

the various suggestions as to meaning or lay a solid foundation for seeking meaning.

Marshack helps develop a way to investigate the severines themselves. He talks of them as intentional systems of markings:

> [I proceed] from an assumption that in the Upper Paleolithic the recognizable image was not derived accidentally from random [severine] marking, first because the [severines] are not random but, more important, because the ability to see an image in a random cluster (or a rock or wall formation) requires culture. It is part of a process of description, classification, comparison, and naming. It is a human, cultural activity. In this regard, the ability to initiate and maintain an image system, such as the [severine], requires naming and language.... [This] is, of course, [in addition to the] basic cognitive, kinesthetic, non-linguistic component in image-making and recognition (Marshack 1977:300).

Though he defers to his predecessors, he also pioneers strategies for this type of research. He writes:

> I tried to develop techniques and a theoretical basis for the intensive internal analysis of the Upper Paleolithic symbolic materials..... My effort was.... directed toward.. .a study of the cognitive processes involved in the formation of an image, a study of the sequence of making an image or a composition or the sequence of accumulating images on a surface.... This enquiry was.... functional and psychological (Marshack 1977:287; see also, for example, 1972, 1975, 1989, 1997).

However, by placing his idea of the development of forms onto the forms themselves, and by expounding water as the meaning of the markings, Marshack retreats from the above

grounded analysis and methodology to speculation, and does so without clearly differentiating between the two approaches. The core of his methodology needs adopting and developing, and his speculations as to meaning and the evolution of 'art' need putting aside.

This paper continues to develop Marshack's more objective and experimental approach to the lines (Sharpe 2004; Sharpe and Lacombe 1999; Sharpe, Lacombe and Fawbert 1998, 2002; Sharpe and Van Gelder 2004), in this instance by differentiating different forms of flutings and illustrating them from Rouffignac Cave. In other words, this work continues the beginning of a remedy for the situation that Clottes and Courtin diagnose and that Marshack meets as a first attempt - and, following his leads, used by Bednarik (for example, Aslin, Bednarik, and Bednarik 1985; Bednarik 1984, 1986a, 1986b, 1986c, 1987, 1990, 1994a, 1994b, 1994c, 1997), d'Errico (for example, 1989, 1991, 1992a, 1992b, 1993, 1994, 1995; d'Errico, Henshilwood and Nilssen 2001), and Lorblanchet (for example, 1984, 1992, 1995, 1999)).

Table 19.1 Terminology

Fluting
Refers to a line drawn with a finger.

Severine
Is suggested for line markings that do not participate in the figurative part of a definitive figure or demonstrable symbol or sign, equivalent to Marshack's term 'meander' but without the restrictive overtones of this word. Thus, the category 'line markings' not only comprises flutings and engravings but, coextensively, also severines, figures, and symbols.

Graphical unit (abbreviated as 'unit')
Refers to flutings drawn with one sweep of one hand or finger (Marshack 1977). (Previously, this was referred to as a 'stream' (for instance, in Sharpe, Lacombe and Fawbert 2002); the terminology has been changed to avoid possible interpretative inferences.)

Hand (alternative to 'unit' for finger flutings)
Refers to the marks sometimes called fingers that the fingers of one hand flute at the same time; so, one can talk of a (left or right) hand of (1, 2, 3, 4, or 5) fingers.

Cluster
Labels an isolatable group of units that exhibit a unity, for instance because they overlay each other.

Panel
Refers to a collection of clusters that appears geographically or otherwise distant from other clusters or on a surface of reasonably uniform orientation.

'Ideational element' (or, abbreviated, the word 'element')
Refers to flutings that together form a basic element of meaning for the fluters, equivalent to Marshack's term, "iconographic unit" (Marshack 1977:300).

Fluting versus engraving
Applies to line markings made with fingers, and the term engraving refers to line markings made with a tool. Within engravings, a difference exists between scratches (animal claw marks), incisions (lines that humans make with flint or other pieces of rock), scorings (lines that humans make with a stick), and bone marks (lines that humans make with a bone).

Terminology

The following terminology may help when discussing flutings (Table 19.1)

Rouffignac Cave

As mentioned above, this paper will continue in the line of Marshack's more objective and experimental approach to the lines, by differentiating different forms of flutings and illustrating them from Rouffignac Cave (see Figure 19.1).

A brief introduction to the geography of Rouffignac Cave will help identify its chambers mentioned below in reference to particular flutings. To avoid possible inferred interpretations of flutings and figures, the names Barrière (1982) gives for several chambers in Rouffignac Cave are replaced with an extension of his use of letters (see the caption to Figure 2; Chamber A1 is the 'Chamber of Undulating Flutings' (Sharpe, Lacombe and Fawbert 2002) and the 'Serpentine' or 'Macaroni' Room or Ceiling (Barrière 1982:88; Plassard 1999:76). A tourist train traverses the most commonly visited chambers in Rouffignac Cave: Chamber G down to and including the Great Ceiling, and the first part of Chamber J. Special guests may also see Chamber A1 and the second part of Chamber J. These areas, plus Chamber E (also known as the 'Leroi Gourhan Gallery'), contain a large portion of the flutings found in Rouffignac, and most of the instances this paper discusses.

Four forms of flutings

Marshack distinguishes several styles among the severines of La Pileta Cave:

> These include idiosyncratic individual 'styles' made in various contemporary traditions... [Some are] meanders and additions made by one, two, or three fingers using a yellow ochre. These are in the early, 'primitive,' basic style. Although many of

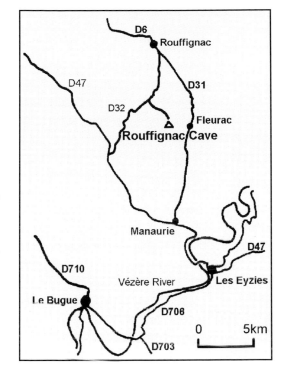

Figure 19.1 Local geography of Rouffignac (after Barrière 1982:Fig. 1).

the markings present a double or triple marking, each is a 'unit'... The style is clear: there is a basic, 'central' meander and then branches or additions are attached or are arranged in proximity. In some panels...the meander is associated with animals: ibex, bull, and 'rhino' or bear... A later, more evolved meander usage [also exists] in which a more formal style begins to give a geometric appearance to the linear, carefully drawn [severine] structure...[of a] core meander consisting of doubled lines and additions... [for example of] attached lateral branches, crossing marks, and linear extensions of the serpentine form (Marshack 1977:301).

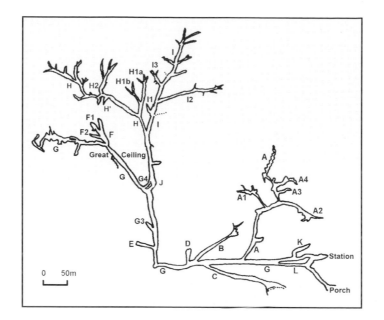

Figure 19.2 Plan of Rouffignac Cave showing the various chambers (after Barrière 1982: Fig. 2; note that J = Barrière's 'Henri Breuil Gallery,' K = 'Gallery of l'Etron de la Vielle,' L = 'Raccourci Gallery', and that Chamber G subsumes the 'Voie Sacrée' or 'Via Sacra').

In developing a parallel instrument to Marshack's suggested set of styles, the term 'form' is preferred to 'style.' The latter may imply a cultural difference between the fluters of different styles, whereas 'form' may relate not only to that possibility, but also to differences caused by differences between the media fluted, the geographies of the places fluted, or the fluting techniques. Four forms of finger flutings are suggested: 'Mirian,' 'Evelynian,' 'Rugolean,' and 'Kirian.' These are the four possible manifestations of two variables: whether fluters moved their lower bodies during fluting and whether they used one or more than one fingers to flute. The sections below will further define these forms and describe them as they occur in Rouffignac Cave.

Before embarking on that, though, a more fundamental and theory-oriented question arises.

How might one adequately establish the relevance of these four forms of flutings to the study of flutings, say in Rouffignac Cave? To do so perhaps requires: 1) describing the four forms and differentiating them one from another; 2) pointing to the existence in Rouffignac Cave of lines satisfying the four descriptions; 3) raising research questions from the form analysis for investigation; and 4) pointing to information about the fluters that the analysis might provide. The sections below will address this series of points.

Mirian form

Definition

Two things define a unit of finger flutings as being of the Mirian Form: lower-body movement on the part of the fluter (as opposed to the fluters only moving their upper bodies), and the unit

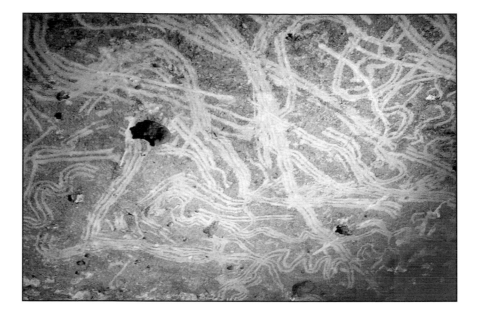

Figure 19.3 Mirian Form flutings in Chamber A1.

comprising more than one line. 'Lower-body movement' means that the people who create these multi-finger units of flutings walk or otherwise move their legs while fluting (thus the lines may extend beyond the arm range of a stationary fluter), or else move their bodies from their hips by, for instance, bending, twisting, or shifting their weight.

The flutings in Chamber A1 of Rouffignac Cave typify the Mirian Form (see Figure 19.3; see also Figure 19.4)

Further description

Besides lower-body movement, several attributes of the Mirian lines in Chamber A1 sometimes stand out (Sharpe and Van Gelder 2004): 1) zigzags or undulations can occur, units that move back and forth from one side to the other down their length; 2) circles and spirals can occur; 3) units can extend some distance, up to several meters; 4) units can lay one over the

other, obliterating the underlying ones; 5) young children made many of the units, though some evidence of adult-sized hands also occurs (Sharpe and Van Gelder 2004).

Distribution in Rouffignac Cave

Chamber A1 contains many Mirian Form flutings (see Figure 19.3). They also occur in large quantities in Chamber E (on the right of the step-down in the ceiling) (see Figure 19.4), in Chamber G (between where Chamber J starts and the Great Ceiling), and in the inward half of Chamber J. The fourth of these collections has weathered poorly in comparison with those in Chamber G, though both are made in Moonmilk. The Mirian fluters of Chambers E and A1 marked through a thin clay deposit on the walls and ceilings, exposing the white of the limestone underneath. The markings in Chamber E have not survived as well as those in Chamber A1.

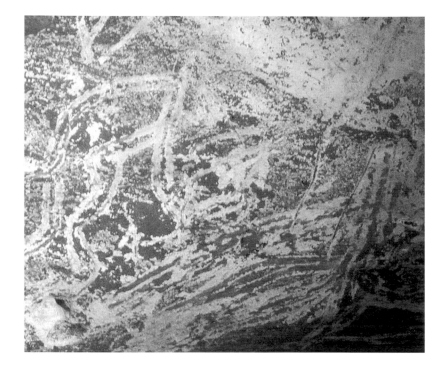

Figure 19.4 Mirian Form flutings in Chamber E.

Comments

The word 'undulating' could apply to those Mirian lines that undulate; indeed, as mentioned above, other publications call the chamber of Rouffignac Cave that contains the flutings characterizing the Mirian Form the 'Chamber of Undulating Flutings,' the 'Macaroni Room,' and the 'Serpentine Room.' The word 'serpentine' (or any version of the word 'snake'), however, suggests too broad a set of meanings for the flutings (that they represent snakes, literally or metaphorically), though the original namers of the room may not have intended this (see Sharpe, Lacombe and Fawbert 2002). Further, the term 'macaroni' frequently refers to finger flutings in a more general context than the nomenclature 'Mirian Form' intends, and to too diverse a set of referents to restrict it to the

Mirian Form. Some authors prefer the term 'meander' (Plassard 1999:60), but this suggests that all the flutings are long, whereas this is not true of many of those in Chamber A1. This leaves such descriptive words as 'undulating,' 'zigzagged,' and 'wavy.' Flutings in the room in question usually appear between undulating and zigzagged, too sharp in their turns to undulate and too curved to zigzag. Perhaps the term 'wave' and its derivatives may be more appropriate.

An important issue, one that other papers address (for instance, Sharpe and Van Gelder 2004), concerns the age of the fluters that the sizes of the flutings suggest. Many of the units occur in three fingers and measuring across them (when held together) provides an indicator of the fluter's age. Many three-fingered measurements made in Chamber A1 are

around 27 mm. Contemporary small children, aged around four to seven, flute three lines at about 27 mm in width. Contemporary teenage and adult hands produce three-finger flutings of 35-50 mm in width. Assuming that this is a valid analysis, it suggests that young children made most of the Mirian Form flutings in Chamber A1, with an occasional older person involved. The current ceiling height is, however, too high for a child to have marked. Did older people hold up the fluting children?

Evelynian form
Definition
Two things define a unit of finger flutings as being of the Evelynian Form: lower-body movement on the part of the fluter and the unit comprising only one line. The people who create these one-finger units of flutings walk or otherwise move their legs while fluting, or else move their bodies from their hips.

Further description, distribution in Rouffignac Cave, and comments
Figure 19.3 shows some Evelynian Form flutings amidst Mirian lines (not the white, much more recent scratches, probably from sticks held up by modern visitors). So far, no concentrations of Evelynian flutings have been found in Rouffignac Cave. However, they do appear in two types of places: among Mirian lines, for example in Chambers A1 and G, and as the outline of several of figures, which are fluted with a single finger and require the movement of the lower body to execute.

Rugolean form
Definition
Two things define a unit of finger flutings as being of the Rugolean Form: the fluter standing in one spot while fluting the unit, and the unit comprising more than one line. The people who flute in the Rugolean Form stand still, move their upper bodies, and mark with more than one finger at a time. The fluter may move between making units, but stands stationary for each unit.

The units within and to the right of the two facing mammoths in Chamber G of Rouffignac Cave (Mammoths 17 and 18; the 'Mammoths of Discovery'; Barrière 1982:20-21) typify flutings in the Rugolean Form (see Figure 19.5-19.6).

Further description
Besides the fluter standing still and using multiple fingers, several attributes of the Rugolean lines in Chambers G and J sometimes stand out: 1) they are vertical, moving downward, with an occasional diagonal unit also moving downward; 2) a few appear fluted by small (children's) fingers; however, adults appear to have made most of them; 3) they tend to lie from shoulder to waist height, the reach of a stationary fluter determining any arcs made; 4) they tend to appear on walls, not ceilings; 5) they are rarely multi-layered, not usually lying over top of one another in a jumble; 5) they appear neat, decisive, and methodically executed.

Distribution in Rouffignac Cave
Rugolean lines appear in many chambers of the cave, often on walls of Moonmilk under bands of flint nodules. Particular concentrations of them occur within and to the right of the two facing mammoths 17 and 18 in Chamber G (as mentioned above), on the walls of Chamber G past its junction with Chamber J, and on the left-hand wall several meters into Chamber J.

Comments
The idea of finger flutings may automatically raise the image of Rugolean markings. As with other forms of flutings, however, it is easy and

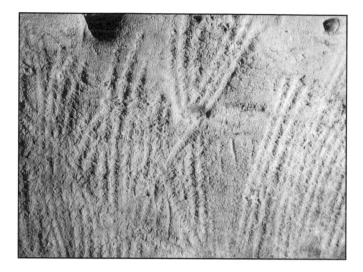

Figure 19.5 Rugolean Form flutings in Chamber G (the right side of the two facing mammoths (Mammoths 17 and 18 ; Barrière 1982: 20-21)).

Figure 19.6 Rugolean Form flutings in Chamber J (on the right side of Barrière's 'Panel of the Patriarch' (Barrière 1982: 131, Fig. 387)).

often mistaken to lump all Rugolean flutings together. For instance, the Rugolean lines in Figures 19.5 and 19.6 tend not to lie over top of each other in a jumble, whereas most of the flut-ings in Koonalda Cave, South Australia – while they are also probably Rugolean lines – form a mesh of overlying and frequently inseparable lines (Maynard and Edwards 1971).

Kirian form

Definition

Two things define a unit of finger flutings as being of the Kirian Form: the fluter standing in one spot while fluting the unit, and the unit comprising only one line. The people who flute in the Kirian Form stand still and mark with one finger.

The left side of the step-down in the ceiling of Chamber E in Rouffignac Cave typify flutings in the Kirian Form (see Figures 19.7–19.8).

Further description

Besides the fluter standing still and using one finger, several attributes of Kirian lines in Chamber E sometimes stand out: 1) they often occur in clusters of six or seven (or 14) semi-parallel lines; 2) their fluters appear to have retouched some of them or added to them with clay smears and stick scorings; 3) they can include motifs such as spirals, circles, interweaving lattices, and uni-centric arcs (arcs with a common starting point) (not all the lines need be parallel or semi-parallel);

4) they do not appear multi-layered, not lying over top of one another in a jumble; 5) they were probably fluted by adults.

Distribution in Rouffignac Cave

Other than in Chamber E, as mentioned above, clusters of Kirian lines do not frequently appear in Rouffignac Cave.

Comments

Were the Kirian lines in Chamber E made in the Neolithic or in medieval times (Barrière 1982)? This casual suggestion merits elucidation by dating the charcoal deposited in some Kirian lines from the ends of burned sticks scraped over and under them. Further, Kirian and Mirian flutings occur side-by-side in Chamber E (Figures 19.4, 19.7–19.8) with little or no apparent difference in weathering and patination.

Discussion

The key distinguishing factors used here to

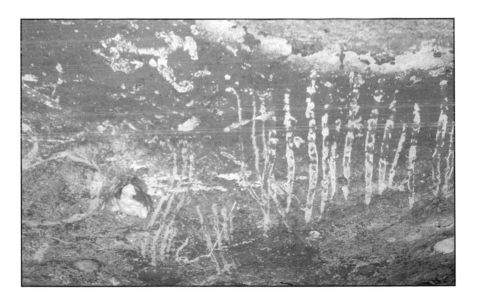

Figure 19.7. The right hand half shows Kirian Form flutings in Chamber E.

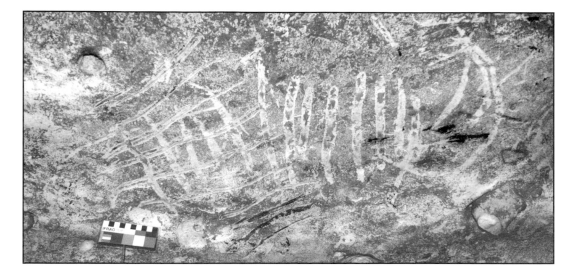

Figure 19.8 Further Kirian Form flutings (the verticals) in Chamber E (with horizontal stick scratches).

define the Mirian, Evelynian, Rugolean, and Kirian Forms are the fluter's lower-body movement, and whether he or she used one or multiple fingers. Several matters arise from these definitions and the presence of such lines in Rouffignac Cave:

Forms coexist in some chambers in the cave (for instance, in Chamber E), sometimes intermingling on a room's wall or ceiling (see Figure 19.9). One can imagine fluters occasionally using one finger when they usually used more than one in that panel, or not overly concerning themselves about where they marked in a particular form in relation to whatever other marks were present. The coexistence of forms is of little importance if the different forms are seen as primarily leading to different questions that can be asked of them based on their means of manufacture.

Thus, the lack of a concentration of Evelynian flutings in Rouffignac Cave (at least the fact that investigations to date have not found one), as opposed to merely their presence in figures or among Mirian lines, need not place a question over the usefulness of the form differentiation as a methodological starting point for investigating the flutings in this cave.

Some features of the flutings are potentially a byproduct of their form; for instance, Mirian flutings can extend longer (several meters) than Rugolean flutings (about 60 cm maximum) because the fluter can walk while making the former, but not the latter. Some features are also potentially a byproduct of the local geography of the cave; for example, the Mirian flutings pointed out above in Chamber A1 can extend longer than Kirian flutings in Chamber E (about 25 cm) because of the larger space available for fluting.

How can one objectively ascertain the difference between flutings made by a fluter moving her or his lower body and those made by a fluter standing still? It may appear obvious when a unit moves way beyond any stationary person's reach or with a unit that starts vertically and then

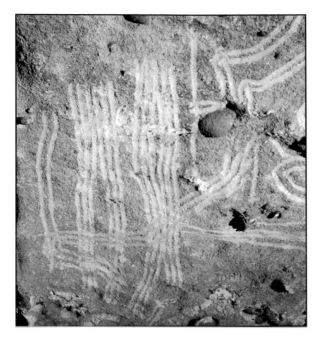

Figure 19.9 Rugolean (on the left) and Mirian Form flutings (on the right) next to each other in Chamber A1, on the left wall at the entrance to the fluted room. One vertical Kirian fluting can be seen in the middle right and another shorter one to the lower right of that.

moves sideways as the fluter moved. However, other circumstances may be more complex. The issue requires further investigation, but probably it needs the isolation of further indicators that relate to the fluter moving or standing in one spot. One avenue that may prove fruitful is to seek what might be called 'jogs' in Mirian lines, where the continuity of the fluting is interrupted when the fluter takes a step while fluting. As another example, certain shapes (for example a circle on a ceiling) require hip, if not leg and feet movement, rather than only movement of the upper body.

Marshack's and Bednarik's classifications of flutings are based on temporal if not developmental or evolutionary schemes, but the differences in flutings that they try to explain need not follow this type of relationship. Rather, the differences could result from different means of manufacture: Bednarik's 'styles,' for example, represent the Rugolean Form (his 'digital fluting' style) and the Mirian Form (his 'conventional macaronis' style). Further, no temporal relationship between the two styles or forms has been convincingly noticed in Rouffignac and hence a strict temporal relationship between the forms cannot be authenticated.

Several questions for further consideration and research remain: other forms besides Mirian, Evelynian, Rugolean, and Kirian - based on variables of manufacture other than lower-body movement and the number of fingers used - may occur, and further investigations may help to isolate them.

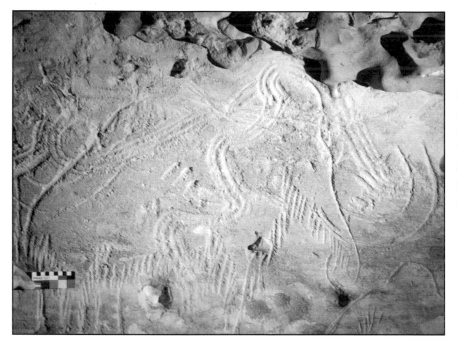

Figure 19.10 A mammoth with flutings in Chamber G, 'Frieze of the Five M a m m o t h s' (Barrière 1982:33: Figs. 66-67).

Is the means of manufacturing flutings (that is, the form division) more helpful in cataloguing and analyzing them than are consistencies in the resulting appearance? The above-mentioned indicator of fluter age (Sharpe and Van Gelder 2004) may promise an affirmative answer. Perhaps, however, after manufacturing techniques are taken into account, consistent differences in appearance may help make further sense of the flutings; wavy lines within some of the drawn mammoths, for instance, may indicate some further useful differentiation (see Figure 19.10).

Further investigations into the factors underlying the forms may yield questions – beyond that of the fluter age – for further investigation.

Why do different forms exist in concentrations as opposed to there being only one form or always a thorough mixture of forms? Perhaps the forms relate to different cultures or traditions, each advocating a different way to flute cave walls. Or perhaps the different forms relate to different behaviors, or to fluters employing different forms for different purposes or meanings, or in response to different needs. On the other hand, does the physical geography of the room, its position in the cave, or the medium employed more directly relate to the fluting form(s) used in it?

This four-form analysis may at present make sense for Rouffignac Cave, but might it also make sense for other caves, locally in the area of Les Eyzies or further away, within southern France and northern Spain, or further afield? Is it universal? It may or may not shed light on the flutings in other caves and establish a useful platform for understanding the fluting phenomenon in general.

The division of flutings by fluter lower-body movement and the use of one or more fingers may hopefully prove a useful tool for the study of flutings in Rouffignac Cave. This hypothesis may, however, prove more confusing than helpful. Time will tell.

Conclusions

Referring to the points raised above concerning the methodological relevance of the analysis of flutings into four forms, this paper has: 1) described each of the four forms (Mirian, Evelynian, Rugolean, and Kirian) and differentiated them one from another; 2) pointed to the existence in Rouffignac Cave of lines satisfying the four descriptions; 3) raised research questions from the form analysis for investigation; and 4) pointed to information about the fluters that the analysis might provide.

The paper, therefore, probably establishes the existence of different forms of finger flutings in Rouffignac Cave, and that this differentiation has merit as a means of categorizing flutings - at least it provides a starting point for mining data regarding the fluters. This takes steps toward understanding the phenomenon of finger fluting. Research now needs to turn to: 1) studying flutings of each form in more detail; 2) comparing clusters of the same form in detail; 3) seeking relationships between clusters of different forms; 4) pursuing further what each of the two variables that define the forms might say about the fluters; and 5) investigating flutings in caves other than Rouffignac.

Perhaps this form analysis and knowledge of the fluters that comes from it may even help crack the issue of fluter intentionality.

Acknowledgments

Thanks are due to those who have helped support this research: Jean and Marie-Odile Plassard, for their support and for permission to work in Rouffignac Cave; the guides while in the cave: Séverine Desbordes, Frédéric Goursolle, and Frédéric Plassard; Union Institute and University, for financial support through its faculty research grants; Robert Bednarik, Jean Clottes, Francesco d'Errico, Sandor Gallus[†], Michel Lorblanchet, Alexander Marshack[†], and Hallam Movius Jr.[†] for discussions and support over many years.

About the authors

Kevin Sharpe[†]

Leslie Van Gelder, Walden University, Minneapolis, Minnesota; 10 Shirelake Close, Oxford OX1 1SN, United Kingdom. E-mail: lvangeld@waldenu.edu.

[†] *deceased*

References

Aslin, G. D., E. K. Bednarik, and R. G. Bednarik

1985 The 'Parietal Markings Project': A progress report. *Rock Art Research* 2(1):71-74.

Barrière, C.

1982 *L'Art Pariétal de Rouffignac: La Grotte aux Cent Mammouths.* Picard, Paris.

Bednarik, R. G.

1984 On the nature of psychograms. *The Artefact* 8:27-32.

1986a Parietal finger markings in Europe and Australia. *Rock Art Research* 3(1):30-61.

1986b Cave use by Australian Pleistocene Man. *Proceedings of the University of Bristol Speleological Society* 17(3):227-245.

1986c Reply to 'Parietal Finger Markings in Europe and Australia.' Further comments. *Rock Art Research* 3(2):159-170.

1987 The cave art of Western Australia. *The Artefact* 12:1-16.

1990 The cave petroglyphs of Australia. *Australian Aboriginal Studies* 2:64-68.

1994a On the scientific study of Paleoart. *Semiotica* 100(2):141-168.

1994b The discrimination of rock markings. *Rock Art Research* 11(1):23-44.

1994c Further comment. Epistemology and Paleolithic rock art. *Rock Art Research* 1(2):118-121.

1997 The global evidence of early human symboling behavior. *Human Evolution* 12(3):147-168.

1999 The speleotherm medium of finger flutings and its isotropic geochemistry. *The Artefact* 22:49-64.

Breuil, H.

1952 *Four Hundred Centuries of Cave Art.* Centre d'Etudes et Documentations Prehistoriques, Montignac, France.

Clottes, J., and J. Courtin

1996 *The Cave Beneath the Sea: Paleolithic Images at Cosquer,* English edition, translated by M. Garner. Harry N. Abrams, New York.

Clottes, J., and D. Lewis-Williams

1998 *The Shamans of Prehistory: Trance and Magic in the Painted Caves,* English edition, translated by S. Hawkes. Harry N. Abrams, New York.

d'Errico, F.

1989 A reply to Alexander Marshack. *Current Anthropology* 39:494-500.

1991 Microscopic and statistical criteria for the identification of prehistoric systems of notation. *Rock Art Research* 8(2):83-93.

1992a A reply to Alexander Marshack. *Rock Art Research* 9:59-64.

1992b Technology, motion, and the meaning of Epipaleolithic art. *Current Anthropology* 33(1):94-109.

1993 La vie sociale de l'art mobilier Paléolithique: Manipulation, transport, suspension des objets en os, bois de cervidés, ivoire. *Oxford Journal of Archaeology* 12:145-174.

1994 *L'Art Gravé Azilien de la Technique à la Signification.* Supplément à Gallia Préhistoire, no. 31. CNRS Editions, Paris.

1995 A new model and its implications for the origin of writing: The La Marche Antler revisited. *Cambridge Archaeological Journal* 5:3-46.

C. Henshilwood, and P. Nilssen.

2001 An engraved bone fragment from c. 70,000-year-old Middle Stone Age levels at Blombos Cave, South Africa: Implications for the origin of symbolism and language. *Antiquity* 75:309-318.

Gallus, A.

1977 Schematization and Symboling. In *Form in Indigenous Art: Schematization in the Art of Aboriginal Australia and Prehistoric Europe*, edited by P. J. Ucko, pp. 370-386. Prehistory and Material Culture Series, no. 13. Australian Institute of Aboriginal Studies, Canberra.

Leroi-Gourhan, A.

1958 La Fonction des Signes dans les Sanctuaires Paléolithiques. *Bulletin de la Société Préhistorique Française* 55:307-321.

Lewis-Williams, D.

2002 *The Mind in the Cave: Consciousness and the Origins of Art.* Thames and Hudson, London.

Lorblanchet, M.

1984 Grotte du Pech-Merle. In *L'Art des Cavernes: Atlas des Grottes Ornées Paléolithiques Françaises*, edited by A. Leroi-Gourhan, pp. 467-470. Ministère de la Culture, Paris.

1992 Finger markings in Pech Merle and their place in prehistoric art. In *Rock Art in the Old World*, edited by M. Lorblanchet, pp. 451-490. Indira Gandhi National Center for the Arts, New Delhi.

1995 *Les Grottes Ornées de la Préhistoire: Nouveaux Regards.* Editions Errance, Paris.

1999 *La Naissance de l'Art: Genèse de l'Art Préhistorique dans le Monde.* Editions Errance, Paris.

Marshack, A.

1972 *The Roots of Civilization: The Cognitive Beginnings of Man's First Art, Symbol, and Notation.* McGraw-Hill, New York.

1975 Exploring the mind of ice age man. *National Geographic* 147(1):64-89.

1977 The meander as a system: The analysis and recognition of iconographic units in Upper Paleolithic compositions. In *Form in Indigenous Art: Schematization in the Art of Aboriginal Australia and Prehistoric Europe*, edited by P. J. Ucko, pp. 286-317. Prehistory and Material Culture Series, no. 13. Australian Institute of Aboriginal Studies, Canberra.

1989 Methodology in the analysis and interpretation of Upper Paleolithic image: Theory versus contextual analysis. *Rock Art Research* 6(1):17-53.

1997 Paleolithic image making and symboling in Europe and the Middle East: A comparative view. In *Beyond Art: Pleistocene Image and Symbol*, edited by M. W. Conkey, O. Soffer, D. Stratman and N. G. Jablonski, pp. 53-92. Memoirs of the California Academy of Sciences, no. 23. California University Press, San Francisco.

Maynard, L., and R. Edwards

1971 Wall markings. In *Archaeology of the Gallus Site, Koonalda Cave*, edited by R. V. S. Wright, pp. 59-80. Australian Aboriginal Studies, no. 26. Australian Institute of Aboriginal Studies, Canberra.

Plassard, J.

1999 *Rouffignac: Le Sanctuaire des Mammouths.* Le Seuil, Paris.

Sharpe, K.

2004 Line markings: Human or animal origin? *Rock Art Research* 21(1):57-84.

Sharpe, K., and M. Lacombe

1999 Line markings as systems of notation? In News 95: International Rock Art Congress Proceedings. Pinerolo, Italy: IFRAO - International Federation of Rock Art Federations, p. 46 and NEWS 95 - International Rock Art Congress Proceedings_files/sharp.htm.

Sharpe, K., and L. Van Gelder

2004 Children and Paleolithic 'Art': Indications from Rouffignac Cave, France. *International Newsletter on Rock Art* 38:9-17.

Sharpe, K., M. Lacombe, and H. Fawbert

1998 An externalism in order to communicate. *The Artefact* 21:95-104.

2002 Investigating finger flutings. *Rock Art Research* 19(2):109-116.

Ucko, P. J.

1992 Subjectivity and Recording of Paleolithic Cave Art. In *The Limitations of Archaeological Knowledge*, edited by T. Shay and J. Clottes, pp. 141-180. Etudes et Recherches Archéologiques de l'Université de Liège, no. 49. Université de Liège, Liège.

DEFINING MODERNITY, ESTABLISHING RUBICONS, IMAGINING THE OTHER – AND THE NEANDERTHAL ENIGMA

Olga Soffer

Introduction: The perils of mixed heritage

The "Neanderthal Enigma" – a range of questions about what happened to the Neanderthals and Middle Paleolithic lifeways in Eurasia some 50 to 30,000 years ago has been a perennial "hot topic" for the last two decades. Despite numerous conferences on the subject, today we are no closer to agreement if the advent of Upper/Late Paleolithic/LSA lifeways resulted from "evolution" or "revolution". In this chapter I argue that this muddled state of affairs is with us largely because of the dual heritage that our evolutionary theories have once we get beyond pure biology. This theoretical amalgam is a nineteenth century unilineal evolutionary construct that conjoined biological insights about how change through time came about with those of social philosophers. These two roots differed significantly in how change was envisioned. The progressive directionality of social philosophy, while broadly congruent with Lamarckian thought, was in an ongoing tension with the innate opportunism of Darwinian biology (Trigger 1989). The net result of this syncretism was to envision human prehistory as a series of universal progressive stages, each featuring specific technologies, subsistence practices, and social organization – something clearly exemplified by Henry L. Morgan's grand scheme, for example.

By the end of that century the depth of human antiquity was recognized, the archaeological record augmented with hominid remains, and the Paleolithic sub-divided within the Stone Age. The social-political realities in the first half of the twentieth century led to a divergence in what Euro-American scholars focused on in Paleolithic research. Scholars in continental Western Europe, after initial paleontological criteria to subdivide the Paleolithic (*e.g.*, the Age of the Reindeer, the Age of the Mammoth and Wooly Rhino), settled on stratigraphy and changes in tool typologies (Sackett 2000). Anglophone scholars, on the other hand, while incorporating earlier Scandinavian interests in the natural environment, focused on technological progress through time (*e.g.*, the Three Ages, dividing the Stone age into the Old and New Stone Ages). Although using different criteria to characterize the Middle and the Upper Paleolithic inventories, both constructs centered on one component of past technologies – durable tools and implements. Both also treated technology as sui generis – as well as assumed a progressive relationship between the two.

Researchers in the East, on the other hand, more influenced by German ethnology as well as by Marx, Engels, and Morgan, emphasized changes in social relationships through time (Boriskovskij 1984; Efimenko 1938; Klejn 1977; Trigger 1989). These diverse vantage points necessarily led to different ways of segmenting the continuous Paleolithic record – into the Lower, Middle, and Upper in the West and into the Ancient endogamous horde and Late kin-based exogamous clan societies in the East (Bordes

1968; Gamble and Roebroeks 1999; Grigor'ev 1968; Klejn 1977; 2001). In spite of these overt differences however, West, Central, and East European scholars all envisioned human prehistory as a series of universal linear evolutionary stages where the global was reflected in the local.

By the second half of the twentieth century, the Paleolithic "when" and "what" having been more or less established, research focus shifted to the "why" - giving rise to questions about ancestral behavior. Political events at the end of the century coalesced the East and West research agendas. Although these newly globalilized "why" questions were informed by ecological insights, they still carried with them many old and problematic assumptions. Specifically, the limited technological repertoire recovered from the sites was taken as a mirror of not only past performance but also of past capacity, the local and arbitrary nature of techno-typological constructs was naturalized and globalized, and technological progress continued to be seen as a self generating product arising from the intersection of hominid genius and need. This accompanied a normative stereotypical approach to behavior - one which was conceptualized on the group level only.

"Modernity" and the "Neanderthal Enigma"

This complex theoretical heritage, together with the accumulated research results, has produced the problematic contested criteria we use today to investigate the "Neanderthal enigma" and to characterize the transition from the Middle to the Upper Paleolithic. The central operating concept appears to be "modernity" - biological and behavioral - yet no agreement is on hand about its definition. While in more innocent days the two were equated, in light of the Near East record as well as of St. Césaire, Arcy (Hublin *et al.* 1996),

and Vindija (Smith *et al.* 1999), today we know that morphology and genetics are best decoupled from archaeology. Debates about "modernity" are ongoing among paleoanthropologists with the significance of particular character sets and DNA sequences in contention (Trinkaus 2005; Wolpoff *et al.* 2004 - both with references).

Debates are also evident in archaeology with discourse increasingly challenging the idea that there are discrete universal signposts or "fossil indices" of modernity diagnostic for all times and all places. In archaeology the "modernity" kitchen list is techno-centered and includes blades vs flakes; ivory, bone and antler technologies vs. just lithic or lithic plus wood ones; personal adornments vs. the unembellished body, and "art" and "decoration" vs. utilitarian minimalism (*e.g.*, Klein 1999, Mellars 2005, Bar-Yosef 2000, 2002). These criteria are more than slippery because they are neither universal nor eternal (Henshilwood and Marean 2003; McBrearty and Brooks 2000; Soffer 1995; Zilhao 2001, Zilhao and d'Errico 2003). The issue of flake vs. blade tools was a quantitative one for Bordes (1968) to begin with - 38% of tools made on flakes meant Middle Paleolithic, 41% Upper Paleolithic. Such a classification system not only rested on an essentialist assumption that the patterns in retouched stone tools are objectively real and meaningful, but also used very different typologies to begin with (Clark 1997a). No wonder a pattern was observed - the typological filter ensured it! Although blade tools were locally important in Southwestern France some 30,000 years ago, they were irrelevant in Australia and the New World until at least the mid-Holocene (Bar-Yosef and Kuhn 1999; Mulvaney and Kaminga 1999). Even in France itself, pre-Upper Paleolithic blade industries are noted at early Middle Paleolithic sites - as is the case in the Caucasus, in the Near East, and in Africa (Bar-Yosef and Kuhn 1999;

McBrearty and Brooks 2000; Kozlowski 1998). Such a waxing and waning blade record clearly indicates that blade tools are not valid markers of "modernity". A similar observation can be extended to all other tool types - be they bladelets, microliths, or grinding stones (contra Bar Yosef 2000, 2002).

More recent technological criteria of core treatment in the different chaînes opératoires - two dimensional or volumetric - are also not universally diagnostic. While Upper Paleolithic Perigord saw volumetric crested cores used, many coeval and equally modern Late Paleolithic Central Asians (Schäfer and Ranov 1998) and Siberians used bifaces and Levallois flake tools (Brantingham et al. 2001; Derevianko 1997; Vasil'ev 2001).

The appearance of bone, ivory, and antler implements also is a local weathervane and not a global one. First, they are found, admittedly sparsely, not only in Middle Paleolithic/Middle Stone Age assemblages - such as at Blombos in South Africa (Henshilwood et al. 2002, Henshilwood and Marean 2003) - but also in earlier ones such as late Acheulean at Salzgitter-Lebenstedt (Gaudzinski 1999a) as well as at Lehringen and Swanscombe, for example. Furthermore, the 400,000 year old Shoeningen wood spears remind us of the ubiquitous preservational bias that our focus on durable media ignore (Thieme et al. 1993). The proliferation of osseous implements in northern Eurasia at one point in Late Pleistocene time and their paucity or absence from the Near East, Australia, or the New World, I would suggest, have more to do with the thermal tolerance and plasticity of antler and bone in northern latitudes - something especially important in stadial times - than with human cognition.

The same critique can be extended to all other items of technology and, in fact, recently has been by McBrearty and Brooks (2001) in their argument that the "modernity revolution" never happened as such but represents a compendium of cumulative innovations first seen in Africa. While we may challenge some of their evidence, their point about the asynchrony and locality are most important.

The same observations are true for "art", for jewelry, engravings, and all other symbolically meaningful inventories. Durable personal adornments are equally local in time and across space and so are painted cave walls and carved figurines. While these inventories proliferate in Upper Paleolithic Eurasia, they are patchily distributed across it (Soffer 1994, 1995). They are sparse indeed on continents such as Australia or North America which were peopled by equally modern humans. These inventories also all but disappear from the locales of their prior proliferation - for example, from Europe at the close of the Pleistocene - only to appear where they were sparse before: the Natufian Levant, for example. Such a mosaic record clearly suggests that neither "the climate" nor unique capacities (i.e., "vitalism") are adequate explanations for these categories of artifacts or for the more mundane ones.

Bar Yosef and Kuhn (1999) have noted that evolutionary trends in Pleistocene Eurasia were historically contingent and not universal. This negates the value of seeing the Middle to Upper Paleolithic transition as a "Revolution" and seeking a core area where it began (contra Sherratt 1997; Bar Yosef 2000, 2002). To do so not only equates a contingent change in human behavior to speciation, but invokes the centuries old "ex Oriente lux" paradigm.

Implicating technology:
Inventions and innovations

We know that the Upper Paleolithic/LSA archaeological records in various - but not all - regions

of the occupied world do show a proliferation of blades and bladelets. These likely relate to changes in the desired supports and the use of complex composite tools. In northern latitudes these supports involved ivory, antler, and bone and signal a proliferation in the diversity and complexity of multi-component composite tools and a greater reliance on them (Bar Yosef and Kuhn 1999). Since this multi-component weaponry was likely used in hunting, what we are seeing, in fact, is a veritable "arms race" where it was, as Kuhn and Steiner (1998) put it, either important to be a better hunter or, maybe, to just look like one.

Exploring why this may have happened places us before a reality that technology, just like the symbolic marking of the self via jewelry or cave walls, is a social phenomenon. As Kranzberg (1989) has pointed out, technology is a very human activity and so is the history of technology. Furthermore, since technology solves problems – to understand both invention and its development we need to embed technology within human decision making from which it emanates (Dobres 2001; Lemonnier 1986, 1992, 1993). It follows from this that seeing technology as a solution to problems calls for specifying the types of problems that it addressed (Torrence 1989; Kuhn and Stiner 1998). For the purposes of this discussion I wish to stress Basala's (1988) point that technology is cultivated to meet perceived needs and that these needs are defined by a particular social matrix. The social matrix, in turn, is constrained by a number of variables that may be discernible in the archaeological record. Specifically, if we combine economic insights that in pre-market societies it is consumption that stimulates production (Gregory 1982), with the understanding that technology is a component of production, we can hypothesize that technological changes in the past likely signal changed wants – more specifically

increased consumption demands. Such changes in demands, as Minnegal (1997) has pointed out, may have resulted from changes in social organization alone - in other words, without requiring increase in population or group size.

Our past studies of prehistoric technologies have followed adaptationist paradigms which favor seeing ecological/economic concerns as primary in human decision making. More resent research points to the importance of the social and political concerns of the decision makers. Seeing technology as meeting perceived needs defined by a particular social matrix allows for new questions and insights. Why does the Upper Paleolithic/LSA initiate what Straus (1997) has called the "Upper Paleolithic arms race" - refinement and rapid change in support and insert types? As noted, Kuhn and Stiner (1998) have suggested that it reflected a desire to be a better hunter or, at least, to look like one. Why want this? Why hunt? What is the payoff? These are questions of performance - real or perceived - and ones which lie squarely in the domain of the social. The beads, the painted animals, and the carved figurines proliferating in some parts of Eurasia point in the same social direction - to the domain of defining the self and the "other" and negotiating the boundaries.

Being modern: Being human

Since I have argued that modern behavior is not about specific artifacts or media, what is it, then, that we can identify as universal features common to all modern humans that we know through history and ethnography? For me the essence of "modernity" is institutionalized interdependence - the various social ties that create permanent inter-sex bonds between adult individuals through such grouping principles as marriage, kinship, and descent ideologies (Graves-Brown 1996; Kuhn and Stiner 1998;

Strum and Latour 1987, Thomas 1998). This interdependence, evidenced in social obligations, is grounded in sharing and protecting beyond the mother and child dyad ubiquitous in all primate societies (Hawks et al. 2001; Ingold 1987; Riches 1982). It is this social construction that permits the division and separation of labor along many possible lines and can be understood as the first manifestation of the specialization of production. The tie between interdependence and the sexual division of labor was highlighted by Collier and Rosaldo (1981) more than 25 years ago, while Hartmann added gendering to it by noting that "From an economic perspective, the creation of gender can be thought of as the creation of the division of labor between the sexes, v the creation of two categories of workers who need each other" Hartmann 1981:371).

Gamble (1999), arguing along similar lines, has recently suggested that "modernity" lies in extra-local ego-centered networks vs. mere co-presence that preceded it. Recent research on primates, however, has shown that ego-centered networks are an important feature of their social organization as well - making such networks not diagnostic of human modernity. Rather, I argue, it is the existence of social categories that distinguishes us from all our hominoid relatives and hominid ancestors. The interdependence underwriting them can be and is expressed through a variety of behaviors that leave behind a material record that ranges from minimal and ephemeral, as in Tasmania for example, to permanent as in Lascaux or Mezhirich. It is this interdependence that constitutes symbolically organized behavior that Stringer and Gamble (1993:207) have argued is "the main structural difference that distinguishes moderns from the ancients". This insight is echoed by Henshilwood and Marean (2004) as well as by Wadley who underscores that: "...Modern behavior is, then, about social

organization and relationships that are expressed and transmitted through symbols" (Wadley 2003:248). While all these authors see "modernity" in symbolically mediated social relationships, they do not problematize how such a uniquely human state of affairs came to be - a question I address below.

Agency, geography, and motherhood

Having outlined my criteria for modernity, I next turn to the Eurasian paleoanthropological record to consider the possible differences between archaic and modern lifeways. I use demographic history as my entrée - focusing on the distribution of the youngest evidence for archaic lifeways.

Demographic histories

Change, be it evolution or extinction, does not happen to individuals - it happens to populations. All populations have histories that show successful periods when they expand into new habitats as well as periods of stress when they contract into refugia. Sometimes refuging is temporary and populations rebound, while with no rebound, local extinctions follow. Research on the extinction of mammoths has shown that it is serial local extinctions that ultimately bring about the extinction of the taxon (Soffer 2000 with references). The young dates for the last mammoths clearly show just how slow a sequence of serial local population extinctions can be before the demise of the last representatives of the taxon occurs. These Holocene mammoths also inform us about the relationship between refugia and lifeways by showing that refugia are locations which provide a species with a suitable niche - offering stable environmental conditions for its way of life, which permit demes to survive and compete successfully.

Research on prehistoric human populations before food production documents that they

were not stable in space or though time. Instead, from initial colonization onward, all continents witnessed settlement discontinuities including local population extinctions (Lahr 1996, 1997; Rochman and Steele 2003 with references). During the Last Glacial Maximum (LGM) some 20,000-18,000 years ago, for example, south-western France and the East European Plain served as refugia for European populations (Soffer and Gamble 1990). Similar range contractions are documented for Africa and Australia also (Butzer 1991; Lahr 1997).

We see the same refuging phenomenon when we look at the youngest Neanderthals and the last of Middle Paleolithic lifeways. Specifically, I argue that the adaptations developed by these archaic hominids over many millennia gave them competitive advantages in very specific regions of Eurasia where they persisted until as late as some 27,000 years ago. I underscore that in this discussion I neither assume a 1:1 relationship between a taxon and a particular technological repertoire, nor do I assume that in the last Neanderthals we see a species before extinction. These were not Wrangel mammoths but hominids with behavioral flexibility that could allow for significant changes – for new lifeways. Thus, rather than discussing species extinction, I only deal with an end to a particular way of life.

Distribution of the sites and fossils

Figure 13.1 plots the distribution of regions with the last chronometrically dated Neanderthals and Middle Paleolithic inventories in Eurasia. All radiocarbon date between some 35,000 and 27,000 years ago. Beginning in the west, they include sites in Iberia (Barton et al. 1999; d'Errico et al. 1998; Straus 1997), possibly Italy (Bietti 1997; Pettitt 1999), southwestern Balkans (Kozlowski 1998, 2000; Smith et al. 1999;

Trinkaus 2005; Wolpoff 1996), the southern Carpatians (Cârciumaru 1998); Southern Russia and Crimea (Chabai and Monigal 1999; Marks and Chabai 1998) and the Caucasus – (Bar-Yosef et al. 2002; Boriskovskij 1984, 1989; Golovanova et al. 1999; Meshvaliani et al. 2004). Moving southeast from the Mediterranean, it may include Syria (Boëda et al. 1998), as well as southern Siberia in the regions of the Altai and Sayan mountains as well as Kuznetsky Altau (Brantingham et al. 2001; Derevianko 1997, Derevianko et al. 1998; Kuzmin and Orlova 1998; Vasil'ev 2001).

Last glacial environments

The period in question falls in the second half of Oxygen Isotope Stage (OIS) 3 – a stage characterized by numerous very brief sharp climatic oscillations including a well marked warm episode at about 40,000 and a cold one at 30,000 years ago in the calendar year chronology of ice and deep sea core data (Van Andel and Davis 2004, with references; Soffer 2000). Reconstructions of biotic zones during both the warmer and colder periods shows that regions occupied by late Middle Paleolithic populations were covered by a mix of broadleaf and coniferous arboreal growth which remained in these areas, although somewhat reduced in extent, throughout the cold stadials including the maximal cold and arid times of the LGM (Grichuk 1992). It is these regions that served as refuges for both deciduous and coniferous species as well as for some Mediterranean evergreens.

While these reconstructions focused on western and central Europe, research on Late Pleistocene Eurasian faunal communities - specifically measures of taxa richness - repeatedly show that all the regions with the youngest Middle Paleolithic sites (the circum-Mediterranean ones as well as southern Siberia) featured the mildest

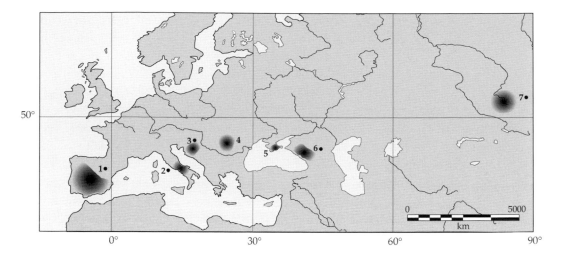

Figure 20.1 Eurasia: Distribution of regions with the last chronometrically-dated Neanderthals and Middle Paleolithic inventories. 1) Spain and Portugal; 2) central Italy; 3) Croatia; 4) Romania; 5) Crimea and adjacent areas; 6) the Caucasus; 7) southern Siberia; shaded areas = Middle Paleolithic inventories; dots = hominid remains.

climates during the last interglacial (Figure 20.2a). The same was true during OIS 4 and the early part of OIS 3 (Figure 20.2b), as well as during the last part of OIS 3 some 35,000–24,000 years ago when these regions served as refuges for a number of relict species (Figure 20.2c) (Agadjanian 2001; Lordkipanidze 1997; Markova et al. 1995; Musil 1985).

Thus, while it is tempting to correlate the distribution of the Last Neanderthals with warm Mediterranean climates, their near absence from the Levant in southwestern Asia and presence in the Altai and Sayan suggest a more complex scenario. To unravel it we need to consider pertinent demographic, physiogeographic, morphological, and archaeological data. When looking at these data, however, it is crucial to remember that, while changes happen to populations, populations are not made of identical clones but consist of a myriad of individuals with diverse interests which, by and large, we have not considered when addressing the deep past. While we cannot recover specific individual motivations from prehistory, we certainly can obtain new insights through an agentic approach that distinguishes groups along the natural cleavage lines such as sex and age, extant in any population.

Eurasian demographic history

Research on the distribution of Middle Paleolithic sites across Eurasia suggests regional differences in the intensity of occupation with the lower warmer provinces witnessing a continuous human presence throughout the late Pleistocene, while the northern areas were not permanently occupied before the Upper Paleolithic (Gamble 1986, 1994; Derevanko 1997; Goebel 1999; Klein 1999). These differences were not about latitude, however, but about the distribution of resources. Specifically, I have argued elsewhere that Middle Paleolithic groups occupied permanently only those regions where the proximity of the plains, foothills, and mountain ranges created a number of ecotones with more complex, diverse,

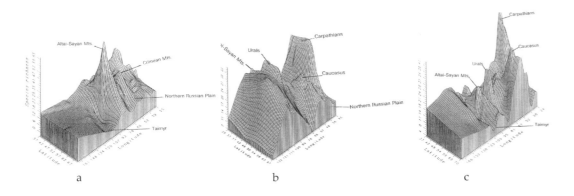

Figure 20.2 Mammal species richness in Central and Eastern Eurasia throughout the Late Pleistocene (after Markova 1995: Figures 5.3-5.5): a) 100-35,000 BP; b) 35,000-24,000 BP; c) 24,000-15,000 BP.

and productive biotic communities during both stadial and interstadial times (Geist 1978; Soffer 1994, 2000). Such areas featured the greatest proximal biotic diversification and it is they that saw more continuous occupation while the more homogeneous open landscapes of Eurasia underwent sporadic colonization and abandonment. This is well illustrated on the East European Plain and its periphery, for example. The plain is a vast flat expanse of land rimmed by north–south running mountain chains which restrict vertical biotic differentiation to its western, southeastern, and eastern margins. During warmer Pleistocene times this region was covered by nemoral forests (Grichuk 1992; Markova *et al.* 1995). At stadial times it changed to open landscapes covered by periglacial steppe – one with a dramatic reduction in latitudinal biotic differentiation and diversification and an increase in the spatial and temporal unpredictability of biotic resources. The only exceptions to this were found in the Dnestr-Prut region in the west, in Crimea in the southeast as well as in the nearby Caucasus. The archaeological record here is highly informative (Soffer

1989). We find early Middle Paleolithic sites in the western, central, and southern parts here. Late Middle Paleolithic sites, on the other hand, are restricted to the western Dnestr-Prut region and to the southern Crimea. Early Upper Paleolithic sites are found in both these regions as well as in the Kostenki-Borshchevo region of the middle Don. Using stratification as a rough gauge of successful occupation, we see that it is precisely those regions with the greatest vertical and biotic diversification that contain evidence for occupation throughout the last Interglacial-Glacial cycle, while the more homogeneous areas were sampled by archaic populations on a one time basis only. A similar pattern, in fact, can be observed throughout Europe, with regions containing the greatest vertical and biotic diversification showing more continuous archaic presence while the more homogeneous parts of Europe witnessed a pattern of waxing and waning of occupation.

The occupation record of eastern Eurasia mirrors this pattern also. The western and northwestern Caucuses have numerous stratified Middle Paleolithic sites (Bar-Yosef *et al.* 2002;

Golovanova *et al.* 1999; Liubin 1993; Lordkipanidze 1997; Meshveliani *et al.* 2004) – in fact, like Crimea (Chabai and Monigal 1999; Marks and Chabai 1998), there are considerably more Middle than Upper Paleolithic ones. The same regionalization is in evidence in Siberia, with multi-layered Middle Paleolithic sites clustering in the southern most diversified landscapes around the Altai and Sayan ranges (Derevianko 1997, Derevianko and Rybin 2003, Derevianko *et al.* 1998 with references; Goebel 1999; Kuzmin and Orlova 1998).

In sum, data from Eurasia indicate that Middle Paleolithic groups were localized in discrete regional patches and continuously present only in regions with the greatest resource diversification. This patterning shows us that the areas where we find the last Neanderthals and Middle Paleolithic lifeways are not cul-de-sacs to which they were pushed by encroaching "moderns", but rather their landscapes of habit.

Neanderthal body

I next turn to the Neanderthal bodies which contains many clues about just why these regions were their landscapes of habit.

Neanderthal morphology indicates that they were much more robust than anatomically modern humans, adapted to significantly greater physical exertion (*e.g.*, Berger and Trinkaus 1995; Churchill 1998; Trinkaus 1981, 1984; Wolpoff 1996). Interpopulation comparisons note a greater gracility of Near Eastern Neanderthals inhabiting lower latitudes when compared to European populations in higher ones, with the more robust Neanderthals reflecting morphological adaptations to life in more stressed northern environments. These observations hold true for both male and female Neanderthals (Frayer 1986). Although common wisdom holds Neanderthal morphology to reflect adaptations

to glacial cold in highly physical ways, little relaxed by culture (Holiday 1997; Hublin 1998; Klein 1999; Wood and Richmond 2000), dissenting views question this (*e.g.*, Finlayson 1999). One problem with the "hyperpolar" thesis is that progressively attenuated Neanderthal traits are seen from about 450,000 B.P. onwards (Condemi 2000; Hublin 1998; Wood and Richmond 2000). This appears an extraordinarily long-lasting adaptation to climate, one that persists through warm interglacial as well as cold glacial cycles while we know that significant morphological differences can occur in <20,000 years (Brace 1997; Hublin 1998). This has led some scholars to argue that demographic histories – small population size and isolation – rather than climate, offer more satisfactory explanations. Others have suggested that the Neanderthal morphology, in addition to reflecting greater physical exertion, may also reflect greater body weight (Alekseev 1993) – I point I will return to later.

While very little attention has been paid to intra-population differences, Frayer (1986) has reported inter-sexual differential gracilization rates in EAMHs – with females gracilizing earlier than the males. Although Neanderthals exhibit about the same degree of sexual dimorphism as do anatomically modern humans, it is important to underscore that both male and female Neanderthals are equally robust and that it is the Neanderthal children who show the most dramatic differences from modern children in much greater robusticity and accelerated development (Trinkaus *et al.* 1998).

Furthermore, Neanderthal remains show greater incidence of stress – both in terms of trauma (Berger and Trinkaus 1995; Richards *et al.* 2000) and in less diagnostic hypoplasia, juvenile dental attrition, and Harris lines (Soffer 1994 with references). Since dental hypoplasia

develops in children between the ages of 2-5, these data, together with the evidence for accelerated development and robusticity, suggest considerably greater stress on Neanderthal children than on their anatomically modern equivalents.

Research on patterns of longevity in Neanderthal and modern populations indicate shorter lifespans for Neanderthals, most of whom died prior to their 45th birthdays (Caspari and Sang-Hee 2004; Trinkaus 1995). In addition to this, a significant drop in juvenile mortality can be observed in Pleistocene moderns (Soffer 1994 with references, *contra* Trinkaus 1995).

Bone chemistry studies of Neanderthal and EAMH diets suggest that the Neanderthals were hyper-carnivorous (Boherens *et al.* 1991, 1999; Fizet *et al.* 1995; Toussaint *et al.* 1998; Richards *et al.* 2000, 2001). This, in turn, implies that to survive, like all other carnivores in northern latitudes, they needed to exploit either very large day ranges or highly diverse environments. In northern latitudes, the inescapable reality of seasonal resource fluctuation dictates that omnivores hibernate while carnivores both range widely and store food in their bodies by gorging in periods of abundance and living off body reserves during the leaner seasons (Geist 1978). This suggests that Neanderthals may also have undergone dramatic fluctuations in body weight between seasons – something that needs to be considered when evaluating their anatomy. Furthermore, if "storing in the self" was a part of the Neanderthal behavioral repertoire, then we can hypothesize greater fertility among Neanderthal females as well as envision the consequences that ensue for this – including more children, earlier weaning for the children, greater stress on the newly weaned young children, and so on.

Finally, questions of language use among Neanderthals have generated much heated debate (*e.g.*, Mithen 1996; Noble and Davidson 1996; Wolpoff *et al.* 2004 - all with references). I find these debates not only inconclusive but sterile as well. Since language does not fossilize, we need to consider just what the proxy measures used for it - from undiagnostic anatomical hardware to material correlates of symbolic behavior - reflect. The working assumption has been - "capacity". As I have argued at length elsewhere, however, this focus on "capacity" totally ignores that any behavior involves not only capacity but also the habitual exercise of this capacity – namely "performance" (Soffer 1994 with references; see also Chase 2001; Donald 1998 for similar points). Questions of performance, in turn, take us into the social realm and into the domain of archaeology (Thomas 1998).

Middle Paleolithic sites and inventories

When we focus on regions occupied by Middle Paleolithic groups rather than on specific sites - something clearly warranted because there is neither the evidence for year round sedentism at specific sites nor can hyper-carnivory be accommodated by sedentary predators - the recovered faunal remains point to regionally circumscribed opportunistic subsistence strategies. Such a focus obviates the need to see such monofaunal sites as Starosel'e, Mauran, Salzgitter-Lebenstadt, or Sukhaia Mechetka (Volgogradskaia) as evidence for specialized hunting in the Middle Paleolithic (*e.g.*, Gaudzinski 1999b). From a regional perspective such sites just reflect repeated return to particular locations with particular abundant resources – something seen time and again among non-human primates, for example (Garber 1987).

This kind of locational fidelity is reflected in the evidence for the procurement and use of raw materials. The lithic inventories show a redundant use of local raw materials regardless of their quality, suggesting a very localized provisioning

system that featured large daily home ranges but relatively small core areas (Soffer 1994; Gamble and Steele 1998) The sizes of these core areas were not uniform across Eurasia – being smaller in more heterogeneous areas such as southwestern France and larger in more homogeneous terrains of Central Europe (Roebroeks *et al.* 1988; Féblot-Augustins 1999; Gamble 1999). On the other hand, there is also a possibility that locally obtained lithic materials found at Middle Paleolithic sites reflect female technologies. Specifically, Brumbach and Jarvenpa's (1997) ethnographic work on hunting among the Chipewyan shows that since male day ranges are larger than those of females, a disproportionately large number of tools found at or near residential sites are those used by females. It is therefore possible that a change from local to extralocal raw material procurement may reflect not only changes in the settlement system but also in social relationships. The exploration of this possibility, however, clearly lies beyond the scope of this paper.

As I have noted elsewhere, Eurasian Middle Paleolithic sites, both open and cave ones, consist of relatively small concentrations of cultural remains which often at least partially overlap one another – suggesting palimpsest occupations (Soffer 1994 with references). Kolen's (1999) studies of features at these sites lead him to conclude that the patterning of material remains around such features suggests aggregate individual rather than group-based utilization of space.

Lastly, there is the issue of symbolism. Although red ocher is present at a number of both Middle Paleolithic and MSA sites, Wadley (2003) has cogently underscored that its possible use for utilitarian purposes makes the mere presence of colorants dubious proxies for symbolic behavior. The issue is more complex with body ornamentation, imagery, and other symbolic paraphernalia.

I have argued that the recovery of some, albeit incredibly few, suggestive items of this kind, such as the Tata plaque or the Berekhat Ram piece, from pre-Upper Paleolithic sites indicates that the capacity to make such items was there but that their non-patterned nature through time and across space is best understood as idiosyncratic manifestations of such capacity rather than as habitual performance (Soffer 1994). The same caveat can be extended to the significance of the Blombos "engraving". Symbols, whether verbal or visual, are a social phenomeon. They are also incredibly ubiquitous and redundant. Their Upper Paleolithic proxies are such – earlier ones are not.

Imagining the "Other" in time
Conceiving differences

The sum of these data suggests that Middle Paleolithic lives were indeed lived differently than modern ones. How to envision this "other" way, however, is another matter. While we have centuries of experience in value-laden classification of "the them" as evidenced in our unilineal evolutionary schemes, such classifications are and always were Eurocentric and judgmental (Trigger 1989). During the last two centuries our predecessors saw the Tasmanians as living fossils of the Lower Paleolithic while Australian Aborigines were Neanderthals incarnate. By the middle of the last century in the Anglo American world ecology replaced conjectural pre-history and the !Kung became Pleistocene "everymen" – albeit shortly thereafter they had to time-share the epoch with the Nunamiut. Of course both groups had to be divested of some things, such as Herero neighbors or snowmobiles, respectively – their histories in other words – but their subsistence practices and social organization were seen as eternal and thus transposable in time (*e.g.,* Lee and De Vore

1968). Such use of assumed "eternal features" led to identifying "logistically organized" hunter-gatherers in the Upper Paleolithic – without problematizing the question of transport technologies that necessarily must underwrite bringing food back in bulk to consumers. Another example, closer to home, was extending sharing, interpersonal dependence, division of labor – in other words, the nuclear family – back into not only the Pleistocene but the Pliocene and even the Miocene (*e.g.*, Lovejoy 1981; Clark 1997b). Doing so does not permit us to learn about the past – it just naturalizes the present and makes the past just its faded copy.

Recent attempts to pinpoint the origins of biparenatal provisioning of the young and thus of the division of labor and food sharing, have argued that the mid-Pleistocene brain expansion somehow is an adequate gauge of such new forms of sociality (*e.g.*, Aiello and Dunbar 1993). These attempts are neither convincing nor satisfactory – first, because they treat hominids as ecological beings only, and second, because archaeological data do not corroborate their constructs.

Given that humans are simultaneously involved in both ecological and social relationships (Ingold 1987), we clearly need extremely broad interdisciplinary insights to investigate the origins of this uniquely human essential. We need insights from biogeography and ecology, but they are not enough because there is no mean or modal species specific behavior. Recent primatological research, as well as research in behavioral ecology, have clearly shown that significant new understanding arises from the realization that different interests exist in all populations of primates, including humans, and that different strategies are available to cope with their environments – both natural and social (Hawkes 1996; Hrdy 1999; Smuts 1999; Zeller 1987). This new

focus both introduces contingency and thus history into ecological studies as well as converges with various social theories that stress the primacy of agency in understanding the human present and past. Together these disparate theoretical domains tell us that neither the Neanderthals nor the EAMHs were all the same. Rather, those populations, just like present day ones, consisted of diverse interests, some of which likely patterned along the apparently universal "fault lines" of age and sex (Hawkes 1996; Ingold 1987, 1994, 1999), regardless how these may have been understood, constructed, or enacted.

Keeping these potential disparities in interests in mind, what can we conclude about the lifeways (Figure 20.3) led by Late Pleistocene people?

I have argued elsewhere that the demographic and archaeological data, together with the evidence for muscle hypertrophy in both sexes, an inherited pattern of dimorphic feeding ranges for the sexes, and very equivocal evidence for divisions of labor and extensive food sharing, suggest that adult members of these small sized co-residential units provisioned themselves (Soffer 1994, 2000, see also O'Connell *et al.* 2002). Given that all primate females do provision their young while very few, if any, males do (Hrdy 1999; Smuts 1999), Neanderthal females most likely did the same. The robusticity and hypertrophy of the Neanderthal children, when compared to EAM ones, not only suggest that their provisioning was inconsistent but also that they may have provisioned themselves at a much earlier age than modern children do. I believe that this is also reflected in much higher juvenile mortality noted for Neanderthal juveniles when compared to EAM ones (Skinner 1996; Soffer 1994). Finally, I also suggest that the shorter Neanderthal lifespans resulted in two-generational groups at best – leaving no viable candidates such as grandmothers to help mothers

feed their young – although I do admit that the "grandmother hypothesis", which suggests that grandmothers likely provided a significant amount of food for their immature kin, is a contested one (Hawkes 1996; Kaplan et al. 2000; Figure 20.3). Since Hrdy (1999) has demonstrated that "allomothering" – meaning helping mothers with the care of their young – appears to be a widespread pattern among both humans and their nearest primate relatives, this contestation is not about help with provisioning of the young, however, but just about the specificity of the personnel involved. The crux of the matter is that increased longevity among the EAMs enlarged the pool of personnel from which such help could be and likely was sought.

The small size of groups that the Neanderthals lived in, together with their restricted territories, necessarily raises questions about group composition and mating. Among social carnivores the pattern is mixed. The lion pride core consists of related females and their young. Among wolves, on the other hand, there is evidence for mating of relatives across generations and thus pack endogamy, but also for emigration of both young males and females (Mech 1970). Most Old World primates, however, with the exception of chimps, have core groups composed of related females with males emigrating at maturity (Smuts 1999). Hunter-gatherer data, on the other hand, show core groups of related

males (Hawkes 1996). Hawkes has suggested that this hunter-gatherer pattern, one not verified by genetic tests, may have been a relatively recent and historically specific development and thus not a suitable eternal gauge. "Common wisdom" has all ancestral hominids after the advent of hunting organized around a core of related males (e.g., Noble and Davidson 1996; Foley and Lee 1996). The arguments offered for this, namely co-operative hunting as a "males-only" kind of thing, is less than a "just so story". Both lions and wolves hunt co-operatively without the need for male genetic bonding. Given the overall primate pattern, we are on safer grounds, I suggest, assuming that the Neanderthals may have followed the generic primate pattern as well – namely, one centered around a core of related females and their young.

The Upper Paleolithic way of life in Eurasia differed from this (Soffer 1994; Figure 13.4). I have extensively discussed the basis for these conclusions elsewhere. Summarizing them, I argue that the UP/LSA featured life in both small and large sized groups as well as seasonal group mobility. At its core lay social awareness of the self and dependence on others, and it was lived through the divisions of labor, sharing, and biparental provisioning of the young. It is during this time that interdependence was institutionalized through the invention of social categories of kinship and descent ideologies and the cleavage

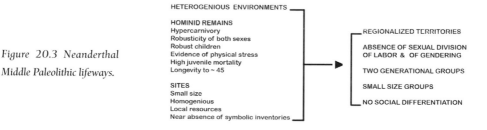

Figure 20.3 Neanderthal Middle Paleolithic lifeways.

NEANDERTHALS: MIDDLE PALEOLITHIC LIFEWAYS

HETEROGENIOUS ENVIRONMENTS

HOMINID REMAINS
Hypercarnivory
Robusticity of both sexes
Robust children
Evidence of physical stress
High juvenile mortality
Longevity to ~ 45

SITES
Small size
Homogenious
Local resources
Near absence of symbolic inventories

REGIONALIZED TERRITORIES

ABSENCE OF SEXUAL DIVISION OF LABOR & OF GENDERING

TWO GENERATIONAL GROUPS

SMALL SIZE GROUPS

NO SOCIAL DIFFERENTIATION

lines along age and sex underscored and imprinted through symbolic paraphernalia such as art, jewelry, engravings, *etc*. It is this interdependence that also permitted permanent occupation of more challenging homogeneous northern landscapes. Writing about people living in challenging Australian environments, McBryde (1987) has observed that social interdependence was ultimately more important than economic independence. The same is true for hunter-gatherers in northern latitudes. This is because the specificity of factors leading to resource unpredictability found in Holocene deserts vs. Pleistocene periglacial steppes is secondary in importance. The primary factor - namely very low resource predictability - is common to both and this is seminal. Interpersonal dependence also permitted larger group sizes (Binford 2001), as well as initiated the "arms race" noted earlier. There were now indeed not only more mouths to feed but also more minds to control.

This newly invented interdependence had both its bright and dark sides, however. Division of labor and food sharing did facilitate longer lifespans (Geist 1978; Caspari and Sang-Hee 2004) and the permanent colonization of open northern landscapes (Ingold 1987). Post-reproductive and post-prime people were now around - able to provide help with the young and longer-term knowledge beyond one's memory. On the other hand it also led to the invention of "the other" - the "them" - with all of the ensuing consequences. The social differentiation we see congealed in such things as Upper Paleolithic body ornamentation and "Venus-wear" is testament to the existence of institutionalized differentiation. Following La Fontaine (1981) I suggest that such material acts of differentiation are signs that the "social glue" is working - binding the different actors into newly created multi-actor social entities. Social differentiation also is

a necessary prerequisite for the creation of sex and age hierarchies and inequality. These negative consequences, ones that may have begun in Upper Paleolithic times, were likely unintended for, as Brightman (1996:722) points out: "Cultural forms are more commonly conceived as the cumulative unwilled by-products of human agency than as the latter's deliberate products."

Neanderthal niches and "last stands"

The structure of the resource base in Eurasian northern environments presented hominids with a set of specific problems solved one way by the archaic populations and another by modern ones (Soffer 1994). These different solutions were not about different capacities but rather about performance - meaning contingent outcome of social patterns, new decisions, and their intended and unintended consequences.

The latitudinal increase in the patchiness and unpredictability of the food resources - their season-specific availability - as well as a decrease in vegetal resources, confronted hominid omnivores with the need to exploit much larger territories than in lower latitudes. Some Eurasian regions - those with more predictable and diverse resources in smaller areas, which happened to be relegated to the southern parts of Eurasia - did so in contrast to more homogeneous plains further north and east. The Middle Paleolithic solution to these realities of northern lands may have been to considerably increase carnivory. Ecological realities in inland Eurasia made terrestrial animal resources more predictable, yet the hypercarnivory apparently adopted exacerbated the need for even greater territories. The positive relationship between carnivory and large territories can be seen even in the ethnographic present, where hunter-gatherers who rely on terrestrial animals annually exploit much larger territories than do groups who subsist on aquatic or vegetal resources

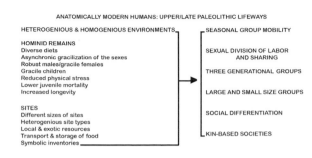

ANATOMICALLY MODERN HUMANS: UPPER/LATE PALEOLITHIC LIFEWAYS

Figure 20.4 Anatomically modern humans: Upper/Late Paleolithic lifeways.

(Binford 2001). In addition, given the inefficiency of the hominid body to convert food into body fat – where roughly two calories of intake are needed for 1 stored (Geist 1978:272) – northern hominid carnivores needed to consume more animal protein than their southern equivalents. The structural need for carnivores to exploit very large territories and be residentially highly mobile, as well as the need for considerably more animal protein by hominid carnivores, would have been extraordinarily costly and stressful to the females, especially pregnant and lactating ones, as well as to their young. The Neanderthal solution was to permanently occupy those regions where female day ranges could be minimized while the physiogeographic realities of Eurasia relegated these to just some regions.

These insights help us understand the patchy spatial distribution of the last Neanderthals. These areas were just such optimal habitats where their ways of life were successful and permitted them, for a time, to continue living them (Soffer 2000). These were, as I have argued elsewhere, ecological rather than geographic refugia, where archaic lifeways permitted relict populations with well honed adaptations to occupy stable niches and remain competitive. They were there not because these areas were forested rather than covered by grasslands (contra d'Errico et al. 1998), Middle Paleolithic lifeways persisted in these refugia for so long

because of the highly specific ways in which archaic hominids exploited the Eurasian environments (Soffer 1994, 2000). Since by some 25,000 years ago we have no Middle Paleolithic sites left in Eurasia, apparently this time there was no rebound for this way of life, and it went extinct.

Conclusions and implications

A global perspective on the Middle Paleolithic "last stands" shows us that environmental determinism is an insufficient explanation. It is unsatisfactory both because of the disjunction between anatomy and culture, and because of growing evidence for change in Eurasian lifeways by the middle Würm (d'Errico et al. 2003; Gamble 1999; Soffer 1994; Stiner 1994; Stiner et al. 1999). Data from the East European Plain, on the other hand, show the probable coterminous presence of different lifeways during the Early Upper Paleolithic – one more Middle and the other more Upper Paleolithic in organization (Soffer 1989; 1994). I have noted that the sum of this evidence indicates that we are not dealing with innate differences in the capacity for particular behavior between the archaics and their successors, but rather just with the habitual practice of that behavior. In sum, what became extinct by some 25,000 BP was not a taxon but a way of living and relating to others.

A Darwinian perspective informs us that adaptation and selection are not about mean/modal

behavior of a generic animal, but about how various interests of diverse constituencies are played out. This is why agency is important and why concerns with the social need to be a part of our research agendas. An evolutionary perspective on our closest living relatives show the presence of male-female bonds of friendship and suggests that these were in place before sharing, divisions of labor, and biparental provisioning of the young came about (Smuts 1999; Strum and Latour 1987). The sequence of what our ancestors came up with next can be teased out from the paleoanthropological record, and the crippled old man from Shanidar and other maimed late Neanderthals may indeed imply that next came sharing of food and the dawn of economic interdependence.

Since no individual of any social species acts in a social vacuum, Strum and Latour (1987:795) argue that for our ancestors "Acquiring the skills to create society and hold it together is then a secondary adaptation to an environment made up, in large part, of conspecifics". I suggest that it is precisely this that we are seeing in the transition record. For Gamble (1999) it is about extending ego-centered networks beyond immediate locality. Since ego-centered networks only involve the contractual players themselves, among modern humans they are ancillary to more permanent obligations institutionalized through kinship ties - in the broad sense of the term - linking individuals across space as well as through time (Ingold 1999; Riches 1982).

For me, as noted before, the archaeological and paleoanthropological records of "modernity" show more permanent institutionalized intersubjectivity. While we can outline a number of reasons why it was in the interest of archaic females to impose such permanent obligations on themselves, we need to understand better the benefits for such "domestication" for the males - to use LaFontaine's (1981) fortuitous term. Since among our closest living relatives it is the tactics of females that shape those of males, environmental realities of northern latitudes may have been one such proximate cause. Others are possible and need to be explored.

A social perspective on technology not only shows that, like language, it is yet another means to create intersubjective bonds (Strum and Latour 1987), but also that it does not drive social evolution but is driven by it. Upper Paleolithic lifeways, contra Gilman (1996), did not arise from improved technology but vice versa. Technology has no volition of its own, it functions in the domain of production, with production wants being socially determined and socially performed. The Upper Paleolithic "arms race" as well as the broadening of the resource base around the Mediterranean during the late Middle Paleolithic may both indicate increased demands on production. Such signs of intensification need not only signal population increase (contra Stiner *et al.* 1999) - they may be signaling social reorganization - specifically, divisions of labor and ideologically and symbolically structured sharing.

In light of all these observations, and given evidence for complex, albeit somatic, sociality of our closest living relatives (Strom and Latour 1987) the Upper Paleolithic "Creative Explosion" then just signals the use of extra-somatic means to do so (Gamble 1999). The symbolic organization of human interactions that we see reflected in this "Explosion" require no genetic mutation point or otherwise (contra Klein 1999). Rather, as Gamble (1999) has pointed out, such novel uses of material culture are best understood as "exaptations".

Using insights from primatology, evolutionary biology, and social theories, I have suggested that the Eurasian archaeological record can best be understood by juxtaposing our primate heritage,

environmental realities of northern Eurasia, and agentic interests. The various material expressions of the social solutions that our ancestors chose were likely incremental and date back to Middle Paleolithic/ MSA times. They were also local - and my scenario just addresses the proximate causes in one region of the occupied world. Thus, as McBrearty and Brooks (2000) have argued, there was no "Upper Paleolithic Revolution" - and there is no point to looking for its core or ancestral core area (*contra* Bar Yosef 2000, 2002; Mellars 2005; Sherratt 1997). To do so is to fall back on Eurocentric bias and a contingent package of purportedly diagnostic traits.

The Pleistocene saw a very long-term creation of deep mutual involvement of people with each other and with the world - one which gave rise to modern intersubjectivity (Gosden 1994). If we are to fully document and understand it, we cannot use the record from just one part of the world and assume that is a necessary and sufficient proxy for the rest. History does not work that way and universal processes are a sum-total of all local expressions. While the basic biological constraints were constant, the environments - both natural and social - differed in time and space. Thus, the proximate causes were necessarily local, the ultimate consequences global.

In sum, then, it is not only Neolithic or Bronze Age "man" that made "himself", but so did "his and hers" Middle and Upper Paleolithic predecessors - creating both their cultures and biologies through day to day decisions and their intended and unintended consequences.

Acknowledgments

This contribution is an ongoing project - one that I have been writing and revising for at least ten years. It is also one that I will, most likely, continue to revise and "evolve" in the next decade as well. An earlier version was published in 2000 and a revised version of that paper was presented at the 2001 CALPE conference in Gibraltar. Yet another revision was presented at a symposium at the 2006 UISPP Congress and is in press in a proceedings volume. In working through the topic of "modernity", I have benefited greatly from discussions with many colleagues, three of whom deserve special gratitude - Meg Conkey, Alma Gottlieb, and Milford Wolpoff. My years on research in Cental and Eastern Europe were seminal and supported over the years by various Fullbright fellowships, grants from the U.S. National Academy of Sciences, the Wenner-Gren Foundation of Anthropological Research, as well as the National Geographic Society. My research was also supported in part by grants from the International Research and Exchanges Board (IREX) with funds provided by the United States Department of State through the Title VIII Program and the National Endowment for the Humanities. My home institution, the University of Illinois, has continuously been supportive of my research as well. None of these organizations is responsible for the views expressed and all are thanked for their support. Finally, I dedicate this chapter to the memory of Alex Marshack - a generous and stimulating colleague who may not have agreed with my thesis here, but we would have had a great time debating it.

About the author

Olga Soffer, Dept. of Anthropology, University of Illinois, Urbana, Illinois 61801, USA; E-mail: o-soffer@uiuc.edu.

References

Agadzhanian, A. K.

2001 Prostranstvennaia struktura mamontovoj fauny Severnoj Evrazii. In *Mamont I ego okruzhenie: 200 let izucheniia*, edited by A.Yu. Rozanov, pp. 220-243. GEOS, Moscow.

Aiello, L. C., and R. I. M. Dunbar

1993 Neocortex size, group size, and the evolution of language. *Current Anthropology* 95:73-96.

Alekseev, V. P.

1993 *Ocherki Ekologii Cheloveka.* Nauka, Moscow.

Barton, R. N. E., A. P. Currant, Y. Fernandez-Jalvo, J. C. Finlayson, P. Goldberg, R. MacPhail, P. Pettitt, and C. B. Stringer

1999 Gibraltar Neanderthals an results of recent excavations in Gorham's, Vanguard and Ibex caves. *Antiquity* 73:13-23.

Bar-Yosef, O.

2000 The Middle and Early Upper Paleolithic in Southwest Asia and neigboring regions. In *The Geography of Neandertals and Modern Humans in Europe and the Greater Mediterranean*, edited by O. Bar-Yosef and D. Pilbeam, pp. 107-156. Peabody Museum Bulletin 8.

2002 The Upper Paleolithic revolution. *Annual Reviews in Anthropology* 31:363-393.

Bar-Yosef, O., and S. Kuhn

1999 The big deal about blades: Laminar technologies and human evolution. *American Anthropologist* 101:322-338.

Bar-Yosef, O., A. Belfer-Cohen, T. Meshveliani, D. S. Adler, N. Tushbramashvili, E. Boaretto, N. Mercier, and S. Weiner

2002 The Middle-Upper Paleolithic boundary in the Western Caucasus. *Journal of Human Evolution* 42:A4-A5.

Basala, G.

1988 *The Evolution of Technology.* Cambridge University Press, Cambridge.

Berger, T. D., and E. Trinkaus

1995 Patterns of trauma among the Neanderthals. *Journal of Archaeological Science* 22:841-852.

Bietti, A.

1997 The transition to anatomically modern humans: The case of peninsular Italy. In *Conceptual Issues in Modern Human Origins Research*, edited by G. A. Clark and C. M. Willermet, pp. 132-147. Aldine de Gruyter, New York.

Binford, L. R.

2001 *Constructing Frames of Reference.* University of California Press, San Francisco.

Bocherens, H., M. Fizet, B. Lange-Badre, B. Vandermeersch, J. P. Borel, and G. Bellon

1991 Isotopic biogeochemistry (13C, 15N) of fossil vertebrate collagen: appliation to the study of the past food web including Neanderthal man. *Journal of Human Evolution* 29:481-492.

Bocherens, H., D. Billiou, M. Patou-Mathis, M. Otte, D. Bon-Jean, M. Toussaint, and A. Mariotti

1999 Paleoenvironmental and paleodietary implications of isotopic biohemistry of Neanderthal and mammal bones in Scladina Cave, Layer 4 (Sclayn, Belgiumj). *Journal of Archaeological Science* 26:599-607.

Boeda, E., J. Connan, and S. Muhesen

1998 Bitumen hafting material on Middle Paleolithic artifacts from the El Kowm Basin, Syria. In *Neanderthals and Modern Humans in Western Asia*, edited by T. Akazawa, K. Aoki and O. Bar-Yosef, pp. 181-204. Plenum Publishing, New York.

Bordes, F.

1968 *The Old Stone Age*. World University Library, New York.

Boriskovkij, P. I. (editor)

1984 *Paleolit SSSR*. Nauka Publishing, Moscow.

1989 *Paleolit Kavkaza i Severnoj Azii*. Nauka Publishing, Leningrad.

Brace, C. L.

1997 Modern human origins: Narrow focus or broad spectrum? In *Conceptual Issues in Modern Human Origins Research*, edited by G. A. Clark and C. M. Willermet, pp. 11 27. Aldine de Gruyter, New York.

Brantingham, P. J., A. I. Krivoshapkin, L. Jinzeng, and Y. A. Tserndagva

2001 The Initial Upper Paleolithic in Northeast Asia. *Current Anthropology* 42:735-747.

Brightman, R.

1996 The sexual division of foraging labor: Biology, taboo, and gender politics. *Comparative Study of Society and History* 687-729.

Brumbach, H. J., and R. Jarven

1997 Woman the hunter: Ethnoarchaeological lessons from Chipewyan life-cycle dynamics. In *Women in Prehistory: North America and Mesoamerica*, edited by C. Claassen and R. A. Joyce, pp. 17-32. The University of Pennsylvania Press, Philadelphia.

Butzer, K. W.

1991 An Old World perspective on potential mid-Wisconsinan settlement of the Americas. In *The First Americans: Search and Research*, edited by T. D. Dillehay and D. J Meltzer. CRC Press, Boca Raton, Florida.

Carciumaru, M.

1998 Le Paléolithique moyen dans le grottes des Carpates Méridionales. In *Anatolian Prehistory at the Crossroads of Two Worlds*, edited by M. Otte, pp. 57-76 E.R.A.U.L. 85.

Caspari, R., and L. Sang-Hee

2004 Older age becomes common in late human evolution. *PNAS* 101:10895-10900.

Chabai, V. P., and K. Monigal (editors)

1999 *The Middle Paleolithic of Western Crimea*, Vol. 2. E.R.A.U.L. 87.

Chase, P. G.

2001 Multilevel information processing, archaeology, and evolution. In *The Mind's Eye*, edited by A. Nowell, pp. 121-136. International Monographs in Prehistory. Archaeological Series 13, Ann Arbor.

Churchill, S. E.

1998 Cold adaptations, heterochrony, and the Neanderthals. *Evolutionary Anthropology* 7:46-61.

Clark, G. A.

1997a Through a glass darkly. In *Conceptual Issues in Modern Human Origins Research*, edited by G. A. Clark and C. M. Willermet, pp. 60-76. Aldine de Gruyter, New York.

1997b Aspects of early hominid sociality: An evolutionary perspective. In *Rediscovering Darwin: Evolutionary Theory and Archaeological Explanation*, edited by C. M. Barton and G. A. Clark, pp. 209-231. Archaeological Papers of the American Anthropological Association 7.

Collier, J. F., and M. Z. Rosaldo

1981 Politics and gender in simple societies. In *Sexual Meanings: The Cultural Construction of Gender and Sexuality*, edited by S. B. Ortner and H. Whitehead. Cambridge University Press, Cambridge, U. K.

Condemi, S.

2000 *The Neanderthals: Homo Neanderthalensis or Homo Sapiens Neanderthalensis? Is there a contradiction between the paleogenetic and the paleoanthropological data?* In *The Geography of Neandertals and Modern Humans in Europe and the Greater Mediterranean*, edited by O. Bar-Yosef and D. Pilbeam, pp. 287-295. Peabody Museum Bulletin 8.

Crevecoeur, I., and E. Trinkaus

2004 From the Nile to the Danube: A comparison of the Nazlet Khater 2 and Oise 1 early modern human mandibles. *Anthropologie* (Brno) XLII:203-213.

Derevianko, A. P. (editor)

1997 *The Paleolithic of Siberia*. University of Illinois Press, Urbana and Chicago, IL.

Derevianko, A. P., A. K. Agadzhanyan, G. F. Baryshnikov, M. I. Dergacheva, T. A. Duypal, E. M. Malaeva, S. V. Markin, V. I. Molodin, S. V. Nikolaev, L. A. Orlova, V. T. Pertrin, A. V. Postnov, V. A. Ul'ianov, I. K. Fedeneva, I. V. Foronova, and M. V. Shun'kov

1998 Arkheologia, geologia I paleogeografiya pleistotsenaiI golotsena Gornogo Altaia. *Izdatel'stvo Instituta arkheologii i etnografii SO RAN*, Novosibirsk.

Dobres, M. A.

2000 Technology and social agency: Outlining a practice framework for archaeology. Blackwell, Oxford.

Donald, M.

1998 Hominid enculturation and cognitive evolution. In *Cognition and Material Culture: the Archaeology of Symbolic Storage*, edited by C. Renfrew and C. Scarre, pp. 7-17. McDonald Institute Monographs, Cambridge.

Dunbar, R. I. M.

1993 Sociality among humans and non-human animals. In *Companion Encyclopedia of Anthropology*, edited by T. Ingold, pp. 756-782. Routledge, London.

Efimenko, P. P.

1938 *Pervobytnoe Obshchestvo*, Second edition. Gosudarstvennoe Sotsial'no-Ekonomicheskoe Izdatel'stvo, Leningrad.

d'Errico, F., J. Zilhao, M. Julien, D. Baffier, and J. Pelegrin

1998 Neanderthal acculturation in Western Europe? A critical review of the evidence and its interpretatons. *Current Anthropology* 39, Supplement: S1-S44.

d'Errico, F., M. Julien, D. Liolios, M. Vanhaeren, and D. Baffier

2003 Many awls in our argument. Bone tool manufacture and use in the Châtelperronian and Aurignacian levels of the Grotte du Renne at Arcy-sur-Cure. In *The Chronology of the Aurignacian and Transitional Technocomplexes. Dating, Stratigraphies, Cultural Implications*, edited by J. Zilhao and F. D'Errico, pp. 247-270. Trabalhos de Arqueologia 33. Instituto Portugues de Arqueologia, Lisboa.

Feblot-Augustins, J.

1993 Mobility strategies in the Late Middle Paleolithic of Central Europe. *Journal of Anthropological Archaeology* 12:211-165.

Finlayson, C.

1999 Late Pleistocene human occupation of the Iberian peninsula. *Journal of Iberian Archaeology* 1:59-68.

Fizet, M., A. Mariotti, H. Bocherens, B. Lange-Badre, B. Vandermeersch, J. P. Boreal, and G. Bellon

1995 Effect of diet, physiology and cclimate on carbon and nitrogen stable isotope of collagen in a Late Pleistocene anthropic palaeoecosystem: Marillac, Charenta, France. *Journal of Archaeological Science* 22:67-79.

Foley, R., and P. Lee

1996 Finite social space and the evolution of human social behavior. In *The Archaeology of Human Ancestry*, edited by J. Steele. Routledge, London, pp. 47-66.

Frayer, D. F.

1986 Cranial variation of Mladec and the relationship between Mousterian and Upper Paleolithic hominids. *Anthropologie* (Brno) 23:243-256.

Gamble, C.

1986 *Paleolithic Europe.* Cambridge University Press, Cambridge.

1994 *Timewalkers.* Harvard University Press, Cambridge, MA.

1999 *Paleolithic Societies of Europe.* Cambridge University Press, Cambridge.

Gamble, C., and W. Roebroeks

1999 The Middle Palaeolithic. A point of inflection. In *The Middle Paleolithic Occupation of Europe*, edited by C. Gamble and W. Roebroeks, pp. 3-22. University of Leiden Press, Leiden.

Gamble, C., and J. Steele

1999 Hominid ranging patterns and dietary strategies. In *Hominid Evolution, Lifestyles and Survival Strategies*, edited by H. Ullrich, pp. 396-409. Edition Archaea, Weimar.

Garber, P. A.

1987 Foraging strategies among living primates. *Annual Review of Anthropology* 16:339-364.

Gaudzinski, S.

1999a Middle Palaeolithic bone tools from the open-air site Salzgitter Lebenstedt (Germany). *Journal of Archaeological Science* 26:125-141.

1999b The faunal record of the Lower and Middle Paleolithic of Europe: Remarks on human interference. In *The Middle Paleolithic Occupation of Europe*, edited by C. Gamble and W. Roebroeks, pp. 215-233. University of Leiden Press, Leiden.

Geist, V.

1978 *Life Strategies, Human Evolution, Environmental Design.* Springer-Verlag, New York.

Gilman, A.

1996 Explaining the Upper Paleolithic revolution. In *Contemporary Archaeology in Theory*, edited by R. W. Preucel and I Hodder, pp. 220-239. Blackwell Publishers, Oxford.

Goebel, T.

1999 Pleistocene human colonization and peopling of the Americas: An ecological approach. *Evolutionary Anthropology* 8:208-226.

Golovanova, L. V., J. F. Hoffecker, V. M. Kharitonov, and G. P. Romanova

1999. Mezmaiskaya Cave: A Neanderthal occupation in Northern Caucasus. *Current Anthropology* 40:77-86.

Gosden, C.

1994 *Social Beings and Time*. Blackwell Publishers, Oxford.

Graves-Brown, P.

1996 Their commonwealths are not as we supposed. In *The Archaeology of Human Ancestry*, edited by J. Steele and C. Gamble. Routledge, London, pp. 347-360.

Gregory, C. A.

1982 *Gifts and Commodities*. Academic Press, London.

Grichuk, V. P.

1992 Vegetation during the maximum cooling of the Last Glaciation. In *Atlas of Paleoclimates and Paleoenvironments of the Northern Hemisphere*, edited by B. Frenzel, M. Pecsi, and A. A. Velichko, pp. 123, map. on pp. 55. Geographical Research Institute, Hungarian Academy of Science and Gustav Fischer Verlag, Budapest-Stuttgart.

Grigor'ev, G. P.

1968 *Nachalo verkhnego Paleolita I proizkhozhdenie Homo Sapiens*. Nauka, Leningrad.

Hartmann, H.

1981 The family as locus of gender, class, and political struggle: The example of housework. *Signs* 6:366-394.

Hawkes, K.

1996 Foraging differences between men and women. In *The Archaeology of Human Ancester*, edited by J. Steele and C. Gamble, pp. 282-305.

Hawkes, K., J. F. O'Connell, and N. G. Blurton Jones

2001 Hunting and nuclear families: Some lessons from the Hadza about men's work. *Current Anthropology* 42:681-709.

Henshilwood, C. S., and C. W. Marean

2003 The origin of modern human behavior: Critique of the models and their test implications. *Current Anthropology* 44:627-651.

Henshilwood, C. S., F. d'Errico, R. Yates, Z. Jacobs, C. Tribolo, G. A. T. Duller, N. Mercier, J. C. Sealy, H. Valladas, I. Watts, and A. G. Wintle

2002 Emergence of modern human behavior: Middle Stone Age engravings from South Africa. *Science* 295:1278-1280.

Holiday, T. W.

1997 Postcranial evidence of cold adaptation of European Neanderthals. *American Journal of Physical Anthropology* 104:245-258.

Hrdy, S. B.

1999 *Mother Nature*. Ballantine Books, New York.

Hublin, J-J.

1998 Climate changes, paleogeography, and the evolution of Neanderthals. In *Neandertals and Modern Humans in Western Asia*, edited by T. Akazawa, K. Aoki, and O. Bar-Yosef, pp. 295-310. Plenum Press, New York.

Hublin, J-J., F. Spoor, M. Braun, F. Zonneveld, and S. Condemi

1996 A late Neanderthal associated with Upper Paleolithic artifacts. *Nature* 381:224-226.

Ingold, T.

1987 *The Appropriation of Nature.* University of Iowa Press. Iowa City.

1994 Introduction to Social Life. In *Companion Encyclopedia of Anthropology*, edited by T. Ingold. Routledge, London, pp. 737-755.

1999 On the social relations of the hunter-gatherer band. In *The Cambridge Encyclopedia of Hunters and Gatherers.* Edited by R. B. Lee and R. Daly. Cambridge University Press, Cambridge, pp. 399-410.

Kaplan, H., K. Hill, J. Lancaster, and A. M. Hurado

2000 A theory of human life history evolution: Diet, intelligence, and longevity. *Evolutionary Anthropology* 9:156-184.

Klein, R.

1999 *The Human Career* Second Edition. University of Chicago Press, Chicago.

Klejn, L.

1977 A panorama of theoretical archaeology. *Current Anthropology* 18:1-42.

2001 Arkheologicheskaia periodizatsiia: podkhody I kriterii. In *Vremya Poslednikh Neandertal'tsev*, edited by L. B. Vishniatskij. Stratum Plus, St. Petersburg, Russia and Kishinev, Moldova, pp. 485-515.

Kolen, J.

1999 Hominids without homes: On the nature of Middle Palaeolithic settlement in Europe. In *The Middle Palaeolithic Occupation of Europe*, edited by W. Roebroeks and C. Gamble. University of Leiden Press, Leiden, pp. 139-176.

Kozlowski, J. K.

2000 The problem of cultural continuity between the Middle and the Upper Paleolithic in Central and Eastern Europe. In *The Geography of Neandertals and Modern Humans in Europe and the Greater Mediterranean*, edited by O. Bar-Yosef and D. Pilbeam. Peabody Museum Bulletin 8, pp. 77-105.

1998 The Middle and the Early Upper Paleolithic around the Black Sea. In *Neandertals and Modern Humans in Western Asia*, edited by T. Akazawa, K. Aoki, and O. Bar-Yosef. Plenum Press, New York, pp. 461-82.

Kranzberg, M.

1989 One last word - Technology and history. In *Context. History and the History of Technology*, edited by S. H. Cutcliffe and R. C. Post. Leigh University Press, and Association of University Presses, Bethlehem, PA and London.

Kuhn, S. L., and M. C. Stiner

1998 Middle Paleolithic "creativity": Reflections on an oxymoron. In *The Prehistory of Creative Thought*, edited by S. Mithen. Routledge, London, pp. 143-164.

Kuzmin, Y. V., and L. A. Orlova

1998. Radioarbon chronology of the Siberian Paleolithic. *Journal of World Prehistory* 12:1-54.

La Fontaine, J. S.

1981 The domestication of the savage male. *Man N. S.* 16:333-349.

Lahr, M. M.

1996 *The Evolution of Modern Human Diversity.* Cambridge University Press, Cambridge.

1997 The evolution of modern human cranial diversity. Interpreting the patterns and process. In *Conceptual Issues in Modern Human Origins Research.* Edited by G. A. Clark and C. M. Willermet, pp. 304-318. Aldine de Gruyter, New York.

Lee, R. B., and I. De Vore

1968 *Man, the Hunter*. Aldine, Chicago.

Lemonnier, P.

1986 The study of material culture today: Toward an anthropology of technical systems. *Journal of Anthropological Archaeology* 5:147-186.

1992 *Elements for an Anthropology of Technology*. Anthropological Papers, Museum of Anthropology, University of Michigan, Ann Arbor.

1993 Introduction. In *Technological Choices*, edited by P. Lemmonier. Routledge, London, pp. 1-35.

Liubin, V. P.

1993 Chronostratigrafiia paleolita Kavkza. *Rossijskaia Arkheologiia* 2:5-14.

Lordkipanidze, D.

1997 Zaselenie gornoi territorii gominidami (vzgliad s Kavkaza). In *Chelovek zaseliaet planetu Zemlia*, edited by A. A. Velichko and O. Soffer. Institute of Geography, Russian Academy of Sciences, Moscow, pp. 78-84.

Lovejoy, O.

1981 The origin of man. *Science* 211:261-268.

Markova, A. K., N. G. Smirnov, A. V. Kozharinov, N. E. Kozantseva, A. N. Simakova, and L. M. Kitacva

1995 Late Pleistocene distribution and diversity of mammals in Northern Eurasia. *Paleontologia i Evolucio*, t. 28-29:5-143. Institut Paleontoogic Dr. M. Crusafont. Diputacio de Barcelona, Barcelona.

Marks, A. E., and V. P. Chabai (editors)

1998 *The Middle Paleolithic of Western Crimea* Vol. 1. E.R.A.U.L. no. 84, Liege.

McBrearty, S., and A. S. Brooks

2000 The Revolution that wasn't: A new interpretation of the origins of modern human behavior. *Journal of Human Evolution* 39:453-563.

McBryde, I.

1987 Goods from another country: Exchange networks and the people of the Lake Eyre Basin. In *Australians to 1788*, edited by D. J. Mulvaney and J. Peter White. Weldon, Syme and Associates, Sydney, pp. 253-273.

Mech, L. D.

1970 The Wolf. The Natural History Press, New York.

Mellars, P.

1996 *The Neanderthal Legacy*. Princeton University Press, Princeton, N. J.

2005 The impossible coincidence. A single-species Model for the Origins of Modern Human Behavior in Europe. *Evolutionary Anthropology* 14:12-27.

Meshveliani, T., O. Bar-Yosef, and A. Belfer-Cohen

2004 The Upper Paleolithic in Western Georgia. In The *Early Upper Paleolithic beyond Western Europe*, edited by J. Brantingham and S. Kuhn. University of California Press, Berkeley, pp. 129-143.

Minnegal, M.

1997 Consumption and production. *Current Anthropology* 25:1-45.

Mithen, S.

1996 *The Prehistory of the Mind: A Search for the Origins of Art, Science and Religion*. Thames and Hudson, London.

Mulvaney, J., and J. Kamminga

1999 *Prehistory of Australia*. Smithsonian Press, Washington, D.C.

Musil, R.

1985 Paleobiography of terrestrial communities in Europe during the Last Glacial. *Acta Musei Nationalis Pragae* XLI B:1–2.

Noble, W., and I. Davidson

1996 *Human Evolution, Language and Mind.* Cambridge University Press, Cambridge.

O'Connell, J. F., I. K. Hawkes, K. D. Lupo, and N. G. Blurton-Jones

2002 Male strategies and Plio-Pleistocene archaeology. *Journal of Human Evolution* 43:831–872.

Pettitt, P. B.

1999 Disappearing from the world: An archaeological perspective on Neanderthal extinction. *Oxford Journal of Archaeology* 18.

Richards, M. P., P. Pettitt, M. C. Stiner, and E. Trinkaus

2001 Stable isotope evidence for increasing dietary breadth in the European mid-Upper Paleolithic. *Proceedings of the National Academy of Science* 98: 6528–6532.

Richards, M. P., P. Pettitt, E. Trinkaus, F. H. Smith, M. Paunovic, and I. Karavanic

2000 Neanderthal diet at Vindija and Neanderthal Predation: The Evidence from stable isotopes. *Proceedings of the National Academy of Science* 97:7663–7666.

Riches, B.

1982 *Northern Nomadic Hunter-Gatherers.* Academic, New York.

Rochman, M., and J. Steele (editors)

2003 *Colonization of Unfamiliar Landscapes: The Archaeology of Adaptation.* Routledge, London.

Roebroeks, W. J. Kolen, and E. Rensink

1988 Planning depth, anticipation and the organization of Middle Paleolithic technology: The "archaic natives" meet Eve's descendants. *Helinium* 28:17–34.

Sackett, J.

2000 Human Antiquity and the Old Stone Age: The Nineteenth Century Background to Paleoanthropology. *Evolutionary Anthropology* 9:37–49.

Shafer, J., and V. Ranov

1998 Middle Paleolithic blade industries and the Upper Paleolithic of Central Asia. In *Anatolian Prehistory at the Crossroads of Two Worlds* Vol. 1, edited by M. Otte. E.R.A.U.L. 85:785–814.

Sherratt, A.

1997 Climatic cycles and programal revolutions: The emergence of modern humans and the beginning of farming. *Antiquity* 71:271–287.

Skinner, M.

1996 Developmental stress in immature hominines from Late Pleistocene Eurasia: Evidence from enamel hypoplasia. *Journal of Archaeological Science* 23:833–852.

Smith, F. H., E. Trinkaus, P. B. Pettitt, I. Karavanic, and M. Paunovic

1999 Direct radiocarbon dates from Vindija G1 and Velika Pecina Late Pleistocene hominid remains. *Proceedings of the National Academy of Sciences* (USA) 96:12281–12286.

Smuts, B. B.

1999 *Sex and Friendship in Baboons.* Harvard University Press, Cambridge, MA.

Soffer, O.

1989 The Middle to Upper Paleolithic transition on the Russian Plain. In *The Human Revolution*, edited by P. Mellars and C. Stringer. Edinburgh University Press, Edinburgh, pp. 714-742.

1993 Upper Paleolithic adaptations in Central and Eastern Europe and man/mammoth interactions. In *From Kostenki to Clovis: Upper Paleolithic-Paleoindian Adaptations*, edited by O. Soffer and N. D. Praslov. Plenum Press, New York, pp. 31-51.

1994 Ancestral lifeways in Eurasia - the Middle and Upper Paleolithic records. In *Origins of Anatomically Modern Humans*, edited by M. H. Nitecki and D. V. Nitecki. Plenum Press, New York, pp. 101-120.

1995 *Artistic Apoggees and Biological Nadirs: Upper Paleolithic Cultural Complexity Reconsidered, in Nature and Culture*, edited by M. Otte. ERAUL 68:617-627, Belgium, Liege.

2000 The last Neanderthals. In *Early Humans at the Gates of Europe*, edited by D. Lordkipanidze, O. Bar-Yosef and M. Otte. E.R.A.U.L. 92:139-146.

Soffer, O., and C. S. Gamble (editors)

1990 *The World at 18,000 BP: Northern Latitudes* Vol. 1. Allen and Unwin, London.

Stiner, M.

1994 *Honor among Thieves*. Princeton University Press, Princeton, N. J.

Stiner, M. C., N. D. Munro, T. A. Turovell, E. Tchernov, and O. Bar-Yosef

1999 Paleolithic population growth pulses evidenced by small animal exploitation. *Science* 282:190-194.

Straus, L. G.

1997 The Iberian situation between 40,000 and 30,000 B.P. in light of European models of migration and convergence. In *Conceptual Issues in Modern Human Origins Research*, edited by G. A. Clark and C. M. Willermet. Aldine de Gruyter, New York, pp. 235-252.

Stringer, C., and C. Gamble

1993 *In Search of the Neanderthals*. Thames and Hudson, New York.

Strum, S. S., and B. Latour

1987 Redefining the social link: From baboon to humans. *Social Science Information* 26:783-802.

Thieme, H., B. Urban, D. Mania, and T. Van Kalfschoten

1993 Schöningen(Nordharzvorland). Eine altpälaolitische Fundstelle aus dem mittlern Eiszeitalter. *Archaeologisches Korrespondenzblatt* 23:147-163.

Thomas, J.

1998 Some problems with the notion of external symbolic storage, and the case of Neolithic material culture in Britain. In *Cognition and Material Culture: The Archaeology of Symbolic Storage*, edited by C. Renfrew and C. Scarre. McDonald Institute Monograph, Cambridge, pp. 149-160.

Torrence, R. (editor)

1989 *Time, Energy, and Stone Tools*. Cambridge University Press, Cambridge.

Toussaint, M., M. Otte, D. Bonjean, H. Bocherens, C. Falgueres, and Y. Yokoyama

1998 Les restes humains neandertaliens immatures de la couche 4A de la grotte Scladina (Andenne, Belgique). C.R. Acad. Sci. Paris. Sciences de la terre et des planetes. *Earth and Planetary Sciences* 236:737-742.

Trigger, B.

1989 *A History of Archaeological Thought*. Cambridge University Press, Cambridge, U. K.

Trinkaus, E.

1981 Neanderthal limb proportions and old adaptation. In *Aspects of Human Evolution*, edited by C. B. Stringer. Taylor and Francis, London, pp. 187–224.

1984 *The Shanidar Neanderthals*. Academic Press, New York.

1995 Neanderthal Mortality Patterns. *Journal of Archaeological Science* 22:121–142.

2005 *Early Modern Humans*. Annual Review of Anthropology. In Press.

Trinkaus, E. , C. B. Russ, and S. E. Churchill

1998 Upper Limb versus Lower Limb: Loading Patterns among Near Eastern Middle Paleolithic Hominids, in Neandertals and Modern Humans in Western Asia. Edited by T. Akazawa, K. Aoki, and O. Bar-Yosef. Plenum Press, New York, pp. 391–404.

Van Andel, T., and W. Davies (editors)

2004 *Neanderthals and Modern Humans in the European Landscape During the Last Glaciation: Archaeological results of the Stage 3 Project*. The McDonald Institute for Archaeological Research Press, Cambridge, U.K.

Vasil'ev, S. A.

2001 Problema perekhoda ot srednego k verkhnemu Paleolitu v Sibiri, in Neandertal'skie refugiumy I arkhaichnyj obraz zhizni. In *Vremya Poslednikh Neandertal'tsev*, edited by L. B. Vishniatskij. Stratum Plus, St. Petersburg, Russia and Kishinev, Moldova, 1:178–210

Wadley, L.

2003 How some archaeologists recognize culturally modern program. *South African Journal of Science* 99:247–250.

Wolpoff, M. H.

1996 *Paleoanthropology*. 1996-1997 edition. McGraw-Hill, New York.

Wolpoff, M. H., B. Mannheim, A. Mann, J. Hawks, R. Caspari, R. Rosenbert, K. R. Frayer, D. W. Gill, and G. Clark

2004 Why not the Neanderthals? *World Archaeology* 36:527–546

Wood, B., and B. G. Richmond

2000 Human evolution: Taxonomy and paleobiology. *Journal of Anatomy* 196:19–60.

Zeller, A.C.

1987 A Role of Children in Hominid Evolution. *Man* N.S. 22:528–557.

Zilhao, J.

2001 *Anatomically Archaic, Behaviorally Modern: The Last Neanderthals and their Destiny*. Dricëntwintigste Kroon-Voordrocht Nederlands Museum, Amsterdam.

Zilhao, J., and F. d'Errico

2003 The chronology of the Aurignacian and Transitional technocomplexes. Where do we stand? In *The Chronology of the Aurignacian and Transitional Technocomplexes. Dating, Stratigraphies, Cultural Implications* edited by J. Zilhao and F. d'Errico. Trabahos de Arqueologia 33, Instituto Portugues de Arqueologia, Lisboa, pp. 313–349.

Evolution
and the Human Capacity

Ian Tattersall

If Alex Marshack can fairly be considered the father of the current technologically-oriented phase of European Ice Age art studies (following the two initial "symbolic" phases dominated successively and distinctively by the Abbé Breuil and André Leroi-Gourhan), nonetheless Alex's pioneering technological investigations were very consciously conducted in the service of understanding the symbolic implications of the unprecedented cultural manifestations of the European Upper Paleolithic. Painstakingly devoted as he was to the exegesis of microscopic and other minute detail (e.g., Marshack 1969, 1970, 1972a), Alex never took his eye off the larger picture of the changing ways in which earlier humans had viewed and interacted with the world around them (e.g., Marshack 1972b, 1972c, 1975, 1976) For he well realized that what, above all, makes *Homo sapiens* unique in the entire history of this planet is that, through the construction of mental symbols, we modern human beings recreate the world that surrounds us in our heads, rather than living, like other organisms, simply in the environment as presented by Nature. Alex's long and productive career was dedicated to improving our understanding of exactly how the hunters of the last Ice Age, clearly symbolic beings, had envisioned their own place in Nature, and to determining how far back in prehistory it is possible to find evidence for aspects of the unprecedented "human capacity" (Marshack 1985) that these long-vanished humans so dramatically exemplified. Alex concluded that,

in attenuated form, the behavioral "roots of civilization" could be traced back into the remotest past, to extinct hominids such as *Homo erectus* and far beyond, in a more or less linear development (see Marshack 1985, 1991). In this short essay I will argue, without apology (for Alex, with his instinctive intellectual generosity, certainly never remonstrated), that the available record instead suggests quite strongly that the current expression of the human capacity is not a simple extrapolation of earlier trends in hominid evolution. Instead, our unique cognition represents an emergent and entirely unforeseeable acquisition rather than a simple refinement of what had gone before. Evidently, although our long ancient evolutionary history was quite clearly a prerequisite of our finally becoming fully human, as Alex emphasized in his "hierarchical" view of the hominid evolutionary process (Marshack 1985), it was not in itself a determinant of that event. We are not, in other words, the end product as we so readily assume of a gradual process of fine-tuning over the eons. And this, in turn, has profound implications for our views of what our "human nature" actually is.

Pattern of innovation
in the hominid record

In trying to place in perspective the nature of the event that occurred in hominid evolution to produce the extraordinary phenomenon of *Homo sapiens*, it is necessary to understand the general pattern of change that has prevailed in the

hominid past. For a very clear tendency has prevailed in the acquisition of significant innovations, both behavioral and physical, throughout hominid evolution. In both realms the pattern has overwhelmingly been one of discontinuous - and uncorrelated - change, with long and essentially uneventful periods intervening between major events.

The origin of the hominid family itself is still somewhat mysterious, but the naming in recent years of several species and genera of early hominids in the period between about 6-7 and 4 myr ago has made it clear that the hominid family tree was bushy from the very start (see Figure 21.1). In other words, the early history of Hominidae was very much like its later phases - and indeed, resembles the history of most other successful mammal groups - in the sense that the dominant signal is consistently one of evolutionary experimentation, of an ongoing exploration of the many ways that there evidently are to be hominid. The one feature that is claimed to be shared by all of the very early fossil hominids - sometimes on rather slender grounds - is that all were upright terrestrial bipeds (see, for example, Leakey *et al.* 2001; Senut and Pickford 2001; Brunet *et al.* 2002). But the early form of bipedality apparently shared by these and later "bipedal apes" of the period from about six to two million years ago is not well characterized as "transitional" between an ancestral arboreality and our modern striding terrestriality. For the early modern body form was evidently a stable and successful adaptation, remaining essentially unchanged for several million years even as a slew of ancient australopith species came and went (Tattersall 1998).

Throughout most of this very long period of what was effectively adaptive if not systematic stasis, it is hard to detect any evidence that our ancient precursors had acquired cognitive capacities significantly in advance of those of today's apes. But at about 2.6 myr ago the invention of crude stone tools announced what it is impossible to interpret as anything other than a significant cognitive advance. For none of the great apes so far tested in experimental situations has yet grasped the notion that one piece of rock needs to be struck by another at a very precise angle to detach a flake with a sharp cutting edge. What's more, by selecting in advance stones of appropriate type and carrying them long distances before making them into tools as required (Schick and Toth 1993), the first stone tool makers demonstrated a level of intentionality that is, for instance, apparently lacking in chimpanzee hunting (Hart and Sussman 2005). Exactly which hominid among the variety of candidates available made the fateful transition to stone tool making is unknown, but it is virtually certain that the hominid concerned possessed an archaic body build and a brain not much larger than one would expect in an ape of similar size. This observation introduces a theme we find repeated throughout hominid history: that biological and technological advances do not go hand in hand. And while it might seem on some level unsatisfying that we cannot "explain" the introduction of a new technology by the arrival of a new kind of hominid, this disconnect between anatomical and behavioral innovation actually makes eminent sense. For there is quite obviously no place that any behavioral innovation can arise, other than within a species (Tattersall 2004).

And we also see reflected here another theme that is pervasive throughout human evolution: that hominid innovations, once established, have tended to persist essentially unmodified for long periods of time. For it was not for another million years that any substantial innovation was made in stone tool making. The earliest stone tools were effective but formless; their

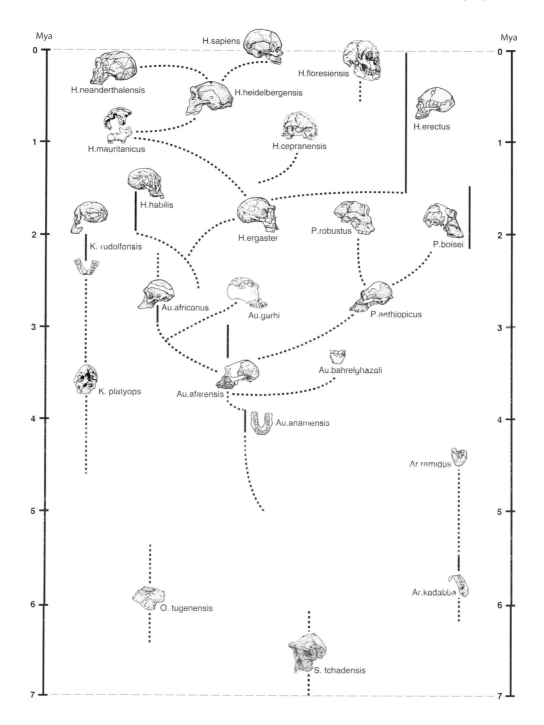

Figure 21.1 One possible family tree of the hominids, principally to give some impression of the diversity of hominid species and their distribution in time and space. Copyright Ian Tattersall.

makers were evidently interested simply in obtaining a sharp cutting edge. But eventually, at about 1.6 myr ago, an entirely new concept was introduced: the so-called "Acheulean handaxe," a largish implement consciously fashioned to a set and regular shape that evidently corresponded to a "mental template" that existed in the toolmaker's mind before fashioning began (Schick and Toth 1993). Here, again, we have evidence of some kind of cognitive advance, even though we know little about how this innovation affected or reflected change in the way the toolmakers saw or interacted with the world around them.

Significantly, hominids of a physically new kind had already been in existence for several hundred thousand years before this innovation was made. For at a little under two million years ago, hominids of essentially modern body build had appeared on the scene. This new kind of hominid is best exemplified by the tall and slender 1.6 myr-old "Turkana Boy" skeleton from northern Kenya (Walker and Leakey 1993). Early upright striders of this kind, with brains a little bigger than those of the bipedal apes, but still not hugely more than half the size of ours today, were the first hominids to be truly emancipated from the forest edge and woodland habitats to which their precursors seem to have been more or less confined. And these new creatures rapidly spread far beyond Africa, the continent of their birth, as witnessed at the extraordinary 1.8 myr-old site of Dmanisi, in the Caucasus (e.g., Gabounia et al. 2002). Yet they did so in the absence of stone tool-working technologies that were any more sophisticated than those of their predecessors, and it is only substantially later that the invention of the Acheulean announces, perhaps, the "discovery" of a new cognitive potential that had lain unexploited since the novel anatomical form had appeared hundreds of thousands of years earlier.

Again, there is a then a long wait for the next technological innovation, in the form of core preparation, whereby a stone "core" was carefully shaped until a single blow would detach a more or less finished tool. And once more this invention came long after a new kind of hominid had shown up in the fossil record, at about 600 kyr ago in Africa and shortly thereafter in Eurasia. It was hominids of this new species Homo heidelbergensis that, some 200 kyr later, apparently introduced such important novelties as the building of shelters and the regular domestication of fire in hearths. However, it is important to note that there is nothing in the archaeological record of these creatures to suggest convincingly that they indulged in symbolic activities.

Certainly among the most accomplished practitioners of prepared-core toolmaking were the Neanderthals, Homo neanderthalensis (Figure 21.2, left). And it is this well-documented species, which flourished in Europe and western Asia following about 200 kyr ago, that provides us with the contrast in which we can best see reflected the uniqueness of our own species, Homo sapiens. For while the Neanderthals had brains as large as ours, invented the burial of the dead, and clearly took care of disadvantaged members of society, they left little direct evidence behind them to suggest that they possessed symbolic consciousness. And these were, too, the archaic hominids whose total eviction by arriving Homo sapiens – whose existences were very clearly drenched in symbol – is best documented. Beginning some 40 kyr ago (and paralleled by similar processes that apparently took place in eastern Asia at about the same time), the Neanderthal eviction took not much more than a dozen millennia to complete (see review by Stringer and Gamble 1993).

As Alex Marshack and many others (see Bahn 1998) have documented, these early European Homo sapiens, known as the Cro-Magnons, were

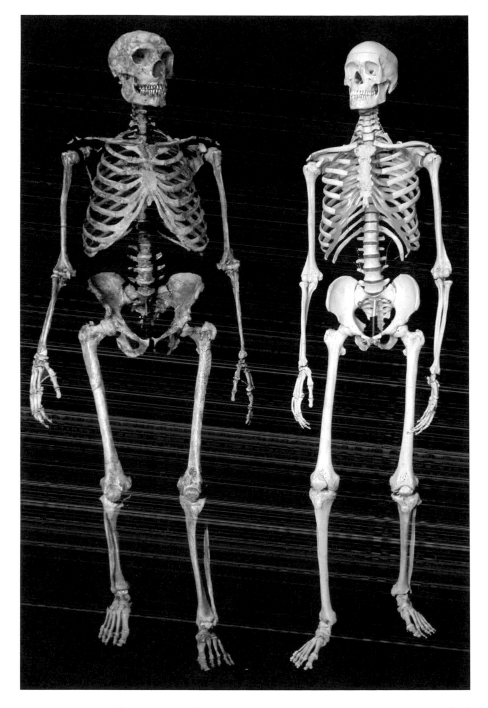

Figure 21.2 A newly reconstructed composite skeleton of Homo neanderthalensis *(left) compared with the skeleton of a modern* Homo sapiens *of similar stature. Note particularly the startlingly different proportions of the rib cage and pelvis. Photo by Ken Mowbray.*

astonishingly creative. They painted powerful images on the walls of caves. They carved exquisite figurines. They decorated everyday objects, and made complex notations on plaques of bone. They played music on bone flutes, and without question they sang and danced as well. In short, there is no doubt that they were us, not only physically but also in their intellectual functions and in their complex perceptions of the world, as Alex did as much as anyone to demonstrate. And the rich material record the Cro-Magnons left behind is distinguished most notably from those bequeathed by most of their predecessors and contemporaries by its clear indications of a symbol-based mode of cognition - a feature that is at the very most highly debatable at all stages of hominid evolution prior to the emergence of *Homo sapiens*. True, Alex, among others, detected evidence for symbolism in a variety of objects deriving from Mousterian and other early contexts (see Marshack 1991, 1997); but it remains undeniable that such manifestations tend to be both isolated and individually arguable, and that they certainly do not provide evidence for the early perfusion of symbolic intellectual processes throughout entire hominid societies, as the Cro-Magnon record so dramatically does.

Still, the Cro-Magnons were very far from being the first creatures who looked just like us. The highly characteristic bony anatomy that distinguishes modern *Homo sapiens* may have had its roots in Africa as long as 160-200 kyr ago (White *et al.* 2003; McDougall, Brown and Fleagle 2005), long before we find the earliest intimations of symbolic behaviors in that continent at about 100-70 kyr ago (Deacon and Deacon 1999; Henshilwood *et al.* 2003). Similarly, while anatomically modern *Homo sapiens* shows up for the first time in the Levant at a little under 100 kyr ago, these early Levantine anatomical moderns were making stone tool kits that were virtually indistinguishable from those made by the Neanderthals with whom they apparently shared this region for upwards of 50 kyr, far longer than the relatively fleeting, if not uneventful, period of cohabitation in Europe (Akazawa, Aoki and Bar-Yosef 1998). Interestingly, the final eviction of the Neanderthals from the Levant came right after the appearance there of stone tools equivalent to those the Cro-Magnons brought with them into Europe (Marks 1993). And what this seems to suggest is that cohabitation or environmental time-sharing of some sort was possible as long as the behaviors of both *Homo neanderthalensis* and early Levantine *Homo sapiens* could best be described as the most sophisticated extrapolations by then achieved of the halting tendencies toward expanding brain size, and presumably also toward increasing cognitive complexity, that had preceded them. But, once *Homo sapiens* began to behave in a "modern" way, the world was evidently faced with an entirely unanticipated phenomenon. And with the advent of a creature with a new way of conceptualizing and interacting with the world, the rules of the evolutionary and ecological games changed entirely. Our species became an irresistible force in Nature, clearly not only intolerant of competition but able to indulge that intolerance.

Set in the context of the overall established pattern of novelty-acquisition over the course of hominid evolution, it seems highly unlikely that what we are seeing in the emergence of modern hominid cognition is simply a "threshold effect," whereby a small incremental change, driven by natural selection, tipped *Homo sapiens* over the edge into an entirely new adaptive zone. Instead, it appears more accurate to view the symbolic modern intellect as the result of a qualitative rather than a quantitative revolution

in hominid cognition: something equivalent in scale developmentally to the unanticipated and apparently abrupt appearance of the essentially modern hominid body skeleton much earlier in hominid evolution.

The advent of symbolic cognition

What was it that happened to permit or to facilitate the apparently radical reorganization of hominid intellectual processes that we see expressed in the archaeological record only well after the emergence of *Homo sapiens* as a distinctive anatomical entity? To approach this question we must recognize that, in evolution, form has to precede function – if only because without form there can be no function (Tattersall 2002). Indeed, it is possible to argue that any evolutionary novelty must arise initially as an "exaptation" (Gould and Vrba 1982), a feature existing independently of any new function for which it might happen to be suited and later co-opted. By the same token, only once a structure has become established in a population may it assume a new role and become an "adaptation" to a new function. What is more, some genetic novelties spontaneously arising within populations may remain there not because they are particularly advantageous, but simply because they don't get in the way. One of the most famous examples of the rather routine phenomenon of exaptation is provided by the feathers of birds, which were evidently used by their possessors as insulation for millions of years before being co-opted as prerequisites of flight. But one might equally cite the origin of hominid terrestrial bipedality, which almost certainly could not have come about if the hominid ancestor had not already favored holding its trunk upright in its arboreal milieu.

Symbolic thought is the product of the physical brain, and it seems pretty safe to conclude that a neural reorganization of some kind within the preexisting hominid brain must have underpinned the transition to symbolic consciousness. When might that reorganization have taken place? It has been argued that this fateful acquisition might have been made relatively late, in a major biological event that did not find expression in the osteological features by which species in the fossil record must necessarily be identified (Klein and Edgar 2002). However, and especially given the early intimations of symbolic behaviors in the southern tip of Africa in the 100-70 kyr period (Deacon and Deacon 1999; Henshilwood *et al.* 2003), it seems more reasonable to speculate that the neural substrate for our remarkable symbolic cognitive abilities was initially acquired as a byproduct of the extensive physical reorganization that we see so clearly reflected in our unique and highly derived osteology (note the dramatic contrast between the *Homo neanderthalensis* – a much more routine hominid – and *Homo sapiens* skeletons shown in Figure 21.2). If so, the potential for symbolic cognition offered by this physical substrate – whatever it was – must have lain unexploited, or at least unexpressed in the material record, for some considerable lapse of time until it was finally "discovered" by its possessors.

This discovery can only have been made, and its symbolic potential unleashed, by means of some behavioral or cultural innovation. And the most plausible candidate for a cultural stimulus of this kind is the invention of language, an activity that is virtually synonymous with our symbolic reasoning ability – and that would certainly be impossible in its absence. Language involves forming intangible symbols in the mind, and it allows us to recombine those symbols in new ways, and to pose the "what if?" questions that permit us to be creative and to perceive and to relate to the world around us in an entirely

unprecedented fashion. Of all characteristic human activities, the acquisition of language is the most convincing behavioral releaser of our symbolic potential, and in this connection it is important to remember that, by this stage in human evolution, the structures that permit the production of the sounds essential to articulate speech had already been in place for tens of thousands of years, having quite evidently been acquired initially in some other functional context entirely. Extraordinary as its product may be, in evolutionary terms this process is a thoroughly mundane one. But its result was evidently an emergent product, rather than the culmination of a gradual and continuous process of honing by natural selection. The new and entirely unanticipated human potential evidently came about through an adventitious – and, by some reckonings at least, serendipitous – combination of elements. In which case, although our vaunted mental capacities would clearly not have been possible in the absence of earlier historical acquisitions, they were not predicted by those acquisitions, and they are not the result of an inexorable progression from primitiveness to perfection under the beneficent hand of natural selection.

Human nature

Until rather recently our hominid precursors were, as far as can be told, nonsymbolic, nonlinguistic creatures. That is to say, however sophisticated they may have been in their modes of communication and interaction with the world around them, at a fundamental level they more closely resembled other primates than modern human beings in these respects. This is not to say that earlier hominids were necessarily inferior to us at all levels. It is just to say that they were different, although it is this difference that may well in the end have made them the losers in the grand competition for ecological space and economic resources that played out among hominids in Africa, Europe and Asia towards the end of the last Ice Age. Prior to the dramatic spread of modern Homo sapiens at some time in the period centering on around 50 kyr ago, it had been routine for several different species of hominid to coexist in some manner throughout the Old World (see Figure 21.1). But in the handful of millennia that followed the emergence of behaviorally modern Homo sapiens, all of our species' hominid competitors rapidly disappeared, in a process that certainly tells us more about the special nature of behaviorally modern Homo sapiens than it tells us about what it means to be a hominid in general.

What is that special nature? The field of evolutionary psychology has taken upon itself to tell us that this nature is definable (starting with a list of "human universals": Wilson 1975) because it is dictated by our genes, themselves honed by eons of natural selection. One problem with this is, of course, that modern human beings quite obviously do not always behave in ways that are evidently "adaptive." But by appealing to a mythical and bygone "environment of evolutionary adaptedness" (see Irons 1998) such behaviors can be "explained" as adaptations to circumstances that no longer exist, neatly avoiding the problem. Infidelity, diabetes, even rape: all have been attributed to the past action of natural selection in ways designed to appeal to our unquestionably reductionist minds (see Wright 1994). After all, Homo sapiens happens to be a storytelling creature, and we will always respond to stories. But this doesn't mean that we were selected to do so, and it is important to appreciate that selectional explanations of human peculiarities only work if it is in fact permissible to single out individual traits as the targets of natural selection. And there is, of course, no way in which this can be the case

(Tattersall 1999). Genes are embedded in genomes of staggering complexity, and physical characteristics are integral parts of intricate wholes. There is no way in which natural selection can single out individual bits of organisms – let alone individual genes – to promote or disfavor, because it is the whole organism that succeeds or fails in the reproductive stakes. In an environment teeming with predators, for example, it's hardly helpful to be the smartest if you are also the slowest, or the most sharp-sighted if you are also the most poorly coordinated. It is the whole organism that thrives or fails reproductively, and whole organisms are in turn part of larger populations on which the ultimate fate of the individual and his or her genes also depends. It is of little use to be the best-adapted of your kind if your entire species is being outcompeted into extinction.

What is more, from the perspective of "human universals" – which almost invariably turn out neither to be universal among humans nor to be general primate traits (Hart and Sussman 2005) – it is hard to understand why our species Homo sapiens so readily yields up examples of virtually any pair of behavioral antitheses you might care to imagine (Tattersall 1998). Individual human beings may be altruistic or selfish, kind or cruel, generous or greedy, good-natured or vicious, cheerful or gloomy. And sometimes both at once; the genocidal monster Adolf Hitler is said to have been kind to children and dogs. On a larger scale, Homo sapiens is the species that created the Buddhas of Bamyan, and the one that blew them up. And on and on, the upshot being that the only species that (as far as we know) agonizes about its own condition is the very one that seems not to have one. Quite simply, there seems to be no central tendency in human nature, something that is hardly explicable by the fine-tuning model of human cognitive

evolution. Balancing the extremes (but only by doing so), Homo sapiens emerges as morally neutral: a species that cannot imagine god without inventing the devil. Of course, it is undeniable that, at least to some extent, individual human beings are "prisoners" of their own genes. But in itself membership in Homo sapiens predicts virtually nothing about behavioral proclivities more specific than the symbolic capacity.

All this falls into place, however, if modern human cognition is indeed an emergent quality rather than one that was finely honed by natural selection. As Alex Marshack emphasized in his concept of "hierarchically organized 'whole brain function'" (Marshack 1985:43), our human brain has a long and accretionary history that has resulted in a rather untidy "layered" structure, in which, for example, connections between "newer" components are mediated through some very ancient structures indeed. What's more, as phylogenetically newer brain components were acquired they did not replace, but rather were superimposed on, older structures. The result is that our modern human behaviors are not uniquely the product of our newer, associative, brain structures and the processes that go on within them. Instead, much of what we intuit, and probably most or all of what we feel, is mediated by some very ancient structures indeed. It is beyond my expertise to speculate as to what precise neural change – or group of genetically interrelated changes – it was that underwrote the behavioral shift to symbolic thought: Alex favored Norman Geschwind's (1964) brilliant early suggestion that cross-modal connections in the occipitoparietal angular gyrus underpinned object-naming and the development of language. But whatever that change was, it was superimposed upon all that had gone before it, with an entirely emergent result. It is clearly this complex and rather messy

history that underlies our often conflicted thoughts and feelings, and our odd combination of emotionality and rationality. And although we justifiably pride ourselves on our reason, it's probably fair to claim that most of us are happy that we are not calculating machines (for could a calculating machine be happy?) – even though we might treat the environment that supports us a bit better if we were.

Alex Marshack devoted the greater part of his career to understanding the diverse and subtle ways in which the Upper Paleolithic peoples of Europe perceived the world around them and explained their place in it to themselves. In the Cro-Magnon record he analyzed with such originality, we have an unparalleled record of ancient human creativity that gives us a brilliant snapshot of a relatively early stage in the discovery of the potential inherent in what Alex termed "the human capacity." This process of discovery evidently began in Africa, in the period around about 100 kyr ago (perhaps haltingly, for these earliest symbolic intimations may conceivably represent a false start: the southern tip of Africa which has yielded them was shortly thereafter depopulated by desiccation for several tens of thousands of years). But it is useful to realize that the initial expressions of the human potential were merely the beginning of a continuing process, rather than constituting an event in themselves. Under present conditions it is vanishingly unlikely (Tattersall, 1995) that biological evolution will intervene to improve human behaviors, or to make us better stewards of the world we live in. But we are still energetically exploring the apparently boundless potential of the emergent acquisition that made us fully human; and it is on success in that ongoing endeavor that we must place our hopes for the human future.

Acknowledgments

My warmest thanks go to Elaine Marshack and Paul Bahn for this opportunity to express my deep appreciation of both the career and the friendship of Alex Marshack.

About the author

Ian Tattersall, Division of Anthropology, American Museum of Natural History, New York, NY 10024, USA.

References

Akazawa, T., K. Aoki, and O. Bar-Yosef (editors)

1998 *Neandertals and Modern Humans in Western Asia.* New York: Plenum Press.

Bahn, P.

1998 *The Cambridge Illustrated History of Prehistoric Art.* Cambridge University Press, Cambridge, UK.

Brunet, M., F. Guy, D. Pilbeam, H. T. Mackaye, A. Likius, D. Ahounta, A. Beauvilain, C. W. Blondel, H. Bocherens, J.-N. Boisserie, L. de Bonis, Y. Coppens, J. Dejax, C. Denys, P. Duringer, V. Eisenmann, G. Fanone, P. Fronty, D. Geraads, T. Lehmann, F. Lihoreau, A. Louchart, A. Mahamat, G. Merceron, G. Mouchelin, O. Otero, P. P. Campomanes, M. S. Ponce de Leon, J.-C. Rage,M. Sapanet, M., Schuster, J. Sudre, P. Tassy, X. Valentin, P. Vignaud, I. Viriot, A. Zazzo, and C. P. Zollikofer

2002 A new hominid from the Upper Miocene of Chad, Central Africa. *Nature* 418:145-151.

Deacon, H., and J. Deacon

1999 *Human Beginnings in South Africa: Uncovering the Secrets of the Stone Age.* David Philip, Cape Town.

Gabounia, L., M. A. de Lumley, A. Vekua, D. Lordkipanidze, and H. de Lumley

2002 Découverte d'un nouvel hominidé à Dmanissi (Transcaucasie, Géorgie). *Comptes rendus de l'Académie des Sciences de Paris Palevol* 1:243-253.

Geschwind, N.

1964 The development of the brain and the evolution of language. In *Monograph Series on language and Linguistics* Vol. 17, edited by C. J. M. Stuart. Georgetown University Press, Washington, DC.

Gould, S. J., and E. Vrba

1982 Exaptation - A missing term in the science of form. *Paleobiology* 8:4-15.

Hart, D., and R. W. Sussman

2005 *Man the Hunted.* Westview Press/Perseus Books, New York.

Henshilwood, C., F. d'Errico, R. Yates, Z. Jacobs, C. Tribolo, G. A. Duller, N. Mercier, J. C. Sealy, H. Valladas, I. Watts, and A. G. Wintle

2003 Emergence of modern human behavior: Middle Stone Age engravings from South Africa. *Science* 295:1278-1280.

Irons, W.

1998 Adaptively relevant environments versus the environment of evolutionary adaptiveness. *Evolutionary Anthropology* 6:194-204.

Klein, R. G., and B. Edgar

2002 *The Dawn of Human Culture.* Wiley, New York.

Leakey, M. G., C. S. Feibel, I. McDougall, and A. Walker

1995 New four-million-year-old hominid species from Kanapoi and Allia Bay, Kenya. *Nature* 376:565-571.

Marshack, A.

1969 Polesini, a reexamination of the engraved Upper Paleolithic materials of Italy by a new methodology. *Rivista di Scienze Preistorichi* 24:219-281.

1970 Le bâton de commandement de Montgaudier (Charente): réexamen au microscope et interprétation nouvelle. *L'Anthropologie* 74:321-352.

1972a *The Roots of Civilization.* McGraw-Hill, New York.

1972b Upper Paleolithic notation and symbol. *Science* 178: 817-828.

1972c Cognitive aspects of Upper Paleolithic engraving. *Current Anthropology* 13:445-477.

1975 Exploring the mind of Ice Age man. *National Geographic* 157(5):62-89.

1976 Some implications of the Paleolithic symbol evidence for the origins of language. *Annals of the New York Academy of Sciences* 280:289-311.

1985 *Hierarchical Evolution of the Human Capacity (54th James Arthur Lecture on the Evolution of the Human Brain).* New York: American Museum of Natural History.

1991 *The Roots of Civilization,* Second Edition. Moyer Bell, New York.

1997 The Berekhat Ram figurine: A late Acheulian carving from the Middle East. *Antiquity* 71:327-337.

Marks, A. E.

1993 The early Upper Paleolithic: The view from the Levant. In *Before Lascaux,* edited by H. Knecht, A. Pike-Tay, and R. White, pp. 5-21. CRC Press, Boca Raton.

McDougall, I., F. H. Brown, and J. G. Fleagle

2005 Stratigraphic placement and age of modern humans from Kibish, Ethiopia. *Nature* 433:733-736.

Schick, K., and N. Toth

1993 *Making Silent Stones Speak: Human Evolution and the Dawn of Technology.* Simon and Schuster, New York.

Senut, B., and M. Pickford

2001 First hominid from the Miocene (Lukeino formation, Kenya). *Comptes Rendus de l' Académie des Sciences de Paris (Sciences Terre)* 332:137-144.

Stringer, C. B., and C. Gamble

1993 *In Search of the Neanderthals.* Thames and Hudson, London.

Tattersall, I.

1995 *The Fossil Trail: How We Know What We Think We Know About Human Evolution.* Oxford University Press, New York.

1998 *Becoming Human: Evolution and Human Uniqueness.* Harcourt Brace, New York.

1999 The abuse of adaptation. *Evolutionary Anthropology* 7:115-116.

2002 Adaptation: The unifying myth of biological anthropology. *Teaching Anthropology: SACC Notes* 9(1):9-11, 39.

2004 What happened in the origin of human consciousness? *Anatomical Record (New Anatomist)* 267B:19-26.

Tattersall, I., and J. H. Schwartz

2000 *Extinct Humans.* Westview Press, Boulder, CO.

Walker, A., and R. E. F. Leakey

1993 *The Nariokotome Homo erectus Skeleton.* Harvard University Press, Cambridge, MA.

White, T. D., G. Suwa, and B. Asfaw

1994 *Australopithecus ramidus,* a new species of early hominid from Aramis, Ethiopia. *Nature* 371:306-312.

White, T. D., B. Asfaw, D. DeGusta, H. Gilbert, G. D. Richards, G. Suwa, and F. C. Howell

2003 Pleistocene *Homo sapiens* from Middle Awash, Ethiopia. *Nature* 423:742-747.

Wilson, E. O.

1975 *Sociobiology: The New Synthesis.* Harvard University Press, Cambridge, MA.

Wright, R.

1994 *The Moral Animal. Why We Are the Way We Are: The New Science of Evolutionary Psychology.* Pantheon Books, New York.

22

JEAN VERTUT†

Alexander Marshack†, with an introduction by Paul G. Bahn

Jean Vertut and Alex Marshack

Had he lived (he died in 1985), Jean Vertut, France's foremost photographer of cave art, would undoubtedly have wished to contribute to this volume in honour of his close friend, Alexander Marshack. The two men collaborated closely for many years, sharing and comparing their pioneering techniques for recording and studying Ice Age imagery. Unfortunately, Jean does not seem ever to have taken a photo of Alex, nor is there any photo of them together. But it seemed right and indeed indispensable for Jean to be represented in some way in this volume, so the best solution seems to be to re-publish a rare document - an account written by Alex as an appendix to a book (Bahn and Vertut 1988) in which he explained something of Jean's methodology and of their relationship. Its moving closing sentence is now, of course, equally applicable to Alex himself.

Paul G. Bahn

I

For almost a dozen years, Jean Vertut, one of the leading engineers and theoreticians in the field of robotics, would fly to engineering and nuclear laboratories in the U.S.A. to discuss developments in the subject and research projects being conducted between France and the United States. On each such visit, he would stop for some days at our apartment in New York, arriving with a valise of documents, a loaf of French farm bread, fresh camembert cheese, a sealed packet of strong French coffee, and hundreds of

Figure 22.1 Jean Vertut ca. 1969. Photo used with the gracious permission of the Vertut family.

transparencies documenting his recent photographic work in the Upper Paleolithic caves. In his last years this included his work in the Volp Caverns, Trois Frères and the Tuc d'Audoubert. The engineering and robotics projects represented his theoretical and practical professional work, part of the sophisticated contemporary effort to replace man in certain specialized areas of production and mechanical motion. The study of Upper Paleolithic art represented Jean's equally professional and technical, but private, personal involvement in the effort to understand the work of the hand and mind of early man,

particularly as found 'at home' in the Franco-Cantabrian region of France and Spain.

On these visits we recognized that these areas of Jean's work and interest both equally represented the capacity, mind and work of man. We would talk without cease for hours about the theoretical and practical problems involved in robotics and engineering. These discussions included the extraordinary complexity of dealing with the real physical world with instruments and sensors, and the even more complex problems of dealing with the real physical and cultural world of man through concepts and symbols. For Jean and me, these problems, if not equivalent, were comparable. We went imperceptibly from one field of discourse to the other. Both theory and technology formed the base of our discussions within these areas. The constraints and limitations present in these human efforts were discussed as well as the techniques and potentials for increasing analysis, understanding and production. It is doubtful whether the Upper Paleolithic symbol systems and cultures were ever discussed in quite this philosophical and technological manner or within such a context.

Jean brought to these highly technical and philosophical discussions a deep interest in religion, that is, in the affective, emotional contents of symbolic imagery and ritual. He once brought with pride a recording in which he, his wife and children, as well as others, had participated in the reconstruction and production of early Christian songs and hymns. In our discussions about image and symbol, Jean referred often to the work of Marcel Jousse, the French Catholic philosopher and semanticist, whose earlier theories on imagery, symbolism, information exchange and education, Jean suggested, had apparently influenced André Leroi-Gourhan, whether consciously or not. We had long discussions about the levels of information in image and symbol, and how these changed during production, during repeated viewing, and during analysis. I added to these discussions an interest in neuropsychology and cognition, in the way in which the human hand and mind work to solve problems in the real and cultural worlds, and the many levels of information that are contained in any cultural set of images and symbols.

In the evening, when the sky and room had darkened, we would project our hundreds of transparencies and photographs, discussing the data or information apparent and missing in each photograph and image. We discussed the techniques that might be used to secure different levels of information from the same image. In the 1970s I had pioneered the use of special analytic techniques for study of the cave images, as I had earlier pioneered the use of the microscope to study the problems of manufacture and use among the mobiliary symbolic materials. With grants from the National Science Foundation and the National Geographic, I had developed the use of infra-red, ultra-violet, and fluorescence techniques, as well as the technique of microscopic photography for the study of a host of specialized problems in the caves. Each image, panel and cave represented different sets of problems and required different sets of analytic techniques. I had deposited a set of results with the Minister of Cultural Affairs in Paris, but also lent Jean my filters, lamps, charts and results, and he tested these in his own cave work. We compared results in these evening discussions, suggesting to each other still newer modes of analysis and documentation.

Jean had pioneered in the effort to recreate the ambience or atmosphere of the cave environment, the overall impression of three-dimensional space and complexity that could not be captured in the flat photographs of animals or details

of tableaux. His photographic reconstructions of the ceiling of bulls in Altamira and the panel of horses and cattle in Lascaux prepared for Leroi-Gourhan's classic volume Préhistoire de l'Art Occidental remain the most widely known images of these two famous tableaux from the two giants of Franco-Cantabrian cave art. In the 1960s he photographed the famous clay bison in the Tuc d'Audoubert, using two lamps. Later he photographed the bison using four lamps, a dramatic three-dimensional photograph that has become the classic representation of these famous clay carvings. The Lascaux panel and the Tuc d'Audoubert photographs were key images in the first exhibition of European Upper Paleolithic art in the United States, which I prepared, with Jean's help, in 1978. In the 1980s, while working with Robert Bégouën to document the caves of Tuc d'Audoubert and Trois Frères, Jean photographed the clay bison in a still more complex manner. He used six lamps to enhance the three-dimensional rendering, photographed the bison in stereoscopic photography, made a wide-angle documentary photograph of the clay bison in their context within the low-ceilinged chamber, for the first time giving us a sense of their size within the chamber (they had seemed over-large and life-sized in the earlier photographs), and finally he documented them in photogrammetry, and then by computer use of the data helped reconstruct a model of the bison for exhibition at the Musée de l'Homme in Paris.

And still Jean was dissatisfied. He made endless close-up, detailed photographs of the bison, documenting the way in which the statues were carved, using tools and hand-modelling, documenting the remnants of unfinished clay left on and around the carvings, the evidence of bat clawmarks around the bison, etc. In this sense, no single photograph was a final or adequate document. Jean and I had for years insisted that

the usual flat photographic document of the cave image and the even more schematic tracing or 'relevé' were inadequate for documenting the analytic complexity to be found in the images and tableaux. It was, therefore, with a sense of profound appreciation that we welcomed and discussed the analytical work of Brigitte and Gilles Delluc in deepening methods of analysis and documentation in their studies of limestone carvings in the home sites and caves of the Aurignacian period in the Dordogne. We welcomed this work as another step in the direction of the necessary methodological analysis that went beyond the simple visual surface observations and analyses of the earlier researchers.

Jean had done the photographs for Leroi-Gourhan in the 1960s, and had slowly come to realize that these photographs, while dramatic and beautiful, were also 'falsifications' and subjective 'abstractions', and that one must, in the next stage, go beyond these simple surface images or 'documents'. He attempted to deepen photography as a documentary means and, therefore, welcomed the cartographic and illustrative method, developed by the Dellucs, of providing information that supplemented the photograph. I had experimented with comparable but simpler techniques of schematically rendering the analytical data that are documented in the photograph but are not apparent to the untrained observer. For these reasons, Jean had arranged a meeting with the Dellucs in Périgueux in 1983, where we discussed technology, theoretical, analytical and interpretative problems; and a need for a joint effort by researchers in the field to discuss the problems and possibilities being opened up in the contemporary period.

Leroi-Gourhan had instituted an earlier stage in the investigation of the cave art by his visual and structural studies of the images; the

relation of the images to each other; and their position, form, and style. While Jean had provided most of the photographic documentation for Leroi-Gourhan's volume, Leroi-Gourhan's work was not analytical in the sense of the work that Jean, among others, then attempted to develop; no single image or composition was given intensive internal study. The young researchers who followed Leroi-Gourhan, including his students the Dellucs, Michel Lorblanchet and Denis Vialou, and an older generation including Jean and myself had begun experimenting with new levels of analysis and interpretation. Jean, as an advocate and discussant, was attempting to circulate information on these many efforts among the researchers and to bring together the separate persons and technologies. Many of the symposia and colloquia that began to appear were in some measure instituted by his persistent advocacy and efforts.

There was no better opportunity to appreciate Jean's perception of the caves as an area of analytic problems than a visit to one with him. I remember a decade ago in one deep chamber in the Tuc d'Audoubert that we came upon an unpublished 'Aurignacian' panel of intertwined incised macaronis or meanders. He and I lay down on the damp clay floor and, like students at work on a puzzle, went line-by-line through the entire composition, attempting to determine the point of beginning (apparently within a crack in the wall) and to reconstruct the sequence and logic or 'strategy' of its subsequent development or construction. The macaroni, exiting at the left from the crack in the wall, then wandered, twisting in every direction, intertwined and interlaced, and crossed over to the other side. We lay on our backs for a long time, discussing how to unscramble and document the composition, and what photographs would be required at points of intersecting and over-crossing lines to determine

priority in engraving. In traditional documentation by tracing or photography, such a panel would have been published as a meaningless mélange of wandering lines (see the abbé Glory's tracings of the Magdalenian macaronis in the volume Lascaux Inconnu, edited by A. Leroi-Gourhan & J. Allain, 1979).

Jean later began the photographic documentation and we discussed his first photographs and the need for closer analysis, but he died before its completion. The macaronis in the Tuc d'Audoubert were perhaps the least interesting evidence of human activity in the cave in the traditional frame of archaeological evidence, but, like sets of intentional fingerprints and spear marks found in the clay in other parts of the cave, they added to the sense of variable and complex symbolic use at times to create images of 'art' and, at other times, images of participatory ritual marking.

In the same cave, we also squeezed into a tiny, difficult-to-reach 'chamber' whose upper portion was only large enough for our two heads and our arms which were used to point out the images and the problems we would like to document by photography and microphotography. The chamber, with its rounded ceiling, had at its center a tiny, crudely engraved horse encircled by a large number of 'P' signs, referred to as a feminine sign in Leroi-Gourhan's classification, a schematic figure apparently derived from the female form. Jean and I examined each sign, trying to recreate its mode of manufacture. Some were clearly made by stone tools, but others by a finger; some were over-engraved or renewed; most were made by right-handed persons, some by the left hand; most were in a sequence or row of 'P' signs, though some, apparently added later, were isolated. We stood there and discussed which images needed microscopic documentation, how the entire composition and sequence of manufacture

could be reconstructed, and what levels of information required documentation.

Jean began the documentation we had discussed, and the following year we spent one long evening going over his preliminary photographs and sketches of the composition. This was not the Jean Vertut of the beautiful photographs but Jean the scientist, analyst and investigator, the technician and developing theoretician. The excitement of these developing analytic efforts and his increasing steps to document the dynamics of cave use and symbolism made him speak often of retiring early from engineering to take a degree in Paleolithic archaeology, and devote all his time to the study of the art. He died in mid-career, both in the field of robotics and in the study and documentation of the caves.

II

Jean Vertut had begun taking photographs of the art in the caves in mid-century before the introduction of modern flash and strobe or of high-quality color films. With each introduction of technology, he drew on his knowledge of engineering to update his cameras, meters, lights, films, and eventually began to use special filters and films. A large part of our discussions in the last few years concerned his use of new techniques and equipment for the analysis or documentation of particular types of problems. At times he developed his own photographic apparatus and technical devices when these were not commercially available. He had begun to use infra-red and ultra-violet in conjunction with special filters, in part following on and enlarging on my earlier efforts. He also began using high contrast color films, developed for biological microscopy, to enhance the cave images. He did macroscopic studies of the engravings to study faint and difficult images. He experimented with stereoscopic photography and three-dimensional

representations of carved and sculptured forms. He conducted photogrammetric studies of the bison of the Tuc d'Audoubert to create a computerized reconstruction of the sculptures. He developed a method of piecing together major cave tableaux (Lascaux, Cougnac, *etc.*) from separate photographs by using arrays of projectors to create overlapping seamless images. He had begun to use Munsell color charts in recent years to verify the accuracy of the colors in his reconstructed panels and cave tableaux, but he also intentionally altered the color values of certain images to increase contrast or heighten faded images. We had both begun an investigation of the uses of computer enhancement to recover images and to unscramble particularly complex accumulations, and were preparing a program to initiate use of the method for particular analytical problems in some of the major caves.

Jean never developed techniques merely for their use but always as a means for attacking and solving particular problems. He not only pioneered in the use of new techniques but encouraged their testing by colleagues. There was never a sense of proprietorship or secrecy in his development of new approaches. This combination of technical advocacy and an ongoing effort to document and present the cave images at different levels of 'information', as he put it, made him one of the pioneers of the present new stage of research and documentation, a research which he had begun when assisting Leroi-Gourhan in mid-century and continued to develop until the time of his death. Without offering a hypothesis as to the meaning of Upper Paleolithic cave art, he contributed enormously to the documentation and to our understanding and appreciation of its complexity and beauty.

Almost every picture that Jean took in the caves of the Tuc d'Audoubert and Trois Frères in the last few years, while working with Robert

Bégouën, was taken to make a point, or to present data on the complexity of the human activity associated with use of the caves and the creation of the diverse images and symbol systems found in these major caves. When he showed his slides, there was a lesson in documentation, analysis and complexity in each. There is a profound sense of loss in his passing and the silence that now accompanies his massive documentation.

About the author

Alexander Marshack [†] was a Research Associate at the Peabody Museum, Harvard University, Cambridge, MA 02138 USA. His documents and photographs were graciously donated to the Peabody Museum and are now archived there.

[†] *deceased*

Reference

Bahn, P. G., and J. Vertut

1988 *Images of the Ice Age*. Windward, Leicester; Facts on File, New York.